ARTODAY

Edward Lucie-Smith

ARTODAY

Φ

Introduction

This book is a survey of the richest, most controversial and perhaps most thoroughly confusing epoch in the whole history of the visual arts – the period from 1960 to the present. This span of thirty-plus years has been variously defined. Some critics have called it Post-Modern, others Late Modern. Still others have thrown up their hands and refused to attach any label to it, while admitting that it is nevertheless very different in tone from the first six decades of the twentieth century, which can be defined as the period occupied by the full flowering of the classic Modern Movement.

The main difference, I believe, is to be found in plurality, absence of hierarchy, and a vast expansion of the cultural base. The usual model for describing the progress of the Modern Movement itself is a dialectic of styles. In this model, each major art style is either a direct retort to, or a commentary upon, those which were its immediate predecessors. Occasionally the model becomes a little more complicated, at times when stylistic development splits into several different branches or streams. Thus, in the hectic years immediately before World War I, Cubism coexisted and overlapped with the development of Expressionism and Futurism. Following that war, Surrealists and Constructivists occupied opposed and mutually hostile camps.

While the stylistic dialogue did not exclude the involvement of art with politics – for example both the Surrealist Movement and Constructivism had strong links, though of different sorts, with Soviet Communism – art historians largely managed to ignore these in discussions of the art itself, only introducing the topic into biographical accounts, or chronologically arranged histories of particular art movements. It seemed that even commentators who were avowedly left-wing in politics found the weapons of formalist art criticism largely sufficient when dealing with Modernist visual materials.

The art of the Modern Movement placed great emphasis on certain characteristics, which have been inherited by its Late Modernist and Post-Modernist successors. Inherited from the Romantic Movement of the early nineteenth century was the notion that art, to be valid, must be the expression of extreme individualism – the outflowing and

embodiment of a unique personality. The cult of genius, which first manifested itself in the late sixteenth century in the attitudes of contemporary biographers (Giorgio Vasari and Ascanio Condivi) towards Michelangelo, was further consolidated in the nineteenth, to the benefit of writers such as Goethe and Byron as well as of painters such as Théodore Géricault, J.M.W. Turner and Eugène Delacroix. Under Modernism, genius was the only truly validating excuse for making art, and there was increasing emphasis on the personality of the artist as opposed to his products.

A further contribution to the morphology of Modernism was made by the Symbolist Movement, itself an off-shoot of Romanticism, which flourished from the 1880s until past the turn of the century. It was Symbolism which consolidated the idea of the artist who existed essentially 'outside', and therefore opposed to, all conventional social structures. It proposed that art itself, instead of being a reflection of the natural world, was a deliberately artificial construct. At the same time it made the first moves towards investing the artwork itself with a mysterious, ambiguous power. Its job was how to be suggestive, not to describe, and from this it was a short step to giving certain works of art the status of holy relics. Paradoxically, this move combined well with a growing cult of personality.

Everything inherited by the Modern Movement from the immediate past inclined it to be transgressive – to challenge artistic norms as well as to flout established visual conventions. Indeed this transgressiveness, this aggression towards both visual and social surroundings, soon came to be seen as one of the distinguishing marks of Modernism.

It is not surprising, therefore, that the Modern Movement began its career as the property of an élite. The artists, their interpreters and their supporters formed a tiny minority within the culture that surrounded them. The new art was essentially unofficial. It had no truck with official institutions, and was particularly hostile to museums. One reason for this was that many Modernist groups were determined to abolish respect for the past, which they felt laid an oppressive weight on the art of the present. Many traces of this feeling can be found in Italian Futurist manifestos – especially significant because the Futurists

1 Théodore Géricault, *Officer of the Hussars*, 1812
Oil on canvas, 349 × 266 cm
(137½ × 104¾ in)
Louvre, Paris

2 Paul Gauguin, *Woman with a Flower*, 1891
Oil on canvas, 70 × 46 cm (27½ × 18 in)
Ny Carlsberg Glyptotek, Copenhagen

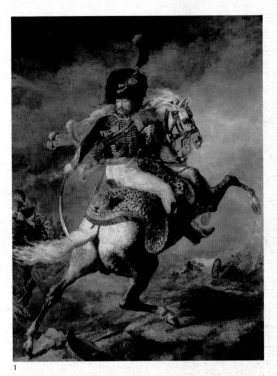

1

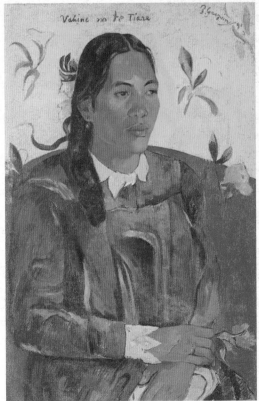

2

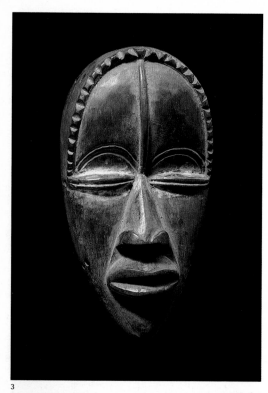

3

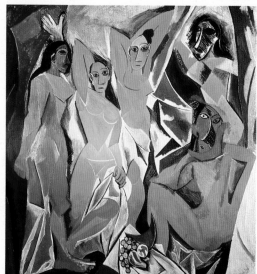

4

were the first organized group of Modernist artists. Here, for example, is a passage from the earliest of all Futurist documents, *The Founding and Manifesto of Futurism*, published in the French newspaper *Le Figaro* in February 1909:

> In truth I tell you that daily visits to museums, libraries, and academies (cemeteries of empty exertion, calvaries of crucified dreams, registries of aborted beginnings!) is, for artists, as damaging as the prolonged supervision by parents of certain young people drunk with their talent and their ambitious wills. When the future is barred to them, the admirable past may be a solace for the ills of the moribund, the sickly, the prisoner ... But we want no part of it, the past, we the young and strong *Futurists*!

The Modernists did not merely reject the past; they made, despite their minority status, more or less exclusive claims to the future. In the long run, they and only they would count. This was, in one sense, just another form of provocation, a way of thumbing their noses at society. In another way, however, it was deeply sincere, and the claim was made with absolute conviction.

In their view, what was that future to be like? I think the answer is obvious: they saw it as entirely Eurocentric. The association between Modernism and Communism, generated by the October Revolution of 1917, has tended to obscure the fact that the Modern Movement, at its inception, if it had conscious political affiliations of any sort, inclined to the authoritarian right, and not to the left. This was certainly true of the Futurists – F.T. Marinetti and his associates. Those who survived World War 1 finished as camp followers of Benito Mussolini.

Because they often viewed art itself in terms of war and conquest, the Modernists were sympathetic to the colonialism of the epoch. In addition to this, they had inherited from Symbolism, and especially from one of its chief standard-bearers, Paul Gauguin, an enthusiastic cult of 'the barbarous'. It was by embracing barbarism that they would be able to overturn existing cultural institutions. Perhaps the outstanding instance of this is the way in which the first generation of Modernists embraced African art. Picasso was not alone in this, though he is now the best-known example: there were also Matisse, Vlaminck, Derain, all of them at one time or another

collectors of 'primitive' objects found in the junk shops of Paris. To them African carvings were as revelatory as Japanese *ukiyo-e* prints had been to an earlier generation of artists.

As Picasso made plain – on one occasion he remarked that Braque did not understand *art nègre* 'because he was not superstitious' – one of the things the first generation of European avant-gardists liked about the art of Africa was its mysteriousness. They felt no desire to shatter that mystery by travelling to Africa itself. Nor did they feel any need for the kind of ethnographical or anthropological information which might give the carvings they admired a proper context. Their relationship with them was one of almost deliberate ignorance and misunderstanding. From these sources there came the cult of 'classical' African art we still have with us today – an art admirable because isolated, undiluted by any European influence.

From this there sprang a general principle of classic Modernism: that it was perfectly legitimate for Europeans to borrow what they liked from non-European, supposedly untainted sources – but there must be no traffic the other way. This attitude makes a curious contrast with another tenet of Modernism from its origins, which was that Modernist attitudes had within them the makings of a universal creed.

The society which invented the Modern Movement did not survive the moment of invention for long. It crumbled into ruins with the outbreak of war in 1914. Naturally the Modernists reacted to events, and frequently they reacted with rage and despair – emotions reflected in the various Dada movements which flourished during the war years and just after them. The fundamental legacy of these movements, even when they appeared to have been forgotten (or, rather, swallowed up by other movements, according to the standard Modernist process) was an underlying element of nihilism. This, at least, would be ready to show itself again as the century moved towards its conclusion. One example is the extraordinary imagery used by painters such as Francis Bacon (Pl. 185) and Jean Rustin (Pl. 214).

The events of World War II, though in some ways even more horrific than those of its predecessor, did not have quite the same impact on the avant-garde, even though their

consequences were necessarily profound in themselves. Looking back over the near half-century which has now passed since the end of the conflict, the two most important results appear to have been these: first a shift in the balance of power in the visual arts to the United States, and second the fact that the Modern Movement was at long last accorded quasi-official respectability. These two events had a far more powerful effect on Modern artists than other factors which seem to feed in to immediately post-war art, such as horror at the Nazi concentration camps, or consuming anxiety about the atomic bomb.

The United States had been a participant in the Modern Movement almost from its beginnings – the vast Armory Show of 1913, seen in New York and Chicago, had confirmed American interest in the new cultural developments which were taking place in Europe. Nevertheless, American artists remained followers rather than leaders until the mid-1940s, a situation summed up by an anecdote about Arshile Gorky. Gorky spent the inter-war period as a notorious pasticheur, and his dependency on European exemplars became something of a joke in the New York art world. On one occasion it was maliciously pointed out to him that Picasso had abandoned the clean-cut edge Gorky had been at such pains to cultivate. 'If Picasso drips – I drip!' he retorted unabashed.

The exodus of almost the entire Surrealist Group to the United States, in order to escape the war in Europe, and a new consciousness of American world leadership, produced the sudden upsurge of artistic self-confidence which created Abstract Expressionism. When the war was over, this home-grown American style proved to have an irresistible attraction on the other side of the Atlantic, as well as in the United States. The apparently universal validity of Abstract Expressionism, replacing predecessors such as Cubism, Constructivism and Surrealism, seemed to be yet another step in the established dialectical process I have already described, different from the others only because it involved a geographical as well as a purely stylistic shift.

The sudden respectability of the Modern Movement sprang from negative rather than positive causes. It was the unrelenting hostility of the Nazis to what they described

as Degenerate Art, and their destruction of artworks and persecution of artists, that greatly accelerated the progress of the new art towards the official centre. The process of institutionalization had begun.

Pop Art was the first major challenge to Abstract Expressionism, and when it emerged it simply seemed to mark yet another dialectical shift. Certainly this was the way in which the situation was read by many of the partisans of till-then triumphant Abstract Expressionism. The way in which Pop artists identified themselves with the consumer culture was for many critics and theoreticians a major intellectual betrayal. Abstract Expressionism had seemed to them, and indeed to the artists themselves, an art of aspiration, a celebration of the individual and of artistic individuality, a generous outflowing of the psyche, careless of all risks. In fact, it was an art of paroxysm, just as the art of the great Romantics had been a century and a half earlier. Pop, deliberately cheap, deliberately blank, came like a slap in the face.

The beginning of the 1960s, when Pop Art first emerged, represented – as it now seems in hindsight – an important historical turning point, in many ways a more important one than the end of World War II. The shock administered by the war had been so profound that it took even the nations whom in the long run it benefited, chief among them the United States, a long time to make a full adjustment to the change. The new mass culture, based on consumerism, needed time to establish itself, but once it did its impact was felt on every aspect of living. Meanwhile the world rapidly grew smaller because of the growth of modern communication networks and the introduction of new technology. This, in turn, meant a breakdown of cultural barriers, some so traditional and long-established that people had not even been fully aware of them. In particular, the distinction between 'Western' and 'non-Western' was greatly diminished. This is not to say, however, that it entirely vanished – it was simply that so-called non-Western cultures had much greater access, not only to the kinds of mass-produced goods and the technological services associated with the West, but also to Western ideas.

Another result, peculiar to the art world, was an enormous growth in the number of

5 Marcel Duchamp, *Fountain*, 1917
Porcelain, height 33.5 cm (14 in)
Indiana University Art Museum,
Bloomington, Indiana

6 Roy Lichtenstein, *In the Car*, 1963
Magna on canvas, 177 × 203.5 cm
(67¾ × 80¼ in)
Scottish National Gallery of Modern Art,
Edinburgh

7 Jackson Pollock, *Number 1A, 1948*,
1948
Oil on canvas, 172.7 × 264.2 cm
(68 × 104 in)
The Museum of Modern Art, New York

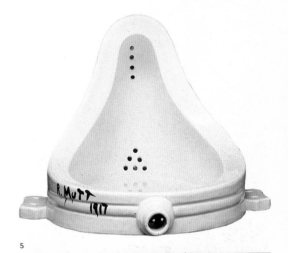

5

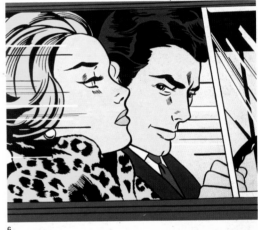

6

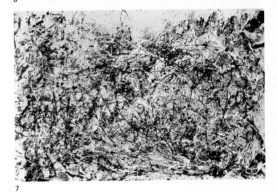

7

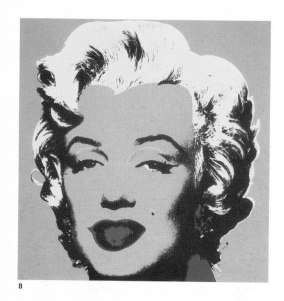

8

museums, and a greater shift in the attitudes of museums towards the public and in the kind of art they made available. Museums were democratized and became more user-friendly. They tried to engage and entertain a broader public, rather than acting as passive repositories: storehouses of knowledge and of objects which visitors themselves had to activate. These developments were linked to a much greater emphasis on contemporary art. For this there were several causes: the greater respectability of the Modern Movement, already mentioned; the fact that contemporary art works were more readily available – an increasing rather than a steadily diminishing supply. Also, and perhaps most of all, the fact that the new museum public seemed to find it easier to connect with objects contemporary with itself.

Here, yet again, we run into something which seems paradoxical, therefore at first glance unexpected. The consumer society was, as everyone agreed, increasingly secular. Yet museums often seemed increasingly like temples – sacred spaces. This was true in two senses. There was the minor element in the comparison – that they often, especially in regions like the Mid-West of the United States, became the new focus for community life. The church picnic and the bring-and-buy were replaced by the exhibition opening and the museum fund-raiser. They also became sacred spaces in a much more profound sense. In a modern society they are the repositories of mana; the place where we go to put ourselves in touch with inexplicable, perhaps somewhat awe-inspiring forces. In a supposedly rational, as well as secular, society they offer a refuge for the irrational, for powers people evoke, perhaps largely from within, but still do not fully comprehend. The exemplary function of the museum was thus in a sense distorted, as was its power to impose stylistic rules.

All this contributed to the breakdown in the structure of the art world reflected in this book, which aims to deal with the newest art and with what immediately preceded it. Quite simply, the old idea of hierarchy collapsed with astonishing rapidity, and was replaced with the rich pluralism we see today. There is no longer a dialectic of styles, but a babel of conflicting ideas about the nature of art.

The first apparent challenge to Pop came

from the Minimal and Conceptual Art of the late 1960s. Critics of the time, who traced this development to things already dormant within Pop Art, were largely in the right. Pop artists had often been more interested in conventions of representation than in the thing represented. This observation can be made about Roy Lichtenstein's interpretations of frames from comic strips, in which he used a vastly enlarged version of the image-creating devices built into cheap colour printing. From conventions of representation it was a brief step to an analysis of conventions of all kinds, among them, as in so much Conceptual Art, an examination of conventions of language and the relationship between words and the world of objects.

Pop was related to Minimal Art in a similar, but slightly different fashion. A Warhol *Soup Can* (Pl. 11) or *Marilyn* (Pl. 8) aimed to reduce a familiar object or icon to the simplest form in which it would remain immediately recognizable. Something was represented, but all the overtones and undertones associated with most attempts at representation were summarily abolished. Minimal Art applied a rather similar process to purely abstract forms.

One of the reasons for the long survival of Minimal Art, which retains a powerful presence in the art world today, was its suitablity to the agendas and purposes of a new generation of museums. Minimal Art represents a process of aestheticization. Effectively, its message to the viewer is that the only viable subject for contemporary art is art itself. If it has a further message, in addition to this, it is that the function of artworks is to energize the spaces in which they are placed by heightening the spectator's awareness of architectural volumes and spatial relationships. Naturally both ideas are extremely acceptable to the new culture which modern museums have evolved. The simpler and 'dumber' the art, as has sometimes been observed, the more it calls for exegesis, and this is a commodity which museums of contemporary art are always ready to supply.

However, the austerity of Minimalism also involves a degree of depersonalization which is less acceptable to a society which feeds on personalities. One of the routes out of this trap was suggested by the artists of the Italian Arte Povera group, where the use of deliberately humble materials gave a very austere kind of art a moral overtone. Arte Povera was also

linked to another tendency which became increasingly prominent in the late 1960s and early 1980s, and which still retains a certain prominence in the art world of today. This was the preference for a kind of work which broke free from all the traditional formats and became a complete environment in its own right. An environment is essentially a kind of stage-set in which the visitor enacts his or her own play. As essentially public works, environments are in step with the public function of the museum or Kunsthalle, and symbolize the way in which avant-garde art, once chiefly the business of the private patron, has translated itself into the non-private, non-élitist sphere.

Environmental works are also an aspect of the dissolution of categories which has greatly affected attitudes of art during the past thirty years. Not merely have the barriers between painting and sculpture dissolved, but a work of contemporary art can now take virtually any physical form, and be made of any sort of material – chipboard to chocolate, words written on the gallery wall, images appearing then dissolving on a television monitor. For Joseph Beuys, perhaps the most influential artist during the period under consideration, art was what he did – every aspect of his activity, simply rising to an intense level when he enacted one of the rituals to which he gave the generic name 'actions'.

It was Beuys who was chiefly responsible for the discovery that the museum could serve as a very effective political platform. His presence at the prestigious Düsseldorf Academy, where he was professor, was symbolic of the extent to which the avant-garde and official culture had already become entangled. The fact that his political activities still went under the rubric 'art' gives some idea of the degree to which categories had now dissolved.

One feature of Minimal Art was that it frequently claimed, not to be a new style in competition with other styles, but to be style-less. This claim, in conjunction with the developments pioneered by Beuys, was to have an unexpected result. Attention began to be diverted from matters of art altogether, and to be refocused on the issues which the art seemed to embody. An intellectual somersault took place: art which seemed to eschew subject-matter gave birth to a kind of art where subject was everything, and the choice of forms of embodiment was of comparatively minor interest.

Following Beuys's lead, minority causes of all kinds discovered that art was an effective instrument of propaganda, and that the museum provided a platform which gave both visibility and credibility. Some of these minorities were minority groupings of a traditional sort. There was a sudden upsurge of interest in African-American art in the United States (in any case a long-established category). Newer minorities such as the Chicanos (immigrant Mexicans settled largely in California and in the South-West) began to

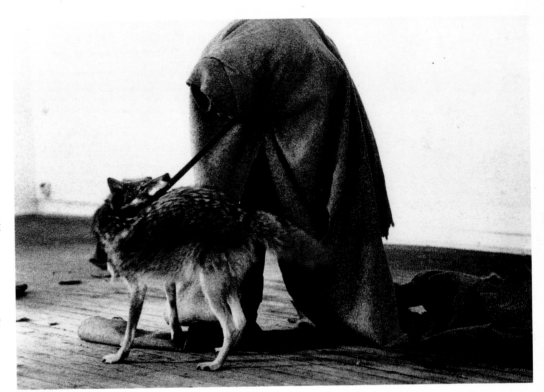

9

attract attention. Others were minorities defined by such things as sexual preference. Homosexual art, for example, began to be recognized as a specific category. It acquired added prominence from the tragedy of the AIDS epidemic. The contemporary art world, like other artistically creative areas, was particularly hard hit.

One group, not technically a minority, but allied with minorities of the kind listed above, was particularly influential. This was the feminists. The feminist assault was three-pronged. First, it demanded parity for women, in an art world which had consistently seemed to favour the creative efforts of men. Second, it

10

sought to create a new feminist criticism which would embrace all the arts. In doing so it borrowed largely from French Structuralist philosophy and from philosopher-psychologists such as Jacques Lacan. Third, it encouraged the creation of a kind of art which would speak about female thoughts and concerns. Since many of the artists affected by feminism felt that traditional forms, such as painting and sculpture, were tainted by patriarchy, they tended to be interested in newer forms of expression, such as environmental work, performance and video.

The upthrust of issue-led minority art presaged a general dissolution of art-world structures. For example, art in the United States now began to regionalize itself, with visibly different kinds of art in different parts of the country. Artists in non-Western countries not hitherto associated with the growth of Modernism began to stake their claims for attention – there were now avant-garde artists, using this term in a purely Western sense, in Far Eastern countries such as Japan and Korea, and even the beginnings of an avant-garde in Communist China. Artists in Africa and India also began to attract attention. Their appearance meant a questioning of the traditional Western attitude that all art in 'mixed' styles was necessarily debilitated from a creative point of view – that is, unless it was the work of a Western artist borrowing from a non-Western source. Logically enough, there was also interest in the work of artists living in minority situations in cultures which were neither European nor North American. The new art of the Australian Aborigines was a case in point. Finally there was an a renewed fascination with the most characteristically mixed art of all – that produced in Latin America.

The contemporary art world is therefore no longer hierarchical, but plural. Its structures, where they exist, are provisional, and so are many of its most characteristic critical formulations. At the same time, however, and definitively, it has passed from the private to the public sphere, and become an aspect of official culture. It is these changes which my book aims to reflect.

There is, however, one issue which is deliberately avoided here, and that is the whole question of the status of photography. It will

not take the reader long to discover that much of the art included in this book has some form of connection with the camera. From the period of Pop Art onwards, artists have routinely appropriated photographic images and incorporated them into their own work. Generally, as in the case of Andy Warhol, these were photographs with no claim to be thought of as works of art in their own right. Since the 1960s, and particularly since the rise of Conceptual Art, the issue has become a great deal more complicated. First, there is the inclusion of the photographic image within the work as an independent 'sign'. Photographs are used in this way by artists such as Joseph Kosuth and John Baldessari. Second, there is the acceptance of certain image-makers whose work is purely photographic, notably Robert Mapplethorpe and Cindy Sherman, as being somehow different from (and by implication superior to) the great twentieth-century photographers who have preceded them, who are still confined within a separate category - who are regarded, not as artists pure and simple, but as artists-with-a-camera. Third, we even have the curious situation where what would be regarded almost universally as bad photographs - by 'bad' I mean aesthetically deficient rather than technically so – are accepted as perfectly valid art: I am thinking here of the images made by Jeff Koons which show him in erotic poses with his wife, the Italian porn-star La Cicciolina. And finally, to bring the whole business full circle, there are the photographs which, in the early 1980s, established Sherrie Levine's claims to be regarded as a serious Conceptual artist. What Levine did was to offer images she had appropriated photographically from art books as 'readymade' works of art in the tradition of Marcel Duchamp, thus challenging, as one learns from the new edition of a well-established dictionary of art and artists, 'received ideas of originality, drawing attention to relations between power, gender and creativity, consumerism and commodity value, the social sources and uses of art.'[1] Among the artists whose work has been taken over in this way by Ms Levine are the painters Mondrian and Malevich, but also the photographers Walker Evans (1903-75) and Edward Weston (1886-1958). One may reasonably ask oneself why Sherrie Levine is accepted as an artist *tout*

court, whereas Evans and Weston, great though their reputations as photographers are, remain outside the pale. One proof that they are indeed outside the pale, incidentally, is that there is no entry for either of them in the dictionary I have just cited.

The conclusion has to be that what is now categorized as photography, and what is categorized as art, depends largely on consensus, and also on accepted convention. No concise, easily comprehensible definition can be found which divides the two activities. To make matters worse, the convention is not fixed, but shifts subtly all the time, as both art and photography develop. The process affects not only what is being created in the present, but what has been done in the past. For example, much Victorian photography, made with no discernible aesthetic intention in mind, has now been shuffled retrospectively into a different sort of pigeonhole, and enjoys the kind of cultural prestige which is bestowed on the better paintings and drawings of the same period. I am thinking here of things such as Eadweard Muybridge's studies of humans and animals in motion.

The tension between photography-as-art and photography-as-photography is of course almost as old as the photographic process itself. In the late 1850s and in the 1860s photographers such as O.J. Rejlander and Julia Margaret Cameron tried to make artworks with the camera which would challenge on their own ground those made by traditional means. Both felt it necessary to intervene in the actual photographic process in order to do so, producing results which moved away from the absolute objectivity of vision which their contemporaries ascribed to the camera. Rejlander made painstaking use of multiple negatives, pieced together to produce results which had never existed in front of the lens; Cameron made skilful use of soft focus. After a brief interval, the cause of the photographer-as-artist was taken up once more by the pictorialists of the 1880s and the 1890s. New technical methods, such as the gum bichromate and bromoil processes, made it possible to produce photographic prints which could almost be mistaken for charcoal drawings or lithographs. The photographers of the Linked Ring, and other leading photographic societies of the time, regarded what they produced as being on an entirely different plane from what was being done either by professional documentary and portrait photographers, working for purely commercial or else for social ends (the documentation of social evils was regarded as a primary task by many late nineteenth-century photographers), or by the many thousands of amateurs whom George Eastman's invention of the Kodak had turned into makers of images.

It is here, essentially, in photography's immense fecundity and also in its chameleon quality, that one hits on the reason for its exclusion as a separate category from what is already a very large book. The field of contemporary art may have widened enormously during the last three decades, in geographical terms, as well as in terms of forms and materials. It is nevertheless tiny in comparison to the territory occupied by photography. The still camera, and its derivatives in film and video, have become the primary image-makers of our time. Only a very small proportion of these images are in fact bearers of any sort of aesthetic intention. One can draw a comparison here between the camera image and the components which go to make up a language - any language. We know that language can be used to make literature. We also know that the vast bulk of what is actually written has no pretensions to being literature at all. Even if one manages to separate from the rest that portion of photographic imagery which does have declared aesthetic intent, one finds that this intent is not unitary. One only has to look at the pages of the magazines addressed to enthusiastic amateur photographers to find that there is a great deal of highly skilled photographic work which remains completely separated, even alienated, from the spectrum of creative assumptions which can be found in late twentieth-century art - assumptions which are, indeed, the core of my text, whether I personally agree with all of them or not.

My decision, therefore, has been not to attempt to tackle material which would clearly burst the boundaries of the book, but to accept the current consensus as it stands. Braver souls than I may attempt more radical solutions.

Pop & After

11 Andy Warhol, *200 Campbell's Soup Cans*, 1962
Oil on canvas, 182.6 × 253.7 cm
(72 × 100 in)

12 Jasper Johns, *Numbers*, 1963–78
Hand-worked aluminium cast,
142.7 × 109.7 cm (56¼ × 43¼ in)

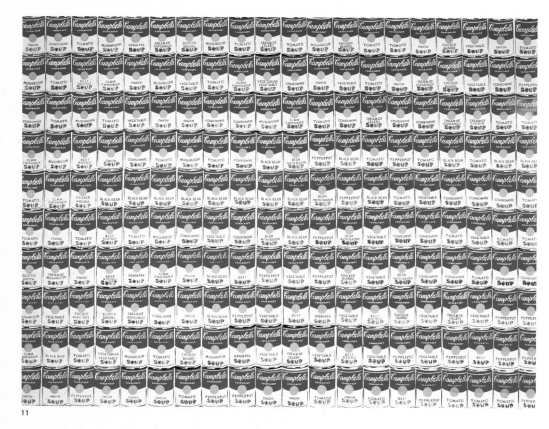

11

To the gallery-going novice of the 1990s, the contemporary art world must resemble a battlefield in the concluding stages of some particularly sanguinary conflict – one that offers no particular evidence as to which are the victors and which the vanquished. Corpses and walking wounded are everywhere. The hierarchy of movements and tendencies, which still seemed quite firmly established twenty-five years ago, is now in ruins, a shattered fort which its defenders have reluctantly abandoned.

It is a significant irony that the art movement still most frequently referred to is Pop Art. In the minds of the general public, if not in those of art world insiders and critics, this is still seen as the accessible face of contemporary art – the part of it that reflects things that are comfortable and familiar and which continue to be constants in people's daily lives. A closer examination of the material does not support the assumption that Pop is a living artistic language. There are many allusions to it in the art of the 1990s, but as a coherent style it is as defunct as Futurism or Cubism.

If asked to choose a truly significant Pop Art picture, in terms of what the future would bring for art, it might well be something like Andy Warhol's *200 Campbell's Soup Cans* (Pl. 11). Yet it now seems significant, not because of its specifically Pop element, but because of the way in which it is linked to the already established achievement of Jasper Johns – for example in the relief cast of *Numbers* (Pl. 12) that Johns started work on soon after the Warhol painting was completed. Both works foreshadow the Minimal and Conceptual Art which was to challenge Pop at the end of the decade. Warhol even predicts, through his deliberate choice of a supremely banal (as compared to a merely inert) motif, the deliberate cynicism and emptiness that were to become so striking a feature of the avant-garde art of the late 1980s and early 1990s, in the hands of artists such as Jeff Koons (Pl. 336) – Koons clearly models himself on aspects of Warhol's personality. Something equivalent can be said about a number of other Pop paintings, especially those which feature lettering alone, or lettering-as-imagery. *Noise* (Pl. 13), by the Californian artist Ed Ruscha has now taken on an entirely different aspect from

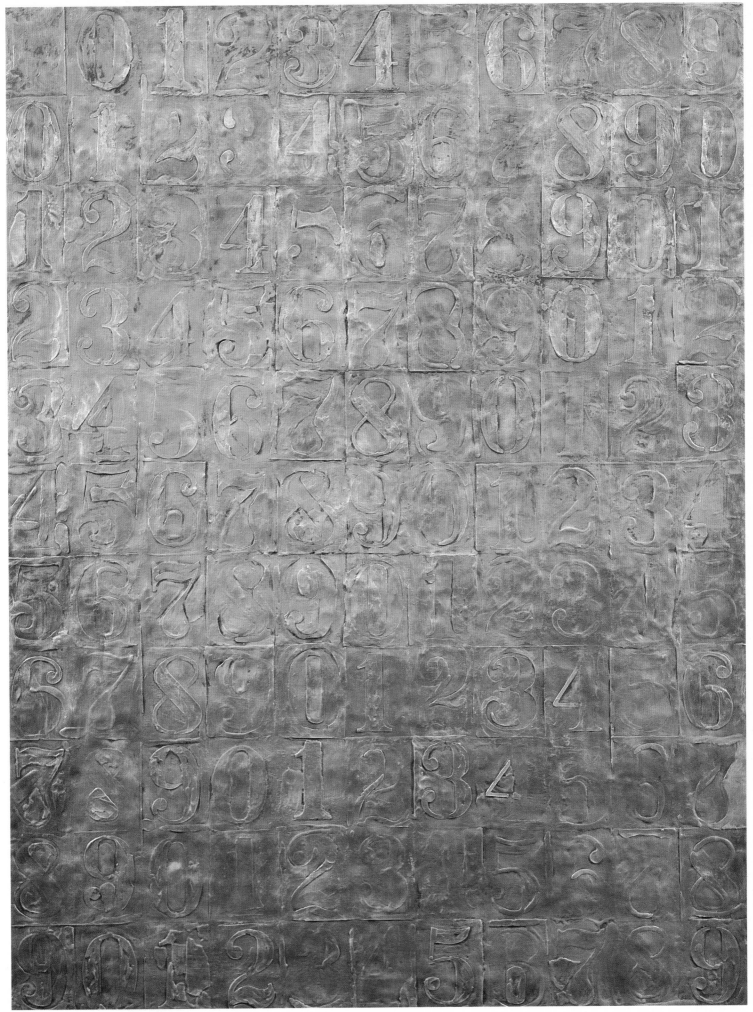

12

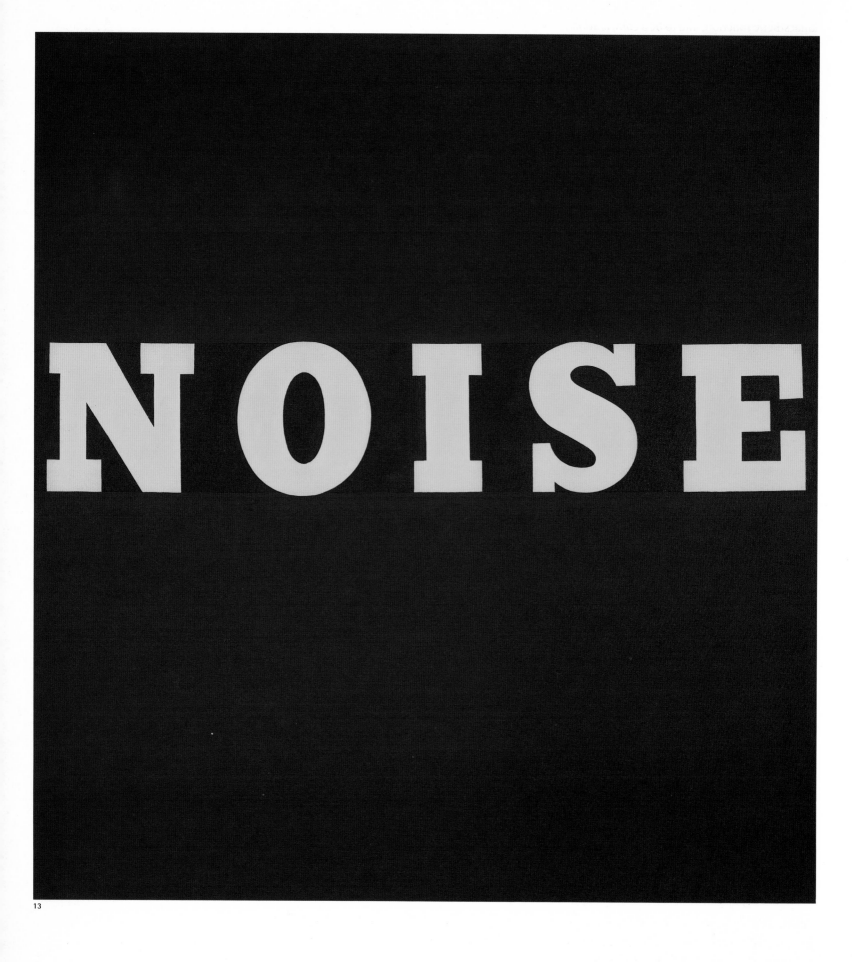

13

the one it possessed at the moment when it was painted. Now, rather than alluding to Pop signage, it seems to have taken on an almost kinaesthetic function, and to be a contribution to the debate, inherent in many sorts of Conceptual work, about what art can and cannot represent.

Some of the Pop artists who seemed stuck in a timewarp that prevented their work from developing beyond the formulae which initially made their reputations have recently enjoyed a revival and thus a kind of revenge on those who dismissed them as hopelessly outdated. One of these is James Rosenquist, who at one time faded almost completely from the American art scene. His recent paintings, such as *Gift Wrapped Doll # 19* (Pl. 14), have much greater refinement of technique than the 'classic' Pop works he made in the 1960s. For Pop exuberance, they substitute something vaguely sinister. They seem like allegories designed to demonstrate where the Pop sensibility went wrong. Another, rather different, case is that of Robert Indiana. Some of the Pop artists have taken a second look at the work they themselves produced in the 1960s, and Indiana's *Decade Autoportrait 1964* (Pl. 15) was painted in 1976, at a moment when the artist's fame was visibly waning. Both imagery and title indicate that it is a nostalgic look back to glory days that already seemed to be over. Now, in the 1990s, it seems to be a work with a significant and easily identifiable place in the history of American art. On the one hand it alludes to classic American images of the 1920s, among them Joseph Stella's *'I Saw the Figure Five in Gold'* (1928) and Gerald Murphy's *Razor* (1924). The connection is also interesting for another reason, which is that Murphy's work ultimately derives from that of the Dadaist, Francis Picabia, universally regarded by art historians as one of the fathers of Pop Art. The line of descent running from Picabia, via Gerald Murphy to Robert Indiana can also be traced a generation further. The next step is the work of Keith Haring, one of the central figures in the New York school of the 1980s. Haring's deliberately hard-edged, inflexible way of treating images had a widespread impact on other artists of his own generation, and can be seen at work, for example, in Tom Otterness's caricatural bronze sculpture of a *Dodo* (Pl. 16). The difference

14 James Rosenquist, *Gift Wrapped Doll #19*, 1992
Oil on canvas, 152 × 152 cm (60 × 60 in)

15 Robert Indiana, *Decade Autoportrait 1964*, 1976
Oil on canvas, 182.7 × 182.7 cm (72 × 72 in)

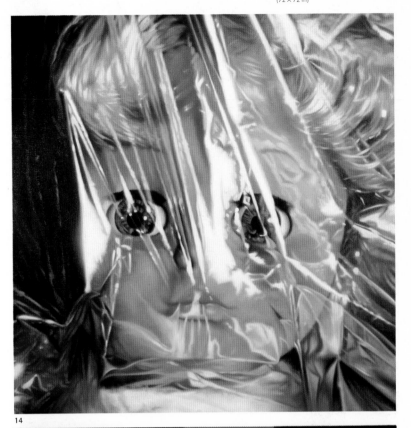

14

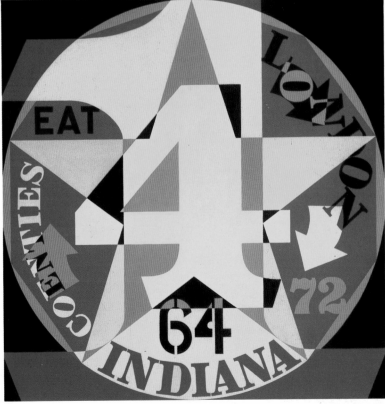

15

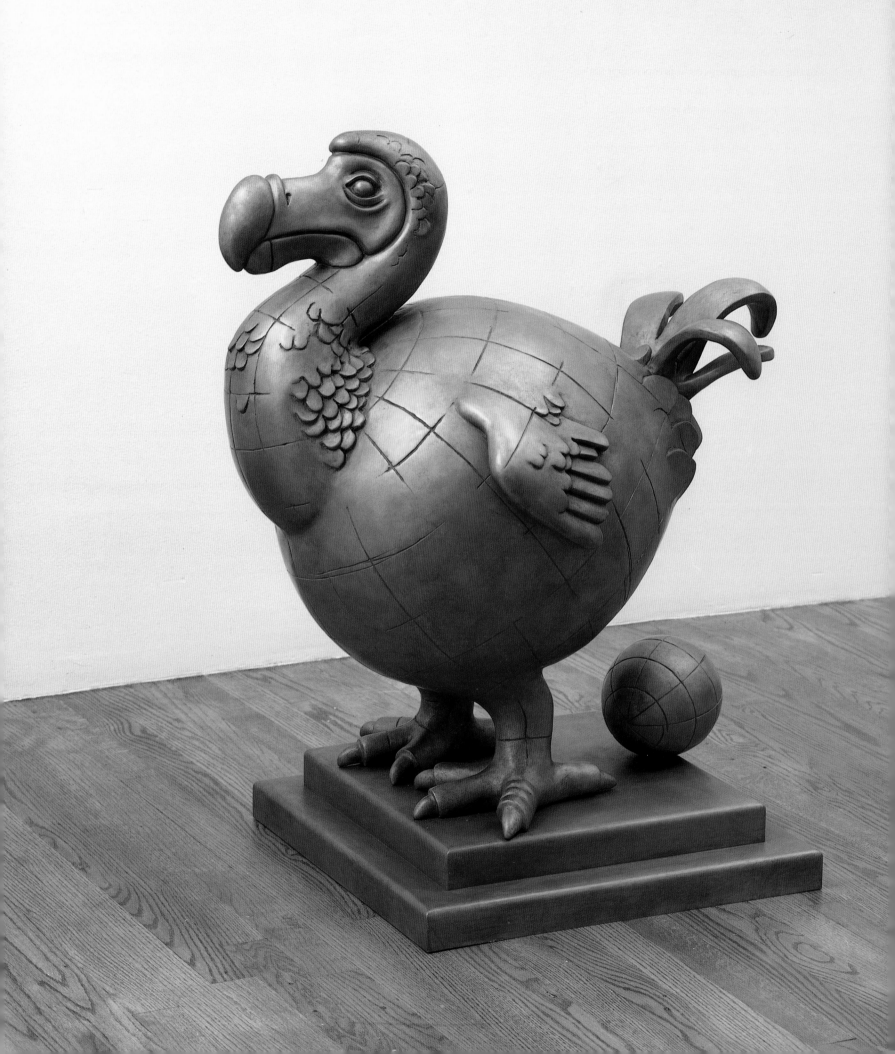

between Haring and Otterness and the artists who preceded them is the deliberate infantilism, the rather self-conscious naïveté, of the art they produced. It is this which makes one keenly aware of how much time had passed since the first Pop images were produced. Haring's *Untitled* (Pl. 17) is a greeting-card image – two figures reaching for a heart that floats in the sky above them, with two dogs barking on either side of them – but Haring's

16 Tom Otterness, *Dodo*, 1989–90
Bronze, 90.2 × 71 × 53.3 cm
(35½ × 28 × 21 in)

17 Keith Haring, *Untitled*, 1982
Sumi ink on paper, 186.6 × 269.2 cm
(73½ × 106 in)

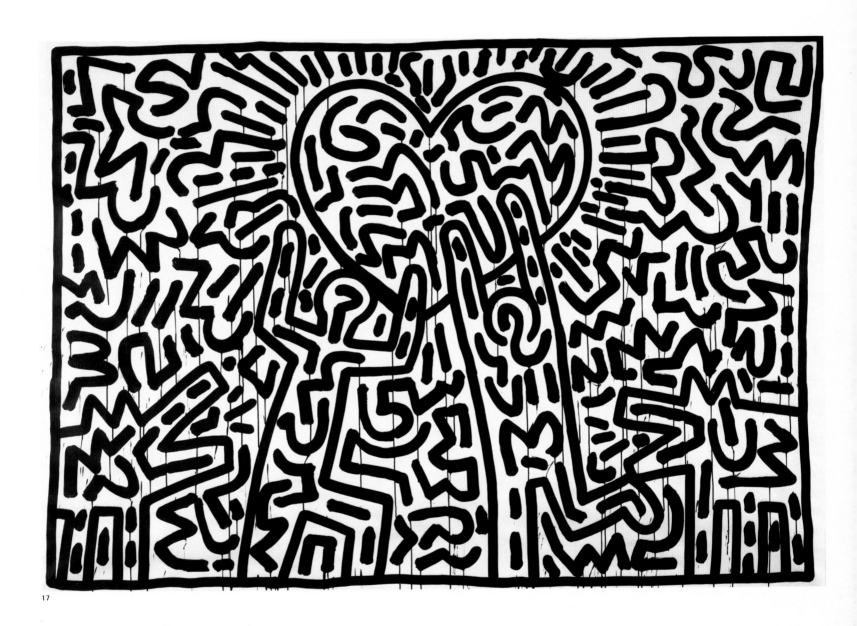

17

deliberately impersonal style makes the sentimentality palatable. Haring gets the best of both worlds: he offers sentimentality to those who respond; those who resist can read the image as ironic.

Much Pop Art of the 1960s and even of the 1970s now seems very dated. This is particularly true of images dealing with sexuality, because the whole climate of opinion has changed since the triumph of the feminist

18 Tom Wesselmann, *Great American Nude No. 41*, 1962
Acrylic and collage on paper,
152 × 122 cm (60 × 48 in)

19 Mel Ramos, *Camilla – Queen of the Jungle Empire*, 1963
Oil on canvas, 76.1 × 66.3 cm
(30 × 26⅛ in)

movement, which has had a particularly strong impact on the world of the avant-garde visual arts. For example, the meanings we attach to Tom Wesselmann's *Great American Nude* (Pl. 18) series are surely different from those which would have been read into them in the 1960s. Wesselmann's celebration of sexuality seems considerably less innocent now that three decades have passed. Mel Ramos's *Camilla – Queen of the Jungle Empire* (Pl. 19) is another typical pin-up-derived image of its period – a time in which such imagery was enthusiastically received as part of the typical mass-cultural mix. Because it is even more stylized than Wesselmann's work, it is less aggressive in tone, but it would still be difficult for an artist to produce something quite so overt today. One proof of this is that some Pop paintings and sculptures have been greeted with protests when re-exhibited recently. One victim of this kind of demonstration has been the British artist Allen Jones, one of whose preferred themes has been sexuality with fetishistic accoutrements, with a particular penchant for skin-tight clothing and high-heeled shoes (Pl. 20). These works have aroused the wrath of committed feminists.

It is true that pin-up images have a power of their own, and a small scattering have survived here and there in the art of the 1990s. One example is illustrated here – Steve Gianakos's *Everyone Knew the Group was Unknown* (Pl. 21). It is interesting to consider the differences from, as well as the similarities to, the work of artists like Ramos and Jones. In Gianakos's painting, the sexuality of the three female figures is deliberately distanced by giving them a 'period' air. These three young women are phantoms from the 1920s or early 1930s – their shoes, their coiffures, even the musical instruments they play, are designed to tell the spectator this. Gianakos's art belongs to the realm of slightly simpering mock-innocence inhabited by artists like Haring and Otterness, and any sexuality in his imagery is thus neatly neutralized.

Because Pop Art was so hugely successful in communicating its ideas to the general public, going directly to them and bypassing often disapproving critics and curators (who were only belatedly converted to the cause), some Pop artists have been able to undertake official commissions of a kind that would once have

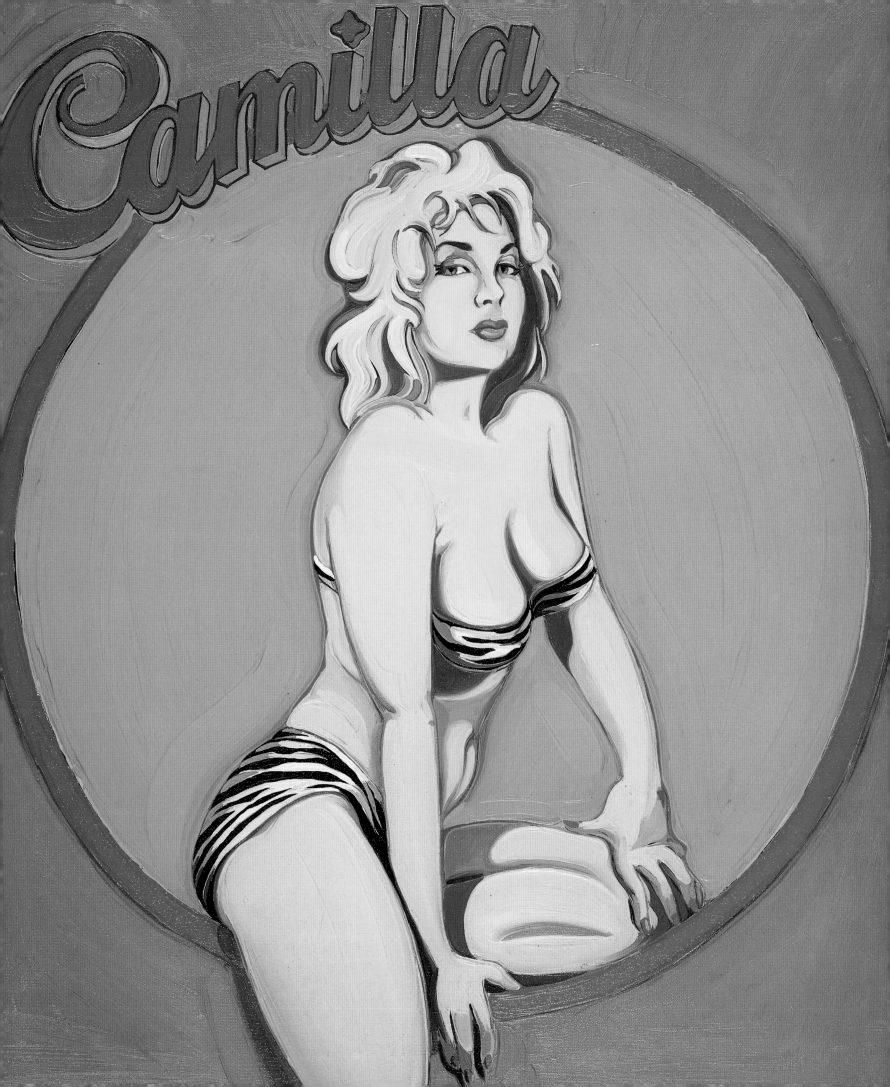

seemed entirely outside the scope either of their intentions or their desires. It seems clear, for example, that the projects for monuments made by the leading Pop sculptor Claes Oldenburg began as not-too-subtle jokes at the expense of the pomposity of many public monuments. They existed only as small drawings and collages – for example, the series of drawings made on a visit to London in 1966, where the artist proposes to replace the statue of Eros in Piccadilly Circus with a group of lipsticks, and Nelson's Column in Trafalgar Square with a gear-shift. The first monument realized to full scale was mobile and temporary – a giant lipstick mounted on caterpillar tracks, dating from 1969.

20 Allen Jones, *Stand In*, 1991–2
Oil on wood with painted fibreglass
figure, 185 × 185 × 63 cm
(72¾ × 73¾ × 24¾ in)

21 Steve Gianakos, *Everyone Knew
the Group was Unknown*, 1991
Acrylic on canvas, 97.7 × 187.7 cm
(38½ × 74 in)

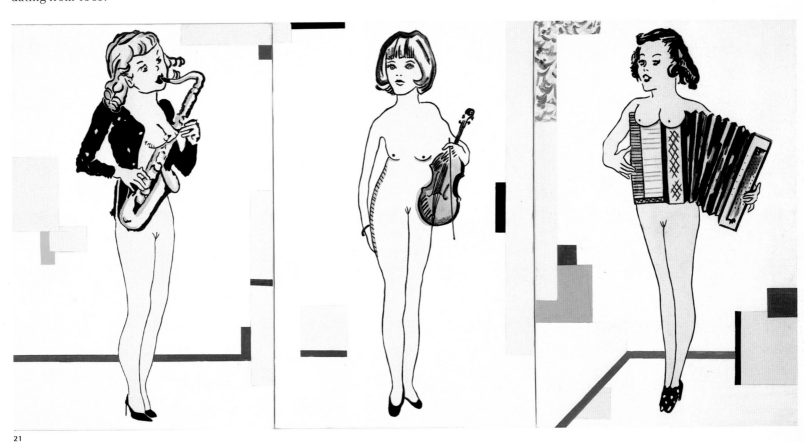

21

It was only in the late 1970s, when Pop art was finally co-opted into the establishment, that Oldenburg was given the opportunity to give form to his ideas on the scale envisaged in his drawings. Since that time he and his second wife, the Dutch artist and curator Coosje van Bruggen, have been responsible for making a whole series of monumental works, some more effective than others (Pl. 22). In general, these huge sculptures have been favourably received, though it is doubtful whether they do add very much to Oldenburg's original sketches, especially since he, like Christo (another artist

who works on a very large scale, Pls. 129–30), is a particularly seductive draughtsman, able to make every mark on the paper tell. Oldenburg's big sculptures are indeed symbolic, but the symbolism is to some extent turned against the artist himself: they demonstrate how very quickly and easily, in a modern Western society, the avant-garde loses its cutting edge, and ceases to be offensive to anyone. To be in perpetual opposition to the established order of things is, after all, one of the core characteristics of avant-gardism.

There are, of course, Pop-derived artworks still being made which have retained their power to cause controversy. An apt example is the painting by the British artist Derek Boshier which turns the letters KKK, the initials of the racist Ku Klux Klan, into three symbolic cowboy boots (Pl. 23). The power of the image is due very largely to its concision – it makes a satirical point in the simplest and most forceful way possible. One reason for its success may be that, though Boshier lived and taught in Texas for some years, he nevertheless remained an outsider there – someone not wholly absorbed into the system.

Another recent example of basically Pop images being used for satiric ends is the elaborate sculpture, *Merry-Go-World or Begat by Chance and the Wonder Horse Trigger* (Pl. 24) by Ed Kienholz and Nancy Reddin Kienholz. Here the heterogeneous materials are taken directly from popular culture. The various animals, for instance, are flea-market finds, discovered on the artists' travels. Because of the authenticity of the source material, which retains an identity of its own, quite apart from the use to which it has now been put, the piece lacks the detachment typical of Andy Warhol. Refusal to assume a moral stance is now regarded by art historians as one of the key characteristics of authentic Pop works taken in general. From the very beginning of his career Kienholz's status as a Pop artist was always in doubt, for two reasons. One was that his work contains surrealist as well as popular elements – there was always something phantasmagoric about it that remained alien to the Pop ethos. This characteristic strengthened rather than weakened in the works made in collaboration with Nancy Reddin, his fifth wife. Even more important was the fact that he always expressed a strong strain of moral

22 Claes Oldenburg and Coosje van Bruggen, *Knife Slicing through Wall*, 1989
Installed on the stucco façade of the Margo Leavin Gallery, Los Angeles, stainless steel blade, 182.7 × 365.3 cm (72 × 144 in)

23 Derek Boshier, *KKK*, 1992
Oil on canvas, 120 × 191 cm (47¼ × 75¼ in)

24 Ed Kienholz and Nancy Reddin Kienholz, *Merry-Go-World or Begat by Chance and the Wonder Horse Trigger*, 1992
Mixed media assemblage, height 292 cm (115 in), diameter 467 cm (184 in)

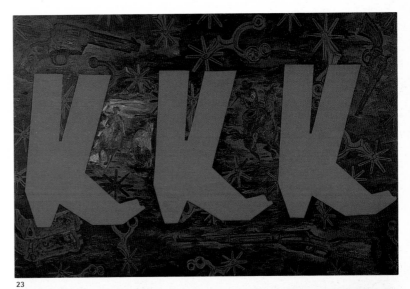

23

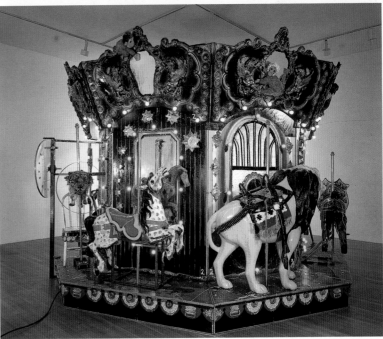

24

indignation, and this kind of moral and social commitment was alien to the ethos of detachment personified by Warhol.

An equivalent strain of moral indignation, but of a less focused and effective sort, surfaces in recent paintings by the British Pop artist Richard Hamilton, whose early collage *Just What Is It Makes Today's Homes So Different So Appealing?* (1956) is often credited with being the very first Pop artwork. *The State* (Pl. 26) is one of a series of recent works, more Photorealist than Pop, devoted to the civil insurrection in Northern Ireland. The closest comparison is with equivalent works by the German artist Gerhard Richter concerned with the Red Army Faction (Pl. 224). To express indignation is almost certainly the purpose of the image, which contrasts a British soldier on patrol in Belfast with an empty country road, but in fact it is difficult to grasp its intended significance without at least some foreknowlege of Hamilton's stance on Irish issues. Is the unpeopled country scene, for example, meant to convey the idea that the British presence in Northern Ireland will sooner or later reduce the region to a desert?

The two artists who, perhaps surprisingly, have most successfully combined elements borrowed from Pop with an element of social commitment are Gilbert & George. At first sight this may seem a paradoxical, indeed a deliberately provocative statement, since Gilbert & George are celebrated, first for the strong element of narcissism that pervaded their early works, and second for their vehemently expressed right-wing views, calculated to irritate and dismay an avant-garde art world which prides itself on carefully cultivated tolerance as a mask for repressive political correctness. Gilbert & George flout the rules in this small universe, and usually contrive to get away with it. One penalty for this is that much of their subject-matter tends to be passed over in embarrassed silence.

Two large photo pieces, *Attacked* (Pl. 27) and *Fair Play* (Pl. 25), are typical of what they have produced recently. In *Attacked*, the image is borrowed from arcade video games. The two artists stand, apparently screaming in protest, tongues extended, surrounded by a hostile cybernetic universe. *Fair Play* is an apparent plea for racial tolerance. Here the artists (frequently but not invariably protagonists in

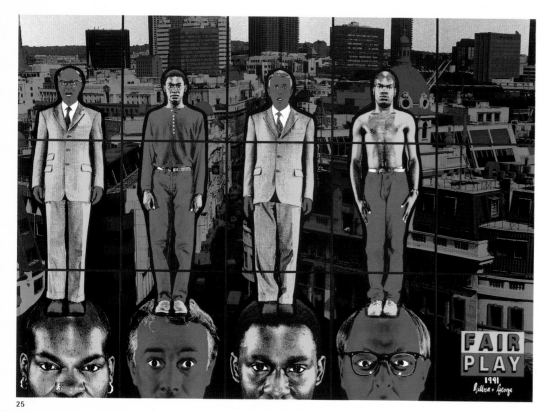

25

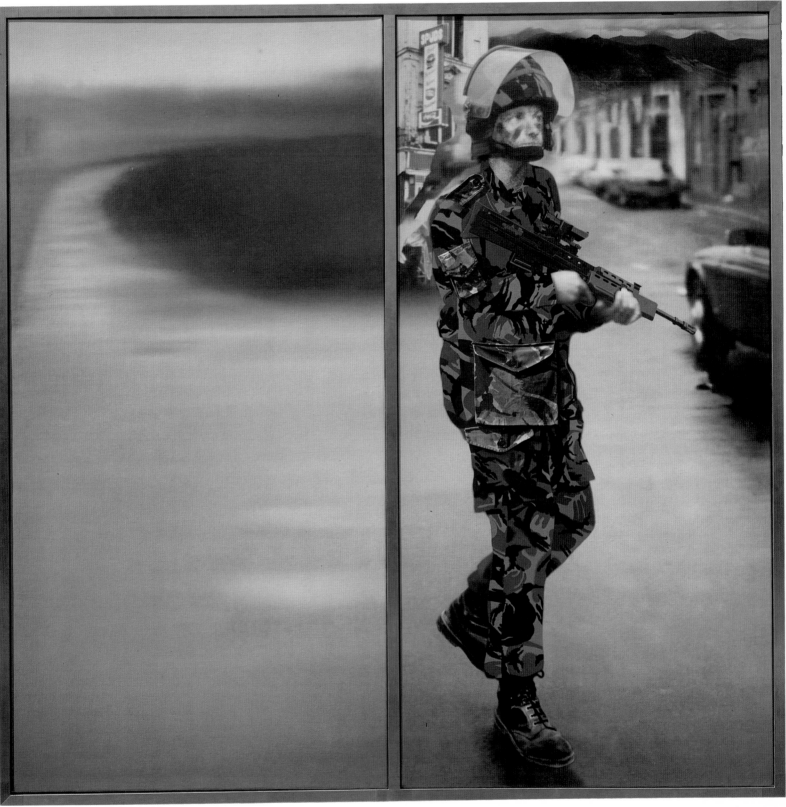

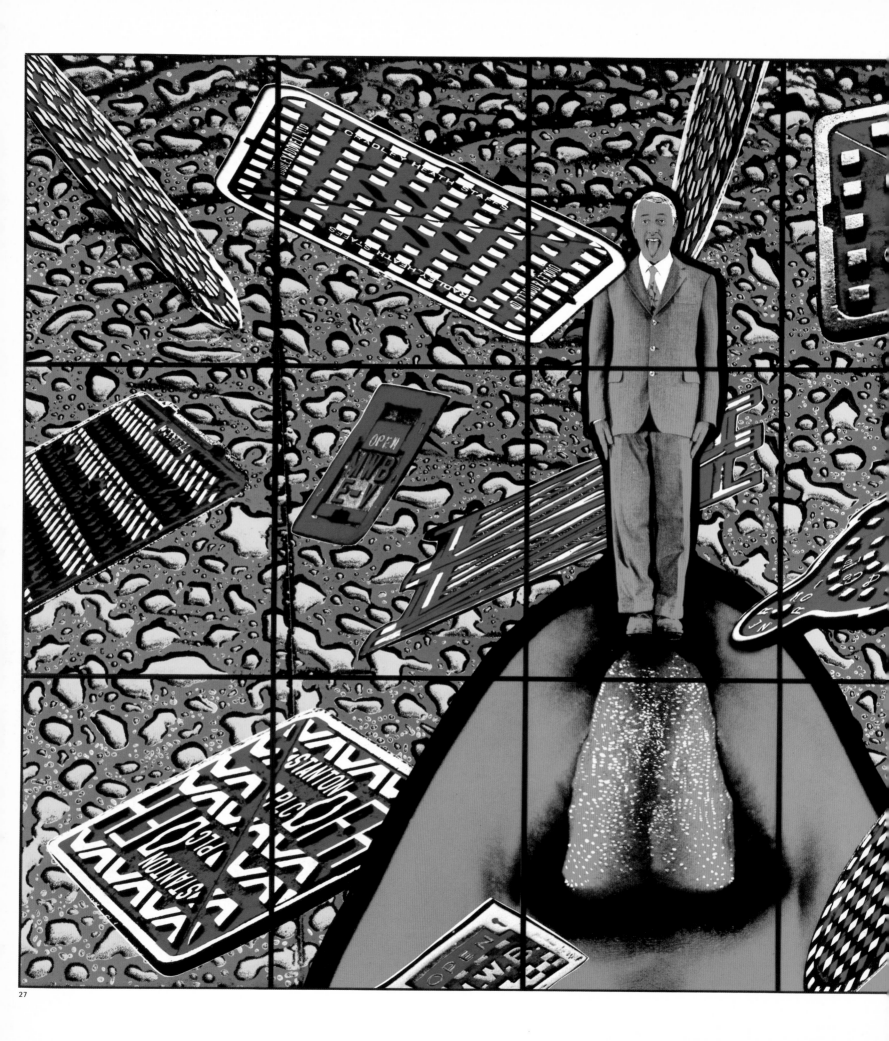

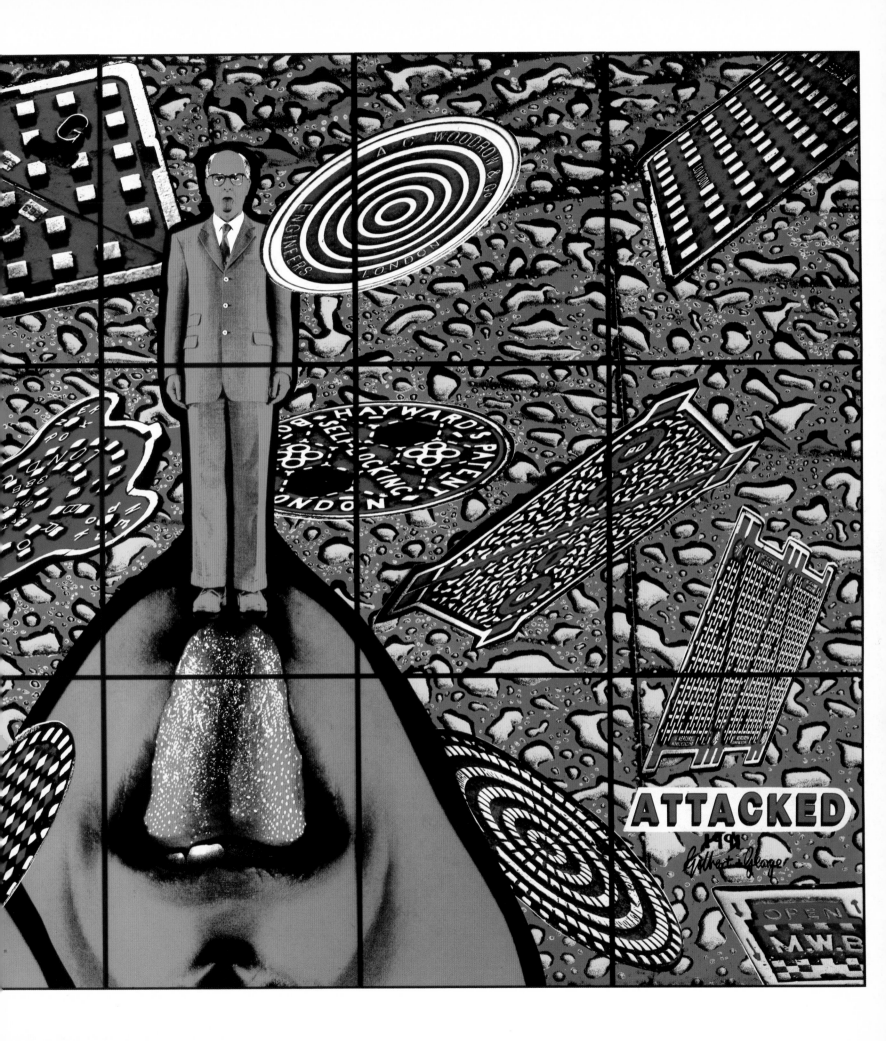

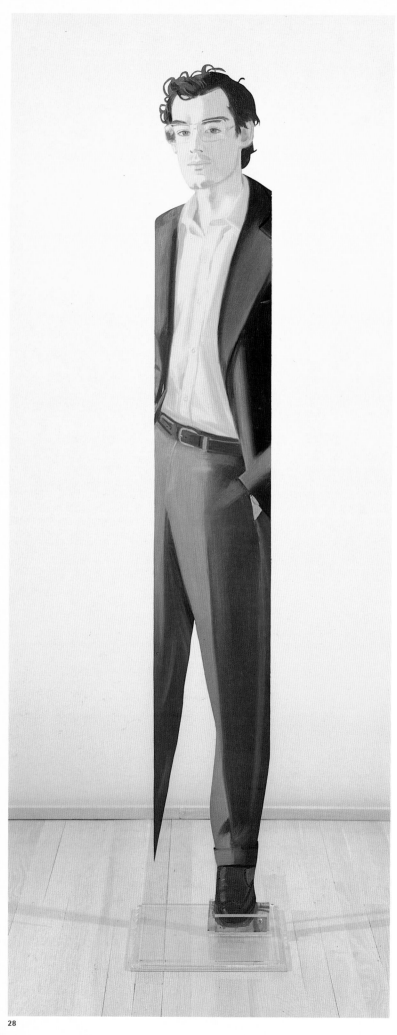

their own work) stand side by side with two muscular Afro-Caribbean youths. The cityscape in the background is the East End of London, with its offices and tower blocks. Each of the four figures is provided with a pedestal – the artists stand on the enlarged heads of the two Afro-Caribbeans, who, in turn, are perched atop the pop-eyed images of Gilbert & George. It is the two whites, not the two blacks, who seem surprised and horrified by the situation.

The comparison between Warhol's work and that of the two British 'sculptors' (a duo who nevertheless count themselves as a single artistic entity) reveals both similarities and dissimilarities. They make extensive use of photography, and employ it in a reductive way, to rid the image of nuances and concentrate its essence. The lurid dayglo colours favoured by Gilbert & George also appear in some of Warhol's most typical paintings, though usually in somewhat reduced strength. In both cases these violent hues seem to signify deliberate fealty to the world of mass culture, where artefacts manufactured cheaply and in quantity constantly challenge nature. But where Warhol is determined to show an icy detachment from his surroundings which modulates into voyeurism, Gilbert & George plunge enthusiastically into the world around them, always ready to pass judgement. Surprisingly enough, some of the closest affinities to their most recent work are to be found in the production of Russian *perestroika* artists, such as Eric Bulatov (Pls. 435–6). Like the Russians, they seem to be desperately trying to make sense of a threateningly unstable universe. Despite the notorious *Disaster* paintings made by Warhol, it can be seen that he comes from a much more stable universe, surer of its own tastes and values, surer, even, of the things which art can, and cannot, attempt to do.

Pop created a climate for figurative art in which certain kinds of imagery, certain ways of presenting imagery, became mainstream. For example, although the American artist Alex Katz is more usually associated with the relatively conservative ethos of Fairfield Porter (a painter who can be described as his country's belated equivalent of Vuillard), he also owes something to Warhol's image-making techniques. The elegant simplification of Katz's *Sanford Schwartz* (Pl. 28) clearly owes

28

something to Warhol's *Marilyns* (Pl. 8) and *Jackies* of the 1960s. The bleached-out, high-key look which glossy magazines use when they want to glamorize their sitters has been subtly adapted. This is still imagery with a Pop feel to it, but it has now gone a long way up-market – further up-market than Warhol himself could manage in his own society portraits, which mostly belong to the later part of his career. Warhol's portraits feel like an artistic sell-out. The bold iconic treatment once

28 **Alex Katz**, *Sanford Schwartz*, 1975
Oil on aluminium, 180 × 25.3 cm
(71 × 10 in)

29 **Konrad Klapheck**, *The Vanity of Fame*, 1978
Oil on linen, 252.4 × 179.5 cm
(99½ × 70¾ in)

30 **Michelangelo Pistoletto**, *Self-Portrait*, 1970
Lithograph and silkscreen on gilt-silver base, 50 × 35 cm (19¾ × 13¾ in)

29

30

applied to genuine celebrities like Jacqueline Kennedy and Marilyn Monroe is now used to produce likenesses of rich nonentities. Katz's portrait work does at least give the feeling that the artist himself is thoroughly at home in the social group to which his sitters belong, and sympathizes with its ethos.

When Pop was exported to the mainland of Europe (British Pop Art was a separate and different genre), what artists took over was the

31 Sigmar Polke, *Liebespaar II*, 1965
Oil and enamel on canvas, 190 × 140 cm
(75 × 55 in)
Saatchi Collection, London

32 Roy Lichtenstein, *Brushstroke*,
1987
Painted aluminium, 9.1 × 5.2 × 2.3 m
(30 × 17 × 8½ ft)

31

photographic look, and sometimes the use of photography itself. The German painter Konrad Klapheck's *The Vanity of Fame* (Pl. 29) makes use of a quasi-photographic technique, but also reverts to one of the prime historical sources of Pop Art, Picabia. In addition, it pays homage to Picabia's associate, the arch-Dadaist Marcel Duchamp, whose bicycle wheel attached to a kitchen stool was the first 'readymade' sculpture. The Italian Michelangelo Pistoletto's *Self-Portrait* (Pl. 30) is generated from an actual photograph, and the presence of a camera as part of the image stresses the reliance on photographic values. The picture is a clever trick: the mirror surface of the background invites the spectator to add his or her evanescent likeness to the permanent presence of the artist. By pausing to look one can become part of the work. Again the emphasis is on a popular, democratic form of realism – but without the wholehearted embrace of mass culture that is the essential core of American Pop Art.

Sigmar Polke's *Liebespaar II* (Pl. 31), an early effort by a German artist who was to become considerably better known in the 1970s and 1980s, goes to almost the opposite extreme, offering a version of one of Roy Lichtenstein's comic-strip couples (Pl. 6), with eccentric Expressionist trimmings. Lichtenstein himself soon moved away from Pop subject-matter, preferring to retain the mannerisms of comic-strip representation – the heavy outlines and areas where tone was represented by a uniform screen of dots – without the content. The visual language he had borrowed, thus detached from its moorings in popular culture, became a means of investigating the pretensions of high culture, and in particular the various manifestations of the twentieth-century avant-garde. One of Lichtenstein's earliest targets was the Abstract Expressionist movement – logically enough since the Abstract Expressionists and their supporters amongst the leading critics of the time were the most vocal opponents of Pop Art. He followed up his paintings based on comic strips with a series of *Brushstrokes* which were designed to poke fun at Abstract Expressionist claims to total spontaneity. The idea fascinated the artist sufficiently to make him push it further in a series of sculptures in which the brushstrokes become bizarre three-dimensional objects (Pl. 32).

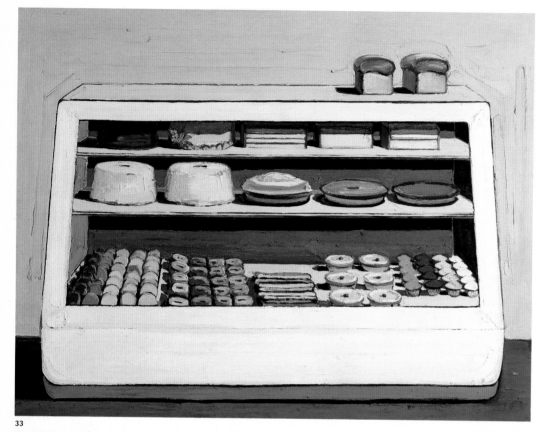

33

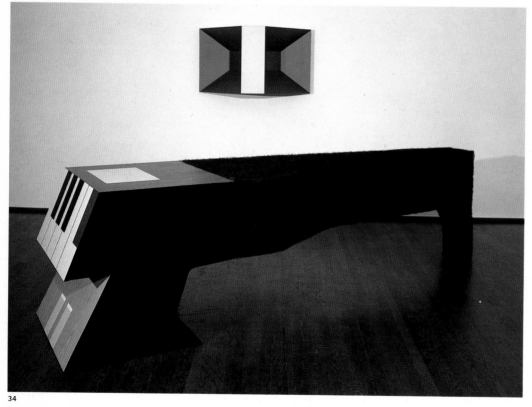

34

Pop became a pervasive influence, and at the same time began to lose its fixed identity as a style. Artists plundered its ideas freely and cheerfully, without really subscribing to its values. Others were co-opted more or less without their consent. A notorious case in point is supplied by the work of Wayne Thiebaud, who is probably the best still-life painter America has produced since the days of William Harnett and John Peto.

Thiebaud's career had a slow and difficult beginning – he was a long time in discovering what he really wanted to do. His great stroke of good luck, however, was to hold a one-man show in New York in 1962 just at the moment when Pop Art was beginning to hit the headlines. He was then forty-one. Thanks to his paintings of commercially produced pies and cakes (Pl. 33), critics immediately labelled him as a colleague of Dine and Oldenburg. This was very far from being the case: Peto, whom I have just mentioned, is a much better comparison, and if one cares to look beyond the United States there is the work of Giorgio Morandi. Thiebaud painted what he did largely because it was there. Chardin, in the eighteenth century, painted silverware goblets and earthen crocks for the same reason – they were the everyday objects that surrounded him.

Pop, in fact, suffered the fate of most truly successful art styles. It began its career as the product of a tightly-knit group of like-minded artists, then was gradually diffused and at the same time diluted, lost its cultish overtones, and became part of a generally available language, with few, if any, avant-garde connotations. By the 1970s, Richard Artschwager, who had with links to the Pop movement, but who never truly belonged to it, was already beginning to parody artists like Claes Oldenburg. Artschwager's *Piano II* (Pl. 34), for example, is related to a number of Oldenburg's early environmental pieces, notably the *Bedroom Ensemble* (1963) shown in the survey exhibition *Pop Art Redefined* (held at the Hayward Gallery, London, in July and August 1969). Artschwager was included in the show, and Oldenburg's effort must therefore have been well known to him. Clearly his reaction to it was hostile rather than admiring.

A somewhat later example of mischievous parody comes from the oeuvre of the young Spanish sculptor Andres Nagel. *I'm Blind, Buy*

33 Wayne Thiebaud, *Bakery Counter*, 1962
Oil on canvas, 139.7 × 182.9 cm
(55 × 72 in)

34 Richard Artschwager, *Piano II*, 1965–79
Plywood, formica and hair,
85.6 × 86.2 × 330 cm (33⅞ × 34 × 130 in)

35 Andres Nagel, *I'm Blind,*
Buy a Pencil, 1990
Mixed media and oil on polyester and
fibreglass, 123.4 × 205.8 × 26 cm
(48½ × 81⅛ × 10¼ in)

35

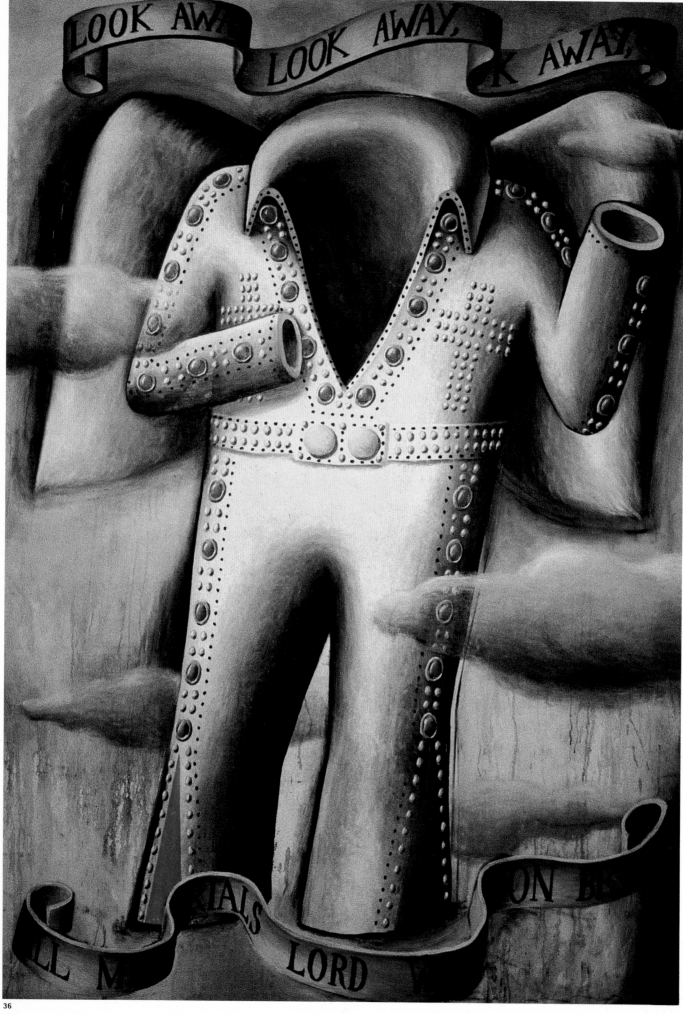

a Pencil (Pl. 35) shows a female version of the Tin Man, from *The Wizard of Oz*, leaning against a giant soft-drink can. The implication is that this beggar is a victim of the consumer society Pop Art set out to celebrate. Yet the satire is nevertheless expressed in a version of Pop's own visual language. It is significant with Nagel, as it is with Sigmar Polke, that Pop is with him a disguise adopted or discarded more or less at will. Other sculptures, though still figurative, are quasi-surrealist in idiom, and owe more to Nagel's compatriot Salvador Dali than they do to Warhol, Oldenburg or Lichtenstein.

Equally mischievous, and equally indebted to Pop Art without fully subscribing to the Pop ethos, is a recent painting by the young Scottish painter Alexander Guy. *The Ascension* (Pl. 36) is the last in a series of canvases celebrating the life and myth of Elvis Presley. Presley was, from the beginning, one of the heroes of the Pop movement, and Warhol, among others, made images of him. Guy chooses to represent him simply by a hollow suit – the glittering stage costume of Presley's latter years. The public persona has swallowed up the individual – only a carapace remains. This carapace is shown, in quasi-naïve style, ascending heavenwards, wreathed in banderoles which give the words of one of Elvis's songs. The painting uses a version of 'popular style' – one equally associated with British inn signs and Latin American votive pictures, but the tone is essentially distanced and ironic. The artist does not subscribe to the cult he is describing. Pop does impose a distance between the artist and his material – as in Lichtenstein's comic-strip paintings – but it is careful not to use the kind of stylistic transposition one finds in Guy's work. The irony comes from the choice of image, not from its manipulation.

Ed Paschke, a Chicago artist once associated with the local group the Nonplussed Some, founded in 1968 as an offshoot of the Pop Movement, offers an instance, not of parody, but of the way in which Pop Art, as it spread, adapted itself to local preconceptions and conditions. *Marblize* (Pl. 37) is a very recent example of Paschke's work, but he is a consistent artist, who has been working in versions of the same idiom almost throughout his career. The image is in debt, not to

photography, but to things seen on the TV screen. It has a psychedelic and also a quasi-Expressionist character that is typical of a great deal of recent Chicago art, much of it quite distinct from the established Pop language of New York and the eastern seaboard. Chicago art provides an early instance of the regionalist currents which were to become important in American art in the course of the 1980s (see Chapter 12, pp. 330ff).

One of the fundamental reasons for Pop Art's success, and for its continuing influence, was its link to the idea of the popular, with a small, rather than a large, 'p'. For the general public, it has been the only art movement of the second half of the century, and perhaps,

36 **Alexander Guy**, *The Ascension*, 1992–3
Oil on canvas, 233.5 × 172.5 cm (92 × 68 in)

37 **Ed Paschke**, *Marblize*, 1993
Oil on linen, 60.8 × 91.3 cm (24 × 36 in)

37

indeed, the only art movement within the general development of twentieth-century Modernism, which has not contained esoteric elements – which, in other words, has been instantly digestible. Because Pop artists seemed to represent familiar things in familiar ways (the ways in which they appeared in magazines and billboards, in movie cartoons and comic strips) the audience felt at home with Pop as soon as it appeared, and still continues to do so. Its more intellectual elements, such as the analysis of codes of representation which is a feature of many classic Pop art works, were comfortably ignored.

From the beginnings of the Pop Art

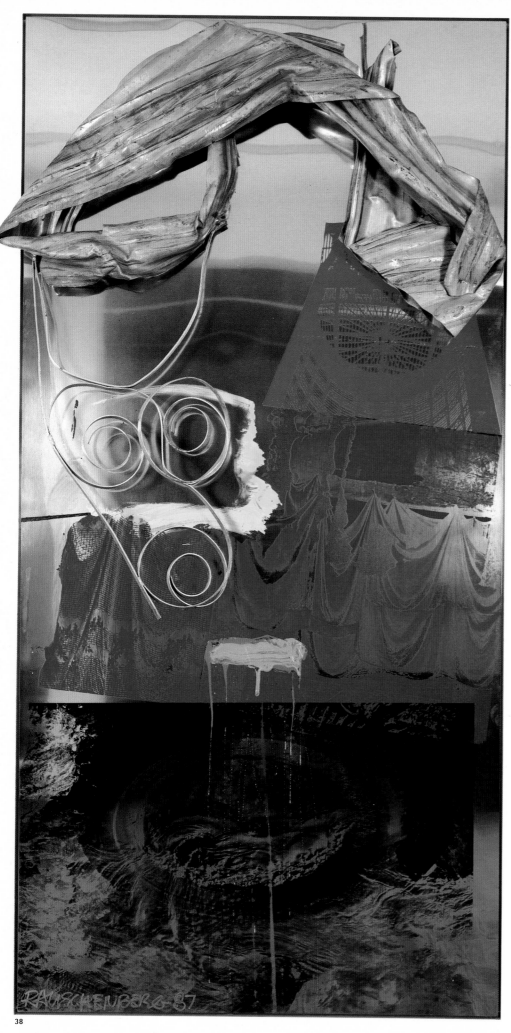

Movement, there were problems with categorization, some produced by the artists themselves, some by the critics who attempted to deal with their work. *Car Crash* (Pl. 39) is a very early work by Jim Dine, one of the best-known of the core Pop Art group in New York. The title suggests intentions connected to Pop – Andy Warhol did a series of paintings concerned with the same subject-matter – but the work itself offers little or nothing that can be identified as Pop imagery. Yet there is a specific connection, quite apart from the identity of the artist. New York Pop Art publicized itself through the semi-improvised performances called Happenings. One of these Happenings was Dine's *Car Crash*, and this painting formed part of the improvised scenery. The silver crosses visible in it were repeated as cut-out motifs that dangled from the ceiling of the room where the Happening took place. The painting is therefore intimately linked with the genesis of Pop, without exhibiting specific Pop Art characteristics. Taken on its own, it remains within the gestural tradition pioneered by the Abstract Expressionists. It has a close relationship, not to artists such as Warhol or Roy Lichtenstein, but to the work of Robert Rauschenberg. Rauschenberg, indeed, continued to work in a similar idiom, one that he had established thirty and more years previously, into the 1980s. His combine-painting *Untitled* (Pl. 38), which dates from as late as 1987, might have been made at any time since the mid-1950s. Rauschenberg's work occupies a curious position on the contemporary art scene, in that it is still unhesitatingly accepted by most spectators as innovatory and fresh, yet belongs in a the strict sense to a historical moment that has long ago passed away. Much of the work done by leading members of the New York school in the last decade and a half can be seen as the product of a struggle to escape from Rauschenberg's still-pervasive influence. Though his reputation has fluctuated much more than that of his erstwhile colleague, Jasper Johns, it is Rauschenberg who has had a much greater influence over later generations of artists, just as Warhol has, on the whole, been much more influential than Roy Lichtenstein. (The irony of this is, of course, that Warhol was once dismissed as a Lichtenstein imitator.)

38

38 Robert Rauschenberg, *Untitled*,
1987
Mixed media, 246 × 131 × 25.3 cm
(97 × 51½ × 10 in)

39 Jim Dine, *Car Crash*, 1959–60
Oil and mixed media on burlap,
152.2 × 160 cm (60 × 63 in)

39

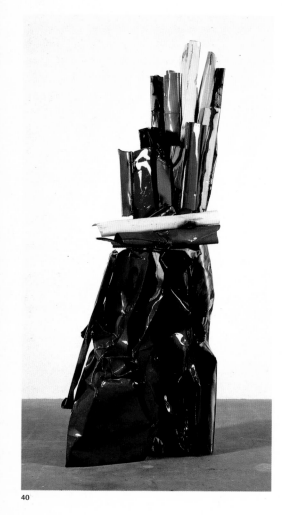

40 **John Chamberlain**, *Etruscan Romance*, 1984
Painted chromium-plated steel,
282 × 124.5 × 79 cm (111 × 49 × 31 in)

41 **R.B. Kitaj**, *From London (James Joll and John Golding)* 1975–7
Oil on canvas, 152.4 × 243.8 cm
(60 × 96 in)

40

Connected to the ethos represented by Rauschenberg and early Dine are the sculptures of John Chamberlain (Pl. 40). Chamberlain's work – which has changed remarkably little since William Seitz featured it in his pioneering exhibition *The Art of Assemblage*, held at the Museum of Modern Art, New York, in 1960 – is made up of scrap metal – painted fragments of automobile bodies. What brings it within the general Pop ethos is not the form of the work, but the fact that it is wholeheartedly committed to urban, industrial materials, and the further fact that it comments by implication on the random violence of that world. Warhol's *Car Crash* paintings, the work by Dine just discussed, and Chamberlain's sculptures form a kind of sequence. Rather than trying to freeze mass culture in place, to analyse and define it, they see it as part of a larger flux. In this sense, they have retained their centrality and contemporary relevance, while other, more typical Pop objects are now period pieces. It is a short step from Chamberlain's sculptures – limited and repetitive though they are – to some works by Joseph Beuys (Pl. 150), who is undoubtedly the central figure in the art of the past thirty years.

One paradox of the Pop Art Movement is that what seemed so neatly circumscribed to the commentators of the time, is now increasingly problematic for art historians. In this respect, it is worth considering the work of R.B. Kitaj. Kitaj, an American domiciled in London, and identified with British rather than American painting, held his first one-person exhibition at the Marlborough Gallery, London, in 1963. Previously, as a student, first at the Ruskin School of Drawing in Oxford, then at the Royal College of Art in London, Kitaj had shown his work at several *Young Contemporaries* exhibitions, just at the time when Pop Art was emerging in Britain. For this reason, and also because of his close friendship with David Hockney, whom he met at the Royal College, Kitaj was immediately seen as a member of the movement, and continues to be treated as such in standard reference books.

Despite this, most of his qualities seem to disqualify him from such a status. Kitaj is a learned, complex painter, fascinated by esoteric knowledge. One of his most impressive paintings, *From London (James Joll and John Golding)* (Pl. 41), is an elaborate double portrait

of two friends, one an art historian, the other an art historian who is also a practising painter – a maker of abstracts. It is full of references to their interests and Kitaj's participation in them. For example, of the three books whose titles are visible, one is a catalogue of work by the French Cubist Fernand Léger (Golding is a specialist in the history of Cubism), another is by or about the Italian Marxist Antonio Gramsci, imprisoned for the last ten years of his life by Mussolini, and the third bears the name of the philosopher Richard Wollheim, a close friend of the artist. The devices used are ones that would have been appropriate to portraiture of an ambitious kind at any moment from the early Renaissance onwards. A comparison springs to mind with Holbein's celebrated *The Ambassadors* in the National Gallery, London – a painting even more ambitious and just as crammed with emblematic devices.

What is modernist about Kitaj's painting is something that has nothing to do with Pop Art – the use of subtly dislocated space in a way that alludes to Cubism. In fact, the work is essentially eclectic, without any strongly emphasized stylistic allegiance, and this is a characteristic which points towards the future. By the time this picture was painted, the Pop Art Movement was already in the process of becoming a kind of time-capsule.

The work and career of Kitaj's great friend David Hockney is also well worth examination in this context. Now that Picasso, Warhol, Salvador Dali and even Francis Bacon are all dead, Hockney is probably the best-known living artist. His celebrity extends well beyond the boundaries of the art world, and his work and personality are not neglected within it. A recent examination of the computer index of art periodicals in the British National Art Library, housed in the Victoria & Albert Museum, indicated that he far outstrips any rival, both in terms of frequency of mention, and in terms of the number of illustrations that art magazines are prepared to give to his work.

Hockney won recognition very early. He was already celebrated, at least within a small but influential circle, when he was still a student at the Royal College of Art. He attracted people as much through his personality and appearance – with owlish spectacles and dyed blonde hair – as through his precocious talent. He seemed to personify the new, daredevil, devil-may-care

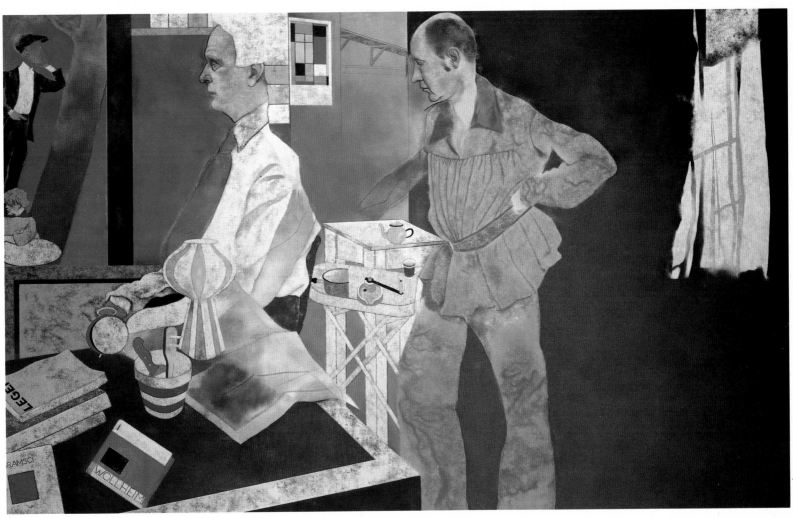

41

London of the Swinging Sixties. Britain was, apart from the United States, the only country to have developed an authentic Pop Art scene of its own making, and few people questioned the idea that Hockney was the most authentic of Pop artists, a central figure in the British wing of the movement.

This idea was reinforced by Hockney's departure for the United States. He first visited America in 1961, but did not get as far as Los Angeles until 1963. The city appealed to him immediately:

> Within a week of arriving there in this strange big city, not knowing a soul, I'd passed the driving test, bought a car, driven to Las Vegas and

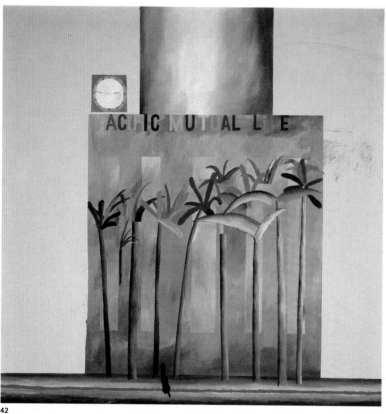

42

won some money, got myself a studio, started painting, all in a week. And I thought, it's just how I imagined it would be.[1]

Hockney's paintings of Los Angeles (Pl. 42) are amongst his best-known works. He gave the city a pictorial identity that it had never possessed previously, and many people now see it through his eyes, just as they see Venice through the eyes of Canaletto and Francesco Guardi. Hockney's spindly palm trees, flat façades and cobalt-blue swimming pools created the current image of the city.

Yet despite their accessibility, it is questionable whether they are Pop pictures in

any meaningful sense, since they neither refer to the conventions of mass culture (advertising billboards, girlie magazines, comic strips) nor use materials that are specifically Pop. What gives them their force is the brilliance of Hockney's graphic handwriting – his economy and vitality of line, his ability to seize on essential details and both concentrate and simplify them. The gifts Hockney employs, in these Los Angeles paintings of the 1960s, are very much like the gifts that Andy Warhol deliberately abandoned when he decided to give up a career as a highly successful fashion illustrator for one as a fine artist. Both were arguably much more gifted as draughtsmen than they were as painters.

Whereas Warhol, having discovered a style, then a technique to go with it, remained relatively stable stylistically throughout the rest of his career, Hockney has been a restless experimentalist. He has been particularly stimulated by new media – paper pulp, polaroid photography – and new electronic devices, such as the photocopier and the fax machine. Much of his later work has been under the spell of the great Modern painters of the first generation: first Picasso, then Matisse. He has been particularly fascinated by the spatial manipulations of the Cubists. The results of all this input from the earlier period of Modernism can be seen in the *Very New Paintings* (Pl. 43) produced in the early 1990s. Hockney fed into these not only what he had learned from Picasso but things that clearly stem from his experience as a stage-designer. The paintings are as close as Hockney has ever come to purely abstract art. They represent illusionistic, but contradictory spaces, without figures – a labyrinthine world in which the eye travels, but is continually forced to return upon itself. In many ways their nearest equivalents are the puzzle-drawings of M.C. Escher, and perhaps some of the *Prison* etchings of Piranesi.

Hockney's most recent paintings are Pop only in a generic sense – they are accessible, popular art. They make a fascinating contrast with the Andy Warhol *Soup Cans* illustrated at the beginning of this chapter, which are not immediately approachable in the same way. In fact what Warhol does is to take a familiar image and alienate us from it through the use of repetition.

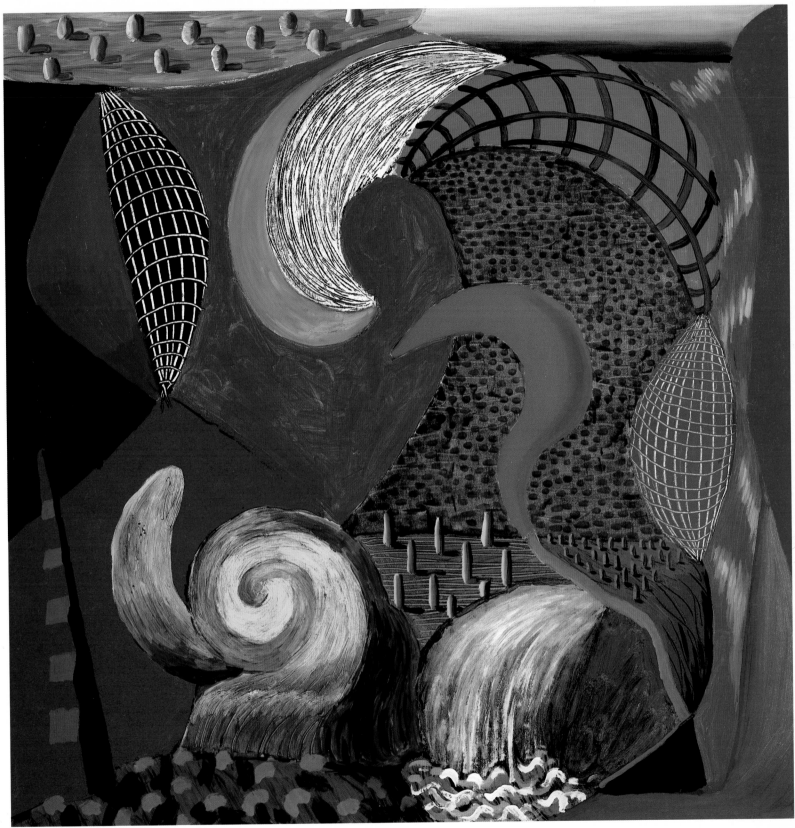

The Survival of Abstraction

44 Victor Pasmore, *Line and Space*,
1967–76
Oil, charcoal and gravure on board,
91.5 × 122 cm (36 × 48 in)

45 Ben Nicholson, *1969*
(Locmariaquer), 1969
Oil on carved board, 29.5 × 50.5 cm
(11¾ × 20 in)

46 Sam Francis, *When White*, 1963–4
Oil on canvas, 251 × 193 cm (98 × 76 in)

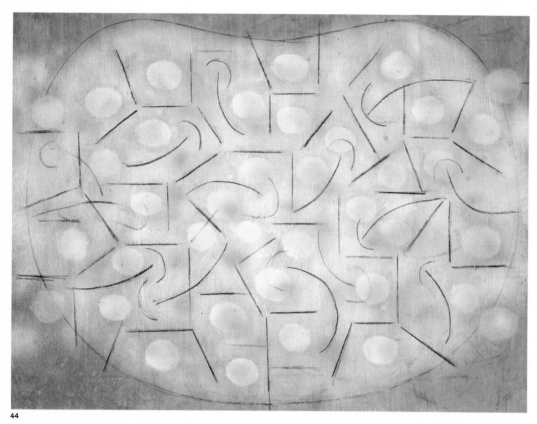

44

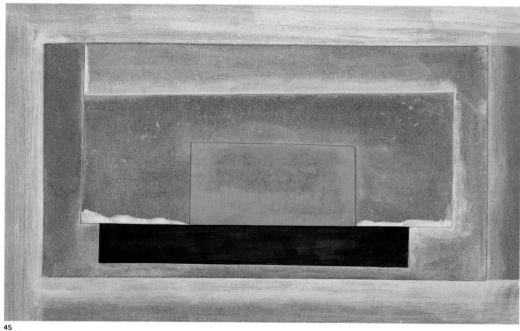

45

To use a kind of critical shorthand, Pop Art, as it exists in the 1990s, might be described as a kind of 'survivor style' in the art scene of the 1990s. This phrase really implies two different kinds of survival. One is the continuing productivity of artists like Hockney, who may once have been closely identified with the movement, but who have now moved away from it; the other is the continuing validity of Pop as an idea and image-bank.

The same comment might be made about other forms of art, many of them linked to art movements that have now passed into history. If we look, for example, at free abstraction, best known in the version we now label Abstract Expressionism, but by no means confined to Abstract Expressionism alone, we still find valid art being made. Often it is of a sort with quite remote connections in the Modernist past. The veteran British artist Victor Pasmore, for example, made work in the 1970s whose link with Mondrian's *Pier and Ocean* series is immediately obvious (Pl. 44). The fact that the Mondrian paintings to which Pasmore's production is linked date from some sixty years previously does not invalidate what the latter has to say. The same was true of the later productions of Ben Nicholson. Nicholson, as a pioneer of Modernism, passed through the experience of Cubism, then Constructivism, and was already producing abstract reliefs in a variant of Constructivist style in the mid-1930s. He continued to make such works into the concluding phase of his career (Pl. 45). During the 1970s, despite the rise of Minimal Art, they seemed very remote in sensibility from anything that surrounded them. They were, however, only one of a number of such survivals, and what one may term the 'survivalist' phenomenon continues to play an important role in the art world of the 1990s.

If Pop has a continuing presence in the art world of the 1990s, so too does Pop's immediate predecessor, Abstract Expressionism. On the whole, it is the slightly less central, less orthodox votaries of the style who have continued to be influential. It has been easier for artistic successors to learn from Sam Francis, for example (Pl. 46), than from Jackson Pollock, because Francis's style is more accommodating to traditional ideas about composition.

Some of the chief beneficiaries of the

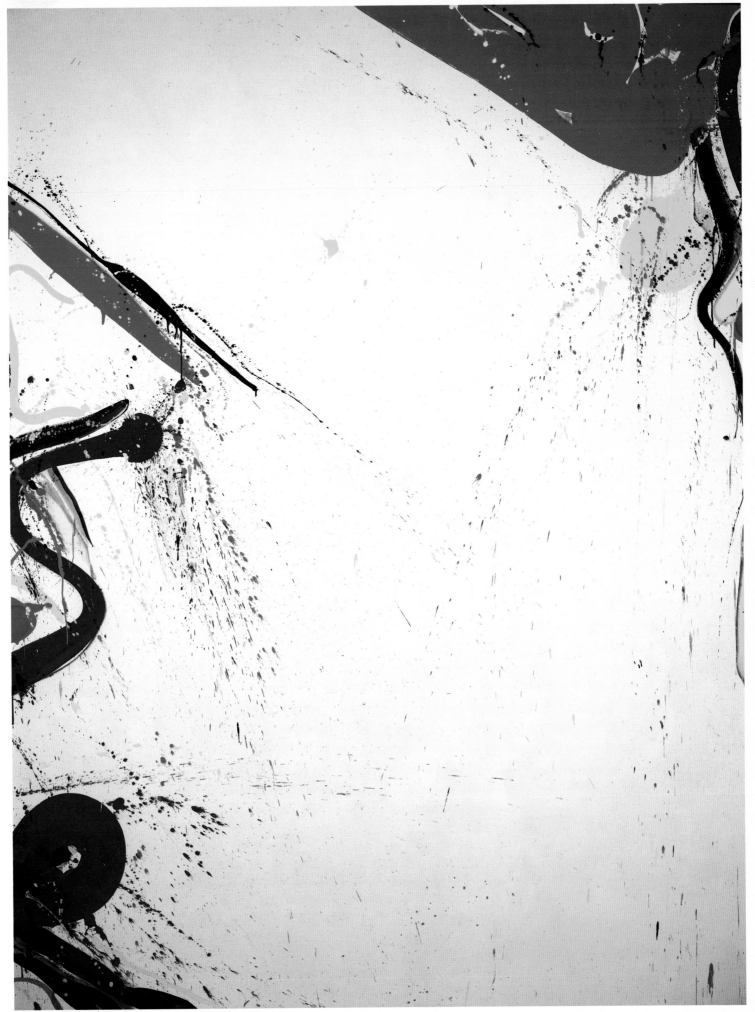

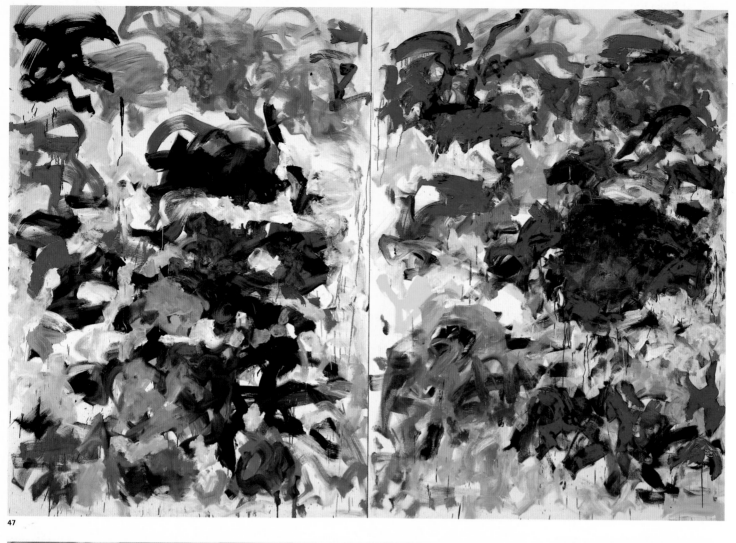

47

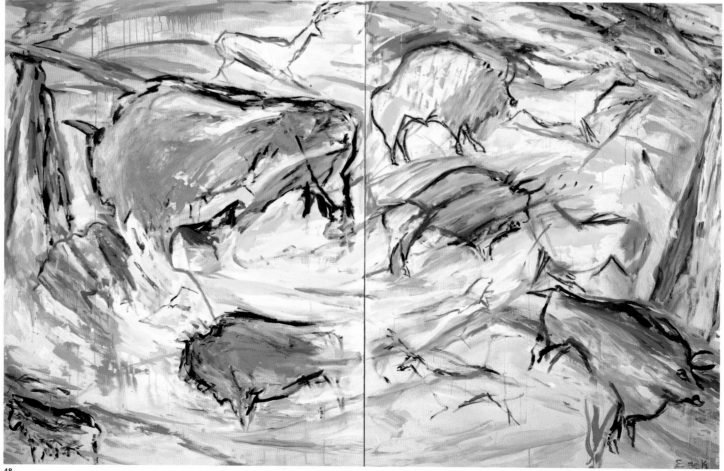

48

The Survival of Abstraction

reconsideration of Abstract Expressionism
have been women, and the increased attention
devoted to their work has obviously had
something to do with the success of the
feminist movement, and the increased
attention paid to women artists in general. For
example, the high quality of Joan Mitchell's
work was universally recognized in the last
years of her life. Mitchell's work has a visible
affinity with that of Francis, which is not
surprising because both chose to spend
substantial periods of their careers in France
and both were therefore influenced by French
art informel as well as by home-grown Abstract
Expressionism. Mitchell's late diptych
Sunflowers (Pl. 47) is also influenced by the
paintings of Monet's *Waterlily* series, which
accounts for the only half-hidden figurative
element.

Another woman Abstractionist who allowed
a figurative element to creep into her work was
Elaine de Kooning, whose *Sun Wall (Cave #
100)* (Pl. 48) is a free paraphrase of Palaeolithic
art. De Kooning's selection of this theme is a
reminder of Abstract Expressionism's interest
in consciously primitive elements, evident,
for instance, in the paintings where Jackson
Pollock ventured into figuration. De Kooning,
however, has also tackled thoroughly modern
themes. An exhibition she held in 1981,
entitled *Hoops and Homers* was partly inspired
by cover illustrations on sports magazines.

Grace Hartigan, prominent in the late 1950s
and early 1960s, but somewhat neglected since
that time, offers an interesting synthesis of
Abstract Expressionist and Pop sensibilities (Pl.
49). As early as 1956 she was quoted as saying:
'I have found my subject. It concerns that
which is vulgar and vital in American life.'[1]
Like those of Mitchell and Elaine de Kooning,
her vibrant abstract paintings often have a
concealed figurative element.

This element is also clearly visible in the
paintings and prints of Helen Frankenthaler
(Pl. 50). Frankenthaler is one of the key figures
in the recent history of American art, since
she was the inventor, in 1952, of the so-called
'soak-stain' technique. Inspired by earlier
experiments with watercolour, she devised
a method of flooding very dilute colour on to
unprimed cotton duck, creating a complete
bond between the support and the medium. The
painting thus became a completely integrated

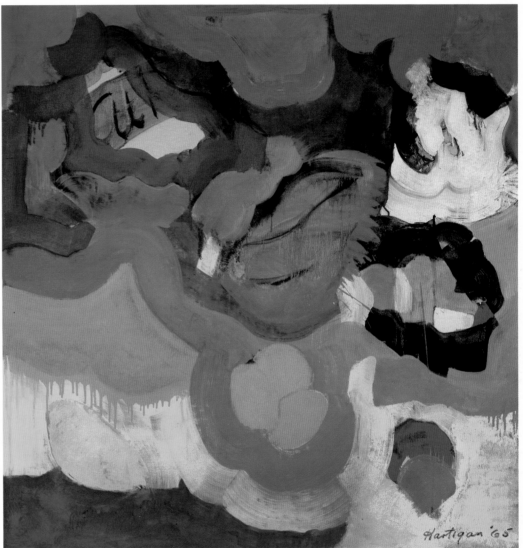

47 **Joan Mitchell**, *Sunflowers*, 1991–2
Oil on canvas, 280 × 400 cm
(110¼ × 157½ in)

48 **Elaine de Kooning**, *Sun Wall
(Cave #100)*, 1986
Acrylic on canvas, 213 × 335 cm
(84 × 132 in)

49 **Grace Hartigan**, *Easter Still Life*,
1965
Oil on canvas, 114.3 × 111.8 cm
(45 × 44 in)

49

50 Helen Frankenthaler, *Tahiti*, 1989
Mixograph on handmade paper,
81.2 × 137.2 cm (32 × 54 in)

51 Jennifer Durrant, *In Your Eyes*,
1992
Acrylic on canvas, 264 × 393 cm
(104 × 155 in)

52 Emilio Vedova, *Disco*
'Non dove '87 – II' (op.4), 1987
Oil on wood, diameter 279 cm (110 in)

object, and the viewer was constantly aware of its identity as a surface. Perhaps because she arrived at this new method via *plein-air* watercolour painting, Frankenthaler's compositions nearly always suggest the presence of a landscape of some kind. She reaches back beyond Abstract Expressionism not to Monet (as is the case with Joan Mitchell) but to late works by J.M.W. Turner. Some of her paintings are reminiscent of the vaporous 'colour beginnings' found in Turner's studio after the artist's death, and now part of the

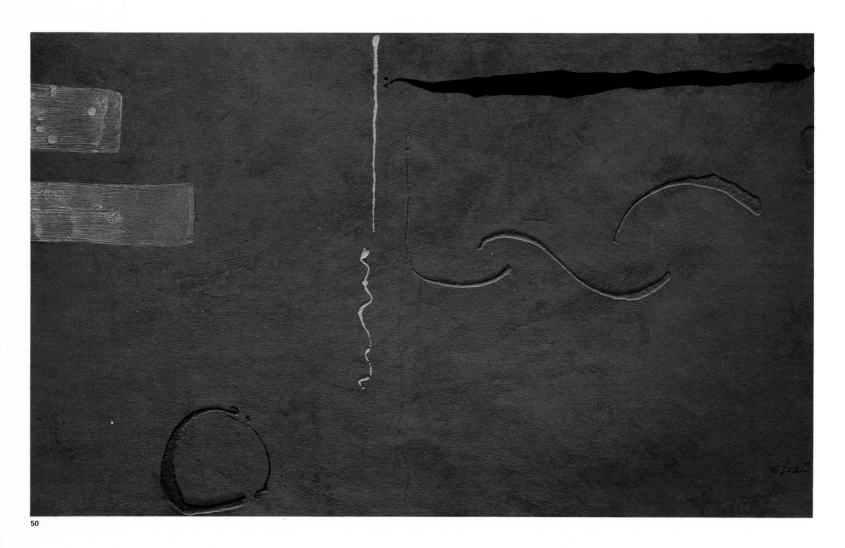

50

vast collection of his work in the Tate Gallery, London.

One British painter who ought to be added to the group of Americans discussed above is Jennifer Durrant (Pl. 51). Durrant's work is consistently more, rather than less, abstract than that of her American colleagues – something that goes contrary to generally held perceptions about the differences between painting in Britain and painting in the United States. Nevertheless, her work has something of the same light-filled, joyful, exuberant quality

51

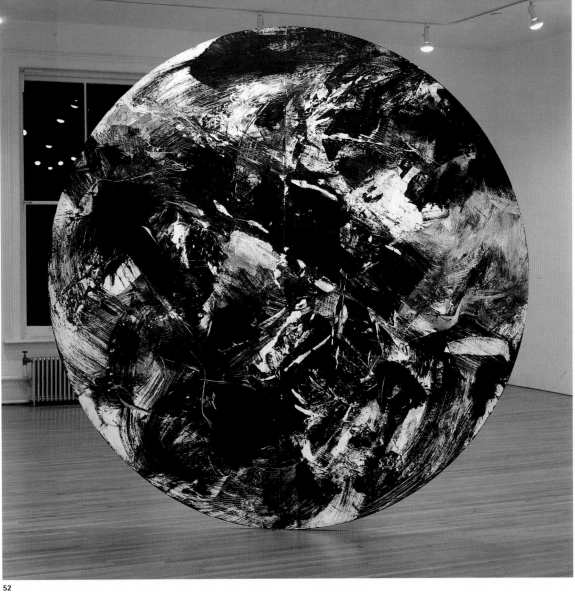

52

54

55 Günther Förg, *Untitled*, 1993
Acrylic on paper, 150 × 120 cm
(59 × 47¼ in)

56 Sean Scully, *Remember*, 1986
Oil on canvas, 243.5 × 317 cm
(96 × 125 in)

55

56

that is typical of these American women painters at their best.

Since abstraction is now so much part of the established language of Modernism, it also comes as no surprise to find there are also male artists who have continued to use it. In some respects this language has moved forward very little. Emilio Vedova's painted discs of the 1980s (Pl. 52) have surfaces whose markings and rhythms would have seemed completely familiar in the 1950s. Similarly, there are visible connections between Jack Tworkov's *Red and Green with a Yellow Stripe* (Pl. 53), painted in 1964, and the lush abstractions made nearly twenty years later by Robert Natkin (Pl. 54). Natkin's paintings are the ultimate development of one tendency in American art – sumptuous colour orchestration can probably be carried no further. The artist takes over techniques from the 'soak-stain' Post-Painterly Abstractionists and adds to them, to achieve a uniquely wide range of technical effects – soaking, sponging, staining, stencilling. As exercises in painterly virtuosity they are unsurpassed, though Natkin has sometimes been unfairly criticized for self-indulgence and lack of intellectual force.

Yet he is out of step with most of the other artists who are still busy exploring the possibilities of painterly abstraction because of his love of complication. One painter whose work does have a certain resemblance to his is the German Gerhard Richter. Richter disconcerts critics by painting in two quite different manners. Some paintings are figurative, and their content is often political (Pl. 224). Others are purely abstract (Pl. 57), at least in intention. However, Richter, like Natkin, often seems to suggest landscape references, perhaps introduced inadvertently and contrary to his own declared intentions. An *Abstraktes Bild* (Abstract Painting – Richter uses this phrase as the generic title for a whole category of his work) of the sort illustrated here will necessarily remind many spectators of Monet's late work, whose imagery pervades so much of the supposedly abstract art of the present day.

One of the ways in which Richter's work does differ from that of Natkin is that he, like his compatriot Günther Förg (Pl. 55), puts greater stress on the presence of an underlying grid. This feature is the result of an interchange

57

58 Robert Moskowitz, *Vincent*, 1989
Oil on canvas, 292 × 137 cm (115 × 54 in)

59 Ellsworth Kelly, *Red Blue Green Yellow*, 1965
2 panels, oil on canvas on board,
222 × 137 × 222 cm (87½ × 54 × 87½ in)

58

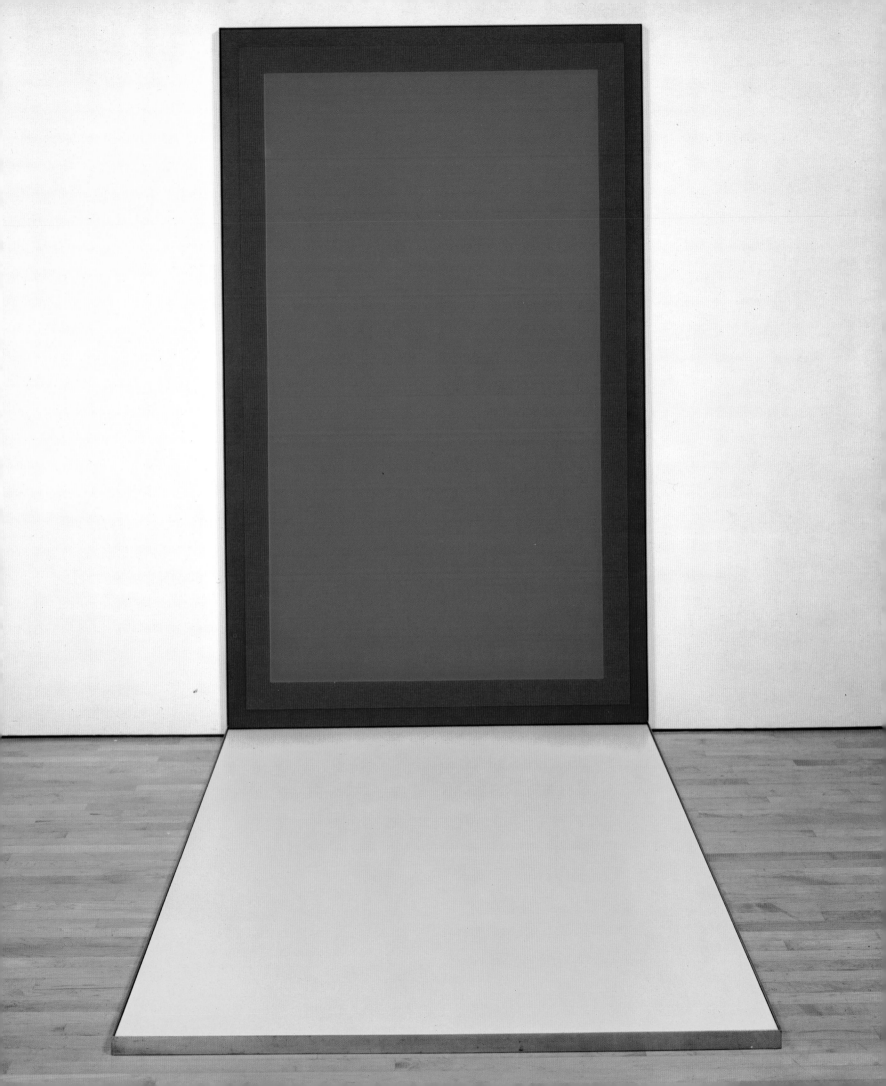

60 Ellsworth Kelly, *Yellow Red Curve I*,
1972
Oil on canvas, 203 × 313 cm
(80 × 123½ in)

61 Bridget Riley, *Fourth Revision of
June 23; Study after Cartoon for 'High
Sky'*, 1991
Gouache on paper, 66 × 86 cm
(26 × 34 in)

60

of ideas with Minimal and Conceptual Art,
as are the heavy vertical stripes that are a
consistent feature of the work of Sean Scully
(Pl. 56). Scully's paintings aim at a kind of
sculptural presence. It is easy to see them as
metaphors, not for landscapes, in the manner
of Monet or Turner, but for buildings, solidly
three-dimensional, planted in the viewer's
space. It is interesting to contrast this approach
with the completely opposite one pursued by
an artist like Robert Moskowitz. Moskowitz's
Vincent (Pl. 58), for instance, is much closer to
figurative painting than anything in Scully's
current work. Once given the clue offered
by the title, the spectator can easily guess that
the painting is a paraphrase of Vincent Van
Gogh's final painting, *Wheatfield with Crows*,
painted at Auvers in July 1890, just before
the artist's suicide. The wheatfield is now an
undifferentiated flat area of yellow, the circular
cloud right of centre has become a white disc,
and the crows are reduced to a single black
boomerang shape. Moskowitz disciplines the
material rather like the painters of Japanese
screens, so as to produce an ethereal, and, it
must be said, rather bloodless effect.

 Though Scully's colour sense (nowadays
rather subdued, though his earlier paintings
were a blaze of brilliant hues) is so different,
one of his possible exemplars in this search
for solidity is the veteran American artist
Ellsworth Kelly. As early as the mid-1960s
Kelly was experimenting with paintings in
unconventional formats (Pl. 59). His real
genius, however, lay in his ability to suggest
the presence of solid volumes by using very
simple contrasts of colour and form. The dart-
shaped *Yellow Red Curve I* (Pl. 60) is a work
of astonishing presence. The red semicircle
carved out of the lower part of a yellow triangle
suggests that the whole form is in motion. Kelly
has found another way to produce an effect
which the Italian Futurist painters achieved
more elaborately, with their vibrating lines of
force. Yet the painting also has another aspect;
the red shape opposed to the yellow one makes
both colours lift from the flat surface – the
line of the semicircle becomes the edge of a
projecting ridge, and the semicircle itself reads
as concave.

 Kelly's work in this manner is as specifically
optical, and as visually challenging as, Op
paintings by Bridget Riley (Pl. 61). Riley,

61

62 Robert Mangold, *Attic Series VII*,
1990
Acrylic and pencil on canvas,
264 × 205.5 cm (104 × 81 in)

63 Kenneth Noland, *Flares: Sunday*,
1991
Acrylic on canvas on wood, with
plexiglass, 66.6 × 100.9 cm
(26¼ × 39¾ in)

62

having begun her career as a maker of optical designs in black and white, has, over the course of the years, evolved into one of the most brilliant and sophisticated of colourists. Her paintings, often with rigidly arranged rows of colour cells, have something in common with Minimalism, and the link is even clearer in Ellsworth Kelly's work, with its broader, simpler colour areas. It is chiefly the dynamism of Kelly's art that helps to separate it from Minimalism. The separation is less distinct in the paintings of Kenneth Noland, a one-time colleague of Helen Frankenthaler, and in those of Robert Mangold, an American artist who owes a good deal to Kelly. Compared with those of the older artist, Mangold's sliced forms are inert, and the lines with which he divides them are not as powerfully activating as Kelly's sizzling colour contrasts.

The fascinating way in which artists of a particular epoch echo and comment upon one another's work is illustrated not only in the link between Kelly and Mangold, but in the less immediately obvious one between Mangold's recent paintings and those of Sean Scully. Mangold's *Attic* series (Pl. 62) uses the 'house' imagery one finds in so many of Scully's paintings, but in a different way, stressing the idea of a building being a hollow space contained within a hollow, more indefinite space, rather than seeing it as a solid block, displacing the air around it.

Kenneth Noland, in his recent *Flares* series, has also used blocks of flat colour as a means of carving space. *Flares: Sunday* (Pl. 63) consists of three adjacent horizontal forms. Each has one long curved edge. In the uppermost shape and the lowest one, this edge is emphasized with a thin stripe of colour. Unlike Noland's earlier stripe paintings, these are dynamic rather than inert. The forms have a soaring rhythm that matches the title. Noland has been able to achieve this by devising a way of working which is essentially a compromise between painting and sculpture.

One of the basic problems in dealing with abstract painting, as opposed to abstract three-dimensional work, is the way in which it has been marginalized by new developments in art. If one looks back half a century, to the rise of Abstract Expressionism, this seems one of the most profound changes to have taken place in the contemporary art world. In the 1940s, it

was undoubtedly painting which led the way, in terms of experimentalism. The sculptors of the epoch were constantly forced to look for equivalents for things that had already happened in painting. This was not in itself a new situation – precisely the same thing can be said about Cubism, where sculptors rather clumsily followed the painters' lead, or where artists who were primarily painters (such as Picasso) experimented with three-dimensional works which were more original than anything which the committed sculptors were able to produce. In the 1970s, the balance changed; it was sculptures, installations, three-dimensional works of all kinds that were now the primary focus of experiment. Abstract, as opposed to figurative, painting was doubly disadvantaged by this situation because figuration offered a language which could convey meanings which were beyond the grasp of abstract art. Abstraction, by its very nature, deals in generalities. Figuration has the power to be absolutely specific – about a person, a place, an event or a thing. Much of the audience for art is stubbornly indifferent to the aesthetic analysis – or, in the case of artists like Ellsworth Kelly, the aesthetic conjuring – which is the main business of the abstract painter.

It is not going too far to say that abstract painting has been one of the main victims of the return to content which is one of the most striking features of the contemporary art of the 1990s. If abstract painting has been a victim of the new situation, what has been the fate of abstract sculpture? This is a difficult question to answer, because there are, in practical terms, two very different kinds of abstract sculpture, recognized on a pragmatic basis by most habitués of the art world, but difficult to separate from one another in words. One kind belongs to the realm of Minimal and Conceptual Art. The other kind operates in a more traditional way. Like free abstraction in painting, it can be seen as another form of 'survivor style'.

The chief reason for the survival of this second variety of abstract sculpture has been a continuing demand for sculpture to undertake tasks which Minimal Art fulfils only with difficulty. The final decades of the twentieth century have been an age of building. Ambitious buildings create equally ambitious

63

64 George Sugarman, *Sculpture for Columbia Plaza*, Cincinnati, Ohio, 1973
Painted steel, 70 × 1675 × 1370 cm
(276 × 660 × 540 in)

65 Charles Ginnever, *Kitsune*, 1988
Steel, vertical section 4 × 6 × 4 m
(13¼ × 19½ × 13¼ ft); horizontal section
3.7 × 4.5 × 8.1 m (12 × 14¾ × 29¾ ft)

66 Albert Paley, *Olympia*, 1990
Painted steel, 9.1 × 3.7 × 2.4 m
(30 × 12 × 8 ft)

64

65

public spaces, beside, amidst and around them. These spaces, in turn, have seemed to demand sculptural adornment. The result has been a steady output of ambitious sculptures which are abstract, but certainly not minimal in any widely understood definition of that term.

Sculpture of this type, because it does not inhabit the museum, is one of the most familiar kinds of contemporary art, but also on the whole one of the least discussed. Such discussion as it does arouse tends to be part of the general debate about architecture and the environment, rather than being involved with issues of content, which are now the staples of the new art criticism. This criticism is generally concerned with the cultural rather than the purely physical context of the work of art, its role as a signifier in terms (say) of the politics of race or gender. The kind of sculpture I am discussing here does not accept such meanings easily.

Among the numerous artists who have been involved with public projects of this type, there are a large number of Americans – not surprisingly, since the United States is a nation that builds vigorously. George Sugarman's 1973 *Sculpture for Columbia Plaza* (Pl. 64) in Cincinnati, and Albert Paley's more recent *Olympia* (Pl. 66), for Promenade II in Atlanta , are both good examples of the genre. The exuberance of the forms, and the striking use of colour, both emphasize the distance between this kind of work and classic Minimalism. Even those sculptors who are more austere, and who are perhaps more interested in the effect their work makes in a landscape, rather than in the way it interacts with an architectural setting, are careful to endow their work with a certain expansiveness. Charles Ginnever's *Kitsune* (Pl. 65) demonstrates the continuing interest felt by a number of American sculptors in the Constructivist tradition. Like much contemporary sculpture in this vein, the traditional stringency of Constructivist thinking is to some extent subverted by an interest in baroque gestures, if not in recognizably baroque forms. The San Francisco-based sculptor Fletcher Benton, for example, builds his sculptures from very simple shapes – triangles, cylinders, segments of circles, often painted in bright colours. Yet a piece like *Balanced/Unbalanced: Three Parts, Yellow Ring* (Pl. 68) conveys a surprising feel of

67 Mark di Suvero, *For Gerard Manley Hopkins*, 1988–9
Installed at Venice Beach, California, 5 December 1990–15 February 1991, painted steel, 10.4 × 15.2 × 15.2 m (34 × 50 × 50ft)

68 Fletcher Benton, *Balanced/Unbalanced: Three Parts, Yellow Ring*, 1990
Painted steel, height 4.3 m (14ft)

68

69 Nicholas Schöffer, *Chronos 8*, 1967
Stainless steel, 335 × 122 × 122 cm
(132 × 48 × 48 in)
Collection of the Virlaine Foundation,
New Orleans

70 Kenneth Snelson, *Virlaine Tower*, 1981
Stainless steel, height 137 m (45 ft)
Collection of the Virlaine Foundation,
New Orleans

71 Lin Emery, *Tree Dance*, 1991
Installed at Hofstra University,
Hempstead, New York, mirror-polished
aluminium, with red facets, height
approximately 6.9 m (22½ ft)

72 Richard Serra, *Tilted Arc*, 1981
Installed in Federal Plaza, New York,
cor-ten steel, 3.7 × 36.5 m (12 × 120 ft)

69

70

71

exuberance. As the title suggests, Benton's sculpture, for all its actual weight and solidity, conveys a slight feeling of precariousness. This feeling is still more pronounced in the recent work of another senior Californian sculptor, Mark di Suvero. Some of di Suvero's most striking recent works have been temporary installation pieces, like his *For Gerard Manley Hopkins* (Pl. 67). Here the need to have a simple structure, capable of being dismantled and moved to another site, has not prevented di Suvero from creating an ambitious, wide-spreading, cantilevered composition.

Perhaps the most startling American public sculptures of this type are the structures made of stainless steel bars and wire created by Kenneth Snelson. By adroitly putting the simple elements he uses in tension, Snelson creates works that seem to defy the force of gravity (Pl. 70). Snelson's slender structures give the appearance of being in motion – it looks as if the stainless steel rods are rising into the air of their own volition.

Not surprisingly, sculpture that actually incorporates motion has retained its popularity for public sites. Invented by the Constructivists, and pioneered by artists like Rodchenko and Naum Gabo, it has been the subject of repeated revivals – in the hands of the American sculptor Alexander Calder, then again in the 1960s, with the work of leading kinetic artists like Nicholas Schöffer (Pl. 69). Today one of the most active sculptors creating kinetic works for public sites is New Orleans-based Lin Emery. Recent commissions have included the brilliant red *Tree Dance* (Pl. 71). This is a good example of the imaginative elegance of some of the work currently being done by leading American sculptors for public sites.

It is worth contrasting abstract sculptures of this type with the sporadic attempts that have been made to use work more closely aligned with the Minimal Art Movement on public sites. One of the more notorious instances is Richard Serra's *Tilted Arc* (Pl. 72). This, enormously admired by critics and by enthusiasts for contemporary art, was considered so threatening by the general public that it had to be removed from its site.

European public sculpture is on the whole less assertive than its transatlantic equivalent. Like public sculpture in the United States, it has more and more tended to be abstract.

72

73 Arnaldo Pomodoro, *Solar Disc*,
1983–4
Bronze, diameter 370 cm (146 in)

74 Beverly Pepper, *San Martino Altar:*
Eternal Celebrant, 1992–3
Cast iron, 306 × 121 × 82 cm
(120 × 47 × 32 in)

75 Mark di Suvero, *Next Two*
Steel, 197 × 197 × 140 cm
(77½ × 77½ × 55 in)

Figurative sculpture in public places is often felt to be too much of a risk, too likely to offend, because too specific. Where public sculpture has a figurative element, then this is usually very general. One of the masters of this kind of generalization has been the veteran Italian artist Arnaldo Pomodoro. Pomodoro, in recent work, has used what are basically abstract forms, but has nevertheless made references to ancient civilizations. This is the case, for instance, with his *Solar Disc*, for the Palace of Youth in Moscow (Pl. 73).

Abstract but non-Minimal sculpture, of what is now a fairly traditional sort, also survives within a museum or even a purely domestic context, but only with some difficulty

73

74

– when confronted with the austerity of true Minimalism, or the bold experimentalism of the sculptures made by artists who followed in the footsteps of the Italian Arte Povera Movement, it seems compromised and hesitant. One can admire the balance of shapes in Mark di Suvero's *Next Two* (Pl. 75), while thinking that the piece is not as effective in isolation as it might be if placed in an architectural setting for which it had been especially designed.

Abstract but non-Minimal sculptors have tried to get around this problem – that of a lack of presence – in various ways. Beverly Pepper, for example, endows what are very simple forms with totemic power in her *San Martino Altar: Eternal Celebrant* (Pl. 74). This, with its

The Survival of Abstraction

76

77

discreet allusion to Christian ritual, acquires a resonance that the same collocation of shapes might not possess without the cultural reference. Much the same can be said about Eduardo Chillida's *Topos – Stele VII* (Pl. 76), which, like Arnaldo Pomodoro's *Solar Disc*, refers to the ancient Mediterranean world. Just as Pepper's *Altar* gathers around itself the aura of long-established religious ritual, *Topos*, while remaining carefully unspecific, seems to mark a boundary, or to commemorate the memory of some person or event.

Perhaps in reaction against the pressure of Minimalist ideas, a number of leading abstract sculptors of the 1960s have increasingly started to use figurative elements in their work. One of the most prominent of these converts is Anthony Caro. Caro's *The Caliph's Garden* (Pl. 78) is like a miniature building – an architect's model for some fanciful Oriental pavilion. The title that the artist has given to the piece indicates that this is not a misreading; that the spectator is meant to see the sculpture as not merely a collocation of forms, but as the trigger for an imaginary narrative. In this sense, it is not so far from the work of a sculptor who would originally have seemed very different from Caro – the Spaniard Miguel Berrocal. Berrocal's intricately interlaced forms (Pl. 77) belong to a very different tradition from that of Caro – that of cast, rather than constructed sculpture. His affinities are with the Surrealist Hans Arp, and perhaps also, in the sculpture illustrated here, with Henry Moore.

With its intricately looped forms, *Salvador y Dalila* reads as a representation of a reclining and embracing couple, related to Moore's long series of *Reclining Figures*. The sense of a teasingly hidden narrative is, however, precisely the same as that conveyed in the sculpture by Caro, and the resemblance is only partially concealed by the disparity in scale.

76 Eduardo Chillida, *Topos – Stele VII*, 1988
Cor-ten steel, 131.4 × 24.8 × 27.9 cm
(51¾ × 9¾ × 11 in)

77 Miguel Berrocal, *Salvador y Dalila*, 1974–8
Polished bronze, 11.4 × 20.9 × 8 cm
(4½ × 8¼ × 3¼ in)

78 Anthony Caro, *The Caliph's Garden*, 1989–92
Naval brass, 174 × 249 × 244 cm
(68½ × 98 × 96 in)

78

Minimal & Conceptual

OM MA NI PAD ME HUM
suma

R.J. Aug 12 82

Almost from its beginning Modernist Art contained a minimal or reductive element. This manifested itself especially clearly at certain moments, and was less prominent at others. Examples from the early Modernist epoch are some of the Suprematist compositions of Malevich; one, painted in 1918 and entitled *White on White*, consists of a white rectangle placed obliquely on a white ground.

In the United States, this tendency started to surface again in the 1950s – at the beginning of his career Robert Rauschenberg painted some all-white canvases, which are now mostly lost. It strengthened throughout the 1960s, and Minimalism and its close ally Conceptual Art came to be regarded as the chief enemies of the then-dominant Pop Art, the 'high art' retort to triumphant vulgarism and populism. As is now apparent in retrospect, they were also something more than that. They marked the beginning of a radical shift in attitudes to contemporary art – so much so that Pop itself, still in most people's minds the visual symbol of the decade, now seems, on closer inspection, to be the expression of a defeated cause.

There is a second historical paradox concealed within the first. Minimal and Conceptual Art, when they were first recognized as new art movements, were usually, and not surprisingly, described as a return to pure aesthetics. The impurities of Pop Art were purged away, and the viewer was invited to return to the contemplation of form as form, colour as colour, and of ideas and concepts as crystalline mental diagrams that side-stepped any need for visual embodiment. Yet the new art, thanks to its preoccupation with the operations of the intellect, eventually opened the door to a return of content in art. Where Pop Art possessed content this was mostly ironic or frivolous. The new art would have nothing to do with this kind of levity. The strategies used for the expression of aesthetic concepts were gradually adapted for quite different purposes. The reductive thrust of Minimalism often led the artists connected with it to maintain that their work was essentially style-less – that is, without any recognizable personal handwriting. Their successors claimed that the all-important content dictated the nature of the embodiment.

Minimalism manifested itself in both painting and sculpture. Artists on the fringes

of Abstract Expressionism, such as Barnett Newman and Ad Reinhardt, had already adopted simplified forms, and a pared-down version of Pollock's calligraphy can be found in the paintings of Cy Twombly, often combined with scribbled words. *Suma* (Pl. 79), a fairly late but typical example of the artist's work, bears, in addition to its title, the syllables of the Buddhist chant '*Om Mani Padme Hum*', suggesting that the artist attaches a mystical meaning to the spiral which fills the main part

79 Cy Twombly, *Suma*, 1982
Oil, crayon and pencil on paper,
140 × 126 cm (55¼ × 49¾ in)

80 Agnes Martin, *Untitled #5*, 1989
Acrylic and pencil on canvas,
183 × 183 cm (72 × 72 in)

80

of the field. Many of Twombly's works are slighter, and consist of rhythmic series of very faint scribblings. Their evanescence suggests that they are to be interpreted as a new version of Malevich's transcendentalism.

Two other painters working somewhat in this vein, but with a much more rigorous and organized sense of design are Twombly's fellow Americans Agnes Martin and Robert Ryman. Martin's *Untitled # 5* (Pl. 80) is typical of the way in which she has worked almost

81 Robert Ryman, *Part 17*, 1993
Oil on corrugated board, 38 × 38 cm
(15 × 15 in)

82 Lucio Fontana, *New York 15*, 1962
Pierced aluminium, 96.5 × 64 cm
(38 × 25¼ in)

83 Frank Stella, *Raft of the Medusa,*
Part 1, 1990
Aluminium and steel, 425 × 413.5 × 403
cm (167½ × 163 × 159 in)

81

82

throughout her career. It uses a regular pattern of graphite lines against a completely even, neutral coloured background.

A rather similar grid appears in a number of Robert Ryman's all-white paintings (Pl. 81), but here the effect is rather different. Because the lines are actually scored into the paint surface, their tendency is to stress the perception of the painting as an object, something with its own physical identity. The effect is rather similar to that found in a number of monochrome works by the prolific Lucio Fontana. Some of these are canvases, slashed or even shot by the artist. Others, like the example illustrated (Pl. 82), are actual metal reliefs. The slashes or piercings are, like Ryman's scored surfaces, a way of stressing the physicality of the contemplated object. There is a similar purpose in the even stripes of Frank Stella's early monochrome canvases. Stella was eventually to become so preoccupied with the idea of physicality that he moved from paintings that were in effect painted reliefs into work which was completely free-standing. The recent *Raft of the Medusa, Part I* (Pl. 83) has a far from Minimal complexity of form, but what it retains from the artist's beginnings is an insistence that the artwork has to be thought of as a 'thing in itself', not as a representation or symbol of something which may exist more fully, and with greater actuality, elsewhere.

One problem with Minimal painting that soon becomes apparent is that, almost by definition, it offers the practitioner very little room for manoeuvre. A monochrome surface, uninflected in any way, remains a monochrome surface. Those artists who have followed Minimalist lines of research have tried various ways of getting around this. One of the commonest is to divide the painting into panels, the choice often made by Brice Marden at the time when he was still working in monochrome (Pl. 84). The visual activity then comes from the contrasts between the various hues – in Marden's case, these are usually subtle and subdued, related to ideas about earth, sea and sky. Yet these associations are not all gain – by hinting, however subliminally, at the presence of landscape, they undermine the absolute independence from context that the most stringent Minimal Art constantly looks for.

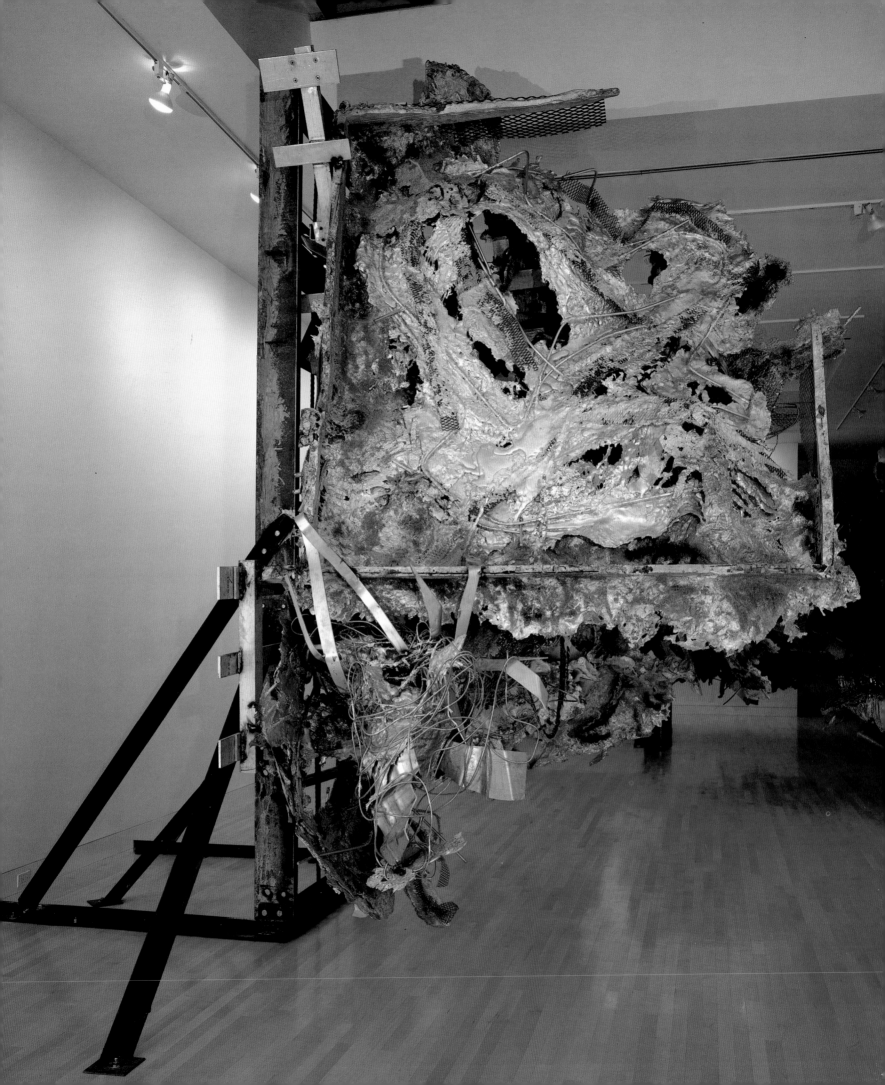

84

85

Minimal & Conceptual

Simply because it concerns itself so much with the idea of the object added to an existing world of objects – the notion of something new and recalcitrant which the universe has to move over and create a place for – the most characteristic expression of the Minimal impulse has been through sculpture. Here the impulse to reduce, to work with absolutely simple, unitary forms was already present at the beginning of the 1960s, in the work of artists such as Carl Andre (Pl. 85).

Andre has acquired a certain notoriety through his employment of readymade materials, and indeed of readymade unitary shapes, such as bricks or metal plates, which he arranges in various configurations. He takes a rather grandiose view of these activities. In a BBC interview I once did with him, he referred to his ambition to be 'the Turner of matter'. There is, nevertheless, more point to what he does than is sometimes admitted by those hostile to the avant-garde in its entirety. Andre's use of standard units can be seen as a play with sequences, and mathematical combinations of various sorts. One element in Andre's work which reappears in that of other Minimal sculptors is the idea that the work, as the spectator encounters it, is an excerpt from something that is possibly much larger – that there is a pattern which can be extrapolated from what one actually sees, and completed in the mind.

This attitude reappears in the sculptures of other Minimal artists, particularly in those of Donald Judd and Sol LeWitt. Judd's stacked box forms fastened to a wall (a work he made in a number of variations, Pl. 88) are another embodiment of the same idea. Like Andre, Judd was interested in mathematical progressions, and expressed this in a number of sculptures – such as one where a number of black rectangular forms were mounted underneath a stainless steel bar, which in turn was fixed to the wall; as the forms grow smaller, progressing from right to left, the gaps between them increased by the same ratio (Pl. 86). LeWitt's gridded box forms are also often arranged in this way, and the spectator is invited to extrapolate an even larger version of the series from the evidence presented in a work such as *Open Geometric Structure IV* (Pl. 89).

The box form was perhaps the most popular idea in Minimal Art. Another artist who has

84 Brice Marden, *Range*, 1970
3 panels, oil and wax on canvas,
155 × 266 cm (61 × 105 in)

85 Carl Andre, *Magnesium-Magnesium Plain*, 1969
Magnesium, 36 units 1 × 30.4 × 30.4 cm
(⅜ × 12 × 12 in) each, 1 × 182.7 × 182.7 cm
(⅜ × 72 × 72 in) overall

86 Donald Judd, *Untitled*, 1991
Black anodized aluminium and stainless
steel, 15.2 × 281 × 15.2 cm (6 × 110¾ × 6 in)

87 John McCracken, *Essence, Multiples, Impulse*, 1993
Resin and fibreglass on plywood, each
box 15.2 x 66 x 25.4 cm (6 x 26 x 10 in)

86

87

88 Donald Judd, *Untitled (Large Stack)*, 1991
Orange anodized aluminium and plexiglass,
457 × 101 × 79 cm (180 × 40 × 31 in)

89 Sol LeWitt, *Open Geometric Structure IV*, 1990
Painted wood, 98 × 438 × 98 cm (38¾ × 172½ × 38¾ in)

89

90 **Ulrich Rückriem**, *Untitled*, 1989
Blue slate, 13.5 × 100 × 100 cm
(5¼ × 39½ × 39½ in)

91 **Alighiero E. Boetti**, *Iron and Wood*,
1967
Iron and wood, height 4.4 cm (1¾ in),
diameter 49.5 cm (19½ in)

92 **Robert Morris**, *Untitled (Circle)*,
1991
Structural steel, height 30.4 cm (12 in),
diameter 396 cm (156 in) when flat

93 **Robert Morris**, *The Ells*, 1965–88
Expanded steel, 3 elements, each
244 × 244 × 61 cm (96 × 96 × 24 in)

90

91

made use of it is the Californian John McCracken. McCracken used to be known for his painted boards, which were simply leant against a wall, rather than being fastened to it. These boards were usually referred to as paintings rather than sculptures. More recent works are definitely three-dimensional and closely related to Judd. The difference is that the artist seems to regard each box form as a separate work, and, though placed at regular intervals, each is painted a different and contrasting hue (Pl. 87).

Another idea which has enjoyed popularity with more than one artist is the use of stacked elements associated with Andre. The German sculptor Ulrich Rückriem has made similar sculptures out of slabs of slate (Pl. 90), but the concept is less 'pure' because the elements are not (as they always are with Andre, within any given sculpture) of identical size. Yet another variation is offered by the Italian artist Alighiero E. Boetti, with a circular sculpture made of an iron ring embedded in slabs of wood (Pl. 91). Here the relationships are more complex still. The wood is divided into eight 'pie slices'. Each of these slices is interrupted, but at the same time bound together, at least metaphorically, by the iron ring.

Because of their completeness, visual as well as conceptual, circles have always been popular with Minimal sculptors. One of the boldest statements of the theme was made by an American artist who is generally regarded as a close colleague of Andre and Judd, despite the fact that only part of his production is Minimal – Robert Morris. His large *Untitled (Circle)* (Pl. 92) is one of the starkest statements made in this idiom.

Both Andre and Judd are (or, in Judd's case, were) notoriously intolerant of other forms of artistic expression. Judd's dislike of the work of Andy Warhol, for instance, was forcefully expressed. The contempt he expressed for so many manifestations in the contemporary art world might even lead one to speculate that the blankness of his own work was a form of defence against emotions which he found threatening. By contrast, Morris, even in Minimalist mode, has flirted with arrangements of form which depart from strict order and symmetry, even if the components remain very simple (Pl. 93). He has also made a range of figurative work in recent years (Pl. 327), which

92

93

94 Günther Förg, *Untitled*, 1990
Acrylic on lead,
280 × 160 cm
(110¼ × 63 in)

95 Dan Flavin, *Untitled (fondly to Margo)*, 1986
yellow and pink fluorescent lights and
fixtures, 487 × 21 × 21 cm
(192 × 8¼ × 8¼ in)

94

departs completely from Minimalist doctrine.

Not surprisingly, given the increasingly heterogeneous nature of contemporary art, Minimal impulses have interacted with others which may on the surface seem to contradict them. Günther Förg's *Untitled* (Pl. 94), for instance, is a large lead plaque, propped against the wall rather than hung on it. Since it is visibly three-dimensional, even if one dimension is very narrow, the spectator tends to perceive it as an object (on a par with other Minimal objects) rather than as a painting. It is really very little different, in all but one respect, from Robert Morris's *Circle*. The one visible difference is that the front surface is painted with a single bright red stripe. Is this enough to make it a painting, rather than a sculpture? The colour contrasts are no more complex than those to be found in Judd's stacked boxes, and the relationships of form are of the same deliberately rudimentary order. The standard system of categorization, used to distinguish Minimal sculpture from attempts at minimality in what is still called 'painting' (the implication being that painting is surface only) is challenged.

It is not surprising to find, given what has already been said about Andy Warhol's *200 Soup Cans* (Pl. 11), that Minimalism has interbred with its supposed rival Pop Art. One of the places where one can see this most clearly is in works made with neon light. Such works have a double character. Neon light has an intimate connection with urban mass culture. It is extensively used for advertising, and many of its associations, of a sociological or psychological kind, are with the tacky, anti-aesthetic milieux which fascinated the artists of the Pop movement. Yet the light sculptures of Dan Flavin, one of the chief artists to make use of neon, are often stringently minimal in form. *Untitled (fondly to Margo)* (Pl. 95) consists of eight fluorescent tubes; four are yellow, four are pink. Each colour is kept together, and the tubes are grouped so as to create a pilaster that fills one corner of the exhibition space. That is, the formal relationships are, once again, of a deliberately rudimentary sort, just as they are in Judd's stacked boxes, or in Gunther Förg's painted lead plaque. Yet it is also obvious that other considerations have to be taken into account. For example, how do we actually define the work – how does it exist for us? The

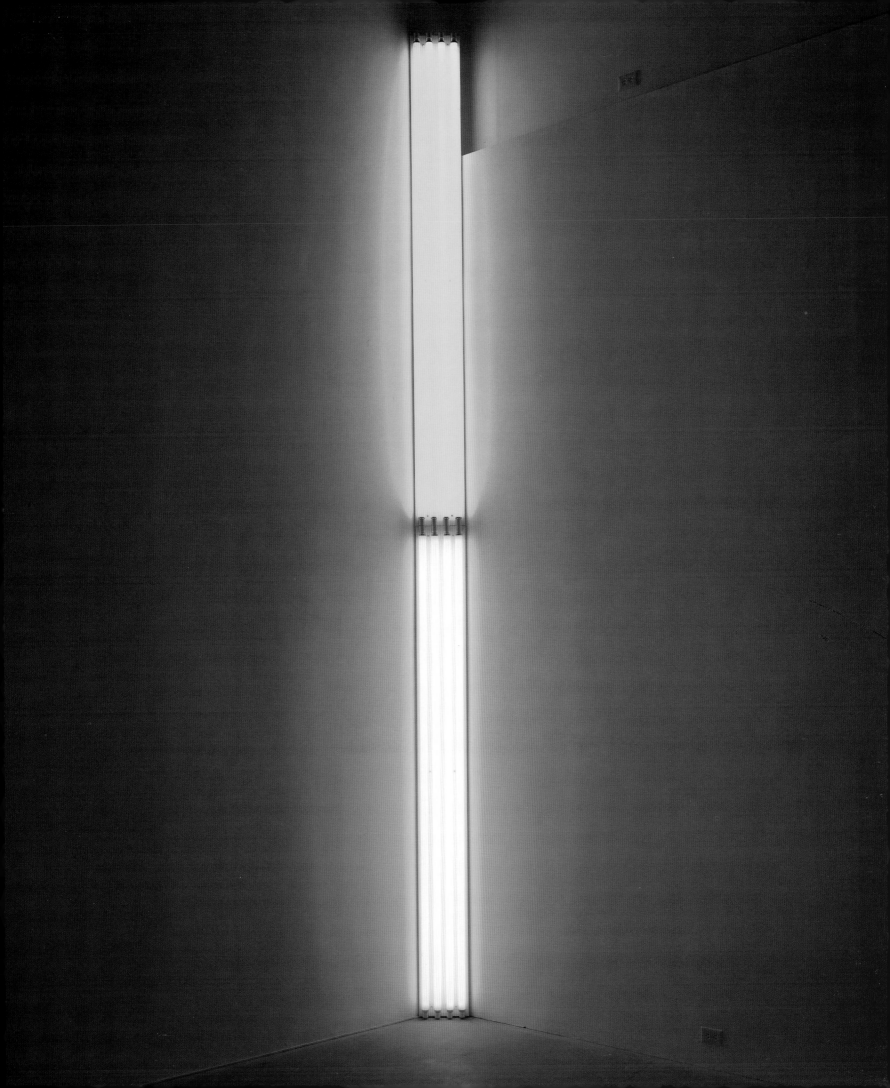

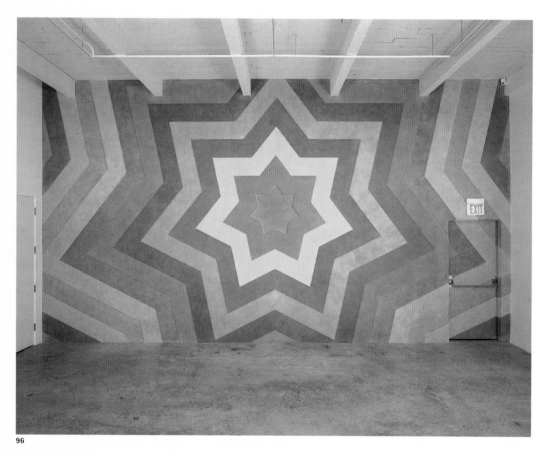

96

answer is obvious – it exists only when the fluorescent tubes are turned on. When they are turned off the aesthetic content, the thing which makes us categorize it as a work of art, is dormant. Another question: what happens when it is activated? It is not merely that the two adjacent colours, the pink and the yellow, react directly upon one another, as two adjacent painted surfaces would do. It is also that the light spills over into the surrounding space, and alters the spectator's perception of that as well. It can be argued, of course, that all large-scale Minimal works do this – that their main interest lies, not in what they are in themselves, but in their function as modifiers. Here, in fact, is one argument for the close connection between Minimal Art and environmental art of all kinds. It also helps to explain why Minimal works tend to be so much more effective in closed spaces (museums or exhibition galleries) than in the open air, even if they are installed as part of a carefully planned architectural setting.

Some Minimal works, such as the elaborate wall drawings of Sol LeWitt, are so intimately and organically linked to the spaces that contain them that no separation is possible – the work exists within the chosen framework, as part of a given architectural volume, and is altered in important respects if re-created, however faithfully, elsewhere.

Wall drawings by LeWitt, such as his *Seven-pointed Star* (Pl. 96) are site-specific, and each is the manifestation of a pattern which exists inside the artist's head. That is, they are a way of bringing this inner pattern, which he carries around with him always, into at least temporary conjunction with a real, physical space. It is significant that LeWitt now seldom executes such works himself – they are carried out, according to his instructions and diagrams, by his assistants. *Seven-pointed Star* is an especially interesting example of his work because it stresses the specifically American roots of this kind of abstract, decorative pattern-making. The design might almost be one taken from an American quilt.

Other practitioners of Minimal pattern-making manipulate and alter spaces in the same way, but in a purer, more rigorous fashion, closely akin to classic Constructivist Art. Daniel Buren's installation *To Alter* (Pl. 98) offers a pattern of wall-high stripes in red,

enclosing groups of short black bars grouped in twos and threes. The elements could scarcely be simpler, nor the patterning more rigorous. As with Andre's stacked bricks and arrangements of metal plates, the point of the exercise is to be discovered in the pattern that is established, not in the actual shapes that are chosen to be, as far as possible, things without identity of their own. The whole process, which integrates intellectual patterning with a particular space, a particular opportunity, has had a major impact even on artists who prefer to keep some links with traditional formats. It is worth comparing the Buren installation with an installation view of recent work by the Swiss artist Olivier Mosset (Pl. 97).

It was inevitable that such a rigorously intellectual art should make the move into words. Here, too, there is sometimes a significant link to Pop. Bruce Nauman's *Having Fun/ Good Life, Symptoms* (Pl. 99) borrows from the techniques used in neon advertising signs – the whole technology was developed for commercial purposes. There are two slightly overlapping spirals of words, which rhythmically flash on and off. The left-hand spiral consists of a number of conjunctions of opposites:

FEVER AND CHILLS. DRYNESS AND WETNESS. NORTH AND SOUTH. EAST AND WEST. OVER AND UNDER. FRONT AND BACK. UP AND DOWN. The right-hand spiral is a series of statements:

I LIVE THE GOOD LIFE I'M HAVING FUN. YOU LIVE THE GOOD LIFE YOU'RE HAVING FUN. WE LIVE THE GOOD LIFE WE'RE HAVING FUN. THIS IS THE GOOD LIFE THIS IS FUN.

The piece is dynamic, the letters chase one another round the two spiral paths and appear with different intensities at different moments. The optimism of the statements which appear on the right is constantly undermined by the pairings on the left, which carry with them a distinct undertone of pessimism.

Conceptual Art, certainly where the lay audience is concerned, is sometimes thought of simply as avant-garde art in which words play a large part, taking the place of the expected visual images. This definition is erroneous, but it is true that art which insists on the power of the word has played a major role in the rise of what is not, strictly speaking, an art movement in the conventional sense, but a new way of thinking about art, or the idea of art, and

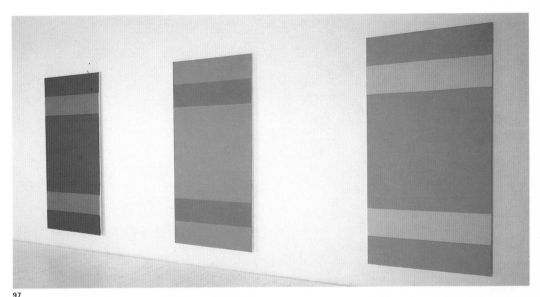

97

98

FIRE AND BRIMSTONE SET IN A HOLLOW FORMED BY HAND

translation of a line from Chénier *a line of thin pale red*

MARATAPLAN!

what this art does. Even the most superficial examination soon makes it obvious that in 'word art' the words operate in very different and often contradictory ways. One can contrast, for example, the different strategies of three well-known artists, two American and one British: Lawrence Weiner, Ian Hamilton Finlay and Joseph Kosuth. Weiner's *Fire and Brimstone Set in a Hollow Formed by Hand* (Pl. 100) is typical of his production. The phrase which is the title marches across the back wall of the gallery in large sanserif capital letters. Yet it isn't the letter forms, nor even their relationship to the space, which are the aesthetic point. It is the phrase itself, and the way in which it resonates in the mind of the spectator/reader. It is noticeable that the words have no absolutely specific meaning. They do not even form a complete sentence. They might be part of a poem – a work of literature rather than a work of art – torn from its context. Weiner seems to be telling us that we are now so habituated to language that the word and the thing are interchangeable. To use the word 'fire' is as good as showing it.

Hamilton Finlay's work is related to that of Weiner, and it is significant that he actually began his career as a poet, not as a visual artist. *Marataplan* (Pl. 101) expresses Hamilton Finlay's obsession with the events of the French Revolution – a constant theme in his work. The main inscription, a single invented word, combines the name of the revolutionary polemicist Marat with the sound of the drums of the French Revolutionary armies – the 'rataplan'. The precise anatomy of the pun is demonstrated not by a change of type-face but a shift in colour. MA (also the feminine possessive) is in black; RATAPLAN is in red. Hamilton Finlay has always been very good at devising intricately compacted puns of this sort – the meaning is much more precisely controlled than it is in the Weiner piece, and the attitude more analytic – though not as coolly analytic as the work of Joseph Kosuth.

Joseph Kosuth's *No Number # 3 (+ 216, After Augustine's Confession)* (Pl. 102) offers a statement about the nature of perception. This is repeated three times over in identical form. Each block of type is mounted on a sheet of plate glass of a different size. These sheets lean against the wall of the gallery – two of them overlap. It is the overlap which provides the

100 Lawrence Weiner, *Fire and Brimstone Set in a Hollow Formed by Hand*, 1988
Installation at Anthony d'Offay Gallery, London, text painted on wall, dimensions variable according to location

101 Ian Hamilton Finlay, *Marataplan*, 1990
Installation at Burnett Miller Gallery, Los Angeles, text painted on walls

102 Joseph Kosuth, *No Number # 3 (+216, After Augustine's Confession)*, 1990
Silkscreened enamel on three glass panels, each panel, from left to right, 80 × 80 cm, 197 × 197 cm, 170 × 170 cm, (31½ × 31½ in, 77½ × 77½ in, 67 × 67 in)

Do I really see something different each time, or do I only interpret what I see in a different way? I am inclined to say the former. But why?—To interpret is to think, to do something; seeing is a state.

Do I really see something different each time, or do I only interpret what I see in a different way? I am inclined to say the former. But why?—To interpret is to think, to do something; seeing is a state.

Do I really see something different each time, or do I only interpret what I see in a different way? I am inclined to say the former. But why?—To interpret is to think, to do something; seeing is a state.

102

There might be a picture of a place where a certain confusion is systematically suppressed; a place where a minor pragmatic violence is sustained by a trivial mechanism of fear. It is a place where Humpty Dumpty has the power of small

factitiousness, an unimportant enemy of public safety. For some reason it is an important place of celebration and display. It is also a place where inundation is ruled out by protocol.

103

clue to what Kosuth is doing, because this very simple device has the effect of blurring several phrases of the text. That is, we are given a demonstration – a direct, optical demonstration – of the truth of the statement that the artist has presented to us.

Kosuth's approach has been used by other artists – for example by the group called Art & Language, which has often concerned itself with the nature of criticism (in particular, the inadequacies and deficiencies of critics who concern themselves with the interpretation of contemporary art). *Hostage XXXII* (Pl. 103) may possibly contain elements of this kind, but they are clearly not the main subject. The subject is more emotional than analytic – the work seems to be about the sense of disturbance which haunts certain places, or filters into certain events. It is also worth noting that *Hostage* is not wholly non-visual. Two blocks of text obscure what seems to be a conventional Impressionist landscape, disfigured by random marks or stains. These stains are an illusion –

104

patches of paint on the glass which covers the canvas, and which in turn carries two panels of text. There are thus several layers of meaning, and the work mimes the way in which one meaning or idea may conceal another in real life, outside the realm of art.

Jenny Holzer has made an international reputation with her 'Truisms' – first simply slogans written on walls, then expressed through the technology of advertising, through light diodes that spell out phrases and sentences. In her recent work she has glamorized the deliberately banal language she employs, increasing the impact but not necessarily the depth of the points she wants to make. Many, though not all, of these points are feminist ones (Pl. 104).

The combination of word and image has become one of the standard stratagems of Conceptual Art. Here, too, there is a link between Conceptual and Pop, since Pop had one of its tap-roots in advertising, and the successful advertisement is usually an

103 **Art & Language**, *Hostage XXXII*, 1990
Glass, oil on canvas on wood,
183 × 122 cm (72¼ × 48 in)

104 **Jenny Holzer**, sign message from the 'Survival' series, New York City, 1983

105 **Victor Burgin**, *Portrait of Waldo Lydecker*, 1991
Text painted on black and white photograph, each panel 138 × 148 cm (54½ × 58¼ in)

105

106

107

indissoluble fusion of the two elements. This is also the case with Victor Burgin's *Portrait of Waldo Lydecker* (Pl. 105). Probably no advertising designer, however, would be bold enough to use type in this particular way. The theme of the piece is no-seeing, and the line of type acts as a blindfold, obscuring the vision of a man who is shown to us both young and old. The implication is that here is an individual who has pursued a feminine ideal – 'the woman hidden in the forest' – without ever finding her.

Type – the single word 'metamorphosis' – blocks in the view in a slightly different way in Amikam Toren's *Armchair Painting (Metamorphosis)* (Pl. 106). It overlies a conventional landscape – the discreet autumnal hues, greys and browns for the trees imply that this is more a piece of theatrical scene-painting than a genuine response to nature. The artist seems to be making a scornful comment on the way in which second-rate artists edit the visible to suit their own purposes.

Language and image are combined in yet another way by the Los Angeles artist Mike Kelley. *Speech Impediment* (Pl. 108) is, as perhaps befits its title, a deliberately clumsy work, carried out in a technique familiar to nursery schools – cut and glued felt. On one side is a crude image of a butcher (female) disembowelling a pig's carcass. On the other, in uneven letters, is an inscription which is only semi-intelligible. The words form a distorted version of the kind of messages sometimes found in contact magazines, where *outré* sexual tastes are coded using groups of initials. The whole work is an allegory of the difficulties of communication encountered by inadequate, sexually dysfunctional individuals.

In *Speech Impediment* the spectator is forced to consider the distinction between letter as letter (one of a number of units which come together to create a word, which in turn conveys a more or less specific meaning), and letters as images in their own right. The distinction is even more salient in works by another Conceptual artist, the British-born David Tremlett, who has enjoyed some of his greatest successes in Paris. In *No Ceiling* (Pl. 107), the oversize letters, and their deliberately clumsy spacing, are the material for a design – something used to create an aesthetic effect, just as purely abstract forms might be. Yet the spectator cannot entirely ignore the fact that

106 **Amikam Toren**, *Armchair
Painting (Metamorphosis)*, 1989
Oil on canvas, 52 × 76 cm (20 × 30 in)

107 **David Tremlett**, *No Ceiling*, 1990
Pastel on paper,
116 × 178.5 cm (45¾ × 70¼ in)

108 **Mike Kelley**, *Speech Impediment*,
1991–2
Felt, 242 × 355 cm (95½ × 140 in)

108

109 **Tom Phillips**, *Curriculum Vitae XII*,
1985 (series completed 1992)
Acrylic on gesso panel,
150 × 120 cm (59 × 47¼ in)

110 **Keith Milow**, *Nash Crome*, 1993
Iron, resin and fibreglass,
48.3 × 71 × 12.7 cm (19 × 28 × 5 in)

111 **Conrad Atkinson**, *Financial Times:
Mondrian Edition*, 1986
Acrylic on canvas,
152 × 132 cm (60 × 52 in)

109

110

the phrase, though left incomplete, conveys a kind of meaning. It is the beginning of a narrative, for which the spectator is invited to supply a conclusion.

A more accessible, also more traditional, use of the fragmentary can be found in works by another British artist, now usually resident in America. Keith Milow's *Nash Crome* (Pl. 110) resembles a fragment of an ancient Roman architrave – the sort of thing one might see in the foreground of an architectural print by Piranesi. The letters are incised into the surface in the grand Roman style used for imperial inscriptions. Their meaning remains wholly mysterious – it seems possible that they comprise only fragments of words, not words or names spelt out in full. The kind of pleasure they offer is associative – more romantic than, but in some ways not unlike, the kind of pleasure offered by Hamilton Finlay's *Marataplan*. What both works certainly have in common is a sense of history – they offer a perspective into the past.

Because Conceptual Art is so often close to literature – it is literary, but in a very different way from the illustrative literary art of High Victorian artists such as William Powell Frith (1819–1909), the painter of *Derby Day* – it has sometimes actually concerned itself with narrative. Some of the most striking examples can be found in the work of Tom Phillips – not only in his ongoing series of works called *A Humument*, each one of which is an altered page from the late Victorian novel *A Human Monument*, by the almost-forgotten W.H. Mallock. Phillips can produce extraordinary effects simply through the selective obliteration of words. On one page, for example, these are the ones that remain: 'too busy to attend – telegram – telegram – liked the look of things – telegram – the right hotel – pose to-morrow.' More recently Phillips has embarked on another series, *Curriculum Vitae*, which narrates the story of his own life. Each painting is a field of type; each painting is also a chunk from a narrative poem. *Curriculum Vitae XII* (Pl. 109) (appropriately enough in view of its position in the sequence) deals with the artist's obsession with the game of cricket – a cricket eleven is often accompanied by a 'twelfth man'.

A use of narrative at a somewhat humbler level can also be found in the satirical

FINANCIAL TIMES

MONDRIAN EDITION

I have bought this
I want this, this will
kill me. This consumes me
These are invisible and are
lethal, I need one.

Anally retentive oil price fall neutralised by saleroom rise in price of contemporary drawings and paintings

The arbitrary and imprecise nature of financial and economic affairs is utterly incompatible with the proper conduct of poetic and aesthetic decisions, Chancellor to act.

Moscow spells out its opposition to hot colors in Financial Times - David Hockney flown in to devise correct color scheme.

AVERAGE DISTRIBUTION OF ART

Row grows between EEC multinationals and AT&T over the multiplicity of readings in Delacroix' painting 'Liberty Leading the people'.

Gorbachev and Kinnock discuss pleasure principle with Matisse.

DESIRE

The desire for objects in which the seductiveness of the end of the world is implicit and leads us blindly says NATO, is cause for some concern. A spokesperson said there is no immediate danger to the public.

Mondrian influences newspaper layout claims art critic

US President says postmodernism is really about the insecurity of dominant Western hegemony in the face of the myriad of visible contradictions evident as the third world and the marginalised gain access to information and channels of communication. Summit talks agree on information and technology embargo.

The great debate - 'Sensuousness or drawing rigour?'

ROTHKO BASE RATE

The landscapes of our desires are smothered in concrete & not ideology asserts P.M.

Arts Council given aesthetic control of front page of Financial Times - Atkinson rejects tokenism insists initial move is transfer of economic base to cultural producers.

AVERAGE POLLOCK YIELD

POWER

MODERNIST SALVAGE INC.

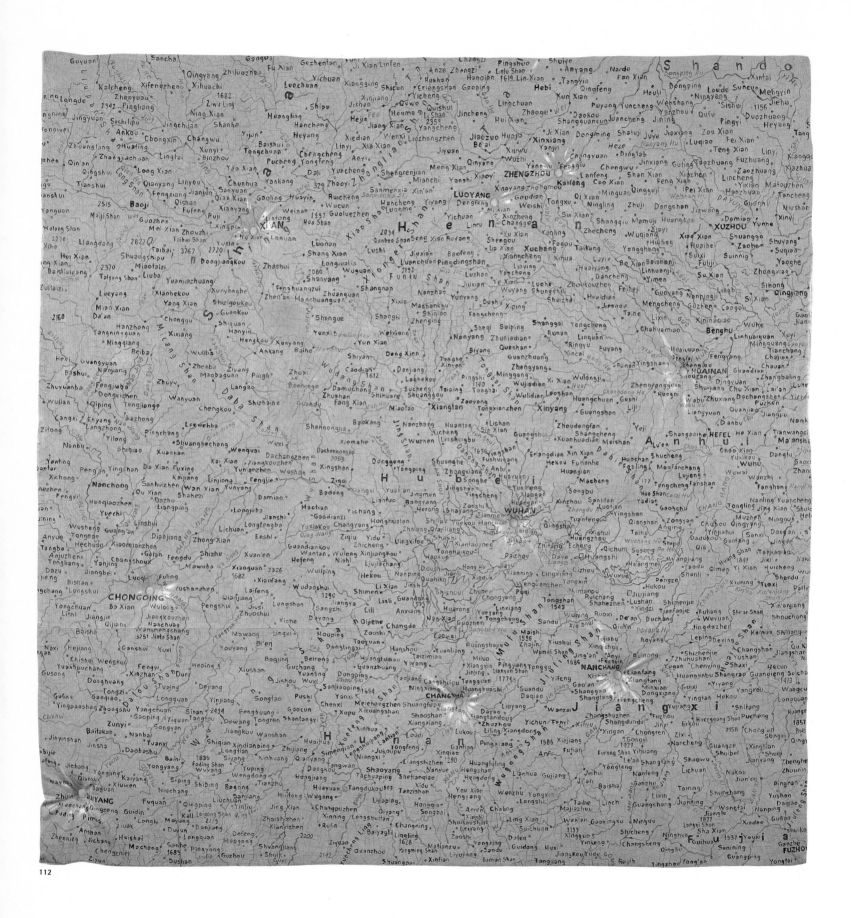

paintings of Conrad Atkinson. Some of the most effective of these are blasts directed at the follies and venalities of the art market (Pl. 111). Here, however, the sketchy looseness of the artist's technique makes it clear that the work is not Conceptual in the most stringent sense – the image is a caricature of a fairly traditional kind, whose subject happens to be a newspaper page, and like all caricatures it is at least a form of representation. In its pure form Conceptual Art states or demonstrates, but does not represent: it is a diagram or a statement, but not a mirror.

The examples of Conceptual Art which I have so far offered have been either North American or British, and the genre, though its debt to Marcel Duchamp is obvious, is generally now thought of as an American invention, one linked, as I have indicated, to the Minimalist impulse. During the past two decades, however, the kind of Conceptual Art which relies on words for all, or at least a large part of its effect, has also flourished in Latin America, and especially in Argentina and in Chile. One of the leading Argentine Conceptualists of the past three decades is Victor Grippo. *Tabla* (Pl. 113) consists of a simple kitchen table, inscribed with a quasi-mystical text which begins with the words 'Sobre esta tabla, hermana de infinità...' (Upon this table, sister of infinity...). The object, thus inscribed, becomes the symbol of the humble but transcendental nature of ordinary objects – Grippo addresses the same subject-matter that Zurbarán does, in his rare still lifes. Guillermo Kuitca, the best-known member of the very youngest generation of Argentine artists, conjoins inscription and humble everyday objects in a similar but more elaborate way. *Das Lied von der Erde (The Song of the Earth –* a title taken from a Mahler song-cycle) (Pl. 112) is a segment of the map of China, painted on a mattress made for a double bed. The metaphor 'earth as bed' is one of the best-established in our culture – and Kuitca here takes it completely literally. The execution of the work (neat enough) does not matter; the impact comes entirely in the mind – in the way in which the piece rearranges attitudes, makes us think about the inner significance of some long-established cliché, some idea or phrase worn smooth as a river pebble by constant use.

Das Lied von der Erde is the visual

112 Guillermo Kuitca, *Das Lied von der Erde*, 1990
Mixed media on mattress, 198 × 198 cm (78 × 78 in)

113 Victor Grippo, *Tabla*, 1978
Wooden table, ink, photograph and plexiglass, 75 × 120 × 60 cm (29½ × 47¼ × 23¾ in)

113

embodiment of an idea, and it is the idea not the embodiment that is primary. The same statement can be made about works which do not use words at all, but whose alignment is nevertheless Conceptual. Jean-Luc Vilmouth's *Views of a Chair* (Pl. 115) consists of a tall narrow side chair, somewhat in the style of Charles Rennie Mackintosh, and twenty mirrors. The mirror panels match, in height and width, the spaces made by the slats in the chair back. The point seems to be that, in approaching the chair – an inanimate everyday object, a passive focus for the gaze – the spectator is (paradoxically) gazed upon by the mirrors, which are this chair's sensors or eyes.

Roger Ackling's *Weybourne (No. 12)* (Pl. 114), by contrast, is simply a small, rectangular

114

block of wood, with a series of regular grooves burned into it. It turns out that these have been created by using glass prisms to focus the rays of the sun on to the surface of the wood, and that the title of the piece is the name of the place where it was exposed to sunlight in this way. That is, the piece, rather than being an object to be looked at in its own right, is a concise record of a process. In order to interpret it, the spectator needs access to information about what has happened.

Art of this sort is very different from that produced by the Abstract Expressionists forty and more years ago. Abstract Expressionist work requires a direct confrontation of psyches, a leap of faith made by the spectator. Knowledge is unnecessary; it is emotion that

counts. Without information, by contrast, Ackling's piece cannot be activated. Despite its block-like shape and the regularity of the markings, *Weybourne (No. 12)* is even significantly different from classic Minimal Art. The reductive shape and repetitive patterning are not the main point: essentially these function simply as information carriers, and to insist on stopping there would be rather like insisting on regarding a book purely as an object, without opening it to discover what might be inside.

Conceptual Art has always had a very close link with photography. There are several reasons for this. One is that photographs provide an easy way of linking image with text (once again the parallel with advertising presents itself). Another is that the photograph seems more impersonal than the hand-made image; the viewer concentrates on the meaning conveyed, not on the handwriting.

A good example of this is an assemblage by the veteran West Coast maker of photo-pieces John Baldessari. *Landscape/Street Scene (with Red and Blue Intrusions – One Deteriorating)* (Pl. 116) is in the classic photo-collage tradition, which dates from well before the birth of either Minimal or Conceptual Art. It pushes the established boundaries of collage a bit further, by creating a situation where the viewer reads each successive item like one of the successive signs in a rebus. Rauschenberg used the word 'rebus' as the title for one of the most celebrated of his works, so that the comparison is a reminder of the link with him, and through him with the original Dada Movement. In this case, however, the conjunction of images is not irrational in the Dada manner but focused on a particular theme – the contrast between untamed nature – the Turkic nomads of the photograph on the left – and the decaying urban culture of the United States, as represented in the scene juxtaposed with it. The fragment of cheap patterned formica seen below reinforces the point.

Photography has been the vehicle for varieties of Conceptual Art which have that quality rare in most avant-garde productions: a sense of humour. One of the great jesters of the contemporary art world is William Wegman, with his large polaroid photographs of the Weimaraners who are his companions and models. *Cendrillon* (Pl. 118) is a typical example

115

116

117 Boyd Webb, *Undrained*, 1988
Colour photograph, 123 × 158 cm
(48½ × 62¼ in)

118 William Wegman, *Cendrillon*,
1993
Polaroid photograph,
76 × 56 cm (30 × 22 in)

118

119 Mark Tansey, *Action Painting II*,
1984
Oil on canvas, 193 × 279 cm (76 × 110 in)

120 Mark Wallinger, *Fathers and
Sons (Blushing Groom and Nashwan)*,
1993
Two panels, oil on canvas, each
81 × 61 cm (32 × 25½ in)

119

– a dressed-up dog posing as Cinderella (or perhaps as the narrator of the fairy-story) – an image given a surreal twist by the presence of a pair of human hands, holding a large book. Wegman's work has a wryness which means that it usually just avoids sentimentality. Some of his work is nevertheless perilously close to the kind of thing which appears on popular postcards. One suspects the Victorians would have produced something similar, had they had the technology.

Another, even more skilful user of the camera is Boyd Webb, whose elaborate colour photographs, on an even larger scale than Wegman's, usually present some kind of visual paradox – such as bizarre denizens of the deep wallowing in a rainy gutter (Pl. 117). Boyd Webb's skill is to piece together a fantasy world which makes anyone who encounters it question his or her sense of reality. The image progresses gently from what is established fact in the normal world (in this case the wrecked umbrella abandoned after a storm) to the purely fantastic sea-creatures, which are part-bird, but also seem to be part-crustacean.

A Conceptual element can also enter, more or less by the back door, into certain kinds of figurative painting. An instance of this is the work of Mark Tansey; it has attracted attention from leading American critics, notably the philosopher Arthur Danto, the author of a book about him. Tansey's paintings are monochromes, painted in a laboriously veristic style – the artist himself always denies that they are genuinely realistic, and the main source seems in fact to be the monochrome illustrations, drawings imitating photographs, which featured in the illustrated magazines of the earlier part of this century. The paintings show 'impossible' events, such as a group of *plein-air* painters busily sketching a space-shuttle launch. The title, *Action Painting II* (Pl. 119), makes it plain that the image is a joke at the expense of Abstract Expressionist spontaneity; and still more so, perhaps, against the notion that making a work of art is an open-ended, essentially unplanned process, an outpouring over which the artist has little control. In his use of visual paradoxes, Tansey has something in common with the great Belgian Surrealist, René Magritte. The difference between them is that Magritte's paradoxes are usually to do with the operations of the unconscious mind; Tansey's always remain on the conscious level – his primary subject-matter is faults in logic.

Another painter whose apparently realistic work conceals a Conceptual programme is the young British artist Mark Wallinger. Wallinger's *Fathers and Sons (Blushing Groom and Nashwan)* (Pl. 120) is part of an ongoing series which comments on the workings of the British bloodstock industry, and on the relationship of this to the wider framework of capitalism. The horses, painted in a deliberately glamorized way, are the anti-heroes in a drama which is more about money than it is about traditional definitions of breeding.

The Conceptual element in the work of the British painter David Pearce is at first sight harder to detect. *Spacious Interior – with Orbital Intrusions* (Pl. 121) is typical of his approach. The main design shows a conventional bourgeois interior, drawn in outline against a background of intense speckled blue. The 'orbital intrusions' of the title are circles or splotches, some in green edged with yellow, some in a flatter blue. All of these intrusive markings are actual additions – the main canvas has been pierced and then patched, sometimes the circular patches are laced into the surface. The random diagonal lines which can be seen in parts of the composition, particularly in its bottom half, are also 'wounds' in the surface, which the artist has afterwards 'healed'.

These devices operate in two quite different ways. In the first place they act out the nature of the artistic process, the degree to which the artist feels endangered by what he does, because all creative activity has a hubristic element. Second, they offer a variation on the theme of the painting-as-object with which I began this chapter – the patches and slashes used by Pearce are akin to the narrow strips of bare canvas which appear in Frank Stella's stripe-paintings. Pearce's work indicates the degree of cross-breeding which has now taken place in contemporary art, and the way in which supposedly different styles or approaches can legitimately be combined in one work. *Spacious Interior* is in its own way a paradigm of the new situation in art – one in which the old stylistic categories have almost completely broken down.

120

Land Art, Light and Space, Body Art

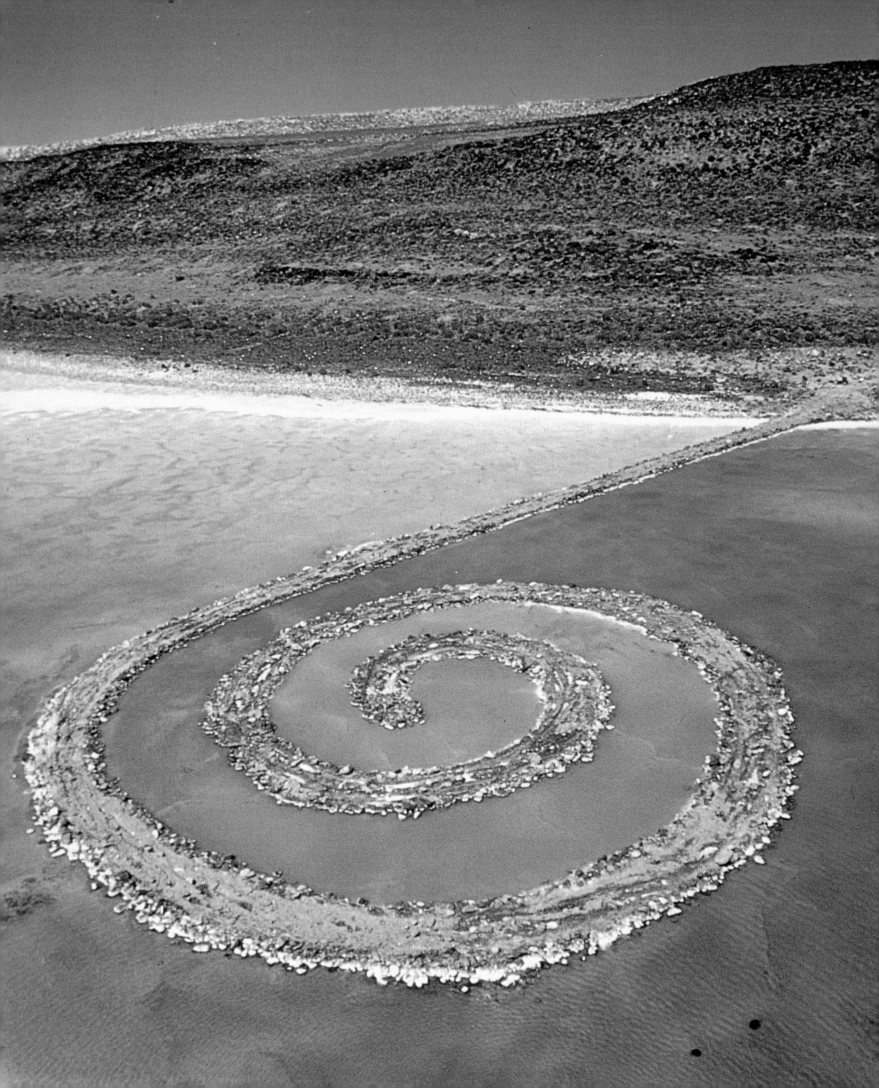

Minimal Art soon ceased to be simply a presentation of simple unitary forms, standing alone or arranged in series. It began to look for an existence outside the art gallery. However, as has already been explained, Minimal works do not exist comfortably in the urban spaces generally assigned to public sculpture. The result of this unease was the birth of what came to be called Land Art. Land Art works were, to begin with, immense earthworks, alterations made to the surface of the earth itself, in accordance with Minimalist principles. Part of their inspiration was prehistoric monuments, like Stonehenge; part of it, less generally admitted but in the long run equally influential, was the eighteenth-century English landscape garden, as this developed in the hands of garden architects such as Capability Brown.

The archetype of Minimal earthworks of this type was Robert Smithson's *Spiral Jetty* (Pl. 122), built on the shores of the Great Salt Lake in Utah. This was, as its name suggests, a spiral projection built out into the waters of the lake, and, almost from the moment of its creation, it acquired legendary status. Many times reproduced, its hold on the imagination of the public for contemporary art is such that few people realize that it is no longer visible, the lake having risen to drown it. Even when it did exist, it was placed in such a remote spot that it was accessible almost entirely through photographs.

The alliance between Land Art and photography is an essential one. As the genre has developed, it has, under the influence of the camera, more and more tended to move away from the idea that such work must, of necessity, be overbearingly monumental. There are several reasons for this shift. One is practicality. Land Art, like all forms of avant-garde activity, remains dependent on the museum, despite the artists' decision to reject the physical framework of museum spaces. When they have made compromises on this latter point, the results have often been faintly ludicrous. When Michael Heizer was asked to exhibit his *Displaced Mountain* (Pl. 123) (a version of his *Displaced/Replaced Mass*) at the Temporary Contemporary Museum in Los Angeles in 1981, the solution was to build an unconvincing painted hardboard replica in the space.

Richard Long, one of the best-known artists associated with the Land Art movement, has

122 Robert Smithson, *Spiral Jetty*, April 1970
Rocks, earth and salt crystals
Great Salt Lake, Utah

123 Michael Heizer, *Displaced Mountain*, 1981
In the course of installation at the Temporary Contemporary Museum, Los Angeles

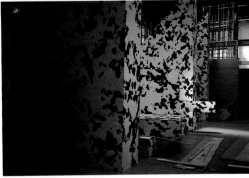

123

124 Richard Long, *Vermont Georgia South Carolina Wyoming Circle*, 1987 Installed at the Donald Young Gallery, Chicago, red, white, grey and green stones, diameter 7.4 m (24¼ ft)

125 Wolfgang Laib, *Two Mountains of Pollen*, 1990 Pollen

found two solutions to the problem. One is to import natural elements into the art gallery, making simple floor designs, for example, with stones found at particular sites. *Vermont Georgia South Carolina Wyoming Circle* (Pl. 124) is an especially elaborate example, since the four groups of stones that make up the design come from four different American states, and the difference in location is expressed through the contrast in colour. Because the design is made of items without any pronounced character of their own, laid in patterns on the floor, the temptation is to associate work of this kind with the floor pieces of Carl Andre. In reality Long's intentions are not similar. Andre gives visible form to mathematical pattern; in Long's case, the work is an evocation of the spirit of place. This is also true of his other characteristic products – photographs which are usually accompanied by brief printed texts and sometimes by maps. These record the long, solitary walks, often through wild and remote country, that Long has undertaken, and the small interventions he has made in the natural order – such an intervention may be no more than bending a row of grass stalks, all in the same direction – an action at the opposite extreme from the great works of excavation, or digging and building, undertaken by artists like Smithson and Heizer. Yet the evidence for Long's interventions is of much the same sort – a documentation, made with the help of the camera, of artworks the audience will never see with its own eyes.

Long's technique of bringing nature directly into the gallery environment, through stones gathered at a specific site, is echoed and paralleled in that of the German artist Wolfgang Laib. Laib, rather than offering stones, offers something much more delicate and ephemeral – squares and little mounds of golden pollen (Pl. 125). Long's stone pieces can be re-created, and (with the help of tracings and diagrams) often are by the museums and private collectors that own them. Laib's celebrations of natural fertility and bounty exist for the instant only.

A British artist whose work is closely related to that of both Long and Laib is Andy Goldsworthy. Goldsworthy's reshaping of the natural scene is done with an even lighter touch than Long's. He covers rocks with a

124

126 Andy Goldsworthy (left to right, top to bottom)

Dome of sticks leaving a hole within a hole in river rock. Scaur Water, Dumfriesshire, 14 October 1991

Red maple leaves held with water, sunny. Ouchiyama River, Japan, 18 November 1991

Yellow elm leaves laid over river rock, low water. Scaur Water, Dumfriesshire, 15 October 1991

Bamboo leaves edging a rock for the rising sun. Ouchiyama-mura, Japan, 22 November 1991

coating of red maple or yellow elm leaves, piles river ice against the shadowy side of a rock in Dumfriesshire, or catches a silhouette in the rising sun (Pl. 126). What he does is meant to be ephemeral, evanescent even. The sentiment here is close to the spirit of Zen; the work implies a rapt, delighted communion with nature which the spectator is invited to share.

Goldsworthy's work has met with a warm welcome in Japan, since it is partly rooted in Japanese religion and philosophy. What is more interesting is the fact that he has met with a popular response in the West as well. Books and films devoted to his work are greeted with enthusiasm by a wide audience, and one suspects that quite a large proportion of this responds specifically to his dialogue with nature, and not to avant-garde work in particular.

Some of Goldsworthy's earliest site-specific pieces were made for Grizedale Forest in Cumbria, England, and this Forestry Commission project now offers one of the largest collections of this kind of work in the world. The Grizedale Forest philosophy is very simple – artists are invited to make work from the materials immediately to hand, in the forest itself. This work then remains for the enjoyment of the large numbers of people who come to walk the woodland trails, within an area which is not simply recreational, but the site of a commercial enterprise where the trees are regularly felled. While the sculptures are never wantonly destroyed, it is recognized, by artists and administrators alike, that they are subject to processes of natural decay, and will eventually return to the soil which gave them birth.

Another contributor to the Grizedale collection is the New Zealand sculptor Chris Booth. Like all the artists invited to make work at Grizedale, Booth was given a free choice of site and materials. His *Celebration of a Tor* (Pl. 127) is not intended as an independent addition to the existing landscape. Booth planned his twisting spiral form so that it points towards a prominent knoll in the middle distance. That is, it makes the existing landscape more visible, more articulate.

There have been a number of artworks made during the past few decades in which Conceptual and Land Art elements were inextricably combined. One of the most

127 Chris Booth, *Celebration of a Tor,* 1993
Slate and wire
Grizedale Forest Sculpture Park, Cumbria

127

128 **Alan Sonfist**, *Time Landscape*,
1975
Drawing and photograph of site

129 **Christo and Jeanne-Claude**,
Wrapped Reichstag, Project for Berlin,
1994
Collage with fabric, coloured crayon,
fabric, pencil, charcoal and photograph
on board; in two parts, 38 × 165 cm
(15 × 65 in) and 106.6 × 165 cm
(42 × 65 in)

128

striking of these was Alan Sonfist's *Time
Landscape* (Pl. 128). This involved replanting
a small patch of Manhattan, so that it bore
only the plants and trees which would have
existed on the spot before the Europeans came.
Essentially a work of this kind counts as art
largely because someone who is self-identified
as an artist made it. Had the relandscaping
been undertaken within a context of scientific
study and experiment, then very probably the
question of whether or not it was 'art' would
never have arisen.

More easily categorizable as art, in the
commonly understood sense, are the projects
undertaken over many years by the Bulgarian
artist Christo and his wife Jeanne-Claude. Their
ambitious enterprises have penetrated the
public consciousness to an unusual degree for
efforts of this sort. One reason for this is that
their work involves a great deal of purely social
organization – obtaining permission from local
and national authorities, raising finance,
mobilizing groups of volunteers. Their latest
project , for a *Wrapped Reichstag* (Pl. 129) is
the latest in a long line of wrapped or swathed
places or objects. The building's significance,
as an emblem of key events in twentieth-
century German history, has meant that
negotiations with the relevant municipal and
political authorities have been protracted.
Yet it is by no means the most ambitious
enterprise of its sort. Christo and his wife have
already carried out ideas which are physically
much more ambitious – for example, their
Surrounded Islands (Pl. 130), in Biscayne Bay
(offshore from Greater Miami). Here eleven
islands in the Bay were wrapped in six-and-a-
half million feet of pink fabric, which made an
aureole around each of them, floating on the
surface of the water.

These 'wrapping' projects are always
temporary, in a physical sense. In the artists'
view, the permanent result is a heightening of
the sense of community, as many people come
together to make the concept a reality, plus the
lingering echo, in collective memory, of the
completed but ephemeral image.

Another vast project, but of a very different
sort, is the still-in-progress work being done at
Roden Crater, at Sedona in the Arizona desert,
by the Californian artist James Turrell. Work
on this began as long ago as 1972, but it is still
chiefly known through Turrell's drawings and

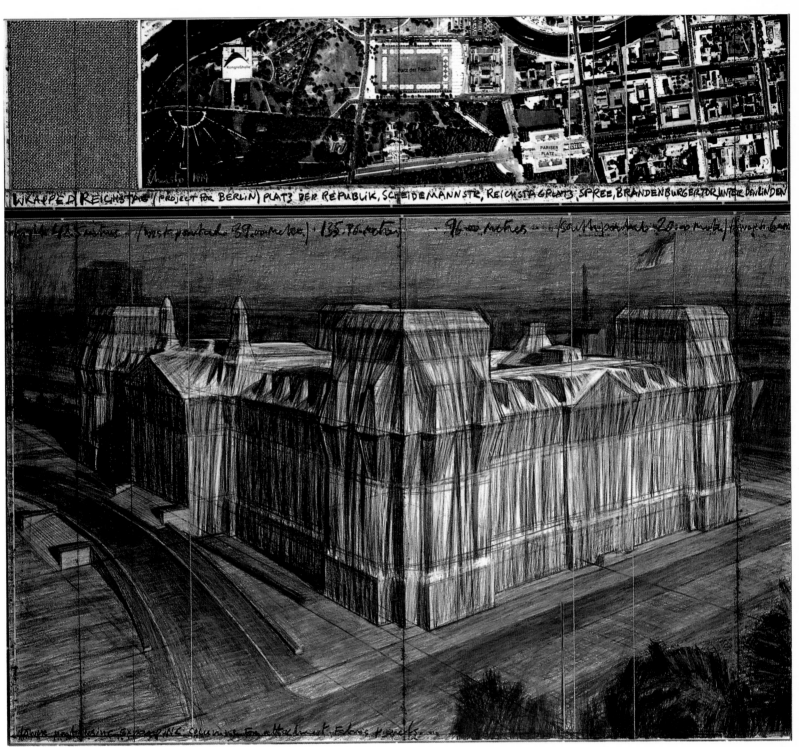

130 Christo and Jeanne-Claude,
Surrounded Islands, Biscayne Bay,
Greater Miami, Florida, 1980–3
Eleven islands surrounded by 6½ million
square feet of woven polypropylene
fabric; seven visible

models (Pls. 131, 132). Turrell is the most
celebrated of a group of American artists who
have made light and space their primary
materials. Projects of this type have made
sporadic appearances since the early 1970s –
an early, relatively simple example was Dennis
Oppenheim's *Polarities* (Pl. 133), which
consisted of a beam of intense light thrown
across a stretch of water, bridging it for the eye,
but leaving it uncrossable.

Turrell manipulates space by means of

131 James Turrell, *Roden Crater
Project: Early Site Plan with White Bowl*,
1992
Beeswax, emulsion, ink, liquitex and wax
pastel on mylar, 101.5 × 147 cm
(40 × 58 in)

132 James Turrell, *Roden Crater
Project: Dark Fumerole*, 1992
Beeswax, emulsion, ink, liquitex and wax
pastel on mylar, 100 × 117 cm
(39½ × 46 in)

133 Dennis Oppenheim, *Polarities*,
1972
Shadow projector throwing a 2,000 ft
(609 m) beam of light

133

carefully directed light, offering a quasi-
mystical experience to the viewer (perhaps
'participant' would, in this case, be a better
term). The Roden Crater is being excavated
so as to leave the extinct volcano apparently
intact, while providing spaces where certain
events will take place:

Every 18.6 years, for example, the moon will
appear dead center in the tunnel of the crater – a
spectacle that should be virtually overwhelming.
At the same time visitors will see a moon-image

cast on the back wall of the tunnel – upside down and backwards, as if in a camera obscura. At the time of the summer solstice an image of the sun in its furthermost sunrise will appear on the opposite wall.[1]

In addition to working on the Roden Crater, latterly with the help of a $350,000 MacArthur grant, awarded to him in 1984, Turrell has undertaken numerous projects in more conventional gallery settings. The trouble with these is that they are not only mostly unphotographable, but also exceedingly difficult to describe convincingly in words. A series of *Light Projections and Light Spaces* created for the Stedelijk Museum, Amsterdam, in 1976, for instance, consisted in part of a series of four apparently empty rooms, each of which resonated with a different colour manufactured in the viewer's own eye. According to a preface written for the show by Edward De Wilde, the then-director of the Stedelijk:

> The window in each cabinet [was] covered with a sheet of black Wilene plastic in which square perforations [had] been cut in order to regulate the incoming light in such a way that the entire space [was] filled with the same kind of light. A screen wall (painted white) [was] erected in front of the window, with an aperture of 13.2 x 48.8 centimeters which [was] in turn covered with layers of coloured and plain transparent paper, giving the suspended light a specific colour. The intensity of the coloured light depend[ed] on the time of day, the time of year, the clouds, in short, the weather. Each cabinet was subject to constant change: a space of ever changing dimensions, immeasurable, a place where the light seem[ed] to hang as some kind of mass.[2]

Another characteristic of these cabinets was that the colours seen changed according to the progression in which the rooms were viewed – forward or backward. These changes were the product of lingering after-images, carried by the spectator himself or herself from one cabinet to the next.

If Turrell's work is elusive, so is that of other members of the same Light and Space group, such as Maria Nordman. In her case the situation is complicated further by the fact that the artist tries to prevent critics from writing about her work, preferring visitors to experience it with no previous preconceptions.

Only a few of these Light and Space works

have achieved a semi-permanent existence at accessible sites. In 1985, Eric Orr, who also bases himself in California, created a *Light Space* (Pl. 135) for the Gemeentemuseum in The Hague. Here the whole area, which is viewed from either end, is lined with scrim, which produces a tunnel of subdued sunlight whose dimensions seem to vary with the intensity of the light itself. People appearing in the razor-edge opening seen at the back of the photograph reproduced here are flattened, and

135

look like figures in a painting. That is, the viewer's perception of space, of three-dimensionality, is gradually called into question by the way in which the space has been transformed.

A more recent work by Orr is his *Lumière* (Pl. 134) installed at the top of an office building in Landmark Square in Long Beach, California. The lasers are used to create a slender pyramid of light, and the building itself is carefully illuminated, using white and blue

134 **Eric Orr**, *Lumière*, 1991
Light sculpture with xenon lights throwing beams two miles into the sky, Landmark Square, Long Beach, California

135 **Eric Orr**, *Light Space*, 1985
Permanent installation at the Gemeentemuseum, The Hague, 7.6 × 15.2 × 15.2 m (25 × 50 × 50 ft)

136

137

Land Art, Light and Space, Body Art

lights, in order to create a base for the sculpture. The notion of the immaterial has fascinated artists ever since the time of Malevich, and Orr is here essentially trying to exceed the ambitions of Minimal Art by taking a minimal form and dissolving it, making it not out of solid matter, but out of pure light.

Artists who are intrigued by, or who work with, light are naturally attracted to media which play with light and its properties – with mirrors, and perhaps most of all with holography. Dan Graham's *Double Triangular Pavilion for Hamburg* (Pl. 136) is an example of play with reflections. The walls of the small structure are both transparent and reflective, so that the pavilion creates a puzzling hiatus in visual reality – the spectator cannot be quite certain what is seen through the walls and what is simply reflected by them.

Holography – necessarily connected with an interest in light – has been a major medium for experimental artists since the early 1980s. At first they tended to concentrate on the grammar imposed by the medium itself – its advantages (such as being able to put two forms in what was apparently the same space, each occupying space which seemed to be demanded by the other); and also its disadvantages (the difficulty of obtaining a clean separation of colours, and the difficulty and expense of working on a large scale). Within these rather stringent terms some of the best work was done by the Dutch-born but American-resident Rudie Berkhout (Pl. 137). Berkhout's holograms were abstractions very much in the long-established Dutch Constructivist tradition.

More recently, the sculptor-holographer-painter Alexander has experimented with a combination of painting and holography in a series called *The Dance of the Souls* (Pl. 138). In these, abstract paintings are combined with holography panels which seem to send rays of light out into the ambient space. The forms and colours of these rays echo the forms and colours of the marks on the canvas, and they change according to the position of the spectator in relation to the work, so that the design is interactive: the painting dances with the viewer.

A work of this kind reaches the very frontiers of a situation where the artist's material is actually the body itself. The

136 Dan Graham, *Double Triangular Pavilion for Hamburg*, 1989
Triangular pavilion with triangular roof rotated 45 degrees

137 Rudie Berkhout, *Delta II*, 1982
Transmission hologram,
30.4 × 40.6 cm (12 × 16 in)

138 Alexander, *The Dance of the Souls – 14*, 1992
Holography and acrylic on canvas,
101.5 × 152 cm (40 × 60 in),
as viewed from left, centre and right

138

tradition of Body Art is rooted in the Happenings of the 1960s. Sometimes these were elaborated until they became multi-part rituals, often in the form of a journey or quest. One of the most striking of these rituals was enacted in the early 1970s, at several times and in different forms, by the British performance group, The Welfare State, now called The Welfare State International.

Sir Lancelot Quail (Pl. 140) was loosely based on the Grail Quest of Arthurian legend. Performers mingled with the audience in a large darkened space, and moved in procession from one performance station to the next. Each station was briefly illuminated, and the audience saw a few mysterious actions or gestures before the space was once again plunged into darkness. Obviously, it is

139

140

extremely difficult to make a distinction here between what belongs to the visual arts and what belongs to the experimental theatre. The techniques used by The Welfare State were extremely close to those employed by leading experimental directors, such as Peter Brooke and Arianne Mnouchkine.

Artists have looked for various solutions to the problem of demarcation. One has been for the artist to proclaim that his or her whole life must be regarded as a cumulative work of art, as was the case with Joseph Beuys. Gilbert & George, in the early part of their career, put great emphasis on the fact that they were to be regarded, not as artists in the conventional sense, with a separation between themselves and their work, but as 'living sculptures'. Their public demeanour – the way they dress,

behave, conduct interviews – continues to be deliberately stylized.

Perhaps the most extreme example of the deliberate melding of the artist and the work is to be found in New Zealand, where the Wizard of Christchurch (Pl. 139) has performed for more than a decade, usually in the Cathedral Square of the city of Christchurch in the South Island. The Wizard has established the personage he has invented to the point where his original identity is now completely effaced. The New Zealand authorities have provided him with a passport which identifies him simply as 'Wizard', and he has even been invited to accompany the Mayor of Christchurch on her travels, as part of the official municipal entourage.

The most interesting aspect of the Wizard is the use to which he puts this carefully constructed identity. The actions of his invented personage are a sharp satire on established ideas of normality, very much in the manner of the original Dadaists, or in those of the French Pataphysicians who flourished immediately after World War II, and who took much of their doctrine from the *Ubu Roi* (1896) of Alfred Jarry. The point about the Wizard, as far as his creator is concerned, is his lack of magical power, the fact that his pretensions are continually deflated by reality. The implication is that this is also the inevitable fate of the bourgeois establishment, when it dares to take itself seriously. The Wizard once remarked to me that he had never been more disconcerted, or indeed frightened, in his life than on the occasion when, after a long drought, he performed a mock rain ceremony at a small town in the South Island, and there was an immediate downpour which lasted for the best part of three days.

The implications of other kinds of Body Art tend to be less healthy. Much of it has a distinctly masochistic tinge. In the early 1970s, the English performance artist Stuart Brisley (Pl. 141) once spent the best part of a week immersed in a bath containing offal and other animal parts. At the same period, the French artist Gina Pane (Pl. 142) performed a series of 'psychic actions', an essential feature of which was slashing her own body until she bled.

Pane and others could trace much of what they did to an earlier figure, the short-lived but immensely influential Italian experimental

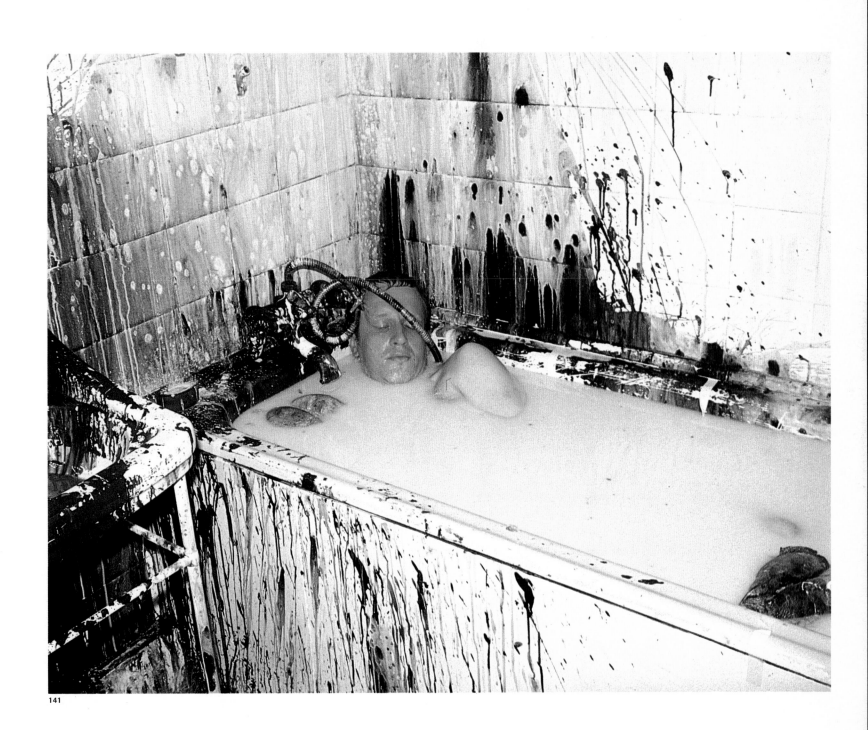

141

143 Piero Manzoni, *Merda d'Artista*,
1961
Human excrement in tin, height 5 cm
(2 in), diameter 6.5 cm (2⅛ in)

144 Marc Quinn, *Self* (detail), 1991
Blood, stainless steel, perspex and
refrigeration equipment,
205 × 60 × 60 cm (81 × 23½ × 23½ in)
Saatchi Collection, London

artist Piero Manzoni (1930-63), one of the
ancestors of the Arte Povera Movement, which
has had a major impact on the art of the last
twenty-five years. Manzoni dabbled in many
of the fields, and played with many of the
ideas, which were to acquire importance in the
late 1960s and become dominant in the 1970s
and 1980s. In 1957, at about the same moment
as the young Robert Rauschenberg, he was
experimenting with all-white canvases. He also
made Minimal works consisting of a single line
on paper, which was kept rolled up in a tube.
His single most provocative gesture, however,
was to package and sell his own bodily
products, including excrement (Pl. 143). The
celebrity of British avant-garde artists like
Marc Quinn, who jumped to prominence in
the 1990s by exhibiting a head made of his
own frozen blood (Pl. 144) might be
considerably diminished if Manzoni were
better remembered.

Indeed, one major conclusion to be drawn
from the various developments discussed in
this chapter and also in the immediately
preceding one devoted to Minimal Art, is the
fact that the whole theory of avant-gardism
has been very much called into question by the
developments of the past twenty-five years.
Ironically, the reason for this is the failure
of the artists themselves to find ways of
exceeding the efforts of their predecessors in
the earlier years of the century. Very little in
Minimalism goes beyond the point reached by
Russian artists of the Revolutionary epoch like
Malevich and Tatlin. Hardly any provocation
has been discovered which exceeds the
provocations offered to bourgeois society by
the original Dadaists, who flourished in Zurich
during World War I. The frontier has refused
to be pushed back, not because of society's
resistance to the process but because of the
artists' own failure to imagine anything
beyond it. This is turn undermines the classic
theory upon which the notion of twentieth-
century avant-gardism is based – that the
frontier exists and can and must be mobile.
Avant-gardists of a traditional sort (the phrase
itself conjures up the nature of the dilemma)
are in the position of frontiersmen who have
just chased the last buffalo over the edge of a
sheer cliff looking out over the Pacific. The new
world they are encountering is not the one that
they envisaged.

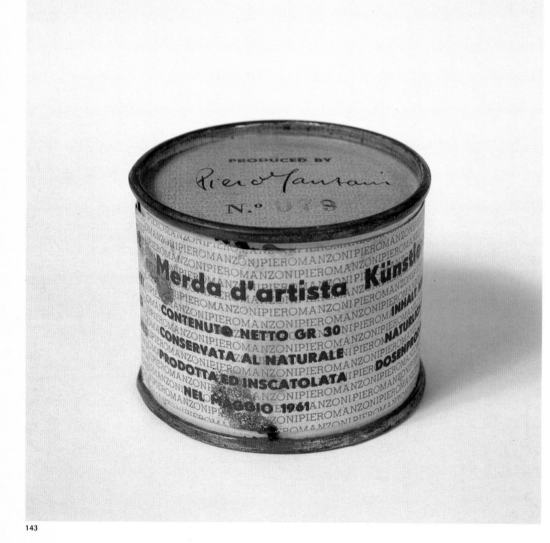

143

Neo-Dada, Arte Povera & Installation

145 Yves Klein, *Blue Venus*, 1962
Painted plaster, 68.5 × 30.4 × 20.3 cm
(27 × 12 × 8 in)
Collection of the Virlaine Foundation,
New Orleans

The rise of Abstract Expressionism, then of Pop Art, tended to concentrate critical attention on the United States, and specifically upon New York, as the main focus for experiment in contemporary art. By the 1960s there was already a perception, especially prevalent among British and American critics, that the old École de Paris was in a state of terminal decline. French critics and curators were aware of this feeling as well. Not unnaturally they resented it, but most were at a loss concerning what, if anything, could be done. The most determined effort to remedy the situation was made by the critic Pierre Restany, who founded the Nouveau Réaliste group in October 1960.

The artists associated with New Realism afterwards came to be thought of as the French answer to Pop, but in fact it was easier to trace connections with the French members of the original Dada Movement, such as Duchamp and Picabia, and with Robert Rauschenberg, who had been responsible for reviving the spirit of Dada in the United States. Seen from the perspective of the present day, the two most important members of the Nouveau Réaliste circle were a pair of boyhood friends from Nice, Yves Klein and Arman.

Like Piero Manzoni, a *provocateur* with whom he had much in common, Klein was tragically short-lived. He shot across the European art scene like a comet, dying of a massive heart attack in 1962. His years of greatest notoriety were those at the very end of his life. Many of his ideas were not entirely original to himself, though he persistently offered them as such. One thing he had in common with both Rauschenberg and Manzoni was his experimentation with monochrome canvases. Always anxious to establish priority over other experimental artists, he claimed to have begun work on these in the 1940s and to have exhibited them privately in 1950. Their first public showing, however, was in Paris in 1956, at the Galerie Colette Allendy. Klein's theoretical basis for these canvases was close to that offered by Malevich for Suprematism – he said that he wanted to rid colour of subjective emotion and thus depersonalize it, while at the same time giving it a metaphysical quality. 'Without doubt,' he said, 'it is through colour that I have little by little become acquainted with the immaterial.' Many of the monochromes were painted in an intense blue

– a hue which the artist actually patented, under the name International Klein Blue (IKB).

It is this colour which covers his *Blue Venus* (Pl. 145), made in the year of his death. Here Klein's links to Dada are much more apparent, as the female torso is a 'readymade', in the sense in which Duchamp used the term – a standard, classical cast of the sort one might find in an art school. By giving it a coating of IKB, Klein indicated his desire to 'dematerialize' Western culture, as this had descended to artists from the European Renaissance. His idea was that the solid realities of Western art, based on a fully realized plasticity, could somehow be made to vanish into a metaphysical empyrean.

Klein's hostility to Western cultural norms sprang from sources which were very little understood in his own lifetime. One was his interest in Oriental philosophy, specifically in Zen Buddhism. This was reinforced by a period he spent in Japan, studying judo: he achieved the rank of Black Belt. Another was his fascination with Rosicrucianism, the hermetic doctrine which had also mesmerized many of the French and Belgian turn-of-the-century Symbolists. Christian Rosenkreuz, said to have been a fifteenth-century visionary though in fact it is doubtful if he ever existed, became the centre of a late nineteenth-century cult which was further embellished with ideas taken from the Cabbala and from Freemasonry. In the 1880s and 1890s its chief propagator in France was the writer and aesthetician Josephin Péladan, self-christened the Sâr Péladan. In 1892, Péladan actually launched a new Salon, in opposition to the official one, at the highly respectable Durand-Ruel Galleries. The Salons de la Rose + Croix continued successfully for a number of years, and helped to create the artistic climate needed for the birth of twentieth-century Modernism. Through his interest in the cult and its ideas, Klein was reverting to the beginnings of the Modern Movement itself, and specifically to the mystical, theosophical aspect which has troubled so many later historians. Many of Klein's pronouncements can be traced to Rosicrucian sources. Among them, the following seems especially significant:

I propose to artists that they pass by art itself and work individually to return to the real life in which man no longer thinks he is the centre of

146 Arman, *Max Beckmann's Colours*, 1987
Acrylic and brushes on canvas, 244 × 152 cm (96 × 60 in)

147 Marcel Broodthaers, *Pense-Bête*, 1963–4
Books, paper, plaster, plastic and wood, 98 × 84 × 43 cm (38½ × 33 × 17 in)

148 Marcel Broodthaers, *Tapis de sable*, 1974
Installation at the Palais des Beaux-Arts, Brussels, sand carpet 225 × 180 cm (88¾ × 71 in), painting 107.5 × 51 cm (42½ × 20 in)

149 Eva Hesse, *Right After*, 1969
Casting resin over fibreglass, cord and wire hooks, 152 × 548 × 122 cm (60 × 215 × 48 in)
Milwaukee Art Museum, Gift of Friends of Art

146

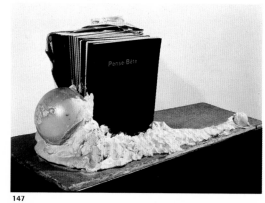

147

148

the universe, but the universe is the centre of the man.[1]

Arman, Yves Klein's boyhood friend in Nice, was also influenced by Zen philosophy, but had another important element to add to the mixture of ideas which went to create New Realism. His most typical works were accumulations or agglomerations of real objects. *Max Beckman's Colours* (Pl. 146), though a relatively recent work, demonstrates his methods, whereby 'real' objects – in this case the paint-soaked brushes – are brought together to create an artwork which challenges one of our most important perceptions about the nature of art: that art is essentially something that transforms what we find in the world of actuality surrounding us, and turns it into something else. Arman perpetually challenges the spectator to say whether this barrier has in fact been crossed or not.

A number of other European artists made significant contributions to the creation of a new artistic climate in the 1960s, Among them were two others who, like Yves Klein, died relatively young. One was the German sculptor Eva Hesse, the other the Belgian Conceptual-Surrealist Marcel Broodthaers. The significance of Hesse's work (Pl. 149) lies in her exceptionally free and experimental attitude towards materials. Some American Minimalists, notably Robert Morris, moved away from rigid geometric forms in favour of shapes imposed by the actual nature of the materials – in Morris's case, strips of cut and draped felt. Hesse is less strictly Minimal, but carries her experimentation with materials much further, to create forms and textures which seem to come directly from the depths of the unconscious mind.

Broodthaers carries the exploration of heterogeneous and deliberately incongruous material even further than Hesse, reverting to the tradition of the Hanover-based Dadaist Kurt Schwitters. *Pense-Bête* (Pl. 147) is a typically baffling and disturbing work. The title, like many of Magritte's titles, incorporates a pun, as the word '*bête*' can be either a noun or an adjective, meaning 'beast' in one form, and 'stupid' in the other. The object, which resembles a snail, with books for its shell, seems to satirize those who think themselves knowledgeable because of what they have found in libraries.

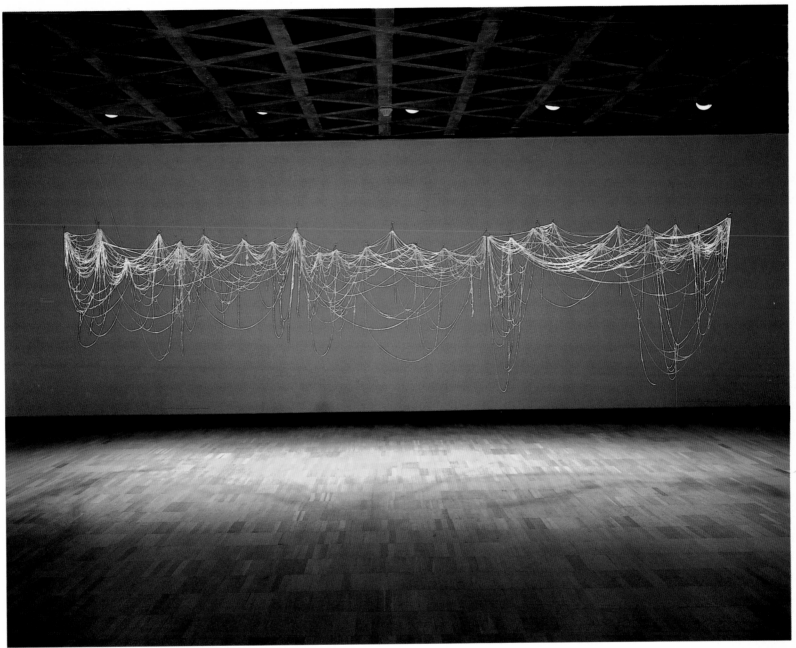

149

150 **Joseph Beuys**, *F.I.U. Difesa della natura*, 1983–5
Automobile, shovels, copper, pamphlets, blackboards, 9.7 × 5.2 m (37 × 17 ft), as installed at Ronald Feldman Fine Arts, New York
Collection of the Solomon R. Guggenheim Museum, New York

150

A Broodthaers installation, Tapis de sable (Pl. 148), made in 1974, incorporates many features still familiar from the avant-garde art which is being produced twenty years later. Essentially the piece is a dramatic tableau, made from a wide variety of materials, among them a potted palm and a painted representation of a palm tree. The intention, once again, is moralistic and satiric – an admonition directed at the bourgeois taste for exoticism – but an exoticism which has to be domesticated and made unthreatening before it is acceptable to the audience.

The generic likeness between Broodthaers's Tapis de sable and many of the installations and environmental pieces made by Joseph Beuys (Pl. 150) in the course of his career is, I think, obvious. Like Broodthaers, Beuys brought together incongruous combinations of objects, and apparently incompatible materials, to create art whose impact was emblematic, rather than aesthetic. When Beuys's career is surveyed as a whole, however, the making of artworks seems peripheral to his central activity. This central activity was not to create art but to be an artist. He redefined the modern artist's calling in so drastic a way that his career marks the most important turning point in the last twenty-five years.

The basic outlines of his biography are well known, though some aspects of it have recently been called into question. Born in 1921, Beuys was drafted into the Luftwaffe in 1940. During his war service, he was wounded a number of times – his most serious misadventure occurred on the Russian front in 1943, when his plane was shot down over the Crimea. Rescued by nomadic Tartars, who saved his life by wrapping him in felt and fat – materials which afterwards acquired talismanic significance for him – Beuys was eventually found by a German search party and taken to a military hospital, where he recovered.

After the war Beuys decided to become an artist, and studied at the State Academy, Düsseldorf, where he was afterwards to be appointed professor. During the mid-1950s he suffered a period of severe depression, which also seems to have been a period of shamanic self-transformation: the primitive witch-doctor often recognizes his own vocation by undergoing either a severe illness or a series of physical and spiritual ordeals, and after overcoming these his whole character is transformed. Beuys is known to have been fascinated by Rosicrucian doctrines at this time. He emerged from this period of trial unshakeably convinced of his own mission:

> Things inside me had to change completely [Beuys said later], there had to be a metamorphosis, physically as well ... This sort of crisis is a sign either of lack of direction or of too many directions being taken at once. It is an unmistakable call to rectify things and to come to new solutions in specific directions. From then on, I began to work systematically, according to definite principles.[2]

In 1961 Beuys was appointed Professor of Monumental Sculpture at Düsseldorf. The position gave him a power-base which he was to use with great skill during the 1960s and 1970s. Soon after his appointment, he became involved with the Neo-Dada group Fluxus. This group contained almost as many composers as it did visual artists, and its bias towards performance pushed Beuys towards the creation of new versions of the Pop Art happening. These, more ritualized than the American originals, soon made Beuys conspicuous, at least within Germany. One of the ways in which Beuys's Actions, as he called them, differed from previous work of the same kind was through the inclusion of shamanic elements. Often there was the idea that what the artist did must also be a purifying ordeal, a sacrifice undertaken for the health of society. The actual artworks that Beuys made tended, more and more, to be simply relics, leftovers and mementoes of his performances.

In the late 1960s, Beuys began to turn towards politics, which he soon designated as Social Sculpture – an art form in its own right. He founded the German Student Party (DSP) in 1967, which in 1971 became the Organization for Direct Democracy through Referendum (People's Free Initiative). The background to his political activity was a bitter conflict with the Düsseldorf Academy over its admissions policy. Because of student demonstrations led by Beuys, this was briefly closed by the police in May 1969.

In the 1970s, thanks to appearances at successive Kassel Documentas (in 1972, 1976 and again in 1982), Beuys became internationally famous. In 1972, for example, the Documenta provided the Organization for

Direct Democracy with an office space to which the public were freely admitted, and here Beuys debated with all comers, for one hundred days in succession, on democracy, art, and related social issues. By the mid-1980s, when his health began to fail – largely because of his wartime ordeals – he was the most celebrated avant-garde artist in Europe, and perhaps in the world.

Beuys's career shifted the emphasis in contemporary art. Since World War II, there had been an increasing tendency to focus as much on the personality of the artist as on what he produced. This was as true of Jackson

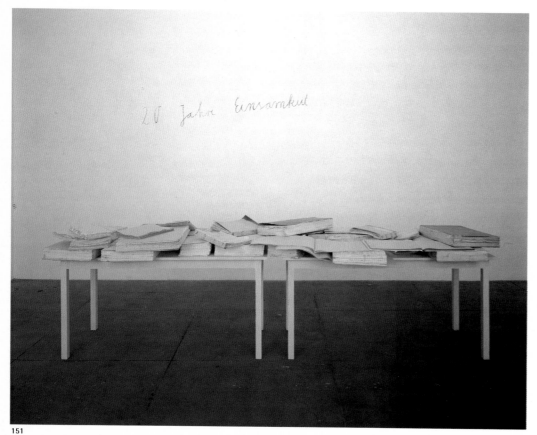

151

Pollock and Andy Warhol (otherwise very different from one another) as it was of surviving giants from the first Modernist epoch, such as Picasso. With the advent of Beuys, the artist's charisma became almost the be-all and end-all. Beuys's costume – jeans, fishing vest and felt hat – became an inseparable part of the total effect, which depended as much on his appearance, gestures and spoken words as it did on anything he actually made.

What he made had no distinguishable style as such. He frequently used certain favourite materials, such as felt, fat, honey and gold, but

their presence was not mandatory, nor did he use them in a set fashion. What mattered was the actual content of each piece – its subject-matter, usually connected with themes such as politics, ecology or the intimate relationship between man and nature, and still more the connection between the natural world and Beuys's own evolving myth. In Beuys's wake many artists were seized with the desire to mythologize their own existence. Even more turned away from the whole problem of style, and concluded that subject-matter was the only thing which counted. In the days of Minimal Art it had seemed that the visual arts avant-garde was condemned to pursue a narrow aestheticism – that the only possible subject for art was art itself. Under Beuys's influence this tendency, in the 1970s and 1980s, gradually reversed itself.

Because Beuys was himself German, it would have been logical if his influence had been most strongly experienced in Germany itself. This was not quite the case. In a general sense, he was indeed extremely influential. Almost single-handed, he returned to German art a sense of its own potentiality. Despite this, many of the German artists of the generation which immediately followed his own turned away from what Beuys was doing – from environmental art and performance work – and re-explored the possibilities offered by conventional formats, notably painting on canvas. Perhaps they felt that Beuys, with his overwhelming personality, was too much to compete with directly.

A partial exception to this was the artist often thought of as being Beuys's closest German disciple, Anselm Kiefer. In addition to making immense brooding paintings on themes drawn from German history, and especially from the history of Germany under the Third Reich, Kiefer made an number of ambitious environmental works. Pieces like Kiefer's *20 Jahre Einsamkeit* (Pls. 151-3) took up where Beuys left off. As in Beuys's own work, the element of self-mythologization is evident. Yet it is also clear that, despite the ambitious scale of the work physically, its psychological scope is narrower: we are back with the conventional problems of the creative artist, seeking a secure place for himself in modern society.

More recently, some women artists of

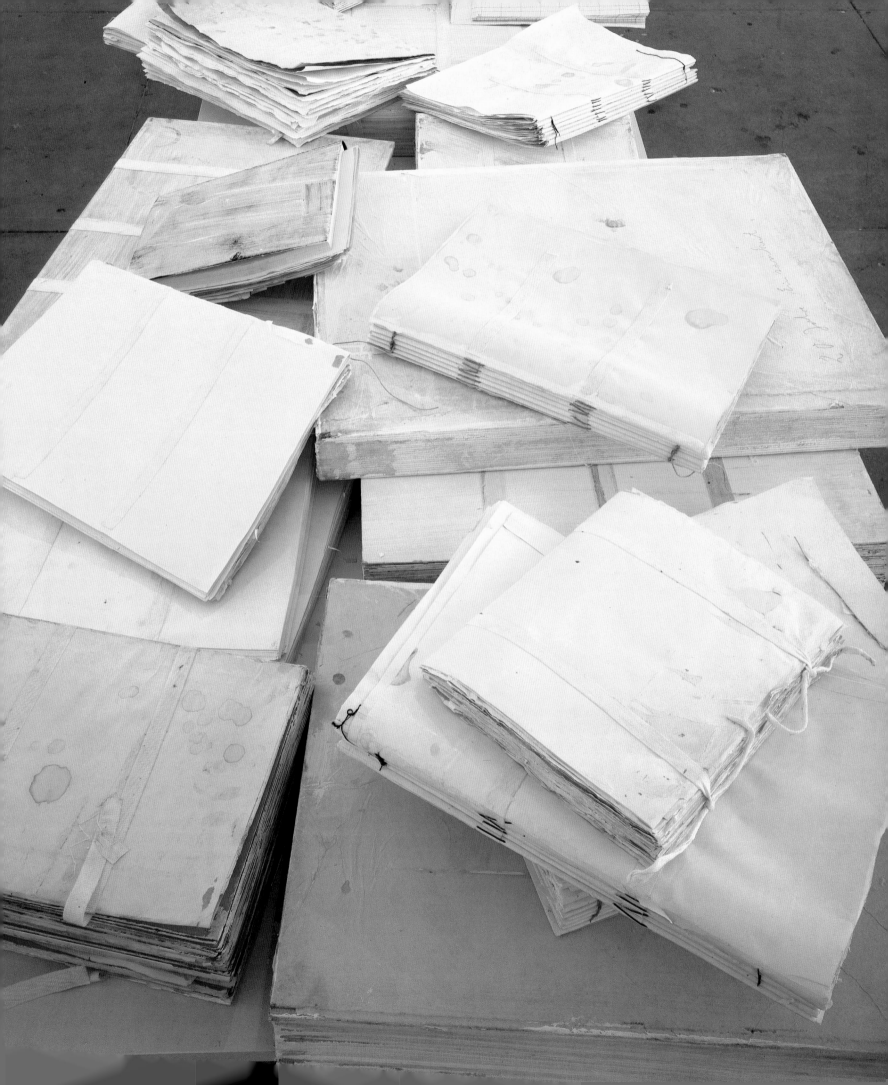

153 Anselm Kiefer, *20 Jahre*
Einsamkeit, 1971–91
Installation at the Marian Goodman
Gallery, New York, paintings, books,
semen and mixed media, dimensions
variable according to location

154 Rebecca Horn, *High Moon,* 1991
Installation at the Marian Goodman
Gallery, New York, two mechanized
Winchester rifles, two plexiglass funnels,
mechanized rods, red paint, steel trough,
mechanized saw, dimensions variable
according to location

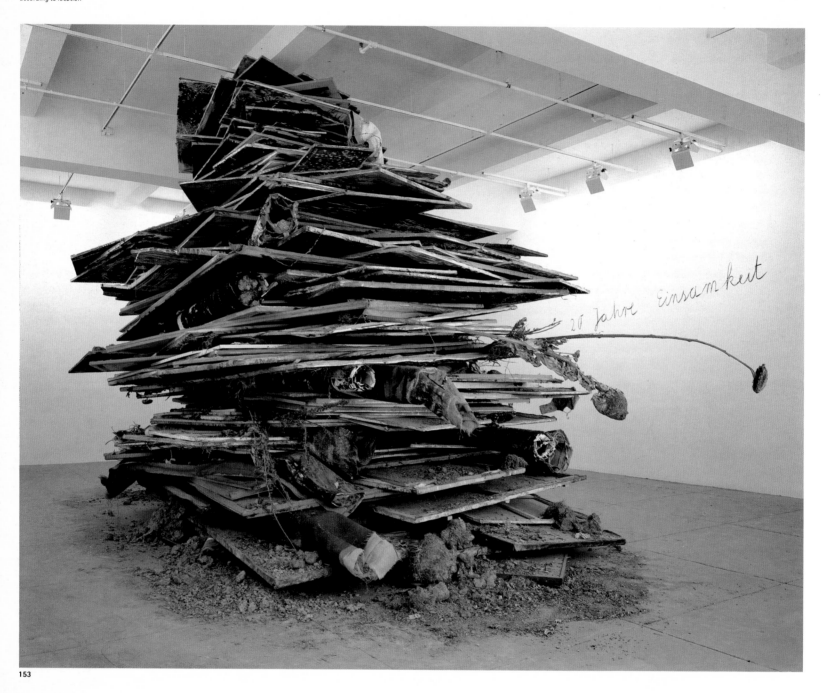

153

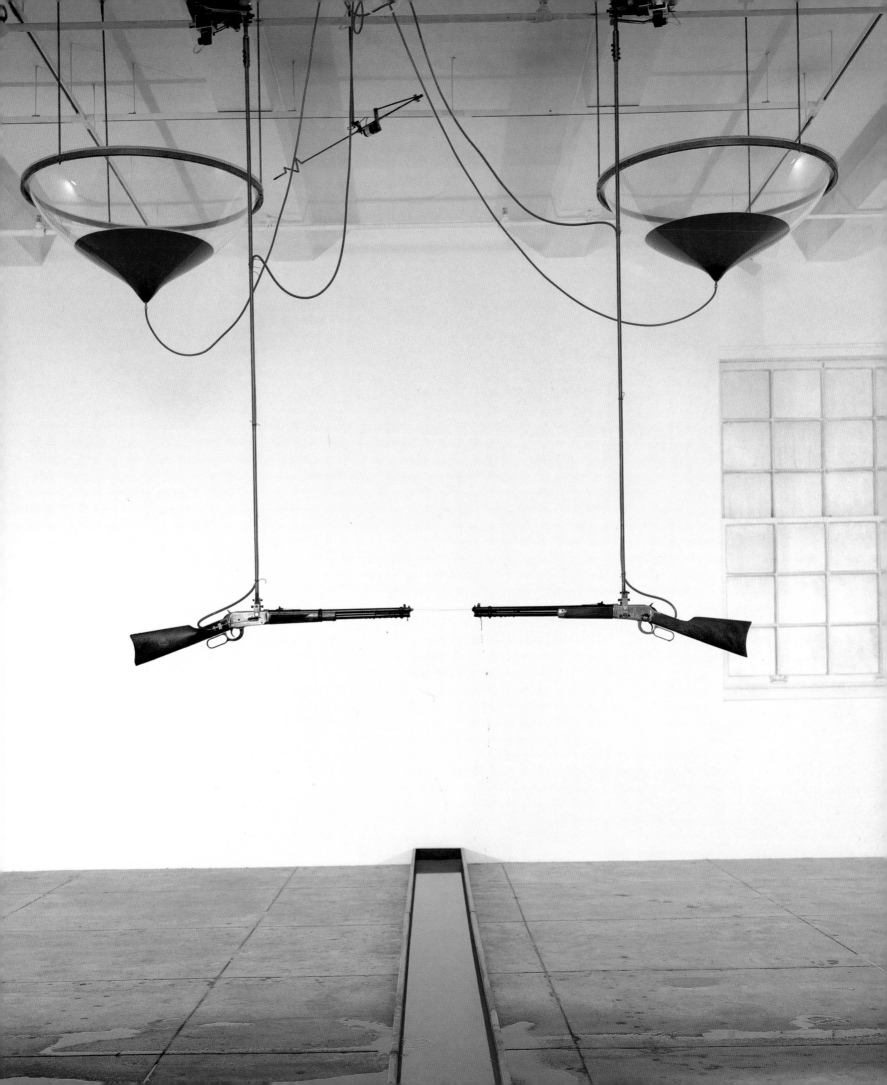

155 Rosemarie Tröckel, *Untitled*
(*Modell mit Kummerfläche*), 1989
Plaster, silver chain, paper and wood,
132.5 × 44.4 × 44.4 cm
(52¼ × 17½ × 17½ in)

156 Luciano Fabro, *Palme*, 1986
Copper and tar on canvas,
139.5 × 132 × 10.1 cm (55 × 52 × 4 in)

155

German origin have felt able to take over aspects of Beuys's methods as makers of objects and environments. Among these are Rebecca Horn, whose savagely effective *High Moon* (Pl. 154) has an unmistakable element of social protest; and Rosemarie Tröckel, whose *Untitled (Modell mit Kummerfläche)* (Pl. 155) offers, with its object on a stool, a direct reminder of Duchamp's first 'readymade', the bicycle wheel, which was similarly mounted. It is worth recalling here that Beuys was keenly aware of Duchamp, but also mildly competitive in his attitude towards him. One of the Actions which made Beuys celebrated in Germany was a piece entitled *The Silence of Marcel Duchamp is Overrated*. This was broadcast live on German television, in 1964.

In Italy, developments which paralleled the work of Beuys began to appear in the late 1960s, and by the beginning of the 1970s had acquired a label – Arte Povera. The name was coined by the critic Germano Celant, who in 1970 organized an influential exhibition under this title at the Museo Civico, Turin. According to Celant:

> Arte Povera expresses an approach to art which is basically anti-commercial, precarious, banal and anti-formal, concerned primarily with the physical qualities of the medium and the mutability of the materials. Its importance lies in the artists' engagement with the actual materials and with total reality and their attempt to interpret that reality in a way which, although hard to understand, is subtle, elusive, private, intense.[3]

This description is so general that it does not leave the reader very much wiser. Are there any other characteristics which can be attributed to this particular form of art? First, as the name suggests, the artworks made by artists belonging to the group were, and, are, often made of self-consciously 'poor' and banal materials. Sometimes this comes close to the work of Beuys – for example in Luciano Fabro's *Palme* (Pl. 156), where the substances are tar and copper. Second, much, but not all, of the work is environmental. Third, it often has a strongly theatrical element. It is not surprising to discover that a number of the artists involved have some kind of theatrical background. The short-lived Pino Pascali, killed in a motor-cycle accident in 1968, actually trained as a theatrical designer, which makes his *Teatrino*

(Pl. 158) directly autobiographical. Fourth, and this is perhaps its most important aspect, Arte Povera encapsulates yet another aspect of the rebellion against the classical past which has made itself felt in the Italian avant-garde from the beginning of Modernism – ever since the appearance of the Futurists. Giulio Paolini's *The Instruments of Passion* (Pl. 157) conjures up the idea of a musical performance by bringing together a clutter of Duchampian 'readymades' – music stands, a photographic floodlight. These, it suggests ironically, are

157

158

the forgotten bystanders, but also perhaps the necessary catalysts, when something suitably and traditionally passionate is made. Despite this hostility towards tradition, the whole history of Italian art continues to echo in many of the objects and environmental pieces produced by members of the group. Fabro's long narrow trestle table draped in white, entitled *Iconografia* (Pl. 160), immediately conjures up memories of the Last Supper, as this was depicted by leading Renaissance masters, among them Leonardo. Giuseppe

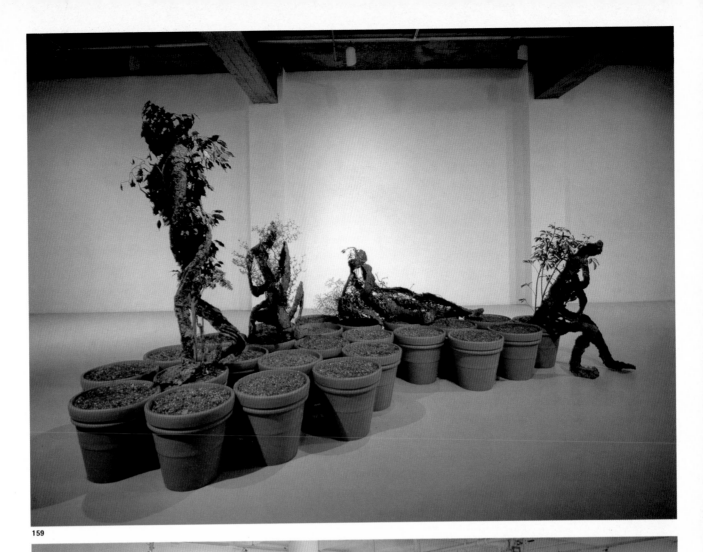

159

160

Penone's *Landscape of Vegetal Gesture* (Pl. 159) recalls the fantasies found in Italian Baroque gardens.

Arte Povera, nevertheless, has considerable variety. It can hint at a carefully concealed romantic narrative, as in Jannis Kounellis's *Untitled* (Pl. 161), which features the mast and sails of a square-rigged ship, plus smoke marks on the surrounding walls which suggest that the setting is the sack of a port, or perhaps the aftermath of a naval battle. Or it can come close to American Minimal Art, or link itself to the Conceptual tendency in America. Perhaps

161 **Jannis Kounellis**, *Untitled*, 1979
Wood, canvas, ropes and smoke stains,
height 397 cm (156½ in)

162 **Mario Merz**, *Untitled*, 1989
Newspapers, glass and neon,
51 × 86 × 693 cm (20 × 34 × 273 in)

163 (overleaf) **Jannis Kounellis**,
Untitled, 1980
Steel, lead, screws, coal and glass,
4.9 × 10.6 m (16 × 35 ft)

162

the best-known example of this is the long series of works devoted by Mario Merz to a celebration of the Fibonacci series of numbers (Pl. 162), the discovery of an Italian mathematician.

The appearance of Arte Povera had a liberating effect on artists in several respects. It made it clear that it was now possible to use any kind of material, in any way the artist liked, to create something which could be convincingly described as art. The clearing of the decks was so thorough that some critics and curators (though few artists) began to

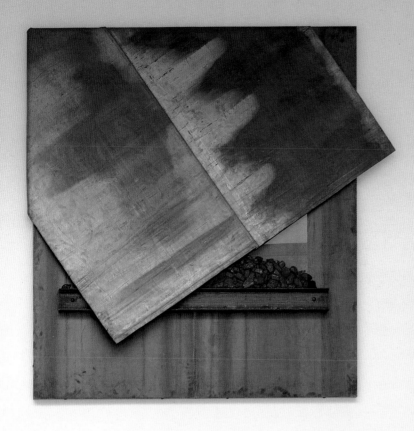

164 Panamarenko, *Toy Model of Space and Flip the Fruitfly (The mechanical Model behind Quantum Mechanics)*, 1992–3
Installation at Ronald Feldman Fine Arts, New York, 9 January 1993–13 February 1993
Book composed of laser photocopies of drawings and writings by Panamarenko, 41.8 × 29.8 × 5.7 cm (16½ × 11¾ × 2¼ in); 15-minute video of Panamarenko addressing the world from Peru; Flip the Fruitfly, metal cellophane wings, electric motors, each 68.4 × 101.5 × 20.3 cm (27 × 40 × 8 in)

165 Jean-Marc Bustamante, *Continents + Tableau*, 1993
Installation at the Donald Young Gallery, Seattle
Tableau: unique colour print, 129.5 × 159.4 cm (51 × 62¾ in)
Continents: carpets and PVC plastic, each 297 × 188 cm (117 × 74 in)

166 Ger van Elk, *Kutwijf/Bitch*, 1992
Painted and varnished wood and framed photographs, 74 × 452 × 63 cm (29¼ × 178 × 24¾ in)

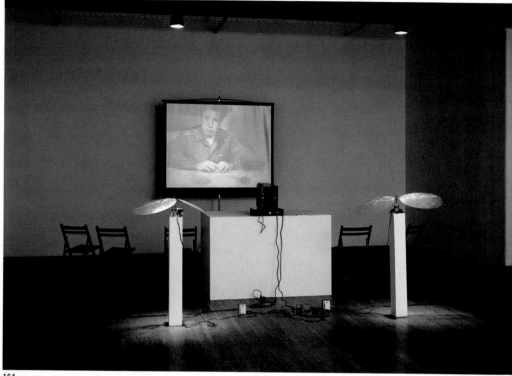

164

proclaim that 'conventional forms' – by which they meant painting and sculpture as these are generally recognized – had now had their day. There was another, and subtler consequence as well – a breaking of stylistic moulds. It was no longer possible for the expert to identify a given artist simply by his handwriting, the way in which he handled the means at his disposal. In the case of an artist like Kounellis, for instance, it was the materials themselves which created the atmosphere of the work, rather than the way in which they are put together. For example, it would probably be difficult for even the most expert eye to find stylistic affinity between Kounellis's *Untitled* of 1979, featuring a sail, and his *Untitled* (Pl. 163) of eleven years later, featuring plates of steel, lead and glass, and shallow troughs holding lumps of coal.

The impact of Arte Povera was most profoundly felt in Europe, where the influence of the new way of thinking, like the influence of Joseph Beuys, was greatly reinforced by successive Kassel Documentas in the 1970s and 1980s. Not only did the theatrical element in Arte Povera fit very well into the kind of framework which the Documenta exhibitions provided (for their many thousands of visitors they were in fact a form of entertainment, a traditional *Wunderkammer* or princely cabinet of freaks and rarities enlarged to an enormous scale). But there was another element as well: a renewed affirmation that European art had something to offer which genuinely could not be found in the United States. It was this impression that Arte Povera's cultural allusiveness helped to reinforce.

In the Low Countries, historically always very responsive to new cultural initiatives, Arte Povera found its equivalent in the work of artists like Panamarenko (Pl. 164) and Ger van Elk. Ger van Elk's *Kutwijf/Bitch* (Pl. 166) nevertheless has something subtly northern European about it – the allusion, here, is not to the classical past, but to the strange monsters invented by that quintessentially anti-classical artist, Hieronymus Bosch.

In France, related work has been done by Jean-Marc Bustamante (Pl. 165) and Christian Boltanski. Boltanski's melancholy celebrations of the universal fact of death have made him one of the best-known contemporary French artists at a period when the international

165

166

167

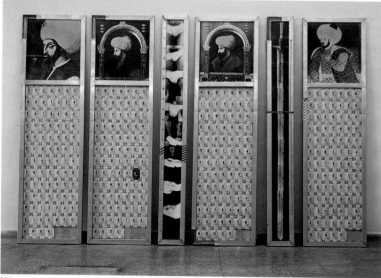

168

reputation of French art taken as a whole
was at an unprecedently low ebb.

The Arte Povera aesthetic has also made
itself felt a great deal further afield – in Mexico,
where a number of recent works by the leading
sculptor Helen Escobedo have been in a version
of this idiom (Pl. 169), and in Turkey. Turkey
presents an especially interesting case because
it is a country with a well-established Islamic
cultural tradition, which has little to do
with what happened to the visual arts in
Europe. With Kemal Ataturk's campaign of
modernization, when a Turkish secular republic
was established after World War I, Turkish
artists were faced with difficult decisions. If
they identified themselves entirely with the
West, and started producing paintings and
sculptures in Western Modernist style, did
this not involve the abandonment of things
which were uniquely their own and therefore
uniquely valuable to the national culture?
If they refused to do so, would they be
marginalized?

The new idiom, chiefly because it drastically
broke stylistic moulds, make it possible to
create works of art which dealt with Turkish
issues in a visibly contemporary fashion. The
results of this new approach can be seen in
recent installation work by Bedri Baykam (Pl.
167), and in work by the sculptor Erdag Aksel.
Aksel's piece *Here and Now and Then* (Pl. 168),
made for the Venice Biennale of 1993, carries
the kind of long historical echo which one also
finds in many Arte Povera installations made
by Italian or Italian-domiciled artists. Its
subject is the most celebrated figure in Turkish
history, the Ottoman Sultan Mehmet II,
the Conqueror, who took possession of
Constantinople in 1453. Reproductions of his
portraits, including one by the Venetian painter
Gentile Bellini, can be seen at the top of the
piece, and the great sword mounted vertically
is modelled on the one said to have belonged to
him. The spaces below the portraits, in each of
the four large panels, are filled with row upon
row of the popular Turkish calendars which can
be bought in markets – poorly printed booklets
which represent a continuation of traditional
Ottoman culture into the modern world – the
'now' of the piece, just as the sword of Mehmet
II and his likenesses are the 'then'. What the
piece does is to ask questions about Turkish
society. How modern is it? How far has it

succeeded in escaping from the Ottoman past? The contemporary idiom is used in a deliberately ironic, self-conscious way.

Inevitably the new way of making art had its effect on American artists as well. In some instances, it is difficult to distinguish their work from what is produced in Europe. Works by Richard Tuttle (Pl. 170) look like wilder versions of the art of Mario Merz, and would seem quite at home in any retrospective of Arte Povera. In others, one is conscious of a kind of logic and structure in American installation work which makes it seem considerably more didactic than European counterparts. *Touch Sanitation* by Mierle Laderman Ukeles (Pl. 172) is a quasi-scientific demonstration, made in the name of art, of the processes which keep a great city healthy and in being. Ukeles has an official position as Artist-in-Residence to the New York City Department of Sanitation. Even Cady Noland's *Deep Social Space* (Pl. 173) is a sociological inventory.

A few environments are more emotional in their impact. Karen Finley's *Memorial Room*, part of a larger installation shown at The Kitchen in New York in January 1992, came about, as she says in her notes for the piece, 'from my need to actualize my grief for victims of AIDS and my dissatisfaction with memorial services, since I feel that traditional religious services are racist, sexist and homophobic.' The room consists of two texts on the walls, a tableau involving four people, and three areas where viewers are invited to perform a task in memory of a deceased loved one. The two texts are 'Lost Hope' and 'In Memory Of'. The tableau consists of four stations – two of these show a sick person with a caring friend at their bedside (Pl. 171); one shows an empty crib; one is a memorial wreath shaped like a heart. There is a large wrought-iron gate – viewers are asked to tie a piece of ribbon on to this in memory of someone who has died of AIDS. There is also a wall of white netting – here viewers are given a red carnation to weave into the net. Finally, there is a Hope Chest: an antique trunk filled with sand where mourners are invited to write the name of someone they loved and lost to AIDS.

Perhaps the most ambitious forms of environmental artwork were those which made use of video. Video has had a chequered history as a medium for fine art, for reasons succinctly

170 Richard Tuttle, *Relative in Our Society*, 1990
Wood, wire mesh, cedar branch, electrical wire, light bulbs, paper and board, 185 × 58 cm (73 × 23 in)

171 Karen Finley, *Memorial Room*, 1992
Installation at The Kitchen, New York, January 1992; detail of the tableau vivant: comforting the suffering

172 Mierle Laderman Ukeles, *Touch Sanitation*, 1984
Detail of *Maintenance City*, multi-media installation at Ronald Feldman Gallery and Marine Transfer Station, 5th St and Hudson River, New York

173 (overleaf) Cady Noland, *Deep Social Space*, 1989
Poles, stanchions, barbecue, chains, horse paraphernalia, red screen, flags, cane, cart, potato chips, napkin, curtain rings, hooks, beercans, miscellaneous metal and plastic, etc., dimensions variable. Seen here as installed in the Massimo de Carlo Gallery, Milan

171

172

174

given by Calvin Tomkins in his 1981 essay 'To Watch or Not to Watch': 'Museum-going is a tiring business, granted, but nothing brings on a nap quicker than a semi-dark room, a sofa, and a little video art.' He added:

> The notion of using video as a purely visual medium seems like a wrong notion to me, for the simple reason that video takes place in time. Visual artists, who are trained to deal with space, often have a very uncertain grasp of time, and of the importance of time-defined arts such as theatre ... Video art asks for the kind of concentration that we are expected to give to painting and sculpture, but it also asks us to give up our time to it. Nothing I have seen to date comes anywhere near to justifying those demands.[4]

As Tomkins notes, the period when video art did seem inevitable was the early 1970s, soon after the appearance of the first portable, relatively inexpensive video cameras. Both sculptors, like Richard Serra, Bruce Nauman and Keith Sonnier, and performance artists, like Joan Jonas, took up the new medium. But many of them soon lost interest and dropped it again. Since then pure video has had a somewhat chequered history. The innovations of such technical pioneers as Ed Emschwiller (1925–90), one of the first to make use of computer-generated imagery, have been absorbed into the commercial mainstream.

What has attracted attention more recently is the use of video as a major component in environmental art. Perhaps the most ambitious works of this type have been produced by Americans such as Bill Viola, Gary Hill, Dara Birnbaum and Judith Barry. Viola describes video as 'a means by which to contemplate reality, and to enter at the same time a world concealed by that reality'.[5] Viola's *To Pray Without Ceasing* (Pl. 174) is a good example of the transcendental strain to be found in his work. *To Pray Without Ceasing* is a continuous projection on a translucent screen mounted in a window. According to Viola, it serves as:

> A contemporary 'book of hours' and image vigil to the infinite day, functioning as an unfolding sequence of prayers for the city. A 12-hour cycle of images plays continuously onto a screen mounted to a window facing the street. The images are projected continuously, 24 hours a day, seven days a week. A voice can be heard quietly reciting a text (excerpts from Walt

Whitman's 'Song of Myself'), audible from
speakers mounted above and on each side of
the window, interior and exterior.

During the day, sunlight washes out the image
and only the voice is present. The video playback
is synchronized to the time of day by computer. All
images are locked to clock time. The 12 sections
or 'prayers' in the work vary in length from 15
minutes to two hours and describe a cycle of
individual and universal life. General sections are:

Light/Fire

Land/Nature

Animals

174 **Bill Viola**, *To Pray without
Ceasing*, 1992
24-hour mixed-media video installation,
as installed at the Donald Young Gallery,
Seattle, dimensions variable according to
location

175 **Gary Hill**, *Suspension of Disbelief
(for Marie)*, 1991–2
4-channel video with 30 12-inch
monitors mounted on an aluminium
beam 1.8 m (7 ft) above the floor, with
computer-controlled switching matrix,
as installed at Le Creux d'Enfer, Thiers

175

Birth

Child

Communities

Travel/Passage

Individual Self

Physical Body

Decay/Disintegration

Dissolution/Submergence

Water/Darkness[6]

Gary Hill's *Suspension of Disbelief (for
Marie)* (Pl. 175) is simpler, but has a similarly
dream-like, contemplative effect. Here a row of
thirty modified video monitors are mounted on

an aluminium beam six feet (1.8 m) above the floor. The images, which represent the fragmented bodies of a man and a woman, flicker sequentially across the screens, meeting, overlapping, then breaking apart in silence. 'Erotic yet elusive, vividly present yet unreachable, this seductive montage of swiftly sequencing images at once conjures up a notion of togetherness and simultaneously withholds it.'[7]

Video installations by women have, interestingly enough, been more sociologically and politically inclined. Dara Birnbaum's work has been described as an attempt to expose the ideological meanings of the mass media and her 1990 piece, *Tiananmen Square: Break in Transmission* was an attempt to look at the role of the news media in the Chinese student uprisings in Peking, using video footage which had not been transmitted to the world in addition to footage that had been seen by millions. In her recent installation *Transmission Tower: Sentinel* (Pl. 176), made for the 1992 Kassel Documenta, however, the actual configuration of the monitors counts for as much as the content of the tapes.

Judith Barry's *Imagination Dead Imagine* (Pl. 177) is a critique of the barrenness of Minimal Art, which refers specifically to Robert Morris's *Four Mirrored Cubes* of 1965. Morris used the mirrors to annul the subject/object relationship between the artwork and the spectator. Barry projects an androgynous head, which looks as if it were contained in a Minimalist cube. This head emits the sound of slow breathing, then is suddenly submerged in liquid which pours over all five visible sides. The spectator reads this liquid as bodily fluid, and the befoulment of the head (recognized as as a substitute for the self) as a violent attack on the supposed 'neutrality' of Minimal Art.

Environmental work of this kind does seem to have had one very important effect on the American art world. It convinced artists, critics and public alike that anything, literally any object, could rank as art, provided that it was presented in a recognizably fine art context. One result was a curious blurring or blending of categories, to an extent unknown in Europe. It is a very short step, for instance, from a real archaeological site, to the exquisitely detailed architectural models of Charles Simonds (Pl. 178), each of which proposes the existence

176 Dara Birnbaum, *Transmission Tower: Sentinel*, 1992
Installation at Documenta IX, Kassel
Variable sections of steel transmission tower, 9-channel colour video with multiple-channel audio (laser disc), with tower obstruction lights. Transmission tower 700 × 67.2 × 67.2 cm (276 × 26½ × 26½ in)

177 Judith Barry, *Imagination Dead Imagine*, 1991
5-screen video projection, 289 × 244 × 244 cm (144 × 99 × 96 in)

177

178 Charles Simonds, *Towers and Wells*, 1982
Clay and wood, 25 × 76 × 76 cm
(10 × 30 × 30 in)

179 Jackie Ferrara, *Taur*, 1982
Pine and poplar, 213 × 183 × 53.3 cm
(84 × 72 × 21 in)
Collection of the Virlaine Foundation,
New Orleans

180 Siah Armajani, *Streets #40*, 1993
Painted steel, copper screen, aluminium
screen, ceramics and brass,
238 × 213 × 244 cm (94 × 84 × 96 in)

178

179

of a purely imaginary civilization. Simonds has been inspired by the miniature models of once-existent buildings which are often to be found in the explanatory displays annexed to archaeological sites. It is the audience's recollection of these which persuades it to enter into the poetic narrative he proposes.

Artists like Siah Armajani and Jackie Ferrara (Pl. 179) offer a slightly surreal paraphrase of architecture, reduced in scale and brought within doors. Their works, however, rather than being relics of civilizations which never in fact existed, are commentaries on the buildings which surround us in reality. Armajani is especially witty in the way in which he elides and conflates functions. In *Streets #40* (Pl. 180), the chief element in a composite piece is a structure which simultaneously evokes a floor, a dining table and a bed. Ferrara evokes the 'anonymous architecture' created by primitive peoples, suggesting obliquely that these represent a life-style superior to our own.

The most interesting result of this collapse of barriers was the erosion of frontiers between fine art and craft. Several things have to be said here. First, the division is essentially Western, a product of the Renaissance. It scarcely existed during the Middle Ages (in the early Middle Ages probably not at all), and it has never been acknowledged in other cultures, for example in that of Japan, where activities such as making swords or creating ceramics for the tea-ceremony have equal rank with painting. Second, the craft tradition has always been particularly strong in the United States – not surprisingly, since the American nation was the creation of immigrants, and the earlier generations of these depended heavily on craft skills for simple survival. Third, one of the most important claims made by the late Modern artist (as is amply demonstrated by the illustrations in this chapter) is the right to use any material in any fashion that he or she chooses.

The symbiosis between contemporary art and contemporary craft will be considered again in Chapter 12 (pp. 333, 338, 353), which deals with the regionalization of American art. For the moment it is interesting to look simply at one aspect: the overlap between avant-garde art and what is usually categorized as furniture. Certain aspects of the furniture-maker's craft had already been absorbed into standard

181 **Wendell Castle**, *Stand-in*, 1993
Mahogany, maple veneer, sycamore
veneer and white oak, 205 × 140 × 61 cm
(81 × 55 × 24 in)

182 **Scott Burton**, *Right Angle Chair*,
1983
Granite, 96.5 × 50.7 × 68.5 cm
(38 × 20 × 27 in)
Collection of the Virlaine Foundation,
New Orleans

183 **Lucas Samaras**, *Box # 122*, 1988
Mixed media, 38.7 × 35.5 × 30.6 cm
(15¼ × 14 × 12 in) (opened);
20.3 × 35.5 × 25.4 cm
(8 × 14 × 10 in) (closed)

181

182

avant-garde practice. This applied especially to the making of boxes. One of the most typically American of all the artists of the first half of the Modernist epoch was Joseph Cornell, whose exquisitely contrived boxes tell the story of his obsessions. In more recent times, this tradition has been continued by Lucas Samaras (Pl. 183), whose magical boxes serve as containers for complete artistic universes. Newer is the tendency for sculpture to become furniture and furniture to become sculpture. An example of the first of these tendencies was the late Scott Burton, whose massive stone seats and chairs (Pl. 182) were more permanent versions of props he had used as a performance artist. Burton's range, however, extended beyond these stone pieces to more practicable forms of seating, which would have looked perfectly at home in an up-market design emporium – more so, indeed, than they did in an art gallery.

The second tendency is summed up in the development of Wendell Castle, probably the best-known furniture craftsman in America. Castle's career has moved through a number of phases. He has made free-form laminated furniture, semi-*trompe l'oeil* pieces (an umbrella stand, for instance, which already contains a carved wooden umbrella), and sophisticated homages to French Art Deco, very much in the manner of Ruhlmann. His recent work, however, has been largely furniture-as-sculpture. *Stand-in* (Pl. 181) is aptly named – is this primarily a piece which can be used (a cupboard for storing objects), or is it primarily an object in its own right? In either role, it is a kind of substitute for what the spectator expects. Castle would increasingly prefer to be judged first as a sculptor, but in this role he has to struggle against his own technical perfectionism. More and more since the advent of Arte Povera, the well-made work finds itself accused of insincerity. This is a problem with which painters and sculptors working in traditional formats have also had to struggle.

Neo-Expressionism

184 Karel Appel, *Lying Nude*, 1966
Oil on canvas, 190 × 230 cm
(74¾ × 90½ in)

185 Francis Bacon, *Study for a
Portrait of John Edwards*, 1989
Oil on canvas, 198 × 147.5 cm
(78 × 58 in)

184

The chief tendency opposed to the rise of Minimal and Conceptual Art, and their affiliate Arte Povera, was usually described as Neo-Expressionism. In fact, the supposedly tidy opposition between the two ways of making art was much less straightforward, and therefore also less tidy, than it seemed. There had always been an Expressionist current within Modernism. Sometimes this gathered sufficient strength to be thought of as a fully-fledged art movement (as was the case with the German Expressionist Movement which flourished immediately before and during World War I). Sometimes it was simply a signal of opposition to the prevailing ethos. In the broad sense, Expressionism was a way of making art which was opposed to all theories, because it placed the primary stress not on system or theory, but on the spontaneous expression of feeling. When, for example, so-called Abstract Expressionists like de Kooning and Pollock made figurative paintings, as they sometimes did, then they were members of a long tradition which descended from pre-Modernist artists like Van Gogh and Munch.

There has always been a tendency to regard Expressionism as a northern rather than a southern phenomenon. In Europe, Germany, the Low Countries and Scandinavia have been more apt to produce artists who could be labelled Expressionist than France and Italy. Those Expressionists who flourished as part of the École de Paris between the wars, chief among them Chaim Soutine, were not French by birth. The idea that this approach to the making of art was something to do with inherited culture and geography was reinforced after World War II, when the chief figurative and Expressionist tendency in Europe was that represented by the artists of the COBRA group, which took its name from the three cities – COpenhagen, BRussels and Amsterdam. Their activity was seen as a retort to the continuing primacy of Paris. Few people were aware, at that point, how soon the predominance of Paris was to be overthrown.

One of the most active members of COBRA was the Dutch painter Karel Appel. His activity as an artist, which continued unabated in the 1960s, 1970s and 1980s, demonstrates the close connection between COBRA and the classic German Expressionism of the years before World War I. *Lying Nude* (Pl. 184),

185

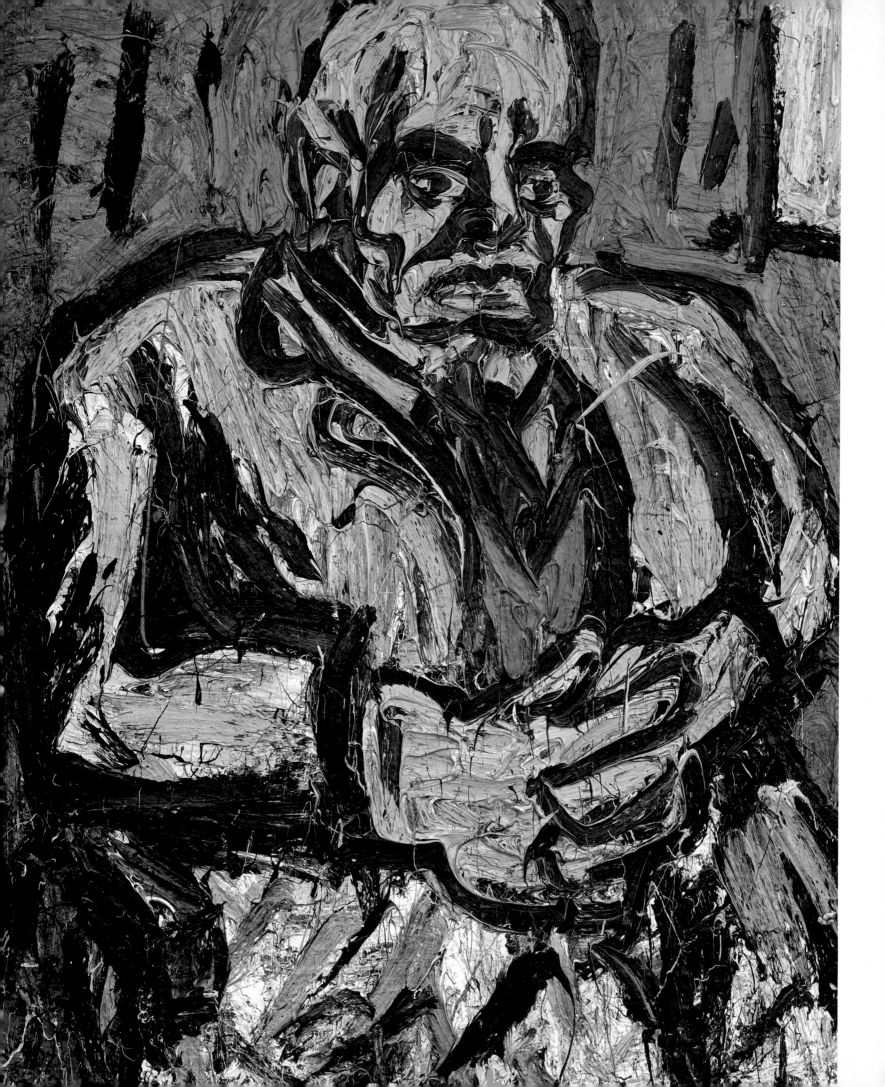

shown here, is strongly reminiscent of the work of Emil Nolde.

Expressionism was also a force in Britain, where artists often remained somewhat detached from the main Modernist currents. The extraordinary distortions found in the work of Francis Bacon, one of the major artistic figures in Britain during the second half of the twentieth century, are not purely Expressionist (Pl. 185), though the adjective was often loosely applied to him. Bacon owed something to Picasso (for example, in his combination of different viewpoints), something to Surrealism, and a good deal to what he learned from photography. The extraordinary air of tension, sometimes hysteria, in his work can, however, be traced back to artists like Munch and Van Gogh. Bacon painted a number of tributes to Van Gogh in the late 1950s, and there is also a self-evident connection between Munch's *The Scream* and Bacon's images of screaming popes from the late 1940s.

A wholly different Expressionist current in British painting manifests itself in the work of Frank Auerbach and Leon Kossoff (Pl. 186). Both artists were pupils of David Bomberg, who began his career as part of the short-lived Vorticist group which flourished in Britain just before and during World War I, as an offshoot of Italian Futurism. Later, in the interwar years, Bomberg moved to a very different and highly personal style in which the image emerges from thickly impastoed paint. This style has been described as 'slow Expressionism', because of the expressive distortions it seems to allow. Yet its roots are not in any continental art movement but in a well-established, purely British tradition. If one looks at recent urban landscapes by Auerbach (Pl. 187), for example, it is immediately apparent that he is the heir not only of Bomberg, but also of Sickert. Sickert is usually seen as someone who learned from Whistler, and most of all from Degas – and therefore as an artist completely removed from the main Expressionist line of descent. Yet what Auerbach finds in him is undoubtedly something which students of Nolde, and even of Chaim Soutine, would find familiar.

Another important British painter whose work now seems to have an Expressionist element is Howard Hodgkin. Hodgkin's simplified, resonantly colourful *Venice Sunset* (Pl. 188) may, simply because of its subject-

186 Leon Kossoff, *Portrait of Father, No. 3*, 1972
Oil on canvas, 152.4 × 121.9 cm
(60 × 48 in)

187 Frank Auerbach, *Mornington Crescent*, 1987–8
Oil on canvas, 114.3 × 139.7 cm
(45 × 55 in)

187

matter, conjure up the late work of J.M.W. Turner. Yet it, too, once one has thought of the comparison, has an undoubted kinship to Nolde, and especially to what Nolde called his 'unpainted pictures' – the small watercolours which he produced clandestinely during the years when his work was banned by the Nazis.

There is a striking contrast between British work of this sort, which arose spontaneously, without a programme, and effectively in opposition to the idea that artists should belong to groups or movements, and the Neo-Expressionism, sometimes called Refigured Painting, which manifested itself in West Germany in the 1960s, and which has been a major force in German art for the past quarter of a century.

Neo-Expressionism was the product of a complex social, cultural and indeed purely national situation. Because the Nazis had persecuted Modernist art, this enjoyed a special prestige in Germany in the years following World War II. On the other hand, the persecution had been so thorough that the whole Modernist tradition had to be rebuilt. In West Germany – the Federal Republic – this at first took the form of a eclectic imitation of current Modernist styles imported from America, and also from elsewhere in Western Europe. In East Germany – the German Democratic Republic – the situation was somewhat different. Because the GDR was a Communist state, within the Soviet bloc, the tendency there was to look for an approved 'socialist' style of art. However, this art did not conform completely to the norms of Soviet Socialist Realism because the rulers of East Germany respected what they saw as their own tradition – the culture of the Weimar Republic which the Nazis had overthrown. The result was that the art they encouraged, in the 1940s and 1950s, contained nostalgic Expressionist elements.

An important figure, linking the art of the DDR to that of the Federal Republic, was Georg Baselitz, born Georg Kern in 1938. Baselitz's native town, whose name he later assumed in shortened form, was Deutschbaselitz, on the East German side of the frontier. He began his studies as an artist at the Hochschule für Bildende und Angewandte Kunst in East Berlin. From this he was expelled for 'social and political immaturity'. He then moved to the

corresponding institution, the Hochschule für Bildende Künste, in West Berlin. It was at this point that he encountered the work of Jackson Pollock, Philip Guston and other American painters, which was first shown in Berlin in the late 1950s. Nevertheless, Baselitz felt he could not shake off the burden of the German past. In 1961, in conjunction with his friend and fellow student Eugen Schönbeck, he issued a manifesto entitled 'Pandemonium I'. In this he wrote:

> I am warped, bloated and sodden with memories. The destinies that make no one look up, I have them all on record ... The influence of stars is undeniable, the purity of the night sky is awesome, only the source is poisoned. The many killings which I daily experience in my own person, and the disgrace of having to defend my excessive births, lead to a malady of age and experience.[1]

The imagery is somewhat obscure, the general tone is rather like that found in the writings of the young Oskar Kokoschka – for example in the play *Mörder, Hoffnung der Frauen* (Murderer, Hope of Women), which marked the beginning of Expressionist theatre in Germany. The general thrust, however is unmistakable: art must take up the burden of the German past.

In West Berlin, Baselitz continued to be a stormy petrel. In 1963, two of his paintings were confiscated, on grounds of obscenity, from an exhibition at a commercial gallery, and only returned after two years of litigation. His reputation also continued to grow. In 1965 he won the prestigious Villa Romana Prize, which provided a year's residence in Florence. The final and decisive step in Baselitz's artistic development was a curious one: in 1969 he began to turn all his images upside-down – painting them thus, rather than painting them the correct way up and inverting the canvas afterwards (Pl. 189). Various explanations have been offered for this practice. Baselitz himself has said: 'The reality is the picture; it is most certainly not in the picture.' The simplest assumption is that the artist now both wants to retain his link with historical Expressionism (through both choice of imagery and actual facture), and at the same time wants to stress a certain degree of separation from the past. Other members of the German Neo-Expressionist grouping have been less self-

188 Howard Hodgkin, *Venice Sunset,* 1989
Oil on wood, 26 × 30 cm (10¼ × 11¾ in)

189 Georg Baselitz, *Adieu, 17.III.82,* 1982
Oil on canvas, 250 × 300 cm (98½ × 118 in)

189

190 Jörg Immendorff, *C.D. ... Eigenlob stinkt nicht*, 1983
Oil on canvas, 150 × 200 cm (59 × 78¼ in)

191 Karl Horst Hödicke, *Ausverkauf*, 1964
Acrylic on canvas, 150 × 97 cm (59 × 38¼ in)

conscious, more willing to initiate direct confrontations with specifically German subject-matter. Nevertheless, Baselitz and Joseph Beuys between them opened the door for the creation of a new German national school. This was an important event in itself, but doubly important because the whole idea of nationality – the expression of national characteristics through art – seemed to run

190

counter to established ideas about the nature of Modernism.

Many of the artists who became involved in the Neo-Expressionist tendency in German art were considerably less reticent in their allusions to German current affairs. One of the most specific was Jörg Immendorff, whose *Café Deutschland* series (Pl. 190) laments the division between the two halves of Germany

191

Neo-Expressionism

192 Karl Horst Hödicke, *Untitled*, 1985
Oil on canvas, 260 × 190 cm
(117½ × 75 in)

193 Wolfgang Petrick, *Zu Preußische Pietà: Der Ritt*, 1987
Charcoal, pastel, pigment, photocopy, collage and gouache on paper, 130 × 100 cm (51¼ × 39½ in)

193

194 Rainer Fetting, *Mabutu Tanz*,
1983
Oil on canvas, 282 × 213.4 cm
(111 × 84 in)

196 Per Kirkeby, *Vaderne*, 1990
Oil on canvas, 200 × 300 cm (78¾ × 118 in)
Musée National d'Art Moderne, Paris

195 Markus Lüpertz, *5 Bilder über das
mykenische Lächeln*, 1985
Oil on canvas, 270 × 400 cm
(106¼ × 157½ in)

and satirizes West German materialism and complacency.

Others, however, preferred a more generalized, also a more nostalgic approach. Karl Horst Hödicke makes only a general comment on the consumer society in *Ausverkauf* (Sell-out), a painting from the 1960s showing a broken shop window full of women's undergarments (Pl. 191). The painting is, nevertheless, interesting because it shows the permeability of Modernist art styles: it demonstrates that interchange was possible between nascent Neo-Expressionism on the one hand and Pop Art on the other. A painting made some twenty years later by the same artist (Pl. 192) shows a more specifically Expressionist style, but the message is no more complex: this manic figure on a rocking-horse, leaping (against all probability) through a flaming hoop seems intended to spell out the idea that war and conquest are a Bad Thing.

There are more subtleties, but also heavy layers of historical reference, in Wolfgang Petrick's *Zu Preußische Pietà: Der Ritt* (Pl. 193). The figure in a gas mask, and the child in a spiked helmet, both recall the work of George Grosz.

One aspect of the original so-called First Expressionism which appealed strongly to a new generation of German artists was the emphasis on the primitive, and on ancient myth and ritual. Rainer Fetting's *Mabutu Tanz* (Pl. 194) is strongly reminiscent of the paintings made by Nolde in 1913–14, as a result of his participation in a German Colonial Office expedition to New Guinea. A similar atmosphere pervades Markus Lüpertz's *5 Bilder über das mykenische Lächeln* (Pl. 195), with its row of archaic figures wearing slightly sinister smiles. The image is a reminder that there has always been a kinship between the Expressionist impulse and the bloodier myths of Ancient Greece. These figures might well be an idea for a new production of the Strauss-Hofmannsthal opera *Electra*, one of the summits of Expressionism in music. *Vaderne* (Pl. 196), by the Danish artist Per Kirkeby, who is closely linked to the German Neo-Expressionists, reverts to an idea we have already seen used by Elaine de Kooning (Pl. 48) – that of making a paraphrase of Palaeolithic art. Kirkeby was influenced both by Joseph Beuys, who was already an influence in

194

195

196

197

Neo-Expressionism

197 **Martin Disler**, *Untitled*, 1989–91
Oil on canvas, 194.5 × 196 cm
(76¾ × 77¼ in)

198 **Bernd Koberling**, *Kormorane III*,
1982
Oil on jute, 115 × 140 cm (45¼ × 55¼ in)

Denmark in the early 1960s, and by Asger Jorn, who was one of the leading members of the COBRA group.

There are many Neo-Expressionist paintings, however, where the burden of specific literary and historical meaning is much less apparent. Sometimes, as in the untitled painting by Martin Disler reproduced here (Pl. 197), the artist seems concerned to convey a non-specific atmosphere of terror and violence. The result is, in an odd way, traditional, since there is a strong echo of some of the Biblical scenes with which Michelangelo adorned the Sistine ceiling. Here the specific reference enters by the back door, perhaps against the artist's will, rather than through his conscious volition. Other paintings still, such as Bernd Koberling's *Kormorane III* (Pl. 198), are emblematic images borrowed from the natural world.

Just as the original Expressionist movement started to tail off into something altogether less feverish and high-pitched, so too there was a lessening of emotional pressure in the German art of the 1980s. Dieter Hacker's *Der Lech* (Pl. 199), for example, contains little which is recognizably Expressionist. Despite its relatively bold handling and strong colour, the actual forms are undistorted and the handling of the nude male figure could, without stretching the adjective too far, be described as 'classical'. There is an even stronger classical echo in Peter Chevalier's *Il Mattino* (Pl. 200), where the gigantic horse's head is borrowed from a Greek or Roman original (perhaps one of the horses of St Mark's in Venice) and where the circular shield leaning against a tree trunk is also a borrowing from antiquity. The probable source here is the work which Giorgio de Chirico was producing in the 1920s, and the painting has some of that nostalgia for the idealized South, 'the land where the lemon trees bloom', which one finds in German artists of the Neoclassical epoch, such as J.F.A. Tischbein (1750–1812) and his nephew J.H. W. Tischbein (1751–1829).

The weakening of the Expressionist impulse in the German art of the 1980s foreshadowed political and economic events which were to undermine its popularity. The great political event was the reunification of Germany thanks to the collapse of the German Democratic Republic. The subject of much Neo-

198

199 Dieter Hacker, *Der Lech*, 1986
Oil on canvas, 160 × 230 cm
(63 × 90½ in)

200 Peter Chevalier, *Il Mattino*, 1987
Oil on canvas, 160 × 200 cm
(63 × 78¾ in)

201 Enzo Cucchi, *Trasporto di Roma*
su un Capello d'Oro, 1991
Oil with steel collage on canvas,
292 × 501 cm (115 × 197½ in)

202 Sandro Chia, *Pisellino*, 1981
Oil on canvas, 198 × 284.5 cm
(78 × 112 in)

199

Neo-Expressionism

Expressionist art had been the political division of the country and the reflections to which this gave rise. The impulse towards a renewal of Expressionism in any case came at least partly from the East. There was something more: the reunification of Germany coincided with what was perhaps the worst economic depression the German state had experienced since World War II. While German Neo-Expressionist art was extremely successful internationally during the 1980s (a success triggered in part by the survey exhibition *A New Spirit in Painting* held at the Royal Academy of Arts in London from January to March 1981), its prosperity also depended on the existence of an eager market of private collectors at home, and these were hard hit by the financial downturn. It has been a recurrent pattern during the period since 1960 that art in more conventional formats, particularly painting, has flourished during periods of prosperity, when private patronage has been dominant; while environmental, site-specific and Conceptual art has been favoured when the responsibility for supporting avant-garde art and artists has reverted to the curatorial community in museums, and to publicly funded arts organizations.

The Neo-Expressionist impetus also manifested itself in Italy, with the work of the 'three C's' – Sandro Chia, Enzo Cucchi and Francesco Clemente. Here, however, it was mixed with other impulses. Of the three artists just named, the most genuinely Expressionist is Cucchi (Pl. 201), with his use of broadly brushed over-scale forms. The immensely prolific Chia (Pl. 202) has often seemed less like an Expressionist, concerned with personal *angst*, than a high-spirited parodist, a brilliantly superficial maker of decorative images. Francesco Clemente is different again, and seems to me the one of these perhaps over-publicized artists who is most worth serious consideration. Clemente spends part of the year in Madras, where he has set up a studio, and much of his work is concerned with ideas derived from Indian philosophy and religion. The schematized heads in *Contemplation* (Pl. 203) are derived from Tantric originals. Works by Clemente of this type can seem rather lacking in visual energy, because too dependent on their original source material. Other paintings, such as *The Magi* (Pl. 204), are more eclectic in their use of cultural source

200

201

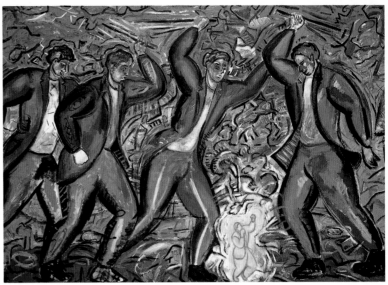

202

203 Francesco Clemente,
Contemplation, 1990
Gouache on paper on canvas,
243 × 248 cm (95¾ × 97¾ in)

204 Francesco Clemente, *The Magi,*
1981
Fresco, 200 × 300 cm (78¾ × 118 in)

205 Bruno Ceccobelli, *Prova in Due
Fuochi*, 1989
Mixed media on wood, 153.7 × 133.3 cm
(60½ × 52½ in)

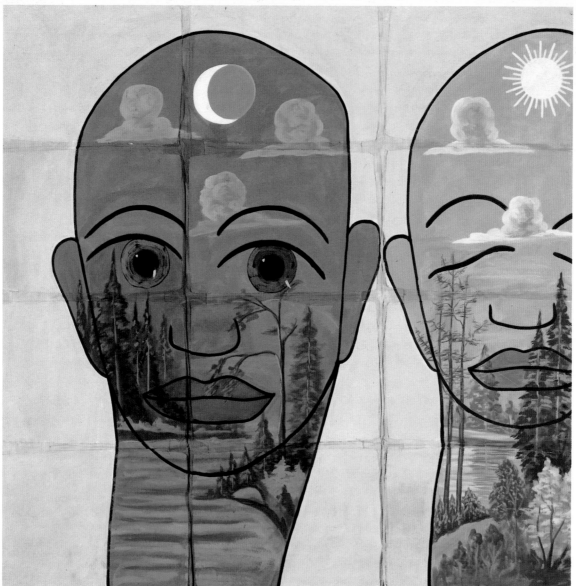

203

204

Neo-Expressionism

Neo-Expressionism

material, and correspondingly more vigorous in effect. Nevertheless, Clemente is an artist who raises the issue of 'primitivism' in acute form. He claims the right, as European artists have done since Gauguin's visits to the South Seas, to take over and recycle exotic images.

Another, less celebrated, Italian artist who borrows in this way, often with more success than Clemente, is Bruno Ceccobelli. His *Prova in Due Fuochi* (Pl. 205) seems to owe something to the Buddhist frescoes found by Sir Aurel Stein along the Central Asian silk route (if this is the case it demonstrates the enormous influence exercised on contemporary culture by illustrated books), but the source is more completely absorbed than it is in Clemente's *Contemplation*. The halo which adorns the central figure is something which Christian and Buddhist iconography have in common, and this helps to assimilate the image to some kind of Western norm. Once again, however, as with Clemente's work, one is struck by the element of nostalgia – the appeal to traditional systems of belief to which the artist himself does not subscribe.

Of all the Italian artists who have been described as Expressionists, the most powerful is Mimmo Paladino (Pl. 206). Paladino's images also seem to make an appeal to the past; the source, here, seems to be Romanesque fresco painting, more specifically the rather crude Romanesque of southern Italy, which is where Paladino comes from: he was born near Benevento. These historical reminiscences are less calculated than Clemente's references to exotic cultures, since Paladino regards his work as being essentially the product of a psychic explosion, which carries what he feels directly to the canvas. This is the classic Expressionist approach to image-making, and it is interesting that the result nevertheless carries with it such a strong cultural echo.

Paladino is one of a number of Neo-Expressionist artists regarded primarily as painters who have made sculptures as well as paintings (Pl. 207), and Baselitz is another. In this they have followed in the steps of the first generation of Expressionists, who often worked in three dimensions as well as in two. Sculptors committed to Expressionism have been much rarer, and have tended to work in relative isolation. Perhaps the largest concentration of figurative sculptors whose work has an accent

207

208 Elisabeth Frink, *Judas*, 1963
Bronze, height 190 cm (75 in)

209 Michael Sandle, *The Drummer*,
1985
Bronze, height 269 cm (106 in)
Collection of the Virlaine Foundation,
New Orleans

208

of this kind are to be found in England – a fact which has passed unrecognized because of the attention directed towards other kinds of British sculptural enterprise – first the work of Caro (Pls. 78, 306) and his followers, then that of Long and Goldsworthy (Pls. 124, 126), and finally that of artists such as Tony Cragg and Richard Deacon (Pls. 307, 314, 315).

Since her recent death (1993), it has become apparent that the key figure in this Expressionist development was Elisabeth Frink. Frink did not suffer from lack of recognition as such. Indeed, one reason why critics tended to ignore her more recent work was that she was regarded as an establishment figure who had failed to move with the times. She herself connected her work to Rodin, who had influenced her greatly as a student, and also to Giacometti. She always insisted that her sculpture was not to be seen in terms of formal relationships, but that each piece was a vehicle for a particular emotion or cluster of emotions. The work she frequently cited in this connection was her *Judas* (Pl. 208) of 1963. What she had to say about it was this:

> Getting to a piece like that is a gradual process, and the idea starts way back. You see something, you like a face or a figure, and you really want to nail it, you want to give it some source in your own mind. For example, with *Judas* I wanted to do this massive figure, and I wanted a figure which was fending off some kind of attack. And the more the idea developed, the more it became for me a figure of betrayal – it was very strange. Ideas often come in a very cockeyed fashion. Judas is quite a strong figure, but he also has a weakness about him. With his arm out, he's making a gesture of invitation, yet fending you off at the same time. Also, he's blinded.[2]

Her account seems to me an excellent description of the processes whereby what is loosely called Expressionist art comes into existence.

Other British figurative sculptors whose work seems to have an affinity with this way of thinking are Michael Sandle, Glynn Williams and Nicola Hicks. Sandle, who was one of the few British sculptors to keep the banner for figurative work flying during the 1970s, has recently worked mostly in Germany, and sculptures like the massive *The Drummer* (Pl. 209) of 1985 seem to sum up the aggressive spirit one associates with

German Expressionism of the first period. Yet, surprisingly, there has been little if any sculpture like this made recently by German artists – Baselitz's woodcarvings, with their deliberately rudimentary forms and brutally rough surfaces, are very different in character, and one has to go as far back as an artist like Barlach to find a really convincing parallel. Yet it does seem unlikely that Sandle's talent would have developed in the way it did had he not found such a warm welcome in Germany.

Glynn Williams and Nicola Hicks have made their careers at home. Williams spent a long period as an abstract sculptor, heavily under the influence of classic modern works like

210

211

Constantin Brancusi's *Endless Column*. His return to figuration in 1981 made him a violently controversial figure in the British art world. Whereas Frink was a modeller, who first worked in plaster then cast her work in bronze, Williams is a carver. Typical of the work he made in the early 1980s is *Hunter: from the African* (Pl. 211). This, though based on a Nigerian bronze seen in the British Museum, is very much the product of virtuoso stone-carving technique. The critic Peter Fuller, an enthusiastic supporter of Williams's work, commented that 'the way in which the stone is cut open to allow the light to play on it and through it, bringing it to life, is reminiscent of

nothing so much as Gothic vaulting.'³ This is an attractive metaphor, but there is another comparison which is more specific – to the early work of Jacob Epstein.

A younger sculptor for whom Elisabeth Frink had great regard, and whose work she often praised, was Nicola Hicks, and it is certainly possible to discern a direct link between Frink's *Judas* and a recent ambitious group by Hicks with a political theme – *Sorry, Sorry Sarajevo* (Pl. 210), carried out in Hicks's usual medium of plaster and straw. Once again the emphasis is on using sculpture as a means of conveying emotion. Indeed, on this occasion there is a specific, indignant political message.

Odd man out amongst this fairly substantial group of British sculptors has been Barry Flanagan (b. 1941). Flanagan began his career in the mid-1960s as a maker of Minimalist soft sculpture and environmental pieces, and later switched to creating figurative bronzes. These bronzes – a favourite theme is the hare – seemed designed to satirize the solemnity of figurative sculptures made in traditional materials. *Large Mirror Nijinski* (Pl. 212) shows a pair of 'March hares' dancing (as hares are traditionally supposed to dance during the mating season), in poses which derive from Baron de Meyer's photographs of the great Russian dancer performing in *L'Après-midi d'un faune*. The deliberately rudimentary modelling makes it clear that Flanagan's intentions are ironic. The traditional appearance of Flanagan's sculptures is deceptive: they belong in the tradition of Dada.

If Britain, Italy and Germany have been the chief locations for a revival of Expressionist art, there have been artists elsewhere whose work shows traces of the forceful subjectivity one associates with this approach to the visual arts. Two impressive instances are the Norwegian Odd Nerdrum and the Frenchman Jean Rustin, though both are essentially completely isolated and independent of any movement or grouping. Nerdrum's bleak paintings are unusual in the contemporary context in more than one way. First, because of their apparent imitation of Old Master technique, with a penchant for Rembrandtesque chiaroscuro; second, because of their strong narrative element. The forms are powerfully modelled but also meticulously painted, with little in the way of Expressionist spontaneity of brushwork. *The Water Protectors*

213 Odd Nerdrum, *The Water
Protectors*, 1985
Oil on canvas, 153 × 183 cm (60¼ × 72 in)

214 Jean Rustin, *Two Women with an
Electric Light Bulb*, 1983
Acrylic on canvas, 130 × 160 cm
(51¼ × 63 in)

213

(Pl. 213) is a painting in a standard early Baroque format invented by Caravaggio, with a group of three figures, seen slightly less than three-quarter length, and pushed close to the picture-plane. Their rough clothing makes them seem timeless – the only things which locate them in the present (or perhaps even in the near future) are the guns two of them are carrying. The implied narrative is perhaps rather like that of the 'Mad Max' films starring Mel Gibson: a glimpse of a future where civilization has completely broken down. What makes me associate Nerdrum with Expressionism in the loosest sense of the term is the climate of feeling his paintings evoke – introverted, tragic, but always threatening to erupt into some form of passionate outburst.

There is more emotional stability but also deep tragic feeling in the work of Rustin (Pl. 214). This French painter, now in his mid-sixties, has had an extraordinary course of development. He was a successful abstract painter until the late 1960s, but, following a career retrospective held at the Musée d'Art Moderne de la Ville de Paris in 1971, he suddenly changed direction and began to make figurative paintings. These paintings now typically represent male and female nudes, often elderly, always completely unidealized. They stare down the viewer, and sometimes go still further, masturbating, pissing, making obscene gestures. The world they inhabit is one of grey corridors and empty or near-empty rooms like prison cells. Rustin says that he attempts to avoid narrative (in this respect, he and Nerdrum are unalike). Despite this, various narrative meanings have been read into his work by commentators: his figures have been seen as mental patients or concentration camp victims. Their real meaning is less specific – they are emblems of a universe without faith or hope. Their redeeming aspect is that they are marvellously painted. Though his range of colour, like his range of subject-matter, is much less varied, Rustin handles paint itself with the mastery of Manet: he is an artist in a tradition which includes not only Manet himself, but Goya, Hals and Velázquez.

It is interesting to compare what he does with the work of younger French artists such as Gérard Garouste, in which the Old Master references are much more self-conscious and specific. In his *Sainte Thérèse d'Avila* (Pl. 215),

214

215

216

Garouste is interested in the externals of a certain kind of Baroque painting; Rustin, without historical trappings, penetrates to its spirit, and demonstrates that the tradition of painterly expressiveness is deeply rooted in European art and does not belong solely to the Modernist current which we choose to label Expressionist.

There have also been similarly isolated artists, whose work has an Expressionist tinge, in the United States. The one who is perhaps most closely related to the whole European tradition of figurative Expressionism is Robert Beauchamp, whose work has never quite received its due in the American art world. *Red Sky* (Pl. 217) is a typically phantasmagoric composition, produced at the end of the 1960s, just as Pop was beginning to cede place to Minimal and Conceptual Art.

Two artists with more substantial reputations who have experimented with versions of Expressionist figuration are Philip Guston and Leon Golub. Guston rose to prominence as an Abstract Expressionist, and it was only in the last phase of his career – he died in 1980 – that he reverted to making figurative images (Pl. 216). These images draw upon sources in American popular culture. The crude, bold drawing style which Guston adopted – the antithesis of the rather sweet and romantic figure paintings he had made when he was young – owes something to the caricatures which appeared in the 'underground' magazines of the 1960s and 1970s. There is a kinship, for example, to the drawings of Robert Crumb. In her book about her father, *Night Studio*, Guston's daughter, Musa Mayer, quotes some notes the artist scribbled at the time of his change of style:

> American Abstract art is a lie, a sham, a cover-up for a poverty of spirit. A mask to mask the fear of revealing oneself. A lie to cover up how bad one can be. Unwilling to show this badness, this rawness ... It is an escape from the true feelings we have, from the 'raw', primitive feelings about the world – and us in it. In America.[4]

Effectively what Guston did was to assimilate elements from American popular culture to the Expressionist ethos: instead of Warhol's cool impersonality, there was a commitment to rawness, to psychic risk, to a sense of personal exposure.

Guston and Leon Golub are not to my

217

Neo-Expressionism

218 **Luis Cruz Azaceta**, *Homo-Fly*, 1984
Acrylic on canvas,
167 × 152 cm (66 × 60 in)

219 **Leon Golub**, *Interrogation III*, 1981
Acrylic on linen,
304 × 421 cm (120 × 166 in)

knowledge frequently paired together. Golub was born in Chicago and trained at the Art Institute there. His early influences included Picasso's *Guernica*, which he first saw as a very young man when it was exhibited in Chicago two years after its completion, and the work of the leading Mexican muralist Orozco. Despite this, his early paintings were politically non-specific – Expressionist reworkings of themes borrowed from Graeco-Roman art, such as the *Gigantomachies* painted in the 1960s. The works which really established Golub's reputation date from somewhat later – first images inspired by the war in Vietnam, then others inspired by civil war, revolution and repression in places like Angola, El Salvador and Chile (Pl. 219). Golub's paintings from this period are more generally classified as 'Realist' rather than Expressionist, and his admirer the American critic Donald Kuspit has made strenuous efforts to distinguish this form of Realism from what he describes as the 'dead-end formalist Realism' of artists such as Philip Pearlstein.[5] Nevertheless the emphasis on torture and other forms of violence seems to spring from fascination as well as horror; it expresses something within the artist as well as something which exists in objective reality. The forms Golub uses change in response to this internal pressure in a way that is familiar from other kinds of Expressionist art.

Because of the emphasis contemporary art in general puts on the artist's subjectivity, much figurative art world-wide is tinged with a characteristic which one is tempted to describe as in some way or other Expressionist. The violent colours and broad handling of the Cuban émigré Luis Cruz Azaceta (Pl. 218) give a special accent to his quasi-surrealist imagery. This is not the alienated world of a Salvador Dali or an Yves Tanguy, but a sarcastic cartoon: the kinship with the kind of handling and the style of drawing to be found in late paintings by Guston is evident. One feels that Azaceta, like Guston, is looking for a kind of rawness of handling which will express his own sense of anguish. Effectively, in an art world which sees itself as hostile to stylistic trickery of any sort, Expressionist handling – the way of using paint once associated solely with the German Expressionists of the early modern period – has become an accepted form of *lingua franca*.

219

Realism in America

220 Malcolm Morley, *US Marine at Valley Forge*, 1968
Oil on canvas, 150 × 125 cm
(59 × 49¼ in)

221 Chuck Close, *Leslie*, 1973
Watercolour on paper,
184 × 144.6 cm (72½ × 57 in)
Pillsburg Family Collection, Fort Worth, Texas

In the late 1960s and early 1970s there was a briefly fashionable movement, chiefly confined to the United States, which went by the name of Super Realism or Photo Realism. It is probable that few late Modernist art styles have been so thoroughly misunderstood. As its name indicates, it was the realist element which drew the attention of critics and commentators, and in particular the artists' dependence on photography. It was this, combined with their use of popular, accessible imagery, that made them seem like the obvious heirs of the Pop artists. Yet it is also clear that many Super Realist artists owed at least as much to the Conceptualist approach which became dominant at about the same epoch as they did to anything learned from Pop.

A good example of this alliance is the early work of Malcolm Morley, a British-born artist who has made his career and reputation in America. Painted in 1968, Morley's *US Marine at Valley Forge* (Pl. 220) is a typical 'patriotic' image, derived from a photograph found on a postcard or reproduced in a brochure. It differs from Pop Art chiefly in the conscious refinement of its technique. The artist has been at pains to reproduce the effect of good-quality colour printing, rather than doing as Roy Lichtenstein did and reproducing the effect of colour printing of the coarsest possible kind. There is also a more fundamental difference of approach. Morley made paintings of this type in a spirit of total detachment from the images and their possible significance. The colour reproduction, chosen almost at random, was squared up, then reproduced on canvas using a matching grid. The artist allowed himself to see only the area he happened to be working on at a particular moment. The interest of the exercise was to discover how exact a reproduction of the chosen original he could produce in these circumstances.

Morley did not continue with this line of exploration, but afterwards became a kind of Neo-Expressionist. Today the best-known and most respected member of the Conceptualist wing of Super Realism is Chuck Close. Now that the movement has lost nearly all of its critical and intellectual support, it is Close's work which theorists have endeavoured to save from the wreck. Close is celebrated for gigantically enlarged images of heads, based

220

222 Ralph Goings, *Golden Dodge*, 1971
Oil on canvas, 152 × 183 cm (60 × 72 in)

223 Charles Bell, *Lucky Lady*, 1990
Oil on canvas, 127 × 228 cm (50 × 90 in)

on snapshot photographs (Pl. 221). He has described how he began this series of portraits in 1968, after a long search for relevant subject-matter. The first painting he produced was a self-portrait in black and white. The technical aberrations of the original photograph – the fact that some areas were out of focus, for example – became 'another kind of information to deal with, something to paint'.[1] When Close decided to move from black-and-white into colour, his method of colour rendering was closely linked to established colour-printing processes, layering one colour over another so as to obtain the desired result. The impersonality of Close's method has often been remarked upon: 'His art is undeniably one of figuration, but it is figuration of the most artificial kind. For all their specificity, Close's portraits are also abstract images and the formal basis underlying their realistic façades is always apparent.'[2] In later paintings, drawings and prints he has been at pains to stress the primacy of method over subject-matter. Images have been built up using visible grid systems which strip his methodology bare.

Other Super Realist painters, like Ralph Goings, have been content to preserve the smooth surfaces which originally won them popularity. Their work differs from that of Close and the early Malcolm Morley in other important respects as well. For example, it pays a great deal more attention to the cultural and social implications of the chosen subject-matter. Ralph Goings, for example, originally became known for a series of paintings featuring pick-up trucks (Pl. 222). He has given an account of how he came to choose this particular category of subject-matter, after being asked to participate in a group show whose theme was 'Views of Sacramento' – he happened to be living there at the time. After a vain search for a suitable motif, his attention was caught by a customized truck in a parking lot:

> There were two or three people standing and looking at it, and I got out and went over and we talked about how much time and money the guy had put into doing it and so forth, and we got to talking about how pick-up trucks became status things in our culture. They weren't really work vehicles any more, they were something people bought when they became affluent, because pick-ups were sort of the last vestige of the Western

222

man, but they weren't really used to do anything but show off.[3]

Goings photographed the truck and made the photograph the basis for a successful painting. His reason for maintaining an apparently photographic style and surface was straightforward:

Photographs so permeate our lives that they have come to have their own reality. We're drenched with photographs; we accept them as normal.[4]

For many of the artists associated with Super Realism the virtuosity of the actual rendering was the whole point of the picture. Charles Bell, who has become well known for his paintings

223

of objects such as glass marbles and pin-ball machines (Pl. 223), points out that they are dependent on photographs in ways which may not even be known to the spectator – for example, because the intensity of light required in order to achieve a particular effect makes it impossible, simply in practical terms, to depict them from life.

The supposed neutrality of Super Realist work, and its symbiotic relationship to photography, attracted collectors just as much as it tended to repel critics. Critics more and more came to see paintings like Goings's *Golden Dodge* and Bell's *Lucky Lady* as empty

224

225

displays of skill. Collectors, on the other hand, tended to covet these works because they thought they delivered value for money. One result has been a curious split in the market. Whereas Super Realism rapidly, as I have already said, fell from critical favour, it has shown remarkable tenacity in the market place. There are now at least three successive generations of Super Realist painters at work in the United States, supplying a private clientele which seems to have much in common with the prosperous bourgeois clientele who bought Dutch genre paintings and still lifes – when these were fresh from the easel in the mid-seventeenth century.

It is an interesting comment, both on American attitudes towards art and on the dominance of photographic imagery in the history of American culture, that the Super Realist or Photo Realist approach made very few inroads among European artists. There is nearly always a specific reason for these rare appearances. The German artist Gerhard Richter, who paints both entirely abstract works (Pl. 57) and realistic imagery, uses photographic conventions as a vehicle for political commentary. His *Brigitte Polk* (Pl. 224), a portrait of one of the members of the Red Army Faction terrorist group, uses the ghostliness of a certain kind of photograph as a way of commenting on the fate of its subject, who either committed suicide in prison or (as some sources have hinted) was killed there. Simon Faibisovich's *Train Station: Soldiers* (Pl. 225) is a work of *perestroika* art from Russia, which seeks to combine the academic stiffness of Soviet Socialist Realism with the vision of the camera.

Even in the United States, Super Realism, like many supposedly rigid artistic formulae, showed considerable powers of variation. Robert Cottingham, in *Kresge's* (Pl. 227), offers one such from a long series of paintings which express his fascination with the lettering on the fascias of theatres, movie-houses, shops and other commercial buildings. The subject-matter is less the fragmentary glimpses of architecture than the energy of the lettering itself, and this, in art-historical terms, carries the spectator back, through aspects of Pop Art (for instance, the painting by Ed Ruscha reproduced in Pl. 13), to the work done by some of the Russian Constructivists, particularly El Lissitzky. A

typical painting by Vija Celmins (Pl. 226) demonstrates that Super Realism and Minimalism are not necessarily irreconcilable.

The original theoreticians of Super Realism always had problems with three-dimensional work – one reason being the obvious one: that representations of this type had no very obvious relationship to photography, which is essentially a system for reducing three dimensions to two. The immediate historical derivation of Super Realist sculpture was from George Segal's life casts. But Segal's figures always retained their otherness. In a classic Segal of the Pop period, the whole point was the alienated quality of the figures, amidst the immaculately reconstructed naturalism of their settings. The figures of John de Andrea (Pl. 228) and Duane Hanson (Pl. 229), though made in the same fashion as Segal's – i.e. through a

226

process of making casts from life – are coloured to resemble life, provided with real hair and glass eyes, and (in Hanson's case) given real clothing and accessories. The imitation of reality is so exact that the sculptures can, on occasion, be mistaken for living people. All of this tends to place them in a tradition which is age-old, rather than Modernist. One thinks of the wax effigies carried in Roman funeral processions, of Spanish seventeenth-century religious sculptures, and also of the waxwork figures shown in places of popular entertainment, such as Madame Tussaud's in London and the Musée Grévin in Paris.

While de Andrea and Hanson have established themselves as the leading artists who produce this kind of work, it is interesting to note that there are marked differences

224 Gerhard Richter, *Brigitte Polk*, 1971
Oil on canvas, 100 × 125 cm (39½ × 49¼ in)

225 Simon Faibisovich, *Train Station: Soldiers*, 1989
Oil on canvas, 284 × 190 cm (112 × 75 in)

226 Vija Celmins, *Untitled*, 1988
Oil on canvas, 35.8 × 46 cm (14⅛ × 18⅛ in)
Collection of Stuart and Lisa Ginsburg

227 Robert Cottingham, *Kresge's*, 1984
Oil on canvas, 244 × 168 cm (96 × 66 in)
Collection of the Virlaine Foundation, New Orleans

228 (overleaf) John de Andrea, *Seated Blond Figure with Crossed Arms*, 1982
Painted polyvinyl, 152 × 86 × 93 cm (60 × 34 × 36¾ in)
Collection of the Virlaine Foundation, New Orleans

229 (overleaf) Duane Hanson, *Bus Stop Lady*, 1983
Polyester resin and fibreglass, life-size
Collection of the Virlaine Foundation, New Orleans

227

BUS STOP LADY
Duane Hanson American
Polyvinyl - Painted 1983

230 **John Ahearn**, *Veronica and her Mother*, 1988
Oil on fibreglass, 180 × 90 × 90 cm
(71 × 35½ × 35½ in)

231 **Rigoberto Torres**, *Girl with Red Halter Top*, 1982–3
Oil on cast plaster, 56.5 × 43.2 × 22.9 cm
(22¼ × 17 × 9 in)

230

between them. De Andrea offers attractive, youthful nude figures, which make one think of the healthy American college students who probably posed for them. There is a constant tension in his work between what is particular and what is idealized. That is, his nudes aspire to the condition of the ideal – of human physical perfection – but constantly fall short of it because they are based on real people. Hanson's figures, by contrast, are forthright statements, with a strong satirical edge – depictions of modern 'types', generally offering a sardonic view of the American blue-collar class. His figures are so astonishingly lifelike that it is often assumed that they must be exact depictions of particular individuals.

However, Hanson himself stresses that this is not the case. In his accounts of his own development, he emphasizes his sense of connection with the sculptures of the past – for example, with the work of the Swede Carl Milles, whom he met when he was a student at the Cranbrook Academy of Art, and with Rodin. In conversation with the curator and critic Kirk Varnedoe he said: 'I see myself, as I started out, rather as a true expressionist.'[5] That is, elements of choice and subjectivity play an important role in what he does, and he alters the appearance of his figures in order to align this with a predetermined idea or 'message'.

A simpler kind of 'message' Realism can be found in the work of two younger sculptors, John Ahearn and Rigoberto Torres, who also make use of a life-casting technique. Ahearn and Torres are essentially community sculptors, working in a deprived area of New York. By making likenesses of friends and neighbours (Pls. 230, 231), they seek to offer a measure of self-recognition and self-respect. The casting process is often conducted in public, and there is an implied comparison with the work done in studios in the same community producing cheap religious figures. Significantly, the Realism of these community portraits is less refined, therefore less deceptive, than that of de Andrea and Hanson.

One of the artists with whom Duane Hanson formed a friendship when he came to New York to live and work was the veteran Alice Neel. At first sight, there is an enormous gap between their respective approaches to making art. At a second inspection, this narrows considerably. *The Family (John Gruen, Jane Wilson and*

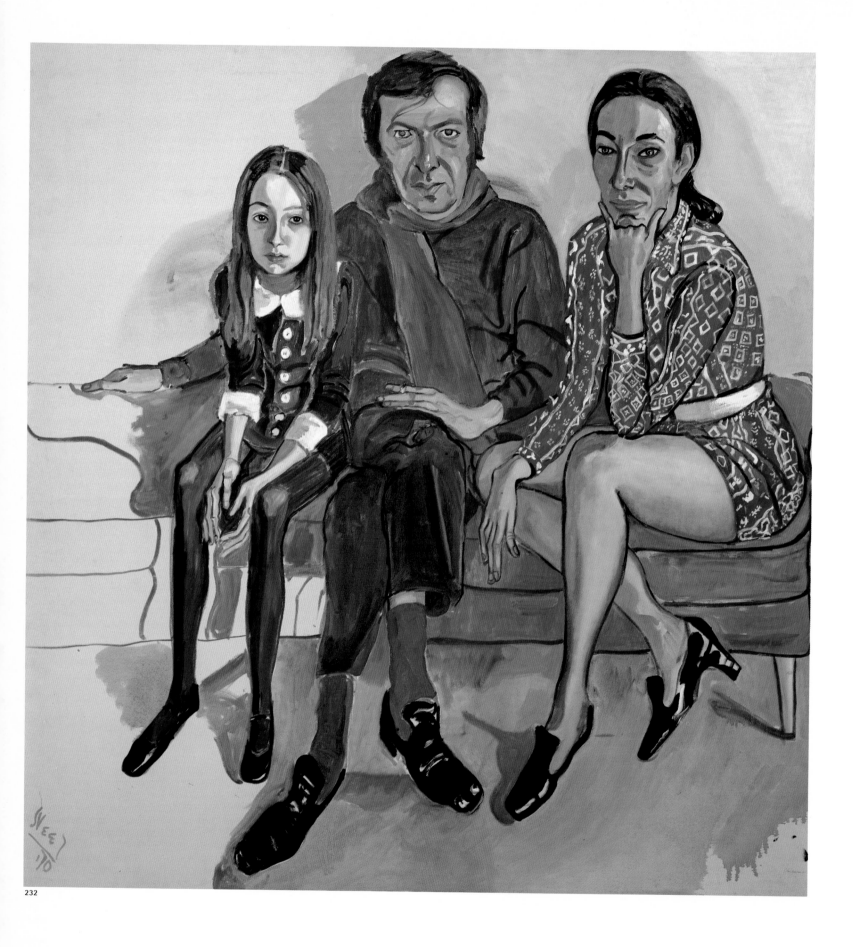

232

Julia) (Pl. 232) is a typical late work by Neel, a group portrait showing an art critic, his wife and young daughter. Like Hanson, Neel intensifies what she has observed, so as to make a clear comment on her sitters – on their relationship to one another as well as on their individual characters. Working in two dimensions, not three, she has no interest in producing a representation linked to photography – the sitters' features, their physical dimensions, are deliberately altered so as to convey a personal reaction. Yet the spectator tends to think of the picture as being 'realistic' because it is so clearly concerned with conveying an idea of what reality is about – what it means to the artist herself, what it might possibly mean to the people in front of her.

Despite the supposed triumph of the avant-garde during the period since World War II, the Realist impulse has in fact remained powerful in contemporary art. One of the places where it has been felt most powerfully is the United States, despite the fact that America, during the post-war period, has also been thought of as the natural home of artistic experiment. If one begins to examine the workings of the Realist impulse in America, and more especially in the American painting of the past three decades, it soon becomes apparent that what one is dealing with is not a unity but a plurality of styles. The word 'realism' is itself notoriously difficult to define – the Concise OED's attempt, 'the representation of life, etc., as it is in fact' – verges on the tautologous. Realist artists have been understood largely as creators whose impulses contradicted what was going on in the rest of contemporary art.

One kind of Realist painting retains a relationship, though by now a somewhat tenuous one, with the Impressionist tradition. The accomplished paintings of Julio Larraz owe a significant debt to Sargent and to other American Impressionists such as William Merritt Chase. However, the true ancestor of Larraz's *The Hunter* (Pl. 233) is Manet's celebrated portrait of Emile Zola, and one sees in both paintings an attempt to hold the mirror up to an aspect of 'modern life'. Sidney Goodman's *Waste Management* (Pl. 235) is also an attempt to reflect contemporary reality, but with a rather different emphasis. The allusion is less to the history of Impressionism than to the

232 Alice Neel, *The Family (John Gruen, Jane Wilson and Julia)*, 1970
Oil on canvas, 147 × 152 cm (58 × 60 in)

233 Julio Larraz, *The Hunter*, 1985
Oil on canvas, 101.5 × 152 cm
(40 × 60 in)

233

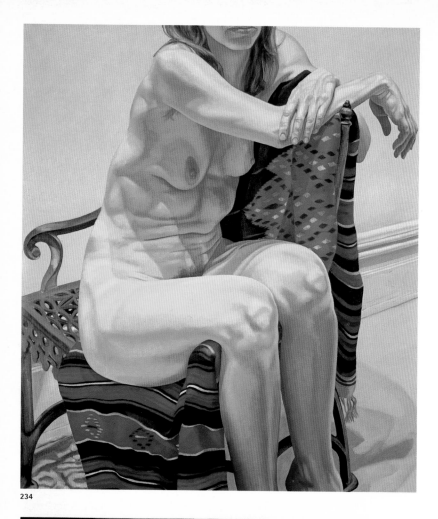

234

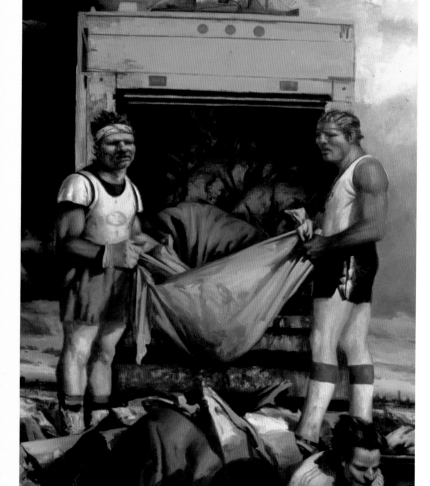

235

Social Realism which flourished in the United States during the 1930s, and to Mexican Muralism, particularly the work of Diego Rivera.

Among the issues raised by a return to Realism are those of the painter's relationship to the artistic culture surrounding him, and also those of his or her relationship to the intellectual structures associated with the art of the past. The American Realist most often named by commentators looking for something with a visibly contemporary sensibility is Philip Pearlstein. Pearlstein's long series of paintings of nudes, sometimes seen singly (Pl. 234), sometimes in groups, is an attempt to reconcile realistic depiction with compositional structures derived from contemporary abstraction. Pearlstein uses subject-matter associated with academic practice – the nude in the studio – but deliberately crops it so as to depersonalize it, and creates formal relationships which are like those of abstract painting. The paintings are a visual paradox – particular in their rendition of detail, but essentially detached from particularity of feeling.

Robert Birmelin uses an even more radical system of cropping to achieve results which are simultaneously Realist and abstract. In *Hands (Interlocked)* (Pl. 236) the spectator 'reads' the subject-matter from part-objects, chief among them the clasped hands of the title. The way in which these part-objects are shown depends both on lessons learned from photographic cropping and lessons learned from the movies – the painting reads like a close-up taken from a film. It is not, however, photographic in terms of detail. The conclusion is that contemporary Realist painting does not have to be Super Realist in any strict sense to have a relationship with the camera.

The continuing dialogue between photography and painting, which began with the invention of photography itself in the early nineteenth century, can be observed particularly clearly in works where the human figure is absent, or plays a limited part. April Gornik's unpeopled *Entering the Desert* (Pl. 237) belongs to a tradition of Romantic landscape painting that can be traced back to German artists of the Biedermeier period, such as Caspar David Friedrich. It also owes something to a celebrated American exemplar,

234 **Philip Pearlstein**, *Female Model
on Chair with Red Indian Rug, 1973*
Oil on canvas, 122 × 106.5 cm
(48⅛ × 42 in)
Ackland Art Museum, University of North
Carolina, Chapel Hill

235 **Sidney Goodman**, *Waste
Management*, 1987–90
Oil on canvas, 246 × 200 cm (97 × 79 in)

236 **Robert Birmelin**, *Hands
(Interlocked)*, 1987
Acrylic on canvas, 121.8 × 198 cm
(48 × 78 in)

236

237 April Gornik, *Entering the Desert*,
1992
Oil on linen, 152 × 304 cm (60 × 120 in)

238 James Doolin, *Bridges*, 1989
Oil on canvas, 183 × 259 cm (72 × 102 in)

237

238

239 Yvonne Jacquette, *Left Wing,*
Boston Industrial Area II, 1990
Oil on canvas, 216 × 179 cm (85 × 70½ in)

240 Janet Fish, *Scaffolding*, 1992
Oil on canvas, 106.7 × 106.7 cm
(42 × 42 in)

239

Georgia O'Keeffe. But the simplification of forms in Gornik's work, as in O'Keeffe's, also owes something to photographers such as Ansel Adams and Edward Weston. The photographic link is even clearer in paintings by the Los Angeles-based James Doolin. In his *Bridges* (Pl. 238), the forced perspective of the bridge structure clearly owes something to a wide-angle lens. This is also the case with Yvonne Jacquette's *Left Wing, Boston Industrial Area II* (Pl. 239), an aerial view with a pronounced photographic character. Here it is not only the perspective and cropping but the all-over sharpness of detail which enforce the comparison.

Scaffolding (Pl. 240), a still life by Janet Fish, evokes the camera in several ways – first by the brilliant high-key colour and the glittering transparency of the objects seen in the foreground, and second by the way in which foreground and background are compressed, thereby suggesting the use of a telescopic lens. Even if these paintings are not actually based on photographs, they all, in their different ways, demonstrate how profoundly the camera has influenced late twentieth-century ways of seeing. This is also true, though in a somewhat subtler fashion, of a typical watercolour by Joseph Raffael, *Site Charmant Autumn* (Pl. 241). Two things evoke photography here. One is the fact that the composition is an arbitrary excerpt from nature, of a sort now made familiar by many natural history photographs, and similar images on television. The other is the intense luminosity of the colour, which has obviously been influenced by the saturated effects now obtainable from certain kinds of photographic emulsion.

Some Realist painters have consciously resisted the hegemony of the camera, but they have not altogether been able to resist its effects. Two well-known painters of this sort in the United States are James Valerio and Jack Beal. Valerio's elaborate landscape-with-figures, *Summer* (Pl. 242), seems, at first glance, like an attempt to revive the ideal of the Pre-Raphaelites. Its rather airless elaboration recalls the work of Holman Hunt, or, even more vividly, John Brett's perverse masterpiece *Val d'Aosta* (1858), of which Ruskin wrote in his Academy *Notes* for the year 1859:

Here, accordingly, for the first time in history, we have by the help of art, the power of visiting a

220-221

Realism in America

240

241 **Joseph Raffael**, *Site Charmant*
Autumn, 1991
Watercolour on paper, 113 × 178 cm
(44½ × 70 in)

243 **Jack Beal**, *The Sense of Sight*,
1986–7
Oil on canvas, 167 × 122 cm (66 × 48 in)

242 **James Valerio**, *Summer*, 1989
Oil on canvas, 244 × 299 cm (96 × 118 in)

241

242

place, reasoning about it, and knowing it, just as if we were there, except only that we cannot stir from our place nor look behind us.[6]
Yet even here, the ambition to achieve total visual completeness seems to refer to photography's undoubted powers in this respect. The landscape in *Summer* is more completely seen than it ever could be in real life.

Beal's elaborate allegory *The Sense of Sight* (Pl. 243) seems to refer rather ruefully to just this situation, since one of the most prominent objects depicted in it is a reflex camera on a tripod. Nevertheless, one notes how careful the artist has been, in this case, to avoid a typically photographic mode of representation. The composition, arranged on a diagonal, brings to mind the elaboration of certain Baroque still-life paintings, while furnishing the space with largely contemporary objects. Yet, in its use of overlapping planes, and sudden spatial jumps, Beal's painting also shows how hard it is for any artist to avoid the legacy of Modernism. *The Sense of Sight*, as well as being a tribute to the Baroque, pays homage to Cubism.

A prominent element in both Valerio's and Beal's work is an emphasis on painterly virtuosity. Contemporary painters, having opted for Realism, are anxious to demonstrate by every means possible the gulf between themselves and that section of the art world which now utterly rejects the notion of craft or skill. Virtuoso skills play a prominent role is the work of a number of younger American figurative artists. Steve Hawley's still life, *White Smoke, Black Smoke* (Pl. 244) shows wonderful skill in handling textures and contrasts of hue. There is also, in this case, an element of *trompe l'oeil*, with the three 'pictures within a picture' seen taped to a board at the left. The erotic content of these little images suggests that the painting has, like Beal's, an allegorical meaning, and is meant to contrast the sacred and the profane. At papal elections, black smoke coming from the chimney where ballot papers are burned indicates that the vote has been indecisive. White smoke shows that a new pope has been elected.

Richard Shaffer's *Self-Portrait* (Pl. 245) shows equal refinement of handling – the way in which the feathers are rendered is especially beautiful. And here too there is

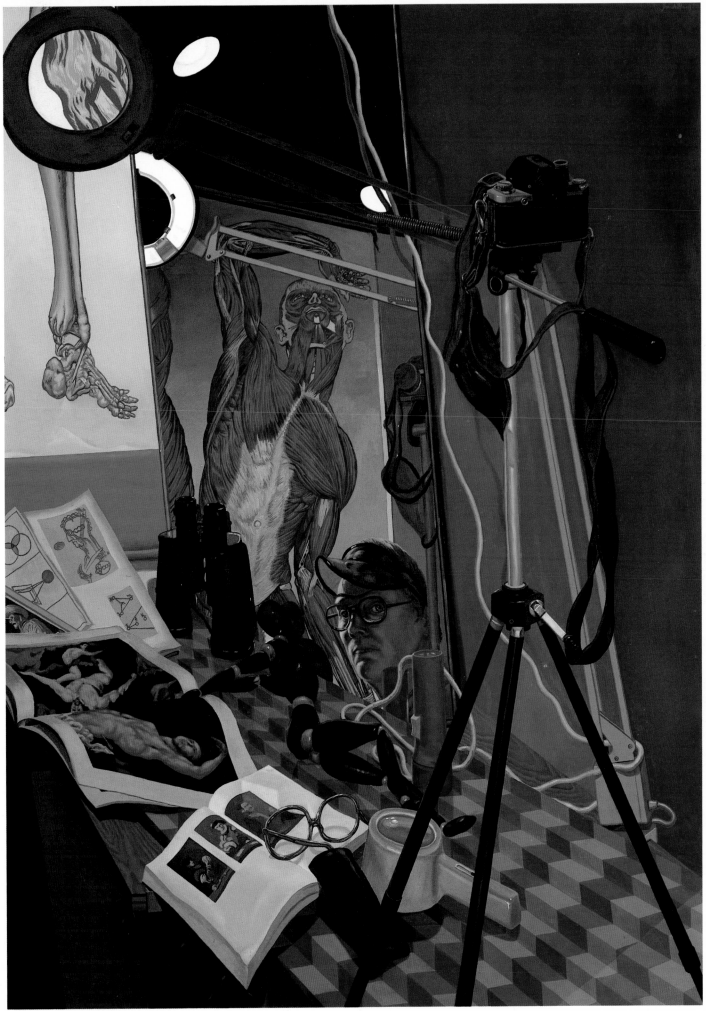

243

244 Steve Hawley, *White Smoke,*
Black Smoke, 1990–3
Oil, wax and resin on board,
112 × 129 cm (44 × 51 in)

245 Richard Shaffer, *Self-Portrait,*
1993
Oil on canvas, 45.6 × 43.1 cm (18 × 17 in)

246 Gregory Gillespie, *Self-Portrait*
with Blue Hooded Sweatshirt, 1993
Oil and resin on wood,
66 × 57 cm (26 × 22½ in)

experimentation with *trompe l'oeil*. The device,
in recent American art, makes a precise
historical reference, as it summons up the
personality of William Harnett, the turn-of-
the-century master of still life whom many
critics now see as a paradigm of the specifically
American sensibility.

Shaffer, in the course of his career, has
painted a whole series of self-portraits, though
not as many as Gregory Gillespie (Pl. 246), who
once said that he had thought of confining
himself entirely to this subject. It is perhaps
not surprising that artists who are committed
not merely to figuration but to some form
of Realism should have been attracted to this

244

245

particular category of subject-matter. First, the
search for a likeness offers one of the best
justifications for Realist practice. Second, self-
portraiture has obvious links to the quest for
the self which is one of the most powerful
motivations in late Modernist art. Third, it
allows the artist to retain 'contemporary'
status, while still exploring some of the
implications of the Old Master tradition. To
choose a trivial but telling example: the blue
sweatshirt that Gregory Gillespie has adopted
for the self-portrait illustrated here is a
thoroughly modern garment, a symbol of the
casualness of the late twentieth-century way of
life. Yet it also has a haunting resemblance to

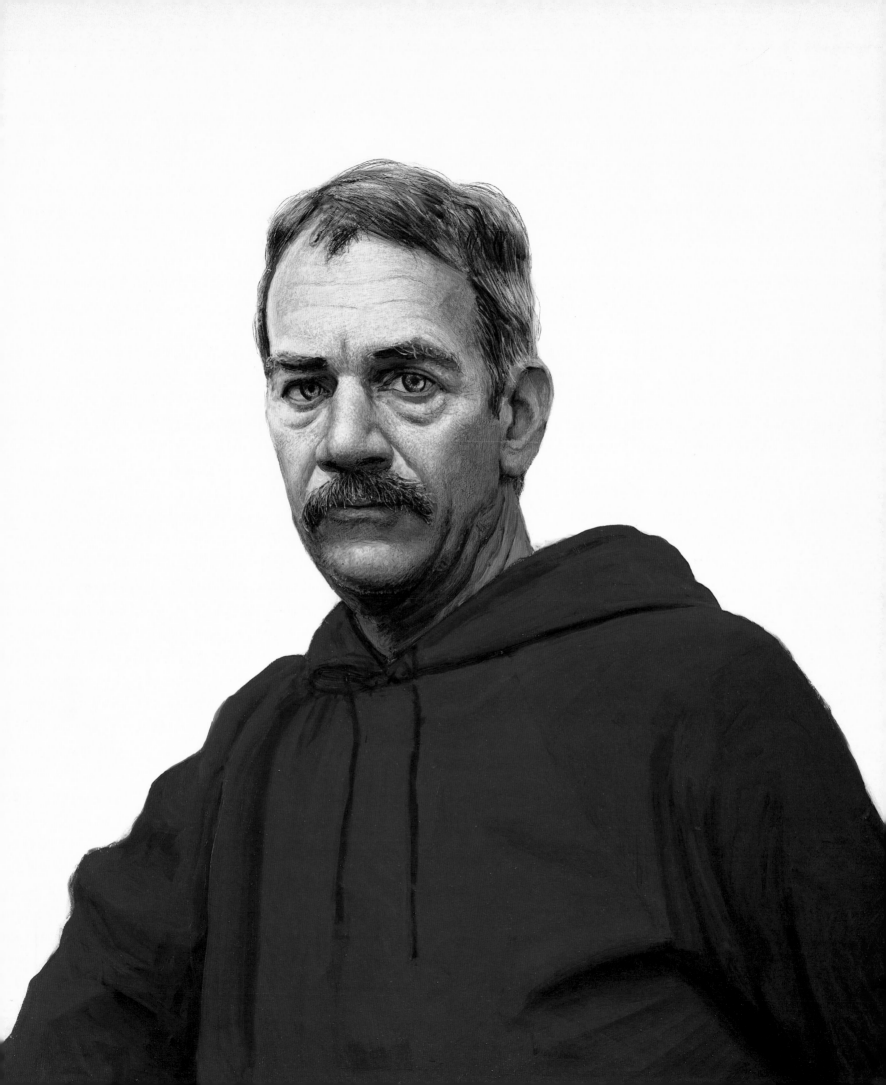

certain late medieval garments, and thus makes a discreet reference to the portraits painted by Jan van Eyck and his immediate followers.

The main motivation in the contemporary Realist self-portrait is, however, a stripping of the self, a confrontation with the viewer of a kind enacted in very literal fashion in William Beckman's *Self-Portrait in Grey Pants* (Pl. 247). Here the artist shows himself with a bare torso, staring directly at the viewer. It is a point of some interest that this painting can be grouped with others painted at the same moment. One is Gregory Gillespie's likeness of Beckman, similarly clothed, but now surrounded by the paraphernalia of the studio (Pl. 248), and

247 William Beckman, *Self-Portrait in Grey Pants*, 1992–3
Oil on wood, 203 × 127 cm (80 × 50 in)

248 Gregory Gillespie, *Portrait of William Beckman*, 1992
Oil, resin and mixed media on wood, 244 × 170 cm (96 × 67 in)

249 William Beckman, My Father, 1988–93
Oil on wood, 185 × 145 cm (73 × 57¼ in)

249

248

the other is Beckman's likeness of his father (Pl. 249), which stresses the family likeness between father and son. What one sees is not merely the exploration of personality, and the idea of individuality, but the very deliberate reconstruction of ideas of tradition and artistic inheritance which the original Modern Movement was at pains to attack. One conspicuous feature of the art of the last thirty years, and especially of much which has been produced recently, is the rebellion against Modernist shibboleths and the exploration of the pre-Modernist heritage. This impulse has been conspicuous in the United States and in Italy, but has also manifested itself elsewhere.

Post-Modernism and Neo-Classicism

One of the most striking developments in the art of the past thirty years is the fashion in which many artists have started to re-examine the pre-Modernist past. Theoreticians dealing with this phenomenon have tended to link it to Post-Modernism in architecture, by which they have meant chiefly the revival of specifically classical forms, under the influence of late eighteenth- and early nineteenth-century architects like Sir John Soane and Karl Friedrich Schinkel. Art movements such as Pittura Colta in Italy have been seen as the equivalent for what was happening in the creation of buildings. Since Post-Modern architecture is often disjunctive or disruptive in its approach to classicism, certain kinds of painting have been perceived as acting in the same spirit. That is, the use of ideas borrowed from the Old Masters, and from the whole repertoire of classical art, has been interpreted as being primarily ironic. If, however, one examines a broader range of material, this supposition becomes untenable.

The reasons why artists should again interest themselves in the painting and sculpture produced before Modernism are not difficult to divine. Becoming an artist is the product of visual curiosity, and painters and sculptors could not isolate themselves altogether from the great works of the past, even if the aesthetic theory of the moment would have little to do with them. In fact, and this was a strange but logical turn of events, the work of the Old Masters, for some experimental artists at least, began to acquire the lure of what was forbidden. There were also, at specific moments, and in particular places, reasons why an artist or a group of artists should turn away from the mainstream and look for inspiration to the artists of the past. The example which springs to mind is Spain in the last days of the Franco regime. If some Spanish artists, and notably a group of Catalans led by Antoni Tàpies, took advantage of the regime's general indifference to the visual arts to develop styles which were related to those prevalent in France and even in the United States, there were others who saw in realism a way of affirming a proud sense of Iberian separatism. Artists like Antonio Lopez-García (Pl. 250) produced work with strong and conscious links to the Spanish *bodegones* of the seventeenth century, painted by artists

such as Zurbarán, Juan Sánchez Cotán and Juan van der Hamen.

In general, however, the impulses which led artists to re-explore the pre-Modernist tradition came from within art itself. For example, when the Super Realist painter Richard Estes completed the first phase of his development, in which the buildings he painted were usually arranged parallel to the picture surface, and started to explore compositional arrangements where the forms were seen in depth (Pl. 251), the pictorial problems he

250 Antonio Lopez–García, *Clothing in Water*, 1968
Oil on wood, 80 × 73 cm (31¼ × 28½ in)

251 Richard Estes, *Holland Hotel*, 1984
Oil on canvas, 114 × 181 cm (45 × 71½ in)

251

encountered inevitably led him towards solutions which had previously been arrived at by the eighteenth-century Venetian view painter Antonio Canaletto. Estes's New York townscapes of the 1980s and 1990s have a strong kinship with Canaletto's familiar views of Venice. It is not merely that both are poets of light – the glitter of light on water in Canaletto's views of the Grand Canal and the Bacino San Marco are, in Estes, replaced by the flashing reflections of New York's expanses of

252

plate glass. It is also that Estes, like his mentor, subtly twists and falsifies the information obtained by mechanical means (where Estes uses a camera, Canaletto used its primitive predecessor, the *camera obscura*) so as to produce compositions which the eye finds it easier to absorb. It is Estes's readiness to make this kind of pragmatic adjustment to what the camera actually shows which has made him one of the most popular and accessible of the whole Super Realist group.

Similar adjustments can be found in the still lifes produced in the early 1980s by Audrey Flack. Here the components are not only more intense in hue than they would be in reality, but are arranged in ways which the laws of gravity would not permit in real life. In *Invocation* (Pl. 253), the effect is intensified by the fact that the main still-life composition is treated as a picture-within-a-picture. Yet the real link with the art of the past comes, not from the use of pictorial tricks, including some borrowed from William Harnett, but from the presence of the skull, which immediately identifies the painting as a *vanitas*, or emblem of the transitoriness of human life. This in turn opens a long historical perspective, since many such paintings were produced in the seventeenth century, especially by artists living and working in northern Europe, under the influence of Protestant ideas about predestination.

In general, as soon as allegorical elements are introduced, the artist concerned begins to demonstrate his or her need for contact with the intellectual systems of the past. If one looks, for example, at two recent works by American artists where the word 'allegory' appears in the title, one is aware of the way in which they reach out to make contact with pre-Modern exemplars. Bruno Civitico's *Allegory of the Senses* (Pl. 252) recalls not only Baroque paintings, where the senses are allegorized, separately or together, but also Courbet's celebrated painting *The Studio*, which is subtitled 'a real allegory'. There is another, less expected, parallel to add to these. Civitico's vision of an artist's studio has much in common with certain Biedermeier and Danish Golden Age compositions – most of all, perhaps with Constantin Hansen's *A Group of Danish Artists in Rome*, painted in 1837 and now in the Statens Museum for Kunst,

252 **Bruno Civitico**, *Allegory of the Senses*, 1992
Oil on canvas, 188 × 188 cm (74 × 74 in)

253 **Audrey Flack**, *Invocation*, 1982
Oil and acrylic on canvas, 162 × 203 cm (64 × 80 in)

254 **Richard Piccolo**, *Allegory of Patience*, 1989
Oil on canvas, 129.5 × 162.6 cm (51 × 64 in)

253

254

255 **Edward Schmidt**, *Nocturne*, 1993
Oil on canvas, 105.4 × 162.6 cm
(41½ × 64 in)

256 **James Aponovich**, *Still Life:*
Penobscot Bay, 1992
Oil on canvas, 152 × 122 cm (60 × 48 in)

Copenhagen. Hansen's painting, in turn, has been seen by scholars as a domesticated paraphrase of Raphael's *School of Athens*. It is worth considering a comment made about Hansen's picture in a recent exhibition catalogue, apropos this comparison with Raphael:

> In both cases the persons represent a cultural élite. In both pictures central, contemporary ideas are debated. But while the portals of Raphael's picture lead to a higher cognition, Hansen's doors open out to contemporary reality, and ancient philosophers have been replaced by level-headed Danish artists.[1]

The *Allegory of the Senses* exemplifies a similar search for a balance between the forces of realism and idealism.

Richard Piccolo's *Allegory of Patience* (Pl. 254) is historically and culturally less complex. The artist's source is one of the collections of emblems which were popular in the sixteenth and seventeenth centuries. His painting shows a female figure chained to a rock, whose chain is gradually being worn away by a jet of water falling from an urn. What is especially interesting in this case is the figurative style, which takes something from Italian Baroque art but perhaps more from the Polish-French artist Balthus – the young girl is very much a Balthus 'type'. The artist simultaneously affirms his interest in the past and his adherence to a more Modern form of realist depiction.

Contemporary artists have, in fact, made an interesting discovery: that, thanks to the chasm opened by Modernism between the art of the twentieth century and that of the more distant past, Old Master sources now share the kind of 'otherness' which was once attributed only to non-Western art. Edward Schmidt's *Nocturne* (Pl. 255) is another work which pays homage to the Italian Baroque, but as much in stylistic terms as in those of content. The probable source is Guido Cagnacci (1601-81). Cagnacci has caught the fancy of twentieth-century art historians because his paintings, especially those of the female nude, have a presence and an immediacy of impact that make them seem anachronistic, in terms of the sensibility of their time. Schmidt has obviously felt this attraction, but his reaction has been to distance the material once again. The composition has a generalized, non-specific character, a degree

255

Post-Modernism and Neo-Classicism

of intellectualization, which immediately convinces us, at a second glance if not at a first, that this is a product of an alienated Modern sensibility.

It is possible to offer quite a range of examples of this kind of alienation, as a characteristic of contemporary figurative art. James Aponovich's *Still Life: Penobscot Bay* (Pl. 256), for example, is not a straightforward depiction of traditional subject-matter. It looks at the motif obliquely, through the eyes of American still-life painters of the mid-nineteenth century, such as John F. Francis (1808–86) and Severin Roesen (working 1848–71). In his authoritative survey of American art, John Wilmerding remarks that Francis's still lifes, notable for their glistening opulence, offer 'an imagery of secular praise and thanksgiving',[2] in tune with the American mood of the time. Aponovich offers only an ironic reflection of this mood, not the thing itself.

One of the most interesting attempts to re-explore the Old Masters has been that made by the Hungarian-French painter Tibor Csernus. Csernus's exemplar is Caravaggio, one of the rare pre-Modern painters who, for biographical reasons as well as those to do with theme and content, has been co-opted as a kind of honorary Modernist. In Csernus's paintings one finds the things now thought of as typically Caravaggist: the violent chiaroscuro, the sense that the whole scene is in some special way emotionally charged. Yet there are important differences as well, most strikingly the absence of clear narrative in most of Csernus's work. It is symptomatic that many of his paintings have no specific titles – the figures move and gesture, but their emotions and purposes are obscure. Csernus allows himself to break rules which Caravaggio generally obeys. In *Untitled (Four Figures)* (Pl. 257), for instance, he obscures most of the heads, and thereby veils their expressions. He detaches Caravaggio's characteristic style from its content, and presents it in isolation. This substitution of the part for the whole is typical of the late Modernist sensibility seen as a whole.

The single most powerful influence on the Post-Modernist figurative painting of the 1980s and 1990s is not, however, Caravaggio, but a very different current of development in European art – the classical tradition, as it

258

259

260

manifests itself in the work of artists such as Nicolas Poussin on the one hand, and Jacques-Louis David on the other. One reason for this is that a reversion to this tradition, generally perceived as quintessentially academic, is the most defiant gesture any artist can make against the shibboleths of contemporary art. It is a way of saying that the situation has reversed itself – that what was once rebellious has become mainstream orthodoxy and that what was once orthodoxy has turned into a form of rebellion. This gesture of rebellion can be seen in its simplest form in John Nava's *Dancer* (Pl. 258). Here the simple, solid forms, the preference for angles rather than curves, and (most of all) the way the figure is placed parallel with the picture-plane are all direct reminiscences of David's *Oath of the Horatii*, the quintessential statement of the rule of classicism in art.

A similarly heartfelt tribute to Poussin can be seen in William Bailey's still life *Prato* (Pl. 259), and a slightly less stringent one in Raymond Han's very similar *Still Life with Orange Tin and Produce Containers* (Pl. 260). The title of Bailey's still life indicates that this arrangement of simple domestic objects is to be regarded as a metaphor for Italian townscape, and it is a very short step from this to some of Poussin's most powerful compositions, for example, to the townscape which forms the background to *Moses Saved from the Waters*, now in the Ashmolean Museum, Oxford. In both Nava's painting and that by Bailey the drastic nature of the transposition, in terms of subject-matter, helps to reinforce the point made by the underlying structure.

Some artists have been prepared to tackle the implications of a classical, or classicizing, subject-matter, as well as classical arrangements of form. A very different painting by Sidney Goodman from the one illustrated in Chapter 7 (Pl. 235) shows a first stage in this process (Pl. 261). The five figures are in contemporary dress, in a contemporary interior, but are arranged and lit in a way which is an obvious tribute to David – the model here is *The Death of Socrates* in the Metropolitan Museum, New York. Goodman can, however, rely not only on the spectator's recollection of David's subject-paintings, but on the echo of his portraits. There is no group portrait by David as elaborate as

259 **William Bailey**, *Prato*, 1993
Oil and wax on canvas, 76 × 102 cm
(30 × 40 in)

260 **Raymond Han**, *Still Life with
Orange Tin and Produce Containers*,
1992–3
Oil on canvas, 71 × 112 cm (28 × 44 in)

261 **Sidney Goodman**, *Portrait of Five
Figures*, 1973–4
Oil on canvas, 132 × 183 cm (52 × 72 in)

261

ART TODAY

262

this, or containing as many figures, but the reminiscences are obvious. The seated figure to the left, for instance, is almost in the pose of David's *Mme de Verninac.*

Michael Leonard's *Dark Mercury Bather* (Pl. 262) tackles a favourite classical subject, the male nude, in a fashion which is on the surface of things straightforward, but in fact dense with cultural allusions. The pose is taken from a statuette by the French eighteenth-century sculptor Jean-Baptiste Pigalle (1714-85) showing the god Mercury tying his sandal; Leonard discovered it because a plaster cast of the piece features prominently in a painting by Chardin. Yet the way the image is presented has Modernist implications. The figure touches the edges of the painted surface at several points, and, pressing against these boundaries, reads as an abstract pattern of solid and void. Leonard is doing some of the same things as Philip Pearlstein (Pl. 234), but is also adding several layers of cultural reference.

Another British artist, Ben Johnson, paints not the figure but architecture. His *Taken Space* (Pl. 264) depicts an interior in the style of Sir John Soane, adorned with three classical statues. The real purpose of the work, however, is to clothe an abstract design with apparently realistic details. Particularly telling, for instance, is the consonance between the arched Venetian window in the background and its reflection in the marble tiles of the floor. The arch of the window is echoed by the lesser arch made by the brackets which support the table, and this shape, too, is reflected in the tiling.

Artists such as Sidney Goodman, Michael Leonard and Ben Johnson maintain a careful balance between classicism and naturalism. In each of the three paintings just discussed it is possible to read the depiction as something entirely naturalistic – a direct reflection of observed reality – and miss the other implications of the image. Other artists have been more insistent on drawing attention to the classical 'core' of the work. *Mother and Child* (Pl. 263) by Alan Feltus is one of a series of works featuring pairs and groups of women. Despite the contemporary clothing and the contemporary details present in the settings, the mask-like faces and simplified limbs make it clear that this is an attempt to return to the world of idealization which has intermittently attracted artists throughout the Modernist

epoch. Comparisons suggest themselves both with the paintings of the Italian artist Felice Casorati (1883-1963), whose best work dates from the mid- and late 1920s, and, in a more general sense, with Picasso's Neo-classical phase, which belongs to the same decade. A similar ambience pervades David Settino Scott's *Si Id Credet Errabit* (Pl. 265), where the two figures of 'magicians' on either side of the composition are dressed in pseudo-classical robes. Settino Scott's painting nevertheless addresses a rather different issue. Feltus is interested in a possible congruence between everyday reality and the heightened realm of idealized classical forms; *Si Id Credet Errabit* is a direct statement about the transforming

263

264

262 Michael Leonard, *Dark Mercury Bather*, 1992-3
Alkyd-oil on board, 84 × 76 cm
(33 × 30 in)

263 Alan Feltus, *Mother and Child*, 1993
Oil on canvas, 100 × 80 cm (39¼ × 31½ in)

264 Ben Johnson, *The Taken Space*, 1990
Acrylic on canvas, 183 × 183 cm
(72 × 72 in)
Collection of the Virlaine Foundation, New Orleans

powers of art – its ability to show us what we know to be impossible. The work is constructed like an elaborate medieval altarpiece, whose wings can be folded back to show successive scenes within. The artist's commitment to classicism is in this case very loose, since the paintings which are revealed as the diptych opens abandon classical models in favour of paraphrasing an artist who could be regarded as the antithesis of classicism, Hieronymus Bosch. What is interesting is the implicit statement, driven home by the gateway-like design of the opening scene, where the figures act as two columns supporting an architrave, that classicism is the essential structure which supports all other forms of art.

265

266

A programmatic commitment to classicism appears in the work of the Italian artists of the Pittura Colta Movement, whose two best-known members are probably Carlo Maria Mariani (Pl. 267) and Alberto Abate. Writing about Mariani, the Italian critic Italo Mussa, the chief theorist of the movement, said that 'his cultivated painting partakes of the poetic (ideal) world of philological erudition, a kind of aesthetic science that carries experience back to the "pre-existent", on which it is impossible for us nowadays to turn our backs.'[3] Mariani's definition of the pre-existent is, however, fairly narrow – the artists of the past to whom he refers include Raphael, Titian, Guido Reni and Jacques-Louis David, but also much lesser lights from the Neoclassical epoch, such as Anton Raphael Mengs, Angelica Kauffmann, the sculptor Lorenzo Bartolini and the painter Vincenzo Camuccini. Of the last of these Stendhal once said: 'these large canvases teach one nothing new and leave no remembrance: they are correct, decent and cold.'[4] Mariani's work bases itself on the ideas enunciated by J.J. Winckelmann, the German scholar whose researches into Greek art were largely responsible for setting the Neoclassical movement in motion. In Modernist terms, we are invited to see it chiefly as another form of Conceptual Art.

Another issue which arises in Mariani's work is the question of appropriation, since his paintings are very often copies or partial copies after other artists. The notion of appropriation does in fact appear sporadically throughout the whole history of Modernism, but it was Pittura Colta which, in the mid-1970s, reformulated it so as to create a kind of art in which the figurative and the conceptual could coexist comfortably. Interestingly enough, precisely similar issues arise in the work of many Super Realist artists, such as Chuck Close and Malcolm Morley.

Abate plays a similar game with the idea of appropriation. At one point, in the course of a long interview about his work, he declares that Marcel Duchamp is his artistic point of reference, but immediately adds 'that he is a master for me doesn't mean that I have to follow in his footsteps.'[5] In fact, many of his real roots are in turn-of-the-century Symbolism, as can be seen from his fascination with the figure of Salome (Pl. 266) and his

265 **David Settino Scott**, *Si ld Credet*
Errabit, 1992
Diptych, oil on wood, 205 × 249 cm
(81 × 98 in)

266 **Alberto Abate**, *Salome (verso)*,
1992
Oil on canvas, 180 × 100 cm (71 × 39½ in)

267 **Carlo Maria Mariani**,
Composition 4 – The Expulsion from
Eden, 1989
Oil on canvas, 180 × 180 cm (71 × 71 in)

267

268 Vittoria Scialoja, *The Bunch of Grapes*, 1992
Oil on canvas, 150 × 100 cm (59 × 39¼ in)

269 Antonella Cappuccio, *Ilaria and Guidarello Finally Meet*, 1993
Oil on canvas, 200 × 150 cm (78¾ × 59 in)

270 Bruno d'Arcevia, *The Flag*, 1992
Oil on canvas, 150 × 200 cm (59 × 78¾ in)

references to Rosicrucianism. There is much in his work which comes, not from Neo-classicists like Camuccini, but from Gustave Moreau.

Essentially what both Mariani and Abate want to do is to create a kind of art that is both elegant and learned, which goes along with the artistic conventions of its time (by placing great emphasis on content and intellectual background), but which at the same time seems to flout them through its emphasis not only on figuration itself but also on an extremely skilled and polished presentation of figurative elements. Figuration is not there for its own sake, as it is in the work of the Realist artists discussed in the preceding chapter, but because it acts as part of a mechanism of provocation.

This is also true, though to a somewhat lesser extent, of other artists associated with Pittura Colta. Vittoria Scialoja's *The Bunch of Grapes* (Pl. 268) is scarcely distinguishable from the kind of painting an Italian Neo-classicist might have produced in the early years of the nineteenth century. Antonella Cappuccio's *Ilaria and Guidarello Finally Meet* (Pl. 269) is more problematical. It follows the pattern set by many paintings of the seventeenth and eighteenth centuries which illustrate Ariosto's poem *Orlando Furioso* or Tasso's *Gerusalemme Liberata*. The combination of female nude with a male figure in armour was one especially liked by Baroque artists for its erotic possibilities. Among the Neo-classicists, however, only Ingres seems to have exploited the combination, in paintings of Ruggiero rescuing Angelica. Cappuccio's version imbues the idea with something indefinably but unmistakably Modern. The specific detail which confirms the contemporary status of the composition is Guidarello's head, a recognizably twentieth-century physiognomy, with no connection to the male types preferred by the late eighteenth- and early nineteenth-century Neo-classicists.

A yet greater degree of stylistic dislocation can been found in Bruno d'Arcevia's *The Flag* (Pl. 270). At first glance it may look like a standard late Baroque-transitional to Neoclassical composition, inspired perhaps by artists such as Gaetano (1734-1802) or Ubaldo Gandolfi (1728-81), but on closer inspection the deliberate anomalies soon become apparent. No artist of the late eighteenth century would have included the Gothic church

268

269

270

Post-Modernism and Neo-Classicism

seen on the left in such a composition, still less the Aztec mask which appears at the centre. There is also the telling fact that the subject of the painting is non-specific, in a peculiarly contemporary way. Comparisons can be made here with the work of Tibor Csernus (Pl. 257). A painting of this kind claims the right to plunder several cultures simultaneously, and this is a thoroughly twentieth-century thing to do.

There are a number of American artists, linked to the Pittura Colta movement but not officially part of it, who have explored classical and Neoclassical source material. The closest to artists like Mariani and Abate is the Californian David Ligare. Ligare's *Hercules Protecting the Balance between Pleasure and Virtue* (Pl. 271) is a painting which, for all its physical solidity of imagery, has a conceptual basis. It makes visible, in emblematic form, an age-old philosophical problem. While there are Old Master paintings showing *Hercules at the Crossroads* (i.e. forced to choose between vice and virtue, as in the well-known painting by Annibale Carracci at Capodimonte), there is none that I know of which ponders Ligare's more complex theme. His aim, however, is precisely the same as that attributed to Annibale by the seventeenth-century commentator G.P. Bellori (1672) – to 'unite nature and the Ideal'.[6] Ligare's figures, unlike those of Mariani and Abate, are not simply imagined, or taken from pre-existing pictorial sources – they are studied again from life, and one can detect in them elements of the superbly beautiful and healthy Californian students Ligare employs as models. A comparison can be made with the sculptures of the Super Realist John de Andrea, who makes use of similar source material.

The situation is somewhat different in the work of the late Milet Andrejevic (Pl. 272), since there the figures are always in modern dress. Andrejevic created modern genre compositions, mostly set in New York's Central Park, which are firmly founded on the example of Poussin. Andrejevic proposes that Poussin's ideal, exactly regulated pictorial world can be translated directly into modern terms.

A somewhat different, but parallel, proposal, is put forward in recent paintings by the Canadian-born André Durand, who lives and works in Britain. Durand's *The Death of Adonis* (Pl. 273) is one of a series of works which are

271 **David Ligare**, *Hercules Protecting the Balance between Pleasure and Virtue*, 1993
Oil on linen, 152 × 142 cm (60 × 56 in)

272 **Milet Andrejevic**, *The Encounter*, 1983
Oil and egg tempera on canvas, 91 × 127 cm (36 × 50 in)

273 **(overleaf) André Durand**, *The Death of Adonis*, 1993
Oil on canvas, 189 × 295 cm (74½ × 116¾ in)

272

commentaries on Michelangelo (Durand believes that Sebastiano del Piombo's *Death of Adonis*, of c.1509, on which his own painting is based, is founded on a design by Michelangelo, who frequently helped Sebastiano with his paintings). At first glance, Durand seems to be using 'appropriation' just as Mariani does. It is only when one looks again that one sees the twentieth-century cityscape that fills the whole horizon. An age-old myth is being put into a modern setting in the most literal way possible. Durand sees this as a way of asserting its universal importance.

Two other artists who subtly modernize the ancient world, each in different ways, are Robert Graham and Peter Saari. Graham's graceful figures, usually but not invariably female (Pl. 274) are the equivalents both of Greek Tanagra figurines in terracotta and of the decorative bronzes from Renaissance workshops. They contain elements drawn from both of these sources but remain unmistakably of our own day. In providing yet another variant of contemporary classicism Graham is asserting the cultural continuity which many contemporary artists seek assiduously to deny.

Peter Saari's deceptively brilliant imitations of ancient fresco fragments (Pl. 275) bring the argument full circle. They are at one and the same time examples of Super Realism, as deceptive in their own way as the *trompe l'oeil* paintings of William Harnett, and examples of the lure exercised by the idea of classicism. They belong to the kind of mock-archaeological trend represented by artists like Charles Simonds (Pl. 178), and they are, at the same time, unarguably apt examples of late Modernist appropriation. The real lesson to be drawn from them is, perhaps, the shaky and provisional nature of any system of stylistic classification, as applied to the contemporary visual arts from the 1970s onward.

274 Robert Graham, *Figure II-G*, 1989–90
Painted bronze, height of figure 37.7 cm (15 in)

275 Peter Saari, *Untitled (Red with Column)*, 1977
Plaster and acrylic on canvas, 228 × 137 cm (90 × 54 in)

British Figurative Painting

Increasing doubts about the validity of purely stylistic classifications led, from the early 1970s onwards, to a greater, though sometimes rather shamefaced, interest in the influence of national origins. Shamefaced because, in the strictest Modernist terms, such an interest was a heresy. It was heretical because it seemed to deny the universal validity of Modernist doctrines, and their applicability to all possible aesthetic situations.

One of the first manifestations of the new nationalism in art was German Neo-Expressionism, which has already been discussed in Chapter 6. This found a measure of intellectual respectability because the artists concerned were so much obsessed with the politics of the situation – Germany's horrific past, the deep divisions in German culture revealed by history, and the physical division of what had been one nation into opposing territories living under different political systems. All of these provided a justification for a measure of conscious 'Germanism' in the art produced by a new generation of German artists. By turning to Expressionism as a source, they also seemed to be reaffirming Modernist values in the face of what Nazism had done to their country.

In Britain, the situation was rather different. British art had never been a secure part of the Modernist cosmos. The triumph of the major art movements which had flourished in the continent of Europe and in the United States had always been both temporary and partial. Vorticism had established a very brief foothold for a form of Futurism; later, in the inter-war period, there was an attempt to establish a British branch of the international Surrealist Movement. This culminated with the major Surrealist exhibition held in London in 1936, which included a number of British participants side by side with members of the Paris-based élite, among them Salvador Dali, who nearly asphyxiated himself when trying to make a speech while wearing a diving suit. The most important British artists to take part – Henry Moore and Paul Nash – were never plausible converts to the Surrealist way of thinking, and soon drifted away from any attachment to the movement. Between the wars some of the most important British artists, chief among them Stanley Spencer, worked in complete isolation from anything the European avant-garde might be doing. At the end of the period, there was in fact a visible reaction away from what was happening in Europe. The restrained naturalistic style of the Euston Road Group, which included William Coldstream and the young Victor Pasmore amongst its members, looked back to the work of the pre-Modernists of the Camden Town School, and to the work of Sickert in particular.

In the 1960s there were, to all appearances, only two major tendencies in British painting, both related to things that were happening in the United States. One was the British version of Pop Art; the other was the abstract work produced by members of the Situation Group (founded in 1960), under the influence of American artists such as Barnett Newman and Ellsworth Kelly (Pls. 59, 60).

This neat dichotomy, however, served to conceal a rather different reality, which was that British art remained stubbornly individualist and detached from outside influences. Its major masters, such as Francis Bacon, pursued their own personal line of development, indifferent to anything that might be happening elsewhere. It took a foreign artist domiciled in London to recognize the reality of the situation. In 1976 R.B. Kitaj curated an exhibition entitled *The Human Clay*, seen first at the Hayward Gallery in London, and later circulated to a long list of other public galleries in Britain, and then (in 1978) to two in Belgium. In his preface to the exhibition catalogue, Kitaj introduced the idea that there existed what he called a School of London, which brought together artists not generally regarded as having much resemblance to each other, among them Bacon, Auerbach, David Hockney and himself.

The artists mentioned have already been discussed in earlier chapters (Pls. 41–3, 185, 187), but there is one important member of Kitaj's School of London who has not so far been considered, Lucian Freud (Pl. 276). Freud's personal history and the development of his reputation and career all follow a totally individual pattern. The grandson of the founder of psychoanalysis, Sigmund Freud, he was born in Berlin in 1922, and came to Britain in 1933, being naturalized as a British subject six years later. Most of his training as an artist was received at the small, informal East Anglian School of Painting and Drawing run

276 Lucian Freud, *Painter and Model*, 1986–7
Oil on canvas, 160 × 120.5 cm
(63 × 47½ in)

277

by Cedric Morris and his partner Lett Haines at Dedham in Suffolk.

Freud was a precociously gifted draughtsman, and made an early reputation as one of a group of Neo-Romantic artists who flourished in Britain immediately after the war. He was at this stage the friend and rival of Francis Bacon, who was some twelve years older, but initially less well known. Their circumstances altered in the course of the 1950s, however. Whereas Bacon gradually became more celebrated, even if always controversial, Freud drifted out of the mainstream of artistic development. Awarded a major prize at the Festival of Britain in 1951, he was by the end of the decade completely overshadowed not only by Bacon himself, but by the new artists, such as Hockney, who were to dominate the British art world in the 1960s. He now found steady patronage in a small, aristocratic circle well away from the circle of public tastemakers. Among his steadiest patrons, for example, was the Duke of Devonshire, who commissioned a series of portraits showing members of his family. The catalogue of the exhibition which totally transformed Freud's reputation, and turned him into a major international star – the retrospective held at the Hirshhorn Museum and Sculpture Garden, Washington DC, in 1987, and at the Hayward Gallery, London, in the following year – lists no major article on his work between 1955 and 1971.

In the intervening years Freud's style had been modified and entirely renewed. The sharp-edged forms typical of his early, Neo-Romantic work had now been replaced by powerful, painterly modelling, built up with the brush. His work did not have the Expressionist flavour characteristic of Auerbach and Kossoff, but, in its pitiless scrutiny of reality, reminded many observers of the German artists of the Neue Sachlichkeit (New Objectivity) style of the 1920s, chief among them George Grosz and Otto Dix. Freud was too young to have known these artists during his Berlin childhood, which overlapped exactly with their heyday, but he seemed to revert to their vision through some kind of unconscious atavism.

Freud's importance to the British art scene was less this, however, than another aspect of his work – an aspect both obvious and yet at the same time easily passed over. Freud is an

entirely studio-bound painter, who depicts
only what he sees in front of him. His work
has no flights of the imagination, of the kind
one discovers in Bacon. This insistence on the
importance of the thing seen can also be found
in the work of British artists whose background
is very different from that of Freud. Euan
Uglow, for example, is a disciple of William
Coldstream, the chief theoretician and
pedagogue of the Euston Road Group. His
female nude, *The Lightest Painting on Earth*
(Pl. 277), is a demonstration of method as well
as a representation of a particular, very simple
subject. The faint vertical and horizontal
lines apparent on the model's face and body
are evidence, deliberately left visible, of
an elaborate process of measuring – the
scaffolding on which the painting has been
constructed.

Leonard McComb's *Still Life with Lemons,
Cannes* (Pl. 278) is another example of this
persistent, almost puritanical approach.
McComb has said: 'In art it is easy to be
personal; the real problem is to speak to
strangers.'[1] This deliberately traditional
composition is a visual statement of the same
point of view. It is intended to demonstrate
what the parameters are – the things which
alone art can do, which lie outside the
capacities of other forms of expression.
McComb intends to recall such great names
as those of Chardin, Cézanne and Matisse,
and he intends to recall them within a very
particular context.

Freud, Uglow and McComb are now
all established artists, but the idea of
representation as a direct assertion of moral
strength persists in the work of younger British
artists, chief among them John Monks, whose
Portrait of a Room (Pl. 279) is once again
an assertion of the necessity for direct
observation, then long and patient labour
to give fullest realization to what has been
observed. His work, like that of his seniors, is
Realist, but it has nothing to do with the vision
of the camera. Reality is something which has
to be penetrated emotionally, comprehended
from within, then made fully available to the
spectator, through patient manipulation of the
artist's materials.

In current British art there is a wide variety
of Realist painting on offer, and much of it
seems to relate to the idea that working in this

278

279

280 Jonathan Waller, *Chainsaw*, 1989
Oil on canvas, 229 × 335 cm (90 × 132 in)

281 Tai Shan Schierenberg,
Crouching Woman with Chair, 1993
Oil on canvas, 35.5 × 25.5 cm (14 × 10 in)

282 Philip Harris, *Two Figures in a
Shallow Stream*, 1992
Oil on canvas, 183 × 107 cm (72 × 42 in)

280

281

fashion has an essentially moral undertone.
The concept seems to unite artists who are in
other respects as different from one another
as Philip Harris and Tai Shan Schierenberg.
Harris's *Two Figures in a Shallow Stream*
(Pl. 282) is a painting whose technique, if not
subject-matter, John Ruskin would surely have
understood, so close does it come to the early
work of artists like Millais and Holman Hunt.
As a piece of brilliant, sharp-focus observation
it gives the lie to any assertion that traditional
skills have now been completely forgotten.
Yet it also seems to go further than this, and to
assert that the artist can actually control the
external world, shape it to his purposes, simply
through faithful intensity of observation.

Schierenberg's *Crouching Woman with
Chair* (Pl. 281) is obviously indebted to Freud.
Paint is used in much the same way, to model
not only the outward appearance but the
psychic essence of the subject. Once again, the
painting is almost as much about the act of
seeing, as it is about what is seen. And it, too,
seems to present this intense visualization as
being essentially a moral act.

The centrality of Realism to the British
painting of the last thirty years has allowed
artists to play many variations on what seems
like a fairly limited theme. If one compares
Jonathan Waller's *Chainsaw* (Pl. 280) to
Shierenberg's painting one notes not only
the change to a very different colour-gamut,
but also the fact that the imagery is slightly
caricatured. The approach here is akin to the
rumbustious attitudes of the eighteenth-
century draughtsman Thomas Rowlandson.

Another instructive pairing, the more
interesting because of the identity of subject-
matter, can be made between the work of two
gifted women artists. Alison Watt's *Winter
Nude* (Pl. 283) takes a subject particularly dear
to Freud, a female nude in the studio, and treats
it with a cool Art Deco classicism reminiscent
of the work of Dod Proctor, a woman artist well
known between the wars in Britain. Jenny
Saville's *Prop* (Pl. 284) shows a very different
nude on a stool, looming and monstrous. The
possible influence here may be the celebrated
photographs of female nudes by the British
photographer Bill Brandt, taken with a pinhole
camera. The two paintings indicate not only
the wide range of stylistic approaches possible
to artists who nevertheless choose to remain

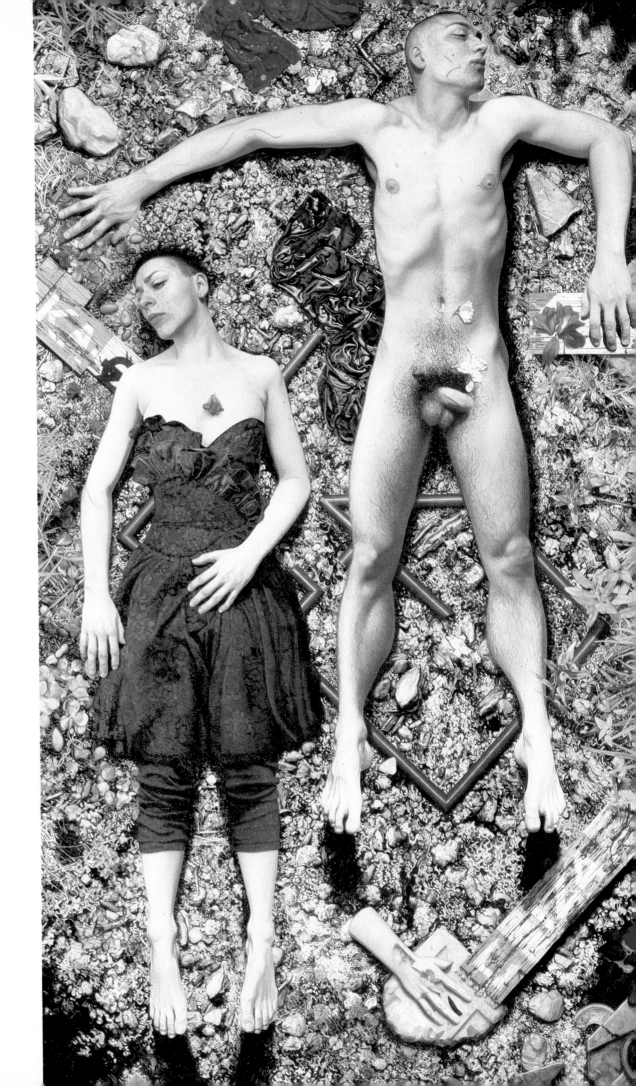

283 Alison Watt, *Winter Nude*, 1992
Oil on canvas, 122 × 137 cm (48 × 54 in)

284 Jenny Saville, *Prop*, 1993
Oil on canvas, 213 × 183 cm (84 × 72)
Saatchi Collection, London

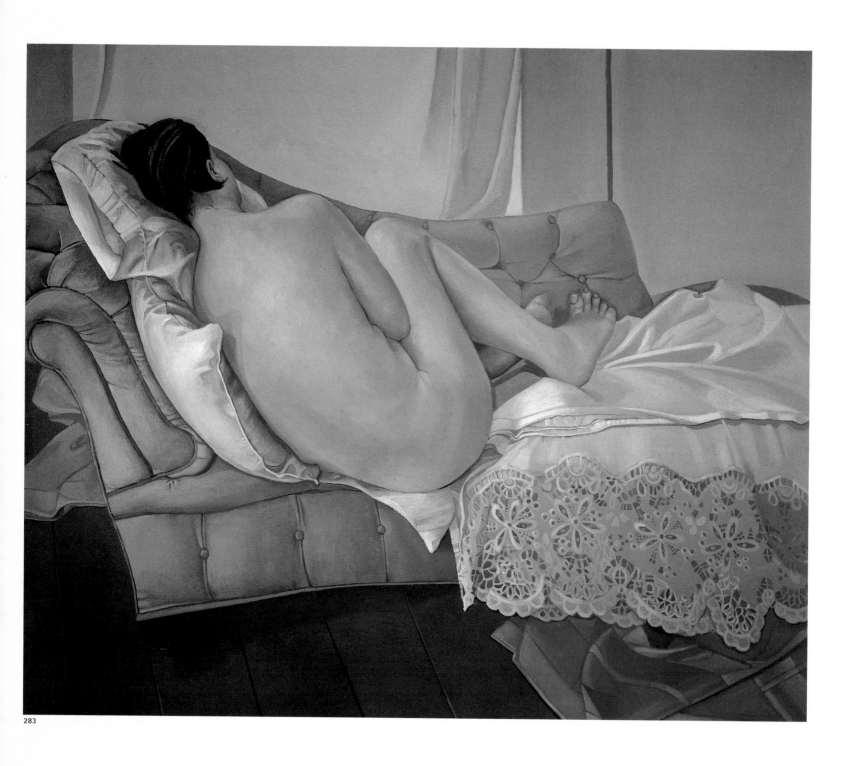

283

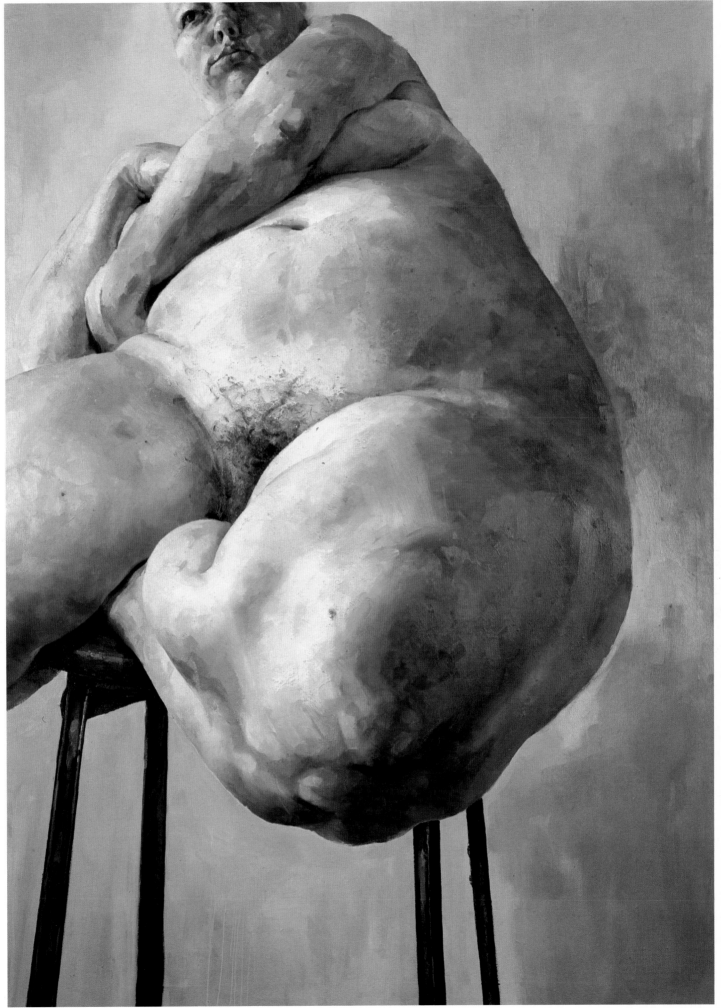

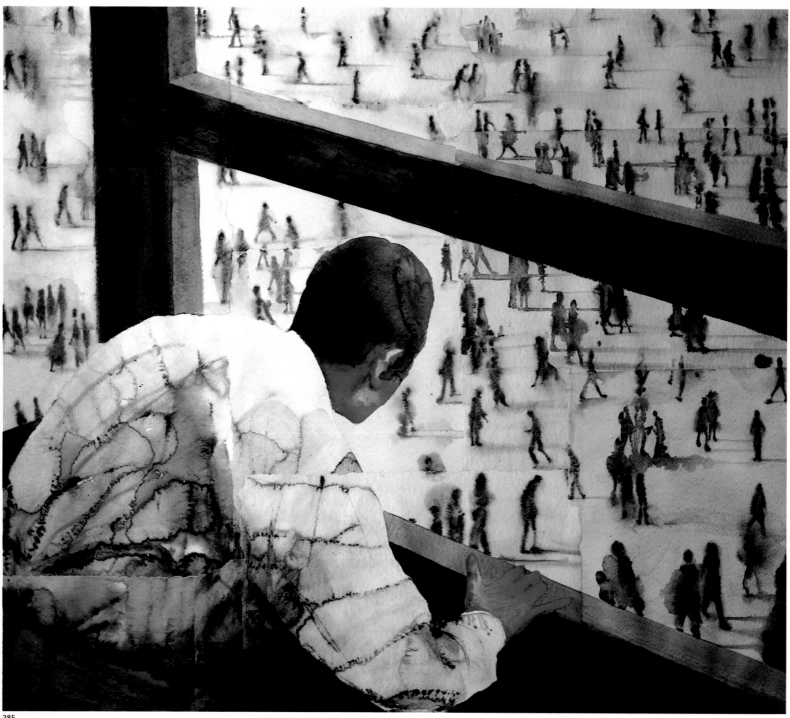

British Figurative Painting

under the Realist umbrella, but also the even larger range of possible references. It is significant, however, that both artists seem to have chosen exemplars who form part of their own national tradition.

Sometimes the references are so absolutely specific that it needs a fairly full acquaintance with the history of British art and other related forms of artistic activity, such as landscape gardening, to catch the full meaning. Ian Gardner has collaborated extensively with the poet-sculptor Ian Hamilton Finlay (Pl. 101). His large watercolour *The Allotment* (Pl. 286) forms part of a series of works which includes other smaller watercolours and notebooks concerning an allotment which he and his wife cultivate near their home town, Lancaster. Gardner sees the allotment as a kind of social paradigm, symbolic of his relationships with the other allotment holders whose patches of ground surround his own, and also as a lineal descendant of the medieval *hortus conclusus*, the enclosed garden which is the traditional emblem of paradise. He has chosen to depict this space using the technique eighteenth-century drawing masters taught their pupils, with flat transparent washes laid over a tinted ground. As he points out, this technique is about as far from the notions of spontaneity and immediacy usually associated with watercolour as it is possible to get. The painting is a rational progression, and expresses all aspects of that progress in the finished result. It is only the deceptively traditional subject which conceals the conceptual basis of the work.

Another British painter who makes skilful use of watercolour is Graham Dean, whose work sometimes has a surreal, dreamlike precision. The solidly realized figure in *Foreign Correspondent* (Pl. 285), for example, gazes from an upper window at what is apparently a vast plaza crowded with figures. The spectator only realizes after looking a second time that these figures are all in monochrome. The voyeur instinctively feels that they have a diminished reality, when compared to himself.

Other British Realists also play with the spectator's perceptions. In a long series of meticulously painted still lifes, Harry Holland shows found objects whose identity is not always immediately apparent (Pl. 287). The viewer reads them as abstractions, while at the

same time remaining aware that they are close to traditional *trompe l'oeil*. Once again there is a precedent in the British art of the inter-war period: Edward Wadsworth used bollards and other anonymous nautical items in much the same fashion.

One direction taken by British Realism has been towards an analysis and criticism of society. This is visible in David Hepher's urban landscapes, where the meticulous depiction of a tower block (the symbol of social deprivation and urban blight in London and other British cities) will be overlaid by brutal graffiti, seemingly sprayed on the window-pane through which the view is seen (Pl. 290). Equally critical, but more romantic and

286

287

rhetorical in their approach, are some of the paintings of John Keane. Keane's *Fairy Tales of London I* (Pl. 288) is not so much a direct representation of urban deprivation as an indignant poetic gloss on the subject. The giveaway is the emblematic skull in the right foreground. Yet even without this clue, and the further clue offered by the title, it would be hard to see this urban mother, trudging through a desolate cityscape with a wire basket of consumer products on her back, as anything other than an 'epic' personage – a heroic type, rather than an individual. It is interesting to compare Keane's vision of the blue-collar class with that of an American Realist such as Duane Hanson (Pl. 229).

285 Graham Dean, *Foreign Correspondent*
Watercolour on paper, 162 × 141 cm
(64 × 55½ in)

286 Ian Gardner, *The Allotment*, 1994
Watercolour on paper, 112 × 91 cm
(44 × 36 in)

287 Harry Holland, *Cone*, 1993
Oil on canvas, 66 × 56 cm (26 × 22 in)

288 John Keane, *Fairy Tales
of London I*, 1992
Oil on canvas, 206 × 163 cm
(81¼ × 64¼ in)

289 Peter Doig, *Window Pane*, 1993
Oil on canvas, 250 × 200 cm
(98½ × 78¾ in)

290 David Hepher, *Ruff n Tuff*, 1993
Oil on canvas, 274.5 × 137 cm
(108 × 54 in)

291 Robert Mason, *Working in the Isle
of Dogs*, 1993
Acrylic on board, 150 × 99 cm (59 × 39 in)

In his paintings of London construction sites Robert Mason takes a much cooler look at urban reality. *Working in the Isle of Dogs* (Pl. 291) might seem a good theme for a contemporary vision of hell, but Mason chooses to treat it with cool detachment. The composition is photo-based, but Mason does not work the image up to a high, sharp-focus polish, choosing instead to half-drown it in iridescent paint. This has the effect of romanticizing the event, rather as J.M.W.

288

289

290

Turner romanticizes the Industrial Revolution in his celebrated painting *Rain, Steam and Speed* (1844). Mason's painting shows the tension between Romanticism and sober recognition of established facts which has long been characteristic of British art. Something similar can be found, expressed by rather different technical means, in recent work by the British-Canadian artist Peter Doig (Pl. 289). Doig's heavily worked surfaces, with their finely graduated colour changes, encourage the

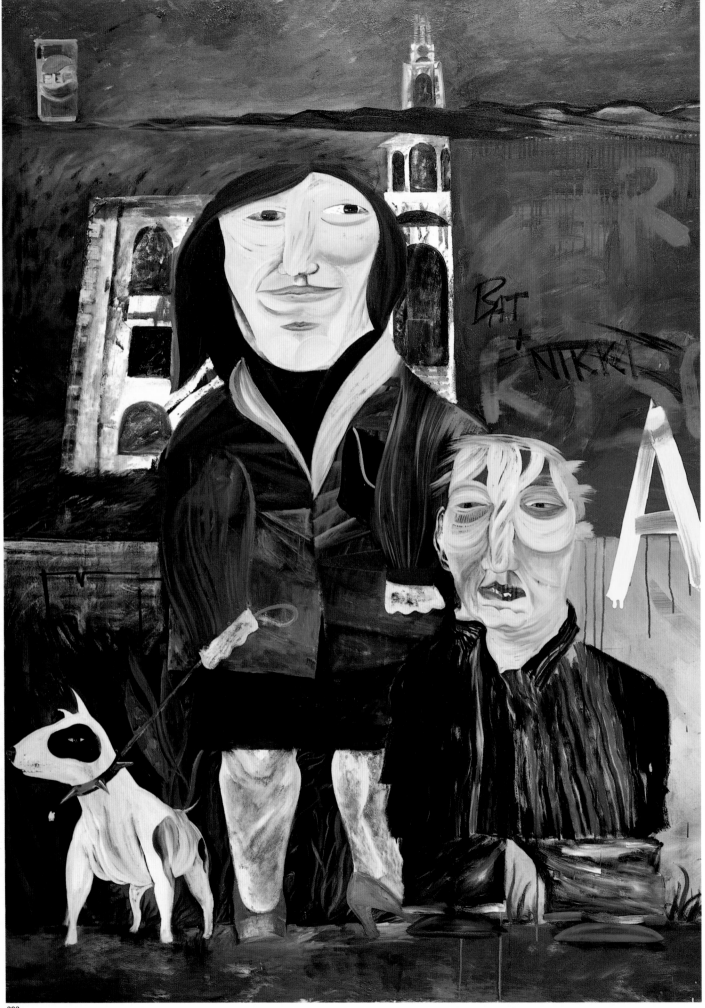

viewer to read the paint surface as something essentially abstract. It is only later that he or she realizes Doig is making a quite precise image of landscape. *Window Pane* uses a version of an idea used by David Hepher to obtain a very different psychological effect: the distant view is deliberately obscured, in this case apparently by a combination of condensation and frost. Doig is something of a specialist in winter scenes.

Not surprisingly, there is a strong element of Expressionism in much recent British painting. This can be attributed to several sources. There is the influence of Bomberg and his followers, particularly that of Frank Auerbach, now one of the most respected of all senior British artists. There is also the impact made in Britain by German Neo-Expressionism, particularly after the *New Spirit in Painting* exhibition held at the Royal Academy of Arts in 1981. One of the British artists included in this was Bruce McLean – he was one of the youngest participants, having been born in 1944. His original reputation was made as one of the collaborators in the performance group Nice Style, which flourished in the mid-1970s, and his paintings were originally an offshoot of props and settings made for this group. McLean's version of Expressionism is therefore much more decorative and lightweight than its German equivalent. Despite the radical difference in texture there is a similarity between McLean's *Oriental Waterfall, Kyoto* (Pl. 293) and Peter Doig's *Window Pane*, especially in the handling of space. In this respect both are descendants of that least Expressionist of painters, James Abbott McNeill Whistler. This similarity, fortuitous or not, supplies yet another example of the way in which the pre-Modernist past constantly makes its presence and influence felt in contemporary British art.

In general, however, the Expressionist strain in British painting is linked to a strong element of social concern. A painting like Jock McFadyen's *Hawksmoor and Pepsi* (Pl. 292) is much more typical in tone than McLean's orientalizing landscapes. McFadyen concentrates here, as in many other paintings, on the problems of urban deprivation. His figures are not realistic portrayals, but projections of states of mind, as well as being emblems of the social condition.

292 Jock McFadyen, *Hawksmoor and Pepsi*, 1988
Oil on canvas, 209 × 152 cm (82½ × 60 in)

293 Bruce McLean, *Oriental Waterfall, Kyoto*, 1982
Acrylic and chalk on cotton, 380 × 150 cm (149½ × 59½ in)

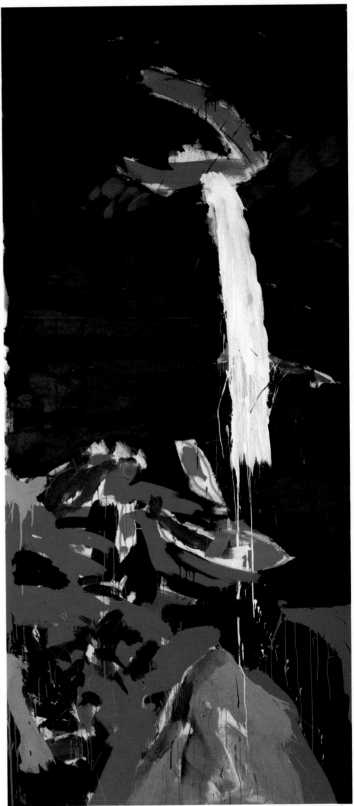

293

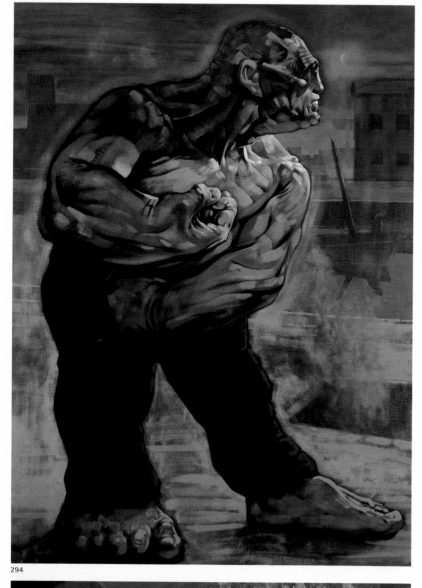

294

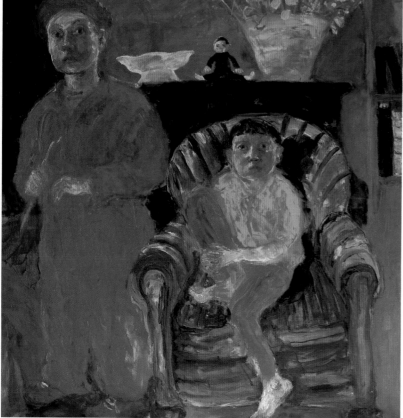

295

A rather similar attitude can be found in the paintings of the extremely prolific Peter Howson (Pl. 294), one of a group of Scottish painters from Glasgow who made a considerable impact on British art in the 1980s. Howson's figures carry a greater freight of historical meaning than those of McFadyen. It is readily evident that he is intent on seeing British, or in this case specifically Scottish, society through the eyes of the German Neue Sachlichkeit – more specifically, through those of Otto Dix. Compared with Dix and his peers, however, Howson seems rhetorical; his work is more about fellow feeling for the deprived than about actual observation of their plight.

A number of British artists have turned to the German art of the early decades of the century, looking for a means of escape from what seems to them the overpowering gentility of the British tradition. One of the most striking of these is Tony Bevan, whose figures, while considerably more naturalistic than those of Howson, have a strange hallucinatory force. Even when Bevan paints a group, as he does in *The Meeting* (Pl. 296), its components are isolated. Lustily singing or shouting, these men and boys stand shoulder to shoulder, but remain essentially alone. One of Bevan's sources here is likely to be Edvard Munch, not German but Norwegian. Bevan, like Munch, is a poet of isolation; he is interested, not in social ills, as Howson seems to be, but in the crushing sense of isolation which seems to haunt so many contemporary artists.

There is also an element of this is the work of the young Welsh painter, Shani Rhys James (Pl. 295). Rhys James, nevertheless, does provide her figures with settings, rather than putting them against the plain backgrounds in glaring colours favoured by Tony Bevan. Her paintings are in one sense very British: they are nearly always autobiographical, sometimes using works of literature, such as Lewis Carroll's *Alice in Wonderland* or *Alice Through the Looking-Glass*, as a form of mask or disguise, but generally tackling the family situation very directly. Her themes are her own relationship to her parents, her insecure upbringing, and her relationship to her own children. One of her artistic mentors is the Scottish painter John Bellany, and the fantasy which surfaces in her work, especially in the 'Alice' pictures, can be related to things discovered in him.

294 Peter Howson, *Blind Leading the Blind V*, 1991
Oil on canvas, 244 × 183 cm (96 × 72 in)

295 Shani Rhys James, *The Red Living Room*, 1992
Oil on canvas, 183 × 183 cm (72 × 72 in)

296 Tony Bevan, *The Meeting*, 1992
Acrylic and powdered pigment on canvas, 292 × 284 cm (115 × 112 in)

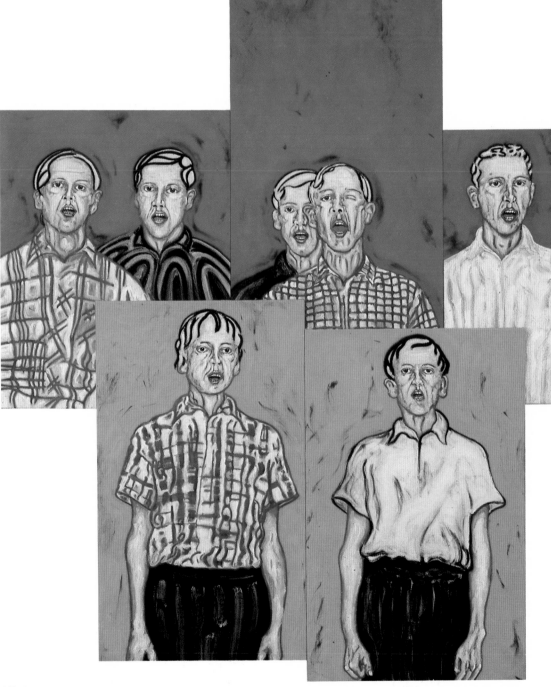

296

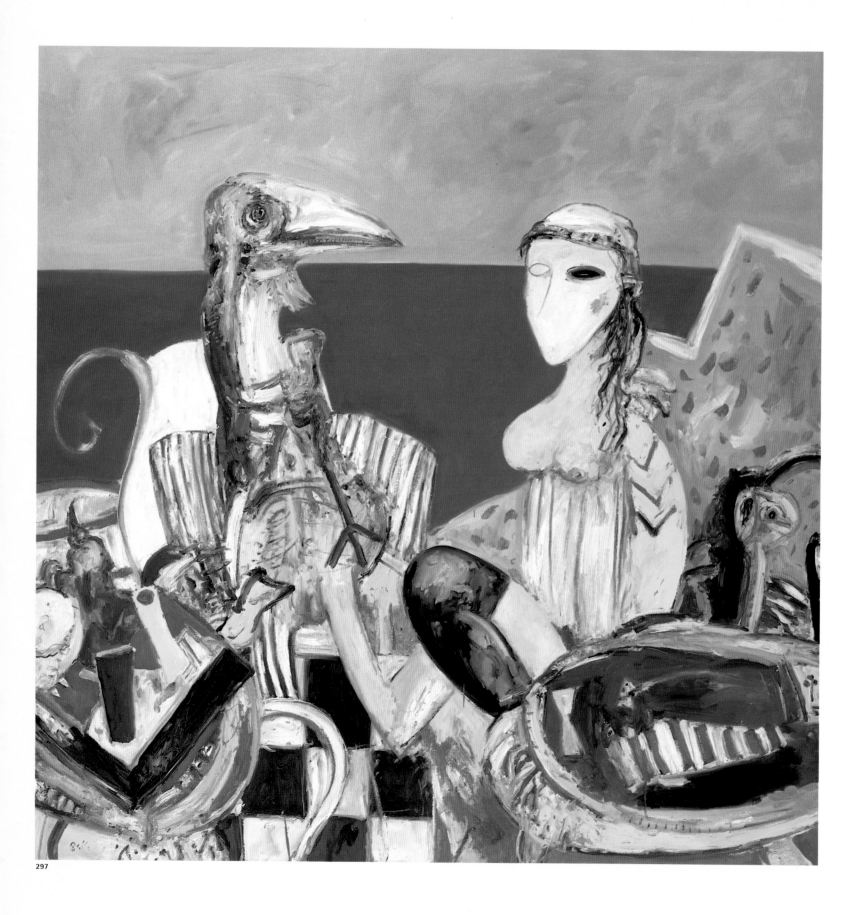

297

Howson was not the first Scottish painter to turn to German art of the earlier part of this century for inspiration. In the 1960s this path was already being trodden by the Edinburgh-trained Bellany, whose mentor was Max Beckmann. Brought up in a small fishing village on the east coast of Scotland, near Edinburgh itself, much of Bellany's most striking imagery is to do with ships and the sea. Bellany is a fantasist, not a Realist. The personages in his paintings undergo strange transformations. In *Lovers by the Sea* (Pl. 297), for example, a man with a bird's head confronts a harpy (or is it a sphinx?). The strongly poetic element in his paintings finds powerful echoes elsewhere in British art – for example, though in very different guise, in the work of his compatriot, Steven Campbell. Campbell's eerie *Dead Man's Cocktail Party* (Pl. 298) shows a skewed and sinister version of the Raising of Lazarus, where the corpse, with arms wrenched backwards, still clutches the bottle from which some elixir is being poured. The composition is perhaps a sardonic comment on the modern custom of holding a party in honour of the deceased, as the up-to-date equivalent of a traditional wake. Campbell uses many devices to dislocate the viewer's perceptions – the most conspicuous being the mountain landscape, completely different in scale, which appears like a kind of predella at the foot of the composition. Another, less obvious, is the clothing: the tweed suits worn by the figures seem to be drawn, not from observation of present-day costume, but from men's clothing advertisements of the 1930s.

Even more fantastic, though making use of the same device of a picture-within-a-picture, is Paula Rego's *The First Mass in Brazil* (Pl. 299). Rego, Portuguese-born but long domiciled in London, has had a remarkable career, moving from a version of Art Brut, influenced by Dubuffet, to her present, much more classical version of figuration. The linking thread has always been not only a strong element of fantasy but also an interest in narrative, and perhaps this is why her work has been so successful in Britain, where the commitment to narrative remains strong. *The First Mass in Brazil* shows a female figure lying fully clothed on a narrow iron bed, in a state of reverie rather than sleep (her eyes are open). Behind her on the wall hangs a painting which

297 John Bellany, *Lovers by the Sea*, 1993
Oil on canvas, 172.5 × 172.5 cm
(68 × 68 in)

298 Steven Campbell, *Dead Man's Cocktail Party*, 1992–3
Oil on canvas, 282.5 × 269 cm
(111¼ × 106 in)

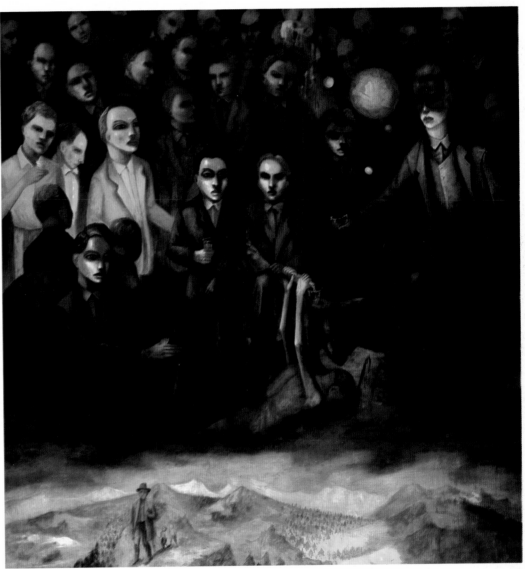

298

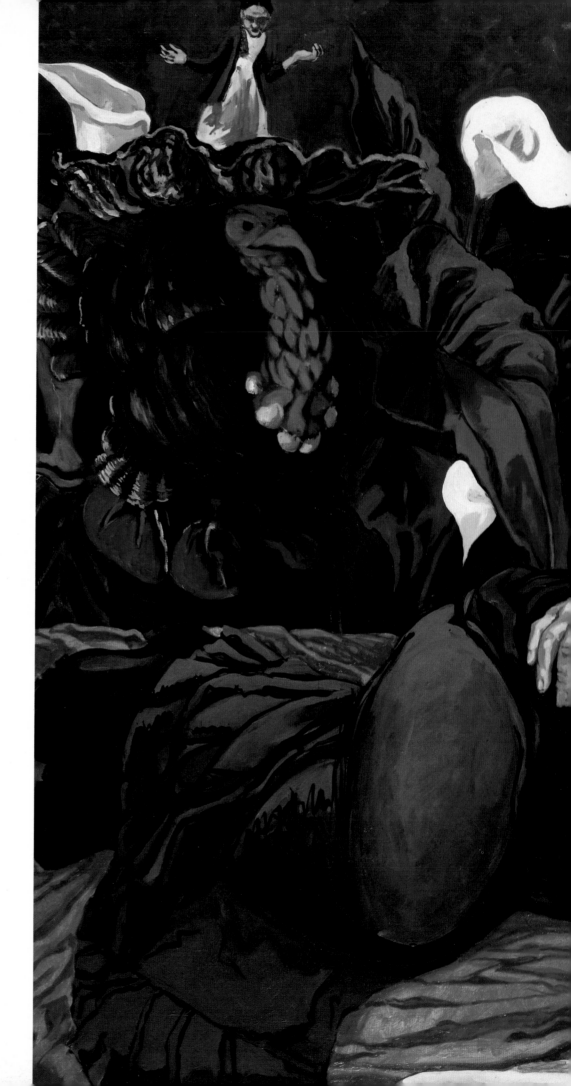

299 Paula Rego, *The First Mass in Brazil*, 1993
Acrylic on paper on canvas,
130 × 180 cm (54¼ × 70⅞ in)

300 **John Kirby**, *Dream of Another Place: The Gift*, 1990
Oil on canvas, 152 × 122 cm (60 × 48 in)

301 **Stephen McKenna**, *The Crossing*, 1990
Oil on canvas, 160 × 120 cm (63 × 47¼ in)

302 **Ansel Krut**, *Annunciation in the Studio*, 1993
Oil on canvas, 184 × 167.5 cm (72½ × 66 in)

shows the event described by the title. Yet this is not a logical or naturalistically depicted space. Under the painting runs what seems to be a trough filled with water, in which miniature human figures are floating or drowning. In a corner is a draped table, with a large turkey cock (symbol of the Americas) amid a clump of arum lilies. Standing in a kind of calyx above the turkey is another miniature figure, her white dress stained with blood. The subject of the painting is therefore the 'fatal impact' which occurs when European civilization comes into touch with non-European counterparts. The painting uses a mixture of old methods and new ones – the kind of allegory one might find in Tiepolo

300

301

combined with the kind of symbolism one might discover in Dalí.

An artist who makes a similarly sophisticated use of symbolic elements, but who combines them with a strong strain of autobiography, is John Kirby. Kirby was a slow starter as an artist, having tried a number of other occupations first, among them those of salesman in a Catholic book shop, stage doorman at Covent Garden Opera and probation officer. His paintings are about his Catholic upbringing, his homosexuality, and his need both to connect with the world yet to withdraw from it. *The Gift* (Pl. 300) combines some of these aspects. The kneeling figure is a self-portrait, identified as such not only by the

features but also by the small bluebird tattoo on the right shoulder, which is identical to one which Kirby himself has in the same position. The stage-prop wings, which appear in a number of other paintings by Kirby, are a reminiscence of school nativity plays, but also an emblem of the effort to achieve a state of goodness. Kirby recalls adjurations to 'be an angel' when he was a small child.

All these elements are presented, rather as they are in Rego, in a very direct, deliberately uninflected way. Kirby's influences are Magritte – for his deliberately matter-of-fact technique rather than his paradoxical imagery – and Balthus. One finds the same stiff, rather signboard-like way of painting in Stephen McKenna (Pl. 301), another British artist whose work has strong symbolic overtones. Here the primary influence appears to be the work done in the 1920s by Giorgio de Chirico. McKenna preserves the poetic element in de Chirico, rather than fastening on his more classicizing aspects, which is what one finds in the artists connected with the Pittura Colta movement, who also make use of him.

It is interesting to compare Kirby's annunciatory angel with the figure which takes the same role in a painting by Ansel Krut, a South-African-born artist who is now part of the British art scene. *Annunciation in the Studio* (Pl. 302) shows a black woman, in a long gown of many colours, kneeling before the painter. Behind her is a canvas which bears the artist's name and some rudimentary pictograms, of the kind associated with the art of African Bushmen. Krut, like Rego in her *First Mass in Brazil*, seems to be commenting on the post-colonial situation, and the artist's responsibilities within it, doing so through a re-examination of the typology of Old Master painting. All four artists – Rego, Kirby, McKenna and Krut – are engaged in a complicated dialogue with the past which is quite unlike the radical break with previous ways of thinking envisaged by the early Modernists.

Another example of this re-exploration, though of a less focused kind, can be found in recent paintings by Kevin Sinnott. Sinnott's *The Poet and his Bride* (Pl. 303) is a tribute to the Orientalist painters of the early nineteenth century – in view of the loose handling, the allusion is to Delacroix rather than to Ingres.

302

303

Once again, however, as in Rego, Kirby and Krut, there is a deliberate cultivation of incongruity. The male figure, lying back despairing or exhausted, is wearing modern dress – the naked odalisque beside him seems to play the role of an unattainable muse-figure.

A similar romanticism, expressed in rather different guise, appears in the work of the poet-painter Christopher Cook. Cook is one of the few British painters of his generation who pays much attention to landscape, or at any rate to the idea of a painting as something which sets the stage for an event. *Underbelly* (Pl. 304), like Stephen McKenna's *The Crossing*, is influenced by Giorgio de Chirico – but de Chirico in a somewhat earlier phase, when he was painting the deserted streets and squares of wartime Turin. De Chirico's arcades have been transformed into an art gallery which is also a kind of street – one cannot tell if the beams spanning the space actually support a ceiling. This ominous corridor ends at a horizon line which may or may not mark the entry to another space. Cook is once again juggling with a number of different traditions or attitudes to painting, some Modernist but others traditionalist. For example, he is alluding to the paintings of art galleries filled with pictures which were popular in the seventeenth century. The emotional tone of the work, however, is set as much by its colour and handling as by its actual imagery, and here, I think, one has to recognize the influence of Turner's paintings of interiors at Petworth – great picture-filled rooms where the forms, especially those near the windows, dissolve in a mist of tinted light.

In fact, the striking thing about much of the painting being made in Britain today is the effort which artists seem to be making to recover and make use of the past . They exploit one very important aspect of contemporary culture – the availability of an enormous range of images – to try and create a fusion of cultures, and in particular a fusion of what is traditional and what is modern. No other contemporary school of painting seems to have attempted this to anything like the same extent: it is one of the things which makes it possible to say that the art produced in Britain during the past thirty years has a distinctive national flavour.

303 Kevin Sinnott, *The Poet and his Bride*, 1992
Oil on canvas, 172 × 185 cm (67¾ × 73 in)

304 Christopher Cook, *Underbelly*, 1991–2
Oil on canvas, 122 × 152 cm (48 × 60 in)

304

New British Sculpture

305 **Lynn Chadwick**, *Sitting Figures*,
1989
Stainless steel, height 191.5 cm (75½ in)

306 **Anthony Caro**, *TB Cyclamen*,
1990–1
Bronze and brass,
84 × 61 × 54 cm (33 × 24 × 21 in)

305

It illustrates the fascinatingly anomalous situation in contemporary art that contemporary British sculpture seems to have so little direct connection with what is being done by British painters. Some British sculptors have already been discussed in Chapters 4 and 6, as part of international styles or tendencies such as Land Art or Neo-Expressionism. It is also possible, however, to view the development of sculpture in Britain within a purely national framework, and to learn something important about it from this perspective. The international success of Henry Moore in the immediate post-war years drastically changed perceptions about British sculpture. Before Moore's day, the only British sculptor to achieve a position of international importance was the eighteenth-century Neo-classicist John Flaxman (1755-1826). Flaxman achieved fame throughout Europe, not through his sculptures themselves, but through his enormously influential outline illustrations to the Greek classics.

The first generation of British sculptors after Moore was largely figurative, and included artists such as Lynn Chadwick (Pl. 305), Kenneth Armitage, Bernard Meadows and Reg Butler, as well as Elisabeth Frink (Pl. 208). The majority of these artists are still active. These, in turn, were followed by a group of abstract sculptors led by Anthony Caro, who were heavily under the influence of American art, that of David Smith in particular. Caro, too, is still active (Pl. 306). It was only after Caro's influence had exhausted itself that British sculpture began to diversify in ways which made it impossible to speak of the dominance of any particular stylistic tendency.

Like artists elsewhere, British sculptors responded to perceived social needs. Sculpture, because it is a more 'public' art than painting, is more likely to be found in the immediate environment rather than sequestered in a gallery, and has always been more immediately responsive to such needs than work in two dimensions. In the early 1970s, when there was a feeling that avant-garde art should somehow be democratized and made accessible to as many people as possible, one response was the creation of purely temporary, interactive works. More recently, with the erection of many ambitious public buildings in Modernist and Post-Modernist architectural styles, there

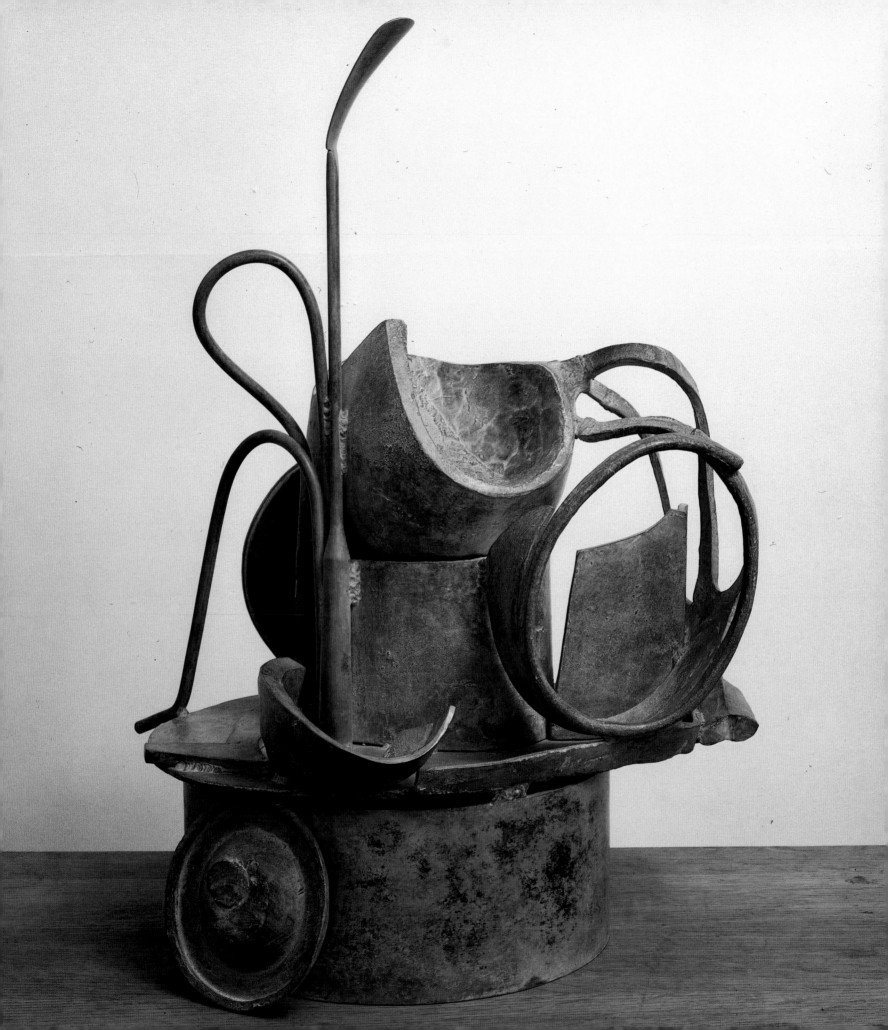

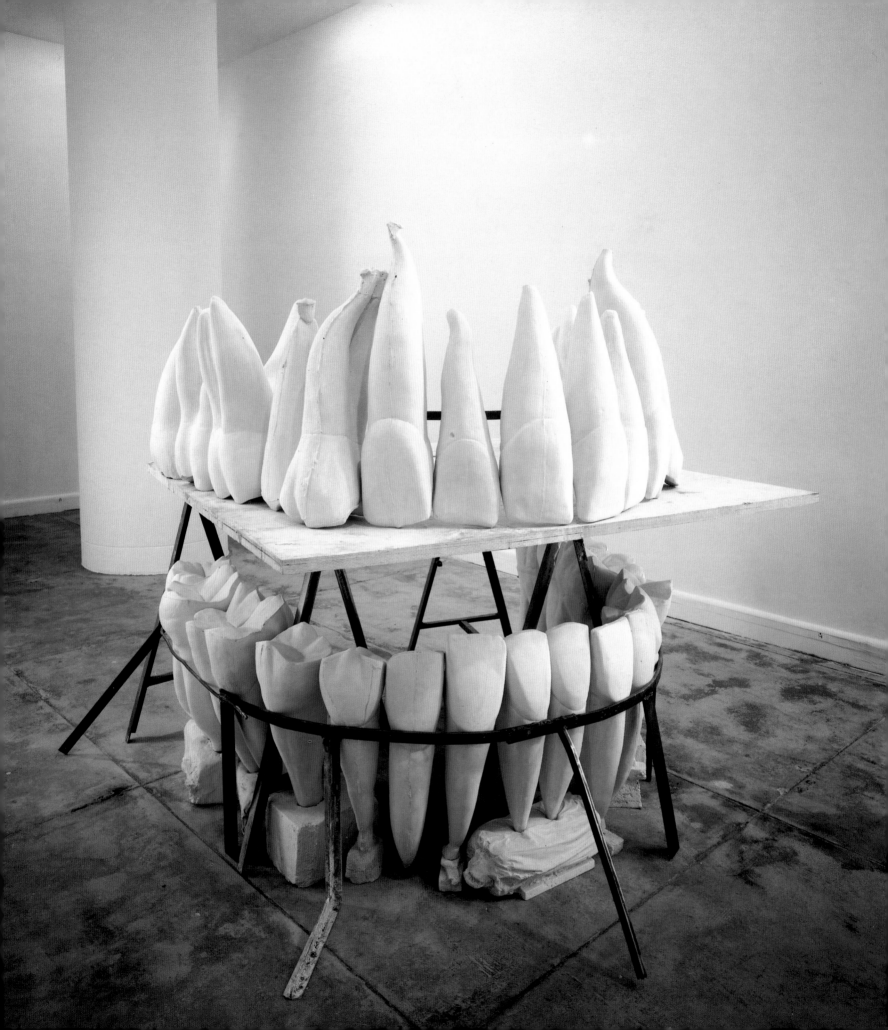

has been a demand for more permanent works in tune with their surroundings. A good example is William Pye's *Chalice* (Pl. 308), which alludes to classical forms, and thus supplies an element of continuity with the past, but also makes expressive use of modern technology.

Art in Britain also responded to shifts in boundaries and changes in categorization within the art world itself. Even when they were not commissioned to create pieces for specific settings, more and more artists were preoccupied with the public sector, and were not creating work which was accessible to private collectors, or amenable to domestic display. The main line of development in current British sculpture is that initiated by Tony Cragg. Cragg is an extremely various and varied artist. When he first appeared on the British art scene, he was chiefly known for works made from urban detritus, such as pieces of plastic salvaged from rubbish dumps. Often these were pinned to a wall so as to form recognizable designs – the Union Jack, for example, or an outline of a Polaris submarine. His work was related to Italian Arte Povera , but had a more directly polemical intent. Later, Cragg made stacked and piled work, once again using salvaged materials, which suggested that he was an urban equivalent for artists like Richard Long (Pl. 124). More recent work still has veered away from either of these tendencies. *Complete Omnivore* (Pl. 307) is a table-like structure made of wood and steel, which encloses and supports a set of giant teeth made of plaster. The references are to Pop Art – particularly to Claes Oldenburg's gigantic enlargements of everyday objects (Pl. 22), and also to the Surrealism of artists such as Dali. An important aspect of sculpture of this type is that its only convincing home is an art gallery.

The artists who can be associated with Cragg are all, like him, essentially makers of assemblages. Bill Woodrow's *L'usine, l'usine* (Pl. 309) brings together the wreckage of various technological and industrial objects, in such a way as to suggest the stultifying nature of life in a modern industrial society. Sculptures of the same sort are also made by David Mach, though generally with a greater sense of fantasy. *Every Home Should Have One* (Pl. 310) combines a discarded cooker,

307 Tony Cragg, *Complete Omnivore*, 1993
Plaster, wood and steel, 154 × 150 × 150 cm (60¾ × 59 × 59 in)

308 William Pye, *Chalice*, 1991
Bronze and stainless steel,
7 x 6 m (22¾ x 19½ ft)
Installed at Fountain Square, 123 Buckingham Palace Road, London

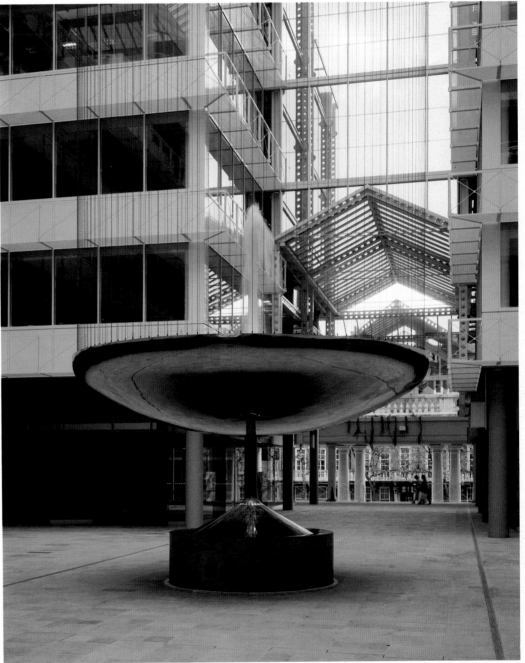

308

309 Bill Woodrow, *L'usine, l'usine*, 1984
Mixed media, dimensions unknown

310 David Mach, *Every Home Should Have One*, 1989
Cooker, microwave, refrigerator and plastic gargoyle, 211 × 127 × 162 cm (83 × 50 × 64 in)

microwave and refrigerator with a figure of a gargoyle, in a cheerful but rather obvious satire on the contemporary worship of consumer objects. Another work by Mach, *The Bike Stops Here* (Pl. 311), is more complex in its implications – and also more interesting, provided that one is a reasonably well-informed student of the history of contemporary art. The up-ended bicycle is a reminder of Marcel Duchamp's first 'readymade' (see Chapter 1, p. 34). The deer

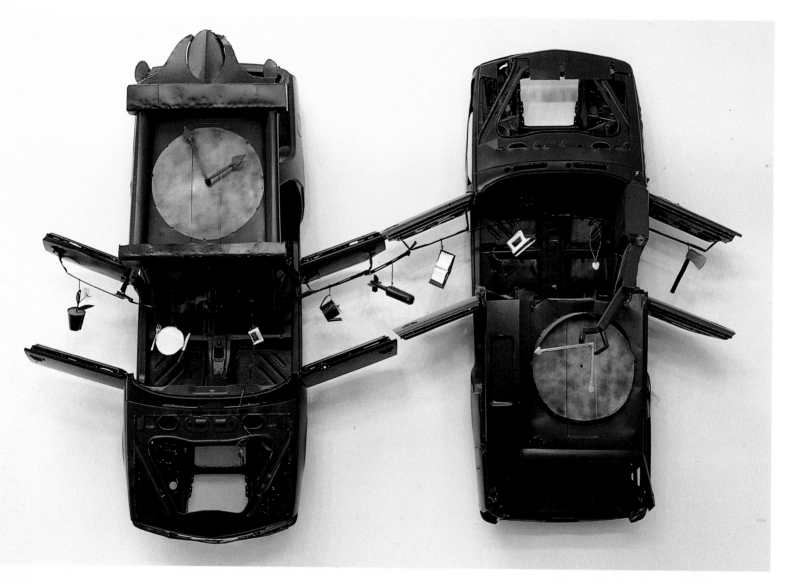

309

head can be seen as a reference to Robert Rauschenberg's combine-painting *Monogram* (Moderna Museet, Stockholm), which features a stuffed goat surrounded by a tyre. And the fact that the deer's antlers are replaced by the handlebars of the bicycle can be read as a reference to a celebrated sculpture by Picasso, in which the seat of a bicycle is combined with the handlebars to create a bull's head (made in 1943, Musée Picasso, Paris). While Mach's piece is a light-hearted compendium of several

New British Sculpture

311 David Mach, *The Bike Stops Here*, 1989
Deer head and bicycle 134 × 134 × 81 cm
(53 × 53 × 32 in)

312 Richard Wentworth, *Gran Falda*, 1990
Aluminium ladder, wire screen and
staples, 411 × 167 × 15 cm
(162 × 66 × 6 in)

313 Richard Wentworth, *Piece of Fence*, 1990
Garden tools and wire, 181 × 228 cm
(71½ × 90 in)

312

313

314

key Modernist works, it also contains a hint
that this line of development is exhausted.

Yet another British sculptor who has
worked in this sort of area, making free use of
commonplace domestic objects, is Richard
Wentworth (Pls. 312, 313). Unlike David
Mach, Wentworth tends to sacralize these
commonplace materials. An ordinary ladder
enclosed within a cage of wire mesh acquires
a metaphysical dimension, almost as if it were
actually the Jacob's Ladder of the Bible, set
aside for ascending and descending angels.

The sculpture of Richard Deacon, who is,
next to Tony Cragg, the best-known British
sculptor of his generation, is often thought
of as being on precisely the same wavelength
as that of artists like Cragg, Woodrow or even
David Mach. This notion will not withstand
any serious examination of the work itself.
Body of Thought (Pl. 314) is a labyrinthine, but
wholy abstract structure, with a number of
standard Deacon trademarks – the feeling that
the forms are under tension, the emphatic use
of visible fixings. By choosing this particular
title, the artist seems to want to tell us that the
forms are a reflection of the motions of the
mind itself. Deacon's work, rather than being a
continuation of certain aspects of Pop, with
moralistic or ironic commentary, continues the
more abstract part of the Surrealist tradition.
Despite the contrast in materials, one can make
a comparison with the sculptures of Hans
Arp, with their swelling biomorphic forms.
However, Deacon differs from the Surrealists in
being essentially an intellectualizing sculptor,
rather than an instinctive or emotional one.
The Interior is Always More Difficult (Pl. 315) is
a visual statement about a problem which has
constantly preoccupied sculptors: the fact that
a sculpture occupies a given volume of space
means that it can sometimes be thought of as a
resistant but hollow skin, enclosing a hidden
space which has to be imagined by the viewer.
Deacon examines this idea by constructing a
sculpture without a true interior, where a top
and a bottom are separated by a translucent
sheet held within a metal frame.

There is a chance but telling resemblance
between this piece and one by a lesser-known
British sculptor of the same generation, John
Gibbons. Gibbons's *The Alliance* (Pl. 316) once
again tackles the question of external and
internal volume, perceived weight and mass

316

317

New British Sculpture

and the perhaps contradictory reality of
genuine weight and mass, by making the main
body of the sculpture an open cage containing
three apparently weighty cylindrical objects.
The cage itself is pressed down by a 'lid'
consisting of two massive circular forms.
Similar preoccupations are visible in Alison
Wilding's *Stain* (Pl. 319). Here the sculpture
makes a hollow enclosure, placed on a cloth.
The cloth both separates the piece from the
surrounding space, and (because it is flat)
suggests a kind of intermediary zone – neither
completely part of the sculpture itself, nor part
of the gallery. The spectator tends to read the
piece as an island, rising from the midst of a
pool, but it is by no means certain that this is
the image Wilding had in mind.

316 John Gibbons, *The Alliance*, 1992
Welded steel, 96 × 314 × 138 cm
(37¾ × 123¾ × 54½ in)

317 Anish Kapoor, *Mother as a Solo*,
1988
Fibreglass and pigment,
205 × 205 × 230 cm (80¾ × 80¾ × 90½ in)
Installed at the Musée St-Pierre, Lyons

318 Vong Phaophanit, *Ash and Silk
Wall*, 1993
Installation at the Thames Barrier,
Eastmore Street, East London,
August-September 1993, glass, silk
and ash; large structure 4 x 14 x 1 m
(13 x 45½ x 1¼ ft); small structure
3.5 x 2 x 1 m (11¾ x 6½ x 1¼ ft)

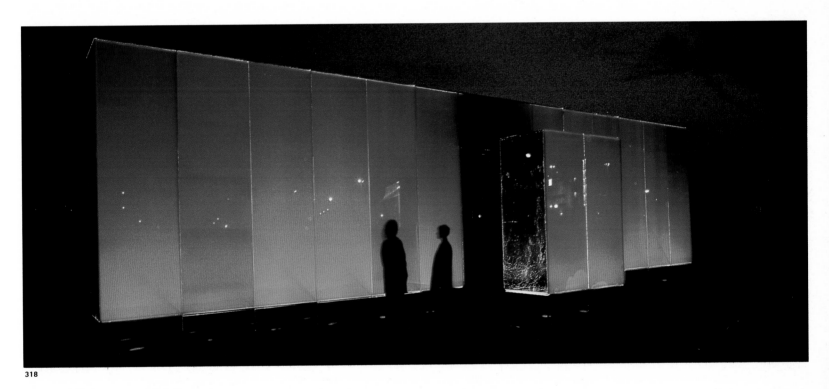

318

One of the problems with art of this type
is that it tends to summon up metaphorical
meanings which may not have been intended
by the artist. Is the cage simply a formal device,
or are we also meant to read it as a metaphor?
One artist who has successfully side-stepped
these problems, and who has become as a result
one of the most internationally celebrated of
the younger generation of British sculptors, is
Anish Kapoor. Kapoor's most typical works are
massive unitary forms, sometimes pierced with
mysterious holes, and covered with brilliant
powdery pigments (Pl. 317). Kapoor, of half-
Indian, half-Jewish descent, has always made
it plain that he has no wish to be regarded as

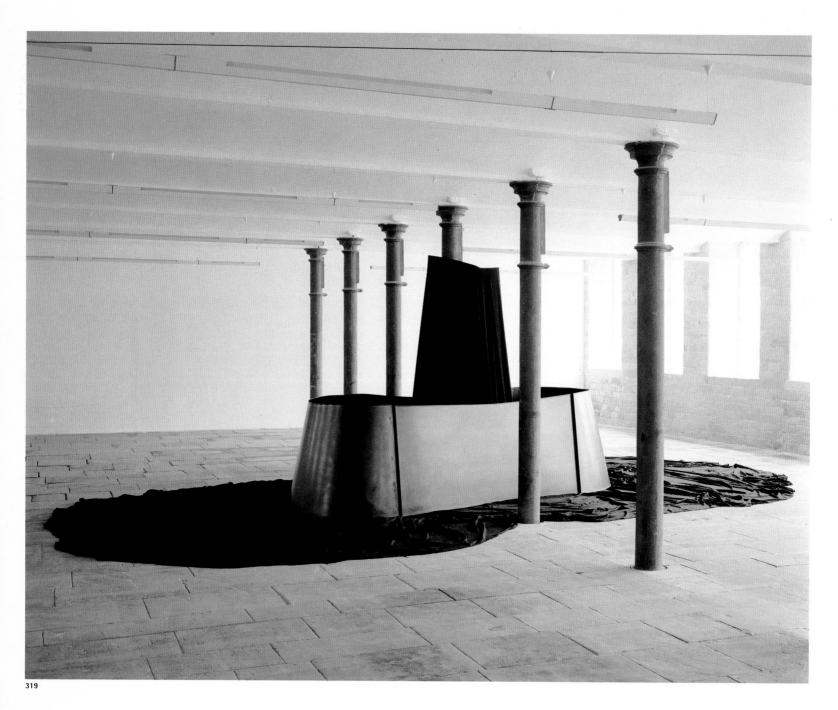

a representative of a transplanted culture in Britain. His characteristic forms do, nevertheless, owe an obvious debt to the ritual objects associated with Hindu Tantrism; and this, in turn, means that they do have a metaphorical dimension. They can also be referred to a long-established European tradition, which finds a spiritual meaning in very simple abstract forms – celebrated examples of this are paintings by Malevich and Rothko. Another artist working in this kind of area is the Laotian-born but now British resident Vong Phaophanit, best known for his *Ash and Silk Wall* (Pl. 318), sited in a park beside the Thames Barrier in East London. The colour of the silk used in this piece – a dark saffron yellow – evokes the robes of Buddhist monks. The ash is the same silk, burned, but prevented from dispersing by the sheets of glass that enclose it. In the wall, there is a gap which the spectator can pass through. The idea is that the audience is being asked to look at the two sides of the artist's own life: the traumatic experiences he has undergone in the process of becoming a Western, or Westernized artist.

Kapoor's work has a link with that of more specifically figurative artists, such as Antony Gormley. Gormley's *A Case for an Angel II* (Pl. 320) is in one sense precisely what its title proclaims it to be: a hollow humanoid form with vast wings attached. Gormley, like Segal, de Andrea and Hanson, began by using moulds made from life, and the shapes thus obtained have continued to influence his work. But the associations evoked are extremely rich: not only does the spectator think of angels as the title invites him to do (thus entering the metaphysical realm also inhabited by Kapoor's work), but he or she is also directed towards a historical perspective. This *Case for an Angel* (an immortal being) is first cousin to an Ancient Egyptian mummy case – which enfolds a corpse but is designed to procure immortality.

Gormley's recent work has – like that of certain American artists such as Charles Simonds (Pl. 178) – an obvious fascination with archaeological discovery. *European Field* (Pl. 321), with its mass of miniature figures, recalls both the *ushabtis* found in Egyptian tombs and the armies of terracotta warriors discovered in the graves of early Chinese emperors.

This is a landscape of dreams. It is not the kind of subject that any sculptor would have

319 **Alison Wilding**, *Stain*, 1991
Installation at Dean Clough, Halifax,
steel, rubber and woollen cloth,
3 x 10 x 4.85 m (10 x 32½ x 15¾ ft)

320 **Antony Gormley**, *A Case for an Angel II*, 1990
Plaster, fibreglass, lead, steel and air,
197 × 858 × 46 cm (77 × 344½ × 18 in)

321 **(overleaf) Antony Gormley**,
European Field, 1991
Terracotta, 40,000 figures varying in
height from 7.6 to 25.4 cm (3 to 10 in)

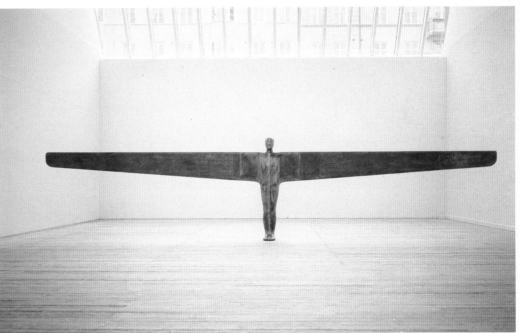

320

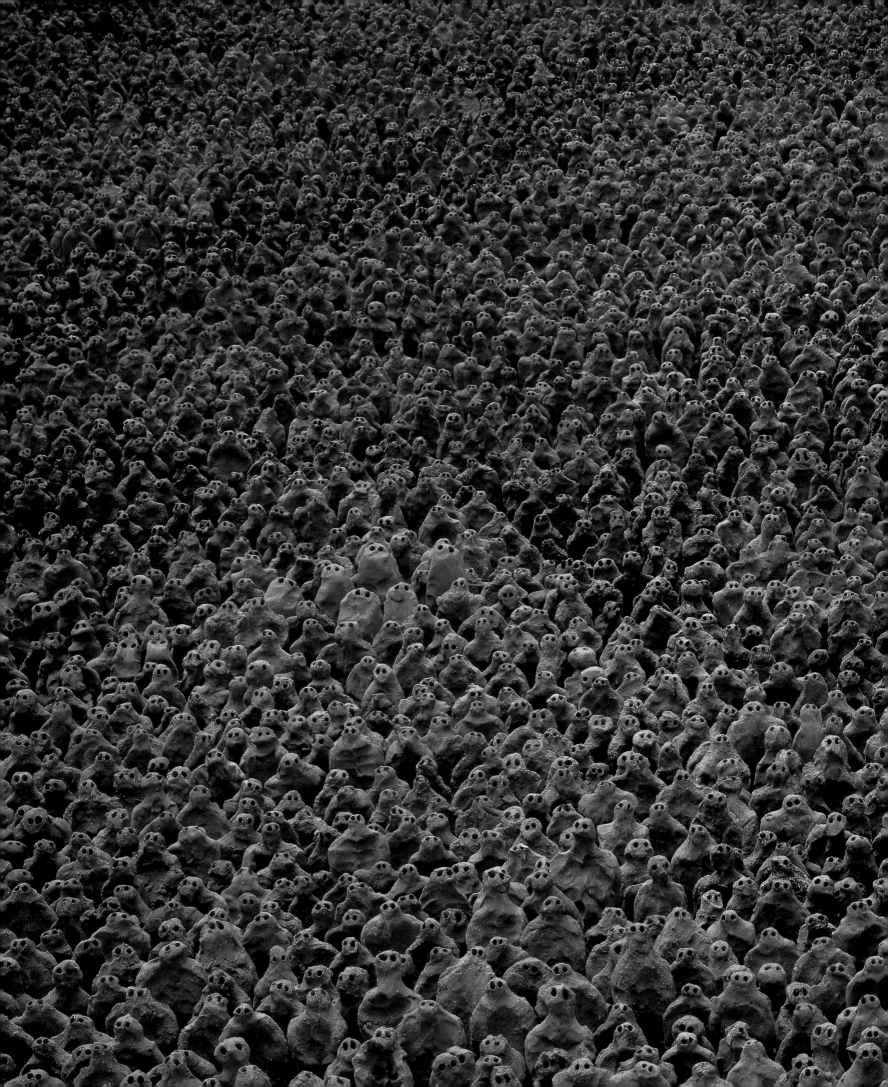

322

323

attempted in the past, and its use of a purely traditional material and technique serves to emphasize the confusion of genres which has overtaken the visual arts in Britain, as elsewhere.

A similarly deft use of repetition and miniaturization occurs in a recent sculpture by Keir Smith (Pl. 322). Even more strikingly than Gormley's figurines in *Field*, this takes sculpture back in the direction of craft, by creating a toy-town panorama which, with its repetitive but not identical elements, mimics what one might find in a model-maker's show. The allusion to craft is significant, since it was the British craft revival, also dating from the 1970s, which filled the space in the market left vacant by sculptors who no longer felt able to work on a domestic scale. A number of leading figures in this revival of craft, particularly ceramicists, eventually decided that it was more accurate to describe themselves as sculptors, rather than as practitioners of craft. One sculptor who successfully crossed the boundary from craft to fine art was Glenys Barton (Pl. 323). Her work, with its slightly Deco feeling, is extremely typical of one current of taste in Britain today, but it is not something which is recognized as representative of British art on the international scene.

Perhaps the most dramatic proof of the current confusion of perceptions about British sculpture is offered by Damien Hirst, the most discussed young artist in the Britain of the early 1990s. The work which established Hirst's reputation in the British art world is entitled *The Physical Impossibility of Death in the Mind of Someone Living* (Pl. 324). It consists of a dead tiger shark floating in a tank of preservative fluid. The shark has been balanced and weighted so that it floats in the middle of its tank, just as though it were floating in its natural element. Once again, however, as with Gormley's *Field*, there is a covert reference to museum culture, though on this occasion it is to the kind of experience offered by an old-fashioned museum of natural history. And once again, as with quite a number of other contemporary artists, among them Gormley, there is an obsessive fascination with the fact of death.

Equally the product of an obsession with the past, but this time directly concerned with the notion of memory, is the work of Rachel

322 Keir Smith, *Coastal Path*, 1993
Jarrah wood railway sleepers, total
length 9.1 m (30 ft)

323 Glenys Barton, *Jean Muir*, 1991
Ceramic, 52.5 × 33 × 16 cm
(20¾ × 13 × 6¼ in)

324 Damien Hirst, *The Physical
Impossibility of Death in the Mind of
Someone Living*, 1991
Glass, steel and tiger shark in 5 per cent
formaldehyde solution,
2.1 × 5.2 × 2.1 m (7 × 17 × 7 ft)
Saatchi Collection, London

324

325 Rachel Whiteread, *Untitled (House)*, 1993
Building materials and plaster, height approx 10 m (32½ ft) (now destroyed)

326 Neil Jeffries, *Light Relief (Suitor)*, 1985
Painted aluminium, 190 × 180 × 70 cm (75 × 71 × 27½ in)

325

Whiteread, whose *Untitled (House)* (Pl. 325) made her almost as much talked about as Damien Hirst. *House* was the most ambitious of a series of works which were casts of negative spaces – the space left under a bed; the volume of a room the artist once occupied. It was a cast of a whole house in the East End of London, scheduled for demolition. According to the artist, it summed up the memories and feelings of the people who once lived there. Made with temporary planning permission from the local council, *House* was as ephemeral as it was massive. Very shortly after its completion, it was destroyed.

There are a few, but only a very few, British artists working in three dimensions who produce work which is directly comparable to the British figurative painting of the 1980s and 1990s. The most conspicuous of these is Neil Jeffries (Pl. 326), whose painted metal reliefs and free-standing pieces have a strong resemblance to the work of painters such as Jock McFadyen. Indeed, some critics would probably argue that they were, for this very reason, not sculpture at all, but an extension of what was purely pictorial.

While there is, as I have said at the beginning of this chapter, a startling difference, certainly at first encounter, between the preoccupations of recent British painting (generally perceived as conservative) and recent British sculpture (generally perceived as radical), they do, at bedrock level, seem to have themes occasionally in common. The most conspicuous of these is a preoccupation with the passage of time and the weight and meaning of past culture.

New Art in New York

327 Robert Morris, *Newest Latest/*
Hope Despair, 1989
Encaustic on aluminium,
183 × 241 cm (72 × 95 in)

328 Brice Marden, *Cold Mountain 2*,
1988–91
Oil on linen, 274 × 365 cm (108 × 144 in)

Since the rise of Abstract Expressionism, New York has been the acknowledged world centre for contemporary art, and it is still the place where major reputations are made, because of its concentration of dealers, taste-makers, collectors, critics and galleries. In particular, it remains the most important market place, the city where artistic success is consecrated by money. This is not to say, however, that it is still the most important generator of artistic styles. There are several reasons for this. One was the increasingly powerful reaction against the idea of style itself as primary, as opposed to content. The New York art of the 1960s, and even of the early 1970s, was an immediately recognizable product, or group of products. Pop, Minimal, Conceptual or Super Realist: these were all labels whose meaning was widely understood, and the majority of artworks on offer in leading commercial galleries, most of them located in New York itself, or given a good housekeeping seal of approval by museum surveys, both in America and in Europe, of what was new and interesting, could be grouped under one or another of these stylistic labels.

Another reason is the fact that New York now has five or six generations of artists, all of them still active and exhibiting their work. The appearance of a new style, a new way of doing things, did not automatically abolish what was there previously, and an increasing plurality of approaches tended to blur stylistic boundaries. This was accentuated by the fact that artists who had been firmly associated with one particular way of working tended suddenly to change direction. Two examples of this are the Minimalists Robert Morris and Brice Marden. Morris's figurative *Newest Latest/Hope Despair* (Pl. 327) has little if anything in common with the Minimal sculptures which made the artist famous (Pls. 92, 93). It is, instead, a broadly painted depiction of the coming down of the Berlin Wall which seems to have something in common with German Neo-Expressionist artists like Jörg Immendorf (Pl. 190). Marden's work has remained abstract, but now, instead of juxtaposing large panels (Pl. 84), each in a single colour, he makes paintings which are intricate traceries of lines (Pl. 328). Where Morris looks across the Atlantic, Marden reverts to the heritage of Jackson Pollock.

A third reason is challenges from other

327

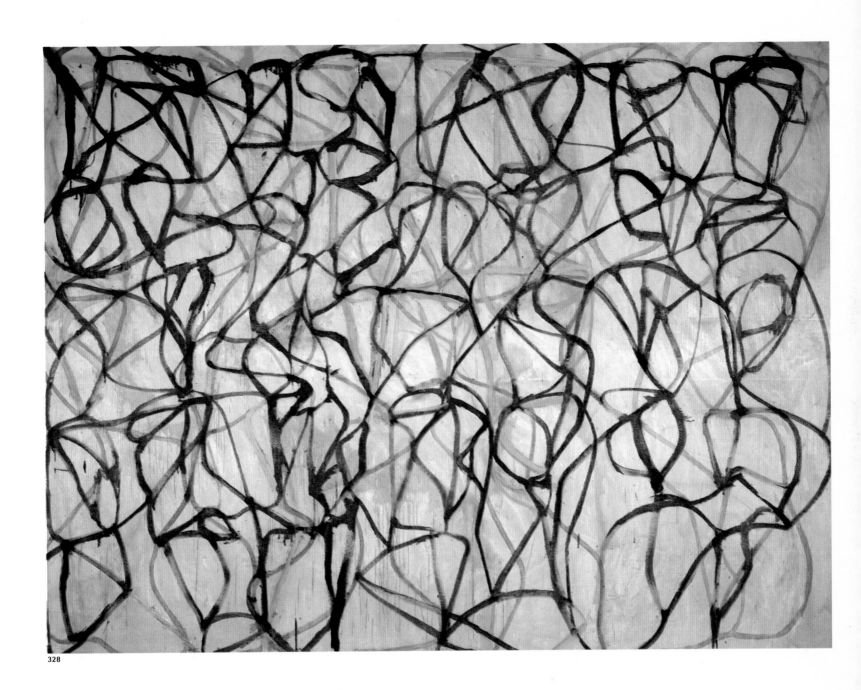

328

centres of artistic innovation. New York had easily crushed attempts to revive the prestige of the École de Paris immediately after World War II. It did not find it so easy to meet the challenge of Italian Arte Povera and German Neo-Expressionism in the 1980s. In particular, the New York art scene remained relatively remote from the career and influence of Joseph Beuys. Beuys's assumption of a shamanic role did not at all fit the pattern established by the New York way of handling art. Though Beuys did have a major retrospective at the Guggenheim Museum in 1979, this was a comparatively belated recognition of an artist

329

who was already enormously influential in Europe.

A fourth reason – perhaps the most decisive of all – is that New York was the victim of its own success in popularizing contemporary art. In theory it remained a mecca for all ambitious artists, just as Paris had been during the inter-war epoch. Yet it became more and more expensive for artists to live there, and in particular it was more and more difficult for unestablished artists to find affordable studio space, despite the characteristic New York economic cycle of boom and bust, which necessarily affected real-estate values.

Meanwhile, thanks largely to the foundation of new museums and the enlargement of old ones, contemporary art became accessible, at any rate in a purely physical sense, throughout the United States. In addition, many artists found niches for themselves in the rapidly expanding American university system. The result was the creation of a series of art communities right across the country. These communities looked to New York for a lead, but they also increasingly resented its unquestioned pre-eminence. They often began to feel that art created in a particular locality ought to address itself to local concerns. Because of this the New York art world increasingly began to find itself cut off from the American hinterland. Its interests and enthusiasms were not automatically those of the broad American audience for art.

One increasingly strong tendency among New York artists was to recycle and vary ideas which were already established. Some of these ideas came from the remoter past of Modernism. Joel Shapiro's sculptures hint at human or animal forms, but their debt to the radical abstraction of Russian Constructivism is nevertheless obvious (Pl. 329), and it is also tempting to ascribe a basically Constructivist origin to Peter Halley's severely abstract designs, with their rectangles and flat areas of colour (Pl. 330). Halley himself, however, has said that the most immediate inspiration for these designs is the rectilinear architecture of New York itself. There are also allusions to architecture in paintings by Philip Taaffe, who is often grouped with Halley by New York critics. In the elaborate *Constellation Elephanta* (Pl. 331) the source seems to be the ironwork and stained glass of some of the city's more elaborate Beaux-Arts buildings. Taaffe's route to this has been somewhat circuitous. Much of his earlier work had a close resemblance to that of the British artist Bridget Riley (Pl. 61), at the period when she was associated with the Op Art Movement of the 1960s. This movement, too, has been seen as a direct descendant of Constructivism.

The sources used by younger members of the New York school were, however, usually much nearer home. Not surprisingly, they addressed themselves to the immediately accessible heritage of American art – most of all to the artists who seemed to offer a guarantee of

331 **Philip Taaffe**, *Constellation Elephanta*, 1993–4
Mixed media on canvas,
353 × 254 cm (139¼ × 100 in)

332 **Louisa Chase**, *Headstand*, 1990–1
Oil on canvas, 203 × 178 cm (80 × 70 in)

332

333 David Salle, *Midday*, 1984
Oil and acrylic on canvas and wood,
289 × 127 cm (114 × 50 in)

334 Kenny Scharf, *Junkle*, 1992
Acrylic, oil and ink on canvas,
188 × 231 cm (74 × 91 in)

continuing American hegemony. Louisa Chase, in *Headstand* (Pl. 332), is visibly the heir of Cy Twombly (Pl. 79), even if her imagery is more specific than his. One extremely pervasive influence on the current New York school, because his work seems to suggest an actual method for making art, as well as useful categories of imagery, was the work of Robert Rauschenberg (Pl. 38). David Salle, for example, is very much in Rauschenberg's debt. *Midday* (Pl. 333) borrows several things from Rauschenberg: the layering of imagery, the deliberate stylistic clashes, the conjunction of figuration and abstraction within the same

333

pictorial arena. These characteristics have led critics to label Salle as a quintessentially Post-Modernist artist, a pioneer of a new style for the 1980s. They are largely mistaken: there is very little in Salle's work which cannot be found in the Rauschenberg of the 1950s.

If Abstract Expressionism had established the world leadership of the New York school, it was Pop which defined New York culture for itself – which seemed to hold up a mirror to the modern metropolis. Even when challenged by Conceptual and Minimal Art, Pop imagery showed a marked reluctance to fade away. The influences which created Pop remained, after

all, very much part of the urban environment; they were things which young artists living and working in the city continued to encounter daily. In the 1970s and early 1980s there was a short-lived but hectic fashion in the New York art world for subway graffiti. These had begun to attract attention from politicians and social commentators rather earlier. In May 1972, the then mayor of New York, John Lindsay, announced an anti-graffiti programme, begging New Yorkers to 'come to the aid of your great city – defend it, support it and protect it!'[1] Predictably, the campaign was a failure, as were subsequent campaigns led by Lindsay's successors. Galleries and taste-makers, fascinated by the designs which appeared on the subway cars, invited some of the 'writers' (as they called themselves) to show in legitimate spaces. The first exhibition of graffiti art took place in the Razor Gallery, in New York's SoHo art district, in September 1973. Very few of these young artists showed any stamina in the New York art world. The most conspicuous exception was the part-Haitian, part-Puerto Rican Jean-Michel Basquiat (Pl. 494).

There was, however, another group of painters who were influenced by graffiti even if not actual participants in the teenage craze which so disturbed the authorities. They included Keith Haring (Pl. 17) and Kenny Scharf. Scharf's bulging, writhing forms have a great deal in common with the fanciful distortions which the graffitists impose on lettering, and a painting like *Junkle* (Pl. 334) is clearly part of the same culture, though it lacks the analytical quality of the original Pop artists. An even more obvious fascination with bizarre ornamental letter forms appears in a work by Ashley Bickerton (Pl. 335). Bickerton belongs to a group a younger New York artists, the most celebrated of whom is Jeff Koons, the most skilled self-publicist of his generation. It is part of the Koons legend that he worked for a period as a Wall Street commodities broker, and his work has sometimes been described by critics as a branch of Conceptual Art – an analysis of the financial workings of the consumer society. It is not certain that Koons himself would accept this, as his declared ambition is to 'communicate with as wide an audience as possible'. The impact of his work on a sophisticated viewer has been well

334

335 **Ashley Bickerton**, *Reg But*, 1983
2 panels, acrylic and latex on board,
244 × 244 cm (96 × 96 in)
Saatchi Collection, London

336 **Jeff Koons**, *Popples*, 1988
Porcelain, 74.3 × 58.4 × 30.5 cm
(29¼ × 23 × 12 in)

described by the American critic and art historian Robert Rosenblum:

> In terms of first-person experience, I still recall the shock of my initial confrontation with Koons's lovingly hideous and accurate reconstructions of the lowest levels of three-dimensional kitsch, from porcelain Pink Panthers and Popples [Pl. 336] to painted wooden bears and angels. We all, of course, have been seeing this kind of stuff for years in every shopping centre and tourist trap, but never before have we been forced, as one is in a gallery setting, to look head on and up close at its mind-boggling ugliness and deliriously vapid expressions.[2]

Rosenblum goes on to make the almost inevitable comparison with Roy Lichtenstein's impact on the art world at the beginning of the 1960s, but admits that the circumstances of Koons and his New York contemporaries were now very different. They could, he says, 'stand comfortably in the triumphs of a now venerable tradition of wallowing in, rather than shielding themselves from, the facts of daily life in a civilization bombarded with commercial come-ons.'[3]

Koons's enlarged versions of kitschy ornaments and commercial souvenirs are, of course, descendants of the 'readymades' of Duchamp. Yet there is a significant difference – they are neither neutral nor ironic, but celebratory. If there is a status quo he aims to subvert, it is that of the supposed avant-garde, and in particular its confidence in its own sophistication, its limitless tolerance of all new experiments. The notorious erotic works – photographs modelled on those to be found in hard-core pornographic magazines, showing the artist and his now estranged wife Ilona Staller performing various sexual acts – are similar acts of provocation, but directed in this case at a rather narrower target: the politically correct segment of the feminist movement which denounces all forms of pornography. The Conceptual element in Koons's work – its element of intellectual terrorism – is stressed by the fact that he is not the actual maker. His sculptures are commissioned from expert craftsmen – the woodcarvings, for instance, are made by Black Forest woodcarvers who generally produce sentimental tourist artefacts. Koons's own role is organizational and supervisory. He is not alone in working in this way. The painter Mark Kostabi, for example,

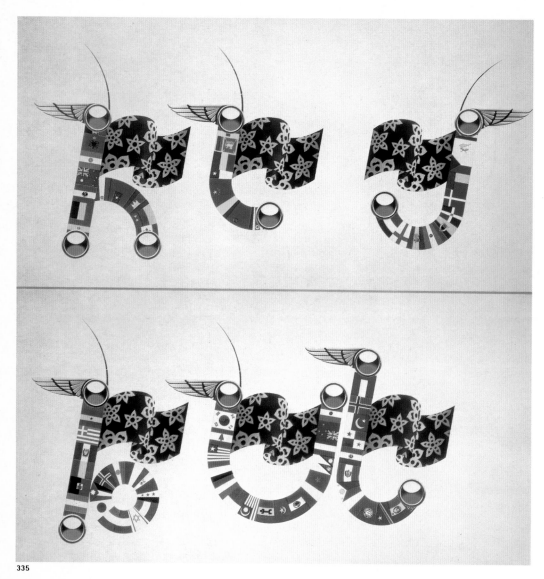

335

337 Alan McCollum, *Perfect Vehicles*, 1988
Moonglo on cement, each jar 198 × 91 × 91 cm (78 × 36 × 36 in)
Collection of the Virlaine Foundation, New Orleans

338 Mark Kostabi, *Simply Irresistible*, 1988
Oil on canvas, 183 × 218 cm (72 × 86 in)

339 John Torreano, *Ghost Gems*, 1989
12 wooden gems of varying sizes, painted wood, each approx
45.5 × 61 × 89 cm (18 × 24 × 35 in)

makes a point of the fact that the only authentic Kostabis are those which he has played no direct part in painting (Pl. 338).

The literalism which Koons uses as a weapon recurs in the work of other members of the New York avant-garde of the 1980s and 1990s – for example in the giant ornamental jars of Alan McCollum (Pl. 337) and the giant gems of John Torreano (Pl. 339). The target here, however, seems to be different from those selected by Koons. It is the sterile, self-righteous perfectionism of Minimal Art.

In addition to works which are provably the direct descendants of the Pop of the 1960s, recent New York art has thrown up many others which are less specifically linked to the original movement but which nevertheless take part of their tone from what the Pop generation produced. This could be said, for example,

337

338

about recent work by Joe Zucker. The peg men in Zucker's installation of the same title (Pl. 340) derive from folk art, but the direct, simplified, iconic presentation of the chosen image clearly owes a great deal to Pop. There is also a combination of Pop and folk elements to be found in Deborah Butterfield's sculptures, originally made of twigs and branches, and now of the same materials cast in bronze (Pl. 341). There is also an indisputably Pop element in the ambitious installations of Jonathan Borofsky (Pl. 342), which look back to the settings which Jim Dine provided for the Happening *Car Crash* (Pl. 39). Yet even the most superficial examination shows the presence of other, non-Pop elements as well. The fleeing ribbon figures on the far wall, for instance, derive from Spanish cave paintings

339

340 **Joe Zucker**, *Peg Men*, 1991
Installation at Aurel Scheibler Gallery,
Cologne, acrylic on peg board,
2.4 × 6.1 m (8 × 20 ft)

341 **Deborah Butterfield**, *Punahele*,
1993
Bronze, 216 × 244 × 91 cm
(85 × 96 × 36 in)

342 **Jonathan Borofsky**
Installation at the Paula Cooper Gallery,
New York, 18 October - 15 November
1980

of the Mesolithic period (*c*. 6000 BC). There is a close parallel in the often-illustrated hunting scene in a cave at Remisia, Castellón.[4]

Borofsky's work serves to emphasize the restless eclecticism of much of the most typical New York art of the post-Minimalist epoch. Rather than being repressive and exclusive, as Minimalism was, it has greedily sucked in elements from anywhere and everywhere, and has plundered all historical periods at will, though generally with the emphasis on the history of Modernism. This has often been accompanied by a symptomatic physical restlessness as well. An example is the plunging perspective used by Elizabeth Murray in *More than You Know* (Pl. 343). The painting only gradually reveals itself as a view of an interior, with a table and two chairs. There is an equal energy in Jennifer Bartlett's

341

340

Spiral: An Ordinary Evening in New Haven (Pl. 344). This, which takes its title from a celebrated poem by Wallace Stevens, has an extraordinary kinetic energy. The three-dimensional tables and traffic cones in the foreground do seem to have been tumbled out of the painted picture-space by a mighty gust of wind. One hesitates to ascribe masculine or feminine characteristics to particular works of art, but this work, and that by Elizabeth Murray, seem to me symptomatic of one of the major changes which has overtaken the New York art world since the Minimalist hegemony began to be challenged – the much greater prominence of women artists.

Another tendency typical of the new situation in art is the emergence of various types of collaborative art, often Conceptually oriented and making use of photography and

342

343

print. *Lack of Compassion*, by the Starn Twins (Pl. 345), is a more subdued version of the art of the British duo Gilbert & George (Pls. 25, 27). The tall narrow upright, with a boy's head at the top and his feet at the bottom (the feet apparently bound by a rope), can be seen as a kind of executioner's post, or even as the upright of a traditional Christian cross. Gilbert & George summon up religious overtones in much the same fashion.

The artist who best represents both the ambition and the hubris of the New York art world does not fit into any of these categories. Julian Schnabel's work has often attracted abuse from hostile commentators, offended not only by the art itself but also by Schnabel's success with collectors and even more by his overweening self-esteem. Schnabel's bombastic pronouncements, and his tendency to imply – sometimes even through the titles of his paintings – that he is on a level with the very greatest, have caused widespread offence. A typical work of the mid-1980s, *Rebirth III (the Red Box) Painted after the Death of Joseph Beuys* (Pl. 346), looks as if it is making a claim to the throne Beuys has just vacated. Yet it also has to be said that this is a wonderfully exuberant and inventive painting, carried out in a manner closer to that of the Viennese turn-of-the-century Symbolist Gustav Klimt (1862-1918) than to that of the contemporary German Expressionists to whom Schnabel has sometimes been compared. Another painting from the same epoch, *The Walk Home* (Pl. 347), is an example of a technique which helped to make Schnabel notorious – his habit of painting on a surface made of broken pieces of crockery. This was suggested to him by a visit to the Parque Güell in Barcelona, designed by the great Catalan Art Nouveau architect Antonio Gaudí (1852-1926), where surfaces are often encrusted with fragments of broken china. Schnabel has said that he adopted this surface because it helped to curb his own fluency as a draughtsman – something which sounds like yet another hubristic remark. Yet it is undoubtedly true that the technique produces a richly textured result. Schnabel, like Courbet (a man of similar temperament) will never be an artist of even, predictable quality, but at the top of his form he is an exciting one.

Other New York painters also show traces of Expressionist influence, but what is now

345

345 Doug and Mike Starn, *Lack of Compassion*, 1987–8
Toned silverpoint, ortho film and wood,
261 × 19 cm (103 × 7½ in)
Saatchi Collection, London

346 Julian Schnabel, *Rebirth III (the Red Box) Painted after the Death of Joseph Beuys*, 1986
Oil and tempera on muslin, 375 × 400 cm (148 × 134 in)

347 (overleaf) Julian Schnabel, *The Walk Home*, 1985
Oil, plates, copper, bronze, fibreglass and bondo on wood,
284 × 589 cm (112 × 232 in)
Collection of the Eli Broad Family Foundation

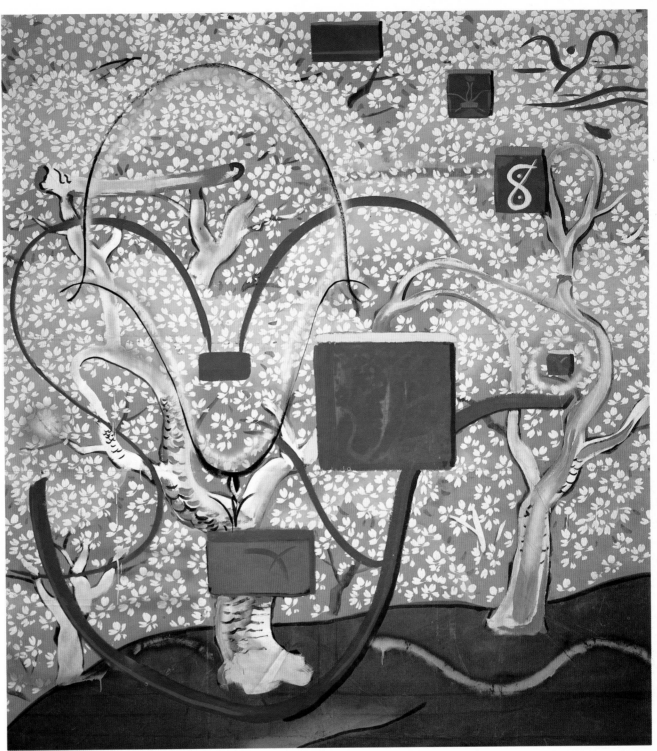

346

348

striking is the slightly directionless eclecticism of American art, and the way in which various styles meet and mingle in the same canvas. A work by Donald Baechler (Pl. 348), for example, combines a graffiti-like figure which seems to owe more to Jean Dubuffet and Art Brut than it does to anything seen on the New York subway, with giant vegetables from some popular recipe book. The effect is quite decorative, but neither convinced nor really convincing.

Another New York favourite is Eric Fischl. Fischl's realist depictions of middle-class American life have been at the centre of a debate about so-called 'bad painting'. Fischl has a particular interest in badly behaved adolescents, as for example in *Squirt* (Pl. 349), where a boy in diving mask and flippers aims a water pistol at a reclining sunbather. The title, in addition to referring to the action, is a pun – a 'squirt' being, in colloquial speech, 'an insignificant and presumptuous person' (Concise OED). What has fascinated Fischl's admirers, however, has been not simply the content of his paintings but the way in which they are painted – the way in which the technique seems barely adequate to convey what the artist intends. Critics have read Fischl's pictures as a deliberate mimesis of the threadbare: a visually impoverished reflection of an impoverished society.

In purely sociological terms, Fischl's paintings make an interesting contrast with things like Annette Lemieux's *Hobo Jungle* (Pl. 350), which uses innovative technique to portray, and at the same time distance, a more traditionally Social Realist subject. In this instance Lemieux's work has something in common with Andy Warhol's chilling *Car Crash* series. Fischl seems stranded in a no-man's land between the traditional and the innovative.

The work of a number of the most mature and interesting artists of the current New York school is stylistically unclassifiable in a slightly different, and less pejorative, sense than that of Fischl, and belongs to no particular school. One could, perhaps, group it with other artworks well received in New York during the 1970s and 1980s to conjure up the idea of a new American Romanticism. To this grouping would belong some of the most striking works exhibited in the city in the course of the past two decades, among them the series of

349 Eric Fischl, *Squirt (for Ian Giloth)*, 1982
Oil on canvas, 173 × 244 cm (68 × 96 in)

350 Annette Lemieux, *Hobo Jungle*, 1992
Fabric, glue, water-based ink and acrylic resin on canvas, two cushions, 213 × 315 × 152 cm (84 × 124 × 60 in)
Collection, Castello di Rivoli, Italy

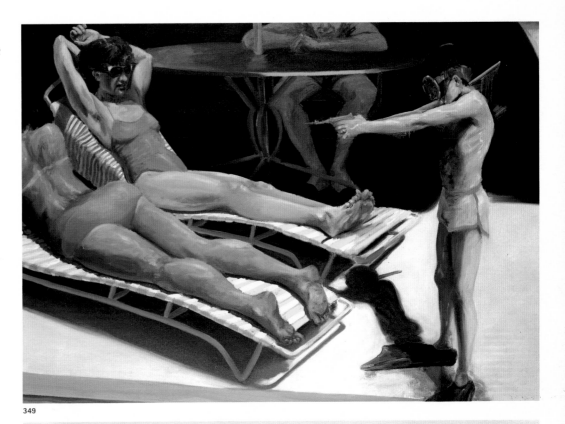

349

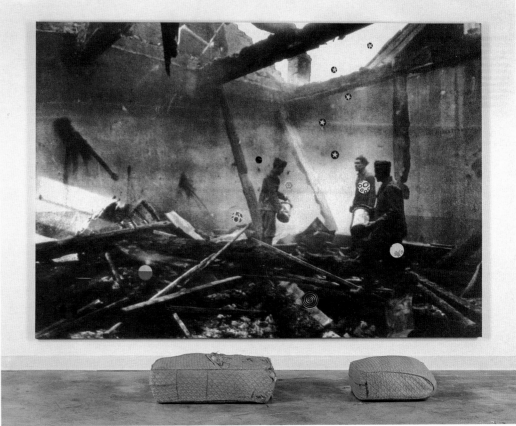

350

351 Susan Rothenberg, *Butterfly*, 1976
Acrylic and matte on canvas,
176.5 × 210.8 cm (69¹/₂ × 83 in)

352 Terry Winters, *Caps, Stems, Gills*, 1982
Oil on linen, 152 × 213 cm (60 × 84 in)

353 Ross Bleckner, *Pressed Flowers*, 1986
Oil on linen, 122 × 102 cm (48 × 40 in)

paintings of horses with which Susan Rothenberg made her reputation (Pl. 351), Terry Winters's paintings of fungi (Pl. 352), and Ross Bleckner's less abstract paintings, such as those featuring chalices or vases of flowers (Pl. 353). Yet it does not take much study to realize that groupings of this type are purely factitious; that there is no strong unifying current in the New York art world, nor has there been for some time. An artist like Dorothea Rockburne, with her intense hues, and fascination with the interaction of space and colour (Pl. 354), is just as typical of the current feeling in the city as the work of the artists just named. It would indeed be possible to propose a comparison between the somewhat transcendental atmosphere

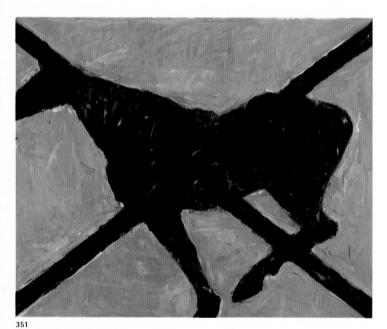

351

352

of Rockburne's work and the West Coast school of Light and Colour (Pls. 134–5), and this comparison could be stretched to include a quite different aspect of Ross Bleckner, typified by a painting such as *Dome* (Pl. 355), which can be seen as an attempt to render the light effects typical of James Turrell in paint.

This loss of stylistic direction is one of the factors which has led to a compensatory emphasis on content rather than style. Some of the more conspicuous results of this will be dealt with in later chapters. Yet there is at the same time an inability, in New York at least, to escape from some of the effects of the Modernist mind-set which has helped to create a widening gulf between critical attitudes there and those which prevail elsewhere.

354 Dorothea Rockburne, *Dividing (the Water under the Firmament from the Waters above the Firmament); Star Path; First Day*, 1994
Wall installation at André Emmerich Gallery, New York, Lascaux aquacryl on gesso-prepared surface, overall height 3.3 m (11 ft)

355 Ross Bleckner, *Dome*, 1990–1
Oil on canvas, 244 × 244 cm (96 × 96 in)
Lambert Art Collection, Geneva

354

326–327 New Art in New York

356 Robert Gober, *Slanted Playpen*,
1987
Painted wood, 92.5 × 127 × 59.6 cm
(36 × 50 × 23½ in)

357 Neil Jenney, *Untitled*, 1983
Oil on canvas, with frame,
122 × 61 cm (48 × 24 in)

356

A good example is the work of Robert Gober, who is, at the moment when this is being written, undoubtedly the most fashionable, most discussed younger artist in New York. Gober's creations are enigmatic – a Super Realist leg sticking out of a wall at the level of the skirting board; wallpaper with images of genitalia; a lay figure wearing a wedding dress; a slanted playpen (Pl. 356). The general perception is that these are images of distress – that Gober is speaking as a gay man in the age of AIDS. Similar meanings have been attached, with the artist's blessing, to a number of Ross Bleckner's paintings, especially those featuring images of chalices. The problem here, and particularly in Gober's case, is that the image remains enigmatic to those on the 'outside'. His work is not a direct statement, but a challenge to fine-spun theological interpretation. The system of symbolism is purely private: it is impossible to guess at what is being said without privileged access to additional information. Even if one compares Gober's work to that of Beuys one sees that there is in Beuys's work at least the remnants of a universal grammar of interpretation (through its references to shamanism), while this is missing in Gober. The most typical New York art is increasingly inaccessible to those who do not have continuous personal contact with the art world in that city.

One consequence of this may be the appearance of artists like Neil Jenney (Pl. 357). Jenney's meticulously painted landscapes, always enclosed in heavy frames of the artist's own design, are a return to the universe of early Romantic artists such as Caspar David Friedrich. At the same time they seem to allude to specifically American painters of the mid-nineteenth century, such as the self-taught Thomas Chambers (born c. 1815, active 1855). In his massive survey of American art, John Wilmerding comments on Chambers's 'uniformly glossy finish' and on the way in which, in his work, 'optical accuracy is submerged in a highly fanciful and vivid design'.[5] These comments can be applied almost exactly to Jenney. What one seems to see here is a piercing nostalgia for a period when America was not a cultural as well as economic and military super-power, and when American art did not have to take up the burden of broad issues.

357

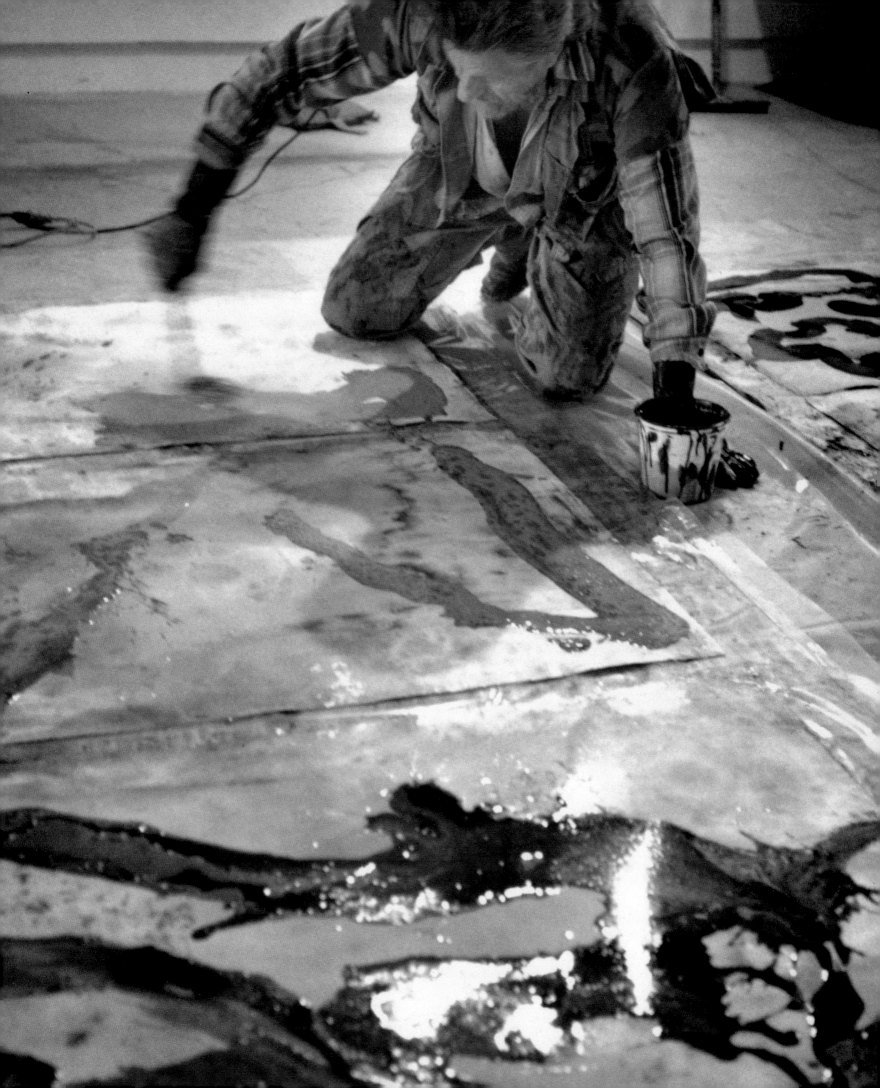

Out of New York

Out of New York

358 **Ed Paschke**, *Spoken Word*, 1992
Oil on linen, 152 × 198 cm (60 × 78 in)

359 **Gladys Nilsson**, *The Swimming Hole*, 1986
Watercolour on paper,
103 × 152 cm (40½ × 60 in)

360 **Jim Nutt**, *DA Creepy Lady*, 1970
Acrylic on plexiglass,
186 × 130.5 cm (73¼ × 51½ cm)

358

359

The major phenomenon in contemporary American art which has largely escaped comment – perhaps because it is so obvious – is the degree to which it has now regionalized itself. There are a number of reasons for this – some have been touched on in the last chapter. They include the immense increase in the number of practising artists; the expense and difficulty of finding studio and living space in New York, and the role played by new museums and also by university art departments as focuses for cultural activity. There are other causes as well, most notably actual differences in regional culture. The cultural climate in northern California, for example, is affected by the fact that California is traditionally a centre for the crafts, and also for various forms of 'alternative' activity. That in Texas is coloured by Texan separatism, and by the proximity of Mexico.

Probably the first of these regional schools to make an impact was that based in Chicago. In the late 1960s, the Hairy Who and other groups offered a very different version of Pop Art from the variety which flourished in New York. This was much less 'cool' than New York Pop, with much greater emphasis on the psychedelic fashions of the late 1960s. It also had greater input from 'outsider art', the equivalent of what was called Art Brut in France. One important source of inspiration was the ex-circus performer and ex-hobo Dwight Yoakum (1886-1976), a self-trained visionary artist of part Native American and part African-American ancestry.

One of the great survivors of the Hairy Who epoch in Chicago art is Ed Paschke. Paschke rather fascinatingly combines an Expressionist element with the more expected influences from Pop (Pl. 37). In his case this is often mediated through images drawn from television, or, as in *Spoken Word* (Pl. 358), from the computer screen. Other artists associated with Chicago, and with the Mid-West often share this rather feverish quality. Those who belong to the Hairy Who generation tend to fall into two categories. Gladys Nilsson and Jim Nutt are almost as much Surrealist as they are Pop. Nilsson's paintings, often in watercolour on paper, use flattened, twisting, ribbon-like forms, intricately woven together. *The Swimming Hole* (Pl. 359) is a characteristically witty example. Scenes of this sort have a

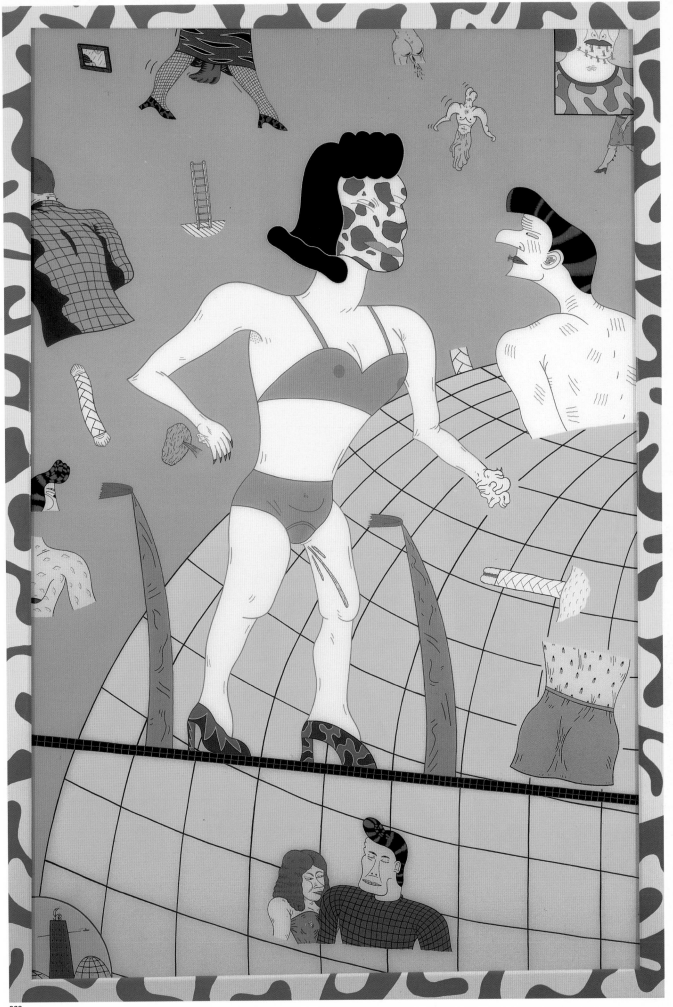

361

resemblance, no doubt a purely accidental one, to the work of the British watercolourist Edward Burra (1905-76), whose work also shows traces of Surrealist influence. Linked to Nilsson's work is that of Jim Nutt, though Nutt's hard outlines and often deliberately brassy colour bring him closer to the world of the comic strip (Pl. 360). There is, nevertheless, a nostalgic element (witness the 1950s hairstyles) which is not present in New York Pop. Another category is represented by the work of Roger Brown. Brown's work is always immediately recognizable because of its strong patterning, often with objects and events arranged in strips so as to fill the whole surface of the canvas. He is also an artist who often

361 Terence La Noue, *Beneath Krakatoa*, 1992–3
Oil on canvas, 218 × 287 cm (86 × 113 in)

362 Dennis Nechvatal, *Youth I*, 1983
Oil on canvas, 221 × 167 cm (87 × 66 in)

363 Roger Brown, *Freedom of Religion*, 1994
Oil on canvas, 122 × 183 cm (48 × 72 in)

362

363

makes strong, direct political and social statements, such as *Freedom of Religion* (Pl. 363). This automatically puts him at a considerable remove from an artist like Andy Warhol, or indeed from a Warhol successor like Jeff Koons. Other examples of Chicago style, less directly connected to the Hairy Who and other groupings of the same period, are Terence La Noue (Pl. 361) and Dennis Nechvatal (Pl. 362). The hot colours and, in La Noue's case, the twisting forms are typical of the Chicago school.

During the late 1970s and in the 1980s, the Chicago art scene seemed, despite the annual presence of the most important commercial art fair in America, to lose ground to other

364 Peter Saul, *The Alamo*, 1990
Oil and acrylic on canvas,
213 × 304 cm (84 × 120 in)

365 David Bates, *Magnolia – Spring*,
1991
Oil on canvas, 152 × 91 cm (60 × 36 in)

366 David Bates, *Lake Texoma*, 1992
Oil on panel, 61 × 122 cm (24 × 48 in)

364

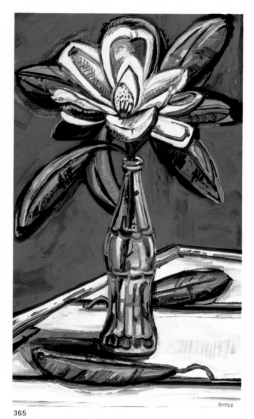

365

regional centres. Some of these, especially in Texas and Louisiana, often show a clear debt to Mid-Western art, much more so in fact than to what was fashionable in New York. Peter Saul, one of the Texas artists most closely associated with the Pop sensibility, shows a rather typical use of hot colour and writhing forms. *The Alamo* (Pl. 364), which treats a quintessentially Texan subject, is typical of Saul's work in a number of respects: in the satiric use it makes of Disney cartoons (treated as the basis for a visual language 'everyone' will understand), in its narrative thrust, and finally in its use of hot, glowing colour.

366

In the 1980s and 1990s there has also been a flourishing school of Texas painters who seem to link Expressionist elements to ideas borrowed from local folk art. Perhaps the best-known of these is David Bates. The presence of the Coca-Cola bottle in *Magnolia – Spring* (Pl. 365) is a typical populist gesture. Bates is also a figure painter and a landscapist. In his *Lake Texoma* (Pl. 366), the prominent pick-up truck offers a signal of Texas identity, as potent here as it is in Ralph Goings's paintings of Californian townscape (Pl. 222).

Nearly all Texas painters still seem to envisage an audience where private patronage

remains dominant. There is much less sense, as there is with art focused on the New York audience and the New York market, that institutions must be thought of as the ultimate patrons and therefore the ultimate audience.

There are other regional characteristics as well – some obvious immediately they are mentioned, others rather less so. There is, for example, a strongly Mexican component in Texan contemporary art, perhaps most powerful and obviously represented in the sculptures and paintings of Luis Jimenez Jr., but also to be found in the work of Jesús Bautista Moroles. Jimenez makes figurative works which are often either celebrations of Texas myths (the pioneer settler or the cowboy) or else heroic representations of Mexican-American life. This is the case with his sculpture *Border Crossing* (Pl. 367), which celebrates the 'wetbacks' – illegal immigrants

368

who swim across the Rio Grande in search of a better life in the United States.

Though Moroles was once Jimenez's student, his work is very different. His sculptures consist of stone forms inspired by Pre-Colombian architecture and large-scale stone artefacts such as calendar stones (Pl. 369). Moroles, with studios near Corpus Christi, and also near Santa Fe, New Mexico, has a busy practice as an architectural sculptor in which many members of his family are involved.

The craft element, residually present in Moroles's work, is prominent in other Texas art, sometimes to the point where it is impossible to decide which category the work truly belongs to. This is the case with William Wilhelmi's celebrations of that totem object, the Texas cowboy boot (Pl. 368), made in

367

367 Luis Jimenez Jr., *Border Crossing*, 1988
Fibreglass, 76 × 20.3 × 20.3 cm
(30 × 8 × 8 in)

368 William Wilhelmi, *Earthenware Cowboy Boots*, 1993
Low-fired clay with airbrush slip design, glaze and gold lustre, largest boot
39.3 × 22.8 × 10.1 cm (15½ × 9 × 4 in)

369 Jesús Bautista Moroles, *Moonscape Bench; Moonscapes; Shell Sculptures*, 1993
Installation at Beach Park, Rockport, Texas, stone

369

370 **Roy Fridge**, *Standing Shaman:*
Shrine/Oracle – Standing In, 1982
Installation at the Betty Moody Gallery,
Houston, mixed media,
264 × 132 × 76 cm (104 × 52 × 30 in)

371 **James Surls**, *On Being in See*, 1985
Wood, 180 × 109 × 114 cm
(71 × 43 × 45 in)
Collection of the Virlaine Foundation,
New Orleans

372 **Jim Magee**, *Untitled*, 1992–3
Steel, lead, grease and oil bath,
106.5 × 106.5 × 12.7 cm (42 × 42 × 5 in)

370

earthenware. James Surls's whittled sculptures, their shapes often suggested by the roots and branches he makes them from, are objects which have elements taken both from the craft tradition and from local folk art (Pl. 371). Also related to this tradition are the sculptures and intallations of Roy Fridge. Fridge's sculptures have, for example, included perfectly practicable and workable boats. His main preoccupation, however, is with the idea of the shaman (Pl. 370) as an alternate or substitute for the creative artist, and one of his reasons for choosing Texas as the setting for his work is its comparative isolation from metropolitan fashions:

> I have lived the life of an 'amateur hermit' [Fridge once wrote] and I have used the shaman as persona – as psychopomp psychological voyager into the uncharted darkness of the unconscious.

371

> The boats, the shrines, the narratives reflect that journey – sometimes actual, sometimes imagined, but always real.[1]

Texas art has room for solitaries and for artists who produce work in unexpected form using equally unexpected materials. Currently one of the most interesting of these is the El Paso-based Jim Magee, whose assemblages are like the work of Kurt Schwitters translated into a local idiom (Pl. 372). The idiom is local because it is affected, just as Schwitters's own visual language was, by the materials available to the artist. The detritus Magee uses is dependent on what kind of machinery gets discarded, and on the finds provided by Texas highways. Many of his sculptures feature tyre-treads stripped from the tyres of the great eighteen-wheelers which thunder along these roads, binding the state together and at the

same time serving to emphasize its vastness.

It is not entirely surprising that the contemporary art of Louisiana has much in common with that of Texas, since communication between the two regions is so easy. The artist most typical of the Louisiana spirit is probably Robert Warrens, who lives and works in Baton Rouge. Warrens is both a painter and a sculptor. His paintings, brightly hued, have some of the populist spirit one also finds in the work of David Bates. In his sculptures (Pl. 373) the influence of folk-art is somewhat stronger than it is in the paintings. These works are sometimes like the assemblages of Ed and Nancy Kienholz (Pl. 24) transposed into a different and less savage key, but they are also influenced by carvings made by southern 'outsider' artists, though these are usually on a less ambitious scale.

373 **Robert Warrens**, *History,*
Geography, and a Cup of Tea, 1990
Mixed media, 244 × 254 × 79 cm
(96 × 100 × 31 in)

374 **Douglas Bourgeois**, *Morris Day*, 1982
Oil on linen, 50.7 × 50.7 cm (20 × 20 in)

375 **Robert Gordy**, *Prowler*, 1985
Monotype, 90 × 68 cm (35½ × 26¾ in)

374

Douglas Bourgeois, working in much smaller formats than those favoured by Warrens, also retains folk elements in his work, though it also has links with Pop (Pl. 374). This is not, however, Pop rendered in the sophisticated spirit of New York, but revelling in the fun and the colour, and also in the absurdity of popular imagery which has something in common with the spirit of the New Orleans Mardi Gras carnival.

Two more aspects of the Louisiana art world can be seen in monotypes by the late Robert Gordy and paintings by Richard Johnson. Gordy was a collector of African art, and the monotype heads which are the most powerful aspect of his work (Pl. 375) are obviously derived from African prototypes. They also have very obvious links to the imagery of the

375

376 Richard Johnson, *Riverfront Break*, 1994
Acrylic on canvas,
175 × 170 cm (69 × 67 in)

377 Ed Moses, *Untitled*, 1987
Oil and acrylic on canvas,
198 × 167 cm (78 × 66 in)

Hairy Who artists of Chicago, and offer a striking proof of the way in which the visual culture of Chicago seems to have travelled down the Mississippi. The pull of African-American folk culture can also be felt, just as it can in Robert Warrens's sculptures – though neither artist is of African-American origin.

Richard Johnson, not born in New Orleans but long resident there, offers a different example of the way in which the Louisiana

376

and specifically the New Orleans environment affect the contemporary art produced there. Johnson is a practitioner of a style sometimes labelled 'abstract illusionism', making paintings where apparently solid but abstract forms float in illusionary space. *Riverfront Break* (Pl. 376) may have been suggested by the industrial forms of the New Orleans waterfront, but these forms do resolve themselves into a recognizable scene. The real point of the work is its resonant, saturated colour, which seems

very much a product of subtropical heat and light. Johnson's painting is a surprisingly direct reaction to the environment in which it has been made.

The two most important subsidiary regions in the United States at the present moment, where contemporary art is concerned, are southern and northern California. There are various reasons for this: the wealth of California itself, the pleasant climate which has attracted many artists to live there, the growth of a museum infrastructure – the foundation of the Museum of Contemporary Art in Los Angeles was an important milestone, and at the time of writing the Museum of Contemporary Art in San Francisco is being rebuilt. Nevertheless, contemporary art still has obstacles to overcome before it becomes as important a part of the culture of California as it is of New York. Chief among these is the instability of the commercial sector. Los Angeles has many fewer commercial galleries than New York, and they were even harder hit by the recession of the late 1980s and early 1990s than their New York equivalents. These galleries do not, as can be seen from the range of acknowledgements in this book, devote themselves solely to the work of artists living and working in California, but their support is important to those who do.

A number of artists whose careers are identified with the Californian scene have already been discussed. They include the late Sam Francis (Pl. 46), 'Light and Space' artists like Eric Orr (Pls. 134-5) and California classicists like Robert Graham and David Ligare (Pls. 274, 271). All of these represent a distinct and clearly identifiable aspect of the Californian sensibility. On the whole, though Ligare now resides near Salinas, they are more representative of Los Angeles than of San Francisco. It does in fact seem to be generally agreed that the two cities produce very different kinds of art. Defining the difference is, nevertheless, a somewhat difficult exercise. The best way of tackling the problem in a small space seems to be to enumerate certain artists and to try and explain, as briefly as possible, in what ways their work might be considered typical of aspects of Californian culture.

Ed Moses (Pl. 377), for instance, can be considered typical of the confident way in which free abstraction has continued to

develop in Los Angeles, at a time when it was virtually dead in New York. This can also be said of the sombre but richly textured recent work of Joe Goode (Pl. 378). Charles Arnoldi's painted abstract reliefs, consisting of intertwined twigs and branches (Pl. 380), are an ingenious and distinctively local solution to the problem of developing a kind of sculpture which would be a convincing parallel to free abstract painting of the kind produced by Moses and others. Craig Antrim's *Small Resurrection* (Pl. 379) is also essentially abstract, despite the element of overt Christian reference. Antrim, born in 1946, was one of the youngest artists included in the Los Angeles

378 Joe Goode, *Essen*, 1993
Oil on canvas, 122 × 122 cm (48 × 48 in)

379 Craig Antrim, *Small Resurrection*, 1984
Acrylic on canvas,
25.4 × 17.8 cm (10 × 7 in)

380 Charles Arnoldi, *Motion Picture*, 1982
Painted branches on plywood,
228 × 223 × 20.3 cm (90 × 88 × 8 in)

379

380

County Museum's great survey exhibition *The Spiritual in Art*, held in 1986-7. A student of Jung, and of Celtic myth and legend, he represents the climate of mysticism and spiritual aspiration that has long formed part of Californian culture.

Other reactions to southern California are ironic or even directly satirical. While California enjoyed no great reputation as a place to make art during the inter-war period, there did flourish a group of local landscapists known as the 'Sunset School' because of their repetitive production of paintings showing the sun setting or the moon rising over the Pacific. These have been affectionately parodied in a

381 Tony Berlant, *L.A.X.*, 1992
Found metal collage, acrylic and
photograph on plywood with steel brads,
304 × 322 cm (120 × 127 in)

382 Peter Alexander, *El Rosario*, 1984
Oil and acrylic on canvas,
91 × 101.5 cm (36 × 40 in)

383 Lari Pittman, *A Decorated
Chronology of Insistence and
Resignation, Untitled #15*, 1993
Acrylic, oil, enamel and glitter on wood,
211 × 203 cm (83 × 60 in)

series of paintings by Peter Alexander (Pl. 382).
The full significance of the imagery does not
disclose itself unless one knows something
about local cultural history. More recently, Lari
Pittman has satirized the Californian consumer
culture as a literal orgasm of greed (Pl. 383).
Making use of Pop elements, the work has an
element of gleeful savagery which is generally
missing from true Pop, though this quality did
make occasional appearances in the work of
the Chicago-based Hairy Who. Less savage,
but still somewhat rueful in its vision of the
city of Los Angeles, is Tony Berlant's collage
L.A.X. (Pl. 381).

Because of the Californian climate, Los
Angeles art lends itself to the making of public
statements. One feature of the city are the
murals which appear not only on the blank

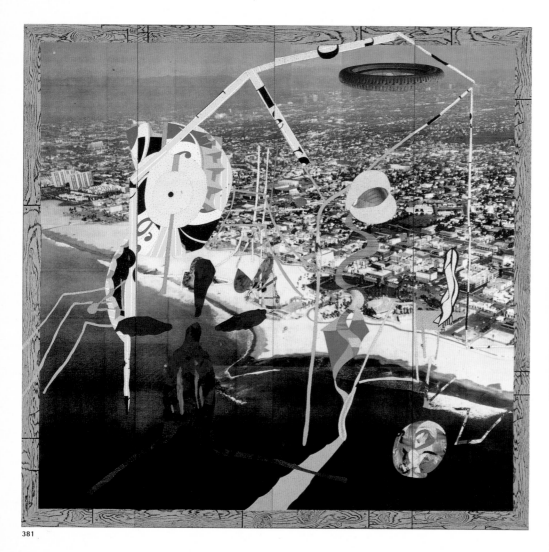

381

382

walls of suitable buildings but in other
locations, such as freeway underpasses. The
tradition can be traced back to the work done
by leading Mexican muralists in the city during
the inter-war period. One of the most active
muralists is Terry Schoonhoven, who used to
work with others under the name 'The Los
Angeles Fine Art Squad', and now works
independently, without collaborators. A recent
commission is a large ceramic tile mural (Pl.
384) for Alameda Station on the new Los
Angeles Metrorail. Schoonhoven's murals
usually have an air of fantasy, and this, which
invites the spectator to travel in time from the
year 1500 to the year 2000, is no exception.

The movies are the obvious parents of the
intricate sculptures made by Michael McMillen
(Pl. 386), which refer to the art of the

383

384 Terry Schoonhoven, *Traveller*,
1991
Ceramic tile mural for Alameda Station,
Los Angeles Metrorail – mural 3 × 7.9 m
(10 × 26 ft), each tile 30.4 × 30.4 cm
(12 × 12 in)

385 Peter Shelton, *Horseheader*,
1990–1
Bronze, 157 × 375 × 122 cm
(62 × 148 × 48 in)

384

385

professional model-maker. The skills employed
are the same as those used in creating various
types of special effects, and it seems likely that
McMillen's work would not take precisely this
form if he were associated with any other city.
McMillen's work has the surrealist edge which
is typical of a good deal of the figurative art
made in southern California. This surrealism
often seems to be an indirect, rather than a
direct and absolutely unequivocal inheritance
from the Surrealist movement in Europe.
Primary sources are the underground comics
and satirical magazines which first made their
appearance in the United States in the mid-
1950s, with the appearance of *Mad* magazine,
and which became increasingly prolific in the
mid- and late 1960s with the rising opposition
to the war in Vietnam. These periodicals
appeared everywhere in America but were
especially successful on the West Coast.
Among the titles from that period were the
Berkeley Barb , published just across the bay
from San Francisco, and the *Los Angeles Free
Press*. Caricaturists like Robert Crumb, who
worked for the underground press, affected the
sensibility of a whole generation of American
artists. One can detect traces of this sensibility
in the strangely disturbing work of the Los
Angeles sculptor Peter Shelton (Pl. 385), whose
work often seems like a extrapolation into
three dimensions of some of the more extreme
inventions of Crumb and his colleagues.
Shelton combines a number of the more salient
aspects of the best Los Angeles art. There is
an influence from Japan – one ambitious
environmental piece consisted of a suspended
pavilion whose floor-plan was that of a human
body, enclosed by Japanese *shoji* screens and
hung by a chain from the roof of the gallery.
There is also a somewhat brutal sense of
humour. Another environment consisted of
rudimentary models of clothing (for example,
a T-shirt), plus models of body parts, including
the viscera and male genitalia, made from cast
iron and once again hung from the ceiling of
the gallery at appropriate heights. The whole
made up a sardonic self-portrait.

San Francisco, a smaller city than Los
Angeles, has always prided itself on its special
relationship with the visual arts. Many artists
choose to live there, even if opportunities to
exhibit locally are more limited than they
would be in southern California. The influence

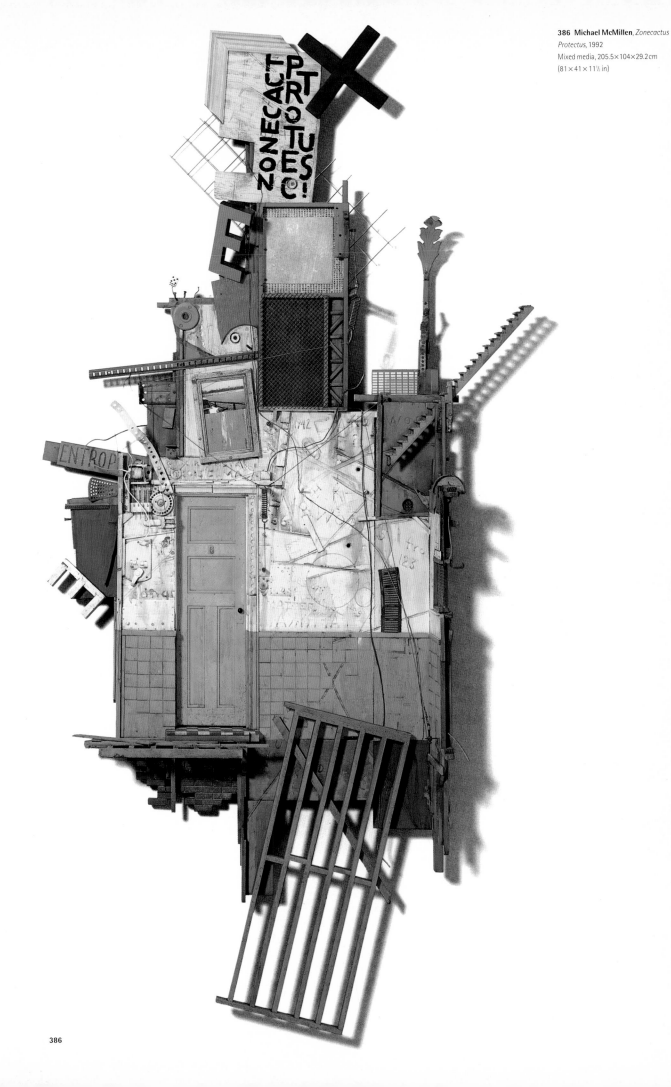

386 **Michael McMillen**, *Zonecactus Protectus*, 1992
Mixed media, 205.5×104×29.2cm
(81×41×11½ in)

386

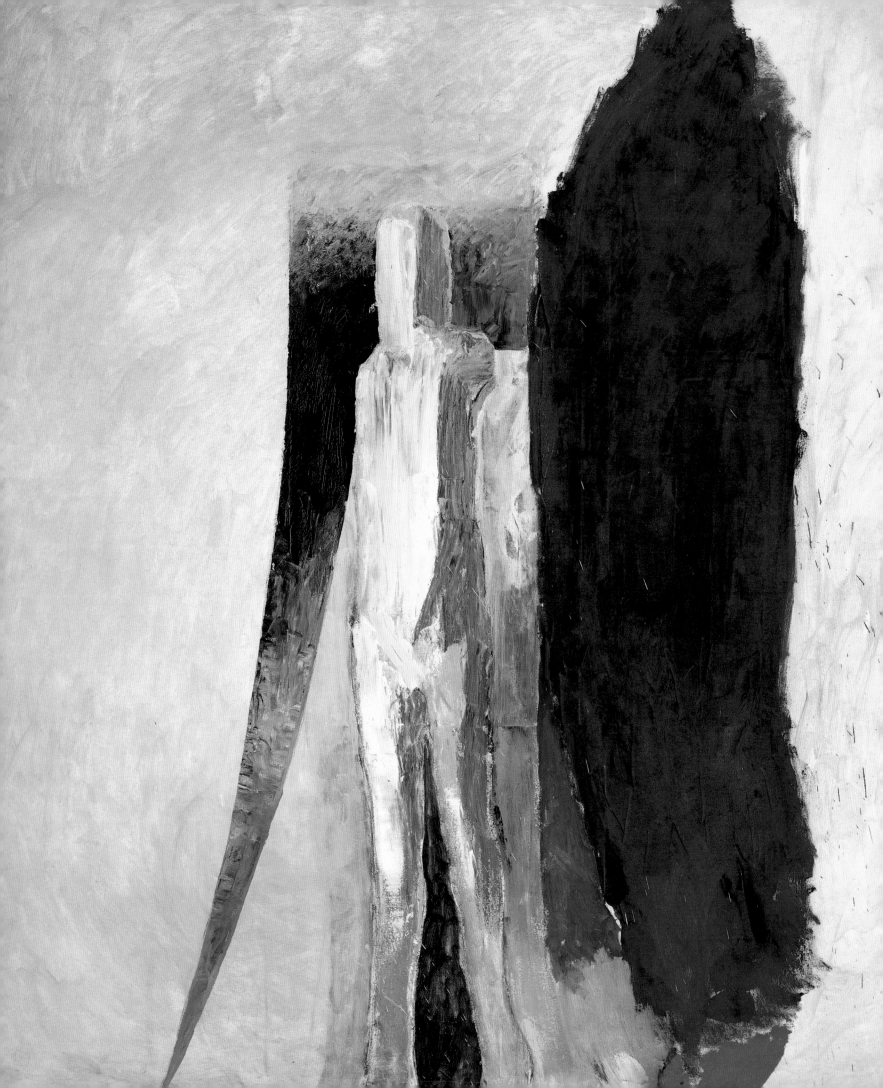

of Abstract Expressionism was at one time extremely strong in the area, thanks to the presence of Clyfford Still at the California School of Fine Arts. The dominance of abstraction eventually led to a revolt, and the mid-1950s saw the emergence of a painterly but nevertheless representational style which came to be known as Bay Area Figuration. Practitioners of figurative painting included David Park, Elmer Bischoff and, for a while, Richard Diebenkorn. More recent Bay Area art has retained its figurative bias, but has tended to part company with the notion of direct observation. One of the few artists to maintain the direction originally taken by Bay Area Figuration is Nathan Oliveira (Pl. 387), whose broadly handled canvases look back to the tradition founded by Park.

A commoner form of figuration is the quirky, jokey narrative work which seems to owe much to the underground magazines which have already been described. Their influence is obvious in the complex designs of William Wiley (Pl. 388), who studied at the San Francisco Art Institute in the 1960s and whose work remains linked to the local ethos even if he no longer lives and works in the city. It can also be seen in the glowing fantasies of Roy De Forest, sometimes called 'the dog painter' because of the frequent presence of these animals in his compositions (Pl. 389).

This element of the bizarre also manifests itself in a great deal of the three-dimensional work produced by Bay Area artists. Significantly, a number of these works are in ceramic, which emphasizes the strong link between art and craft in the local creative community. This link exists elsewhere in the north-west of the United States. It manifests itself, for example, in the ambitious sculptures in glass which emerge from the studio in Seattle of Dale Chihuly (Pl. 392). In the Bay Area, however, this marriage between art and craft is often given an instantly recognizable humorous twist, exemplified in David Gilhooly's visual pun *Bowl of Chocolate Mousse* (Pl. 391).

The two most ambitious ceramic sculptors associated with the region go somewhat beyond this. Viola Frey's massive figures in glazed ceramic act out primitive allegories, in a way which leaves the spectator uncertain whether or not the intention is satirical. She

387 Nathan Oliveira, *Untitled Standing Figure # 6*, 1990
Oil on canvas 243 × 213 cm (96 × 84 in)

388 William Wiley, *Taking Liberties*, 1989
Watercolour on paper,
50.7 × 76 cm (20 × 30 in)

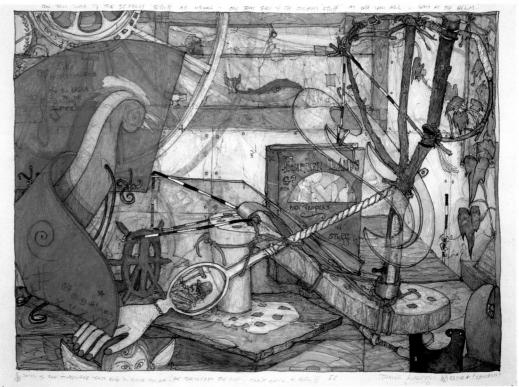

388

389 Roy De Forest, *Big Foot, Dogs and College Grad*, 1985
Polymer on canvas, 226 × 241 cm
(89 × 95 in)

390 Robert Arneson, *Classical Exposure*, 1972
Terracotta, 244 × 91 × 61 cm
(96 × 36 × 24 in)

391 David Gilhooly, *Bowl of Chocolate Mousse*, 1989
Ceramic, 25.4 × 15.2 × 17.8 cm
(10 × 6 × 7 in)

seems to want to return the spectator to a more innocent world, while simultaneously calling into question the moral and cultural values which this willed innocence defends (Pl. 393).

The work of the late Robert Arneson – in some ways the quintessential Bay Area artist – has a sharper edge. Much of Arneson's work is concerned with self-portraiture. He often used his own likeness as a basis for irreverent jests at the expense of the classical tradition, and also at the expense of art world pomposity in general (Pl. 390). Arneson was aware of the

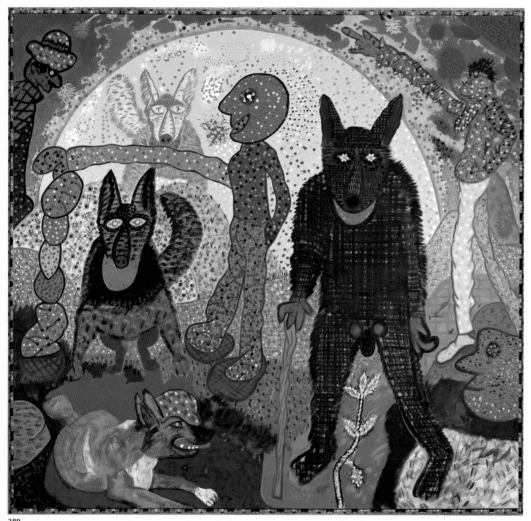

389

390

degree to which his work irritated many of the pundits of the New York art world – in the earlier part of his career, at least, he was frequently a focus for the hostility which some New York critics felt for the more unrepentantly populist aspects of Californian art. This populism now seems like the true source of the vitality to be found in much American regional art – a vitality now sometimes lacking in its metropolitan counterpart.

392 Dale Chihuly, *Venturi Window*,
1992
Installation at the Seattle Art Museum,
brown glass, 4.9 × 14.6 × 2.1 m
(16 × 48 × 7 ft)

393 Viola Frey, *Two Women and a
World*, 1990–1
Glazed ceramic, 212 × 604 × 173 cm
(83½ × 238 × 68 in)

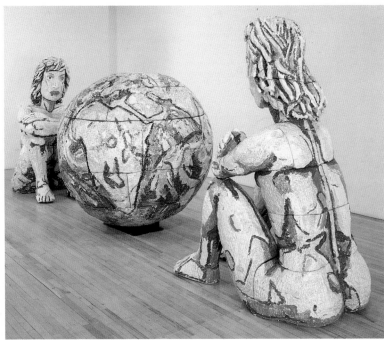

393

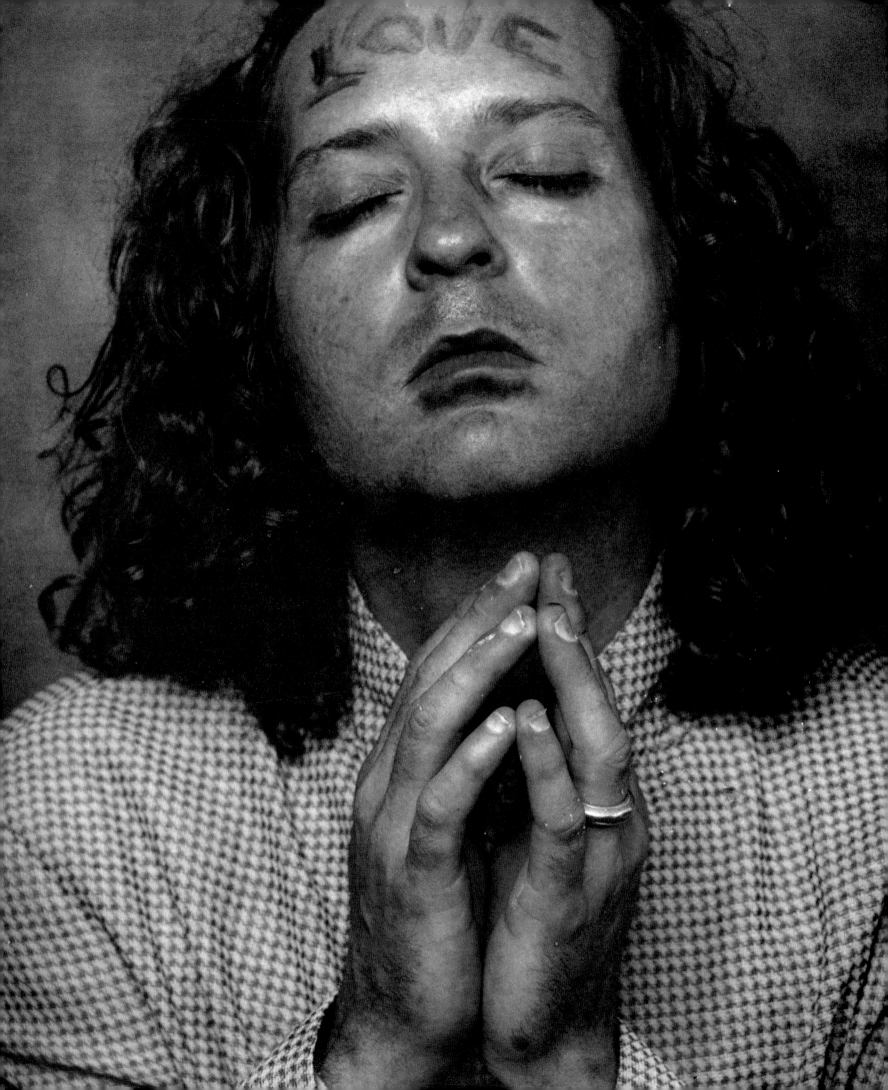

Latin America

394 Carlos Cruz–Diez, *Physichromie
No. 1053*, 1976
Painted metal and wood relief,
150 × 100 cm (59 × 39½ in)

395 Francisco Toledo, *El Amnistiado*,
1975
Gouache and ink on paper,
76.5 × 57 cm (30 × 22½ in)

396 Rufino Tamayo, *Mascara Rojo*,
1977
Oil on canvas, 101.5 × 81.2 cm
(40 × 32 in)

394

395

Perhaps the first sign of challenge to established hierarchical structures in the world of contemporary art was the return to prominence of Latin American artists. Latin American art had enjoyed a moment of prominence once before, in the heyday of Mexican Muralism. In 1931-2 Diego Rivera, leader of the Muralist school, was given the second one-person exhibition staged by the fledgling Museum of Modern Art in New York; the first had been dedicated to the work of Henri Matisse. Rivera's show drew 52,000 visitors and received much favourable comment from reviewers. Since that high point, however, Latin American painting and sculpture had drifted from the consciousness of the taste-makers and critics of the United States and Western Europe. The Latin American artists who continued to attract attention were safely assimilated into various Western art movements. The veteran Cuban Wifredo Lam was seen chiefly as a child of the Surrealist movement; the Chilean Matta was valued mainly for the part he had played in the creation of Abstract Expressionism. In Matta's case this was perhaps reasonable enough, since he had left Chile as a very young man and had taken on a European, then a North American, identity.

Where developments in Latin America impinged on what was happening elsewhere, the Latin American element was largely misunderstood. For example, the first signs of a revolt against the dominance of Muralism and its values in Latin America came from an idiosyncratic return to Constructivist ideals (at a time when these were deeply out of fashion elsewhere) under the influence of the veteran Uruguayan Constructivist Joaquín Torres-García (1874-1949), who had returned to Montevideo in 1937 after a long absence in Europe and set up a school there. The new Constructivism first manifested itself in Argentina in the mid-1940s, with the appearance of two rival groups, Madí and Arte Concreto-Invención. From here it spread to other Latin American countries, such as Brazil, Colombia and Venezuela. Venezuelan artists such as Jesús Rafael Soto and Carlos Cruz-Diez (Pl. 394) played a prominent part in the Kinetic Art movement, derived from Constructivism, which briefly figured as a rival to Pop in the 1960s, but their Latin American identity was scarcely mentioned. One reason for this may have been the deliberate impersonality of their work, which repelled any speculation about the personal life of the artist.

Nevertheless, the 1960s did witness the gradual emergence of certain major Latin American reputations. One artist who was already well established, and who now began to move towards the centre of the stage, was the veteran Mexican Rufino Tamayo (Pl. 396). Tamayo, born in 1899, belonged to the same generation as the three major Muralists Rivera, José Clemente Orozco and David Alfaro Siqueiros, but had been slower to establish himself as a major figure. It was not until 1948, when he had a major official retrospective in Mexico City, that he began to be recognized as a possible leader. When the rebellion against Muralist dominance finally came, in the mid-1950s, Tamayo's work became the most important point of reference for younger Mexican artists. Particularly important to them were his frequent use of folk motifs, and his tendency to refer to the realities of Mexican life in the present, rather than to the glories and tragedies of the past.Tamayo was now the leader of the new Mexican school, and several generations of figurative artists in Mexico are heavily dependent on him. One example of this dependence is the immensely prolific Francisco Toledo (Pl. 395). Like Tamayo, Toledo makes use of sources in Mexican folk-art, which gives

a vivid national flavour to everything he does.

Another Latin American artist who made an impact on the imagination of an international public is the Colombian Fernando Botero. Botero first emerged as a figure to be reckoned with at the beginning of the 1960s, with versions of paintings by Old Masters such as Velázquez. These paraphrases of cultural icons (Pl. 397) already show the painter's characteristic morphology, a deliberate exaggeration of forms which makes everything plump and roly-poly. Botero has always denied that there is any deliberate satirical intention in this:

> The deformation you see is the result of my involvement with painting. The monumental and, in my eyes, sensually provocative volumes stem from this. Whether they appear fat or not does not interest me. It has hardly any meaning for my painting. My concern is with formal fullness, abundance. And that is something entirely different.[1]

However, he has also claimed that it is his intention to produce a specifically 'Colombian' art, and his versions of earlier masters must be approached from this point of view. He seems to need to emphasize both Latin America's dependence on the European heritage, and its growing distance from it.

In addition to producing altered versions of European masterpieces, Botero has painted scenes of contemporary Colombian life, most notably a series of vigorous brothel scenes apparently based on memories of such establishments in his native Medellín. These paintings have often been seen as visual equivalents to the 'magic realism' of the Colombian writer Gabriel García Marquez. Whether or not this is the case, the paintings serve to stress the strongly narrative element which appears in much recent Latin American art – something which makes it seem different from European and North American counterparts.

Artists like Cruz-Diez on the one hand and Botero on the other define the frontiers of recent Latin American art – much more so than the great names of the immediate past, such as Diego Rivera. Rivera's work was prophetic in one way, however, because abstraction has flourished less strongly in Latin America than figurative painting. Even artists who are apparently committed to abstraction, like the

397 Fernando Botero, *Alof de Wignacourt (after Caravaggio)*, 1974
Oil on canvas, 254 × 191 cm (100 × 75¼ in)

398 Gunther Gerzso, *Blanco – amarillo – azul*, 1970
Oil on board, 46 × 63.5 cm (18 × 25 in)

398

399

400

veteran Mexican painter Gunther Gerzso (b. 1915), often turn out to have a figurative substratum. Gerzso has always asserted that his work, far from belonging to the Latin American Constructivist tradition (where it has often been placed by critics), is in his own terms 'realistic' – a response to the Mexican landscape and pre-Hispanic culture (Pl. 398). The architectural substratum often visible in Gerzso's work is also usually visible in that of the Argentinian artist Marcello Bonevardi (Pl. 399), a disciple of Torres-García who has made his career largely in the United States. It is also visible in paintings by another Argentinian, Pérez Celis (Pl. 401).

One aspect of Latin American abstraction which often puzzles outside observers is the apparent lack of influence from North American Abstract Expressionism. There is good reason for this – the fact that, south of the Mexican border, Abstract Expressionist art was often considered to be an instrument of cultural imperialism. Where Abstract Expressionist art did have an impact, it was often in countries which were conscious of being culturally backward and in a hurry to catch up with the modern world. Nowhere is this more clearly the case than in Peru – no exhibition featuring abstract art was seen there until after the end of World War II. The most distinguished Peruvian artist of the modern epoch is Fernando de Szyszlo (Pl. 400), whose work does indeed show traces of Abstract Expressionist influence. Far more powerful than this, however, are the ideas taken from the stupendous Andean landscapes of Peru and from pre-Columbian weavings. Often these suggestions are so strong that his work, like Gerzso's, seems abstract in name only.

There is a link between the paintings produced by Szyszlo on one side of the Andes and the fibre works done by the Colombian Olga de Amaral on the other. Amaral's work is essentially unclassifiable (Pl. 403). It combines the properties of off-stretcher painting with those of what is commonly called 'craft'. The lavish use of gold is a deliberate recollection of the riches of the Pre-Columbian civilizations of the region. Like Szyszlo, Amaral tries to find a contemporary expression for the difficult concept of 'indigenism' – something which runs through much, but by no means all of Latin American art.

399 **Marcello Bonevardi**, *Hexagram,*
1969
Construction, canvas on wood,
157 × 122 cm (62 × 48 in)

400 **Fernando de Szyszlo**, *Mar de
Lurin,* 1993
Oil on canvas, 104 × 104 cm (41 × 41 in)

401 **Pérez Celis**, *The Meaning of the
West,* 1990
Oil and acrylic on canvas,
203 × 355 cm (80 × 140 in)

401

402

It is an essential element in contemporary
Latin American art that it is always stylistically
mixed. It is interesting, for example, to note
how the Pop spirit transformed itself under
Latin American circumstances. It became much
more directly political. An important artist who
has never had quite the impact he deserves
outside his own country is the Argentine
Antonio Berni. Berni's art underwent a long
and complex development. At one time he
was very much under the spell of Picasso's
notorious *Massacre in Korea*, and of the
post-war French Social Realism of artists like
Boris Taslitzky. His final style, achieved by
the beginning of the 1960s, is much more
unexpected and exuberant than this pedigree
might suggest. His typical late works deal with
the fate of the Argentine underclass. He has
two characters drawn from this class – the
prostitute Ramona Montiel, and the street
urchin Juanito Laguna (Pl. 402). He sums up
their lives in narrative collages made from
urban detritus. The wry satire of these works,
and their direct narrative thrust, are typically
Latin American, and their tone is consequently
very different from the willed blankness of
much American Pop. What remains Pop about
them is the emphasis on urban mass culture
and its products. Another Latin American artist
who makes use of Pop elements in a different
and highly original way, giving them a
distinct political twist, is the Mexican Alberto
Gironella. Gironella's boxed collage *Octavio
Paz* (Pl. 404) is a tongue-in-cheek tribute to
Mexico's most distinguished living author.

Pop influences in contemporary Latin
American art coexist with many others. While
it is certainly not true, as has often been
asserted (following a bombastic declaration
made by one of the founders of the Surrealist
movement, André Breton), that Latin American
art is 'essentially surrealist', there are still many
traces of Surrealist influence in Latin America,
perhaps more than in any other region. This is
evident in the sculptures of Jim Amaral (Pl.
405) (the husband of the Colombian fibre artist
Olga de Amaral), and equally apparent in the
paintings of the Peruvian Herman Braun-Vega
(Pl. 407). Yet Braun-Vega's canvases, with their
witty and improbable juxtapositions of artists
and art-styles, also indicate another and
perhaps more important trait, the rejection
by Latin American artists of the conventional

403

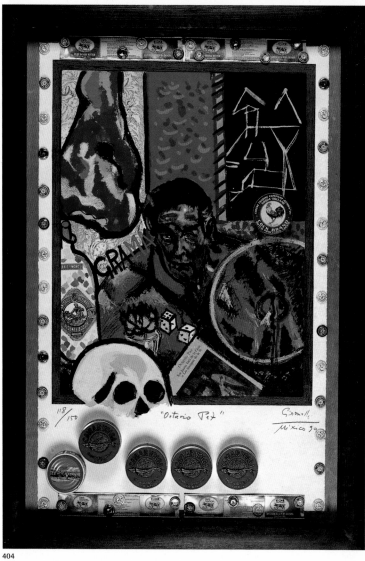

404

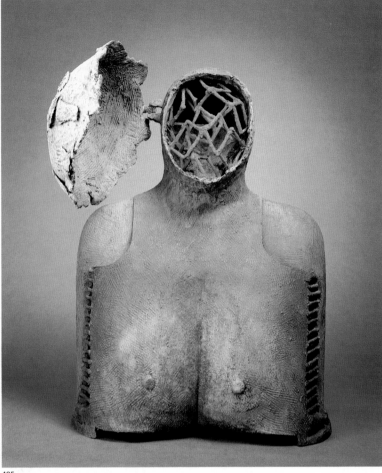

405

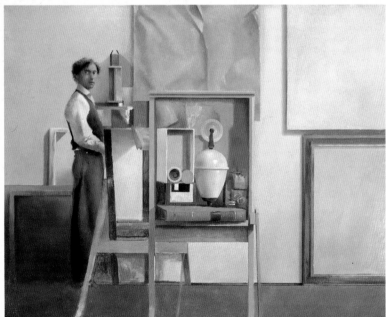

406

boundaries of avant-gardism. One encounters a subtler version of the same dislocation in the landscapes of the Uruguayan painter José Gamarra. In Gamarra's *Nightfall* (Pl. 408), the boat floating through an Amazonian landscape contains personages from many different myths and epochs: Superman at the prow, a Spanish conquistador at the stern, and in the middle a couple of dogs, a bearded seaman who might belong to any epoch, and – sitting bolt upright and clutching his pitchfork – the Devil in person. What is really striking is the way in which the scene is rendered. Gamarra borrows the actual mode of representation from the Dutch landscape painter Frans Post, who visited Brazil in the mid-seventeenth century. It is the deliberate archaism of the technique which gives fullest impact to the scene.

Other Latin American artists experiment with versions of Old Master methods. In Colombia, Botero is not alone in his fascination with the art of the pre-Moderns. Luis Caballero is the master of a powerful academic technique, and uses this to produce disturbing figurative compositions (Pl. 409), which meld together the Spanish religious art of the seventeenth century, the chronic violence of present-day Colombia, and allusions to the artist's own homosexuality. The mixture of references makes sure that we immediately acknowledge the purely contemporary nature of the representation. Another Colombian artist, Juan Cardenas, uses an extremely accomplished figurative style, more nineteenth-century than seventeenth-century, as the vehicle for a long-continued essay in self-interrogation (Pl. 406).

Yet another style which has had a great attraction for Latin American painters is a form of Expressionism, as can be seen from an early work by one of the most accomplished Latin American artists now working, the Venezuelan Jacobo Borges. Borges's *Espantapajaro de Choluma* (Pl. 412), quite apart from its intrinsic merits, is of great historical interest, because it antedates the Neo-Expressionist revival which was to take place in Europe (see Chapter 6, pp.172ff.). It is even a year or two ahead of Georg Baselitz's commitment to the style. Similar Expressionist experiments were made in Argentina, by the members of the Otra Figuración group, whose members included Jorge de la Vega, Ernesto Deira and Luis Felipe Noé. Noé's *Christ Before the People* (Pl. 410)

405 Jim Amaral, *Dead Poet VI*, 1992
Painted bronze, 54 × 45 × 25 cm
(21¼ × 17¼ × 9¾ in)

406 Juan Cardenas, *Variation on a Still Life*, 1990
Oil on canvas, 56.4 × 71.6 cm
(22¼ × 28¼ in)

407 Herman Braun-Vega, *Fame, after Vermeer, with Goya and Picasso*, 1984
Acrylic on canvas,
195 cm × 300 cm (77 × 118 in)

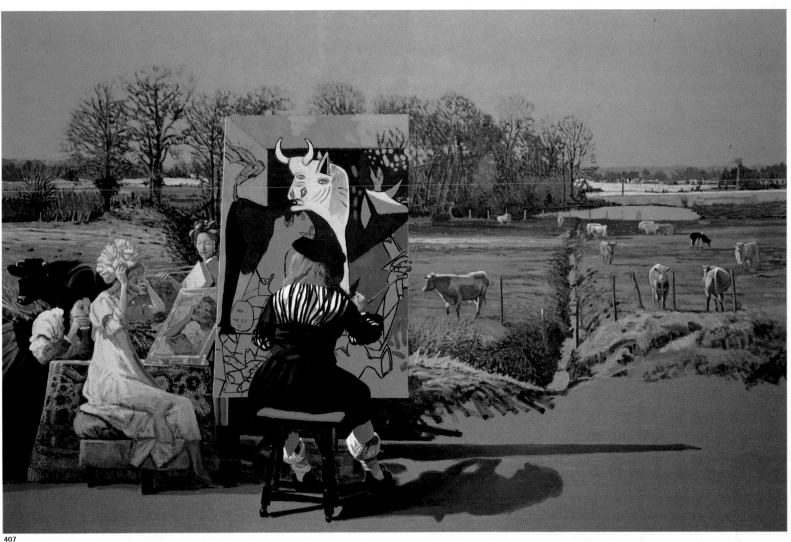

407

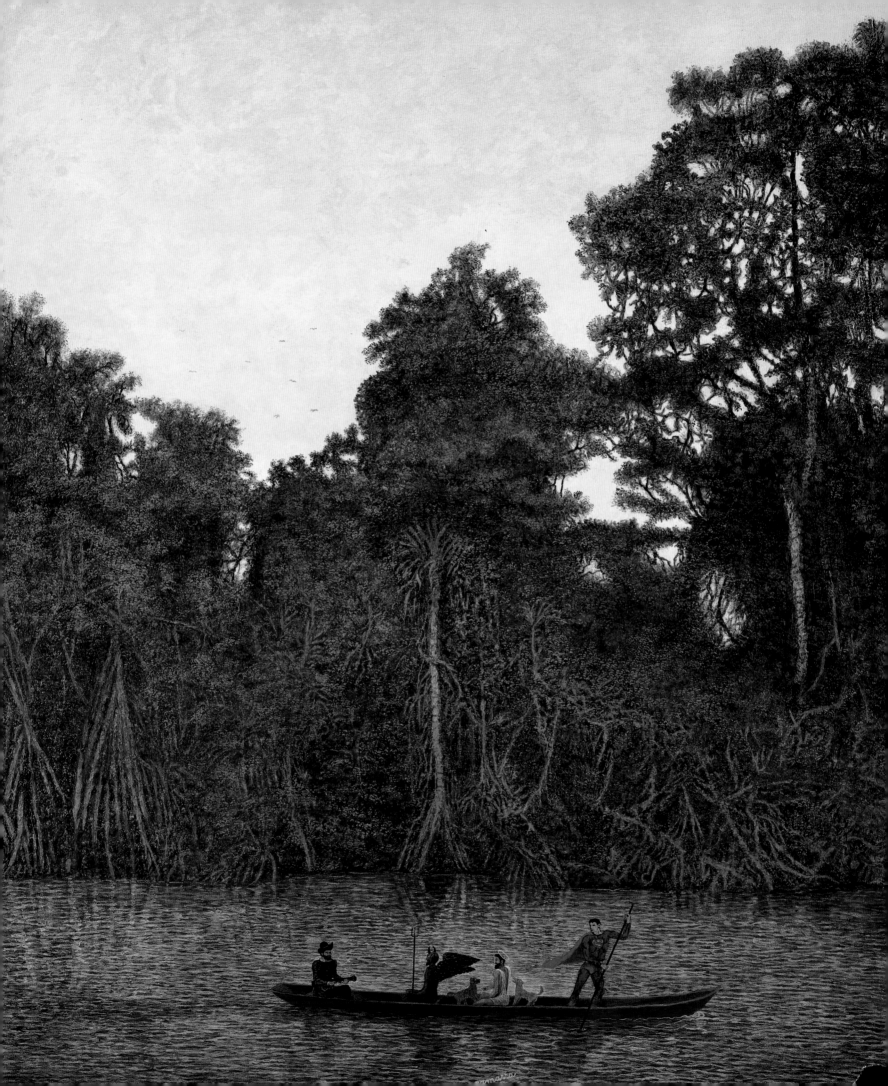

408 José Gamarra, *Nightfall*, 1993
Oil and acrylic on canvas,
150 × 150 cm (59 × 59 in)

409 Luis Caballero, *Untitled*, 1984
Charcoal and thinned oil on paper,
114 × 146 cm (45 × 57½ in)

409

has an inventive savagery which exceeds that of any European equivalent, and serves as a reminder of the chronic violence of Latin American life.

In later work Borges has espoused a more reflective style. Especially striking are paintings such as *The Groom* (Pl. 411), which attempt to find a visual equivalent for the passage of time, with a subtle layering of images within a space whose boundaries seem to shift as one looks. Here, perhaps even more obviously than in the paintings of Botero, one finds a parallel in the visual arts for the novels of Gabriel García Marquez.

Borges belongs to what is now a fairly senior generation of Latin American artists. The 1980s

410 Luis Felipe Noé, *Christ before the People*, 1963
Mixed media on canvas,
190 × 115 cm (75 × 45¼ in)

411 Jacobo Borges, *The Groom*, 1975
Acrylic on canvas,
119 × 119 cm (46¼ × 46¼ in)

412 Jacobo Borges, *Espantapajaro de Choluma*, 1960
Oil on canvas, 94 × 131 cm (37 × 51¼ in)

411

412

saw the emergence of a vigorous new generation, helped by increasing international recognition. The most active nations tended to be, not surprisingly, the larger ones. Argentina, which has always suffered from the perception that its artists are too 'European' in style, and therefore (paradoxically) not sufficiently individual in flavour for the international market, produced a brilliant new generation of artists, among them the young Conceptualist Guillermo Kuitca (Pl. 112), Miguel d'Arienzo (Pl. 413), Ricardo Cinalli (Pl. 415) and Alfredo Prior (Pl. 414). D'Arienzo offers a gently satiric vision of Argentine middle-class and lower middle-class life, looking back not only to Berni (whose social indignation he lacks) but

413 Miguel d'Arienzo, *Salon Mariano
Acosta*, 1993
Tempera on canvas,
142 × 165 cm (56 × 65 in)

414 Alfredo Prior, *Untitled*, 1993
Mixed media on corrugated board,
189 × 117 cm (74½ × 46 in)

415 Ricardo Cinalli, *Encuentros VII*,
1993
Tempera on board,
32 × 26 cm (12½ × 10¼ in)

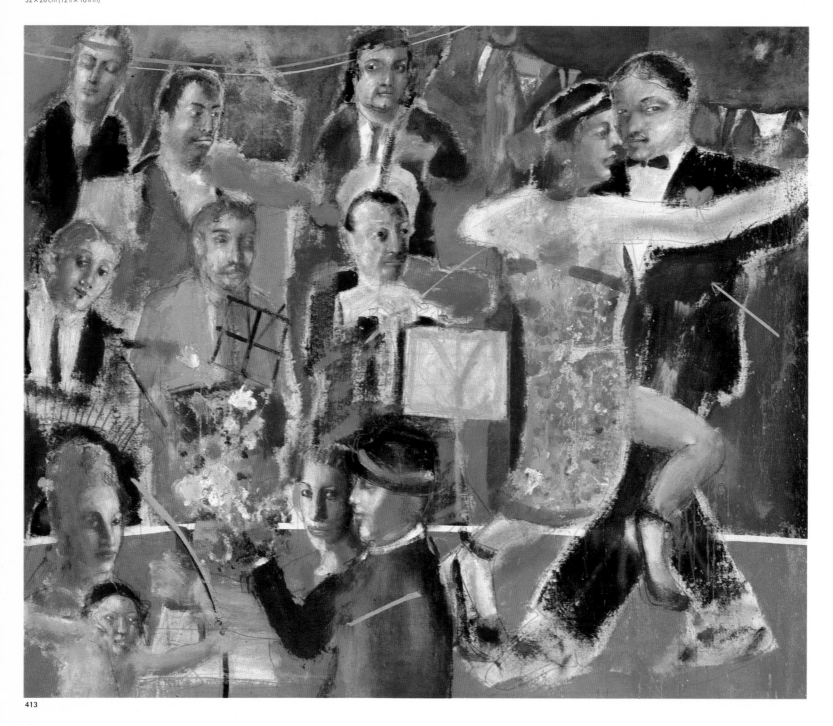

413

also to the Argentine art of the early Modern period, which was heavily influenced by the artists of the Italian Novecento Group, such as Carlo Carrá and Mario Sironi. Given the complex political history of Argentina and the relationship between this and the rise and fall of Italian Fascism, d'Arienzo's borrowings from this source are loaded with deliberate irony for his home audience. Cinalli is also a classicist, but of a different sort, influenced by the later work of Giorgio de Chirico rather than by members of the Novecento group, the classicizing artists who flourished under Mussolini. Amongst his most original compositions are those showing figures in a claustrophobic, box-like setting. The box, and the fragmentation of the figures themselves, seem to act as metaphors for the Argentine cultural situation – on the one hand confined and isolated by distance, on the other trying to make sense of a jumble of cultural baggage brought from Europe. The metaphor is especially poignant when the fragmented figure, as here, is that of the crucified Christ. Prior, like a number of Latin American painters, is extremely fluid in style, making sudden jumps from one way of working to another. He also has the disconcerting, but thoroughly Latin American habit of combining apparently incompatible styles and approaches. A recent untitled work features a gigantic teddy bear – first cousin to Koons's *Popples* (Pl. 336) – rendered in a version of the Neo-Expressionist manner. On the crown of the bear's head are three blobs which on close examination resolve themselves into nightmarish human heads in the manner of the great French Romantic painter Théodore Géricault (1791-1824). The clash of associations is so jarring that the spectator wonders how to react: he has stepped through the looking glass into a totally unpredictable world. Looking at the recent history of parts of Latin America, some might say, however, that an image of this sort was, nevertheless, a brilliant and imaginative way of catching the true spirit of the region.

Despite the political violence in Colombia, Colombian artists have continued to produce interesting work. The stringent figuration of Colombia's middle-generation artists, product of the demanding academic methods taught in Colombia's major art schools, is now often replaced by a much greater degree of fantasy.

414

415

416

Ramiro Arango, for instance, carries Botero's paraphrases of the Old Masters a step further, converting familiar Old Master compositions into fantastic still lifes, with pears, gourds and coffee-pots standing in for the human figures (Pl. 417). A very different aspect of contemporary Colombian art can be found in the work of Ofelia Rodriguez, who comes from Baranquilla on the coast. Rodriguez makes both paintings and constructions (Pl. 418). These have a tropical exuberance which serves as a reminder that Colombia has a deeply divided cultural heritage – Spanish and Indian, highland and lowland, populist and highly educated (Colombian Spanish is always rated

416 Kim Poor, *Curumin*, 1993
Enamel on metal,
68.5 × 76 cm (27 × 30 in)

417 Ramiro Arango, *Celestial Conversation*, 1990
Pastel on canvas,
116 × 83 cm (45¼ × 32¼ in)

418 Ofelia Rodriguez, *Dangerous Box with one Tit*, 1993
Mixed media, height 31 cm (12¼ in),
circumference 36 cm (14¼ in)

417

418

as the best and purest spoken in South America). Rodriguez's boxes in particular are yet another commentary on the idea of magical transformation, which has played so prominent a role in recent Colombian culture.

There has also been an enormous amount of recent artistic activity in Brazil. Here the range of styles has been vast. Some Brazilian artists, like Kim Poor, have concentrated on creating poetic evocations of the fast-vanishing rain-forest and the lives of the Brazilian Indians (Pl. 416). Others have been more interested in evocations of contemporary life in Brazilian cities, often choosing unconventional formats. Environmental work, for example, enjoyed

419 Alex Vallauri, *Casa* (detail), 1985
Installation at the São Paulo Bienal,
mixed media

420 Daniel Senise, *Untitled*, 1986
Acrylic on canvas,
150 × 250 cm (59 × 98½ in)

421 Hilton Berredo, *Pindorama III*,
1989
Acrylic on rubber,
231 × 520 cm (91 × 205 in)
Museum of Modern Art, Rio de Janeiro

419

420

great popularity in Brazil during the 1980s, just
as it did almost throughout Latin America. This
may have been because art in the region often
takes on a theatrical, public aspect and an
environment serves to turn the spectator from
an outsider into a participant – someone who
is offered a role in the play. A good example of
this was the environment shown by Alex
Vallauri in the São Paulo Bienal of 1985
(Pl. 419). This was a satirical re-creation of a
middle-class home, seen as the mirror of a
newly aspirant bourgeoisie, now beginning to
assert itself in the no-man's land between the
very rich and the very poor. This rise of the
middle class was a striking phenomenon in
the Brazil of the 1980s, especially in the city
of São Paulo itself. Brazilian painting often
reinterpreted Pop Art in local terms and opted
for off-stretcher formats, as in the work of
Hilton Berredo (Pl. 421). Berredo uses strips of

421

rubber (a typically Brazilian product) to create
'industrialized' versions of the Brazilian jungle.
There was also a form of Brazilian Neo-
Expressionism, once again mingled with Pop
elements. One leading exponent of this style is
Daniel Senise (Pl. 420). Also typical of Brazil,
however, was a kind of art which lay at
completely the opposite extreme – an art of
intellectual jokes. These are given a sharp
political edge in the work of a younger
Brazilian Conceptual artist and maker of
assemblages, Jac Leirner. *Que sais-je?* (Pl. 422)
is about waste, and also about information
overload. Leirner symbolizes these ideas in one
of the assemblages of plastic carrier bags which
have become a regular means of expression
with her. The bag advertises a product (in this
case most of the bags advertise magazines
and books). Yet it becomes meaningless when
discarded and separated from what it once

422 Jac Leirner, *Que sais-je?*, 1993
Plastic bags and polyester wrapping,
129 × 150 cm (51 × 59 in)
Collection of Monica and Xavier Mora

422

423 Arturo Duclos, *La Gran Utopía*,
1991
Oil, acrylic and enamel on canvas, with
added collage elements, dimensions
unknown

424 Alejandro Colunga, *The Last
Supper*, 1990
Oil on canvas, 260 × 530 cm
(102½ × 209 in)
Fundación Cultural Gallo, Guadalajara,
Mexico

425 Eugenio Dittborn, *Armail
Painting*, 1986
Mixed media on paper, dimensions
unknown

held. And it is not biodegradable, so it refuses
to vanish away. Other Brazilian artists tackle
similar issues by making installations –
installation work has long been popular
throughout Latin America. Alex Vallauri, for
example, criticized the tendency to regard
Brazilian life as inherently exotic by making
installations which parodied the life-style of
São Paulo's middle class.

Chile, during the dark years of the Pinochet
dictatorship, developed a new avant-garde,
which has blossomed since the return to
democracy. Among the most prominent figures
in the self-christened 'School of Santiago' are
Eugenio Dittborn and Arturo Duclos. Dittborn
has made an international reputation with his

423

424

425

'Airmail Paintings'. These works travel round
the world as folded sheets, and the envelopes
that contain them, and even the fold marks
which are the result of their voyages, become
part of the total 'story' of the artwork. Chile,
because of its geographical situation, has often
tended to feel isolated from other cultures;
Dittborn's works, which build up into large
installations, are a way of overcoming this.
They also, however, refer directly to aspects
of Chilean society. The example illustrated,
for instance, uses 'found' images of Chilean
petty criminals (Pl. 425). Duclos's work often
involves bringing together various images and
emblems, which have to be read like a rebus.
Like Dittborn, Duclos has something in

common with the *perestroika* artists of the
1980s who appeared in Russia; that is, his
work often contains coded references to the
Pinochet years, and to the ideas propagated by
the dictatorship. The idea of 'utopia', in his
painting *La Gran Utopia* (Pl. 423), must be seen
as something deeply ironic.

In Mexico, the revolution brought about by
Tamayo, and by José Luis Cuevas, the *enfant
terrible* of Mexican art and ruthlessly polemical
leader of the so-called 'Ruptura' of the 1950s
and 1960s which finally broke the dominance
of the Muralists, seemed by the 1970s to be in
some danger of running out of steam. Cuevas's
own position was a special one. A draughtsman
rather than a painter, self-absorbed, but still
fascinated by Mexican contemporary life, his
work is a unique visual record of his thoughts
and feelings, one of the most intimate and
unsparing ever produced by a twentieth-century
artist (Pl. 426). As the majority of Mexican
artists pursued the folkloristic, indigenist
direction which first Tamayo, then his disciple
Francisco Toledo, seemed to indicate as correct,
Cuevas appeared more and more isolated. All
this was to change after the great Mexican
earthquake of 1985, which marked the moment
when a new and gifted generation of artists
appeared on the Mexican scene.

These artists – the leading figures included
Alejandro Colunga (Pl. 424), and Julio Galán
(Pl. 427) – combine folk elements, and
especially borrowings from 'colonial' rather
than Pre-Columbian sources (*retablos* or votive
paintings in the case of Galán), with much
more directly autobiographical elements which
recall not only the work of Cuevas but that of
Frida Kahlo, the wife of Diego Rivera, whose
work is as intimate and personal as Rivera's is
rhetorical and public. The new Mexican art was
not as separatist as Mexican painting has been
in the past. In Colunga's work, in particular,
it is possible to see links with European Neo-
Expressionism, though the saturated, resonant
colour still demonstrates the artist's intimate
link with the whole Mexican heritage, and
especially with that part of it which descends
from Tamayo. Yet, by appealing to a common
heritage, the new art of Mexico has contrived
to remain accessible to a wider public than
most of its European and North American
equivalents. Much of this heritage is religious,
and it is no accident that allusions to religion,

426 José Luis Cuevas, *Self-Portrait
with Diary*, 1980
Mixed media, 72.4 × 72.4 cm
(28½ × 28½ in)

427 (overleaf) Julio Galán, *Yes and
No*, 1990
Diptych, acrylic and collage on canvas,
305 × 518 cm (120 × 204 in)

426

427

428 Roberto Marquez, *La Teoría de Son Juana*, 1993
Oil on canvas,
122.4 × 122.4 cm (48¼ × 48¼ in)

429 Jorge Tacla, *Espacio para un Discurso*, 1989
Diptych, oil on linen, 250 × 221 cm
(98½ × 87 in)

even if these are not always orthodox, recur so often in the recent Mexican art illustrated here.

Not all of Mexican, or even of Latin American art, is as easy to interpret as this comment may suggest. For example, while religion certainly enters into the recent painting by the young Mexican artist Roberto Marquez illustrated here (Pl. 428), since the poem quoted above the reclining female nude is the work of the famous mystic Son Juana de la Cruz, the image offers an ambiguous gloss on her words:

> What profit in pursuing me, oh world?
> In what do I offend you when my sole intent
> Is to place beautiful things in my mind,
> Not my mind amid your beauties?

It suggests that , on the contrary, the truly important thing is the life of the body. The painting makes a fascinating pair with another, by the Chilean painter Jorge Tacla, showing a figure apparently on its deathbed, floating amidst mysterious signs. The title is *Espacio para un Discurso (Space for a Discourse)* (Pl. 429). Here, too, the spectator is asked to enter a speculative realm. In neither case, however, does this realm have the threatening barrenness of much recent Conceptual art, or the glib patness of, for example, Christian Boltanski's meditations upon the fact of death.

What gives Latin American art its force, in the present situation, is the connection it has maintained with the general run of human activity. Here, at least, contemporary art is not confined to an emotional ghetto; it attempts to deal with life's great problems in a direct way, and it has maintained contact with a broad public within Latin America itself.

428

Perestroika Art

Latin American art had been involved with Modernist ideas since the early 1920s. The history of Modernism in Russia antedated this by more than fifteen years. The pre-war and pre-revolutionary years had seen the appearance of innumerable avant-garde groups in St Petersburg and Moscow, often with wonderfully picturesque names – the 'Blue Rose', the 'Knave of Diamonds', the 'Donkey's Tail'.

This situation did not endure, for two reasons. One was the increasing hostility of the communist regime towards the activities of experimental artists, which culminated in Stalin's clampdown of 1932-4. In 1932 all literary and artistic organizations were disbanded by decree of the Central Committee of the All-Union Communist Party. In 1934, Socialist Realism was presented as the only viable artistic doctrine at the First All-Union Congress of Soviet Writers.

Long before this, however, there had been signs of a loss of energy within the Russian avant-garde itself, and by the late 1920s a great deal of artistic energy was going into parallel activities, especially into the applied arts and photography. This diversion of aim was not wholly surprising, since Constructivism itself had become increasingly hostile to the whole notion of easel-painting, and indeed to the idea of the artwork as a separate entity. The task of the artist was increasing perceived to be the reshaping and restructuring of the whole social environment.

After the Stalinist clampdown, Russian art inhabited a separate universe from that of Western Modernism – or this, at least, was the general perception of artists and critics in the West. The official artists favoured by the Communist regime, rather than looking to the great masters of Modernism for inspiration, referred themselves to a specifically Russian tradition, that of the Itinerants or Wanderers – the group of Realist artists who had flourished in Russia in the late nineteenth and early twentieth centuries. This group included the gifted portraitist Ivan Kramskoi (1837-87), famous for his likenesses of writers such as Tolstoy and Nicolai Nekrasov; the landscapist Isaac Levitan (1861-1900); and the many-talented Ilya Repin (1844-1930). Despite the fact that Repin chose to separate himself from the new Russia (he died in exile, in his house just across the Finnish border), his historical

scenes, portraits and politically oriented genre scenes became the established models for the new Soviet art.

Even after the tide turned against them, some of the surviving members of the original avant-garde who remained in Russia continued to work, but now more or less in secret, and without their original energy and optimism. Malevich, once the most radical of them all, returned to figurative painting in the late 1920s, and his last five years, before his death in 1935, were spent largely on a series of portraits of his friends and members of his immediate family.

The situation in Russian art did not really begin to change until Stalin's death in 1953, and even then change was at first very slow. Russian art, which had for more than twenty years been almost completely cut off from artistic developments in the West, began to have intermittent contact with what was going on outside its own country. One major stimulus was the Sixth World Festival of Youth and Students held in Moscow in the summer of 1957. A feature of this was an enormous exhibition – over 4,500 works – of painting and sculpture by young artists from 52 countries. One result was the appearance of the Soviet unofficial art movement. Towards the end of the 1950s certain artists began to hold private exhibitions in the homes of sympathetic members of the Russian intelligentsia, and these were followed by others held in scientific research institutes and various club premises. The movement surfaced in public in 1962, when a number of paintings and sculptures by younger and more experimental members of the Artists' Union (the official organization which embraced all forms of artistic activity) were included in a large exhibition held to mark the thirtieth anniversary of the Union's Moscow Section. This exhibition was held in the city's biggest exhibition hall, the Manège, and triggered a furious tirade from its most important visitor, the Party chairman, Nikita Khrushchev.

The unofficial movement continued into the 1970s, and attracted wide publicity through exhibitions organized on an *ad hoc* basis. The first of these, held on a patch of waste land near Moscow in September 1972, was attacked by police disguised as workers. Paintings were thrown into dump-trucks or run over by

bulldozers, and a number of participants and spectators were arrested. The violence was counterproductive from the point of view of the authorities, since Western journalists had been in attendance, and what happened was widely reported in the Western press. Examples of the new art began to find their way out of Russia, and in January 1977 a large representative exhibition opened at the Institute of Contemporary Arts in London. Similar exhibitions were also seen elsewhere.

Despite the instinctive sympathy felt by Western artists and critics for persecuted colleagues in the Soviet Union, unofficial art, once it became known in the West, did not receive a particularly good press there. It was perceived as being both eclectic and derivative, a feeble rehash of things already better done by Western avant-garde artists. Ernst Neizvestny (b. 1925), the sculptor who confronted Krushchev on behalf of his colleagues, and who emigrated from Russia in 1976, has never in fact established an artistic reputation on a par with his undoubted historical importance. Some of the artists who figured in the 1977 show, among them Eric Bulatov, Francisco Infante and Ilya Kabakov, have, however, survived as important figures in the story of the return of Russian art and Russian artists to the contemporary scene.

The story of this return is best told, not in simplistic terms of a rebellion against the Soviet establishment, which in the end succeeded, but in those of the gradual, then more rapid, changes affecting Soviet society in the post-Stalin years, which eventually led to the collapse of the Soviet Union itself. The Russian art which now ranks as 'contemporary' is in many ways more intimately linked to the tradition of Socialist Realism than it is to that of the original Russian avant-garde. An artist like Oleg Kudryashov (Pl. 430) is very much a maverick in terms of the new Russian art, because his work is abstract, and does relate to the history of Constructivism of the Russian Revolutionary epoch – to Tatlin's classic *Corner Reliefs* in particular.

The changes in Soviet art which took place after the death of Stalin involved a gradual reinterpretation of Socialist Realist doctrine. Official artists like Evsei Moiseenko adopted a looser, somewhat more romantic style, while making use of approved precedents in the

430 Oleg Kudryashov, *Construction*, 1987
Paper construction with drypoint and watercolour, 73.5 × 68.2 × 36.5 cm (29 × 27 × 14½ in)
Pushkin Museum, Moscow

430

431 Evsei Moiseenko, *August*, 1980
Oil on canvas, 190 × 220 cm (75 × 86½ in)

432 Dmitri Zhilinski, *The Year 1937*,
1987
Tempera on canvas, 220 × 160 cm
(86½ × 63 in)
State Tretyakov Gallery, Moscow

433 Lev Tabenkin, *Eagles*, 1987
Oil on canvas
210 × 186 cm (82½ × 73¼ in)

431

Soviet past. Moiseenko's *August* (Pl. 431) derives from the work of the Petersburg Symbolist, and former member of the Blue Rose group, Kuzma Petrov-Vodkin, who afterwards threw in his lot with the Revolution. Petrov-Vodkin's *Death of the Commissar*, painted in 1928, became one of the best-loved icons of Soviet art. Another Soviet academician, Dmitri Zhilinski, produced work which was heavily influenced by traditional icon painting – the religious connotations of these were forgiven because of the impeccable 'Russianness' of the source. However, it was not until 1987 that Zhilinski was able to exhibit his highly personal autobiographical painting *The Year 1937* (Pl. 432), which depicts the arrest of the artist's father by the Secret Police. As Matthew Cullerne Bown points out, there is an implicit parallel with Repin's painting *The Arrest of the Propagandist* (1880-92), and thus a suggested comparison between Stalinist and Tsarist repression.[1]

Another factor for change in the art of the late Soviet period was a gradual return to a style which has never been automatically associated with Russia in the West – Figurative Expressionism. For Russian artists, the chief exemplar for this style was Alexsandr Drevin (1889-1939), persecuted under Stalin for his refusal to conform. It is Drevin's influence which can be detected in the work of practitioners of the so-called 'Severe Style' of official art, such as Nikolai Andronov, and also in that of much younger artists such as Lev Tabenkin (b. 1952). Tabenkin's *Eagles* (Pl. 433), painted in 1987, is distinguishable from typical works by Drevin only because of its much larger scale.

These experiments indicated that the boundaries for artists were being loosened. What they did not in the end indicate was the precise direction which the new Russian art would take. A much clearer indication of this came from the work and careers of Vitaly Komar and Aleksandr Melamid. Trained in the Russian tradition of official art, these two artists began their collaboration in 1972, painting a mural for the Alley of Heroes at a Young Pioneers Summer Camp. In the early and mid-1970s they were much involved in the activities of the nascent group of dissident artists in Moscow, participating both in the outdoor exhibition which was broken up by the

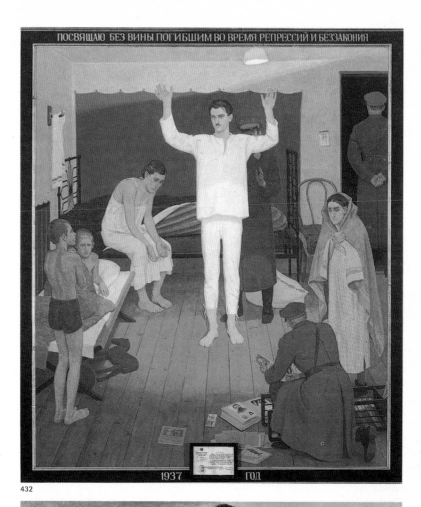

432

433

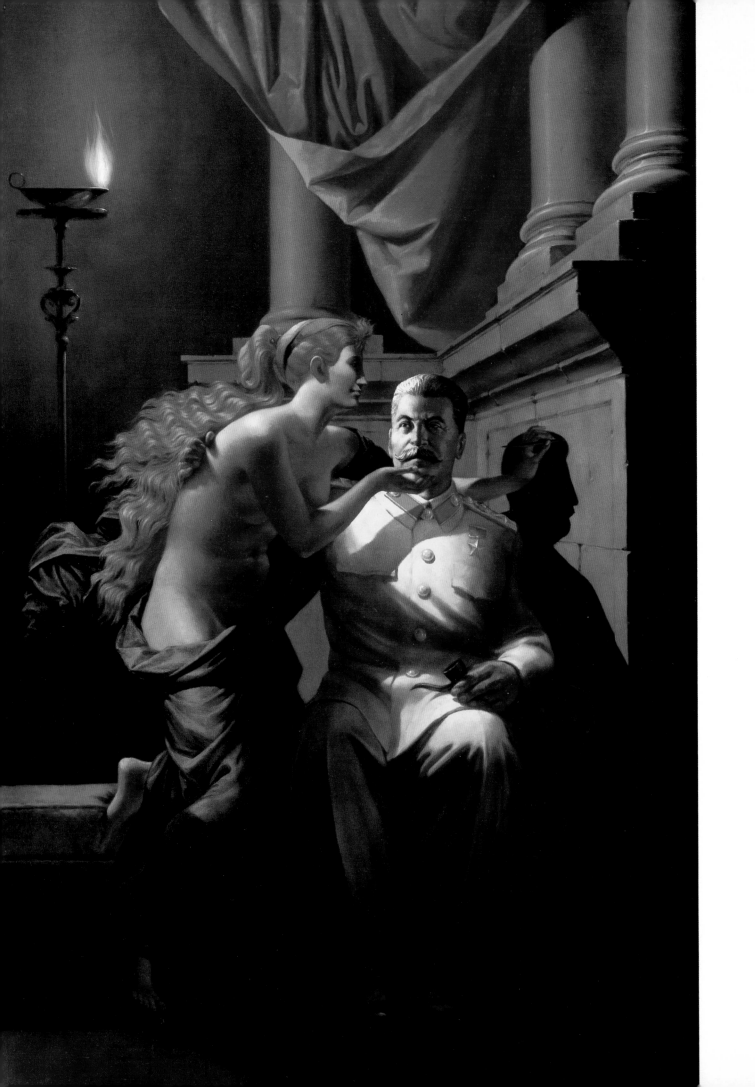

authorities, and in a subsequent outdoor show at Izmailovsky Park which had an enormous impact on the public. In 1976 they held their first exhibition in New York, which was also the first public showing of what a friend of theirs had already labelled 'Sots Art' – the Soviet version of Pop. The artists liked the term and it stuck, though it gives a somewhat false impression of what they do. Far from celebrating mass culture, as Pop Art does, their work seeks to deconstruct an official culture imposed from above. In 1978 the duo emigrated to the United States, where they have lived and worked ever since.

What made Komar and Melamid famous was the skill with which they parodied the Soviet official style at its most kitsch. The satire is at its most telling in a series of paintings devoted to the official cult of Stalin. In *The Origin of Socialist Realism* (Pl. 434), the dictator is inspired by a partly nude muse, who chucks him lovingly under the chin. The style is Davidian classicism at its most grandiose. In the Western world the paintings appealed because they allowed the audience to have its cake and eat it – to enjoy the traditional skills of the artists while at the same time relishing the ironic comedy of the imagery. In Russia, this and similar work had a much more complex resonance. Both in their daily lives, and in dealing with the censored but often quietly rebellious forms of artistic expression the authorities allowed them to enjoy – books and films were more generally accessible in this respect than paintings and other works of visual art – Russian audiences were well accustomed to unravelling codes and reading subtexts. As the regime began to liberalize itself, artists began to turn its own characteristic imagery against it. The paintings of Eric Bulatov, in particular, chronicle the decline and fall of Soviet Russia through images carefully culled from the standard Soviet repertoire, built up over many years – under Stalin and his immediate successors, and finally under Brezhnev. Bulatov adopts different strategies in different compositions. *Perestroika* (Pl. 435) turns the established imagery of the regime, and even its standard typographical forms, against itself. The two hands, one holding a hammer and the other a sickle, which are the focus of the composition, are a quotation, instantly recognizable to any

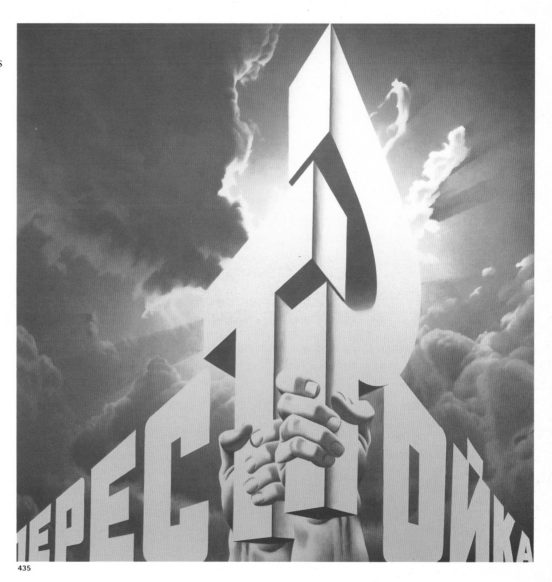

435

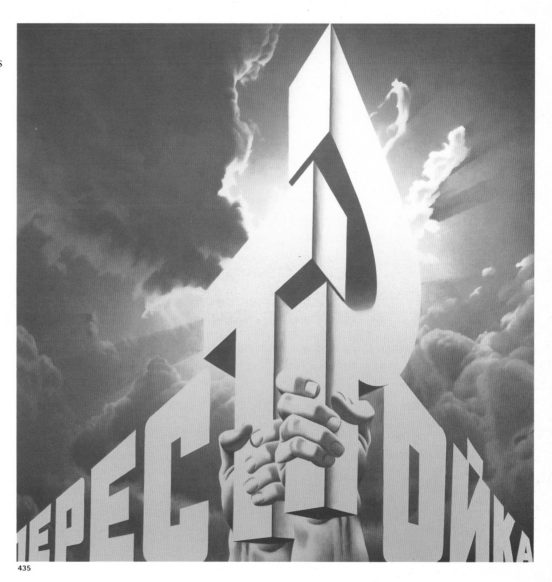

434 **Komar & Melamid**, *The Origin of Socialist Realism*, 1982–3
Oil on canvas, 183 × 122 cm (72 × 48 in)

435 **Eric Bulatov**, *Perestroika*, 1988
Oil on canvas,
274 × 269 cm (108 × 106 in)

436 Eric Bulatov, *Farewell Lenin*, 1991
Oil on canvas,
120.5 × 119 cm (47½ × 47 in)

437 Igor Kopistiansky, *Construction*,
1990
Installation at the Phyllis Kind Gallery,
New York, oil on unstretched, rolled and
unrolled canvases, 3.3 × 3 × 4.3 m
(11 × 10 × 14 ft)

438 Svetlana Kopistianskaya, *Story*,
1990
Installation at the Phyllis Kind Gallery,
New York, mixed media, 3.5 × 9.1 × 2.6 m
(11½ × 30 × 8½ ft)

436

Russian, from a famous sculptural group by the Socialist Realist sculptor Vera Mukhina, representing a worker and a collective farm girl. This group, made in 1937 at the height of Stalin's purges, has been described ironically as 'the Soviet Statue of Liberty'. *Farewell Lenin* (Pl. 436) is a piece of allegorical realism – an elderly woman carrying a shopping bag walks past a poster of Lenin which is wrinkled and about to peel from the hoarding. Her eyes are fixed, not on the once-sacrosanct image, but on a street-sweeping gang working in the far distance. The truly cutting thing here is the fact that the painting, so bluntly hostile to everything Soviet ideology held dear, is nevertheless in the most meticulous possible version of the Socialist Realist manner.

Other leading Russian artists of the *perestroika* epoch have been concerned with more rarefied forms of cultural analysis. Igor Kopistiansky (Pl. 437) makes constructions out of paintings, rolled and unrolled. These, he says, are 'an ironic reaction to the belief that the arts have to be "useful" – i.e. that they should fulfil a definite function: a decorative, educational or polemical one.'

> In my work [Kopistiansky says] I used copies of quite varied paintings. The choice has little to do with taste. The paintings come from wholly different periods, styles and painters. The only thing they have in common is: they belong to art. In so far as I hereby avoid creating works of my own, I produce things out of items already fashioned, I create new contexts and play with art, which for me is a game of the spirit and intellect on the highest level.[2]

This is to say that he turns pre-existing works of art into Duchampian 'readymades'.

Svetlana Kopistianskaya works in much the same way with literary texts, using them as the basis for assemblages, often of ambitious scale (Pl. 438).

Perhaps the two key figures of this transitional epoch in Russian art, and the two most likely to survive a turbulent period, are Francisco Infante and Ilya Kabakov. Infante is by far the lesser-known of the two outside Russia – perhaps because of his non-Russian name, and also because of the fact that his work is largely ephemeral, at least in its three-dimensional form. What he does is to create open-air installations which exist only in order to be photographed. The objects which Infante

437

438

439 Francisco Infante, *Artefacts*, c.1990
Three examples from a series of photographic images of open-air installations

440 Ilya Kabakov, *He Lost His Mind, Undressed, Ran Away Naked*, detail of *Installation III*, 1983–90
Installation at Ronald Feldman Fine Art, New York, 6 January–3 February 1990, incorporating five Socialist Realist murals, acrylic on paper, eight painted masonite panels and mixed media

439

adds to the landscape setting create spatial ambiguities, and, at the same time, stress the role played by evanescent effects of light (Pl. 439). His work combines several different traditions – the rapt contemplation of the Russian landscape found in nineteenth-century Russian painters such as Levitan, ideas borrowed from the tradition of Russian Constructivism, and a Conceptual element taken from recent American art. The use of the camera is not merely a matter of convenience; it is a way of placing his imagery at one remove from the viewer.

Ilya Kabakov, on the other hand, is the Russian artist of the new generation who has made most impact in the West. Though he makes much use of texts, usually indecipherable to the Western audience, his popularity is due to the emotional accessibility of his work, and in particular his ambitious installations (Pl. 440). Kabakov evokes the realities of late Soviet and post-Soviet society: the hypocrisy, the decay of institutions, the daily struggle to survive, but at the same time celebrates the resilience of the human spirit in the face of so many frustrations and privations. The Constructivists who sided with the Revolution looked forward to an utopian future. For Kabakov an optimism of this kind is no longer possible: 'I see this fundamental conflict,' he says, 'of speech devoid of meaning and of meaning not given form by speech – in everything which surrounds me, and above all in myself.'[3]

Infante and Kabakov address themselves to universal ideas, and equally universal dilemmas. The rest of the 'new' Russian art often seems fixated on the codes and idioms of an already obsolete social system. It represents a brief moment of transition, when Soviet censorship lifted but before the regime itself fell. It deconstructed Soviet reality for those intimately acquainted with the symbolic language of the regime. That symbolic language is now itself obsolete and likely to take any art which depended on it into oblivion.

The Far East

European and American criticism has found it difficult to deal with the contemporary art of the Far East. One cause of this difficulty is simple ignorance – Japan and Korea in particular now produce very large numbers of artists working in 'Western' styles, but their artistic relationships to one another, and to the Western models they appear to follow, are by no means clear, nor are the historical structures of development which have brought them to this particular point.

Of the two cultures, that of twentieth-century Japan is by far the best-known, though successive exhibitions of contemporary Japanese artists in the United States and in Europe have often served to confuse the pattern still further. Just as Japanese art began to influence Western painting almost as soon as Japan was opened to the West, so too Japanese art began to absorb Western influences, importing such novelties as the Western use of perspective. In the first half of the century Japanese artists imitated Western styles in a passive way – absorbing Impressionism, Post-Impressionism, Futurism and Constructivism, and finally going on to Surrealism, which even now continues to have a particular appeal for the Japanese public. This absorption, however, was never complete, not least because of the wide technical gap between Western-style painting (using oil on canvas) and traditional Japanese-style work (using ink on paper). Gradually a tripartite art world developed: there were artists who used traditional materials and tried to continue the purely Japanese tradition; there were artists who worked in a conservative Western style, in a loose sense related to Impressionism; and there were artists who wanted to provide a Japanese equivalent for the contemporary Western avant-garde. It has been estimated (by Geraldine Norman, art and auction room correspondent of the *Independent* newspaper) that this latter group represents only 20 per cent of the total production of art in Japan, and considerably less than that in terms of financial share of the market.

World War II cut off all contacts with Western artists. The allied occupation of Japan did not come to an end until 1950, and it was only at this point that the Japanese art world was able to resume contacts with what was happening in the United States and in Europe.

The first initiative was a series of ambitious survey shows of new Western art. One of these included two paintings by Jackson Pollock, but a much greater impact was made by the exhibition *Modern Art of France*, held in 1951, which show-cased the new French *art informel*. It was this show which offered a context for the foundation of the Gutai group in 1954.

The moving spirit in Gutai was Jiro Yoshihara (1905-72), a leading artist who was also an independently wealthy businessman. Yoshihara wanted to see the creation of a new art which would be specifically and visibly Japanese, but which would also be able to learn from American and European exemplars. In 1955 and 1956 Gutai held two open-air art exhibitions containing radical, often intentionally temporary artworks, and accompanying art events. Critics have seen in the art Gutai produced at this period an anticipation of many of the ideas afterwards attributed to Italian Arte Povera (see Chapter 5, pp.146ff). In the later 1950s, the group swung towards work in more conventional formats, closely linked to the French abstract painting of the time. One reason for this was the need to make money for the artists, who were not as rich as Yoshihara himself. Another was the interest of the French critic Michel Tapié, who had been one of the chief promoters of *art informel* in Europe. There were Gutai exhibitions in New York in 1958, at the well-regarded Martha Jackson Gallery, and in Europe in 1959. The group survived until Yoshihara's death in 1972, but immediately collapsed without its central figure.

Gutai and its fate supplied a number of pointers concerning the development, or lack of it, of the Japanese contemporary school. Artists such as Matasaka Kubota essentially offer a refined, delicately 'orientalized' version of existing Western ideas (Pl. 441). This is not surprising if one considers the fact that Kubota has lived and worked in Italy since 1979. His work is still very much in the tradition of Gutai. Similarly, the sculptures of Takashi Narahara (Pl. 442) are closely linked to European and American practice, but have a refinement of craftsmanship which offers some clue as to their origins.

Those Japanese artists who have built major international careers have mostly had to do so by living outside Japan. Shusaku Arakawa,

441 Matasaka Kubota, *La Traccia (evoluzione) E-19*, 1992
Mixed media on canvas,
160 × 130 cm (63 × 51¼ in)

442 Takashi Narahara, *Structure 86-E-52*, 1986
Dolerite, 28 × 30 × 17 cm
(11 × 11¾ × 6¾ in)

442

443 **Shusaku Arakawa**, *At War (Who or What is This?)*, 1990
Two diptychs, acrylic and graphite on canvas, the first 304 × 457 cm (120 × 180 in) overall, the second 335 × 457 cm (132 × 180 in) overall; plus a ramp with six panels, mixed media on board with rope, each 122 × 122 cm (48 × 48 in)

444 **Yayoi Kusama**, *Mirror Room (Pumpkin)*, 1990
Mixed media,
200 × 200 × 200 cm (79 × 79 × 79 in)
Hara Museum of Contemporary Art

443

445

446

The Far East

usually known only by his last name, has lived and worked in New York since 1962. His work is closely related to the Minimal and Conceptual movements which dominated American art in the late 1960s and early 1970s, but one can also see in it evidence of his early training as a mathematician (Pl. 443). Yayoi Kusama, though she recently represented Japan at the Venice Biennale, has been an American citizen since 1966. Her spectacular mirrored environments (Pl. 444) seem like a distinctively Japanese extension of the Pop sensibility. Some aspects of these works recall the imagery of Japanese video games.

445 Takashi Murakami, (left) Rose – Gold, 1992
Gold leaf on wood,
125 × 125 × 6 cm (49¼ × 49¼ × 2½ in)
(right) Rose – Platinum, 1992
Platinum leaf on wood, 125 × 125 × 6 cm
(49½ × 49¼ × 2½ in)

446 Tetsuya Noda, Diary, 11 September 1968, 1968
Woodcut and silkscreen on Japanese paper, 82 × 82 cm (32¼ × 32¼ in)

447 Akira Arita, Untitled, 1992
Oil on canvas, 381 × 762 cm (150 × 300 in)

447

Another well-known Japanese artist who stresses the international, cross-cultural aspect of his work is Tetsuya Noda. Noda's visual diaries (Pl. 446) tell the story of his mixed marriage to an Israeli woman, using photo-based imagery. The most obviously Japanese thing about them is their immaculately skilful use of print-making techniques.

Where artists are less known in the West, the temptation·is to insist, perhaps too vehemently, on the traditionally Japanese origins of their imagery. The pristine metallic monochromes of Takashi Murakami, for example (Pl. 445), recall decorative Japanese screens and sliding doors,

with backgrounds made of gold leaf. Yet they also have a Western ancestry, in the *Monogolds* of Yves Klein. One has here a cultural corridor of mirrors, since it is certain that Klein, who spent a period of his life in Japan, originally borrowed the idea from things he had seen when he was there.

A similar mingling of Eastern and Western elements can be found in the painting of Akira Arita, and the sculptures of Kyubei Kiyomisu and Kyoji Takubo. What seems to mark out Arita's work from Western equivalents is a disciplined neatness which the smearings and scumblings surrounding the main forms cannot disguise (Pl. 447). Kiyomisu's *Red Dragon* (Pl. 449) is a Japanese solution for a now universal problem – that of how to relate

448 Kyoji Takubo, *Obelisk*, 1985
Wood, concrete, gold, oilstain and coal tar, 700 × 70 × 70 cm (276 × 27½ × 27½ in)

449 Kyubei Kiyomizu, *Red Dragon*, 1984
Painted aluminium. left element, length 13.75 m (45 ft); right element, length 10.4 m (34 ft)
Collection of the Taisho Marine & Fire Insurance Company, Ltd

450 Masaaki Sato, *Newsstand No. 59B*, 1991–2
Oil on canvas, 168 × 203 cm (66¼ × 80 in)

449

450

Modern sculpture to Modern architecture within the context of a public space. Abstracting the form of the dragon, he has produced a piece which gives a distinctive twist to the tradition founded by David Smith and Anthony Caro. Takubo's *Obelisk* (Pl. 448), on the other hand, has a relationship to the work done by Californian Light and Space artists such as Eric Orr (Pls. 134-5).

To Western eyes, the most difficult Japanese art to absorb is what should on the face of it be the easiest, because theoretically closest to the Western tradition. Masaaki Sato's paintings of news-stands (Pl. 450) seem at first glance like standard Super Realist fare. It is only on a second look that the spectator discovers how much of the lettering – all of it in English – is

reversed so as to offer a mirror image. The painting offers an allegory of the difficulty in communication between East and West, and also of the artist's feeling of isolation when living and working in New York. In Naoto Nakagawa's shoreline close-ups (Pl. 451) the sense of disturbance is subtler. The elements used might easily appear in traditional Japanese art, but here they are treated with astonishing and in the end rather troubling meticulousness. It is as if we are being forced to see more than we are really capable of seeing. Certain forms, such as the napped flint arrowhead at the upper left, hint at the presence of man, and this object in turn is brought into a formal relationship with the stone above it in a way which suggests that the natural chaos is struggling to recover order of a kind which a traditional Japanese artist would have imposed on the same material.

Recent Japanese art has shown both a tendency to reconsider traditional modes of expression and a sharper edge of cultural and social criticism. The sculptures of Katsura Funakoshi (Pl. 452) use a very ancient technique – camphor wood carved and pieced together, with realistic details, such as eyeballs in marble. Similar techniques are employed in the extremely naturalistic portrait sculptures of the Kamakura Period (1185-1392). Yet Funakoshi is clearly not an imitator – his aim is to produce human images which have a universal significance, which are neither specifically Eastern nor specifically Western. His ambition to endow them with a kind of elusive spirituality is expressed through ambiguous and rather evasive titles. A strong force in Funakoshi's work is his Catholicism, which (in Japanese terms) implies opposition to traditional nationalist values.

Yasumasa Morimura looks to the masterpieces of the West as material for cross-cultural appropriation. In his photographs, which parody Western masterpieces, he himself plays all the roles. In *Playing with Gods (# 3)* (Pl. 453), Morimura plays – in duplicate – two tourists at the foot of a cross borrowed from a Lucas Cranach Crucifixion. His work has been referred both to the Japanese tradition of the *onnagata* (female impersonator) and to the craze for Western things amongst Japanese teenagers. It has been said that, 'through a union of opposites, the artist aims at a notion

451 Naoto Nakagawa, *Portrait of Sand*, 1991
Mixed media on canvas,
277 × 193 cm (109 × 76 in)

452 Katsura Funakoshi, *The Distance from Here*, 1991
Painted camphor wood and marble,
height 82 cm (32¼ in)

453 Yasumasa Morimura, *Playing with Gods (# 3 Night)*, 1991
Colour photograph,
360 × 250 cm (141¾ × 98½ in)

452

453

454

455

of perfection akin to that of the Greeks."¹ This seems a little unlikely. Morimura is a kitsch ironist in the manner of Jeff Koons (Pl. 336), but the division of cultures offers him more material to work with than is available to Koons.

The most openly political of the younger generation of Japanese artists is Yukinori Yanagi. Yanagi has dared to make fun of the Japanese flag, in an installation which transforms the national emblem into an advertising sign (Pl. 454). His most celebrated and controversial piece, however, is his *World Flag Ant Farm* (Pl. 455). In this, perspex boxes are filled with coloured sand – the design in each box represents a different national flag. The boxes are connected with plastic tubes, and ants are introduced. The ants, in their journeyings from one compartment to another, steadily disrupt the patterns which are emblems of nationality. For Yanagi, these ants are the living representatives of the anarchic forces within nature which make artificial frontiers ridiculous. The idea has been less than sympathetically received not only by old-fashioned nationalists but also by animal rights activists.

The development of contemporary Korean art in some ways parallels that of contemporary art in Japan. This is not surprising because, for much of the twentieth century, Korea remained under Japanese rule. The earliest Korean paintings in Western style were produced under Japanese influence, and follow in the footsteps of the Impressionists. A new beginning for Korean art did not take place until the conclusion of the Korean War in 1954. Because American influence was preponderant in South Korea in the years after the war, artists tended at first to follow American models, though many members of the first generation of Modernists received their artistic education in Paris.

The most powerful and cohesive group in this first generation are the so-called Monochromists, abstract painters who produce monochrome, or largely monochrome, canvases with heavily textured surfaces. One of the best- known members of this group is Ha, Chong-Hyun (Pl. 456). Ha's paintings are created by means of a very personal technique. The support is coarsely woven hessian – cloth woven of hemp fibres is traditional in Korea,

454 Yukinori Yanagi, *Hinomaru Illumination*, 1992
As installed at the Fuji Television Gallery, neon and painted steel,
350 × 450 × 40 cm (138 × 177 × 15⅛ in)
Museum of Art, Koichi

455 Yukinori Yanagi, *The World Flag Ant Farm* (detail), 1990
Ants, coloured sand, plastic boxes and plastic tubes – 170 boxes, each 20 × 30 cm (8 × 12 in), seen here as installed at LACE, Los Angeles, 1991

456 Ha, Chong-Hyun, *Conjunction 91-37*, 1991
Oil paint pushed through coarsely woven hempen cloth,
194 × 260 cm (76½ × 102½ in)

456

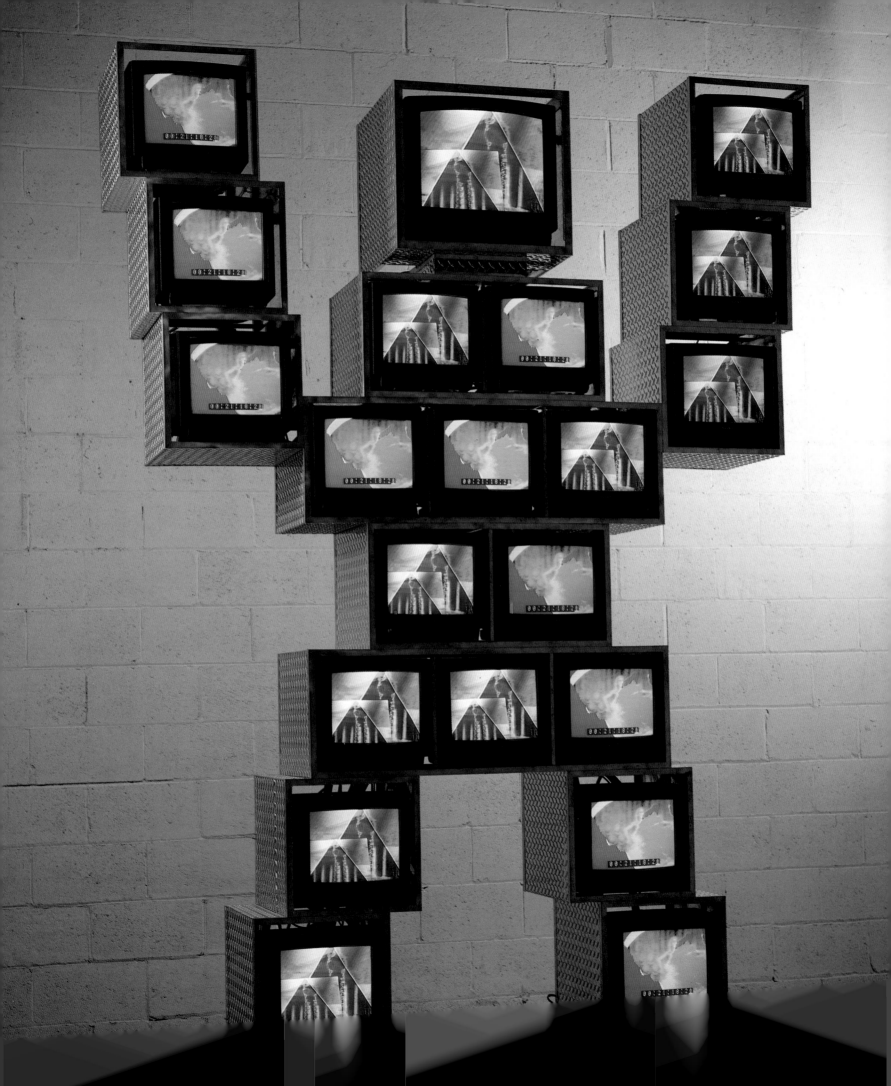

known since the very beginnings of Korean civilization. The artist, rather than applying paint to the front of this surface, pushes it through from the back, then works it further with his fingers, spatulas and other tools. The result is simultaneously architectural and calligraphic. Architectural because the canvas has the character of a screen or wall, calligraphic because the pattern of marks on the worked surface is like half-effaced Korean script.

With its extreme refinement, Ha, Chong-Hyun's work makes a striking contrast with that of the Korean artist whose work is now best known internationally, Nam June Paik. In the 1960s Paik lived and worked in Europe as an associate of the Fluxus Group and a colleague of Joseph Beuys. His flamboyant experiments with video monitors were a statement of allegiance to the new world of high technology. Paik continues to work along these lines, but has increasingly tended to abandon any real commitment to video as such, used as artists such as Bill Viola or Gary Hill use it (Pls. 174-5), in favour of works which play in various ways on the *fact* of television, as something which has an increasingly dominant role in people's lives. His recent *Electro-Symbio Phonics for Phoenix* (Pl. 457) builds television sets into crudely anthropomorphic figures, giants who stand with arms raised threateningly aloft. The form itself counts for much more than what the sets are showing. In terms of his own culture, Paik is a somewhat isolated figure. Despite the fact that Korea, like Japan, is now one of the major manufacturers of electronic goods, Korean artists have mostly chosen to go in an entirely different direction. Bong, Tae Kim, who represents the middle generation of artists in the country, makes paintings and prints inspired by Buddhist mandalas (Pl. 458). The violent colours are inspired by Korean folk art.

Yet another approach to the problem of being both contemporary and Korean appears in the work of Kim, Jong-Hak. Kim's paintings are figurative (an increasing tendency in Korean contemporary art). They mostly represent very simple objects, which are presented on a giant scale (Pl. 459). The medium is coloured paper pulp on a paper foundation. Hand-made paper is integral to traditional Korean culture, and this is another example of the desire to preserve age-old

457 Nam June Paik, *Electro-Symbio Phonics for Phoenix* (detail), 1992
60 television sets, plus neon panels

458 Bong, Tae Kim, *Nonorientable 94-114*, 1994
Acrylic on canvas,
182 × 182 cm (72 × 72 in)

458

459 Kim, Jong-Hak, *Three Pears*, 1993
Mixed media on paper,
250 × 358 cm (98½ × 141 in)

elements within a contemporary framework typical of today's Korean art, which is currently reacting sharply against an overdose of Western influences.

Not unexpectedly, the situation is entirely different in China. Here the concept of 'contemporary art', as this is generally understood in the West, is a complete novelty. Most observers would date its emergence to the year 1989, when China changed course towards a market economy. Under Mao, and especially under the Red Guards, artists often found themselves fiercely persecuted. If the old 'scholar painting', made with brush and ink, was disapproved of, so too was any kind of art which showed Modernist, therefore Western, influence. Two kinds of art were permitted – the most stringent kind of Socialist Realism, and art of a primitive and simple kind, produced collectively in peasant communes. The new Chinese art regards these peasant paintings with smiling irony, as can be seen from the work of Yu Youhan (Pl. 461), Wang Guangyi (Pl. 460) and Wang Ziwei (Pl. 462). Yu Youhan has been one of the great critics of the cult of Mao. Wang Guangyi extends this criticism to cover all forms of propaganda art. He once, in an interview, contrasted art with what people saw on the television evening news. In the latter, he noted the viewer was both manipulated and informed about the world. On the other hand, the spectator looking at one of his paintings was free to draw his or her own conclusions.[2] In the work of the youngest of the three artists, Wang Ziwei, there is also an element of sentimentality, nostalgia for an era already starting to fade from memory. There is, nevertheless, something sardonic about the decision to show Mao with a Christian emblem, since Christians were brutally persecuted during the period of the Cultural Revolution. Essentially these paintings, like *perestroika* art in Russia, require some knowledge of the recent history of the country and of the complexities of ideological coding, if they are to be fully understood. In Yu Youhan's painting, for example, the blonde girl, simply because she is blonde, must be read as an emblem of Westernization.

Other artists simply make use of the new freedoms to represent what would formerly have been regarded as unacceptable subject-matter. This is the case with Liu Wei, who

460 **Wang Guangyi**, *Great Criticism: Casio*, 1993
Oil on canvas, 150 × 120 cm (59 × 47¼ in)

461 **Yu Youhan**, *Mao and Blonde Girl Analysed*, 1992
Acrylic on canvas, 86 × 115 cm (34 × 45 in)

462 **Wang Ziwei**, *Mao with the Saviour*, 1993
Acrylic on canvas,
115 × 151 cm (45½ × 60 in)

461

462

463

464

paints the political élite and the bureaucracy in a style which has its roots in the *Neue Sachlichkeit* of Weimar Germany (Pl. 463). More savage is the work of Zeng Fanzhi. Zeng's *Meat: Reclining Figures* (Pl. 464) is brutally lacking in idealism. It treats human beings as essentially degraded, and the composition itself, with its confusing lack of firm orientation, or even of a decisive single viewpoint, is deliberately designed to disorient the viewer.

The interesting thing about these paintings is not only their disillusioned tone but the fact that they have so little connection with the long history of Chinese art. Japanese and Korean Modernists turn back to national traditions for inspiration, even when they no longer use traditional techniques. For the moment at least, this is not the case in China. The only recent Chinese art with avant-garde aspirations which alludes to traditional scroll painting, for instance, is that made by exiles like Gu Wenda, now resident in America. In an installation made in 1993 for the Museum of Modern Art in Oxford (Pl. 465), Gu combined scroll paintings, displaying made-up characters, with empty cots and a floor stained with dried placenta. This was intended as a comment on the conflict between Western oedipal theory and the Confucian respect for ancestors once practised in China. Interestingly, the calligraphic scrolls, when shown in China in the mid-1980s, provoked the closure of the exhibition by the authorities, because the inscriptions were deliberately fractured and nonsensical. A more traditional kind of scroll painting is, however, making its return to favour, just as it has long been in favour in Hong Kong and Taiwan, where work by master ink-and-brush painters of the twentieth century brings very high prices, just as it does in Japan and Korea.

Modern Indian art has been evolving since the beginning of the Modern Movement, and has a much more complicated history than its Japanese, Korean or Chinese counterparts. It has also, paradoxically, made much less impact in the West. Basically, the Indian painting in Western style made at the present day has its roots in three different traditions. One is that founded by members of the Tagore family, specifically Abanindranath Tagore (1871-1951) and his brother Rabindranath (1861-

1941). The poet and philosopher Rabindranath is the more important of the two in a general cultural sense, but he only began to paint in 1928, and his work remained that of a gifted amateur. It is his younger sibling who is regarded as the founder of the Bengali School, which dominated Indian painting until 1947. The Tagores were intellectuals, and Indian nationalists, but they were also members of the financial and intellectual élite. Abanindranath's work is a romantic derivation from Indian court art of the Mughal period. In his book on the Bengali School, Jaya Appasamy gives this description of him:

> For the most part, however, his studio remained in Calcutta. The immense city round him was like a protective shell. Sitting on his famous south verandah he wandered over time and space only in dreams. Abanindranath's work reflects to a degree his contemplative imaginative life, where there was a certain amount of luxury and caprice rather than ardour of spirit. His art is not born of hard struggle nor is there any great self-analysis or suffering in it. It is on the whole joyous and optimistic, and affirms the need for fantasy and 'beauty' as a kind of spiritual nourishment.[3]

A second strand in early twentieth-century Indian art came, not from court art, but from the vigorous tradition of Indian folk painting. This strongly influenced another leading Indian artist of the first half of the century, Jamini Roy (1887-1973). His sources included not only the Kalighat folk paintings made by artisan painters in connection with a famous shrine dedicated to the goddess Kali on the outskirts of Calcutta, but *kanthas* (embroidered quilts) and *alpana* (floor decorations).

Yet a third source was purely Western. The first Indian artist to paint confidently in a Modern Western style was the tragically short-lived Amrita Sher-Gil (1913-41), the daughter of a Sikh father and a Hungarian mother. Educated in Paris, Sher-Gil brought to India a knowledge of the Post-Impressionists (her major influences were Gauguin and Modigliani). But she also travelled widely within India in order to study cave-shrines, such as Ajanta, and the great south Indian temples.

If these strands continue to blend uneasily in the Indian art of the present, the reasons are partly organizational and also partly economic. India has never developed a strong

465

infrastructure of public and commercial galleries. The Indian Triennales, held in Delhi and modelled on the Venice Biennale, the São Paulo Bienal and the Kassel Documenta, have been only fitfully successful. There is no well-informed community of collectors who patronize local artists – such as exists, for example, in Korea. The result is that Indian artists have had difficulty in making careers for themselves. Older artists, such as the late Avinash Chandra, have often chosen to settle in Europe. Chandra's best work, which dates from the 1960s, combines Indian tantric symbolism with Expressionist handling (Pl. 466). Chandra, though he received considerable acclaim when he first settled in England in the late 1950s, never succeeded in making a comfortable place for himself in the British art world. Discomforted by the rise of Pop Art, he made his way to New York, where once again he failed to settle, finally returning to Britain in 1972 to find that he was now regarded as a complete outsider.

Younger artists who have remained in India have chosen more specifically Indian subject-matter. Manjit Bawa's *Untitled* (Pl. 467) shows a quintessentially Indian image – Krishna playing the flute. The precise outlines recall Indian miniature painting, but the way the forms are treated obviously derives from European Surrealism. Bikash Bhattacharjee's *Inauguration of a Tube Well* (Pl. 468) depicts a subject associated with the modernization of India, and does so in a way which can be linked to aspects of Soviet Socialist Realism. It must nevertheless be remembered that there is a well-established tradition of 'realistic' depiction of this kind in India. It was created by the artists who made watercolours showing aspects of daily life for the British patrons of the eighteenth and nineteenth centuries. The images shown here illustrate the unresolved nature of contemporary Indian art, especially when compared to what is being produced by Far Eastern neighbours.

466 Avinash Chandra, *Untitled*, 1961
Oil on canvas, 91 × 71 in (36 × 28 in)

467 Manjit Bawa, *Untitled*, 1984
Oil on canvas, 66 x 85 cm
(26 x 33½ in)

468 Bikash Bhattacharjee,
Inauguration of a Tube Well, n.d.
Oil on canvas, 122 × 122 cm (48 × 48 in)

467

468

African & Afro-Caribbean Art

469 Osi Adu, *The Wise Old Man*, 1992
Oil on canvas, 122 × 117 cm (48 × 46 in)

470 **Twins Seven Seven**, *God of Iron*,
1989
Coloured inks on cut and superimposed
layers of wood, 122 × 61 cm (48 × 24 in)

469

The African continent has only very recently begun to attract attention from the historians of contemporary art. This may seem strange in view of the fact that traditional, or as it is sometimes called, 'classical' African art made such a major contribution to the development of the Modern Movement, thanks to borrowings made by Picasso and others. Effectively, African art owed its sudden popularity with the European avant-garde to two things. One was the Symbolist cult of the 'barbarous', prominent in the literature of the late nineteenth century and a contributory force in Gauguin's late paintings, created during his residence in Oceania. It is no accident that one of the last and finest of these bears the title *Contes Barbares*. African art was liked by a new generation of European artists because it was not only barbarous, but satisfyingly mysterious and resistant to rational interpretation.

Effectively this situation could not last. Though some African artworks found their way into European collections as early as the late fifteenth century (Benin ivory carvings are known to have been imported into Portugal at that period), the great influx really began in the mid-nineteenth century. African carvings, mostly in wood, were brought back by traders and missionaries, and started to find their way into the ethnographical collections which were being created in response to the scientific spirit of the time, as well as into the humble Parisian curiosity shops where the young artists of the burgeoning École de Paris discovered them. They were not at first regarded as being works of art in a traditional, European sense. Rather, they were trophies of colonization and conquest, evidence of the superiority of European culture and, most of all, material for rational enquiry into the development of humankind.

The interest taken in this material by the artists of the Modern Movement effectively canonized the art of tribal Africa. Many of the pioneer collectors of avant-garde art also became collectors of tribal African sculpture, and it was very often the same dealers, such as Paul Guillaume, who supplied objects in both categories. At the same time, ethnographers began to analyse what had once been an undifferentiated mass, and to assign masks, carving and other artefacts to particular tribes

and to connect them to particular rituals and ceremonies. Neither the collectors nor the ethnographers liked work which showed traces of European influence – for them, it was 'corrupt' and had lost its aesthetic power. What this meant, in purely practical terms, was that the development of African art was compulsorily frozen in its tracks. It was defined by experts and enthusiasts as something which belonged to a very limited period of production. Little of the 'classical' African art known to specialists was older than the mid-nineteenth century, when Europeans penetrated most regions of the continent and began collecting in earnest. The reason was that African sculpture was mostly made of perishable materials, chiefly wood, and did not survive for long in a tropical climate. Work made after *c.*1930, when the process of European colonization was virtually complete, inevitably showed traces of outside influence. When this was absent, then it was usually the product of spiritless copying, made to fulfil the demands of the eager European market. In attempting to preserve what they saw as the purity of African art, European enthusiasts had virtually destroyed it.

This situation started to change when the process of decolonization began in earnest after World War II. European scholars like Ulli Beier, who taught at the University of Ife in Nigeria and founded the Oshogbo sculptors' workshop, began to put the continuing art of Africa into a different perspective. Beier's book *Contemporary Art in Africa*, published in New York in 1968, was a pioneering study in the field. Yet Beier's attitudes were sometimes ambiguous. Writing in 1959 about a church door by the leading Nigerian carver Lamidi Fakeye, Beier had this to say:

> What is important is not the absolute merit of
> the door, but that the process of adaptation and
> integration is actually taking place; and that from
> this new process there may eventually come a
> style of carving that will express the mind of the
> new African.[1]

The general assumption seems to have been that the revival of African art would be university and mission led, with inevitable European involvement. Revolution and civil war in Africa meant that this hope was largely deceptive. Visiting Africa in search of material for the Documenta IX exhibition at Kassel,

which he directed, the curator Jan Hoet was horrified by what he found:

> In the empty academies even the windows have vanished. Smashed during coups or by time. I could see from the broken remains of the tables that had once been used for drawing and sculpture that they had once been academies. But there were no students, no professors, not even a secretariat. When I saw those shattered doors, the collapsed ceilings and the countless tokens left by the torrential rainstorms I realized there was nothing here to suggest that anything might change in the near future. There I was, looking for art beyond any infrastructure.[2]

There did appear in Africa, nevertheless, a kind of art which tried to combine traditional symbols with forms and formats which would put it on the same kind of footing as contemporary European expressions. A simple example of this is a painting by the Ghanaian artist Osi Adu (Pl. 469). Here the medium and format and even the colour scheme are quintessentially European, but the basic design is taken from a traditional Ashanti doll (where the head would be circular rather than square).

A more elaborate instance of traditional affiliation is the work of Twins Seven Seven. Youngest and only survivor of seven pairs of twins, Twins Seven Seven dates his awakening as an artist to contact with Ulli Beier and the Austrian-born painter and sculptor Suzanne Wegner at Oshogbo. His paintings, made on wooden panels, recount Nigerian legends (Pl. 470). The intricate designs, with one form growing out of another, have something in common with Makonde sculptures from the other side of the African continent. Like Makonde work, they have something hectic and visionary about them – an agitation which is alien to traditional African art but appropriate to a culture in transition.

What enthusiasts for the new African art perhaps anticipated in the 1960s was the emergence of many more artists like the Sudanese Ibrahim El-Salahi. El-Salahi has had a distinguished if somewhat storm-tossed career. After training at the School of Fine and Applied Art in Khartoum, he became head of the department of painting and drawing there, but was later forced to go into exile for political reasons, and now lives and works in the Gulf States, exhibiting frequently in Europe. El-Salahi is an *évolué* , ready to compete on equal

470

471 Kwabena Gyedu, *Rising Expectation*, 1992
Acrylic on canvas,
102 × 152 cm (40 × 60 in)

472 G. Odutokun, *Dialogue with Mona Lisa*, 1991
Gouache on paper,
76 × 56 cm (30 × 22 in)

473 Ibrahim El-Salahi, *Untitled*, c.1990
Four panels, pen and ink on paper, each panel 114 × 114 cm (45 × 45 in)

471

terms with any European rival. Yet there is also more to it than this: as his name indicates, the artist is a Muslim. His frequent use of African forms, such as faces which derive from African masks (Pl. 473), is therefore an 'exoticism' in terms of his own culture. A similar form of exoticism appears in the work of Kwabena Gyedu. In his *Rising Expectation* (Pl. 471), mask-like heads once again appear, and it is evident that the whole structure of the composition owes a great deal to Picasso's *Demoiselles d'Avignon*, but also, especially in the patterned background, to traditional Ghanaian weaving. The African artist is here turning to European Modernism for suggestions as to how best to use quintessentially African material.

A gouache by G. Odutokun adds a further twist to this story of cultural exchanges. *Dialogue with Mona Lisa* (Pl. 472) appropriates the best-known of all European images, the famous portrait by Leonardo da Vinci, and combines it with an African figure. The African figure paints, the Mona Lisa carves, and a further element is added by the miniature Mondrian patterned on her breast. European artists have, of course, recently been very fond of cross-cultural combinations of this sort, and there is no reason why an African artist should not embark on them as well. The one caveat must be that the image seems addressed to a purely European, or at least an entirely Westernized audience.

Recently, a different kind of contemporary African art has attracted attention. This art has little to do with art schools organized on the Western model – its practitioners are generally self-taught. While their work has certainly attracted attention from Western critics and curators, it is still intimately related to the facts of contemporary African life. The most celebrated of these artists is the ebullient Zairean Chéri Samba. Samba left his native village in Lower Zaire for the capital, Kinshasa, in 1972. He found employment there in a studio which made advertising signboards, and later set up on his own in the same line of business, while at the same time drawing strip cartoons for a local newspaper. In 1975 he began to transfer these cartoons on to canvas. Samba's paintings are vehicles for exuberantly outspoken social commentary (Pls. 474, 476), and have, certainly at first sight, little or

472

473

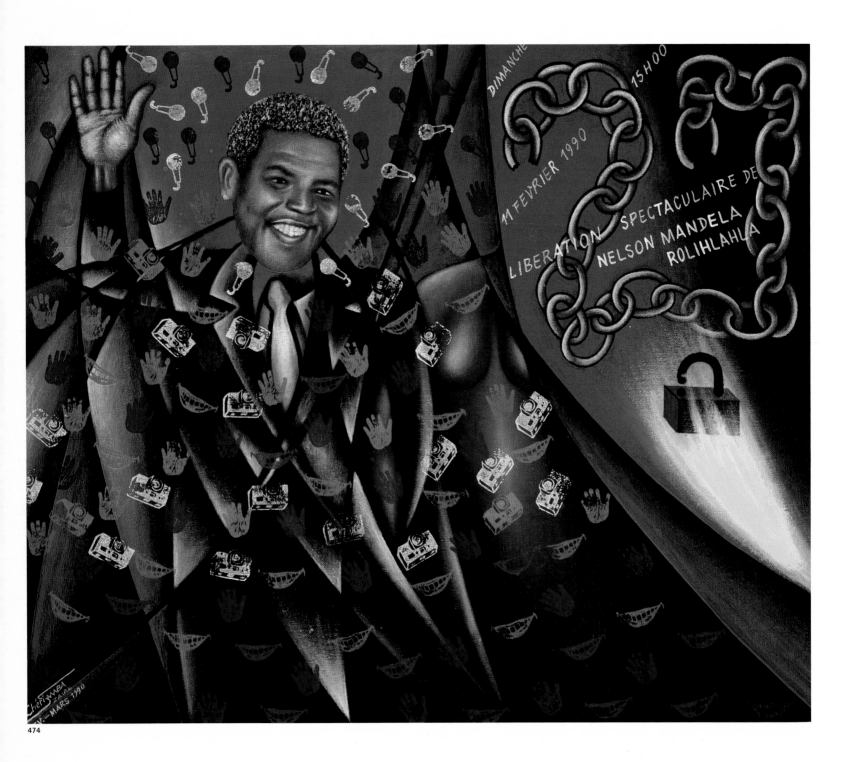

474

nothing to do with traditional African ways of making imagery. They are, however, profoundly African in their humour, their outspokenness and their gift for story-telling. Samba has a close follower in his younger brother, Cheïk Ledy, who worked with him for a while before setting up an independent studio. Ledy's work is equally exuberant in its depiction of contemporary African life (Pl. 475).

The art of Samba and Ledy is purely secular. The continuing strength of African religion manifests itself in the mysterious, rebus-like paintings of the Benin artist Cyprien Tokoudagba. Tokoudagba works as a restorer at the National Museum in Abomey, Benin, and has also painted numerous murals for voodoo buildings. The paintings on canvas (Pl. 477), which he has been producing since 1989, are

475

an offshoot of these murals, which are often collections of signs and objects with symbolic significance both to the voodoo cult and to the person who has offered the commission. The forms will not seem profoundly African, especially to a Western observer, but the meanings could not be more so. The paintings themselves, though in Western format, are a direct expression of an impeccably traditional aspect of African life.

The fantastic architectural maquettes made by yet another Zairean, Bodys Isek Kingelez (Pl. 480) reflect another aspect of Africa – its capacity to dream, and the way in which those dreams are often constructed from elements borrowed from the West. Kingelez, like Tokoudagba, has close links with traditional

474 Chéri Samba, *Libération Spectaculaire de Nelson Mandela*, 1990
Acrylic on canvas,
53.3 × 63.5 cm (21 × 25 in)

475 Cheïk Ledy, *Taxi de la Cité*, 1991
Acrylic on canvas,
130 × 127 cm (51¼ × 50 in)

476 Chéri Samba, *Conférence Nationale*, 1991
Acrylic on canvas, 66 × 81.2 cm (21 × 25 in)

477 Cyprien Tokoudagba, *Daguessou '92*, 1992
Acrylic on canvas,
150 × 243 cm (59 × 95¼ in)

476

477

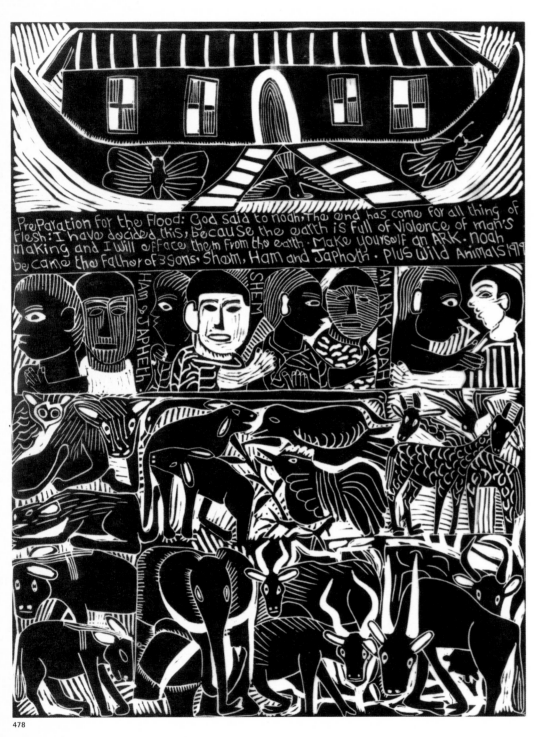

Preparation for the Flood: God said to noah, The end has come for all thing of flesh: I have decided this, because the earth is full of violence of man's making and I will efface them from the earth. Make yourself an ARK. noah became the father of 3 sons, Shem, Ham and Japhoth. Plus wild Animals 1999

478

African art – he was originally a restorer of traditional masks. The architectural models, constructed without any knowledge of the world of Western architecture (Kingelez's only contact with this are the colonial buildings left behind in Zaire, formerly the Belgian Congo, by the Belgian government), are the visible manifestation of an escapist imaginary world. The artist accompanies them with elaborate descriptive texts and commentaries. They are an African equivalent of the models evoking imaginary civilizations made by the American artist Charles Simonds (Pl. 178). The accidental likeness suggests that there are, after all, some universal impulses in contemporary art.

The fascinating and imaginative art being produced in West and Central Africa has not been matched by work from other parts of the African continent. The Makonde sculptures in hardwood from East Africa are not copies of traditional work but are, nevertheless, almost entirely a 'tourist' art form, produced for export. The same can be said about Zimbabwean soapstone carvings. In South Africa, before the fall of apartheid, there was a considerable production of prints by black artists, mostly linocuts, as this was the cheapest and simplest print medium available. Nearly all the artists who made them had at one time or another passed through the mission-run art school at Rorke's Drift in Natal, as this was the only institution where a black artist could obtain any form of professional training. The most distinguished alumnus of this school was not, however, genuinely South African. John Muafangejo was an Ovambo, born in Angola, in a polygamous tribal family, but brought up in Windhoek, capital of what was then the South African protectorate of South West Africa, now the independent republic of Namibia. Muafangejo's mother took refuge with the Anglican missionaries in Windhoek from the political troubles which had already started to disturb the Angolan borderlands, and it was they who recognized her son's talent. Muafangejo's powerfully designed prints deal with African proverbs and stories, and occasionally with political matters. His most characteristic themes, however, are the Christian story (Pl. 478) and his own struggles to transform himself from being someone who found his identity in traditional tribal life and custom, into someone who was fully

Westernized. The prints which deal with this second theme are often naïvely self-revealing, but they also have a tragic undertone.

It is interesting to compare the art now being produced in Africa with contemporary art in the English-speaking West Indies, and particularly with that from Jamaica. Until recently, Jamaica, in common with other Afro-Caribbean nations, had little visual culture which was distinguishably its own. The African elements which survived in Jamaican society, after the trauma of the Middle Passage and the long oppression of slavery, were the intangible ones – African turns of speech, African proverbs and story-telling, African elements in music, and the remnants of African religion (voodoo was renamed *obeah*, and its practice was strictly forbidden by the white colonial

478 John Muafangejo, *Preparation for the Flood*, 1979
Linocut on paper, 61 × 47 cm (24 × 18½ in)

479 Leonard Daley, *Untitled*, n.d.
Acrylic on canvas,
62 × 62 cm (24½ × 24½ in)

480 Bodys Isek Kingelez, *Palais d'Ihunga*, 1992
Paper, cardboard and mixed media,
50 × 70 x38 cm (19¾ × 27½ × 15 in)

479

480

regime). With the coming of Jamaican independence, there arose the desire to create a national art. Basically this art has taken two forms – there are 'intuitives' (self-taught artists) like Leonard Daley, and there are artists who have gone through some version of the art school process. Daley's work (Pl. 479) makes a fascinating contrast with that of Chéri Samba, who is equally self-taught . His art has been described as 'a claustrophobic, hysterical world of spirits, spectres and "bad-minded" people'[3] – it offers the image of a much more stifling society than the one Samba inhabits.

Milton George attended the Jamaica School of Art (now, since 1987, called the Edna Manley School of the Visual Arts) part-time, but is still essentially self-taught. His paintings (Pl. 482), with their violently Expressionist

481 African, *Sunlings*, 1993
Oil, pastel and acrylic on paper,
97 × 132 cm (38¼ × 52 in)

482 Milton George, *The Risen Christ*,
1993.
Acrylic on canvas paper,
85 × 65 cm (33½ × 25½ in)

483 Petrona Morrison, *Assemblage II*,
1993
Metal assemblage, height 290 cm (114 in)

imagery, have something in common with those of Daley. Their African elements – such as the mask-like faces – are not a simple statement of allegiance to the idea of Africa, but part of an elaborate commentary on cultural ambiguity. Much the same thing can be said about the totem-like sculptures of Petrona Morrison (Pl. 483), which allude, though only distantly, to African art. Morrison's background is in a sense typically Jamaican. Her pattern of studies – first a period at MacMaster University in Ontario, Canada, then a further one at Howard University in Washington – is that of many members of the educated class, and more like that found in Latin America than in Africa. Her course at Howard University was, however, Afrocentric – until recently a fairly unusual focus for Jamaican intellectuals. Her work, made of industrial materials, belongs firmly in the tradition of the American sculptor David Smith, and if she is reaching out to Africa it is in the manner of many African American artists, from the Western side of the divide.

African (Robert Cookthorne), educated at the Jamaica School of Art, belongs to the newest generation of Jamaican artists. He is wholly committed to the idea of an African consciousness:

> He has no sense of patriotism towards Jamaica; he is loyal only to the concept of Africa, home of the blackman. For him Jamaica is 'the least blackest country', 'reggae is a dilution' and 'dancehall' another detour for distracting the youth from true goals of renewal and self-preservation. African is a self-confessed extremist, for him there are no shades of grey, merely black and white. His work is about raising black consciousness so that it will not be obliterated or subsumed by white economic and cultural oppression.[4]

One cannot doubt the sincerity of this intent, but it is useful to remove African's work from a Western context and to put it in that of contemporary African art (Pl. 481). When it is compared with that of Samba, Ledy, Tokoudagba and Kingelez it seems to belong to a totally different social and aesthetic universe.

481

482

483

Racial Minorities

484

485

Although African (Pl. 481) is a Jamaican artist, his preoccupation, as his own statements make clear, is not with nationality or geographical identity, but with race. Race has, indeed, become one of the leading topics in contemporary art. This, in turn, is part of a much wider development. Since the 1960s the really revolutionary change in avant-garde visual expression is that it has become subject-based, rather than finding its identity in terms of style. That is, it has to some extent come full circle. When the Modernist rebellion against nineteenth-century norms began, one of its chief aversions was the narrative, subject-based art which the new generation of artists associated with the great annual Salons. Their means of expressing their disenchantment with the prevailing situation was the manipulation of style. When Matisse painted a portrait of his wife with a broad green streak down her nose, he was implying that the actual content of the painting counted for very little when put into the scale against the visual language he had chosen to employ in creating this particular image. Now many artists reject this attitude: they want to involve themselves with the great social issues of the day.

This feeling is, in part at least, linked to their changed relationship to the museum. When the Modern Movement began, it was largely sustained by the patronage of private individuals, who backed the artists against the official hierarchy. Many, though certainly not all, of the most significant exhibitions which made the new art accessible to the public were held in private, rather than public galleries. This situation has entirely changed, and the change has largely taken place since World War II. Museums have become the theatre in which the avant-garde acts out its ever-changing drama; they have also become, as many critics have pointed out, sacred spaces, fulfilling many of the functions once given over to the church. As such, they have become a natural forum for moral and sociological debate; their 'sacred' character gives added authority to statements made within their walls. One of the first artists to take full advantage of this was Joseph Beuys. As Beuys's career modulated from making artworks to attempts at direct political action, he found that his fame in the art world made the museum a natural platform: he certainly achieved much greater visibility for his ideas by

working in a museum and exhibition context than he would have been able to attain outside. His appearances at successive Kassel Documentas are a striking case in point (see Chapter 5, pp. 141–2).

One of the chief topics of debate during the past decade has been the position of racial minorities within developed Western societies, and it is not surprising that the art world has been drawn into this. Afro-Caribbean artists working in Britain are a case in point. Many, but not all of them, have chosen to concentrate on the question of racial identity. Keith Piper is typical of a new generation of Afro-Caribbean artists born in Britain in his preoccupation with racial themes, and particularly with the Middle Passage and the history of slavery. Characteristic modes of expression include video and elaborate installation work (Pl. 484). A similar theme is tackled in quite a different way by the sculptor Hew Locke, who is of Guyanese descent. Locke's *Ark* (Pl. 485) is also about the passage from Africa – a fantastic model boat filled with figures of all kinds, which suggests that a whole world was transported with the slaves from Africa to the Americas. Another Afro-Caribbean artist, Sonia Boyce, examines, not the past but the present, and more particularly the position of Afro-Caribbean women. Her *Do You Want to Touch?* series (Pl. 486) consists of small objects made of hair. They refer to the elaborate plaited hair-styles worn by Caribbean women as a sign of difference from their white sisters. The title contains an element of feminist as well as racial challenge.

Eugene Palmer was born in Jamaica but trained as an artist in England, including a stint at the prestigious Goldsmiths' College in South London, famous for its output of Conceptual sculptors. Much of his work, in reaction to this, is deliberately conservative. 'He is repainting history, mimicking the Old Masters and usurping their models in order to claim or reclaim the presence of the black within a "grand tradition" of narrative painting and portraiture.'[1] Recent paintings, such as *The Brother* (Pl. 487), are conservative not only in the way in which they are painted, but also in the dress of the figures and in the type of landscape background chosen. Their true significance emerges only when they are viewed within the context supplied by artists

484 Keith Piper, *The Nation's Finest*, 1990
7-minute Betacam S.P. video, made in collaboration with M.O.V.E. and the Cornerhouse, Manchester, for the Manchester Olympic Video Exhibition

485 Hew Locke, *Ark*, 1992–4
Wood, steel, papier maché, cardboard, plaster, glue and mixed media, 335 × 457 × 152 cm (132 × 180 × 60 in)

486 Sonia Boyce, *Do You Want to Touch?*, 1993
Hair, various sizes

486

487 Eugene Palmer, *The Brother*, 1993
Oil on canvas 213 × 152 cm (84 × 60 in)
Norwich Gallery, Norfolk Institute of Art

488 Anthony Daley, *Lime Leaf*, 1991
Oil on canvas, 112 × 97 cm (44 × 38¼ in)

487

such as Piper, Locke and Boyce. Though the style may be different, Palmer is exploring the same range of subject-matter.

It is, nevertheless, perfectly possible for an Afro-Caribbean artist working in Britain to reject a racial context for his work completely. This is the case with Anthony Daley, whose broadly brushed semi-abstracts suggest a West Indian or Afro-Caribbean connection only in the most peripheral way, through their references to tropical vegetation (Pl. 488).

Probably the oldest minority art to be firmly identified as such is the work produced by African-Americans. Whereas Afro-Caribbean artists have only very recently started to establish a presence for themselves in Britain, African-Americans were making art long before the advent of the Modern movement. Untrained black 'limners' or face-painters were at work in early nineteenth-century America, and they were followed in due course by more sophisticated artists such as the landscape painter Robert Ducanson (1817-72), who painted in the manner of the Hudson River School, and Henry Ossawa Tanner (1859-1937), who was briefly a pupil of Thomas Eakins. Tanner came from a family of high achievers – his sister, Halle Tanner, was the first woman (not merely the first black woman) to be admitted on examination to practise medicine in the state of Alabama. Yet his career had little that was militant about it. He painted very few pictures featuring blacks, and in mid-career emigrated to France, where he established himself as a painter of rather conservative Biblical subjects.

The discovery of African art by Picasso and other Modernists had a profound impact on what was produced by African-American painters and sculptors, who now felt that there was an alternative tradition which they could look towards. They were urged in this direction by a new generation of black intellectuals, chief among them Alain Locke, a Harvard-educated philosopher who later became a professor at Howard University in Washington. Locke wrote an influential essay 'The Legacy of the Ancestral Arts', published in 1925, which is still a fundamental document in the history of twentieth-century African-American art. The one problem was that the African art which African-Americans now saw as 'exemplary' was essentially a version shaped by European

489 Romare Bearden, *Family*, 1967
Collage on paper,
56 × 44 cm (22 × 17½ in)

490 Adrian Piper, *Vanilla Nightmare
8*, 1986
Drawing on the *New York Times*,
70.4 × 56 cm (27¾ × 22 in)

491 Betye Saar, *View from the
Sorcerer's Window*, 1966
Mixed media, 76 × 38 cm (30 × 15 in)

492 Alison Saar, *Man Child*, 1991
Painted wood, tin and bottle, height
86 cm (34 in)

489

490

sensibilities and perceived through European eyes. One can see this clearly in the work of Romare Bearden (Pl. 489), who came into direct contact with some of the giants of Modernism – Braque and Brancusi in particular – on a visit to Paris in 1950, and who later became one of the standard bearers of the Civil Rights movement in art. The other element which played its part in creating a new African-American style was folk or untutored art by black – chiefly Southern – artists.

Another member of this generation was Betye Saar. Saar's mixed-media assemblages (Pl. 491) are often attempts to produce Modern fetishes – parallels for those found in a genuinely African context. Others are satires on white stereotyping, for example of the cowboy as a hero figure. Betye Saar's daughter Alison Saar has also looked at African fetish statues as a source of inspiration. Her *Man Child* (Pl. 492) makes use of found materials in a way which is familiar from art from Africa itself, where the detritus of European mass culture is ingeniously recycled. The problem with all these attempts to make a new Africa in America is that the spectator is aware of the artist's self-consciousness, of an attempt to create a kind of 'primitivism' which doesn't come into existence spontaneously.

More directly militant are the performances and artworks of Adrian Piper. Piper is very light-skinned, and she plays on the ambiguity of her position within the racial structure. *Vanilla Nightmare # 8* (Pl. 490) is an altered advertisement from the *New York Times* – the department store Bloomingdale's offering the Christian Dior scent Poison. Into this Piper has inserted her own self-portrait, and a group of menacing African heads, one of which seems to bite her on the breast. The message is feminist as well as African-American: the drawing satirizes sexual as well as racial stereotyping.

One striking thing about African-American art, nevertheless, is that leading artists of African-American descent increasingly tend to reject the idea that their primary duty is to represent African-American culture. The most celebrated black artist of the 1980s, Jean-Michel Basquiat, made frequent use of 'black' imagery, but he was always at the same time anxious to stress the universality of his interests. His paintings, rooted in the graffiti movement in New York (see p. 406), but

491

492

493 Sam Gilliam, *Around a Circular Dining Room Table (Ellison)*, 1990
Acrylic on sculpted canvas; acrylic and enamel on aluminium,
207 × 134.5 × 66 cm (81½ × 53 × 26 in)

494 Jean-Michel Basquiat, *Untitled*, 1984
Acrylic, silkscreen and oilstick on canvas,
233.5 × 195.5 cm (88 × 77 in)

493

superior to any of its other products, have a very wide frame of cultural reference – allusions to African art occur, but may be mixed up with many other things, even references to atomic science (Pl. 494). Basquiat was of part-Haitian, part-Puerto Rican ancestry – something which already removed him from the central African-American tradition. His ambition was not to carve a niche for African-American culture, but to compete on equal terms with his mentor, Andy Warhol.

Before Basquiat's sudden emergence on the scene, the best-known African-American painter was probably Sam Gilliam, who continues to occupy a considerable place on the American art scene. Gilliam is, and always has been, an abstract painter, whose work eschews overt symbolism. Originally a member of the Washington Colour School, his affinities are with artists like Morris Louis and Kenneth Noland, especially with the former. In recent years he has pushed Louis's experiments with off-stretcher work much further than Louis himself did, producing work which is part-painting and part-sculpture (Pl. 493). Gilliam has caused considerable irritation amongst African-American militants, and has sometimes been accused of 'Uncle Tom-ism' because of his insistence on being judged purely as an artist, not as a generic representative of minority culture.

Martin Puryear, now perhaps the most celebrated African-American sculptor, is similarly insistent, despite the fact that he is one of the few African-American artists who has direct experience of Africa, having worked in Sierra Leone as a member of the Peace Corps. Puryear's studies took him from Africa to Sweden, where he studied print-making and sculpture at the Royal Swedish Academy, and then to Japan, where he became familiar with Japanese craft aesthetics. Swedish influences – especially what he learned from the master cabinet-maker James Krenov – and Japanese ones are more immediately visible in his work than African ones (Pls. 495-6). Attempts to align his work with African artefacts have been made by enthusiastic critics, but seem fruitless in the face of Puryear's own statement that, when in Africa, he felt like an outsider – not part of the customs of the people among whom he lived.

Another leading African-American sculptor

495 Martin Puryear, *Verge*, 1987
Painted pine and red cedar,
171 × 218 × 119 cm (67½ × 86 × 47 in)
Collection of the Edward R. Broida Trust,
Los Angeles

496 Martin Puryear, *Lever # 2*, 1989
Rattan, ponderosa pine, ash, cypress,
180 × 743 × 140 cm (71 × 293 × 55 in)

496

497 Jimmie Durham, *Untitled*, 1993
Mixed media,
45 × 143 × 15.8 cm (17½ × 56¼ × 6¼ in)

498 John Scott, *Thorn Bush Blues
Totem*, 1991
Painted steel, height 246 cm (97 in)

is John Scott, who lives and works in the South
– a significant fact in itself, since hitherto
African-American artists associated with the
Modern Movement have tended to make their
careers either in the big cities of the North,
or else in California. Scott belongs to a group
of kinetic sculptors in New Orleans, some
African-American like himself, some white,
like Lin Emery (Pl. 71). He is directly in the
main line of descent for sculpture of this type,
since he once worked with George Rickey who
is, in turn, the chief artistic heir of Alexander
Calder. Made of painted steel, Scott's work is
visibly the product of an industrial culture.
The artist, however, does say that part of the

497

inspiration for recent pieces like *Thorn Bush
Blues Totem* (Pl. 498) comes from the African
legend of the diddley bow – the hunter's
bow which, after the kill, was turned into an
improvised one-stringed fiddle and played to
appease the spirit of the animal. The connection
between these sculptures and African culture in
general is, nevertheless, tenuous.

 In fact, both African-American and Afro-
Caribbean art, whatever the declared intentions
of the artists, and whether or not they identify
with the idea of Africa, essentially belongs
to a Western context. The contemporary art
of Africa is produced under very different
conditions, and for a very different public (that

is, when it does not fall into the category of 'art for export', as is the case with many skilful copies of traditional artefacts). The 'Africa' which is the focus of aspiration for African-American artists in the United States, and also for Afro-Caribbeans, whether working in the West Indies or living and working in Britain, is an ideal, a cultural concept rather than a mass of solidly existing facts. This ideal, though in theory opposed to the European civilization which has treated men and women of African descent with such cruel injustice, is in fact shaped by it. It has been shaped not only by the creators of the Modern Movement, such as Picasso, but by the philosophers of the eighteenth century, such as Jean-Jacques Rousseau, the inventor of the 'noble savage'.

While African-American art seems to have been loosening its boundaries and moving away from the idea that the artist should primarily represent the minority to the majority, other minorities within America have been insisting on the validity of claims to a separate cultural identity. These assertions take many forms. For example, artists of Native American origin have now begun to stake a claim to be fully acknowledged by the American art world. Jimmie Durham makes mysterious ritual objects, using industrial as well as traditional elements (Pl. 497). Fritz Scholder, of mixed German, Irish, French and Luizeno Indian descent , has produced many powerful images as a tribute to his Indian heritage in the course of a long and distinguished career (Pl. 499). These paintings not only refer to Scholder's Indian background, but, through their bold forms, reaffirm the idea that there is a separate tradition of South-Western art, in line of descent from painters such as Georgia O'Keeffe, Andrew Dasburg and Maynard Dixon.

Scholder's situation, firmly located within a recognized historical framework, is very different from that of the Chicano artists who have begun to assert their presence in California, and especially in and around Los Angeles, during the past two decades. Chicanos are Americans of Mexican descent – though not all Mexican-Americans would accept the designation. Chicano art arose chiefly as a popular, untutored phenomenon. Its inspiration came from several sources – Mexican murals, which were seen as an

499

affirmation of Mexican identity; Cuban revolutionary posters, made widely available through a handsome picture book, *The Art of Revolution, 1959-70*, published at the beginning of the 1970s; the popular wall paintings often found in Mexican *pulquerias* or drinking places, and chromo-lithographic illustrations from Mexican popular calendars. It manifested itself most dramatically in the murals painted at the Estrada Courts Housing Project, East Los Angeles, and other similar situations, during the mid-1970s (Pl. 500). Whereas African-American artists were often struggling to get away from the 'minority' designation, it was precisely their affirmation of proud, even aggressive, minority status which attracted art-world attention to Chicano culture. This attention has now been affirmed by several exhibitions, including a major survey held at the Wight Art Gallery, University of California, Los Angeles, in 1991.

Chicano art is not the only form of Latino art to establish a presence in the United States. I have already talked of artists of Mexican descent such as Luis Jimenez and Jesús Bautista Moroles (Pls. 367, 369), who form an important part of the art scene in Texas. There are also artists of Mexican descent living on the west coast of the United States who are not identified with the Chicano movement, such as Roberto Gil de Montes (Pl. 501). Though their work contains elements which are visibly Mexican, it also responds to the cultural climate of the United States, and that of the particular region that they inhabit. This is even more obviously true of the work of Puerto Rican painters and sculptors such as Rafael Ferrer (Pl. 502), who lives much of the time in New York, and Arnaldo Roche (Pl. 503), who received his artistic education at the Art Institute of Chicago and who continues to work in the United States. These artists are simultaneously North American and Hispanic in sensibility, part of the full complexity of North American culture, yet with undeniable links to the art produced by the nations of Latin America. The one difference – but it is an important one – between what these artists produce and self-defined Chicano art is that what they make is seen primarily as the product of an individual, and only later in terms of the racial or national group with which that individual is identified. To be a 'minority artist'

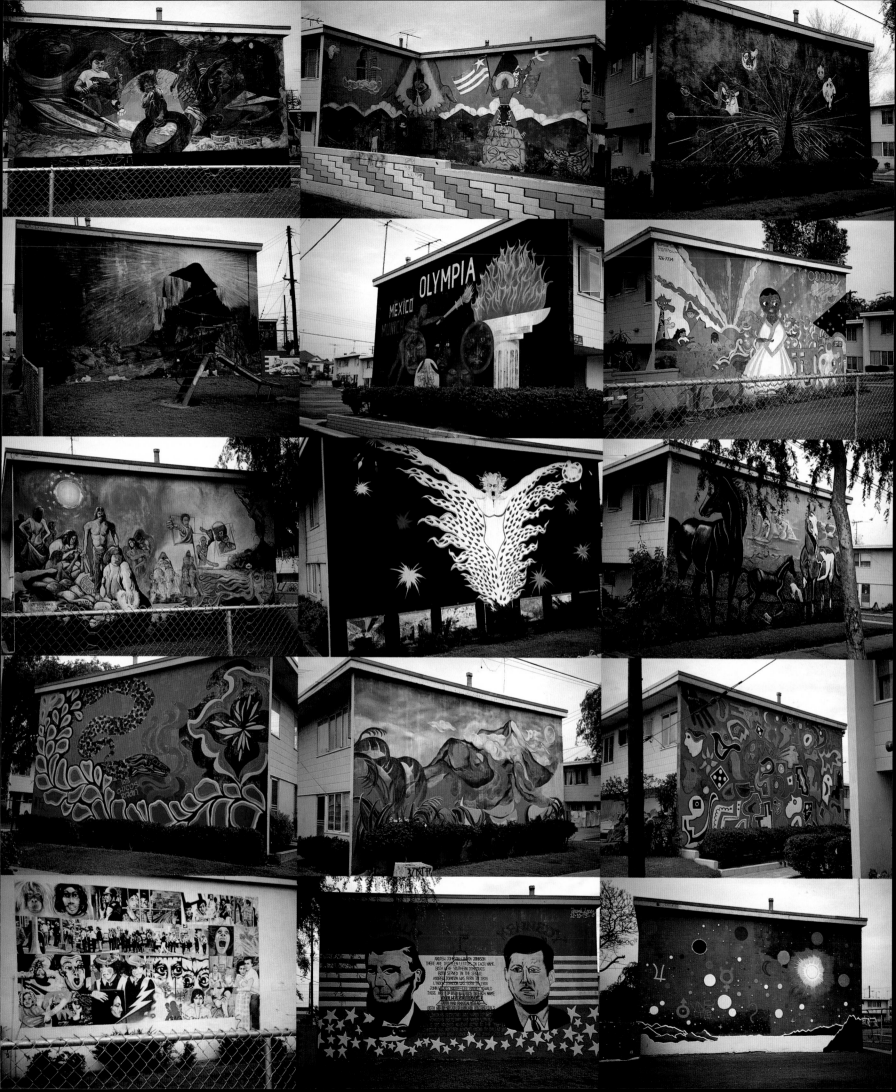

is, here as elsewhere in America, not only
a question of how the artist is perceived by
outsiders, but also of how he perceives himself.

In other regions of the world this is less self-
evidently the case. New Zealand, for example,
is an officially bi-racial and bi-cultural society,
divided into Maori and not Maori, or *pakeha*.
The Maori, occupiers of the land before the
Europeans came, have successfully preserved
a vigorous tribal culture, increasingly self-
assertive in cultural terms, as well as in matters
of more directly practical import, such as land
rights, which have recently been pursued under
the provisions of the Treaty of Waitangi (1840).
Art plays a prominent role in traditional Maori
culture, but it is an art of decorative carving
rather than of painting, or the production of
independent sculptural objects. The main foci
for the activity of traditional Maori carvers are
the huge *wakas*, or ceremonial canoes, which
are the bearers of tribal identity, and *meraes*,
or meeting houses, elaborately decorated
buildings which combine a social with a sacred
function. *Meraes*, in particular, continue to be
built, so that there is a continuing outlet for the
efforts of traditional carvers.

At the same time, however, Maoris have
begun to be absorbed into the essentially
pakeha world of contemporary art. The senior
figure in this cross-over process is Ralph
Hotere. Hotere's work, though sometimes
informed by specifically Maori concepts,
remains firmly within the Western tradition,
as in, for example, his ambitious *Aramoana*
(Pl. 507), despite the presence of inscriptions
in the Maori language.

Younger artists of Maori descent have
transferred traditional Maori images, found
in carving, to paintings in Western formats.
This is the case with Robyn Kahukiwa's
Hineteiwaiwa (Pl. 506), where the central
group of mother and child is influenced by the
relief carvings one might find on a Maori
merae. A further Maori element is added by
the greenstone *tiki* or pendant the mother is
wearing. The artist says that the painting 'is
about recovering our spirituality – i.e.
traditional Maori religion'. New Zealand artists
of Maori descent have also made use of Maori
symbols in quasi-abstract work, as happens
in the work of Shane Cotton (Pl. 505). These
paintings are much appreciated in New
Zealand itself, and have attracted support from

501 Roberto Gil de Montes, *Dia y
Noche*, 1986
Oil on wood and tin,
(36.8 × 30.5 × 7.6 cm) 14½ × 12 × 3 in

502 Rafael Ferrer, *Isabel de Torres*,
1992
Oil on canvas,
142 × 106.5 cm (56 × 42 in)

503 Arnaldo Roche, *Here You Only
Can Die as a Man*, 1993
Oil on canvas, 213 × 304 cm (84 × 120 in)

502

503

504

public galleries and the New Zealand Arts Council. They are not, however, always fully accepted by the councils of Maori elders as an authentic expression of Maori culture.

The situation in Australia is different again. Here the descendants of white settlers have had to try to come to terms with the recalcitrant facts of Australian nature, and with both settler and Aboriginal myths. The *Ned Kelly* and *Burke and Wills* series painted in the 1940s by Sidney Nolan (1917-92) are an example of the first: they celebrate the equivalent of the American pioneer myth transferred to a different setting. Recent paintings by Nolan's contemporary Arthur Boyd, now the senior figure in white Australian art, have been a meditation on Ayer's Rock (Pl. 504), the extraordinary desert monolith which is perhaps the most sacred of

505

Australian Aboriginal sacred spots. These recent works nevertheless continue to owe a great deal to Western European tradition. In this case they have a clear relationship to the landscapes painted in the 1940s by the American Abstract Expressionist Willem de Kooning. White Australian painting has recently been challenged by enormous recent enthusiasm for the paintings which are now being produced in quantity by Aboriginal artists. Though the process of European colonization took place at the same epoch, the European impact on the lives of the Aborigines was much more severe than it was on the existence of the Maori. Despised by the settlers, Aboriginal tribesmen were often hunted down like vermin. In the early part of the twentieth century the Australian government pursued a

506

507

policy designed to persuade, or failing that, to force Aboriginals to abandon their old semi-nomadic life in exchange for life in fixed settlements in the outback. Here they scraped an existence in squalid and impoverished conditions.

The original impulse towards the creation of a new art came from Europeans looking for a way to provide a better life for the Aborigines – a better life in material terms, as well as a renewed sense of tribal identity. In 1971 a European art teacher, Geoffrey Bardon, arrived to teach children at the school in Papunya, an outback settlement established in 1960 for members of a number of different Aborigine tribal groups. It was he who encouraged a number of adults in the settlement to paint a mural using traditional images on the walls of the school. Traditionally these images were used for rock paintings, ephemeral ground paintings, or designs painted on the participants' own bodies as part of tribal ceremonies. They were also secret, related to the concept of Dreamings, which was central to Aboriginal culture. Dreamings are myths, but also property, owned by a particular individual within a tribal kinship group, and licensed by him for use by others, who have secondary rights in the same Dreaming. In addition to being narratives, presented in largely abstract form, paintings of Dreamings also serve as charts or maps.

Once objections to the public disclosure of Dreamings had been overcome, and the murals successfully completed, the men who had made them wanted to continue to paint, and Bardon encouraged this by providing materials – synthetic paints and boards. The earliest paintings were small in scale, painted flat on the ground or held in the artist's lap. They were often painted to be seen from any viewing orientation (Pl. 508). The colours used were the standard earth colours already familiar to the artists (Pl. 509). While some of the early work contained schematic or even naturalistic depictions of objects, the general tendency was for it to become more abstract, as this helped to conceal what the artists still felt to be secret information. At the same time the artists began to move from working on board to working on canvas, since canvas could be rolled for transportation (Pl. 511). Women's art, neglected at first by enthusiasts for the new

508 Tim Leura Tjapaltjarri, *Wild Potato Bush (Yam) Dreaming*, 1972 Poster paint and PVA on board, 69 × 60 cm (27¼ × 23¾ in)

509 Old Walter Tjampitjimpa, *Snake (in the Water) Dreaming*, 1972 Paint on board, 46 cm × 42 cm (18 × 16½ in)

509

510 **Gordon Bennett**, *Blooding the Dogs*, 1991
Watercolour on paper,
37 cm × 27 cm (14½ × 10¾ in)

511 **Nosepeg Ununti Tjupurrula**,
Tingari Cycle, 1987
Acrylic on canvas,
59 cm × 91 cm (32¼ × 35¾ in)

512 **Ada Bird Petyarre**, *Women's Dreaming*, 1992
Acrylic on canvas,
60.5 × 120 cm (23¾ × 47¼ in)

510

Aboriginal art, was given increased recognition in the 1980s and 1990s (Pl. 512).

Aboriginal art won quick recognition for several reasons. First, white Australians had begun to feel guilty about their past treatment of Aborigines, and were looking for ways to make amends. Second, this was an art which seemed to speak for Australia itself – an Australia liberated from foreign influences. Third, and perhaps entirely by accident, the painted Dreamings matched Western preconceptions about abstract art and how it operated. Fourth and last, the distinctive 'dot' style which appeared in many of the paintings, perhaps derived from sand or earth paintings, made Aboriginal work immediately recognizable. It fitted a preconceived framework and yet possessed its own character.

The defect of Aboriginal art as a reflection of contemporary Australian culture was that it was essentially static. While seeming to right an injustice done to a minority group, its success imposed a view of what Aborigines were which was quite a long way from the whole truth. Many people of Aboriginal origin are also of mixed race; many Aborigines live (as the majority of Australians do) in large cities.

Inevitably a new and very different kind of art arose to represent their point of view. Urban Aboriginal art, as it has come to be called, is a much less comfortable product of racial difference than the quasi-abstract Dreamings produced in the outback. One of the chief representatives of the style is Gordon Bennett. Bennett is of mixed race. As a child, he was conditioned to see the Aboriginal heritage purely from a white point of view. Later, he retained a consciousness of the way in which Western (Cartesian) rationality continues to shape attitudes to Aboriginal culture. This awareness is symbolized by his use of grids in his paintings.

Bennett's work, being consciously Post-Modern, is also stylistically quite variable. His most effective images are those which denounce white Australia's conduct to the black man with direct narrative force (Pl. 510). Unlike the Aboriginal paintings now accepted as standard, they have nothing concealed or coded about them. They are, however, just as legitimate an expression of racial difference as the painted Dreamings which have now achieved such a world-wide success.

511

512

Feminist & Gay

While racial minorities benefited from the shift towards an art based on content, and from the new availability of the museum as a platform for political and social controversy, they were not necessarily the chief beneficiaries of change. The reason, as I have suggested in the section of the last chapter dealing with African-American art, was that successful artists were often uneasy about being stereotyped in racial terms: they saw what they did as something which reached beyond their own cultural situation and had universal meaning.

The situation was slightly different with two other categories. An African-American artist might feel that he (or she) might have no choice but to declare himself (or herself), simply because of the obvious facts of skin colour and racial type. To be a feminist artist, or an artist linked to some aspect of gay liberation, was, on the other hand, a deliberately made, conscious decision.

In the developed countries, feminist art has been one of the most powerful forces for change within the contemporary art world since the early 1970s. The feminist movement has had a particularly powerful impact on the art of the United States. The progress of feminist art has not, however, been free of controversy. First, there have been feminist theoreticians who felt that the attempt to define an 'art of women' was tantamount to creating a ghetto for female creativity – that the effort contained a suggestion that this was different from other kinds of creativity. Women artists, they said, should not be separated from male colleagues in critical discourse: what was needed was to gain recognition for what women had achieved , to make sure that they were not ignored in favour of men. In art-historical terms this led to a vigorous search for 'forgotten' women artists who could be placed on pedestals of equal height to those already provided for males. Applied to the early history of Modernism, this insistence on equality could produce some strange results. Weak artists like Marie Laurencin (1885-1956), or distinctly marginal ones like Tamara de Lempicka (1898-1980) were sometimes, in the face of all the evidence, promoted to central positions within the history of the Modern Movement.

Second, there was often a feeling that it was unacceptably judgemental to try and make distinctions between the work of one woman artist and that of another. Histories of feminist art therefore tended to degenerate into long lists of women artists, living and dead, with little indication that some might be more important than others, both in terms of their actual aesthetic achievement, and in terms of the influence they had on the artistic situation of their time.

Third, there was often a wariness, among artists committed to feminism, about making use of traditional forms, such as paint on canvas. Much feminist art was made in new media, such as video. A great deal of it consisted of environmental work or performances. While this avoided direct comparison with male achievement, it also meant that a high proportion of feminist effort went into art which was ephemeral, and which survived chiefly in the shape of documentary photographs and written accounts – that is to say, at second or even third remove. The tendency was accentuated by the fact that feminism's point of entry to the avant-garde art world was often, logically enough, through the Conceptual Art movement, one of the ruling orthodoxies of the early 1970s.

Feminist art (and feminist criticism, which went hand in hand with the new art made by women) did, however, have an important impact on the intellectual structures of the art world taken as a whole. The route to Conceptual Art had been through Minimalism, and its initial focus had been aesthetic rather than social. For example, as can be seen clearly from the work of Joseph Kosuth (Pl. 102), much early Conceptual work was about the different ways in which the spectator apprehended the world – through direct experience of the object itself, through visual representation of the object, and through written description. Feminist art opened up the situation – its makers were interested not in aesthetics as such, but in the situation of women within society and in history. The weapons feminist critics used in order to deal with this range of material were often ideas borrowed from French Structuralist philosophy, and also from the late offshoot of this put forward by Jacques Derrida. A work of art was a 'signifier', and the duty of the critic was not so much to explore its aesthetic effect as to 'deconstruct' it and assess its effect on the context surrounding it. A consciously feminist work might also undertake this task of

deconstruction on its own account, without the
need for outside interpretation.

This had further consequences. The chief of
them was that any feminist work must – when
viewed in the light of feminist criticism – be
regarded as essentially provisional: as a nexus
of ideas which happened to be producing a
particular kind of activity within a situation

513 **Judy Chicago**, *The Dinner Party*,
1979
Mixed media, length of each side
14.6 m (48 ft)

513

which was itself always fluid and transitional.

The work of the major feminist artists of the
early 1970s is already taking on colourings
which it did not necessarily possess at the
moment when it was made. Perhaps the most
celebrated feminist artwork of the period,
and still a major totem of the whole feminist
movement, is *The Dinner Party* by Judy

514 **Miriam Schapiro**, *All Purpose Fan*, 1979
Acrylic and fabric on paper,
56 × 76 cm (22 × 30 in)

515 **Louise Bourgeois**, *Cell (Three White Marble Spheres)*, 1993
Glass, metal, marble and mirror,
213 × 213 × 213 (84 × 84 × 84 in)

Chicago (Judy Cohen Gerowitz) (Pl. 513). *The Dinner Party* is a table set for a triple eucharist: a celebration of thirty-nine women who played major roles in history and art. Each place-setting celebrates one of these women. The plates are decorated with variants of a 'butterfly' or vagina motif, in celebration of women's sexuality. *The Dinner Party*, though entirely conceived by Judy Chicago, was a co-operative enterprise, designed to make use of skills which are traditionally regarded as female, such as stitchery and china painting. The work has not always had a good press from feminist critics. One called it 'a shrine to an unknown woman whose colour, sexuality, class, struggles and achievement are without political context'.[1] Yet it did play a major role in awakening a wide audience to the possibilities of feminist art.

An important early associate of Judy Chicago was Miriam Schapiro, whose fame has now been somewhat eclipsed by that of her colleague. The two women jointly created and directed the Feminist Art Program at the California Institute of the Arts at Valencia in 1971, the first of its kind and the model for many other courses of the same type. Among Schapiro's most typical products are her *Fans* (Pl. 514). These lavishly decorative objects are a celebration of something which the artist sees as specifically female, in terms of use as well as in taste.

Another kind of feminist art which made an impact in the 1970s was a direct celebration of sexuality, as seen from a female viewpoint. Perhaps the most striking examples are the work of the sculptor Louise Bourgeois. Bourgeois's work is allied to the pre-war Surrealist tradition, notably to Giacometti in his early, Surrealist phase and also, on occasion, to that of Post-Minimalist European artists like Eva Hesse (Pl. 149). Bourgeois is a much more ambiguous, more visceral kind of artist than the declared feminists such as Chicago, but the faintly threatening quality of her work (at least to the male viewer) is undoubtedly intended, as too is the claim, implicit in so many of her sculptures, that woman artists are entitled to deal with sexual topics directly and in their own terms, without making concessions to the male frame of reference. Bourgeois's *Cell (Three White Marble Spheres)* (Pl. 515) is typical of her recent production – it

514

516 **Nancy Spero**, *Marlene, Lilith, Sky Goddess*, 1989
Hand printing and printed collage on paper, nos 1 to 4 of 7 panels, each panel 279 × 51 cm (110 × 20 in)

517 **Ana Mendieta**, *Untitled*, 1982-3/1993
Photograph of earthwork with carved mud, New Mexico, 157 × 122 cm (61¾ × 48 in)

518 **Audrey Flack**, *Egyptian Rocket Goddess*, 1990
Bronze, height 106.5 cm (42 in) with base

is also strongly reminiscent, though made on a much larger scale, of Giacometti's *The Palace at 4 a.m.*

Many feminist artists have chosen to look back in time, in search of a different historical context for their efforts. This was the case with the Cuban-American artist Ana Mendieta, whose work expressed her fascination with primitive cultures. Much of what she did was site-specific, images of the female body carved in sand or mud (Pl. 517). These images were intended to refer back to the cult of the Great Goddess, which flourished in the ancient Near East and in Minoan Crete – a cult which has been revived by contemporary feminists as a counterbalance to male-dominated Christianity.

516

517

Similar images occur in the work of Nancy Spero (Pl. 516), who has plundered world mythology in the name of feminist art, and in the later work of Audrey Flack, who has now moved away from her original preoccupation with Super Realist imagery (Pl. 253). Flack's *Egyptian Rocket Goddess* (Pl. 518) is an interesting combination of modes; it plunders both Ancient Egyptian art and the Art Deco revival of Ancient Egyptian style in search of a strong female presence. The snakes entwined round the figure's arms are those of the Minoan Mother Goddess. This use of appropriation, and of complex cultural references, is typical of feminist art, where the analysis of ideas is always more important

519 Mary Kelly, *Post Partum
Document, Documentation VI*, 1978–9
Slate and resin, one of 18 units, each
35.6 × 27.9 cm (14 × 11 in)
Collection of the Arts Council of Great
Britain

520 Cindy Sherman, *Untitled # 193*,
1989
Colour photograph,
160 × 106.5 cm (63 × 42 in)

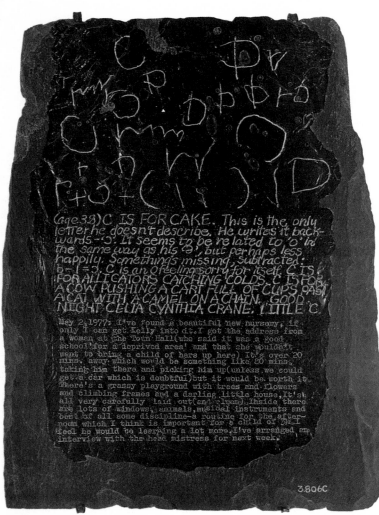

519

than complete originality of form.

Feminist art which is not historically based is often an analysis of women's roles in society. Perhaps the most famous examples of this are the long series of self-portraits based on movie-stills made by Cindy Sherman. In these she enacts a series of roles from imaginary films (Pl. 520). She uses these charades as a way of analysing female gender stereotypes.

Mary Kelly's *Post Partum Document* (Pl. 519), probably the most celebrated feminist work made by a British artist, contains a less fragmented narrative. The complete series is an analysis of the artist's relationship with her son, from the time of his birth onwards, and of the gradual separation enforced by society. In her introduction to the book which reproduces the piece in its entirety, the American critic Lucy R. Lippard described it bluntly as 'the story of a cultural kidnapping and of a woman's resistance to it, made active by visual and verbal analysis'.[2] The panel illustrated is a record of the period during which the child begins to read and write. The top register shows the child's own efforts, the middle one gives the mother's commentary, and the bottom one is an excerpt from her diary of the same period. It will be noted that, while the piece has strong intellectual and narrative interest, its aesthetic content, in any conventional sense of the term, is almost nil.

Barbara Kruger is another feminist artist who relies heavily on written content, though in her case this is often given striking visual form (Pl. 521). Her mixture of typography and photographs is influenced by Russian Constructivist posters, for example those designed by the Shternberg brothers in the mid-1920s, and what she offers is a rather similar form of agitprop, but now backed by resources of modern technology which were not available to the Shternbergs. The effect is strident, but undoubtedly highly effective. Totally different is an installation piece by Annette Messager, *The Pikes* (Pl. 522). Here a whole range of objects and images are presented on the tips of metal spikes, like grisly trophies. The artist seems to meditate on the disconcerting contents of her own unconscious mind.

Barbara Bloom's installation, *The Reign of Narcissim* (Pl. 525) is perhaps feminist only by default, in the sense that the artist holds up a

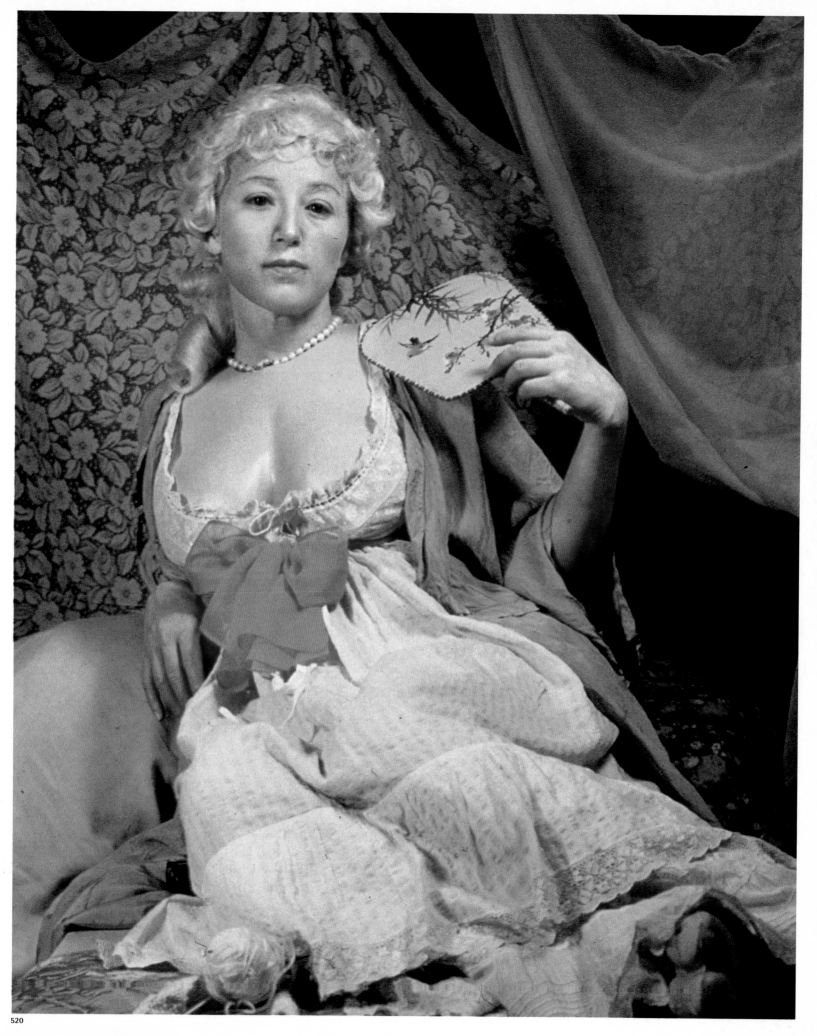

You pledge
allegiance to your dick and to the pussy for which it stands?

All violence
is the illustration of a pathetic
stereotype

hebe kike yid hymie
spic wop dago mex
cunt gash snatch
pussy spook sambo
nigger boogie slant
nip chink jap faggot

homo fairy hebe kike
yid hymie spic wop
dago mex cunt gash
snatch pussy spook
sambo nigger boogie
slant nip chink jap
faggot queer homo

521 Barbara Kruger, *Untitled*, 1991
Installation at the Mary Boone Gallery,
New York, 5–26 January 1991,
photographic silkscreen on paper, floor
lettering vinyl paint, dimensions variable
according to location

522 Annette Messager, *The Pikes*
(detail), 1992–3
183 metal pikes, stuffed objects,
mixed media, dimensions variable

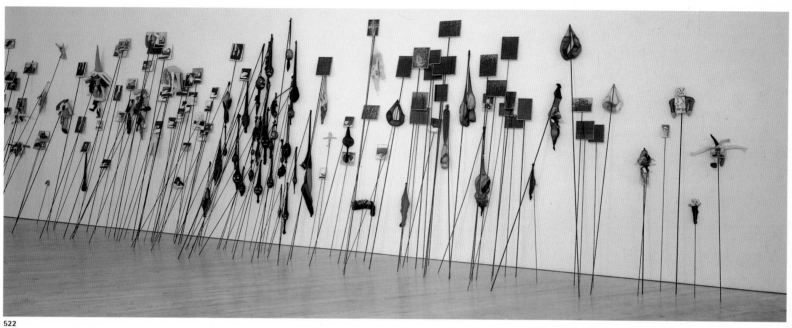

522

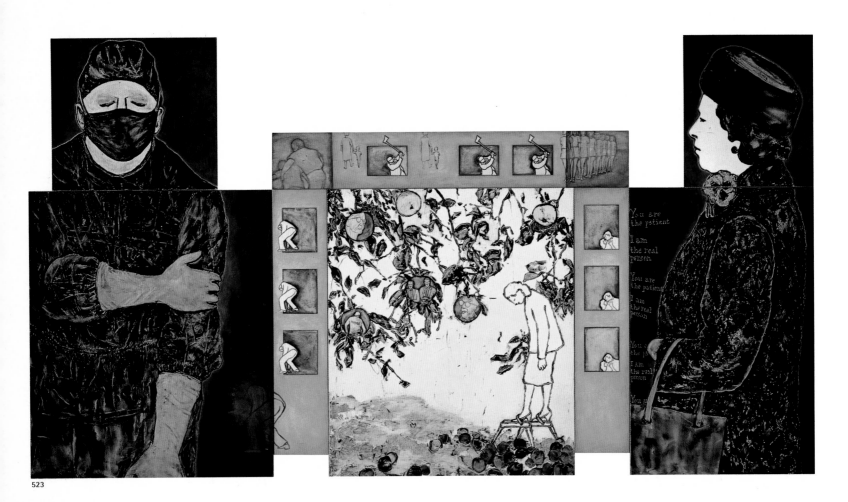

523

mirror to herself in a gentle satire on female self-love and self-preoccupation. She created a bland Neoclassical salon filled with busts and cameos reproducing her own image, plus imitation Louis XVI chairs upholstered in a pattern showing her signature. Also included were her astrological chart, her dental X-rays, and even a box of chocolates stamped with her own silhouette. One critic (female) found it 'smug and self-referential', but later recanted, noting resignedly, 'that's what narcissism is.' Bloom's work, always very subtle, is a corrective to the idea that all art which touches on feminist issues has to be militant.

Not surprisingly, much recent feminist art has been about women's relationship to their

524

525

own bodies. Male dominance of the medical profession and the attitudes of male doctors to female patients are the theme of Ida Applebroog's *Emetic Fields* (Pl. 523). A panel on the right offers a standard, repetitious statement: 'You are the patient – I am the real person – You are the patient – I am the real person ...' Either the patient can't get through to the doctor that she is 'real' – that she is something more than just a unit for professional manipulation – or the doctor himself is asserting that he alone has reality.

Much feminist work dealing with sickness is an expression of terrible pain. The series made by Hannah Wilke before her death from cancer (Pl. 524) shows her bald from the effects of

chemotherapy. Previous series, and the performances they sprang from, had been both a celebration of the female body and a condemnation of male attitudes towards it. Nancy Fried has made a series of powerful terracotta sculptures concerning her own breast-surgery for cancer and her reactions towards it (Pl. 526). I suspect male attitudes to work of this type may be very different from female ones. The male impulse is to turn away, to avoid the issues they raise. For women they have an element of aggression – through their embodiment of things that men don't want to know – and of therapeutic rage.

Fried is one of the few lesbian artists whose lesbianism is an issue in her work. Most of the lesbian artists who have wanted to tackle issues of gender and sexuality have until recently preferred to do so in a generally feminist rather than a specifically homosexual context. One of the rare exceptions to this rule has been the young British artist Sadie Lee. Her *Bona Lisa* (Pl. 527) is yet another twist on a theme originally used by Marcel Duchamp in his notorious version of the Mona Lisa with a moustache, *L.H.O.O.Q.* Here Leonardo's famous sitter appears with cropped hair and a collar and tie – an ironic comment on the popular image of a 'butch' lesbian.

Gay males have not been similarly reticent. One of the first artists to paint openly homosexual images for a non-specialist audience was David Hockney. His *Domestic Scene, Los Angeles* (Pl. 528) was an innovative painting because of its matter-of-factness: its implication that the subject-matter was no big deal. In this respect it was a great contrast to paintings like Francis Bacon's *Two Men on a Bed*, painted exactly a decade earlier, with its atmosphere of furtive excitement. In the 1970s and to some extent later, the advent of homosexual liberation enabled gay artists to give open expression to ideas and feelings which in earlier times would have had to be much more carefully coded. Often they looked for enabling myths. George Dureau's paintings (Pl. 529) look to Graeco-Roman art, and also to the traditions of Mardi Gras in New Orleans, the city here he was born and still lives. The New Mexico artist Delmas Howe combines Graeco-Roman myth with the myth of the cowboy (Pl. 530). Both of these artists offer an idyllic, idealized world, a guilt-free celebration of a

526

527

528

529

530

sexuality which no longer considers itself to be forbidden. In this respect – in its hedonistic emphasis – gay male art tends to differ considerably from its feminist counterpart. This is equally true of a different kind of gay art, which has developed and made more explicit the homosexual implications already present in much of Andy Warhol's work. The ultimate celebration of this new, liberated sexuality is to be found not in the work of a painter or sculptor but in that of a photographer, Robert Mapplethorpe. Like Cindy Sherman, Mapplethorpe succeeded in gaining full acceptance an an artistic creator, rather than being consigned to the ghetto generally reserved for practitioners of photography, however eminent (for some of the issues raised by photography in the context of late twentieth-century Modernism, see the introduction to this book). As skilled a player of the New York 'art game' as Warhol, who was one of his mentors, Mapplethorpe explored areas of sexuality, most of all those to do with sado-masochism, which had never previously been made a subject for art. He also flirted with racial taboos in the male nudes of his 'Black Males' series (Pl. 531), where the sitters are deliberately deprived of all personality, and are reduced to the status of purely sexual objects. Mapplethorpe used to boast that he had participated in every activity, however *outré*, seen represented in his photographs. He also used to boast that he had never received a really hostile review. Since he was absolutely certain of his own direction, the issue of censorship was of very little interest to him, and he would undoubtedly have regarded the great censorship controversy which surrounded his work after his death as an irrelevance (though perhaps a useful one, since he understood the value of notoriety). His status, both as a victim of censorship and as the best-known victim of AIDS in the American art world, has given his work overtones which Mapplethorpe himself never originally intended.

The linked issues of censorship and AIDS have between them given an entirely different colouring to the whole question of gay male sexuality and the sexual liberation of homosexual men. Since the beginning of the 1980s there has been a considerable output of art which is connected in one way or another

531

532

with the AIDS epidemic. I have already touched briefly on this topic when speaking of the work of the New York artists Robert Gober and Ross Bleckner (Pls. 353, 355-6). AIDS art is often much less about sexuality than about emotions of loss and rage. These were, for example the primary subject-matter of the best-known 'AIDS artist' of the 1980s, David Wojnarowicz, himself a victim of the disease. A work like *We are Born into a Preinvented Experience* (Pl. 534) contains nothing that is explicitly sexual. It takes the sexual context for granted, and directs its ire at the rotten state (as the painter sees it) of contemporary American society. *Why the Church can't/won't be Separated from the State* (Pl. 532) does have explicit imagery, but one has to look for it carefully – it forms part of an extremely elaborate amalgam of imagery and text. The density of Wojnarowicz's art has often been praised, but, despite the undoubted

533

passion it expresses, it is just this which leads one to doubt its effectiveness as propaganda. Other artists drawn into the controversy about the disease because they themselves were victims included two from Britain, though controversies there were, in general, less fierce than in the United States. Like Wojnarowicz, both were writers as well as painters. David Robilliard died too young to leave any very considerable body of work behind him. His paintings (Pl. 533) generally consist of brief gnomic statements, accompanied by deliberately rudimentary drawings. Their general theme is that of the dilemmas, particularly dilemmas of immediate choice, which confront victims of the disease. Derek Jarman was a much more conspicuously public figure than Robilliard, thanks rather more to his writing and to his activities as an experimental film director than to his work as a

534

535 John Boskovich, *Rude Awakening*, 1993
Installation at the Rosamund Felsen Gallery, Los Angeles, 16 October - 13 November 1993

536 Derek Jarman, *Blood*, 1992
Oil on photocopies on canvas, 251.5 × 179 cm (99 × 70½ in)

painter. He did, however begin his career as an artist – at one time, in the early 1960s, he was even considered a plausible rival to David Hockney – and he returned to painting at the end of his life. Far more than any other artist so far discussed here, with the exception of Wojnarowicz, Jarman was concerned to give a public face to the epidemic, and to protest about the treatment meted out to its victims. He was especially indignant about the attitudes of the tabloid press, and a number of his late paintings, such as *Blood* (Pl. 536), were painted over scare headlines found in mass-circulation British newspapers such as the *Sun*. This deliberate intensification of material already filled with rage and hysteria was intended to expose its innate absurdity as well as its innate mendacity. It is, however, doubtful whether it achieves its intended effect. Jarman simply seems to answer rage with rage.

This in general is true of AIDS art taken as a whole. John Boskovich's installation *Rude Awakening* (Pl. 535), with its phalanxes of cheap buddhas and feeding bottles in the shape of teddy bears, features a black and gold plaque whose wording is borrowed from the kind of advertisement male prostitutes insert in the *Advocate* and other homosexual journals. The message is one of which the Victorians would have approved: 'The wages of sin is death.'

The fact that twentieth-century art has come full circle from its beginnings, and has returned to the moralism which was one of the things which the Modern Movement originally tried to shake off, is nowhere better demonstrated than in what are now supposed to be its most radical manifestations, and most specifically perhaps in much feminist and gay art, which is *par excellence* an art dominated by content. Of the worthiness of the cause in each case one can have no doubt. Where the effectiveness of the expression is concerned it sometimes seems better to leave the question open. Will the 1990s be remembered as the decade in which the visual arts, for a while at least, ceased to be primarily visual?

535

Notes

Introduction (pp. 8-13)
1 Entry for Sherrie Levine (1947–) in *The Thames and Hudson Dictionary of Art and Artists*, revised, expanded and updated, London, 1994, pp. 213–14.

Pop and After (pp. 16-45)
1 *David Hockney*, by David Hockney, London, 1976, p. 97.

The Survival of Abstraction (pp. 48-73)
1 Dorothy Miller, ed., *Twelve Americans* (exh. cat.), Museum of Modern Art, New York, 1956, p. 53.

Land Art, Light and Space, Body Art (pp. 112-33)
1 Jan Butterfield, *The Art of Light and Space*, New York, 1993, p. 85.
2 Quoted by Butterfield, op. cit., p. 75.

Neo-Dada, Arte Povera & Installation (pp. 136-69)
1 Klein, quoted by Thomas McEvilley, in *Yves Klein: 1928-1962 – a Retrospective*, Houston and New York, 1982, p. 243.
2 Quoted by Heiner Stackelhaus, *Joseph Beuys*, New York, 1991, pp. 52-3.
3 Quoted in the article on Arte Povera in the *Oxford Companion to Twentieth-Century Art*, ed. Harold Osborne, Oxford, 1981.
4 Reprinted in Calvin Tomkins, *Post- to Neo-: The Art World of the 1980s*, New York, 1988, pp. 92-7.
5 Quoted by Marie Luise Syring, 'The Way of Transcendence: On the Temptation of St Anthony', in Marie Luise Syring, ed., *Bill Viola: Unseen Images* (exh. cat.), Städtische Kunsthalle, Düsseldorf, and Whitechapel Art Gallery, London, 1992, p. 21.
6 *Bill Viola: Unseen Images*, op. cit.
7 Lynn Cooke in 'Gary Hill: Beyond Babel', *Gary Hill* (exh. cat.), Stedelijk Museum, Amsterdam, and Kunsthalle, Vienna, 1993.

Neo-Expressionism (pp. 172-201)
1 Quoted in Thomas Krens, Michael Govan and Joseph Thompson, eds., *Refigured Painting: The German Image 1960-88*, New York, 1988, p. 254.
2 Elisabeth Frink in Edward Lucie-Smith and Elisabeth Frink, *Frink: a Portrait*, London, 1994, pp. 116-19.
3 Peter Fuller, catalogue essay for the Glynn Williams exhibition at the Piccadilly Festival and the Bernard Jacobson Gallery, London, May–July 1985, no pagination.
4 Musa Mayer, *Night Studio: a Memoir of Philip Guston*, New York, 1988, p. 170.
5 Donald Kuspit, *Leon Golub: Existential/Activist Painter*, New Brunswick, 1985, p. 6.

Realism in America (pp. 204-27)
1 Lisa Lyons and Martin Friedman, *Close Portraits*, Minneapolis, 1980, p. 30.
2 Op. cit., p. 34.
3 Interview with the artist in Linda Chase, *Ralph Goings*, New York, 1988, p. 22.
4 Linda Chase, op. cit., p. 22.
5 Kirk Varnedoe, *Duane Hanson*, New York, 1985, p. 29.
6 Quoted in *The Pre-Raphaelites* (exh. cat.), Tate Gallery, London, 7 March–28 May 1984, p. 175.

Post-Modernism and Neo-Classicism (pp. 230-51)
1 *Danish Painting: The Golden Age* (exh. cat.), National Gallery, London, 5 September–20 November 1984, p. 140.
2 John Wilmerding, *American Art*, Harmondsworth and New York, 1976, p. 100.
3 Italo Mussa, *Carlo Maria Mariani*, Rome, 1980, p. 39.
4 Quoted in Italo Mussa, op. cit., p. 106.
5 *Alberto Abate*, Milan, 1990, no pagination.
6 Quoted in *Mostra de Carracci* (exh. cat.), Palazzo dell'Archiginnasio, Bologna, September/October 1956, p. 212.

British Figurative Painting (pp. 254-77)
1 *Leonard McComb* (exh. cat.), Serpentine Gallery, London, October/November 1983, p. 66.

New Art in New York (pp. 302-29)
1 Quoted in Craig Castleman, *Getting Up: Subway Graffiti in New York*, New York, 1982, p. 137.
2 Robert Rosenblum in *The Jeff Koons Handbook*, London, 1992, p. 15.
3 Ibid., p. 17.
4 See Edward Lucie-Smith, *Art and Civilization*, London and New York, 1992, plate 1.10.
5 John Wilmerding, *American Art*, Harmondsworth and New York, 1976, p. 103.

Out of New York (pp. 332-57)
1 Annette Carolozzi, *Fifty Texas Artists*, San Francisco, 1986, p. 38.

Latin America (pp. 360-85)
1 Quoted in Edward Lucie-Smith, *Latin American Art of the 20th century*, London, 1993, p. 166.

Perestroika Art (pp. 388-97)
1 Matthew Cullerne Bown, *Contemporary Russian Art*, Oxford, 1989, p. 31.
2 Artist's statement in *The Quest for Self-Expression: Painting in Moscow and Leningrad, 1965-1990* (exh. cat.), Columbus Museum of Art, Columbus, Ohio, 1990, p. 108.
3 Matthew Cullerne Bown, op. cit., pp. 78-81.

The Far East (pp. 400-21)
1 *Against Nature: Japanese Art in the Eighties* (exh. cat.), Grey Art Gallery & Study Center, New York University, New York, 1989, p. 81.
2 *China Avant-Garde* (exh. cat.), Haus der Kulturen der Welt, Berlin, 1993, p. 155.
3 Jaya Appasamy, *Abanindranath Tagore and the Art of his Times*, Delhi, 1968.

African and Afro-Caribbean Art (pp. 424-33)
1 Quoted by Marshall Ward Mount, *African Art: The Years since 1920*, Indiana University Press, 1973, p. 36.
2 Jan Hoet, in *Africa Now: the Jean Pigozzi Collection*, Gröningen, 1991, p. 29.
3 Petrine Archer-Straw, *Home and Away: Seven Jamaican Artists*, London, 1994, p. 14.
4 Petrine Archer-Straw, op. cit., p. 10.

Racial Minorities (pp. 436-57)
1 Petrine Archer-Straw, op. cit., p. 30.

Feminist and Gay (pp. 460-79)
1 Karen Woodley, in *Artrage*, no. 9/10, 1985.
2 Lucy R. Lippard, Foreword to Mary Kelly, *Post Partum Document*, London, 1983, p. x.

Artists' Biographies

The brief biographies of the artists illustrated in this book given here are not intended to be complete. Their purpose is to offer the reader a guide to further research. Wherever possible each biography includes the following information: the artist's date and place of birth, current place of residence, and artistic education, together with indications of one or two solo exhibitions, recent ones wherever possible. To these are added one or several publications – books, exhibition catalogues, or, failing these, articles in magazines giving an assessment of the artist's work. These publications are usually in English, but useful items in other languages – French, German, Spanish and Italian and Portuguese – have not been excluded, especially if they are well illustrated. In some cases, however, it has been impossible to find personal and other details about the artists included in the book.

Abate, Alberto Italian Post-Modern figurative painter, b. 1946, Rome. Lives in Rome
Solo exh.: 1984, XLI Venice Biennale; 1988, Centro Culturale 'Ausoni', Rome
Lit.: *Alberto Abate*, Milan, 1990
Photo: the artist

Ackling, Roger British Conceptual artist, b. 1947, Isleworth, London
Solo exh.: see Lit.
Lit.: *From Art to Archaeology* (exh. cat.), South Bank Centre, London 1991
Roger Ackling: Flooded Margins (exh. cat.), Annely Juda Fine Art, London, 1994
Photo: Annely Juda Fine Art, London

Adu, Osi African painter
Photo: Visual Arts Library

African (Robert Cookthorne) Jamaican painter, b. 1960, Kingston, Jamaica. Lives and works in Kingston. Educ. 1983 (graduated) the Jamaica School of Art (since 1987, the Edna Manley School of the Visual Arts), where he now teaches
Solo exh.: 1985, Suti Gallery, Bern; 1990, Suti Gallery, Bern
Photo: October Gallery, London

Ahearn, John American Realist sculptor, b. 1951, Binghampton, NY. Lives in NY. Educ. 1973, BFA, Cornell University, Ithaca, NY
Solo exh.: 1979, Fashion Moda, NY; 1990, Nelson Atkins Museum of Art, Kansas City
Lit.: *South Bronx Hall of Fame: Sculpture by John Ahearn and Rigoberto Torres* (exh. cat.), Contemporary Arts Museum, Houston, 1991
Photo: Brooke Alexander, NY

Aksel, Erdag Turkish sculptor, b. 1953, Izmir, Turkey. Lives in Ankara. Educ. 1977-9 West Virginia University (BFA and MA); 1985, Dokuz Eyuk University, Izmir (Social Sciences Institute). Associate Professor of Art at Bilkent Uiversity, Ankara
Solo exh. in Morganstown, West Virginia, Izmir and Ankara. Represented Turkey in the 1993 Venice Biennale
Lit.: *Erdag Aksel, Works*, Ankara, Turkey, 1993
Photo: the artist

Alexander British sculptor, painter and holographer, b. 1927, London. Lives in Santa Monica. Educ. St Martin's School of Art, London
Solo exh.: 1990 (retrospective), Modern Museum of Art, Santa Ana, CA; 1991, National Art Museum, Seoul, Korea
Lit.: Lucie-Smith, Edward, *Alexander*, London, 1992
Photo: the artist

Alexander, Peter American sculptor and painter, b. 1939, Los Angeles. Lives in Malibu, CA. Educ. 1957-60, University of Pennsylvania, Philadelphia; 1960-2, University of London, England; 1962-3, University of Southern California, Los Angeles; 1965, University of California, Los Angeles
Numerous solo exh. in commercial galleries
Lit.: Schipper, Merle, 'Sunsets and Velvets: a Ten Year Survey', *Images and Issues*, nos. 7-8, 1983
Photo: the artist

Amaral, Jim (John James) American-Columbian painter, b. 1933, California. Lives in Bogota, Colombia. Educ. 1954, BFA, University of Stanford; 1954, post-graduate work, Cranbrook Academy of Art. 1958, Married Olga Ceballos and settled in Colombia. 1967, Professor of Drawing at the University of Bogota
Numerous solo exh. in galleries in Colombia and the United States
Lit.: Mallarino de Rueda, Sylvia, *Arte Colombiano en el Siglo XX*, Bogota, 1987
Photo: the artist

Amaral, Olga Ceballos de Colombian tapestry weaver, b. 1932, Bogota. Lives in Bogota. Educ. 1951-2, Colegio Mayor de Cundinamarca; 1954-5, studied textiles at Cranbrook Academy of Art. 1958, married Jim Amaral. 1966, Director of the tapestry and weaving course at the Universidad de los Andes, Bogota. 1971, opened a gallery-workshop in Bogota for tapestry and exhibition of the work of other weavers
Numerous solo exh. in Colombia and the United States
Lit.: Larsen, Jack Lenor, *Olga de Amaral: Tapestries from the 'Moonbasket' and 'Montaña' Series* (exh. cat.), Louise Allrich Gallery, San Francisco, 1989
Photo: the artist

Andre, Carl American Minimal sculptor, b. 1935, Quincy, MA. Lives in NY. Educ. working with other artists, notably Frank Stella
Solo exh. (selected): 1968, Städtisches Museum, Mönchengladbach; 1969, Haags Gemeentemuseum, The Hague; 1970, Solomon R. Guggenheim Museum, NY; 1971, St Louis Art Museum; 1973, Museum of Modern Art, NY; 1975, Kunsthalle, Berne; 1988, Palacio de Cristal, Madrid
Lit.: Andre, Carl and Hollis Frampton, *12 Dialogues 1962-1963*, Halifax, Nova Scotia, 1981
Bourdon, David, *Carl Andre, Sculpture, 1959-1977* (exh. cat.), Laguna Gloria Art Museum, Austin, Texas, 1978
Photo: Paula Cooper Gallery, NY

Andrejevic, Milet 1925-89, Jugoslav-American Post-modern figurative painter, b. Petrovgrad, Yugoslavia, d. NY. Educ. 1940-4, School of Applied Arts, Belgrade; 1944-51, Academy of Fine Arts, Belgrade
Solo exh.: 1980, Robert Schoelkopf Gallery, NY
Lit.: Campbell, Lawrence, 'Milet Andrejevic', *Art in America*, December 1988, pp. 149-50
Photo: Visual Arts Library

Antrim, Craig American painter, b. 1941, Pasadena. Lives in Los Angeles. Educ. 1965, BFA, University of California, Santa Barbara; 1970, MFA, Claremont Graduate School. Numerous teaching posts in California
Solo exh.: 1981, Laguna Beach School of Art, CA; 1981, Saddleback College, Mission Viejo, CA; 1986, California School of Art, Bakersfield, CA
Lit.: Dillenberger, John, *The Visual Arts and Christianity in America*, NY, 1988
Photo: the artist

Aponovich, James American still-life painter, b. 1948, Nashua, New Hampshire. Lives in New Hampshire. Educ. 1971, University of New Hampshire
Solo exh.: 1979, Currier Gallery of Art, Manchester, NH; 1982, St Anselm's College, Manchester, NH
Lit.: Gardner, Christine, 'James Aponovich', *American Artist*, vol. 49, November 1985, pp. 60-5
Photo: Tatistcheff Gallery, NY

Appel, Karel Dutch-American painter and sculptor, b. 1921, Amsterdam. Lives in NY. Educ. 1940-3, Royal Academy of Fine Arts, Amsterdam
Solo exh. (selected): 1985, Florence, Palazzo Medici; 1985, Kunstmuseum, Bonn
Lit.: Frankenstein, Alfred, *Karel Appel: The Art of Style and the Styles of Art*, NY, 1980
Restany, Pierre, *Street Art: le second souffle de Karel Appel*, Paris, 1982
Photo: Marisa del Re Gallery, NY

Applebroog, Ida American painter, b. 1929, Bronx, NY. Lives in NY. Educ. 1948-50, New York State Institute of Applied Arts and Sciences; 1965-8, Art Institute of Chicago
Solo exh.: 1978, Whitney Museum of American Art, NY; 1987, Chrysler Museum, Norfolk, VA; 1990, Contemporary Art Museum, Houston
Lit.: *Ida Applebroog: Happy Families, a Fifteen-Year Survey* (exh. cat.), Contemporary Arts Museum, Houston, 1990
Photo: Ronald Feldman Fine Art, NY

Arango, Ramiro Colombian painter, b. 1946
Lit.: Lucie-Smith, Edward, *Latin American Art of the 20th Century*, London, 1993
Photo: the artist

Arakawa Shusaku Japanese painter, printmaker and Conceptual artist, b. 1936. Lives in NY
Solo exh.: 1975, Henie Onstad Museum, Oslo; 1977, Städtische Kunsthalle, Düsseldorf; 1979, Minneapolis Institute of Arts; 1983, Wadsworth Atheneum, Hartford, Conn.; 1984, Aldrich Museum of Contemporary Art, Ridgefield, Conn.; 1987, Seibu Museum, Tokyo; 1989-90, William College Museum, Williamstown, Mass., touring to Touko Museum of Contemporary Art, Japan, and Joseloff Gallery, University of Hartford, Conn.
Lit.: *Arakawa* (exh. cat.). Städtische Kunsthalle, Düsseldorf, 1977
Arakawa and Madeline H. Gins, *The Mechanism of Meaning: Work in Progress (1963-1971, 1978) Based on the Method of Arakawa*, NY, 1979
Photo: Ronald Feldman Fine Art, NY

Arita, Akira Japanese painter and draughtsman, b. 1947, Osaka. Lives in the USA
Exh.: 1980-1, *American Drawings in Black and White, 1970-1980*, Brooklyn Musem, NY
Photo: Fuji Television Gallery, Tokyo

Armajani, Siah Iranian-American sculptor, b. Tehran, 1939. Educ. 1963, BA, Macalester College, St Paul, Minnesota
Solo exh.: 1985, Institute of Contemporary Art, Philadelphia; 1987, Kunsthalle, Basle and Stedelijk Museum, Amsterdam; 1988, List Visual Arts Center, Massachusetts Institute of Technology, Cambridge, Mass.; and see Lit.
Lit.: *Siah Armajani* (exh. cat.), Kunsthalle, Basle/Stedelijk Museum, Amsterdam, 1987
Photo: Max Protetch Gallery, NY

Arman French-American maker of assemblages, b. 1928, Nice, France. Now US citizen, lives NY. Educ. École Nationale des Arts Décoratifs, Paris; Ecole du Louvre
Numerous solo exh. including 1982, Kunstmuseum, Hanover; 1988, Musée des Beaux Arts, Nîmes
Lit.: *Arman 1955-1991: a Retrospective* (exh. cat.), Houston Museum of Fine Arts, 1991
Kuspit, Donald, *Arman. Monochrome Accumulations 1986-1989*, Catalogue Raisonné, Stockholm, 1990
Lamarche-Vadel, *Arman*, NY, 1990
Marck, Jan van der, *Arman*, NY, 1984
Martin, Henry, *Arman*, NY, 1973
Photo: Marisa del Re Gallery, NY

Arneson, Robert American sculptor, 1930-92, b. Benicia, CA. Educ. 1952-4, California College of Arts and Crafts; 1957-8, Mills College, Oakland
Solo exh.: see Lit.
Lit.: Foley, Suzanne, and Stephen Prokopoff, *Robert Arneson* (exh. cat.), Museum of Contemporary Art, Chicago, 1974
Photo: Frumkin/Adams Gallery, NY

Arnoldi, Charles American painter and sculptor, b. 1946, Dayton, Ohio. Lives in Los Angeles. Educ. 1968, Chouinard Art Institute, Los Angeles
Solo exh.: 1988, Museo Italo Americana, San Francisco
Lit.: *Jan Butterfield, Charles Arnoldi, Laddie John Dill* (exh. cat.), California State University, Fullerton, 1983
Livingston, Jane, *Charles Arnoldi/A Survey 1971-1986* (exh. cat.), Art Club of Chicago, 1986
Wilder, Nick, *The Recent Paintings of Charles Arnoldi* (exh. cat.), University of Missouri/Kansas City Art Gallery, 1987
Photo: the artist

Art & Language British Conceptual art group, which came into being with the founding of the Art & Language Press in 1968, and the publication of the first issue of the journal *Art-Language* in 1969
Lit.: Harrison, Charles, *Essays on Art & Language*, Oxford, 1991
Photo: Marian Goodman Gallery, NY

Artschwager, Richard American sculptor, b. 1923, Washington, DC. Lives in Brooklyn, NY. Educ. Cornell University; also studied with Amédée Ozenfant
Solo exh.: see Lit.
Lit.: *Artschwager* (exh. cat.), Centre Georges Pompidou, Paris, 1989
Richard Artschwager (exh. cat.), Kunsthalle, Basle, 1985
Richard Artschwager (exh. cat.), Whitney Museum of American Art, NY, 1988
Photo: Leo Castelli Gallery, NY

Atkinson, Conrad British Conceptual artist, b. 1940, Cumbria. Lives in London. Educ. 1961, Liverpool College of Art; 1965, Royal College of Art, London; 1967, Manchester College of Art
Solo exh.: 1981, Institute of Contemporary Art, London
Lit.: Nairne, Sandy, and Caroline Tisdall, eds., *Conrad Atkinson: Picturing the System*, London, 1981
Photo: Ronald Feldman Fine Arts, NY

Auerbach, Frank British 'School of London' painter, b. 1931, Germany, British citizen. Lives in London. Educ. 1948-52, St Martin's School of Art, London; 1952-5, Royal College of Art, London
Solo exh.: 1986, British Pavilion, XLII Venice Biennale; 1989, Rijksmuseum Vincent Van Gogh, Amsterdam
Lit.: Hughes, Robert, *Frank Auerbach*, London, 1990
Photo: Marlborough Fine Art (London) Ltd

Azaceta, Luis Cruz Cuban-American Neo-Expressionist painter, b. 1942, Mariano, Cuba, US citizen 1967. Lives in New Orleans. Educ. 1969, School of Visual Arts, NY
Solo exh.: see Lit.
Lit.: *Luis Cruz Azaceta* (exh. cat.), Galeria Ramis Barquet, Monterrey, Mexico, 1993
HELL: Luis Cruz Azaceta: Selected Works from 1978-93 (exh. cat.), The Alternative Museum, NY, 1994
Photo: Frumkin/Adams Gallery, NY

Bacon, Francis British 'School of London' painter, 1910-92, b. Dublin, d. Madrid. Self-taught
Solo exh. (retrospectives): 1962, Tate Gallery, London; 1971, Grand Palais, Paris
Lit.: Gowing, Lawrence, and Sam Hunter, *Francis Bacon*, London, 1989
Russell, John, *Francis Bacon*, NY, 1971
Photo: Marlborough Fine Art (London) Ltd

Baechler, Donald American painter, b. 1956, Hartford, Conn. Educ. 1974-7, Maryland Institute, Baltimore; 1977-8, Cooper Union, NY; 1978-9, Hochschule für Bildende Kunst, Frankfurt
Exh.: 1989, Whitney Biennale, Whitney Museum of American Art, NY
Lit.: Ellis, Stephen, 'Donald Baechler', *Art in America*, vol. 77, June 1989
Photo: Tony Shafrazi Gallery, NY

Bailey, William American Realist painter, b. 1930, Council Bluffs, Iowa. Lives in New Haven, Conn. Educ. 1951, University of Kansas School of Fine Arts; 1955, Yale University, New Haven
Solo exh.: 1988, Rhode Island School of Design
Lit.: Strand, Mark, *William Bailey*, NY, 1987
Photo: André Emmerich Gallery, NY

Baldessari, John American Conceptual artist, b. 1931, National City, California. Lives in Santa Monica, CA. Educ. 1953, San Diego State College; 1954-5, University of California, Berkeley; 1955, University of California, Los Angeles; 1957-9, Otis Art Institute, Los Angeles
Solo exh.: 1989, touring retrospective
initiated by the Museum of Contemporary Art, Los Angeles
Lit.: *John Baldessari* (exh. cat.), Santa Barbara Museum of Art, 1986
Photo: Margo Leavin Gallery, Los Angeles

Barry, Judith American video artist, b. Columbus, Ohio. Lives in NY. Educ. 1986, MA in Communication Arts, Computer Graphics, NY Institute of Technology
Solo exh. and screenings: 1991, Institute of Contemporary Art, London; 1992, Fondation pour l'architecture, Brussels, travelled to Musée des Beaux-Arts, Dunkirk, and Palais Jacques Coeur, Bourges; 1992, de Appel, Amsterdam; 1993, MOPT, Madrid; 1993, Presentation House, Vancouver
Lit.: Barry, Judith, and Brad Miskett, *Rouen: Touring Machines/Intermittent Futures* (exh. cat.), Rouen, 1993
Barry, Judith, *Public Fantasy. An Anthology of Critical Essays, Fictions and Project Descriptions by Judith Barry* (exh. cat.), ICA, London, 1991
Photo: Nicole Klagsburn, NY

Bartlett, Jennifer American painter, environmental artist, b, 1941, Long Beach, CA. Lives in NY. Educ. 1963, Mills College, Oakland; 1964-5, Yale University
Solo exh.: 1986, Cleveland Museum of Art
Lit.: Russell, John, Jennifer Bartlett, *In the Garden*, New York, 1982
Jennifer Bartlett (exh. cat.), Walker Art Center, Minneapolis, 1985
Photo: Paula Cooper Gallery, NY

Barton, Glenys British ceramic sculptor, b. 1944, Stoke-on-Trent. Lives in Essex. Educ. 1968-71, Royal College of Art, London
Solo exh.: 1976, Princessehof Museum, Leeuwarden, Holland
Lit.: *Glenys Barton: Artists and Green Warriors* (exh. cat.), Flowers East Gallery, London, 1990
Photo: Flowers East, London

Baselitz, Georg German Neo-Expressionist painter and sculptor, b. 1938 (Georg Dern), in Deutschbaselitz, Saxony. Lives in Derneberg, Lower Saxony. Educ. 1956-7, Kunstakademie, East Berlin; 1957-64, Akademie der Künste, West Berlin
Solo exh.: see Lit.
Lit.: Franzke, Andreas, *Georg Baselitz*, Munich, 1989
Georg Baselitz, Cologne, 1990
Gohr, Siegfried, *Georg Baselitz Respecktive* (exh. cat.), Kunsthalle der Hypo-Kulturstiftung, Munich, 1992
Szeeman, Harald, *Georg Baselitz* (exh. cat.), Kunsthaus, Zurich, 1990
Photo: Michael Werner Gallery, NY and Cologne

Basquiat, Jean-Michel African-American painter, 1960-88, b. NY, d. NY. Self-taught
Solo exh. (retrospective): see Lit.
Lit.: Marshall, Richard, *Jean-Michel Basquiat* (exh. cat.), Whitney Museum of American Art, NY, 1992
Photo: Robert Miller Gallery, NY

Bates, David American painter, b. 1952, Dallas. Lives in NY. Educ. 1976-7, Southern Methodist University, Dallas
Solo exh.: 1988, touring retrospective
organized by the Fort Worth Museum of Art, Texas
Lit.: Carlozzi, Annette, *50 Texas Artists*, San Francisco, 1986
Photo: Arthur Roger Gallery, New Orleans

Bawa, Manjit Indian painter, b. 1941, Dhuri, Punjab. Lives in Delhi. Educ. College of Art Delhi; London College of Printing, Warden, Essex, England. 1967-71, worked as a silk-screen printer in London. 1972, returned to Delhi
Solo exh.: 1972, India Fine Arts and Crafts Society, Delhi; 1979, Dhoomi Mal Gallery, Delhi
Lit.: *Contemporary Indian Art, from the Chester and Davida Herwitz Family Collection* (exh. cat.), Grey Art Gallery and Study Center, NY University, NY, 1986
Photo: Daniel Herwitz Collection, West Hollywood

Baykam, Bedri Turkish painter and environmental artist, b. 1957, Ankara, Turkey. Lives in Istanbul and Paris. Educ. 1977-9, Sorbonne, Paris; 1980-3, California College of Arts and Crafts, Oakland. Lived in California, 1980-7
Solo exh.: 1994, Ataturk Cultural Center, Istanbul
Lit.: Bedri Baykam, *Livart, ...* (exh. cat.), Galerie Lavignes-Bastille, Paris, 1994
Photo: the artist

Beal, Jack American Realist painter, b. 1931, Richmond, VA. Lives Oneonta, NY. Educ. 1950-3, Norfolk Division, College of William and Mary – Virginia Polytechnic Institute; 1953-6, Art Institute of Chicago
Solo exh.: 1973-4, Ten-Year Retrospective, Boston University, Virginia Museum of Fine Arts and Museum of Contemporary Art, Chicago
Lit.: Shanes, Eric, *Jack Beal*, NY, 1993
Photo: Frumkin Adams Gallery, NY

Bearden, Romare African-American artist, 1914-88, b. Charlotte, NC. Educ. 1936-7, Art Students League, NY, under Georg Grosz; 1943, studied advanced mathematics at Columbia University, NY; 1951, studied philosophy and art history at the Sorbonne, Paris
Solo exh. (retrospective): see Lit.
Lit.: *Memory and Metaphor: the Art of Romare Bearden, 1940-1987* (exh. cat.), Studio Museum in Harlem, NY, 1991
Schwartzman, Myron, *Romare Bearden: His Life and Art*, NY, 1990
Photo: Visual Arts Library

Beauchamp, Robert American Neo-Expressionist painter, b. 1923, Denver, Colorado. Lives in NY. Educ. 1949, Cranbrook Academy of Art; also studied at the Hans Hofmann School of Art, NY
Solo exh.: 1974, University of South Florida, Tampa
Lit.: Glueck, Grace, 'Robert Beauchamp', *NY Times*, October 1979
Photo: M-13 Gallery, NY

Beckman, William American Realist painter, b. 1942, Maynard, Minn. Educ.1962-6, St Cloud State University, Minn.; 1966-8, University of Iowa, Iowa City
Exh.: see Lit.
Lit.: *William Beckman; Gregory Gillespie* (exh. cat.), Rose Art Museum, Waltham, Mass., 1984
Hunter-Stiebel, Penelope, *William Beckman: Dossier of a Classical Woman* (exh. cat.), Stiebel Modern, NY, 1991
Photo: Forum Gallery, NY

Bell, Charles Super Realist painter, b. 1935, Tulsa, Oklahoma. Educ. University of Oklahoma, Norman
Solo exh.: 1991-2, Museum of Art, Fort Lauderdale
Lit.: Geldzahler, Henry, *Charles Bell: the Complete Works, 1970-1990*, NY, 1991
Photo: Louis K. Meisel Gallery, NY

Bellany, John Scottish Neo-Expressionist painter, b. 1942, Port Seton, Scotland. Lives in Cambridgeshire, London and Edinburgh. Educ. 1960-5, Edinburgh College of Art; 1965-8, Royal College of Art, London
Solo exh.: 1983-4 (touring retrospective), Ikon Gallery, Birmingham; Graves Art Gallery, Sheffield; Third Eye Centre, Glasgow; Rochdale Art Gallery; Hatton Gallery, Newcastle-upon-Tyne; Walker Art Gallery, Liverpool; Maclaurin Art Gallery, Ayr (and see Lit.); 1986, National Portrait Gallery, London
Lit.: *John Bellany: Paintings, Watercolours and Drawings 1964-86* (exh. cat.), National Gallery of Modern Art, Edinburgh, 1986
Photo: Flowers East Gallery, London

Bennett, Gordon Australian painter of partly European and partly Australian aboriginal origin, b. 1955, Monto, Queensland. Lives in Brisbane. Educ. Brisbane Institute of Art; 1986-8, Queensland College of Art
Exh.: 1994, Adelaide Biennale; 1993, 9th Sydney Biennale, Art Gallery of New South Wales
Lit.: Lingard, Bob, and Fazal Rizvi, '(Re)membering, (Dis)membering: "Aboriginality" and the Art of Gordon Bennett', *Third Text*, no. 26, spring 1994
Photo: Bellas Gallery Brisbane and Sutton Gallery, Melbourne

Benton, Fletcher American abstract sculptor, b. 1931, Jackson, Ohio. Educ. 1956, University of Miami, Ohio
Numerous solo exh. with John Berggruen Gallery, San Francisco
Lit.: Lucie-Smith, Edward, *Fletcher Benton*, NY, 1990
Photo: the artist

Berkhout, Rudie Dutch-American holographer, b. 1946, Amsterdam. Lives in NY. Educ. studied holography at the NY School of Holography, NY Art Alliance Inc., and also at Brown University, Providence
Solo exh.: Museum of Holography, NY
Lit.: Lucie-Smith, Edward, *Art in the Seventies*, Oxford, 1980
Photo: the artist

Berlant, Tony American maker of assemblages, b. 1941, NY. Lives in Los Angeles. Educ. University of California, Los Angeles
Solo exh.: 1978 and 1984, Newport Harbor Art Museum
Lit.: *Tony Berlant, New Work 1990-3* (exh. cat.), L. A. Louver Gallery, Venice, CA, 1993
Photo: L. A. Louver Gallery, Venice, CA

Berni, Antonio Argentinian painter and maker of assemblages, b. 1905, Rosario, Argentina, d. 1981, Buenos Aires. Son of an immigrant Italian tailor; employed in a glass workshop while studying drawing and painting at the Catalonian Centre in Rosario. Educ. 1925, André Lhote's School in Paris and the Grande Chaumière under Othon Friesz. Returned to Rosario, 1930
Solo exh.: 1984 (posthumous), Museo Nacional de Bellas Artes, Buenos Aires
Lit.: *Antonio Berni: Obra Pictorica, 1922-1981* (exh. cat.), Museo Nacional de Bellas Artes, Buenos Aires
Photo: Ruth Benzacar Galeria de Arte, Buenos Aires

Berredo, Hilton Brazilian painter, b. 1954, Rio de Janeiro
Has represented Brazil in exh. abroad, including 1988, Musée d'Art Moderne de la Ville de Paris; 1986, Hara Museum, Tokyo
Lit.: *Modernidade: art brésilien du 20e siècle* (exh. cat.), Musée d'Art Moderne de la Ville de Paris, 1987
Photo: Museum of Modern Art, Rio de Janeiro

Berrocal, Miguel Spanish sculptor, b. 1933, Algaidas, nr. Malaga. Lives at Crespières, nr. Paris, and in Verona, Italy. Educ. Accademia de San Fernando, Madrid
Solo exh.: 1968, Badisches Kunstverein, Karlsruhe; 1968, Palais des Beaux-Arts, Brussels; 1985, Palacio de Velásquez, Madrid
Lit.: 'Berrocal', *L'Oeil*, no. 368, March 1986
Figuerola-Ferretti, Luis, 'Berrocal', *Goya*, no. 184, January/February 1985
Dietrich, Barbara, 'Berrocal', *Das Kunstwerk*, vol. 38, February 1985
Photo: Rolly Michaux Galleries Ltd, Boston

Beuys, Joseph 1921-86, German sculptor and performance artist, b. Krefeld, d. Düsseldorf. Educ. 1947-51, Staatliche Kunstakedemie, Düsseldorf
Solo exh.: see Lit.
Lit.: Borer, Alain, et al., *Joseph Beuys* (exh. cat.), Kunsthaus, Zurich; Museo Nacional Centro de Arte Reina Sofia, Madrid; and the Centre Georges Pompidou, Paris, 1993-4
Stackelhaus, Heiner, *Joseph Beuys*, NY, 1991
Temkin, Ann and Bernice Rose, *Thinking is Form: The Drawings of Joseph Beuys*, London, 1992
Tisdall, Caroline, *Joseph Beuys* (exh. cat.), Guggenheim Museum, NY, 1979
Zweite, Armin, *Joseph Beuys: Natur Materie Form*, Munich, 1992
Photo: Ronald Feldman Fine Arts, NY

Bevan, Tony British figurative painter, b. 1951, Bradford. Educ. 1968-71, Bradford School of Art; 1971-4, Goldsmiths College, London; 1974-6, Slade School of Art, London
Solo exh.: 1987-8, Institute of Contemporary Arts, London, touring to Orchard Gallery, Derry; Kettles Yard, Cambridge; Cartwright Hall, Bradford
Lit.: Cameron, Dan, *Tony Bevan* (exh. cat.), L. A. Louver Gallery, NY, 1991
Photo: L.A. Louver Gallery, Venice, CA

Bhattacharjee, Bikash Indian painter, b. 1940, Calcutta. Lives in Calcutta. Educ. 1963 (diploma in fine arts), India College of Arts and Draughtsmanship, Calcutta. 1968-73, taught at the India College of Arts and Draughtsmanship. 1973 to date, faculty member of the Government College of Arts and Crafts, Calcutta.
Lit.: *Contemporary Indian Art, from the Chester and Davida Herwitz Family Collection* (exh. cat.), Grey Art Gallery and Study Center, NY University, NY, 1986
Photo: Daniel Herwitz Collection, West Hollywood

Bickerton, Ashley American Conceptual artist, b. 1959. Lives in NY. Educ. 1982, California Institute of the Arts; 1985, Whitney Museum Independent Studies Program
Solo exh.: 1993, La Jolla Gallery; 1993, Quint Krichman Projects, San Diego
Lit.: Armstrong, Richard, *Mind over Matter: Concept and Object* (exh. cat.), Whitney Museum of American Art, NY, 1986
Photo: Saatchi Collection, London

Birmelin, Robert American Realist painter, b. 1933, Newark, NJ. Lives in Leonia, NJ. Educ. 1956, Cooper Union, NY; 1960, Yale University
Solo exh.: 1991, Morris Museum, Morristown, NJ
Lit.: Berlind, Robert, 'From the Corner of the Mind's Eye: the Paintings of Robert Birmelin', *Art in America*, March 1991
Photo: Claude Bernard Gallery, NY

Birnbaum, Dara American video artist. Educ. 1969, BArch, Carnegie Mellon University, Pittsburgh; 1973, BFA Painting, San Francisco Art Institute; 1976, Certificate in Video/Electronic Editing, New School for Social Research, NY
Solo exh. and screening: 1993, CAPC Musée d'Art Contemporain Entrepôt, Bordeaux
Lit.: Hall, Doug, and Sally Jo Fifer, eds., *Illuminating Video: an Essential Guide to Video Art*, NY and Berkeley, 1990
Photo: Paula Cooper Gallery, NY

Bleckner, Ross American painter, b. 1949, NY. Lives in NY. Educ. 1971, NY University; 1973, California Institute of Fine Arts
Solo exh.: see Lit.
Lit.: *Ross Bleckner* (exh. cat.), Kunsthalle, Zurich, 1990
Photo: Mary Boone Gallery, NY

Bloom, Barbara American maker of environments and installations, b. 1951, Los Angeles
Exh.: 1992, Carnegie Museum of Art, Pittsburgh
Lit.: Mifflin, Margot, 'Barbara Bloom, My Work is More like a Movie Set', *ArtNews*, February 1993
Photo: Jay Gorney Modern Art, NY

Boetti, Alighiero E Conceptual and 'Arte Povera' artist, 1940-94
Included in numerous survey exh. of Arte Povera. Grand Prix for Sculpture, XLIV Venice Biennale, 1990. Major retrospective 1993, Kunstmuseum, Lucerne
Lit.: Boatto, A., *Alighiero E Boetti*, Ravenna, 1984
Photo: Salvatore Ala Gallery, NY

Bonevardi, Marcello Argentinian painter, b. 1929, Buenos Aires. Lives in NY. Educ. 1948-51, University of Cordoba, Argentina
Solo exh.: 1979, Galeria del Retiro, Buenos Aires
Lit.: *Three Artists from Argentina* (exh. cat.), Hara Museum of Contemporary Art, Tokyo, 1982
Photo: Bonino Gallery, NY

Bong, Tae-Kim Korean painter and printmaker, b. 1937. Educ. College of the Fine Arts, Seoul National University, BFA 1961; Otis Art Institute, Los Angeles, 1961-6, BFA and MFA
Solo exh.: 1973, Pacific Culture Asia Museum, Pasadena, CA; 1992, Donga Museum, Puchun, Korea; 1993, Gong Pyung Art Centre, Seoul, Korea
Lit.: Sung, Rok Suh, 'Taste of Ancient Tales & Profundity: On the Nonorientable of the Work of Bong, Tae-Kim', *Art in Korea*, 15 November 1993
Photo: the artist

Booth, Chris New Zealand site-specific sculptor, b. 1948, Kawakawa, Bay of Islands, New Zealand. Lives and works in Ker Keri, New Zealand. Educ. 1967-8, School of Fine Arts, University of Canterbury, Christchurch; 1968-70, studied in England and Italy
Solo exh.: 1989, Robert McDougall Art Gallery, Christchurch; 1992, Reyburn House, Whangarei
Lit: *Chris Booth: Sculpture*, Auckland, 1993
Photo: the artist

Borges, Jacobo Venezuelan painter, b. 1931, Caracas. Lives in NY and Caracas. Educ. 1949-51, Escuela de Artes Plásticas Cristobal Rojas, Caracas. 1952, received a bursary which allowed him to study in Europe
Solo exh.: 1987 (touring), Museo de Monterrey, Mexico; Museo de Arte Contemporáneo Rufino Tamayo, Mexico City; Staatliche Kunsthalle, Berlin; Muso de Arte Moderna, Bogotá; Museo de Arte Contemporáneo, Caracas
Lit.: Ashton, Dore, *Jacobo Borges*, Caracas, 1982
Photo: CDS Gallery, NY

Borofsky, Jonathan American sculptor and maker of environments, b. 1942, Boston, Mass. Educ. 1964, Carnegie Mellon University; 1966, Yale University.
Solo exh.: 1981, Contemporary Arts Museum, Houston; 1984, Philadelphia Museum of Art
Lit.: Springfeldt, Bjorn, *Jonathan Borofsky* (exh. cat.), Moderna Museet, Stockholm, 1984
Photo: Paula Cooper Gallery, NY

Boshier, Derek British Pop artist, b, 1937, Portsmouth. Educ. Yeovil School of Art; Royal College of Art, London
Solo exh.: 1973, Whitechapel Art Gallery, London, and see Lit.; 1981, Contemporary Arts Museum, Houston
Lit.: *Derek Boshier: Texas Works* (exh. cat.), Institute of Contemporary Arts, London, 1982
Photo: the artist

Boskovich, John American environmental artist, b. 1956, San Pedro, CA. Lives in Long Beach, CA. Educ. 1980, California State University, Long Beach
Exh.: 1982, Mills House Arts Complex, CA; Los Angeles County Museum; Orange County Center for Contemporary Art, Santa Ana, CA
Photo: the artist and Rosamund Felsen Gallery, Los Angeles

Botero, Fernando Colombian painter, b. 1932, Medellin. Lives in NY and Paris. Educ. 1953, Academía de San Fernando, Madrid; 1954, Prado Museum, Madrid
Numerous solo exh., including *Botero: Antologica 1949-1991*, Palazzo delle Exposizioni, Rome, 1991
Lit.: Ratcliff, Carter, *Botero*, NY, 1980
Spies, Werner, *Fernando Botero: Paintings and Drawings*, Munich, 1992
Photo: Nohra Haime Gallery, NY

Bourgeois, Douglas American painter, b. 1951, Gonzalez, Louisiana. Educ. Louisiana State University, Baton Rouge
Solo exh.: 1983, Southeastern Center for Contemporary Art, Winston-Salem, NC; 1984, Fine Arts Museum of the South, Mobile, Alabama
Photo: Arthur Roger Gallery, New Orleans

Bourgeois, Louise Franco-American sculptor, b. 1911, Paris. US citizen. Lives in NY. Educ. 1932-5, Sorbonne, Paris; 1936-7, École du Louvre; 1936-8, Académie des Beaux-Arts, Paris
Solo exh.: see Lit.
Lit.: *Louise Bourgeois* (exh. cat), Serpentine Gallery, London, 1985
Louise Bourgeois (exh. cat.), Rijksmuseum Kröller-Müller, Otterlo, 1991
Wye, Deborah, *Louise Bourgeois* (exh. cat.), Museum of Modern Art, NY, 1983
Photo: Robert Miller Gallery, NY

Boyce, Sonia British Afro-Caribbean artist, b. 1962, London. Lives in London. Educ. 1980-3, Stourbridge College of Art and Technology
Solo exh.: 1986, Black-Art Gallery, London; 1986, AIR Gallery, London; 1988, Whitechapel Art Gallery, London
Lit.: Araeen, Rasheed, *The Other Story: Afro-Asian Artists in Post-War Britain* (exh. cat.), Hayward Gallery, London, 1989
Photo: Centre 181 Gallery, London

Boyd, Arthur Australian painter, b. 1920, Murrumbeena, near Melbourne. Lives in North Nowra, New South Wales. Mainly self-taught
Solo exh.: see Lit.
Lit.: McKenzie, Janet, *Arthur Boyd at Bundanon*, London, 1994
Pearce, Barry, *Arthur Boyd: Retrospective* (exh. cat.), Art Gallery of New South Wales, Sydney, 1993
Photo: Wagner Art Gallery, N.S.W. Australia

Braun-Vega, Herman Peruvian painter, b. 1933, Lima. Lives in Paris
Solo exh.: 1989 (retrospective), Musée Henri Boez, Maubeuge, France, and see Lit.
Lit.: *Herman Braun-Vega* (exh. cat.), Antigua Museo España de Arte Contemporanea, Madrid, 1992
Photo: the artist

Brisley, Stuart British Performance artist, b. 1933, Grayswood, Surrey. Lives in London. Educ. 1949-54, Guildford School of Art; 1954-9, Royal College of Art, London; 1959-60, Akademie der Bildenden Künste, Munich; 1960-2, Florida State University, Tallahassee
Solo exh.: see Lit.
Lit.: *Stuart Brisley* (exh. cat.), Tate Gallery, London, 1982
Photo: Visual Arts Library

Broodthaers, Marcel Belgian Conceptual and environmental artist, 1924-76, b. Brussels, d. Cologne. Mainly self-taught
Solo exh. (retrospectives): see Lit.
Lit.: *Marcel Broodthaers (1924-1976)* (exh. cat.), Galerie Nationale du Jeu de Paume, Paris, 1991
Marcel Broodthaers (exh. cat.), Tate Gallery, London, 1980
Photo: Maria Gilissen, Gilissen Estate, Brussels

Brown, Roger American painter, b. 1941, Hamilton, Alabama. Educ. 1968-70, Art Institute, Chicago
Solo exh.: 1987-8, Hirshhorn Museum and Sculpture Garden, Washington DC
Lit.: Lawrence, Sidney, *Roger Brown*, NY, 1987
Photo: Phyllis Kind Gallery, NY and Chicago

Bulatov, Eric Russian perestroika artist, b. 1933, Sverdlovsk. Educ. 1946-52, Moscow School of Art; 1952-8, Surikov Institute, Moscow
Solo exh.: see Lit.
Lit.: *Eric Bulatov: Moscow* (exh. cat.), Institute of Contemporary Arts, London, 1989
Photo: Phyllis Kind Gallery, NY and Chicago

Buren, Daniel French environmental artist, b. 1938, Boulogne-Billancourt. Lives in Paris. Educ. 1946-56, Lycée Condorcet, Paris; 1960, École Nationale Supérieure des Métiers d'Art
Solo exh.: see Lit.
Lit.: *Daniel Buren: c'est ainsi et autrement = so ist es und anders* (exh. cat.), Kunsthalle, Bern, 1983
Photo: Weber Gallery, NY

Burgin, Victor British Conceptual artist, b. 1941, Sheffield. Lives in London. Educ. 1962-5, Royal College of Art, London; 1965-7, Yale University
Solo exh.: 1977, Van Abbemuseum, Eindhoven; 1986, Institute of Contemporary Arts, London
Lit.: Burgin, Victor, *The End of Art Theory; Criticism and Post-modernity*, Atlantic Highlands, NJ, 1986
Photo: Galerie Durand-Dessert, Paris

Burton, Scott American sculptor, 1939-89, b. Greensboro, Alabama, d. NY. Educ. 1957-9, studied painting with Leon Berkowitz in Washington DC, and with Hans Hofmann in Provincetown, Mass.; 1962, Columbia University, NY; 1963, NY University
Solo exh.: see Lit.
Lit.: Richardson, Brenda, *Scott Burton* (exh. cat.), Baltimore Museum of Art, 1986
Scott Burton: Skulpturen, 1980-9 (exh. cat.), Kunstverein für die Rheinlande und Westfalen, Düsseldorf, 1989
Photo: Virlaine Foundation, New Orleans

Bustamante, Jean-Marc French photographer and Conceptual artist, b. 1952, Toulouse. Educ. 1969-72, Toulouse University; 1973-5, studied photography with Denis Brihat in Provence. 1975-7, lived in Mauritius; 1978-81, worked as a photographer for the magazine *Connaissance des Arts* in Paris; 1983-7, worked with Bernard Bazile under the joint name BAZILEBUSTAMANTE
Solo exh.: 1993, Art Gallery of York University, Toronto; 1994, Kunsthalle, Bern; 1994, Kunstmuseum, Wolfsburg
Lit.: *Bustamante* (exh. cat.), Kunsthalle, Berne, 1989
Photo: Donald Young Gallery, Seattle

Butterfield, Deborah American sculptor, b. 1949, San Diego, CA. Lives in Billings, Montana. Educ. 1971-3, University of California, Davis
Solo exh.: 1982, Walker Art Center, Minneapolis
Lit.: *Deborah Butterfield, Jerusalem Horses* (exh. cat.), Jerusalem, 1981
Photo: Edward Thorp Gallery, NY

Caballero, Luis Colombian painter, b. 1943, Bogotá. Educ. 1961-2, Universidad de Los Andes, Bogotá; 1963-4, Académie de la Grande Chaumière, Paris. 1969, settled in Paris. Lives in Paris
Solo exh.: 1991, Grey Art Gallery, NY University
Lit.: Lucie-Smith, Edward, *Luis Caballero: Paintings and Drawings*, London, 1992
Luis Caballero: Retrospectiva de una confesion, Bogotá, 1991
Photo: Galerie Albert Loeb, Paris

Campbell, Steven Scottish figurative painter, b. 1953, Glasgow. Lives and works at Kippen, Stirlingshire, Scotland. 1970-7, steel works maintenance engineer. Educ.1978-82, Glasgow School of Art. 1982-6, lived in NY. 1986-8, lived in Glasgow. 1990, Artist in Residence, Art Gallery of New South Wales, Sydney
Solo exh.: 1990-1, Third Eye Centre, Glasgow, touring to Oriel Mostyn Gallery, Llandudno; Aberdeen Art Gallery; Whitworth Art Gallery, Manchester; Southampton City Art Gallery
Lit.: Macmillan, Duncan, *The Painting of Steven Campbell: the Story so Far*, Edinburgh and London, 1993
Photo: Marlborough Fine Art (London) Ltd

Cappuccio, Antonella Italian 'nuova maniera' painter, b. 1946, Ischia. Lives and works in Rome
Solo exh.: 1986, April-May, Musée d'Art Contemporain, Clermont-Ferrand; 1986, Sept.-Oct., Prieuré de Montverdun, Saint-Étienne; 1987, *Orpheus*, in the Sagrato del Duomo, Milan (exhibition organized by the Comune di Milano); 1988, Italian Consulate General, Lyons
Lit.: Gatti, G., *La Nuova Maniera Italiana*, Milan, 1986
Photo: Koplin Gallery, Santa Monica

Cardenas, Juan Colombian painter, b. 1939, Popayán. Lives in Bogotá. Educ. 1962, Rhode Island School of Design
Solo exh.: see Lit.
Lit.: *Juan Cardenas: peintures et dessins* (exh. cat.), Galerie Claude Bernard, Paris, 1980
Photo: Claude Bernard Gallery, NY

Caro, Anthony British sculptor, b. 1924, New Malden. Lives in London. Educ. 1946-7, Regent Street Polytechnic Institute; 1947-52, Royal Academy Schools, London; 1951-3, worked as an assistant to Henry Moore
Solo exh.: 1969, Hayward Gallery, London, and see Lit.
Lit.: Blume, Dieter, *Anthony Caro: Catalogue Raisonné*, 4 volumes, Cologne, 1981; 5th volume, Cologne, 1991
Carandente, Giovanni, *Caro at the Trajan Markets – Rome*, NY, 1994
Waldman, Diane, *Anthony Caro*, NY, 1982
Photo: André Emmerich Gallery, NY

Castle, Wendell American sculptor and furniture maker, b. 1932, Emporia, Kansas. Lives in Rochester, NY. Educ. 1958-61, University of Kansas
Solo exh.: 1989, Detroit Institute of Arts
Lit.: *Angel Chairs: New Work by Wendell Castle* (exh. cat.), Peter Joseph Gallery, NY, 1991
Taragin, Davina Spiro, *Furniture by Wendell Castle*, NY, 1989
Photo: Peter Joseph Gallery, NY

Ceccobelli, Bruno Italian painter, b. 1952, Todi. Lives in Rome
Solo exh.: see Lit.
Lit.: *Bruno Ceccobelli: Ultima Materia* (exh. cat.), Centre Saidye Bronfman, Montreal, 1993
Verna, Claudio, 'Bruno Ceccobelli' (interview), *Flash Art* (international edition), no. 124, Oct./Nov. 1985, pp. 66-8
Photo: Annina Nosei Gallery, NY

Celis, Pérez Argentinian painter, b. 1939, Buenos Aires. Lives in NY. Educ. School of Fine Arts, Buenos Aires
Solo exh.: 1991, Nagoya Art Gallery, Japan; 1992, Centro Cultural Recoleta, Buenos Aires
Lit.: Castle, Frederick Ted, Peter Frank and Rafael Squirru, *Pérez Celis*, NY, 1988
Pérez Celis: Viaje al Interior de la Materia, Buenos Aires, 1994
Photo: Anita Shapolsky Gallery, NY

Celmins, Vija American painter, b. 1938, Riga, Latvia. Lives in NY. Educ. 1955-62, Herron School of Art, Indianapolis; 1962-5, University of California, Los Angeles
Solo exh.: see Lit.
Lit.: Tannebaum, Judith, *Vija Celmins* (exh. cat.), Institute of Contemporary Art, University of Pennsylvania, Philadelphia, 1992
Photo: McKee Gallery, NY

Chadwick, Lynn British figurative sculptor, b. 1914, London. Lives near Stroud, Gloucestershire. Trained as an architectural draughtsman, but mainly self-taught
Solo exh.: 1970, Louisiana Museum, Humlebaek, Denmark
Lit.: Farr, Dennis, and Eva Chadwick, *Lynn Chadwick, Sculptor, 1947-1988*, Oxford, 1990
Photo: Marlborough Fine Art (London) Ltd

Chamberlain, John American sculptor, b. 1927, Rochester, Indiana. Educ. 1951-2, Art Institute of Chicago; 1955-6, Black Mountain College, North Carolina
Solo exh.: 1971, Solomon R. Guggenheim Museum, NY; 1987, Museum of Contemporary Art, Los Angeles
Lit.: Poetter, J., and Donald Judd, *John Chamberlain* (exh. cat.), Kunsthalle, Baden-Baden, 1991
Sylvester, Julie, *John Chamberlain: a Catalogue Raisonné of the Sculpture, 1954-1985*, NY, 1986
Photo: Margo Leavin Gallery, Los Angeles

Chandra, Avinash Indian painter, 1931-92, b. Simla, d. London. Educ. 1947-52, Delhi Polytechnic. 1956, came to live in London; 1965, moved to NY; 1971, returned permanently to London
Solo exh.: 1985, Patricia Judith Gallery, Miami; 1987, Horizon Gallery, London
Lit.: Araeen, Rasheed, *The Other Story: Afro-Asian Artists in Post-War Britain* (exh. cat.), Hayward Gallery, London, 1989
Photo: Tu Stern, London

Chase, Louisa American painter, b. 1951, Panama City. Lives in NY. Educ. 1973, Syracuse University, NY; 1975, Yale University
Numerous solo exh. with Robert Miller Gallery, NY and other galleries
Lit.: Moorman, Margaret, 'Louisa Chase', *Art News*, vol. 88, summer 1989
Photo: Brooke Alexander Gallery, NY

Chevalier, Peter German Neo-Expressionist painter, b. 1955, Karlsruhe. Lives in Berlin. Educ. 1976-80, Hochschule für Bildende Künste, Braunschweig
Solo exh.: Kunstverein Freiburg, Freiburg, 1985
Lit.: *Peter Chevalier* (exh. cat.), Raab Galerie, Berlin, 1983
Photo: Studio d'Arte Cannaviello, Milan

Chia, Sandro Italian Transavant-garde painter, b. 1946, Florence. Lives in NY, Rhinebeck, NY and Montalcino, Tuscany. Educ. 1962-7, Istituto d'Arte, Florence; 1967-9, Accademia di Belle Arti, Florence
Solo exh.: see Lit.
Lit.: *Sandro Chia* (exh. cat.), Kestner Gesselschaft, Hanover, 1983
Sandro Chia: novanta spina al vento (exh. cat.), Museum Moderner Kunst, Vienna, 1989
Photo: Nohra Haime Gallery, NY

Chicago, Judy American feminist artist, b. 1939, Chicago. Lives in Santa Fe, New Mexico. Educ. 1962-4, University of California, Los Angeles.
Solo exh.: 1979, *The Dinner Party*, San Francisco Museum of Modern Art, followed by showings at the Brooklyn Museum, NY, and elsewhere
Lit.: Chicago, Judy, *The Dinner Party: A Symbol of our Heritage*, Garden City, 1979
Chicago, Judy, *Through the Flower, My Struggle as a Woman Artist*, NY, 1977
Judy Chicago: The Dinner Party (exh. cat.), Kunsthalle, Frankfurt, 1987
Photo: Through the Flower, Chicago

Chihuly, Dale American glass artist, b. 1941, Tacoma, Washington. Lives in Seattle. Educ.1965, University of Washington, Seattle; 1967, University of Wisconsin, Madison; 1968, Rhode Island School of Design
Solo exh.: see Lit.
Lit.: *Dale Chihuly: a Decade of Glass* (exh. cat.), Bellevue Museum, Bellevue, Washington, 1981
Photo: the artist

Chillida, Eduardo Spanish sculptor, b. 1924, San Sebastian. Lives in San Sebastian. Educ. 1943-6, Colegio Mayor Jiménez, Madrid (studying architecture); 1947, studied drawing at a private academy. 1948, moved to Paris; 1951, returned to Spain
Solo exh.: 1980, Solomon R. Guggenheim Museum, NY; 1980 (retrospective), Palacio de Cristal, Parque del Retiro, Madrid; 1981 (retrospective), Museo de Bellas Artes, Bilbao
Lit.: Paz, Octavio, *Eduardo Chillida*, Paris, 1979
Selz, Peter and James Johnson Sweeney, *Chillida*, NY, 1986
Photo: Tasende Gallery, La Jolla

Christo and Jeanne-Claude Bulgarian-French environmental artists, both b. 1935. Christo (Christo Javacheff), b. Gabrovo, Bulgaria; Jeanne-Claude Christo (Jeanne-Claude de Guillebon), b. Casablanca, Morocco. Educ. 1952, Jeanne-Claude, Baccalaureat in Latin and Philosophy, University of Tunis; 1953-6, Christo, studied at the Fine Arts Academy, Sofia; 1956, Christo arrived in Prague; 1957, Christo studied for one semester at the Vienna Fine Arts Academy; 1958, Christo arrived in Paris – first packages and 'wrapped objects'. Projects include: 1976, *Running Fence, Sonoma and Marin Counties, 1972-6*; 1983, *Surrounded Islands, Biscayne Bay, Greater Miami, Florida, 1980-3*; 1991, *The Umbrellas, Japan-USA, 1984-91*, Ibaraki, Japan, and California
Lit.: Bourdon, David, *Christo*, NY, n.d.
Bourdon, David, *Christo, Running Fence (Sonoma and Marin Counties, CA, 1972-76)*, NY, 1978
Bourdon, David, *Christo: Surrounded Islands: Biscayne Bay, Greater Miami, Florida, 1980-3*, NY, 1986
Photo: Christo and Jeanne-Claude

Cinalli, Ricardo Argentinian painter and muralist, b. 1948. 1973, arrived in England. Lives in London. Educ. 1977, Harrow School of Art; 1978-80, Hornsey College of Art
Exh.: 1993, Accademia Italiana, London
Lit.: Russell Taylor, John, *Ricardo Cinalli*, Florence, 1992
Photo: the artist

Civitico, Bruno Italian-American Post-Modern figurative painter, b. 1942, Dignano d'Istria, Italy; 1955, Naturalized US citizen. Educ. 1960, studied with George Weber, Rutgers University; 1966, BFA, Pratt Institute, NY; 1968, MFA, Indiana University
Lit.: Jencks, Charles, *Post-Modernism: The New Classicism in Art and Architecture*, NY, 1988
Photo: Contemporary Realist Gallery, San Francisco

Clemente, Francesco Italian Transavant-garde painter, b. 1952, Naples. Lives in Rome, Madras and NY. Self-taught
Solo exh.: see Lit.
Lit.: Auping, Michael, *Francesco Clemente* (exh. cat.), John and Mable Ringling Museum of Art, Sarasota, 1985
Francesco Clemente: Bilder und Skulpturen (exh. cat.), Kestner-Gesellschaft, Hanover, 1984-5
Percy, Ann and Raymond Foye, *Francesco Clemente: Three Worlds* (exh. cat.), Philadelphia Museum of Art, 1990
Photos: Gagosian Gallery, NY/ Anthony d'Offay Gallery, London

Close, Chuck American Super Realist painter, b. 1940, Monroe, Washington. Lives in NY. Educ. 1962, University of Washington School of Art; 1964, Yale University; 1964-5, Academy of Fine Arts, Vienna
Solo exh.: 1973, Museum of Modern Art, NY
Lit.: Brehm, Margrit, et al., *Chuck Close: Works 1967-1992*, Stuttgart, 1994
Lyons, Lisa and Robert Storr, *Chuck Close*, NY, 1987
Lyons, Lisa, and Martin Friedman, eds., *Close Portraits* (exh. cat.), Walker Art Center, Minneapolis, 1980
Poetter, Jochen and Helmut Friedel, eds., *Chuck Close* (exh. cat.), Kunsthalle, Baden-Baden, and Kunstbau Lenbachhaus, Munich, 1994
Photo: Pace Wildenstein, NY

Colunga, Alejandro Mexican painter, b. 1948, Guadalajara, Jalisco. Educ. 1968-71, studied architecture at the University of Guadalajara; 1971, worked with an itinerant circus company; 1971-3, studied music at the Conservatorio del Estado, Guadalajara
Solo exh.: 1982, Museum of Modern Art of Latin America, Washington DC; 1986, Museo de Monterrey, Monterrey
Lit.: Sullivan, Edward J., and Jean Clarence Lambert, *Alejandro Colunga 1966-1986* (exh. cat.), Museo de Monterrey, Monterrey, 1986
Photo: Galería Alejandro Gallo, Guadalajara, Mexico

Cook, Christopher British painter, b. 1959, North Yorkshire. Lives in Exeter. Educ. 1978-81, Exeter University/Exeter College of Art; 1983-6, Royal College of Art, London
Solo exh.: see Lit.
Lit.: *Christopher Cook, Between the Lights* (exh. cat.), Oldham Art Gallery, 1992
Photo: Jason/Rhodes Gallery, London

Cottingham, Robert American Super Realist painter, b. 1935, NY. Lives in NY. Educ. 1959-65, Pratt Institute, NY (degree in advertising art). Lived in London 1972-76
Solo exh.: 1983, Wichita Art Museum, Wichita, Kansas; 1986, The Museum of Art, Science and Industry, Bridgeport, Conn.
Lit.: Lucie-Smith, Edward, *American Art Now*, Oxford, 1985
Arthur, John, *Realism-Photo-Realism* (exh. cat.), Philbrook Art Center, Tulsa, Oklahoma, 1980
Photo: Virlaine Foundation, New Orleans

Cragg, Tony British sculptor, b. 1949, Liverpool. Lives in Düsseldorf. Educ. 1969-72, Wimbledon School of Art; 1973-7, Royal College of Art, London
Solo exh.: see Lit.
Lit.: *Tony Cragg* (exh. cat.), Hayward Gallery, South Bank Centre, London, 1987
Photo: Marian Goodman Gallery, NY

Cruz-Diez, Carlos Venezuelan Op artist, b. 1923, Caracas. Lives in Paris and Caracas. Educ. School of Plastic and Applied Arts, Caracas. Later directed the art department of McCann-Erickson, Caracas (1946-51), and in 1957 founded the Estudio de Artes Visuales for Industrial Design
Solo exh.: 1976, Galerie Denise René, Paris; 1976, Museo de Arte Moderno, Mexico City; 1981, Museo de Arte Contemporáneo, Caracas
Lit.: Boulton, Alfredo, *Cruz-Diez*, Caracas, 1975
Photo: Galerie Denise René, Paris

Csernus, Tibor Franco-Hungarian Post-Modern painter, b. 1927, Kondoros, Hungary. 1964, settled in Paris. Lives in Paris. Educ. 1952, Budapest Academy of Fine Arts
Solo exh.: see Lit.
Lit.: Paget, Jean, *Tibor Csernus* (exh. cat.), Galerie Claude Bernard, Paris, 1982
Photo: Claude Bernard Gallery Ltd. NY

Cucchi, Enzo Italian Transavant-garde painter, b. 1949, Morro d'Alba. Lives in Ancona and Rome. Educ. Accademia di Belle Arte, Macerta, but also largely self-taught
Solo exh.: see Lit.
Lit.: Cucchi, Enzo, *Sparire (Disappearing)*, 2 vols, NY, 1987
Enzo Cucchi (exh. cat.), Centro per l'arte contemporanea Luigi Pecci, Prato, 1989
Enzo Cucchi (exh. cat.), Fundacíon Caja de Pensiones, Madrid, 1985
Enzo Cucchi (exh. cat.), Solomon R. Guggenheim Museum, NY, 1986
Photo: Blum-Helman Gallery Inc., NY

Cuevas, José Luis Mexican figurative draughtsman, b. 1934, Mexico City. Lives in NY, Paris and Mexico City. Self-taught apart from one term, at age ten, at the Escuela Nacional de Pintura Escultura y Grabado, 'La Esmeralda', Mexico City
Solo exh. (retrospectives): 1976, Musée d'Art Moderne de la Ville de Paris; 1980, Museum of Modern Art of Latin America, Washington DC, and Museo de Monterrey, Mexico
Lit.: Cuevas, José, et al., *Les Obsessions noires de José Luis Cuevas*, Paris, 1982
Photo: Tasende Gallery, La Jolla, CA

Daley, Anthony British Afro-Caribbean painter, b. 1960, Jamaica. Lives in London. Educ. 1978-9, Leeds College of Art; 1979-82, Wimbledon College of Art; 1982-3, Chelsea School of Art
Solo exh.: see Lit.
Lit.: Chambers, Eddie, *The Dub Factor* (exh. cat.), Midlands Contemporary Art Ltd, Birmingham, 1992
Hubbard, Sue, *Anthony Daley* (exh. cat.), Flowers East, London, 1992
Photo: Flowers East, London

Daley, Leonard Jamaican 'intuitive' painter, b. c. 1930. Self-taught. Has been painting since 1962, but no works done prior to 1989 have been discovered
Exh.: see Lit.
Lit.: Archer Straw, Petrine, *Home & Away: Seven Jamaican Artists* (exh. cat.), October Gallery, London, 1994
Photo: The October Gallery, London

d'Arcevia, Bruno Italian 'nuova maniera' painter, b. 1946 Arcevia. Lives in Rome
Solo exh.: 1987, Palazzo dei Capitani, Bagno di Romagna; 1986, Museo F. Narvaez, Isla de Margarita, Venezuela
Lit.: Calvesi, M., and G. Gatti, *Bruno d'Arcevia*, Rome, 1989
Photo: Koplin Gallery, Santa Monica

d'Arienzo, Miguel Argentinian painter, b. 1950, Buenos Aires. Lives in Buenos Aires. Educ. University of Buenos Aires; 1977-80, teamwork and study in the studio of Julio Martinez Howard
Solo exh.: 1991, Aerolineas Argentinas, Madrid; 1990, Recoleta Cultural Centre, Buenos Aires; 1988, Cultural Centre Malvinas, Buenos Aires
Photo: Durini Gallery, London

de Andrea, John American Super Realist sculptor, b. 1941, Denver, Colorado. Lives in Santa Cruz, CA. Educ. 1961-5, University of Colorado, Denver; 1966-8, University of New Mexico, Albuquerque
Solo exh.: 1982, Aspen Center for the Visual Arts, Colorado
Lit.: *John De Andrea* (exh. cat.), Galerie Isy Brachot, Paris and Brussels, 1988
Masheck, J., 'The Verist Sculptors, 2 Interviews: Duane Hanson/John De Andrea', *Art in America*, Dec. 1972
Photo: Virlaine Foundation, New Orleans

de Forest, Roy American figurative painter, b. 1930, North Platte, Nebraska. Lives in San Francisco. Educ. 1950-2, California School of Fine Arts; 1952-8, San Francisco State College
Solo exh.: see Lit.
Lit.: Clisby, Roger D., *Roy De Forest* (ex. cat.), Sacramento Museum, 1980
Photo: John Natsoulas Gallery, Davis, CA

de Kooning, Elaine American Abstract Expressionist painter, 1920-89, b. Brooklyn, d. East Hampton. Educ. American Artists School, NY; Leonardo da Vinci School, NY (with Conrad Marca-Reilli)
Solo exh.: 1973, Montclair Art Museum
Lit.: de Kooning, Elaine, *Spirit of Abstract Expressionism: Selected Writings*, NY, 1994
Photo: Fischbach Gallery, NY

de Szyszlo, Fernando Peruvian abstract painter, b. 1925, Barranco, Lima. Lives in Peru. Educ. 1944-6, School of the Plastic Arts, Catholic University, Lima
Solo exh.: 1985, Museum of Contemporary Latin American Art, Washington DC; 1988, Museo de Arte Contemporáneo Internacional Rufino Tamayo, Mexico City
Lit.: *Fernando de Szyszlo*, Bogotá, 1991
Photo: the artist

Deacon, Richard British sculptor, b. 1949, Bangor, Wales. Lives in London. Educ. 1969-72, St Martin's School of Art, London; 1974-7, Royal College of Art, London; 1977, Chelsea School of Art (studying history of art)
Solo exh.: see Lit.
Lit.: *Richard Deacon: Sculptures 1987-1993* (exh. cat.), Kunstverein, Hanover, 1993
Photos: Marian Goodman Gallery, NY

Dean, Graham British painter and film-maker, b. 1951, Birkenhead. Lives in Brighton
Exh.: 1993, Documenta-Halle, Kassel; 1993, Musée des Beaux-Arts, Montreal
Lit.: Morris, Susan, 'Graham Dean', *Arts Review*, vol. 40, November 1988
Photo: Jill George Gallery, London

Di Suvero, Mark American sculptor, b. 1933, Shanghai, China. Lives in San Francisco. Educ. 1953-4, San Francisco City College; 1956, University of California
Solo exh.: see Lit.
Lit.: *Mark Di Suvero: Valence* (exh. cat.), Musée de Valence, 1994
Cooke, Lynne, 'U.S. Steel' [Mark Di Suvero], *Art in America*, vol. 76, Oct. 1988, pp. 168-71
Weinberg, Mimi, 'Thunder in the Mountains: Mark Di Suvero at Storm King', *Arts Magazine*, vol. 60, Feb. 1986, pp. 38-42
Photo: L.A. Louver, Inc, Venice, CA

Dine, Jim American painter and sculptor, b. 1935, Cincinnati, Ohio. Educ. University of Cincinnati; Boston Museum School; 1958, BFA, Ohio University
Solo exh.: 1984, Walker Art Center, Minneapolis; 1990, Nelson-Atkins Art Museum, Kansas City
Lit.: Beal, G.W.J., *Jim Dine: Five Themes*, NY, 1984
Photo: Visual Arts Library

Disler, Martin Swiss painter and sculptor, b. 1949, Seewen, Solothurn. Lives in Paris. Educ. at a Catholic boarding school, but essentially self-taught as an artist
Solo exh.: 1985, Musée d'Art Moderne de la Ville de Paris, Museum Folkwang, Essen, and Kunsthalle, Bremen; 1987, Kestner Gesellschaft, Hanover, and Museum Moderner Kunst, Vienna
Lit.: *Cross-Currents in Swiss Art* (exh. cat.), Serpentine Gallery, London, 9 March-8 April 1985
Photo: Studio d'Arte Cannaviello, Milan

Dittborn, Eugenio Chilean 'mail artist', b. 1943, Santiago. Lives in Santiago. Educ. 1962-5, Universidad de Chile, Santiago; 1966, escuela de Fotomecánica, Madrid; 1967 and 1969, Hochschule für Bildende Künste, Berlin; 1968, École des Beaux-Arts, Paris
Lit.: Brett, Guy, and Sean Cubitt, *Camino Way. The Airmail Paintings of Eugenio Dittborn*, Santiago, 1991
Photo: the artist

Doig, Peter British painter, b. 1959, Leith, Scotland. 1966-79, lived in Canada. Lives in London. Educ. 1979-80, Wimbledon College of Art; 1980-3, St Martin's college of Art, London
Solo exh.: 1991, Whitechapel Art Gallery, London; 1994 Victoria Miró Gallery, London
Lit.: *Things As They Are* (exh. cat.), Riverside Studios, London, 1984
Unbound: Possibilities in Painting (exh. cat.), Hayward Gallery, London, 1994
Photo: Victoria Miró Gallery, London

Doolin, James American painter, b. 1932, Hartford, Conn. Lives in Los Angeles. Educ. 1954, Philadelphia University; 1958-60, Pratt Institute and NY University; 1971, University of California, Los Angeles
Solo exh.: 1986, Laguna Art Museum, CA
Lit.: Edward Lucie-Smith, *American Art Now*, Oxford, 1985
Photo: Koplin Gallery, Santa Monica

Duclos, Arturo Chilean painter and installation artist, b. 1959, Santiago. Lives in Santiago. Educ. 1984, Catholic University of Chile
Solo exh.: 1992, Jean-Marc Paras Galerie, Paris
Lit.: Macucha, Guillermo, *Ora Pro Nobis*, Santiago, 1991
Photo: the artist

Durand, André Anglo-Canadian Post-Modern painter, b. 1956. 1969, settled in London
Solo exh.: 1981, Edinburgh Festival; 1984, Musée du Château Ramzay, Montreal and City Hall, Toronto; Newport Art Museum, Newport, Rhode Island. Portraits include: H.H. The Dalai Lama; H.H. Pope John Paul II; Mother Teresa of Calcutta; H.R.H. The Prince of Wales
Photo: the artist

Dureau, George American painter/photographer, b. 1930, New Orleans. Lives in New Orleans. Educ. 1952, Louisiana State University; 1955, Tulane University, New Orleans.
Solo exh.: 1977, Contemporary Arts Center, New Orleans
Lit.: Dureau, George, *New Orleans: 50 Photographs*, London, 1985
Photo: Arthur Roger Gallery, New Orleans

Durham, Jimmie American poet, writer, political activist, performance artist and sculptor, b. 1940, Washington, Arkansas, of Cherokee ancestry.
Lit.: Lippard, Lucy R., 'Jimmie Durham: Post-modernist Savage', *Art in America*, vol. 81, Feb. 1993, pp. 62-9
Schiff, Richard, 'The Necessity of Jimmie Durham's Jokes: "Indian Arts and Crafts Act of 1990"', *Art Journal*, vol. 51, Fall 1992, pp. 74-80
Photo: L.A. Louver Gallery, Venice, CA

Durrant, Jennifer British abstract painter, b. 1942, Brighton. Lives in London. Educ. 1959-63, Brighton College of Art; 1963-5, Slade School of Fine Art, London
Solo exh.: see Lit.
Lit.: *Jennifer Durrant: Painting* (exh. cat.), Serpentine Gallery, London, 1987
Photo: Salander-O'Reilly Galleries, NY

El-Salahi, Ibrahim Sudanese painter and graphic artist, b. 1930, Omdurman. Lives in the Gulf States. Educ. Slade School of Fine Art, London
Lit.: *Ibrahim El-Salahi: Images in Black and White* (exh. cat.), Savannah Gallery of Modern African Art, London, 1992
Photo: Savannah Gallery of Modern African Art, London

Emery, Lin American kinetic sculptor
Solo exh.: 1985, Hunter Museum, Chattanoga; 1989, Alexandria Museum of Art, Alexandria, Louisiana; 1991, Columbus Museum of Art, South Carolina; 1991, Art Museum of Southeast Texas, Beaumont
Photo: the artist

Escobedo, Helen Mexican site-specific sculptor, b. 1934, Mexico City. Lives in Hamburg and Mexico City. Educ. 1951, Motolin University, Mexico City; Mexico City College, Mexico City; Royal College of Art, London; 1954, Master's Degree, Royal College of Art
Solo exh.: 1992, St John's College and Museum of Modern Art, Oxford; 1992, Museo Rufino Tamayo, Mexico City; 1993, giant installation, Parque de la Paz, San José, Costa Rica; 1993, Cooper-Union, NY; 1993, installation at the ex-Convento de Santa Teresa, Mexico D.F.; 1993, two installations for the University of Antwerp, Belgium
Lit.: Eder, Rita, *Helen Escobedo*, Mexico City, 1982
Photo: the artist

Estes, Richard American Super Realist painter, b. 1936, Kewanee, Illinois. Educ. 1952-6, Chicago Art Institute
Solo exh.: 1979 (touring retrospective), Museum of Fine Arts, Boston, Toledo Museum of Art, Nelson-Atkins Gallery, Kansas City, Hirshhorn Museum and Sculpture Garden, Washington DC
Lit.: Meisel, Louis K., *Richard Estes: the Complete Paintings 1966-1985*, NY, 1986
Photo: Louis K. Meisel Gallery, NY

Fabro, Luciano Italian 'Arte Povera' artist, b. 1936, Turin. Lives in Milan
Solo exh.: 1981, Museum Folkwang, Essen and Museum Boyman-van Beuningen, Rotterdam
Lit.: De Sanna, J., *Fabro*, Ravenna, 1983
Luciano Fabro: Works 1963-1986 (exh. cat.), Fruitmarket Gallery, Edinburgh, 1986
Celant, Germano, *Arte Povera*, Milan, 1969
Photo: Salvatore Ala Gallery, NY

Faibisovich, Simon Russian Super Realist painter, b. 1949, Moscow. Educ. 1959-64, Moscow Secondary Art School; 1972, Moscow Architectural Institute
Exh.: see Lit.
Lit.: Bowlt, John E., *The Quest for Self-Expression: Painting in Moscow and Leningrad 1965-1990* (exh. cat.), Columbus Museum of Art, Ohio, 1990
Photo: Phyllis Kind Gallery, NY and Chicago

Feltus, Alan American figurative painter, b. 1943, Washington DC. Educ. 1961-2, Tyler School of Fine Arts, Temple University, Philadelphia; 1966, Cooper Union, NY; 1968, Yale University
Solo exh.: 1987, Wichita Art Center
Lit.: Feltus, Alan, 'Living and Working in Italy', *American Artist*, vol. 56, Aug. 1992, pp. 54-7
Photo: Forum Gallery, NY

Ferrara, Jackie American sculptor, b. 1929, Detroit. Lives in NY
Solo exh.: see Lit.
Lit.: *Jackie Ferrara Sculpture: a Retrospective* (exh. cat.), John and Mabel Ringling Museum of Art, Sarasota, 1992
Photo: Virlaine Foundation, New Orleans

Ferrer, Rafael Puerto Rican painter and installation artist, b. 1933, San Juan, Puerto Rico. Educ. 1951-2, Syracuse University, NY; 1952-4, University of Puerto Rico, Mayaquez
Solo exh.: 1985, Minneapolis College of Art and Design; 1985, Beaver College, Glennside, Pennsylvania
Lit.: *The Latin American Spirit: Art and Artists in the United States, 1920-1970* (exh. cat.), The Bronx Museum of the Arts, NY, 1989
Photo: Nancy Hoffman Gallery, NY

Fetting, Rainer German Neo-Expressionist artist, b. 1949, Wilhemshaven. Lives in NY and Berlin. Educ. 1972-8, Hochschule der Künste, Berlin
Solo exh.: see Lit.
Lit.: *Rainer Fetting* (exh. cat.), Museum Folkwang, Essen, 1986
Rainer Fetting: Berlin/New York: gemälde und skulpturen (exh. cat.), Nationalgalerie, Berlin, 1990
Photo: Dolly Fitterman Fine Arts, Minnesota

Finley, Karen American performance and installation artist. Lives in Nyack, NY. Educ. 1981, San Francisco Art Institute, MFA 1985
Solo exh.: 1992, Museum of Contemporary Art, Los Angeles; 1992, The Kitchen, NY; 1993, Gallery 76, Ontario College of Art, Toronto; 1993, Intermedia Arts, Minneapolis
Lit.: Finley, Karen, *Enough is Enough*, NY, 1993
Finley, Karen, *Shock Treatment*, NY, 1990
Photo: the artist

Fischl, Eric American figurative painter, b. 1948, NY. Educ. 1972, California Arts Institute, Valencia
Solo exh.: 1986, Whitney Museum of American Art, NY; 1990, Walker Art Center, Minneapolis
Lit.: Schjeldahl, Peter, *Eric Fischl*, NY, 1988
Photo: Thomas Ammann, Zurich

Fish, Janet American realist painter, b. 1938, Boston, Mass. Lives in NY. Educ. Smith College and Yale University
Solo exh.: see Lit.
Lit.: *Janet Fish: Recent Paintings and Pastels, 1980-1985* (exh. cat.), Smith College Museum of Art, Northampton, Mass., 1986
Photo: the artist

Flack, Audrey American Realist painter and sculptor, b. 1931, NY. Lives in NY. Educ. 1951, graduated from Cooper Union, NY; 1952, BFA Yale University; 1953, NY University, Institute of Fine Art
Solo exh.: 1992, Wight Art Gallery, University of California, Los Angeles, Butler Institute of American Art, Youngstown, Ohio, National Museum of Women in the Arts, Washington, DC
Lit.: Flack, Audrey, *On Painting*, NY, 1981
Gouma-Paterson, Thalia, *Breaking the Rules: Audrey Flack, a Retrospective* (exh. cat.), J.B. Speed Art Museum, Louisville, Kentucky, 1992
Photo: Louis K. Meisel Gallery, NY

Flanagan, Barry British sculptor, b. 1941, Flintshire, North Wales. Educ. 1958, Birmingham College of Arts and Crafts; 1960-3, St Martin's School of Art, London
Solo exh.: see Lit.
Lit.: *Barry Flanagan* (exh. cat.), Centre Georges Pompidou, Paris, 1983
Photo: Waddington Galleries, London

Flavin, Dan American sculptor with light, b. 1933, NY. Self-educated
Solo exh.: 1992, Solomon R. Guggenheim Museum, NY
Lit.: Bismarck, Beatrice von, *Dan Flavin: Installationem im fluoreszierendem Licht, 1989-1993* (exh. cat.), Stuttgart, 1993
Dan Flavin: Drawings, Diagrams and Prints, 1972-1975 (exh. cat.), Fort Worth Museum of Art, Fort Worth, Texas, 1977
Poetter, Jochen, *Dan Flavin. Neue Anwendungen fluoreszierenden Lichts*, Stuttgart, 1991
Photo: Margo Leavin Gallery, Los Angeles

Fontana, Lucio Italian painter and sculptor, 1899-1968, b. Rosario di Santa Fe, Argentina, d. Milan. Educ. 1928-30, Accademia di Brera, Milan
Solo exh. (retrospectives): 1978, Solomon R. Guggenheim Museum, NY; 1987, Centre Pompidou, Paris
Lit.: Crespoliti, Enrico, *Fontana: catalogo generale*, 2 vols., Milan, 1986
Photo: Leo Castelli Gallery, NY

Förg, Günther German abstract painter, b. 1952, Füssen. Lives in Areuse, Switzerland. Educ. 1973-9, Akademie der bildenden Künste, Munich
Solo exh.: see Lit.
Lit.: *Günther Förg: Painting, Sculpture, Installations* (exh. cat.), Newport Harbor Museum, Newport Beach, California, 1989
Photo: Luhring Augustine, NY

Francis, Sam American Abstract Expressionist, 1923-94, b. San Mateo, CA, d. Santa Monica. Educ. 1943-50, University of California, Berkeley; Atelier Fernand Léger, Paris
Solo exh.: 1991, Katonah Museum of Art, NY
Lit.: Michaud, Yves, *Sam Francis*, Paris, 1991
Selz, Peter, *Sam Francis*, NY, 1982
Photo: Goldstrom Gallery, NY

Frankenthaler, Helen American Post-Painterly abstractionist, b. 1928, NY. Lives in NY. Educ. 1949, Bennington College, Vermont; also studied with Rufino Tamayo and Hans Hofmann
Solo exh.: 1993, National Gallery of Art, Washington DC
Lit.: Elderfield, John, *Frankenthaler*, NY, 1989
Rose, Barbara, *Helen Frankenthaler*, NY, n.d.
Photo: The Remba Gallery/Mixografia Workshop, Los Angeles, Mexico City

Freud, Lucian 'School of London' painter, b. 1922, Berlin. 1933, emigrated to Britain; 1939, naturalized British subject. Lives in London. Educ. 1938, Central School of Arts and Crafts, London; 1939-41, East Anglian School of Drawing and Painting, Dedham, Suffolk
Solo exh.: 1992-3, Art Gallery of New South Wales, Sydney, and Art Gallery of Western Australia, Perth; 1993, Whitechapel Art Gallery, London, Metropolitan Museum, NY, and Museo Nacional Centro de Arte Reina Sofia, Madrid
Lit.: Gowing, Lawrence, *Lucian Freud*, London, 1982
Lampert, Catherine, *Lucian Freud: Recent Work* (exh. cat.), Whitechapel Art Gallery London, 1993
Lucian Freud: Paintings (exh. cat.), The British Council, London, 1987
Lucian Freud: the Complete Etchings 1946-1991 (exh. cat.), Thomas Gibson Fine Art Ltd, London, 1991
Lucian Freud: Works on Paper (exh. cat.), South Bank Centre, London, 1988
Photo: Visual Arts Library

Frey, Viola American ceramic sculptor, b. 1933, Lodi, CA. Educ. 1952-3, Stockton Delta College, Stockton, CA; 1953-6, California College of Arts and Crafts, Oakland; 1956-8, Tulane University, New Orleans. 1970-present, Professor of Art, College of Arts and Crafts, Oakland. 1978, Artist's Fellowship, National Endowment for the Arts
Solo exh.: 1991, Norton Gallery of Art, West Palm Beach, Florida
Lit.: *It's All Part of the Clay: Viola Frey* (exh. cat.), Moore College of Art, Philadelphia, 1984
Photo: Asher-Faure Gallery, Los Angeles

Fridge, Roy American site-specific and installation artist, b. 1927, Beeville, Texas. Lives in Port Aransas, Texas. Educ. 1944-6, University of Texas, Austin; 1946-8, US Navy; 1948-50, Baylor University, Waco, Texas. Began making sculpture in 1957. 1969-73, taught programme on 'Film in Art' for University of Oklahoma, Norman, Oklahoma
Solo exh.: 1985, Art Museum of South Texas, Corpus Christi
Lit.: Carlozzi, Annette, *50 Texas Artists*, San Francisco, 1986
Photo: Visual Arts Library

Fried, Nancy American feminist sculptor, b. 1945, Philadelphia. Lives in NY. Educ. 1968, University of Pennsylvania, Philadelphia
Solo exh.: 1991, Joan Whitney Payson Gallery of Art, Westbrook College, Portland, Maine
Lit.: Borum, Jenifer P., 'Nancy Fried', *Artforum*, vol. 28, Feb. 1990
Heartney, Eleanor, 'Nancy Fried at Graham Modern', *Art in America*, vol. 76, Apr. 1988
Photo: the artist

Frink, Elisabeth British figurative sculptor, 1930-93, b. Thurlow, Suffolk, d. Woolland, Dorset. Educ. 1947-9, Guildford School of Art; 1949-53, Chelsea School of Art
Lit.: Lucie-Smith, Edward, and Elisabeth Frink, *Frink: a Portrait*, London, 1994
Willder, Jill, *Elisabeth Frink, Sculpture: Catalogue Raisonné*, Salisbury, Wiltshire, 1984
Photo: Estate of Elisabeth Frink

Funakoshi, Katsura Japanese sculptor, b. 1951, Morioka City. Lives in Tokyo. Educ. 1971-5, Tokyo University of Art and Design; 1975-7, Tokyo National University of Fine Arts and Music
Solo exh.: see Lit.
Lit.: *Katsura Funakoshi: Sculpture* (exh. cat.), Annely Juda Fine Art, London, 1991
Photo: Annely Juda Fine Art, London

Galán, Julio Mexican painter, b. 1958, Múzquiz, Coahuila. 1970, moved with his family from Múzquiz to Monterrey. Now lives partly in NY and partly in Mexico. Educ. 1978-82, studied architecture at the University, Monterrey
Solo exh.: 1990, Witte de With Center for Contemporary Art, Rotterdam; 1994, Museo de Monterrey
Lit.: *Julio Galán* (exh. cat.), Annina Nosei Gallery, NY, 1989
Julio Galán: Exposicion Retrospectiva (ex. cat.), Museo de Monterrey, 1994
Sims, Lowry Stokes, *Julio Galán* (exh. cat.), Museo de Monterrey, 1987
Photo: Annina Nosei Gallery, NY

Gamarra, José Uruguayan painter, b. 1934, Tacuarembo. Lives in Paris. Educ. 1952-9, Escuela de Bellas Artes, Montevideo. 1960-3, lived in Brazil.
Solo exh.: 1979, Musée Municipal des Beaux-Arts, Tourcoing; 1984, Casa de las Américas, Havana
Lit.: *José Gamarra* (exh. cat.), Galerie Albert Loeb, Paris, 1992
José Gamarra (exh.cat.), Donald Morris Gallery, Birmingham, Michigan, 1987
Photo: Galerie Albert Loeb, Paris

Gardner, Ian British watercolourist, b. 1944, Lancaster. Educ. 1961-5, Lancaster School of Art; 1965-6, Nottingham College of Art
Solo exh.: 1992, Midland Contemporary Art, Birmingham; 1993, Dean Clough, Halifax
Lit.: Mosser, Monique, and Georges Teyssot, eds., *The History of Garden Design from the Renaissance to the Present*, London, 1991
Photo: the artist

Garouste, Gérard French Post-modern painter, b. 1946. Lives in Paris. Educ. Académie de la Grande Chaumière and Académie Charpentier, Paris; 1968, École des Beaux-Arts, Paris. 1966-, numerous designs for theatrical productions
Solo exh.: 1984, Musée de Boudon-Lancy; 1986, Musée d'Art Contemporain, Montreal
Lit.: *Gérard Garouste*, Kyoto, 1989
Photo: Galerie Durand-Dessert, Paris

George, Milton Jamaican painter, b. 1939, Asia, Manchester, Jamaica. Lives in Portmore, St Catherine, Jamaica. Educ. attended the Jamaica School of Art part-time. 1978, awarded a National Gallery of Jamaica Fellowship
Solo exh.: 1987, The Frame Centre Gallery, Kingston, Jamaica; 1990, Mutual Life Gallery, Kingston, Jamaica
Lit.: Archer Straw, Petrine, *Home and Away: Seven Jamaican Artists* (exh. cat.), October Gallery, London, 1994
Photo: October Gallery, London

Gerzso, Gunther Mexican painter, b. 1915, Mexico City. Lives in Mexico. Educ. in Mexico and Switzerland, then studied theatre design and cinematography at Cleveland Playhouse, Ohio. Art Director for various film directors, including John Ford and Luis Buñuel
Solo exh.: 1970, Phoenix Museum, Arizona
Photo: Galeria de Arte Mexicana, Mexico City

Gianakos, Steve American Post-Pop painter, b. 1938, NY. Lives in NY. Educ. School of Visual Arts, NY
Solo exh.: 1989, University Gallery, University of Massachusetts, Amherst
Lit.: *Gianakos – 4 Scandinavian Exhibitions* (exh. cat.), Stockholm, 1986
Photo: Barbara Toll Fine Art, NY

Gibbons, John British abstract sculptor, b. 1949, Ireland. Lives in London. Educ. 1969-70, Limerick School of Art; 1970-2, Crawford Municipal School of Art, Cork; 1972-6, St Martin's School of Art, London
Solo exh.: see Lit.
Lit.: Harrison, Michael, *John Gibbons, Sculpture 1981-1986* (exh. cat.), Arts Council, London, 1986
Photo: Flowers East, London

Gil de Montes, Roberto Mexican painter, b. 1950, Guadalajara. 1957, emigrated to the US. Lives in Los Angeles. Educ. 1972-6, Otis Art Institute; 1976-8, California State University, Los Angeles
Solo exh.: 1985, Jan Baum Gallery, Los Angeles
Lit.: Beardsley, John, and Jane Livingstone, *Hispanic Art in the United States*, (exh. cat.), Museum of Fine Arts, Houston, 1987
Photo: Jan Baum Gallery, Los Angeles

Gilbert & George British sculptors, George b. 1942, Devon, England; Gilbert b. 1943, Dolomites, Italy. They live in London. Educ. (George), Dartington Adult Education College; Dartington Hall College of Art; Oxford School of Art; (Gilbert), Wolkenstein School of Art; Hallein School of Art; Munich Academy of Art; (both), 1967, St Martin's School of Art, London
Solo exh.: 1985, Solomon R. Guggenheim Museum, NY; 1987, Hayward Gallery, London
Lit.: Jahn, Wolf, *The Art of Gilbert & George*, London, 1989
Photo: the artists

Gilhooly, David American ceramic sculptor, b. 1943, Auburn, CA. Educ. 1965-7, University of California, Davis
Numerous mixed exh., including the Whitney Museum of American Art, NY, 1970, 1971, 1974 and 1982
Lit.: Spreight, Charlotte, *Images in Clay*, NY, 1983
Albright, Thomas, *Art in the San Francisco Bay Area, 1945-1980*, Berkeley, CA, 1985
Photo: John Natsoulas Gallery, Davis, CA

Gillespie, Gregory American Realist painter, b. 1936, Roselle Park, NJ. Educ. Cooper Union, NY; San Francisco Art Institute
Solo exh. (retrospective): 1977, Hirshhorn Museum and Sculpture Garden, Washington DC, and University of Georgia Art Museum, Athens, Georgia
Lit.: Lerner, Abram, *Gregory Gillespie* (exh. cat.), Hirshhorn Museum and Sculpture Garden, Washington DC, 1977
William Beckman; Gregory Gillespie (exh. cat.), Rose Art Museum, Waltham, Mass., 1984
Photo: Forum Gallery, NY

Gilliam, Sam African-American abstract painter, b. 1933, Tupelo, Miss. Lives in Washington DC. Educ. 1952-61, University of Louisville, Kansas
Numerous solo exh. in commercial galleries, including Galerie Simonne Stern, New Orleans, 1994
Lit.: Allen, Jane Addams, 'Letting Go (the Art of Sam Gilliam)', *Art in America*, vol. 74, Jan. 1986
Gawlak, Annie, 'Sam Gilliam: Solids and Veils', *Art Journal*, vol. 50, spring 1991
Photo: Koplin Gallery, Santa Monica

Ginnever, Charles American abstract sculptor, b. 1931, San Mateo, CA. Lives in Putney, Vermont. Educ. 1953-5, in Europe with Ossip Zadkine and Henri Hayter; 1957, California School of Fine Arts; 1959, Cornell University
Solo exh.: 1987, Seattle Art Museum, Washington
Lit.: Schlinke, Britton, 'Illusions of a Different Space', *Artweek*, vol. 18, 11 July 1987
Photo: Gerald Peters Gallery, Santa Fe

Gironella, Alberto Mexican painter, b. 1929, Mexico City. Lives in Mexico City. Educ. 1942-8, Hispanic-Mexican Academy, Mexico City; 1951, National Autonomous University, Mexico City
Solo exh.: 1984, Museo Rufino Tamayo, Mexico City
Lit.: Eder, Rita, *Gironella*, Mexico City, 1981
Photo: Iturralde Gallery, Los Angeles

Gober, Robert American sculptor and installation artist, b. 1954, Wallingford, Conn. Lives in NY. Educ. 1974, Tyler School of Art, Temple University, Philadelphia; 1976, Middlebury College, Vermont
Solo exh.: 1992, Museo Nacional Reina Sofia, Madrid; 1988, Art Institute of Chicago
Lit.: *Robert Gober* (exh. cat.), Museum Boymans-van Beuningen, 1990
Photo: Paula Cooper Gallery, NY

Goings, Ralph American Super Realist painter, b. 1928, Corning, CA. Educ. 1953, California College of Arts and Crafts; 1965, California State University, Sacramento
Solo exh.: 1977, Museum of Modern Art, NY
Lit.: Chase, Linda, *Ralph Goings*, NY, 1988
Photo: Louis K. Meisel Gallery, NY

Goldsworthy, Andy British site-specific sculptor, b. 1956, Cheshire. Lives in Cumbria. Educ. 1974-5, Bradford College of Art; 1975-8, Preston Polytechnic, Lancashire Annex
Solo exh.: see Lit.
Lit.: Friedman, Terry, with Andy Goldsworthy, *Hand to Earth: Andy Goldsworthy sculpture 1976-1990*, Leeds, 1990
Photos: the artist

Golub, Leon American figurative painter, b. 1922, Chicago. Lives in NY. Educ. 1942, University of Chicago; 1949-50, Art Institute of Chicago
Solo exh.: 1985-6, Corcoran Gallery, Washington DC, and Museum of Fine Arts, Boston
Lit.: Kuspit, Donald, *The Existential/Activist Painter: The Example of Leon Golub*, New Brunswick, NJ, 1985
Photo: Eli Broad Family Foundation, Los Angeles, photograph courtesy Josh Baer Gallery, NY

Goode, Joe American painter, b. 1937, Oklahoma City. Lives in Marina del Rey, CA. Educ. Chouinard Art Institute, CA
Solo exh.: 1977, Contemporary Arts Museum, Houston
Lit.: Brougher, Nora Halpern, *Looking Through the Work of Joe Goode* (exh. cat.), James Corcoran Gallery, Santa Monica, CA, 1990
Photo: L.A. Louver, Venice, CA

Goodman, Sidney American painter, b. 1936, Philadelphia. Lives in Philadelphia. Educ. 1958, Philadelphia College of Art
Solo exh.: 1984, Wichita Museum, Kansas
Lit.: Schwabsky, Barry, 'Sidney Goodman: Beyond Expressionism and Realism', *Arts Magazine*, vol. 59, Sept. 1984
Photo: Terry Dintenfass Gallery, NY

Gordy, Robert American painter and printmaker, 1933-85, b. Jefferson Island, Louisiana, d. New Orleans. Educ. 1951-5, Louisiana State University, Baton Rouge; 1953, Yale University; 1955, State University of Iowa, Iowa City
Solo exh.: see Lit.
Lit.: Baro, Gene, *Robert Gordy, Paintings and Drawings 1960-1980* (exh. cat.), New Orleans Museum of Art, 1980
Photo: Arthur Roger Gallery, New Orleans

Gormley, Antony British sculptor, b. 1950. Lives in London
Solo exh.: 1992, San Diego Museum of Contemporary Art, La Jolla, and see Lit.; 1993, Montreal Museum of Fine Arts, Montreal
Lit.: *Antony Gormley* (exh. cat.), Malmö Konsthall, Tate Gallery, Liverpool and Irish Museum of Contemporary Art, Dublin, 1993-4
Photos: the artist

Gornik, April American landscape painter, b. 1953, Cleveland, Ohio. Educ. 1971-5, Cleveland Art Institute; 1976, Nova Scotia College of Art and Design
Solo exh.: 1988, University Art Museum, California State University, Long Beach
Lit.: Yau, John, 'April Gornik', *Artforum*, Sept. 1990
Photo: Edward Thorp Gallery, NY

Graham, Dan American Conceptual artist and site-specific sculptor, b. 1942, Urbana, Illinois. Lives in NY
Solo exh.: see Lit.
Lit.: *Dan Graham, Pavilions* (exh. cat.), Kunsthalle, Berne, 1983
Graham, Dan, *Selected Works, 1965-72*, NY, 1972
Photo: Marian Goodman Gallery, NY

Graham, Robert American figurative sculptor, b. 1938, Mexico City. US citizen, lives in Los Angeles. Educ. 1961-3, San Jose State College; 1963-4, San Francisco Art Institute
Solo exh.: 1988, Los Angeles County Museum; 1981, Walker Art Center, Minneapolis (and travelling)
Lit.: *Twenty One Figures By Robert Graham* (exh. cat.), Robert Miller Gallery, NY, 1990
Photo: Robert Miller Gallery, NY

Grippo, Victor Argentinian Conceptual artist, b. 1936, Buenos Aires. Lives in Buenos Aires. Educ. Universidad Nacional de la Plata, Buenos Aires (studied chemistry); Escuela Superior de Bellas Artes, Buenos Aires
Solo exh.: see Lit.
Lit.: Glusberg, Jorge, *Victor Grippo – Obras de 1965 a 1987* (exh. cat.), Fundacion San Telmo, Buenos Aires, 1989
Glusberg, Jorge, *Victor Grippo*, Buenos Aires, 1980
Photo: Rith Benzacar Galeria de Arte, Buenos Aires

Gu Wenda Chinese installation artist, b. 1955, Shanghai. Lives in the US. Educ. School of Arts and Crafts, Shanghai; 1981, Zhejiang Academy of Fine Arts
Exh.: See Lit.
Lit.: *China Avant-Garde* (exh. cat.), Haus der Kulturen der Welt, Berlin, and Museum of Modern Art, Oxford, 1993
China's New Art, Post-1989 (exh. cat.), Hanart T Z Gallery, Hong Kong, 1993
Photo: Visual Arts Library

Guston, Philip American Abstract Expressionist and Neo-Expressionist painter, 1913-80, b. Montreal, d. Woodstock, NY. Educ. 1927, Manual Arts High School, Los Angeles; 1930, Otis Art Institute, Los Angeles. 1934, worked as a muralist in Morelia, Mexico
Solo exh.: 1982 (retrospective), Whitechapel Art Gallery, London
Lit.: Mayer, Musa, *Night Studio: a Memoir of Philip Guston*, NY, 1988
Photo: McKee Gallery, NY

Guy, Alexander British painter, b. 1962, St Andrews. Lives in London. Educ. 1980-4, Duncan of Jordanstone College of Art, Dundee; 1985-7, Royal College of Art, London
Solo exh.: 1993, Glasgow Art Gallery and Museum
Photo: the artist

Gyedu, Kwabena African artist
Photo: Visual Arts Library

Ha, Chong-Hyun Korean abstract painter, b. 1935, Kyeong-Nam. Educ. 1959, graduated from School of Painting, Hong-Ik University, Seoul. Currently Professor at the College of Fine Arts, Hong-Ik University, Seoul
Solo exh.: 1979, Muamatsu Gallery, Tokyo; 1984, Hyun-Dai Gallery, Seoul
Lit.: *Ha, Chong-Hyun* (exh. cat.), Hyun-Dai Gallery, Seoul, 1984
Photo: the artist

Hacker, Dieter German Neo-Expressionist painter, b. 1942, Augsburg. Lives in Berlin. Educ. 1960-5, Akademie der Bildenden Künste, Munich
Solo exh.: 1979, Kunstlerhaus, Stuttgart
Lit.: *Dieter Hacker: Der Mythos des Bildes* (exh. cat.), Kunstverein, Hamburg, 1985
Photo: Marlborough Fine Art (London) Ltd.

Halley, Peter American abstract painter, b. 1953, NY. Lives in NY. Educ. Yale University; University of New Orleans
Solo exh.: see Lit.
Lit.: Deitch, Jeffrey, and Peter Halley, *Cultural Geometry* (ex. cat.), Deste, Foundation for Contemporary Art, Athens, 1988
Peter Halley (exh. cat.), Museum Hans Esters, Krefeld, 1989
Photo: Galerie Bischofberger, Zurich

Hamilton, Richard British Pop artist, b. 1922, London. Lives in London. Educ. St Martin's School of Art and Westminster Technical College (evening classes); 1938-40 and 1946, Royal Academy Schools; 1948-51, Slade School of Art
Solo exh.: 1979, Tate Gallery, London; 1992, Tate Gallery, London
Lit.: *Richard Hamilton* (exh. cat.), Tate Gallery, London, 1992
Photo: Anthony d'Offay Gallery, London

Hamilton Finlay, Ian Scottish Conceptual and installation artist, b. 1925, Nassau, Bahamas. Lives in Stonypath, Scotland. Self-taught
Solo exh.: see Lit.
Lit.: Bann, Stephen, *Ian Hamilton Finlay* (exh. cat.), Arts Council of Great Britain, 1977
Homage to Ian Hamilton Finlay: an Exhibition of Works (exh. cat.), Victoria Miró Gallery, London, 1987
Photo: Burnett Miller Gallery, Los Angeles

Han, Raymond American still-life painter, b. 1931, Honolulu. Educ. Honolulu Academy of Arts; Art Students League, NY
Solo exh.: 1982, Munson Williams Proctor Institute, Utica, NY; 1995, Honolulu Academy of Arts
Lit.: Hornung, David, 'Raymond Han', *Art News*, vol. 88, Dec. 1989
'A Survey of Contemporary American Still Lifes', *American Artist*, vol. 50, Feb. 1986
Photo: Forum Gallery, NY

Hanson, Duane American Super Realist sculptor, b. 1928, Alexandria, Minn. Lives in Davie, Florida. Educ. Macalester College; University of Minnesota; Cranbrook Academy of Art
Solo exh.: see Lit.
Lit.: Bush, Martin H., *Duane Hanson*, Wichita, Kansas, 1976
Duane Hanson: Skulpturen (exh. cat.), Kunsthalle/Kunstverein, Tubingen, 1990-2
Livingstone, Marco, *Duane Hanson* (exh. cat.), Montreal Museum of Fine Arts, 1994
Varnedoe, Kirk, *Duane Hanson*, NY, 1985
Photo: Virlaine Foundation, New Orleans

Haring, Keith American post-Pop painter, 1958-90, b. Kutztown, Pennsylvania, d. NY. Educ. Ivy School of Art, Pittsburgh; 1978-9, School of Visual Arts, NY
Solo exh.: 1990, University Galleries, Illinois State University, Normal, Illinois, and see Lit.
Lit.: Celant, Germano, et al., *Keith Haring*, Munich, 1992
Celant, Germano, *Keith Haring* (exh. cat.), Castello di Rivoli, Turin, Konsthall, Malmö, Deichtorhallen, Hamburg and Museum of Art, Tel-Aviv, 1994-5
Gruen, John, *Keith Haring*, Englewood Cliffs, NJ, 1991
Photo: Tony Shafrazi Gallery, NY

Harris, Philip b. 1965, British painter
Photo: Merz Gallery, London

Hartigan, Grace American painter, b. 1922, Newark, NJ. Lives in Baltimore. Educ. privately
Solo exh.: 1967, University of Chicago
Lit.: Mattison, Robert Saltonstall, *Grace Hartigan: A Painter's World*, NY, 1990
Photo: Dolly Fitterman Fine Arts, Minnesota

Hawley, Steve American Realist painter, b. 1950, Brooklyn, NY. Educ. 1972-3, School of the Museum of Fine Arts, Boston
Solo exh.: see Lit.
Lit.: Lucie-Smith, Edward, *Steve Hawley* (exh. cat.), Alexander F. Milliken Inc., NY, 1984
Photo: the artist

Heizer, Michael American Land artist, b. 1944, Berkeley, CA. Educ. 1963-4, San Francisco Art Institute
Solo exh.: see Lit.
Lit.: *Michael Heizer* (exh. cat.), Museum Folkwang, Essen, 1979
Michael Heizer (exh. cat.), Waddington Galleries, London, 1990
Michael Heizer. Sculpture in Reverse (exh. cat.), Museum of Contemporary Art, Los Angeles, 1984
Photo: Visual Arts Library

Hepher, David British figurative painter, b. 1935, Surrey. Lives in London. Educ. 1955-61, Camberwell School of Art and Slade School of Art, London
Solo exh.: 1971, Serpentine Gallery, London; 1974, Whitechapel Art Gallery, London
Lit.: *David Hepher: New Paintings* (exh. cat.), Flowers East, London, 1989
Photo: Flowers East, London

Hesse, Eva German-American sculptor, 1936-70, b. Hamburg, d. NY. Educ. 1952, High School of Industrial Arts, NY; 1953, Pratt Institute, NY; 1954, Art Students League, NY; 1954-7, Cooper Union, NY; 1957-9, Yale University
Solo exh.: see Lit.
Lit.: Barette, Bill, *Eva Hesse, Sculpture: Catalogue Raisonné*, NY, 1986
Eva Hesse: a Memorial Exhibition (exh. cat.), Solomon R. Guggenheim Museum, NY, 1972
Photo: Milwaukee Art Museum, Gift of Friends of Art, photograph courtesy the Robert Miller Gallery, NY

Hicks, Nicola British figurative sculptor, b. 1960, London. Lives in London. Educ. 1978-82, Chelsea School of Art; 1982-5, Royal College of Art
Solo exh.: see Lit.
Lit.: *Nicola Hicks: Sculpture and Drawings* (exh. cat.), Flowers East at London Fields, 1994
Nicola Hicks: Fire and Brimstone (exh. cat.), Flowers East, London, 1991
Photo: Flowers East, London

Hill, Gary American video artist, b. 1951, Santa Monica, CA. Lives in Seattle. Educ. 1969, Art Students' League, Woodstock, NY. 1973, began working with video. 1974-6, employed as a TV-lab co-ordinator for Woodstock Community Video. 1975-7, Artist-in-Residence at the Experimental Television Center, Binghampton, NY. 1984-5, lived in Japan. 1985, moved to Seattle, established video programme at Cornish College for the Arts
Solo exh.: 1993, Museum of Modern Art, Oxford; 1994, Hirshhorn Museum, Washington DC
Lit.: Devriendt, Christine, *L'Oeuvre vidéo de Gary Hill*, Rennes, 1990-1
Photo: Donald Young Gallery, Seattle

Hirst, Damien British Conceptual artist, b. 1965, Bristol. Lives in London and Berlin
Solo exh.: 1992, Jay and Donatella Chiat, NY; 1993, Jablonka Galerie, Cologne; 1993, Regen Projects, Los Angeles
Lit.: *Damien Hirst* (exh. cat.), Institute of Contemporary Arts, London, and Jay Jopling, London, 1991
Shone, Richard, *Damien Hirst* (exh. cat.), British Council, London, for the Turkish Biennial, Istanbul, 1992
Shone, Richard, *Some Went Mad, Some Ran Away...* (exh. cat.), Serpentine Gallery, London, 1994
Photo: Saatchi Collection, London

Hockney, David British Pop artist, b. 1937, Bradford, England. Lives in Los Angeles and Malibu. Educ. 1953-7, Bradford School of Art; 1959-62, Royal College of Art, London
Solo exh.: see Lit.
Lit.: *David Hockney: A Retrospective* (exh. cat.), Los Angeles County Museum of Art, 1988
Hockney, David, *David Hockney by David Hockney*, London, 1976
Livingstone, Marco, *David Hockney*, NY, 1981
Photos: the artist

Hodgkin, Howard British painter, b. 1932, London. Lives in London. Educ. 1949-50, Camberwell College of Art, London; 1954-6, Bath Academy of Art, Corsham
Solo exh.: 1984, Whitechapel Art Gallery, London, and see Lit.
Lit.: Graham-Dixon, Andrew, *Howard Hodgkin*, London, 1994
Haenlein, Carl, et al., *Howard Hodgkin, Bilder 1973 bis 1984* (exh. cat.), Kestner Gesellschaft, Hanover, 1985
Photo: the artist

Hödicke, Karl Horst German Neo-Expressionist painter, b. 1938, Nuremberg. Lives in Berlin. Educ. 1959, Technische Universität, Berlin; 1959-64, Hochschule für Bildende Künste, Berlin
Solo exh.: 1981, Haus am Waldsee, Berlin; 1977, Badischer Kunstverein, Karlsruhe
Lit.: *K.H. Hödicke: Berliner Ring: Bilder und Skulpturen 1975-1992* (catalogue issued for the Berlin Kunstverein), Stuttgart, 1993
Photos: courtesy Galerie Eva Poll, Berlin; courtesy Studio d'Arte Cannaviello

Holland, Harry British Realist painter, b. 1941, Glasgow. Lives in Cardiff. Educ. 1965-9, St Martin's School of Art, London
Solo exh.: 1991 (retrospective), Newport Art Gallery, Gwent (Welsh Arts Council touring exhibition); Leicester Art Gallery, 1980
Lit.: Lucie-Smith, Edward, *Harry Holland. The Painter and Reality*, London, 1991
Photo: Jill George Gallery, London

Holzer, Jenny American Conceptual artist, b. 1950, Gallipolis, Ohio. Lives in NY. Educ. 1968-70, Duke University, Durham, NC; 1970-1, University of Chicago; 1972-3, Ohio University, Athens; 1975-6, Rhode Island School of Design
Solo exh.: see Lit.
Lit.: Waldman, Diane, *Jenny Holzer* (exh. cat.), Solomon R. Guggenheim Museum, NY, 1989
Photo: Barbara Gladstone Gallery, NY

Horn, Rebecca German installation artist, b. 1944, Michelstadt. Lives in Germany. Educ. 1964-9, Fine Arts Academy, Hamburg; 1971-2, St Martin's School of Art, London
Solo exh.: 1994, Serpentine Gallery and Tate Gallery, London, and Solomon R. Guggenheim Museum, NY
Lit.: Celant, Germano, et al., *Rebecca Horn* (exh. cat.), Solomon R. Guggenheim Museum, NY, 1994
Photo: Marian Goodman Gallery, NY

Hotere, Ralph New Zealand painter, b. 1931, Mitimiti, North Island. Lives in Careys Bay, Port Chalmers. Educ. St Peter's College; Auckland Teachers' College; King Edward Technical College, Dunedin
Solo exh.: see Lit.
Lit.: *Pacific Rim Diaspora* (exh. cat.), Long Beach Museum of Art, 1990
Smith, Peter, *Ralph Hotere: a Survey, 1963-73* (exh. cat.), Dunedin Public Art Gallery, Dunedin, NZ, 1974
Photo: Auckland City Art Gallery, Auckland, NZ

Howe, Delmas American painter, b. 1935, El Paso, Texas. Lives in Truth-or-Consequences, New Mexico. Educ. Yale University; School of Visual Arts, NY; Art Students League, NY
Solo exh.: 1994, Copeland-Rutherford Gallery, Santa Fe
Lit.: Howe, Delmas, *Rodeo Pantheon*, London, 1993
Photo: Copeland Rutherford Fine Art, Santa Fe

Howson, Peter Scottish painter, b. 1958, London. 1962, moved to Scotland. Lives and works in Glasgow. Educ. 1975-7, 1979-81, Glasgow School of Art. 1977-9, various jobs including service in Scottish Infantry. 1981-5, travel in Europe. 1985, Artist in Residence, University of St Andrews
Solo exh.: 1991, McLaurin Art Gallery, Ayrshire; 1993, McLellan Galleries, Glasgow
Lit.: Heller, Robert, *Peter Howson*, Edinburgh and London, 1993
Photo: Flowers East, London

Immendorff, Jörg German Neo-Expressionist painter, b. 1945, Bleckede. Lives in Düsseldorf and Hamburg. Educ. 1963-6, Kunstakademie, Düsseldorf (1964-6 work with Joseph Beuys)
Solo exh.: see Lit.
Lit.: *Jörg Immendorff* (exh. cat.), Museum Boymans-van Beuningen, Rotterdam, 1992
Jörg Immendorff, Malermut Rundum (exh. cat.), Kunsthalle, Berne, 1980
Photo: Michael Werner Gallery, NY and Cologne

Indiana, Robert American Pop artist, b. 1928, New Castle, Indiana. Lives in Vinalhaven, Maine. Educ. John Herron School of Art, Indianapolis; Munson-Williams-Proctor Institute; Art Institute of Chicago; Showhegan School of Painting and Sculpture; University of Edinburgh and Edinburgh College of Art
Solo exh.: 1984, National Museum of American Art, Washington DC
Lit.: Mecklenburg, Virginia M., *Wood Works: Constructions by Robert Indiana*, Washington DC, 1984
Photo: Marisa del Re Gallery, NY

Infante, Francisco Russian Conceptual artist, b. 1943, Vassilyevka, near Moscow. Educ. 1957-62, Surikov Art Institute; 1962-6, Moscow College of Decorative and Applied Arts; 1966-8, Moscow Art School
Solo exh.: see Lit.
Lit.: *Artefakte Francisco Infante* (exh. cat.), Wilhelm Hack Museum, Ludwigshafen, 1989
Photo: International Images, Sewickley, Pennsylvania

Jacquette, Yvonne American Realist painter, b. 1934, Pittsburgh. Lives in NY. Educ.1952-6, Rhode Island School of Design
Solo exh.: see Lit.
Lit.: *Yvonne Jacquette: Recent Drawings and Pastels, 1982-3* (exh. cat.), St Louis Art Museum, St Louis, 1983-4
Photo: Brooke Alexander, NY

Jarman, Derek British painter, film-maker, writer and homosexual activist, 1942-94, d. London. Lived in London and Dungeness
Exh.: see Lit.
Lit.: *Derek Jarman, Evil Queen: the Last Paintings* (exh. cat.), Whitworth Art Gallery, Manchester, 1994
Derek Jarman, Queer (exh. cat.), Manchester City Art Galleries, Manchester, 1992
Photo: Richard Salmon Ltd, London

Jeffries, Neil British figurative sculptor, b. 1959, Bristol. Educ. 1978-82, St Martin's School of art, London
Solo exh.: see Lit.
Lit.: *Neil Jeffries* (exh. cat.), Flowers East, London, 1990
Photo: Flowers East, London

Jenney, Neil American Realist painter (originally a Conceptual artist), b. 1945, Torrington, Conn. Lives in Winchester Center, Conn.
Solo exh.: see Lit.
Lit.: Rosenthal, Mark, *Neil Jenney: Retrospective* (exh. cat.), Berkeley, CA, 1980 Patkin, Izhar, 'Two Artists Sitting under a Tree: chez Neil Jenney's Lumberyard', *Artforum*, vol. 31, Oct. 1992, pp. 80-2
Photo: Foster Goldstrom Gallery, NY

Jimenez, Luis, Jr. American sculptor of Mexican origin, b. 1940, El Paso, Texas. Lives in Hondo, New Mexico. Educ. 1964, University of Texas, Austin; 1964, Ciudad University, Mexico City
Solo exh.: see Lit.
Lit.: *Luis Jimenez, Sodbuster* (exh. cat.), Museum of Fine Arts, Dallas, 1985
Photo: Lew Allen Gallery, Santa Fe, New Mexico

Johns, Jasper American painter, b. 1930, Augusta, Georgia. Lives in upper NY State. Educ. University of South Carolina
Solo exh.: numerous, including Museum of Modern Art, NY, 1968, 1970, 1992
Lit.: Crichton, Michael, *Jasper Johns*, London, 1994
Francis, Richard, *Jasper Johns*, NY, 1984
Jasper Johns: Paintings, Drawings and Sculptures 1954-1964 (exh. cat.), Whitechapel Art Gallery, London, 1964
Kozloff, Max, *Jasper Johns*, NY, 1968
Orton, Fred, *Figuring Jasper Johns*, London, 1994
Rosenthal, Mark, *Jasper Johns: Work Since 1974* (exh. cat.), Philadelphia Museum of Art, 1988
Photo: Margo Leavin Gallery, Los Angeles

Johnson, Ben British painter, b. 1946, Wrexham, North Wales. Lives in London. Educ. Royal College of Art, London
Solo exh.: see Lit.
Lit.: *Ben Johnson: Structuring Space* (exh. cat.), Fischer Fine Art, London, 1986
Photo: Virlaine Foundation, New Orleans

Johnson, Richard A. American abstract illusionist painter, b. 1942, Minneapolis, Minnesota. Educ. 1965, Minneapolis College of Art and Design (BFA); 1967, Washington University, St Louis (MFA); 1967-8, Prix de Rome, Fellowship in Painting, American Academy, Rome
Solo exh.: 1981, Southeastern Center for Contemporary Art, Winston-Salem, North Carolina; 1991, Taylor University Art Museum, Waco, Texas
Lit.: Frank, Peter, *Richard Johnson/John Scott* (exh. cat.), Alexandria Museum of Art, Alexandria, Georgia, 1993
Photo: Galerie Simonne Stern, New Orleans

Jones, Allen British Pop artist, b. 1937, Southampton. Educ. 1955-9, Hornsey College of Art, London; 1959-60, Royal College of Art, London
Solo exh.: 1979, retrospective 1959-1979, Walker Art Gallery Liverpool, touring to Serpentine Gallery, London; 1992-3, Middlesborough Art Gallery
Lit.: *Allen Jones* (exh. cat.), Waddington Galleries, London, 1993
Livingstone, Marco, *Allen Jones, Sheer Magic*, London, 1979
Photo: the artist

Judd, Donald American Minimal sculptor, 1928-93, b. Excelsior Springs, Missouri, d. NY. Educ. 1947-53, Art Students League, NY; 1953, 1958-61, Columbia University
Solo exh.: see Lit.
Lit.: Fuchs, Rudi, et al., *Donald Judd: Spaces* (exh. cat.), Stankowski Foundation, Stuttgart, 1994
Haskell, Barbara, *Donald Judd*, (exh. cat.), Whitney Museum of American Art, NY, 1989
Poetter, Joachim, *Donald Judd* (exh. cat.), Staatliche Kunsthalle, Baden-Baden, 1989
Photos: Margo Leavin Gallery, Los Angeles

Kabakov, Ilya Russian environmental artist, b. 1933, Dniepropetrorsk. Lives in Moscow. Educ. 1945-51, MSCHS School, Moscow; 1951-7, Surikov Institute, Moscow
Solo exh.: 1987, Centre National des Arts Plastiques, Paris; 1988, Kunstmuseum, Berne; 1989, Institute of Contemporary Arts, London
Lit.: *Ilya Kabakov, He Lost his Mind, Undressed, and Ran Away Naked* (exh. cat.), Ronald Feldman Fine Art, NY, 1990
Photo: Ronald Feldman Fine Art, NY

Kahukiwa, Robyn Maori painter, b. Australia, 1940, of Maori descent through her mother. Lives in New Zealand. Trained as a commercial artist with the *Adelaide News*, S. Australia. Returned to New Zealand aged 19. 1972-82, art teacher, Mana College. Full-time artist since 1983
Solo exh.: 1992, Te Taumata Gallery, Auckland; 1993, Jonathan Jensen Gallery, Christchurch
Lit.: *The First Asia-Pacific Triennial of Contemporary Art* (exh. cat.), Queensland Art Gallery, Brisbane, 1993
Photo: the artist

Kapoor, Anish British-Indian sculptor, b. 1954, Bombay. Lives in London. Educ. 1973-7, Hornsey College of Art, London; 1977-8, Chelsea College of Art
Solo exh.: see Lit.
Lit.: *Anish Kapoor: British Pavilion XLIV Venice Biennale* (exh. cat.), British Council, London, 1990
Raye, Helen, *Anish Kapoor* (exh. cat.), Albright-Knox Art Gallery, Buffalo, 1986
Photo: Musée St Pierre, Lyons, courtesy Visual Arts Library

Katz, Alex American painter, b. 1927, NY. Educ. Cooper Union, NY; Showhehan School of Art, Maine
Solo exh.: 1974-5, Whitney Museum of American Art, NY and Virginia Museum of Art
Lit.: Hunter, Sam, *Alex Katz*, NY, 1992
Photo: Visual Arts Library

Keane, John British figurative painter, b. 1954, Hertfordshire. Lives in London. Educ. 1972-6, Camberwell School of Art
Solo exh.: see Lit.
Lit.: Weight, Angela, *Gulf/John Keane* (exh. cat.), Imperial War Museum, London, 1992
Photo: Flowers East, London

Kelley, Mike American Conceptual artist, b. 1954, Detroit. Lives in Los Angeles. Educ. 1976, University of Michigan, Ann Arbor (BFA); 1978, California Institute of the Arts, Valencia (MFA)
Solo exh.: 1991, Hirshhorn Museum and Sculpture Garden, Washington DC; 1992, Kunsthalle, Basle, touring to Portikus, Frankfurt, and Institute of Contemporary Arts, London; 1993, Whitney Museum of American Arts, NY
Lit.: Kellein, Thomas, *Mike Kelley*, Basle and London, 1992
Photo: Rosamund Felsen Gallery, Los Angeles

Kelly, Ellsworth American abstract artist, b. 1923, Newburgh, NY. Educ. 1941-2, Pratt Institute, NY; 1946-8, Boston Museum School; 1948-9, École des Beaux-Arts, Paris
Solo exh.: see Lit.
Lit.: Boehm, Gottfried, *Ellsworth Kelly: Yellow Curve*, Stuttgart, 1992
Cembalest, Robin, 'Ellsworth Kelly, "Everything becomes abstract"', *ArtNews*, vol. 91, Dec. 1992, pp. 98-103
Coplans, John, *Ellsworth Kelly*, NY, n.d.
Ellsworth Kelly: Paintings and Drawings 1963-1979 (exh. cat.), Stedelijk Museum, Amsterdam, 1979
Goosen, E.C., *Ellsworth Kelly* (exh. cat.), Museum of Modern Art, NY, 1972
Photo: Leo Castelli Gallery, NY

Kelly, Mary American feminist Conceptual artist, b. 1941, Minnesota. Lives in London. Educ. in the US and in Italy; 1968-70, St Martin's School of Art, London
Lit.: Kelly, Mary, *Post Partum Document*, London, 1983
Photo: Arts Council of Great Britain, courtesy the artist

Kiefer, Anselm German Neo-Expressionist painter and maker of environments, b. 1945, Donaueschingen. Lives in Buchen (Odenwald). Educ. 1965-6, University of Freiburg (law and French); 1966-8, University of Freiburg (painting); 1969, Akademie der Bildenden Künste, Karlsruhe; 1970-2, Kunstakademie Düsseldorf (under Joseph Beuys)
Solo exh.: 1986, Stedelijk Museum, Amsterdam; 1987, (touring retrospective), Art Institute of Chicago, Philadelphia Museum of Art, Museum of Modern Art, NY
Lit.: Rosenthal, Mark, *Anselm Kiefer: Retrospective* (exh. cat.), Art Institute of Chicago, 1987
Photo: Marian Goodman Gallery, NY

Kienholz, Ed and Nancy American environmental artists (Ed Kienholz 1927-94, b. Fairfield, Washington, d. Hope, Idaho; Nancy Reddin Kienholz b 1943). Roxy's was Kienholz's first major installation, a replica of a 1943 Las Vegas bordello, completed 1961. Married his fifth wife, Nancy Reddin, 1972. She became a collaborator in his later works
Lit.: Pincus, Robert L., *On a Scale that Competes with the World: the Art of Edward and Nancy Reddin Kienholz*, Berkeley, CA, 1990
Photo: L.A. Louver Gallery, Venice, CA

Kim, Jong-Hak Korean painter, b. 1954. Lives in Seoul. Educ. in Paris.
Solo exh.: see Lit.
Lit.: *Recent Paintings by Kim, Jong-Hak* (exh. cat.), Seoul Contemporary Arts Center, 1994
Photo: the artist

Kingelez, Bodys Isek African object-maker, b. 1948, Kimbenbele, Zaire. 1980s, worked as a restorer in the Musée National, Kinshasa.
Solo exh.: 1991, Jean-Marc Patras Galerie, Paris; 1992, Haus der Kulturen der Welt, Berlin
Lit.: *Home and the World: Architectural Sculpture by Two Contemporary African Artists: Aboudramana and Bodys Isek Kingelez* (exh. cat.), Museum for African Art, NY, 1993
Photo: Jean Pigozzi Collection

Kirby, John British painter, b. 1949, Liverpool. Lives in Eire. 1965-7, shipping clerk; 1967-9, salesman in a Catholic bookshop; 1969-71, assistant to the director at Boys Town, Calcutta; 1971-82, a variety of jobs, most in social work, including a period as a probation officer; 1982-5, St Martin's School of Art, London; 1986-8, The Royal College of Art, London
Seven solo exh., the most recent being 1994, *The Company of Strangers*, Flowers East at London Fields, London
Lit.: Lucie-Smith, Edward, *John Kirby: The Company of Strangers*, Edinburgh, 1994
Photo: Flowers East, London

Kirkeby, Per Danish Neo-Expressionist painter, b. 1938, Copenhagen. Lives in Copenhagen. Educ. 1957-64, University of Copenhagen (studying geology); 1962, Experimental Art School, Copenhagen
Solo exh.: see Lit.
Lit.: *Per Kirkeby: Recent Painting and Sculpture* (exh. cat.), Whitechapel Art Gallery, London, 1985
Photo: Michael Werner Gallery, NY and Cologne

Kitaj, R.B. American 'School of London' painter (originally often classified as a Pop artist), b. 1932, Chagrin Falls, Ohio. Lives in London. Educ. 1960, Ruskin School of Art, Oxford; 1962, Royal College of Art, London
Solo exh.: see Lit.
Lit.: Livingstone, Marco, *R.B. Kitaj*, Oxford, 1985
Morphet, Richard, et al., *R.B. Kitaj: a Retrospective* (exh. cat.), Tate Gallery, London, 1994
Rios, Julián, *Kitaj; Pictures and Conversations*, London, 1994
Photo: Visual Arts Library

Kiyomisu, Kyube Japanese sculptor, b. 1922
Solo exh.: see Lit.
Lit.: *Kyube Kiyomisu* (exh. cat.), Sakura Gallery, Nagoya, 1988
Photo: Fuji Television Gallery, Tokyo

Klapheck, Konrad German painter, b. 1935, Düsseldorf. Lives in Düsseldorf. Educ. Kunstakademie, Düsseldorf
Solo exh.: 1985 (touring retrospective), Kunsthalle, Hamburg, Kunsthalle, Tubingen, Staatsgalerie moderner Kunst, Munich
Lit.: *Klapheck: peintures et dessins* (exh. cat.), Galerie Lelong, Paris, 1990
Photo: Edward Thorp Gallery, NY

Klein, Yves French 'New Realist', 1928-62, b. Nice, d. Paris. Educ. 1944-6, École Nationale de la Marine Marchande and École Nationale des Langues Orientales, Nice; 1952-3, Kodokan Institute, Tokyo (studying judo)
Solo exh. (retrospectives): see Lit.
Lit.: Restany, Pierre, *Yves Klein*, NY, 1982
Yves Klein (exh. cat.), Centre Georges Pompidou, Paris, 1983
Yves Klein (exh. cat.), The Jewish Museum, NY, 1967
Photo: Virlaine Foundation, New Orleans

Koberling, Bernd German Neo-Expressionist painter, b. 1938, Berlin. Lives in Berlin. Educ. 1958-60, Hochschule für Bildende Künste, Berlin
Solo exh.: 1986, Aarhus Kunstmuseum, Aarhus, and Kunstverein Braunschweig; 1985, Bielefelder Kunstverein, Bielefeld
Lit.: Krempel, Ulrich, *Bernd Koberling*, Stuttgart, 1991
Photo: Studio d'arte Cannaviello, Milan

Komar and Melamid Russian perestroika artists (Vitali Komar b. 1943, Moscow; Aleksandr Melamid b. 1946, Moscow). Both live in NY. Both Educ. Stroganov Institute of Art and Design, Moscow
Solo exh.: 1990, Brooklyn Museum, NY
Lit.: Ratcliff, Carter, *Komar & Melamid*, NY, 1988
Photo: Ronald Feldman Fine Arts, NY

Koons, Jeff American post-Pop artist, b. 1955, York, Pa. Lives in NY. Educ. Maryland Institute of Art, Baltimore; 1975-6, Art Institute of Chicago. Spent five years as a Wall Street commodities broker
Solo exh.: see Lit.
Lit.: *Jeff Koons* (exh. cat.), San Francisco Museum of Modern Art, 1992
Koons, Jeff, *The Jeff Koons Handbook*, London, 1992
Photo: the artist

Kopistianskaya, Svetlana Russian perestroika artist, b. 1950, Voronesh. Lives in Lvov. Educ. Faculty of Architecture of the Polytechnic Institute, Lvov
Exh.: see Lit.
Lit.: *Artisti Russi Contemporanei: Contemporary Russian Artists* (exh. cat.), Museo d'Arte Contemporanea, Prato, 1990
Photo: Phyllis Kind Gallery, NY and Chicago

Kopistiansky, Igor Russian perestroika artist, b. 1954, Lvov. Lives in Lvov. Educ. School of Art, Lvov
Solo exh.: Kunsthalle, Innsbruck
Lit.: *Artisti Russi Contemporanei: Contemporary Russian Artists* (exh. cat.), Museo d'Arte Contemporanea, Prato, 1990
Photo: Phyllis Kind Gallery, NY and Chicago

Kossoff, Leon British 'School of London' painter, b. 1926, London. Lives in London. Educ. 1949-53, St Martin's School of Art, also studied 1950-2 with David Bomberg at the Borough Polytechnic
Solo exh.: 1981, Whitechapel Art Gallery, London; 1981, Museum of Modern Art, Oxford
Lit.: *Leon Kossoff* (exh. cat.), Anthony d'Offay Gallery, London, 1988
Photo: Visual Arts Library

Kostabi, Mark American Conceptual and post-Pop artist, b. 1960, Los Angeles. Lives in NY. Educ. 1978, Fullerton Community College, CA; 1979-81, California State University, Fullerton
Solo exh.: 1981, Newport Harbor Museum of Art, Newport Beach, CA
Lit.: Politi, Gian Carlo, and Helena Kontova, 'Mark Kostabi' (interview), *Flash Art International*, no. 153, summer 1990
Photo: Ergane Gallery, NY

Kosuth, Joseph American Conceptual artist, b. 1943, Toledo, Ohio. Lives in NY. Educ. 1955-62, Toledo Museum School of Design; 1963-4, Cleveland Art Institute; 1965-7, School of Visual Arts, NY
Solo exh.: 1990, Brooklyn Museum, NY
Lit.: *Joseph Kosuth, Art after Philosophy and after: Collected Writings 1966-1990*, Cambridge, Mass., and London, 1991
Photo: Margo Leavin Gallery, Los Angeles

Kounellis, Jannis Greek-Italian 'Arte Povera' sculptor, b. 1936, Piraeus, Greece. 1956, emigrated to Italy. Lives in Rome. Educ. Accademia di Belle Arti, Rome
Solo exh.: see Lit.
Lit.: Friedel, Helmut, *Jannis Kounellis* (exh. cat.), Städtische Galerie im Lenbachhaus, Munich
Haenlein, Carl, ed., *Jannis Kounellis: Frammenti di Memoria* (exh. cat.), Kestner-Gesellschaft, Hanover, 1991
Jannis Kounellis (exh. cat.), Museo di Rivoli, Turin, 1988
Jannis Kounellis: Esposizione di Paesaggi Ivernali (exh. cat.), Palazzo Fabroni, Pistoia, 1994
Moure, Gloria, *Kounellis*, Barcelona, 1990
Photo: Salvatore Ala Gallery, NY

Kruger, Barbara feminist Conceptual artist, b. 1945, Newark, NJ. Lives in NY. Educ. Syracuse University; Parsons School of Design, NY; School of the Visual Arts, NY
Solo exh.: 1990, Duke University Art Museum, Durham, NC
Lit.: *Barbara Kruger* (exh. cat.), National Art Gallery, Wellington, New Zealand, 1988
Linker, Kate, *Love for Sale: The Words and Pictures of Barbara Kruger*, NY, 1990
Photo: Mary Boone Gallery, NY

Krut, Ansel British figurative painter, b. 1959, Cape Town, South Africa. Lives in London. Educ. 1983-6, Royal College of Art, London
Solo exh.: see Lit.
Lit.: *Ansel Krut* (exh. cat.), Fischer Fine Art, London, 1989
Photo: Jason/Rhodes Gallery, London

Kubota, Matasaka Japanese painter, b. 1945
Solo exh.: see Lit.
Lit.: *Kubota* (exh. cat.), Kodama Gallery, Osaka, 1989
Photo: Kodama Gallery, Osaka

Kudryashov, Oleg Russian printmaker, b. 1932, Moscow. Lives and works in London. Educ. 1942-7, IZO (State Art Studio), Moscow; 1949-51, Moscow Art School. 1953-6, National Service, Red Army. 1956-8, Moscow Animation Film Studios. 1958-74, member of the Moscow Union of Soviet artists. 1974, emigrated to London
Solo exh.: 1992, Pushkin Museum of Fine Arts, Moscow; 1990, The Central House of Artists, Moscow; 1988, The Douglas Hyde Gallery, Trinity College, Dublin; 1983, Riverside Studios, London
Lit.: *Oleg Kudryashov* (exh. cat.), Riverside Studios, London, 1982
Photo: the artist

Kuitca, Guillermo Argentinian painter, b. 1961, Buenos Aires. Lives in Buenos Aires. First exh. his work at the age of 13. Worked in the early 1980s as a theatre director and designer
Solo exh.: 1990, Witte de With Center for Contemporary Art, Rotterdam; 1991, Museum of Modern Art, NY
Lit.: Becce, Sonia, *Kuitca*, Buenos Aires, 1989
Photo: Annina Nosei Gallery, NY

Kusama, Yayoi Japanese-American environmental artist, b. 1941, Matsumoto City. Lives in the US. Educ. 1948-51, Arts and Crafts School, Kyoto; 1957-8, Art Students League, Brooklyn Arts School, and Washington Irving School, all in NY
Solo exh.: 1989, Center for International Contemporary Arts, NY, and Museum of Modern Art, Oxford
Lit.: Karia, Bhupendra, *Yayoi Kusama: a Retrospective* (exh. cat.), Center for International Contemporary Arts, NY, 1989
Minamura, Toshaki, *Yayoi Kusama* (exh. cat.), Tokyo, 1986
Photo: Fuji Television Gallery, Tokyo

La Noue, Terence American painter, b. 1941, Hammond, Indiana. Educ. 1964, Ohio Weslyan University; 1965, Hochschule für Bildende Kunste, Berlin; Cornell University, Ithaca, NY
Solo exh.: 1977, Philadelphia Museum of Art
Lit.: Ashton, Dore, *Terence La Noue*, NY, 1992
Photo: Zolla/ Lieberman Gallery, Chicago

Laib, Wolfgang German environmental artist, b. 1950, Metzingen. Educ. 1968-74, Tübingen University (medical studies)
Solo exh.: 1981, Staatliche Kunsthalle, Baden-Baden, and see Lit.
Lit.: *Wolfgang Laib* (exh. cat.), Kunstmuseum, Lucerne, 1990
Photo: Galerie des Beaux-Arts, Brussels

Larraz, Julio Cuban-American painter, b. 1944, Havana. Lives in Miami. Arrived in the US in 1961, and began painting in 1967. Has lived in Grandview, NY, and in Paris
Solo exh.: 1983, Wichita Falls Museum and Art Center, Texas; 1986, Museo de Arte Moderna, Bogotá; 1987, Museo de Monterrey, Mexico
Lit.: *Outside Cuba, Fuera de Cuba* (exh. cat.), Zimmerli Art Museum, Rutgers University, New Brunswick, NJ, 1987
Photo: Nohra Haime Gallery, NY

Ledy, Cheïk African painter, b.1962, Kinto M'Vuila, Zaire. Lives and works in Kinshasa. Began painting in 1977 as the assistant of his brother, Chéri Samba, before setting up his own studio
Lit.: *Africa Now: The Jean Pigozzi Collection* (exh. cat.), Groninger Museum, Groningen, 1991
Photo: The Jean Pigozzi Collection

Lee, Sadie British painter and lesbian activist, b. 1967, York. Lives in London. Educ. 1986, Epsom School of Art
Exh.: 1994, Manchester City Art Galleries
Lit: Cooper, Emmanuel, *A Sexual Perspective*, 2nd edn, London, 1994
Photo: Jill George Gallery, London

Leirner, Jac Brazilian Conceptual artist, b. 1961, São Paulo. Lives in São Paulo. Educ. 1979-84, Fundaçao Armando Alvarez Penteado, São Paulo
Solo exh.: 1991-2, Museum of Modern Art, Oxford, Institute of Contemporary Arts, Boston, and the Walker Art Center, Minneapolis
Lit.: Ferguson, Bruce, *Viewpoints: Jac Leirner* (exh. cat.), Walker Art Center, Minneapolis, 1992
Photo: Museum of Modern Art, Rio de Janeiro

Lemieux, Annette American Conceptual artist, b. 1957, Norfolk, VA. Lives in NY. Educ. 1977, Northwestern Connecticut Community College; 1978, Hartford Art School, University of Hartford
Solo exh.: 1988, Wadsworth Atheneum, Hartford, Conn.; 1989, John and Mable Ringling Art Museum, Sarasota, Fla.
Lit.: Armstrong, Richard, *Mind over Matter: Concept and Object* (exh. cat.), Whitney Museum of American Art, NY, 1990
Photo: Josh Baer Gallery, NY

Leonard, Michael British figurative painter, b. 1933, Bangalore, India. Lives in London. Educ. 1954-7, St Martin's School of Art, London
Solo exh. (retrospectives): 1977, Gemeentemuseum, The Hague; 1989, Artsite Gallery, Bath
Lit.: Lucie-Smith, Edward, *Changing II: Drawings by Michael Leonard*, London, 1992
Michael Leonard, Paintings, London, 1985
Photo: the artist

LeWitt, Sol American Minimal sculptor, b. 1928, Hartford, Conn. Lives in NY. Educ. 1949, Syracuse University, NY
Solo exh.: see Lit.
Lit.: LeWitt, Sol, *Autobiography*, NY and Boston, 1980
Reynolds, Jock, *Sol LeWitt: Twenty-Five Years of Wall Drawings, 1968-1993* (exh. cat.), Addison Gallery of American Art, Andover, 1993
Sol LeWitt (exh. cat.). Museum of Modern Art, NY, 1978
Sol LeWitt, Drawings 1958-1992 (exh. cat.), Haags Gemeentemuseum, The Hague, 1992
Sol LeWitt: Structures 1962-1993 (exh. cat.), Museum of Modern Art, Oxford, 1993
Sol LeWitt: Walldrawings, 1984-1988 (exh. cat.), Kunsthalle, Berne, 1993
Photos: Lisson Gallery, London; Donald Young Gallery, Seattle

Lichtenstein, Roy American Pop artist, b. 1923, NY. Educ. 1946-9, Ohio State University
Solo exh.: see Lit.
Lit.: Adelman, Bob, *The Art of Roy Lichtenstein: Mural with Blue Brushstroke*, London, 1994
Alloway, Lawrence, *Roy Lichtenstein*, NY, 1983
Cowart, Jack, *Roy Lichtenstein, 1970-1980*, NY, 1981
Roy Lichtenstein (exh. cat.), Musée d'Art, Lausanne, 1993
Waldman, Diane, *Roy Lichtenstein*, NY, 1993
Photo: Leo Castelli Gallery, NY

Ligare, David American Post-Modern painter, b. 1945, Oak Park, Illinois. Lives in Salinas, CA. Educ. Art Center College of Design, Los Angeles
Solo exh.: 1984, University Art Museum, University of California, Santa Barbara
Lit.: Lucie-Smith, Edward, *American Realism*, London and NY, 1994
Photo: the artist

Liu Wei Chinese painter, b. 1965, Beijing. Lives in Beijing. Educ. 1989 (graduated) Mural Painting Department, Central Academy of Fine Arts, Beijing
Exh.: 1994, Marlborough Fine Art, London
Lit.: *China's New Art, Post-1989* (exh. cat.), Hanart T Z Gallery, Hong Kong, 1993
Photo: Marlborough Fine Art (London) Ltd

Locke, Hew British Afro-Caribbean sculptor, b. 1959, London, of Guyanese parents. Spent his childhood in Guyana before returning to live in London. Educ. (graduated 1994), Royal College of Art, London
Photo: the artist

Long, Richard British environmental, Conceptual and site-specific sculptor, b. 1945, Bristol. Educ. 1962-5, West of England College of Art, Corsham; 1966-8, St Martin's School of Art, London
Solo exh.: see Lit.
Lit.: *Richard Long, Walking in Circles* (exh. cat.), South Bank Centre, London, 1991
Photo: Donald Young Gallery, Seattle

Lopez-García, Antonio Spanish Realist painter, b. 1936 Tomelloso, Ciudad Real. Lives in Madrid. Educ. with his uncle, Antonio Lopez-Torres, then 1950-5, Escuelas de Bellas Artes, San Fernando, Madrid. 1956, travelled to Italy and Greece
Solo exh.: 1956, Sal de Exposiciones de Ateneo, Madrid; 1985, Musée d'Art Moderne, Brussels; 1985, Museo de Albacete, Spain
Lit.: *Antonio Lopez-García: Paintings, Sculptures and Drawings 1965-1986* (exh. cat.), Marlborough-Gerson Gallery, NY, 1986
Photo: Claude Bernard Gallery Ltd, NY

Lüpertz, Markus German Neo-Expressionist artist, b. 1941, Liberec, Bohemia (now in the Czech Republic). Lives in Berlin and Düsseldorf. Educ. 1955-63, Werkunstschule, Krefeld; Kunstakademie, Krefeld; Kunstakademie, Düsseldorf
Solo exh. (retrospective): 1987, Museum Boymans-van Beuningen, Rotterdam
Lit.: *Markus Lüpertz* (exh. cat.), Städtische Galerie im Lenbachhaus, Munich, 1986
Photo: Michael Werner Gallery, NY and Cologne

McClean, Bruce British Neo-Expressionist artist, b. 1944, Glasgow. Educ. Glasgow Art College; St Martin's School of Art
Solo exh.: 1985, Tate Gallery, London; 1989, Museum van Hedendaagse Kunst, 's-Hertogenbosch
Lit.: Gooding, Mel, *Bruce McClean*, Oxford, 1990
Photo: Anthony d'Offay Gallery, London

McCollum, Alan American Conceptual artist, b. 1944, Los Angeles. Lives in NY
Lit.: *Allan McCollum: Perfect Vehicles* (exh. cat.), The John and Mabel Ringling Museum, Sarasota, Florida, 1988
Goldstein, Anne and Mary Jane Jacob, *A Forest of Signs* (exh. cat.), Museum of Contemporary Art, Los Angeles, 1987
Photo: Virlaine Foundation, New Orleans

McComb, Leonard British figurative painter and sculptor, b. 1930, Glasgow. Lives in London. Educ. 1945-7, Junior Arts School, Manchester; 1954-6, Regional College of Art, Manchester; 1956-60, Slade School of Art, London
Solo exh.: see Lit.
Lit.: *Leonard McComb: Drawings, Paintings, Sculpture* (exh. cat.), Serpentine Gallery, London, 1983
Photo: the artist

McCracken, John American Minimal artist, b. 1934, Berkeley, CA. Lives in Los Angeles. Educ. 1962, California College of Arts and Crafts
Solo exh.: 1987, Newport Harbor Art Museum
Lit.: Leffingwell, Edward, ed., *The Sculpture of John McCracken* (exh. cat.), PS 1 Gallery, NY, 1986
Photo: L.A. Louver Gallery, Venice,CA

McFadyen, Jock Scottish Neo-Expressionist painter, b. 1950. Paisley. Lives in London. Educ. 1973-4, Chelsea College of Art, London
Solo exh.: 1991-2 (touring), Imperial War Museum, London, Glasgow Kelvingrove Art Gallery, Manchester City Art Gallery; 1988, Harris Museum and Art Gallery, Preston
Lit.: Lubbock, Tom, *Fragments from Berlin* (exh. cat.), Imperial War Museum, London, 1991
Photo: Flowers East, London

Mach, David British Conceptual and environmental sculptor, b. 1956, Methil, Scotland. Educ. 1974-9, Duncan of Jordanstone College of Art; 1979-82, Royal College of Art, London
Solo exh.: see Lit.
Lit.: *David Mach* (exh. cat.), Tate Gallery, London, 1988
Photo: Barbara Toll Fine Art, NY

McKenna, Stephen British painter, b. 1939, London. Lives in Rome and Donegal. Educ. 1959-64, Slade School of Art, London
Solo exh.: 1985, Institute of Contemporary Arts, London; 1986 Städtische Kunsthalle, Düsseldorf
Lit.: *Stephen McKenna* (exh. cat.), Museum of Modern Art, Oxford, 1983

McMillen, Michael American sculptor, b. 1946, Los Angeles. Educ. California State University, Northridge; University of California, Los Angeles
Solo exh.: 1977, Los Angeles County Museum; 1978 Whitney Museum of American Art, NY
Lit.: Knight, Christopher, 'Michael C. McMillen', *Art & Architecture*, fall 1981
Photo: L.A. Louver Gallery, Venice, CA

Magee, James American sculptor, b. 1946, Fremont, Michigan. Lives in El Paso. Educ. Alma College (BA)
Solo exh.: 1992, San Antonio Museum of Art, San Antonio, and Diverse Works, Houston, Texas; 1993, El Paso Museum of Art, Texas
Lit.: *James Magee* (exh. cat.), San Antonio Museum of Art, San Antonio, Texas
Sherman, Sandra, 'Titles-Entitlement: Rhetoric and Reappropriation in the Art of James Magee', *Pre-Text: Journal of Rhetorical Theory*, vol. 14.1-2, summer 1994
Photo: the artist

Mangold, Robert American painter, b. 1937, North Tonawanda, NY. Educ. 1956-60, Cleveland Art Institute; 1959-63, Yale University
Solo exh.: 1992, Allen Memorial Art Museum, Oberlin, Ohio, and Le Consortium, Dijon, France
Lit.: Kertess, Klaus, *Robert Mangold: the Attic Series* (exh. cat.), Pace Gallery, NY, 1992
Photo: Donald Young Gallery, Seattle

Manzoni, Piero Italian Minimal and Conceptual artist, 1933-63, b. Soncino. Educ. Accademia di Brera, Milan
Solo exh. (retrospectives): 1971, Galleria Nazionale d'arte Moderna, Rome; 1974, Tate Gallery, London
Lit.: Battino, Freddy, *Piero Manzoni: catalogue raisonné*, Milan, 1991
Photo: Galerie Marie-Puck Broodthaers, Brussels

Mapplethorpe, Robert American photographer, 1946-89, b. NY, d. Boston. Educ. 1963-70, Pratt Institute, NY
Solo exh. (retrospective): Whitney Museum of American Art, NY, 1988
Lit.: Celant, Germano, *Mapplethorpe* (exh. cat.), Louisiana Museum, Humlebaek, 1992
Celant, Germano, *Mapplethorpe versus Rodin*, Milan, 1992
Danto, Arthur C., *Mapplethorpe*, NY, 1992
Photo: Robert Mapplethorpe Foundation

Marden, Brice American abstract artist, b.1938, Bronxville, NY. Educ. Boston University; Yale University
Solo exh.: see Lit.
Lit.: *Brice Marden: Paintings, Drawings and Etchings* (exh. cat.), Kassel and NY, 1993
Richardson, Brenda, *Brice Marden: Cold Mountain*, Houston, 1992
Photo: Mary Boone Gallery, NY

Mariani, Carlo Maria Italian Post-Modern painter, b. 1931, Rome. Lives in Rome. Educ. Accademia dei Belle Arti, Rome
Solo exh.: 1979, Kunsthalle, Cologne
Lit.: Mussa, Italo, *Carlo Maria Mariani*, Rome, 1980
Photo: Studio d'Arte Cannaviello, Milan

Marquez, Roberto Mexican painter, b. 1959, Mexico City. Lives in Jersey City, NJ. Educ. 1978-83, Instituto Tecnológico de Estudios Superiores de Occidente, Guadalajara
Solo exh.: see Lit.
Lit.: Sullivan, Edward J., *Roberto Marquez: Sojourns in the Labyrinth* (exh. cat.), Tucson Museum of Art, Arizona, 1994
Photo: Riva Yares Gallery, Scottsdale, Arizona and Santa Fe, New Mexico

Martin, Agnes American abstract painter, b. 1912, Maklin, Saskatchewan, Canada. US Citizen. Lives in Lamy, New Mexico. Educ. Columbia University; University of New Mexico
Solo exh.: see Lit.
Lit.: *Agnes Martin* (exh. cat.), Whitney Museum of American Art, NY, 1992
Photo: Pace-Wildenstein, NY

Mason, Robert British figurative painter, b. 1946, Leeds. Lives in London. Educ. 1963-5, Harrogate School of Art; 1965-8 Hornsey College of Art, London
Solo exh.: 1986, Yale Center for British Art, New Haven
Lit.: *Robert Mason: Broadgate Paintings and Drawings 1989-90*, London, 1990
Photo: the artist

Mendieta, Ana Cuban Conceptual artist, 1948-85, b. Havana, d. NY. Educ. University of Iowa
Solo exh. (retrospectives): 1987-8, The New Museum of Contemporary Art, NY; 1992, Cleveland Center for Contemporary Art, Cleveland, Ohio
Lit.: Barreras del Rio, Petra, and John Perreault, *Ana Mendieta: A Retrospective* (exh. cat.), The New Museum of Contemporary Art, NY, 1992
Spero, Nancy, 'Tracing Ana Mendieta', *Artforum*, April 1992
Photo: Laura Carpenter Fine Art, Santa Fe

Merz, Mario Italian 'Arte Povera' artist, b.1925, Milan. Lives in Turin. 1945, imprisoned for his activities as a partisan. Self-taught
Solo exh.: see Lit.
Lit.: *Mario Merz* (exh. cat.), Albright-Knox Art Gallery, Buffalo, 1984
Szeeman, Harald, *Mario Merz*, 2 vols., Zurich, 1985
Photo: Margo Leavin Gallery, Los Angeles

Messager, Annette French Conceptual and environmental artist, b. 1943, Berck. Lives in Malakoff. Educ. 1962-6, École Nationale Supérieure des Arts Décoratifs, Paris
Solo exh.: 1981, Museum of Modern Art, San Francisco; 1983, Musée des Beaux-Arts, Calais; 1984, ARC/Musée d'Art Moderne de la Ville de Paris
Lit.: Pagé, Suzanne, *Annette Messager* (exh. cat.), Musée d'Art Moderne de la Ville de Paris, 1984
Messager, Annette, *La Femme et …*, Geneva, 1975
Photo: Josh Baer Gallery, NY

Milow, Keith British Conceptual artist, b. 1945, London. Lives in NY. Educ. 1962-7 Camberwell School of Art, London;1967-8, Royal College of Art, London
Solo exh.: 1975, Arnolfini Gallery, Bristol; 1976, Kettles Yard, Cambridge; 1977, Walker Art Gallery, Liverpool
Lit.: *Keith Milow, One Hundred Drawings 1988-1989* (exh. cat.), Nigel Greenwood Gallery, London, 1989
Seymour, Anne, *The New Art* (exh. cat.), Hayward Gallery, London, 1972
Photo: Nohra Haime Gallery, NY

Mitchell, Joan American Abstract Expression painter, 1926-93, b. Chicago, d. Vétheuil, France. Educ. Smith College, Northampton, Mass.; 1944-7, Art Institute of Chicago
Solo exh.: 1971, Everson Museum, Syracuse, NY; 1974, Whitney Museum of American Art, NY
Lit.: Bernstock, Judith E., *Joan Mitchell*, NY, 1988
Storr, Robert, and Yves Michaud, *Joan Mitchell* (exh. cat.), Musée des Beaux-Arts, Nantes and Galerie Nationale du Jeu de Paume, Paris, 1994
Photo: Robert Miller Gallery, NY

Moiseenko, Evsei Russian painter, b. 1916. Lives in St Petersburg. Educ. 1931-5, Moscow Kalinin Technical Institute for Art and Industry; 1947, Repin School for Painting, Sculpture and Architecture, Leningrad
Solo exh.: 1985, Russian Museum, Leningrad
Lit.: *Russische und Sowjetische Kunst – Tradition und Gegenwart: Werke aus sechs Jahrhunderten* (exh. cat.), Kunstverein für die Rheinlande und Westfalen und Städische Kunsthalle, Düsseldorf, Staatsgalerie, Stuttgart and Kunstverein, Hanover, 1984-5

Monks, John British figurative painter, b. 1954, Manchester. Lives in London. Educ. 1972-5, Liverpool College of Art; 1975-6, John Moores Scholarship, Liverpool; 1977-80, Royal College of Art, London
Solo exh.: 1989, Cleveland Gallery, Middlesborough, and Bluecoat Gallery, Liverpool; 1991, Lanchester Gallery, Coventry Polytechnic; 1993, Manchester City Art Galleries
Lit.: *John Monks* (exh. cat.), Introduction by David Lee, Beaux-Arts Gallery, London, 1994
John Monks: Paintings 1990-93 (exh. cat.), Manchester City Art Galleries and Paton Gallery, London, 1994
Photo: the artist

Morimura, Yasumasa Japanese Conceptual artist, b. 1951, Osaka. Lives in Osaka. Educ. Kyoto City University of Art
Exh.: see Lit.
Lit.: Cooke, Lynne, *Reorienting: Looking East* (exh. cat.), Third Eye Centre, Glasgow, 1990
Deitch, Jeffrey, and Dan Friedman, eds., *Artificial Nature* (exh. cat.), Deste Foundation for Contemporary Art, Athens, Geneva and NY, 1990
Photo: Luhring-Augustine, NY

Morley, Malcolm British painter, b. 1931, London. Lives in the United States. Educ. 1953, Camberwell School of Arts and Crafts, London; 1957, Royal College of Art, London
Solo exh. (touring retrospective): 1983-4, Whitechapel Art Gallery, London, Kunsthalle, Basel, Boymans-van Beuningen Museum, Rotterdam, Corcoran Art Gallery, Washington DC, Museum of Contemporary Art, Chicago, Brooklyn Musem, NY
Lit.: Sylvester, David, *Malcolm Morley* (exh. cat.), Anthony d'Offay Gallery, London, 1990
Photo: Visual Arts Library

Moroles, Jesús Bautista Mexican-American sculptor, b. 1950, Corpus Christi, Texas. Lives in Rockport, Texas. Educ. 1975, El Centro College, Dallas; 1978, North Texas State University, Denton
Solo exh.: 1992, Museum of South-East Texas, Beaumont, Texas
Lit.: Beardsley, John, and Jane Livingstone, *Hispanic Art in the United States* (exh. cat.), Museum of Fine Arts, Houston, 1987
Chaplik, Dorothy, 'Jesús Bautista Moroles', *Latin American Art*, fall 1991
Photo: the artist

Morris, Robert American sculptor, originally Minimal, now figurative, b. 1931, Kansas City. Educ. 1948-50, Kansas City Art Institute; 1948-50, University of Kansas City (engineering degree); 1953-5, Reed College, Oregon; 1955 San Francisco Art Institute; 1962-3, Hunter College, NY
Solo exh.: 1992, Museum of Contemporary Art, Chicago
Lit.: Berger, Maurice, *Robert Morris, Minimalism and the 1960s*, NY, 1989
Photos: Margo Leavin Gallery, Los Angeles; Leo Castelli Gallery, NY

Morrison, Petrona Jamaican sculptor, b. 1954, Manchester, Jamaica. Lives and works in Kingston, Jamaica. Educ. 1976, McMaster University, Ontario, Canada (BFA); 1986, Howard University, Washington (MFA)
Solo exh.: 1991, Maconde Gallery, Kingston
Lit.: Archer Straw, Petrine, *Home and Away: Seven Jamaican Artists* (exh. cat.), October Gallery, London, 1994
Photo: October Gallery, London

Moses, Ed American abstract painter, b. 1926, Long Beach, CA. Lives in Venice, CA. Educ.1955-8, University of California, Los Angeles
Solo exh.: 1990, Santa Monica Heritage Museum, Santa Monica, CA
Lit.: Koplos, Janet, 'Slow motion', *Art in America*, vol. 80, June 1992
Photo: L.A. Louver Gallery, Venice, CA

Moskowitz, Robert American abstract painter, b. 1935, NY. Lives in NY
Solo exh.: 1979, La Jolla Museum of Contemporary Art
Lit.: Rifkin, Ned, *Robert Moskowitz*, London and Washington DC, 1989
Photo: Blum Helman Gallery, NY

Mosset, Olivier Swiss Minimal artist, b. 1944, Berne. Lives in NY. Educ. several Swiss schools (until 1965), and also worked with Tinguely, Spoerri and Arman
Solo exh.: 1987, Musée St-Pierre d'Art Contemporain, Lyons; 1986, Aargauer Kunsthaus, Aargau, Switzerland; 1985, Musée des Beaux-Arts, La Chaux-de-Fonds, Switzerland
Lit.: Eirenhofer, Nancy, *Painting About Painting* (exh. cat.), William Paterson College, Wayne, NJ, 1981
Photo: John Gibson Gallery, NY

Muafangejo, John Namibian printmaker, 1943-87, b. Ovamboland, Angola, d. Katutura, Namibia. Educ. 1978-9, Rorke's Drift Center, Natal
Solo exh.: 1991-2, travelling retrospective organized by the Museum of Modern Art, Oxford
Lit.: Levinson, Orde, ed., *I Was Lonleyness – The Complete Graphic Works of John Muafangejo*, Cape Town, 1992
Photo: private collection

Murakami, Takashi Japanese painter, b. 1962, Tokyo. Educ. 1986, Tokyo National University of Fine Arts and Music (BFA); 1988, Tokyo National University (MFA); 1993, Tokyo National University (DPhil)
Solo exh.: 1991, Art Gallery of Tokyo National University of Fine Arts and Music; 1992, Rontgen Kunst Institut, Tokyo; 1993, Hiroshima Museum of Contemporary Art
Photo: Scai The Bathhouse Shiraishi Contemporary Art Inc., Tokyo

Murray, Elizabeth American painter, b. 1940, Chicago. Educ. 1962, Art Institute of Chicago; 1964, Mills College, Oakland
Solo exh.: 1990, Cleveland State University; 1990, University of Wisconsin, Milwaukee; 1990, Arkansas Art Center, Little Rock
Lit.: Graze, Sue, and Kathy Halbreich, *Elizabeth Murray* (exh. cat.), Museum of Contemporary Art, Los Angeles, 1987
Photo: Paula Cooper Gallery, NY

Nagel, Andres Spanish figurative sculptor and printmaker, b. 1947, San Sebastián. Lives in San Sebastián. Educ. 1965-71, University of Navarre, Pamplona (studying architecture)
Solo exh.: 1990, Meadows Art Museum, Dallas, and Modern Museum of Art, Santa Ana, CA; 1991, Museo Rufino Tamayo, Mexico City, and Museo de Monterrey, Mexico
Lit.: Lucie-Smith, Edward, *Andres Nagel*, NY, 1992
Photo: Tasende Gallery, La Jolla

Nakagawa, Naoto Japanese painter, b. 1944
Solo exh.: 1994, Victoria Munroe Gallery, NY
Lit.: Koplos, Janet, review in *Art in America*, vol. 82, April 1994
Photo: Fuji Television Gallery, Tokyo

Narahara, Takashi Japanese sculptor, b. 1930, Mito. Lives in Sweden. Educ. Mushashino Art University
Solo exh.: 1982, Kristianstad Museum; 1985, Tonenilla Art Hall
Lit.: *Narahara* (exh. cat.), Galerie Denise René, Paris, 1987
Photo: Galerie Denise René, Paris

Natkin, Robert American abstract painter, b.1930, Chicago. Lives in West Redding, Conn. Educ. 1970, Kansas City Art Institute; 1973, University of California, Davis
Solo exh.: 1990, Seattle Art Museum (and travelling)
Lit.: Fuller, Peter, *Robert Natkin*, NY, 1981
Natkin, Robert, *Subject Matter and Abstraction – in Exile*, St Albans, 1993
Photo: the artist

Nauman, Bruce American Conceptual and environmental artist, b. 1941, Wayne, Indiana. Educ. 1964, University of Wisconsin, Madison; 1966, University of California, Davis
Solo exh.: 1991, Museum Boymans-van Beuningen, Rotterdam; 1991, Espai Pblenou, Barcelona
Lit.: Halbreich, Kathy, and Neal Benezra, *Bruce Nauman. Catalogue Raisonné* (exh. cat.), Walker Art Center, Minneapolis, 1994
Van Bruggen, Coosje, *Bruce Nauman*, NY, 1988
Photo: Leo Castelli Gallery, NY

Nava, John American Post-Modern painter, b. 1947, San Diego. Educ. 1968, College of Creative Studies, University of California, Santa Barbara; 1973, Via Schifanoia, Florence, Graduate School of Fine Arts
Solo exh.: 1982, Johnson Art Gallery, University of Redlands, Redlands, CA; 1986, University Art Gallery, Sonoma State University, Sonoma, CA
Lit.: Lucie-Smith, Edward, *American Realism*, London and NY, 1994
Photo: Koplin Gallery, Santa Monica

Nechvatal, Dennis American Neo-Expressionist painter, b. 1948, Dodgeville, Wisconsin. Educ. 1966-7, Loras College, Dubuque, Iowa; 1967-71, Stout State University, Menomonie, Wisconsin; 1971-4, Indiana University, Bloomington
Solo exh.: see Lit.
Lit.: Nechvatal, Dennis, *Images for a New Age* (exh. cat.), Herron Gallery of Art, Indianapolis, 1983
Photo: Zolla/ Lieberman Gallery, Chicago

Neel, Alice American figurative painter, 1900-84, b. Merion Square, Pennsylvania, d. NY. Educ. 1921-4, Philadelphia School of Design for Women (now Moore College of Art); 1924, Chester Springs Summer School, Pennsylvania Academy of Fine Arts
Solo exh.: 1974 (retrospective), Whitney Museum of American Art, NY; 1975 (retrospective), Georgia Museum of Art, University of Georgia, Athens, Georgia; 1981, Artists' Union, Moscow
Lit.: Hills, Patricia, *Alice Neel*, NY, 1983
Robert Miller Gallery, NY

Nerdrum, Odd Norwegian Post-Modern painter, b. 1944. Lives in Oslo. Educ. Art Academy, Oslo. Also studied under Joseph Beuys in Düsseldorf
Solo exh.: 1985, Delaware Art Museum, Wilmington; 1988, California State University Art Museum, Long Beach, toured to Museum of Contemporary Art, Chicago, Madison Art Center, Madison, Wisconsin, The Nelson-Atkins Museum of Art, Kansas City; 1994-5, New Orleans Museum of Art, toured to Arkansas Art Center, Little Rock, University of Iowa, Iowa City, Patrice and Beatrice Haggerty Museum of Art, Maquette University, Milwaukee, Joslyn Art Museum, Omaha
Lit.: Kuspit, Donald B,, 'Odd Nerdrum: the Agency of the Immediate', *Arts Magazine*, Sept. 1984, pp. 122-3
Pettersson, Jan Åke, *Odd Nerdrum*, Oslo, 1988
Photo: Martina Hamilton and Associates Inc, NY

Nicholson, Ben British painter and maker of reliefs, b. 1894, Denham, Buckinghamshire, d. 1982, London. Educ. 1910-11, Slade School of Fine Art, London
Numerous solo and retrospective exh., including 1978-9 Albright-Knox Art Gallery, Buffalo, Hirshhorn Museum and Sculpture Garden, Washington DC, and the Brooklyn Museum, NY; 1993-4, Tate Gallery, London, and Musée d'Art Moderne, St-Étienne
Lit.: Lynton, Norbert, *Ben Nicholson*, London, 1993
Photo: private collection

Nilsson, Gladys American painter, b. 1940, Chicago, Lives in Wilemette, Illinois. Educ. 1962, Art Institute of Chicago
Solo exh.: Whitney Museum of American Art, NY, 1973
Lit.: *Who Chicago?* (exh. cat.), Ceolfrith Gallery, Sunderland Arts Centre, Sunderland, 1981
Photo: Phyllis Kind Gallery, NY and Chicago

Noda, Tetsuya Japanese printmaker, b. 1940, Shiranui Township, Kumanoto Prefecture. Lives in Tokyo. Educ. 1959-65, Tokyo University
Solo exh.: 1981, Fukuoka City Museum, Japan; 1980, Ikeda Museum of Twentieh Century Art, Itoh, Japan
Lit.: *Tetsuya Noda, Works 1982-84* (exh. cat.), Fuji Television Gallery, Tokyo, 1983
Photo: Fuji Television Gallery, Tokyo

Noé, Luis Felipe Argentinian Neo-Expressionist painter, b. 1933, Buenos Aires. Lives in Buenos Aires. Educ. 1951-5, studied law at the Universidad de Buenos Aires; 1951-2, studied painting in the workshop of Horacio Butler
Solo exh. (retrospective): 1987, Museo de Artes Plásticas Eduardi Sivori, Buenos Aires
Lit.: Casanegra, Mercedes, *El color y las artes plasticas: Luis Felipe Noé*, Buenos Aires, 1988
Photo: Ruth Benzacar Galeria de Arte, Buenos Aires

Noland, Cady American environmental artist, b. 1956, Washington DC. Lives in NY
Solo exh.: 1990, Luhring Augustine Hetzler Gallery, Santa Monica, CA
Lit.: Deitch, Jeffrey, *Strange Abstraction* (exh. cat.), Touko Museum of Contemporary Art, Japan, 1991
Photo: Anthony Reynolds Gallery, London

Noland, Kenneth American Post-Painterly Abstractionist, b. 1924, Asheville, NC. Lives in South Salem, NY. Educ. 1946-8 and 1950, Black Mountain College; 1948-9, with Ossip Zadkine in Paris
Solo exh.: see Lit.
Lit.: Moffett, Kenworth, *Kenneth Noland*, NY, 1977
Waldman, Diane, *Kenneth Noland: A Retrospective* (exh. cat.), Solomon R. Guggenheim Museum, NY, 1977
Wilkin, Karen, *Kenneth Noland*, NY, 1990
Photo: Salander-O'Reilly Galleries, NY

Nutt, Jim American painter, b. 1938, Pittsfield, Mass. Lives in Wilemette, Illinois. Educ. 1958-9, Washington University, St Louis; 1965, Art Institute of Chicago
Solo exh.: 1980, Rotterdamse Kunstichting, Holland
Lit.: *Who Chicago?* (exh. cat.), Ceolfrith Gallery, Sunderland Arts Centre, Sunderland, 1981
Photo: Phyllis Kind, NY and Chicago

Odutokun, G. African artist
Photo: Visual Arts Library

Oldenburg, Claes, and **Coosje van Bruggen** American Pop sculptors and installation artists, Claes Oldenburg b. 1929, Stockholm. Educ. 1951, Yale University; 1952-4, Art Institute of Chicago
Solo exh.: 1991, Walker Art Center, Minneapolis
Lit.: Rose, Barbara, *Claes Oldenburg* (exh. cat.), Museum of Modern Art, NY, 1969
Oldenburg, Claes, and Coosje van Bruggen, *Large Scale Projects*, London, 1994
Photo: Margo Leavin Gallery

Oliveira, Nathan American painter, b. 1928, Oakland, CA. Educ. 1950, Mills College, Oakland; 1952, California College of Arts and Crafts
Solo exh.: 1986, Stanford University Art Gallery, Palo Alto, CA
Lit.: Cummings, Paul, 'Interview: Nathan Oliveira talks with Paul Cummings', *Drawing*, vol. 10, July/August 1988
Photo: Salander-O'Reilly Galleries, NY

Oppenheim, Dennis American Conceptual, site-specific and installation artist, b. 1938, Mason City, Washington. Lives in NY. Educ. California College of Arts and Crafts; University of Hawaii; Stanford University, CA
Solo exh.: 1984, Whitney Museum of American Art, NY
Lit.: Heiss, Alanna, *Dennis Oppenheim: selected works 1967-90, and the mind grew fingers*, NY, 1992
Photo: Visual Arts Library

Orr, Eric American 'Light and Space' artist, b. 1939, Covington, Kentucky. Lives in Venice, CA. Educ. University of California at Berkeley; University of Mexico; New School for Social Research; École de Pataphysique, Paris; University of Cincinnati
Solo exh.: 1985, Gemeentemuseum, The Hague (permanent installation); 1989, Hyundai Gallery, Seoul, Korea
Lit.: Butterfield, Jan, *The Art of Light and Space*, NY, 1993
Photo: the artist

Otterness, Tom American post-Pop sculptor, b. 1952, Wichita, Kansas. Educ. 1970, Art Students League, NY; 1973, Whitney Museum of American Art, NY
Solo exh.: see Lit.
Lit.: *Tom Otterness, The Tables* (exh. cat.), IVAM Centre Julio Gonzalez, Valencia, 1991
Photo: Brooke Alexander, NY

Paik, Nam June Korean video artist, b. 1932, Seoul. Educ, 1956, University of Tokyo
Solo exh.: 1989, San Francisco Museum of Modern Art
Lit.: Decker, Edith, *Paik Video*, Cologne, 1988
Herzogenrath, Wulf, *Nam June Paik, Fluxus Video*, Munich, 1983
Nam June Paik: Video Time – Video Space (exh. cat.), Kunsthalle, Basle, 1991
Nam June Paik: Video Works 1963-1988 (exh. cat.), Hayward Gallery, South Bank Centre, London, 1988
Photo: Dorothy Goldeen Gallery, Santa Monica

Paladino, Mimmo Italian Transavant-garde artist, b. 1948, Paduli, near Benevento. Lives in Milan and southern Italy. Educ. 1964-8, Liceo artistico di Benevento
Solo exh.: see Lit.
Lit.: *Mimmo Paladino: Bilder und Zeichnungen 1981-1982* (exh. cat.), Von der Heydt Museum, Wuppertal, and Städtische Galerie, Erlangen, 1982
Mimmo Paladino: Arbeiten von 1977 bis 1985 (exh. cat.), Städtische Galerie im Lenbachhaus, Munich, 1985
Tidholm, Thomas, *Mimmo Paladino*, Stockholm, 1991
Photos: courtesy Nohra Haime Gallery, NY; Dolly Fitterman Fine Arts, Minnesota

Paley, Albert American abstract sculptor, b.1944, Philadelphia. Lives and works in Rochester, NY. Educ. 1962-6 and 1966-9, Tyler School of Art, Temple University, Philadelphia (BFA and MFA)
Solo exh.: 1991, University of the Arts, Philadelphia; 1991 Renwick Gallery, Washington DC
Lit.: *Albert Paley: Sculpture* (exh. cat.), University of the Arts, Philadelphia, 1991
Photo: Paley Studios, Rochester, NY

Palmer, Eugene Jamaican Afro-Caribbean painter, b. 1955, Kingston, Jamaica. Lives in London. Educ. 1974-5, Art Foundation, Sutton Coldfield; 1975-8, Wimbledon College of Art, London; 1982-3, Garbett College; 1983-5, Goldsmiths' College, London
Solo exh. at Bedford Hill Gallery, 198 Gallery and Duncan Campbell Gallery, London
Lit.: Archer Straw, Petrine, *Home & Away: Seven Jamaican Artists* (exh. cat.), October Gallery, London, 1994
Photo: The October Gallery, London

Panamarenko Belgian installation artist, b. 1949, Antwerp. Lives in Antwerp. Educ. 1955-60, Konglichen Akademie fur Schone Kunst, Antwerp
Solo exh.: see Lit.
Lit.: *Panamarenko* (exh. cat.), Kunstverein, Hanover, 1991
Panamarenko: a Retrospective 1965-1985 (exh. cat.), Museum of Contemporary Art, Antwerp, 1989
Photo: Ronald Feldman Fine Art, NY

Pane, Gina French performance artist, 1939-90
Solo exh.: 1990, Centre d'Art Contemporain Pablo Neruda, Corbeil-Essonnes, France
Lit.: Lawless, Catherine, 'Entretien avec Gina Pane', *Cahiers du Musée National d'Art Moderne*, no. 29, autumn 1989
O'Dell, Cathy, 'The Performance Artist as a Masochistic Woman', *Arts Magazine*, vol. 62, summer 1988
Restany, Pierre, 'Partitions de Gina Pane', *Domus*, no. 669, February 1989
Photo: Visual Arts Library

Paolini, Giulio Italian 'Arte Povera' artist, b. 1940, Genoa. Lives in Turin. Trained as a graphic designer
Solo exh.: see Lit.
Lit.: *Giulio Paolini* (exh. cat.), Galleria Nazionale d'Arte Moderna, Rome, 1988
Giulio Paolini (exh. cat.), Musée des Beaux-Arts, Nantes, October-December 1987
Photo: Marian Goodman Gallery, NY

Pascali, Pino Italian 'Arte Povera' artist, 1935-68, b. Bari, d. Rome in a motorcycle accident. Educ. 1955, Liceo Artistico, Naples; 1959, Accademia di Belle Arti, Rome
Solo exh. (retrospectives): see Lit.
Lit.: *Pino Pascali (1935-1968)* (exh. cat.), Pac di Milano, 1987-8
Pino Pascali: la reconstrucción de la naturaleza 1967-1968 (exh. cat.), IVAM Centro Julio Gonzalez, Valencia, 22 September – 22 November 1992
Photo: Galerie Durant-Dessert, Paris

Paschke, Ed American artist, linked to Pop, b. 1939, Chicago. Lives in Chicago. Educ. 1961 and 1970, Art Institute of Chicago
Solo exh. (retrospective): 1975, Contemporary Art Center, Cincinnati
Lit.: Benezra, Neal, *Ed Paschke*, NY, 1990
Photo: Phyllis Kind Gallery, NY and Chicago

Pasmore, Victor British abstract painter and maker of constructions, b. 1908, Chelsham, Surrey. Lives in Malta. Educ. 1927-30, Central School of Art, London
Solo exh. (retrospective): 1965, Tate Gallery, London
Lit.: Lynton, Norbert, *Victor Pasmore: Paintings and Graphics 1980-1992*, London, 1992
Photo: Marlborough Fine Art (London) Ltd

Pearce, David British Conceptual artist and painter, b. 1949, Bristol. Lives in London. Educ. 1968-9, London School of Film Technique; 1970-3, Chelsea College of Art, London; 1973-6, Royal College of Art, London, Film Department. 1976-84, earned living as a dealer in oriental art and antiquities. 1981, resumed painting. 1988-90, worked in Amsterdam
Solo exh.: 1993, The Warehouse Gallery, Amsterdam
Lit.: Lucie-Smith, Edward, *Race, Sex and Gender in Contemporary Art*, London, 1994
Photo: the artist

Pearlstein, Philip American Realist painter, b. 1924, Pittsburgh. Lives in NY. Educ. 1949, Carnegie Institute, Pittsburgh; 1955, Institute of Fine Arts, NY University
Solo exh. (touring retrospective): 1983-4, Milwaukee Art Museum, Brooklyn Museum, NY, Pennsylvania Academy of Art, Philadelphia, Toledo Museum of Art, and the Museum of Art, Carnegie Institute, Pittsburgh
Lit.: Bowman, Russell, *Philip Pearlstein: the Complete Paintings*, NY, 1983
Photo: Visual Arts Library

Penone, Giuseppe Italian 'Arte Povera' artist, b. 1947, Garessio Ponte, Piedmont. Lives in Turin. Educ. 1966-8, Accademia di Belle Arti, Turin
Solo exh.: see Lit.
Lit.: Bradley, Jessica, ed., *Giuseppe Penone* (exh. cat.), National Gallery of Canada, Ottawa, 1983
Celant, Germano, *Giuseppe Penone*, Milan, 1989
Giuseppe Penone (exh. cat.), Musée des Beaux-Arts, Nantes, 1986
Photo: Marian Goodman Gallery, NY

Pepper, Beverly American abstract sculptor, b. 1924, Brooklyn, NY. Lives in Umbria, Italy. Educ. Pratt Institute and Art Students League, NY; and in Paris with Fernand Léger and André Lhote
Solo exh.: 1986, Albright Knox Art Gallery, Buffalo
Lit.: Kraus, Rosalind, *Beverly Pepper – Sculpture in Place*, NY, 1986
Photo: André Emmerich Gallery, NY

Petrick, Wolfgang German Neo-Expressionist artist, b. 1939, Berlin. Lives in Berlin. Educ. 1958-65, Hochschule für Bildende Künste, Berlin
Solo exh.: 1975-6, Neue Galerie, Aachen, Konsthall, Göteborg, and Kunsthalle, Kiel
Lit.: *Aspekt Großstadt* (exh. cat.), Künstlerhaus Bethanien, Berlin, 1977
Photo: Galerie Eva Poll, Berlin

Petyarre, Ada Bird Australian Aboriginal painter, b. c. 1930. Lives at Utopia Station, Australia
Exh.: see Lit.
Lit.: *Aratjara: Art of the First Australians* (exh. cat.), Kunstsammlung Nordrhein-Westfalen, Düsseldorf, 1993
Photo: Corbally Stourton Contemporary Art Ltd, London

Phaophanit, Vong Laotian-British installation artist, b. 1961, Savanahhket, Laos. Lives in Bristol. Educ. 1980-5, École des Beaux-Arts, Aix-en-Provence
Solo exh.: 1988, Chapter Arts Centre, Cardiff; 1991, Arnolfini Gallery, Bristol
Lit.: Tyler, Christian, 'Shedding Light on the Paddy Fields of Art', *Financial Times*, 6 November 1993
Dyer, Richard, 'Vong Phaophanit: Ash and Silk Wall', *Third Text*, vol. 26, spring 1994
Photo: the artist

Phillips, Tom British painter and Conceptual artist, b. 1937, London. Lives in London. Educ. St Catherine's College, Oxford; Camberwell School of Art, London
Solo exh.: see Lit.
Lit.: Paschal, Huston, *Tom Phillips: Works and Texts* (exh. cat.), Royal Academy of Arts, London, 1992
Photo: the artist

Piccolo, Richard American Post-Modern painter, b. 1943, Hartford, Conn. Lives in Rome. Educ. Art Students League, NY; 1966, Pratt Institute, NY; 1968, Brooklyn College, NY
Solo exh.: 1976, Suffolk Community College, Long Island, NY; 1977, American Academy in Rome
Photo: Contemporary Realist Gallery, San Francisco

Piper, Adrian African-American performance and installation artist, b. 1948. Lives in Wellesley, Mass. Educ. 1966-9, School of Visual Arts, NY; 1970-4, City College of NY (BA, Philosophy); 1977-8, University of Heidelberg; 1981, Harvard University (PhD, Philosophy). Currently Professor of Philosophy, Wellesley College, Wellesley, Mass
Solo exh.: 1992, Grey Art Gallery, NY; 1992, Monasterio de Santa Clara, Moguer (Huelva), Spain; 1993, New Langton Arts, San Francisco; 1993, City Gallery of Contemporary Art, Raleigh, NC; 1993, Art Awareness, Lexington, NY
Lit.: Adcock, Craig, *Dispossessed Installations. Steve Barry, John Pekner, Adrian Piper, Bill Viola, Mierle Laderman Ukeles* (exh. cat.), Florida State University Gallery and Museum, Tallahassee, 1992
Adrian Piper (exh. cat.), Ikon Gallery, Birmingham, 1991
Photo: John Weber Gallery, NY

Piper, Keith British Afro-Caribbean painter and installation artist, b. 1960, Birmingham. Educ. 1979, Lanchester Polytechnic, Coventry; 1980-3, Trent Polytechnic, Nottingham; 1984-6, Environmental Media Course, Royal College of Art, London. 1982, staged 'The First National Black Art Convention', Wolverhampton Polytechnic
Solo exh.: 1988, Greenwich Festival, London
Lit.: Araeen, Rasheed, *The Other Story: Afro-Asian Artists in Post-War Britain* (exh. cat.), Hayward Gallery, London, 1989
Mercer, Kobena, 'Engendered Species (Black Masculinity as seen by Danny Tisdale and Keith Piper)', *Artforum*, vol. 30, summer 1992, pp. 74-7
Photo: the artist

Pistoletto, Michelangelo Italian artist linked to 'Arte Povera' and Pop, b. 1933, Biella, Piedmont. Lives in Turin. Educ. trained under his father, who was a professional picture-restorer
Solo exh.: see Lit.
Celant, Germano, *Pistoletto: Division and Multiplication of Mirrors* (exh. cat.), P.S. 1, NY, 1988
Lit.: *Michelangelo Pistoletto* (exh. cat.), Staatliche Kunsthalle, Baden-Baden, 1988
Pistoletto (exh. cat.), Forte di Belvedere, Florence, 1984
Photo: Visual Arts Library

Pittman, Lari American Conceptual artist, b. 1952, Los Angeles. Educ. 1970-3, University of California, Los Angeles; 1974, California Institute of Arts, Valencia
Solo exh.: 1982-3, Newport Harbor Art Museum, Newport Beach, CA
Lit.: Cameron, Dan, 'Sweet Thing', *Artforum*, vol. 31, Dec. 1992
Photo: the artist and Rosamund Felsen Gallery, Los Angeles

Polke, Sigmar German artist linked to Neo-Expressionism and Pop, b. 1941, Oels (now Olesnica, Poland). Lives in Hamburg and Cologne. Educ. 1961-7, Kunstakademie, Düsseldorf
Solo exh.: 1976, Kunsthalle, Düsseldorf, Stedelijk Van Abbemuseum, Eindhoven and Kunsthalle, Tübingen
Lit.: *Sigmar Polke* (exh. cat.), Stedelijk Museum, Amsterdam, 1992
Tosatto, Guy and Bernard Marcadé, *Sigmar Polke* (exh. cat.), Carré d'Art, Nîmes, and IVAM Centro Julio Gonzalez, Valencia, 1994
Photo: Saatchi Collection, London

Pomodoro, Arnaldo Italian abstract sculptor, b. 1925, Morciano di Romagna. Lives in Milan. Originally worked as a theatrical designer, then (from 1950) as a designer of jewellery. His first exhibition of sculptures was held in Milan in 1955
Solo exh.: 1976, Musée d'Art Moderne de la Ville de Paris
Lit.: Mussa, Italo, *Luoghi fondamentali, sculture di Arnaldo Pomodoro*, Milan, 1984
Photo: the artist

Poor, Kim (Elizabeth Kimball de Alberquerque) Brazilian painter working in enamel. Lives in London. First exhibited at age 12 in Rio de Janeiro. Educ. Beaux-Arts Institute of Brazil, Rio de Janeiro; Parsons School of Design, NY (with Larry Rivers); Skidmore College, NY; 1982, enrolled at the Central School of Art and Design, London, to pursue interests in enamelling and printmaking
Solo exh.: 1979, Thumb Gallery, London; 1992, Durini Gallery, London; 1993, Durini Gallery, London
Photo: the artist

Prior, Alfredo Argentinian painter, b. 1952, Buenos Aires. Lives in Buenos Aires
Solo exh.: 1990, Centro Cultural Recoleta, Buenos Aires.
Lit.: Glusberg, Jorge, *Del pop a la nueva imagen*, Buenos Aires, 1985
Photo: Ruth Benzacar Galeria de Arte, Buenos Aires

Puryear, Martin African-American abstract sculptor, b. 1941, Chicago. Educ. 1963, Catholic University, Washington DC; 1971, Yale University
Solo exh. (travelling retrospective): 1991-2, Art Institute of Chicago, Hirshhorn Museum and Sculpture Garden, Washington DC, Museum of Contemporary Art, Los Angeles
Lit.: Benezra, Neal, *Martin Puryear* (exh. cat.), Art Institute of Chicago, 1994
Photo: Edward R. Broida Trust, Los Angeles, courtesy McKee Gallery, NY

Pye, William British abstract sculptor, b. 1938. Lives in London. Educ. 1958-61, Wimbledon School of Art, London; 1961-3, Royal College of Art
Solo exh.: see Lit.
Lit.: *William Pye, Sculpture for Public Places*, Aberystwyth, 1980
Photo: the artist

Quinn, Marc British sculptor and Conceptual Artist, b. 1964, London. Lives in London. Educ. University of Cambridge. Spent a period as assistant to Barry Flanagan
Solo exh.: 1988, Jay Jopling, London; 1991, Grob Gallery, London
Lit.: Corris, Michael, 'Marc Quinn', *Artforum*, vol. 30, Jan. 1992
Kent, Sarah, *Young British Artists II* (exh. cat.), Saatchi Collection, London, 1993
Photo: Saatchi Collection, London

Raffael, Joseph American figurative painter, b. 1933, Brooklyn, NY. Educ. 1953-4, Cooper Union, NY; 1954-6, Yale School of Fine Arts; 1958-9, Fulbright Fellowship to Florence and Rome
Solo exh.: 1991, Butler Institute of American Art, Youngstown, Ohio; 1991, Farleigh Dickinson University Gallery, Madison, NJ; 1992, Hunter Museum of Art, Chattanooga, Tennessee
Lit.: Henry, Gerrit, 'Joseph Raffael', *Art in America*, vol. 79, May 1991
Photo: Nancy Hoffman Gallery, NY

Ramos, Mel American Pop painter, b. 1935, Sacramento, CA. Lives in Oakland, CA. Educ. 1954, Sacramento Junior College; 1957-8, Sacramento State College
Solo exh. (retrospective): 1975, Museum Haus Lange, Krefeld, Germany
Lit.: *Mel Ramos: the Artist's Studio* (exh. cat.), Louis K. Meisel Gallery, NY 1989
Photo: Louis K. Meisel Gallery, NY

Rauschenberg, Robert American Neo-Dadaist, b. 1925, Port Arthur, Texas. Educ. 1946-7, Kansas City Art Institute and School of Design; 1947, Académie Julian, Paris; 1948-9, Black Mountain College, North Carolina; 1949-50, Art Students League, NY
Solo exh. (retrospective): 1977-8, National Collection of Fine Arts, Washington DC, Museum of Modern Art, NY, San Francisco Museum of Modern Art, Albright Knox Art Gallery, Buffalo and Art Institute of Chicago
Lit.: Kotz, Mary Lynn, *Rauschenberg: Art and Life*, NY, 1990
Tomkins, Calvin, *Off the Wall, Robert Rauschenberg and the Art World of our Time*, NY, 1980
Photo: Leo Castelli Gallery, NY

Rego, Paula Anglo-Portuguese figurative painter, b. 1935, Lisbon. Lives in London. Educ. 1952-6, Slade School of Fine Art, London. Lived in London 1963-7; lived in Portugal 1967-75. Settled in London 1976
Solo exh.: 1988, Serpentine Gallery, London
Lit.: McEwen, John, *Paula Rego*, London, 1992
Photo: Marlborough Fine Art (London) Ltd

Rhys James, Shani Welsh Neo-Expressionist painter, b. 1953, Australia. Came to live in Britain (London) aged 9. Now lives near Welshpool, Powys. Educ. 1972-3, Loughborough College of Art; 1973-6, St Martin's School of Art, London
Solo exh.: see Lit.
Lit.: *Shani Rhys James, Blood Ties* (exh. cat.), Wrexham Library Arts Centre, Wrexham, 1993
Photo: the artist

Richter, Gerhard German figurative and abstract painter, b. 1932, Dresden. Lives in Cologne. Educ. 1952-7, Hochschule für Bildende Künste, Dresden; 1961-3, Kunstakademie, Düsseldorf
Solo exh.: see Lit.
Lit.: Buchloh, B.H.D., *Gerhard Richter: Catalogue Raisonné of the Paintings*, 3 vols, Stockholm, 1993
Gerhard Richter (exh. cat.), Tate Gallery, London, 1991
Gerhard Richter: Atlas (exh. cat.), Ludwig Museum, Cologne, 1989
Photos: courtesy Marian Goodman Gallery, NY; Galerie Liliane & Michel Durand-Dessert, Paris

Riley, Bridget British Op artist, b. 1931, London. Lives in London. Educ. 1949-52, Goldsmith's College of Art, London; 1952-5, Royal College of Art, London
Solo exh.: see Lit.
Bridget Riley, *Paintings and Drawings 1951-1971* (exh. cat.), Hayward Gallery, London, 1971
Bridget Riley. *Works 1959-78* (exh. cat.), Albright-Knox Gallery, Buffalo, 1978
Kudielka, Robert, *Bridget Riley: According to Sensation, Paintings 1982-1992* (exh. cat.), Nuremberg and the South Bank Centre, London, 1992
Photo: Karsten Schubert Ltd, London

Robilliard, David British painter, poet and homosexual activitst, 1952-88. Essentially self-taught
Exh.: 1992, Royal Festival Hall, London
Lit.: Robilliard, David, *If Love Bites, What Does Hate Do?* Manchester, 1993
Photo: Jill George Gallery, London

Roche, Arnaldo Puerto Rican painter, b. 1955, Santluce, Puerto Rico. Lives in Chicago and Puerto Rico. Educ. 1974-8, School of Architecture of the University of Puerto Rico; 1979-84. School of the Art Institute, Chicago
Solo exh.: 1986, Museo de la Universidad de Puerto Rico
Lit.: Sturges, Hollister, *New Art from Puerto Rico* (exh. cat.), Museum of Fine Arts, Springfield, Mass., 1990
Photo: Frumkin/Adams Gallery, NY

Rockburne, Dorothea American abstract painter, b. 1921, Verdun, Quebec. US citizen. Lives in NY. Educ. Black Mountain College, North Carolina
Solo exh. (ten-year retrospective): 1989, Rose Art Museum, Brandeis University
Lit.: Yau, John, *Light and Dark* (exhib. cat.), Andre Emmerich Gallery, NY, 1989
Photo: André Emmerich Gallery, NY

Rodriguez, Ofelia Colombian painter and maker of assemblages, b. Baranquilla, Colombia. Lives in London. Educ. 1964-9, Universidad de los Andes, Bogota; 1970-2, Yale University (MFA)
Solo exh.: 1990, Foundation for the Development of International Scientific Relations, Frankfurt
Lit.: Ruy-Sánchez, Alberto, and Edward Lucie-Smith, *Ofelia Rodriguez* (exh. cat.), Galeria Ramis Barquet, Mexico City, 1994
Photo: the artist

Rosenquist, James American Pop artist, b.1933, Grand Fork, North Dakota. Educ. 1948, University of Minnesota, Minneapolis; 1954-5, Art Students League, NY; 1965, Aspen Institute of Humanist Studies, Colorado (Eastern philosophy and history)
Solo exh.: see Lit.
Lit.: Goldman, Judith, *James Rosenquist* (exh. cat.), Art Museum, Denver, 1985
Goldman, Judith, *James Rosenquist*, NY, 1985
Photo: Leo Castelli Gallery, NY

Rothenberg, Susan American Neo-Expressionist painter, b. 1945, Buffalo, NY. Educ. 1966, Cornell University; 1967, George Washington University; Corcoran Museum School, Washington, DC
Solo exh.: 1992-4, Albright-Knox Art Gallery, Buffalo, and travelling to other locations
Lit.: Simon, Joan, *Susan Rothenberg*, New York, 1991
Photo: Saatchi Collection, London

Rückriem, Ulrich German sculptor, b. 1938, Düsseldorf. Lives in Cologne. Educ. 1957-9, trained as a stonemason in Düsseldorf; 1959, studied briefly at the Werkunstschule, Cologne
Solo exh.: 1986, Rijksmuseum Kröller-Müller, Otterlo; 1987, Kunstsammlung Nordrhein-Westfalen, Düsseldorf, Abteiberg Museum, Mönchengladbach, and Kölnischer Kunstverein, Cologne
Lit.: Fuchs, Rudi, *Ulrich Rückriem: Skulpturen 1968-70* (exh. cat.), Van Abbemuseum, Eindhoven, 1977
Ulrich Rückriem (exh. cat.), Museum of Modern Art, Oxford, 1976
Photos: Galerie Liliane & Michel Durand-Dessert, Paris

Ruscha, Ed American Pop artist, b. 1937, Omaha, Nebraska. Lives in Venice, CA. Educ. Chouinard Art Institute, Los Angeles
Solo exh.: see Lit.
Lit.: Bois, Yve-Alain, *Ed Ruscha: The Word Paintings*, NY, 1993
Ed Ruscha (exh. cat.), Lannan Museum, Lake Worth, Florida, 1988
Edward Ruscha: Paintings (exh. cat.), Museum Boymans-van Beuningen, Rotterdam, 1985
Photo: Leo Castelli Gallery, NY

Rustin, Jean French figurative painter, b. 1926, Montigny-lès-Metz. Lives in Paris. Educ. 1947-53, École des Beaux-Arts, Paris
Solo exh.: 1994, Die Markiesenhof, Bergen-op-Zoom, Holland; 1994, Städtisches Galerie Schoss Oberhausen, Germany
Lit.: Lucie-Smith, Edward, *Jean Rustin*, London, 1991
Noël, Bernard, Marc Le Bot and Michel Troche, *Rustin*, Paris, 1984
Rustin (exh. cat.), Städtisches Galerie Schloss Oberhausen, 1994
Photo: Jean Rustin Foundation, Antwerp

Ryman, Robert American Minimal painter, b. 1930, Nashville, Tenn. Lives in NY. Educ. 1948-9, Tennessee Polytechnic Institute; 1949-50, George Peabody College, Nashville, Tennessee
Solo exh.: see Lit.
Lit.: Storr, Robert, *Robert Ryman* (exh. cat.), Tate Gallery, London, and Museum of Modern Art, NY, 1993
Photo: Marc Blondeau, Paris

Saar, Alison African-American figurative sculptor, b. 1956, Los Angeles. Lives in Brooklyn, NY. Educ. 1978, Scripps College, Claremont, CA; 1981, Otis Art Institute, Los Angeles
Exh.: see Lit.
Lit.: Shepherd, Elizabeth, ed., *Secret Dialogues, Revelations: the Art of Betye and Alison Saar* (exh. cat.), The Wight Art Gallery, University of California, Los Angeles, 1990
Photo: Jan Baum Gallery, Los Angeles

Saar, Betye African-American mixed-media artist, b. 1926, Los Angeles. Educ. University of California, Los Angeles; University of Southern California; Long Beach State College; San Fernando Valley State College
Exh.: see Lit.
Lit.: *Betye Saar* (exh. cat.), Museum of Contemporary Art, Los Angeles, 1984
Shepherd, Elizabeth, ed., *Secret Dialogues, Revelations: the Art of Betye and Alison Saar* (exh. cat.), The Wight Art Gallery, University of California, Los Angeles, 1990
Photos: Visual Arts Library

Saari, Peter Post-Modern American painter, b.1951, NY. Educ. 1969-70, School of Visual Arts, NY University; 1974, C.W. Post College, Long Island University, Greenvale, NY; 1972-3, Tyler School of Art, Rome; 1976, Yale University, Yale School of Art
Exh.: 1988, *Classical Myth and Imagery in Contemporary Art*, The Queens Museum, Flushing, NY
Lit.: Martin, Richard and Harold Koda, *The Historical Mode: Fashion and Art in the 1980s*, NY, 1988
Photo: OK Harris, NY

Salle, David American post-Pop painter, b. 1952, Norman, Oklahoma. Educ. 1973-5, California Institute of Arts, Valencia
Solo exh.: 1989, Tel Aviv Museum of Art, Israel
Lit.: Dickhoff, Wilfried, and David Salle, *David Salle* (exh. cat.), Michael Werner Gallery, Cologne, 1989
Photo: Pace-Wildenstein Gallery, NY

Samaras, Lucas Greek-American photographer and maker of boxes and assemblages, b. 1936, Kastoria, Greece. US citizen. Educ. 1959, Rutgers University; 1959-62, Columbia University
Solo exh.: 1989-90, Denver Art Museum and travelling to other locations
Lit.: Indiana, Gary, *Lucas Samaras, Chairs and Drawings* (exh. cat.), Pace Gallery, NY, 1987
Photo: Pace-Wildenstein Gallery, NY

Samba, Chéri African painter, b. 1956, Kinto M'Vuila, Zaire. Lives and works in Kinshasa. Left his native village in 1972 to work in Kinshasa, where he found employment in a shop making signboards. Later set up his own signboard workshop, at the same time drawing strip cartoons for the periodical *Bilenge Info*. In 1975 began to transfer his cartoons on to canvas
Solo exh.: see Lit.
Lit.: *Chéri Samba: a Retrospective* (exh. cat.), Provinciaal Museum voor Moderne Kunst, Ostend, and Institute of Contemporary Arts, London, 1989
Photo: Annina Nosei Gallery, NY

Sandle, Michael British figurative sculptor, b. 1936, Weymouth, Dorset. Lives in Karlsruhe, Germany. Educ. 1954-6, Douglas School of Art and Technology, Isle of Man; 1956-9, Slade School of Fine Art, London
Solo exh.: see Lit.
Lit.: *Michael Sandle: Sculpture and Drawings 1957-88* (exh. cat.), Whitechapel Art Gallery, London, 1988
Photo: Virlaine Foundation, New Orleans

Sato, Masaaki Japanese painter, b. 1941, Kofu City. Lives in NY. Educ. 1962-6, Kofu Fine Arts Institute; 1967-9, Heatherly School of Fine Arts, London; 1971-4, Brooklyn Museum Art School, NY; 1974-6, Pratt Institute, NY
Solo exh.: see Lit.
Lit.: *Masaaki Sato: New York Works 1970-1990* (exh. cat.), Yamanashi Prefectural Museum of Art, Japan, 1990
Photo: Fuji Television Gallery, Tokyo

Saul, Peter American painter, linked to Pop Art, b. 1934, San Francisco. Lives in Austin, Texas. Educ. 1950-2, Stanford University, California School of Fine Arts; 1956, Washington University
Solo exh. (touring retrospective): 1989-90, Aspen Art Museum, Colorado, Museum of Contemporary Art, Chicago, Laguna Gloria Art Museum, Austin, Texas, Contemporary Arts Center, New Orleans
Lit.: Carlozzi, Annette, *50 Texas Artists*, San Francisco, 1986
Photo: Frumkin/Adams Gallery, NY

Saville, Jenny British painter, b. 1970, Cambridge. Educ. 1988-92, Glasgow School of Art
Exh.: 1990, National Portrait Competition, National Portrait Gallery, London; 1990, Van Gogh Self-Portrait Competition, Burrell Gallery, Glasgow
Lit.: Kent, Sarah, *Young British Artists III, Simon Callery, Simon English, Jenny Saville* (exh. cat.), Saatchi Gallery, London, 1994
Photo: Saatchi Collection, London

Schapiro, Miriam American feminist artist, b. 1923, Toronto, Ontario. US citizen. Lives in NY. Educ. 1945-9, University of Iowa
Solo exh.: 1992, Colorado State University, Fort Collins
Lit.: Schapiro, Miriam, *Women and the Creative Process*, Manchester, 1974
Photo: Visual Arts Library

Scharf, Kenny American post-Pop artist, b. 1958, Los Angeles, Educ. 1958, School of Visual Arts, NY
Solo exh. in commercial galleries in NY, London, Los Angeles, Tokyo, Düsseldorf
Lit.: Deák, ed., *Kenny Scharf*, Kyoto, 1989
Photo: Tony Shafrazi Gallery, NY

Schierenberg, Tai Shan British figurative painter, b. 1962, England. Lives in London. Educ. 1982-5, St Martin's School of Art, London; 1985-7, Slade School of Art, London
Solo exh.: 1992, Angela Flowers Gallery at London Fields, London
Photo: Flowers East, London

Schmidt, Edward W. Post-Modern American painter, b. Ann Arbor, Mich., 1946. Educ. 1964-71, Pratt Institute, NY; 1964-71, Art Students League, NY; 1967, Shohegan School of Painting; 1967-8, Ecole des Beaux-Arts, Paris; 1972-4, Brooklyn College (MFA), NY; 1978, Atelier 17, Paris (studied printmaking with S.W. Hayter)
Solo exh.: 1988, Brooklyn College of Art, NY; 1990, Suffolk Community College, Brentwood, NY
Lit.: Stanger, Karen, 'Edward Schmidt: Images of Arcadia', *American Artist*, Dec. 1993
Cass, Caroline, *Grand Illusions – Contemporary Interior Murals*, London, 1988
Jencks, Charles, *Post-Modernism: The New Classicism in Art and Architecture*, NY, 1988
Photo: Contemporary Realist Gallery, San Francisco

Schnabel, Julian American Neo-Expressionist painter, b. 1951, NY. Lives in NY. Educ. 1973, University of Houston, Texas; 1973-4, Whitney Independent Study Programme, NY
Solo exh.: 1986, Whitechapel Art Gallery, London (also in Paris and the US)
Lit.: McEvilley, Thomas, *Julian Schnabel: Paintings 1975-1986* (exh. cat.), Whitechapel Art Gallery, London, 1986
Schnabel, Julian, *C.V.J. – Nicknames of Maitre D's and other Excerpts from Life*, NY, 1987
Photos: Pace Wildenstein, NY

Schöffer, Nicholas Hungarian-French kinetic sculptor, b. 1912, Kalocsa, Hungary. 1936, emigrated to France; 1948, French citizen. Lives in Paris. Educ. 1932-5, School of Fine Arts, Budapest; 1936-9, École des Beaux-Arts, Paris
Solo exh.: 1980, Nicolas Schöffer Exhibition, Kalocsa, Hungary (inaugural exhibition); 1982, Mcsarnok/Museum of Modern Art, Budapest; 1984, IRCAM, Paris
Lit.: Haas, Angeliki, *Nicolas Schöffer*, Paris, 1975
Photo; Virlaine Foundation, New Orleans

Scholder, Fritz American painter of Native American origin, b. 1937, Breckenridge, Minn. Lives in Scottsdale, Arizona. Educ. University of Kansas; Wisconsin State University; Sacramento City College; Sacramento State University; University of Arizona
Solo exh. (retrospective): 1981, Tucson Museum of Art
Lit.: Taylor, Joshua C., et al. *Fritz Scholder*, NY, 1982
Photo: Riva Yares Gallery, Scottsdale and Santa Fe

Schoonhoven, Terry American painter and muralist, b. 1945, Freeport, Illinois. Lives in Los Angeles. Educ. 1967, University of Wisconsin; 1967-9, University of California, Los Angeles
Solo exh.: 1980, Arco Center for Visual Arts, Los Angeles
Lit.: Lucie-Smith, Edward, *American Art Now*, Oxford, 1985
Photo: Koplin Gallery, Santa Monica

Scialoja, Vittoria Italian 'maniera nuova' painter, b. 1942
Photo: Koplin Gallery, Santa Monica

Scott, David Settino American Post-Modern painter, b. 1938, Harrisburg, Pennsylvania. Lives in Morro Bay, CA. Educ. California State University, Long Beach, CA; Scripp's College, Claremont, CA; San Bernardino Valley College, San Bernardino, CA
Solo exh.: 1994, Fullerton College Fine Art Gallery, Fullerton, CA, Fresno Art Museum, Fresno, CA, and San Bernardino Valley College, San Bernardino, CA
Lit.: Dills, Keith, 'A Return to Tradition', *Artweek*, 15 January 1988
Hinton, Susan, 'Comparing Cultura Myths', *Artweek*, 21 November 1987
Boutelle, Patricia, and Holly Wilson, *Uncovering the Past: Tribute and Parody* (exh. cat.), Long Beach Museum of Art, Long Beach, CA, 1986
Photo: Koplin Gallery, Santa Monica

Scott, John African-American sculptor, b. 1940, New Orleans. Lives in New Orleans. Educ. 1962, Xavier University, Louisiana; 1965, Michigan State University
Exh.: see Lit.
Lit.: Frank, Peter, *Richard Johnson/John Scott* (exh. cat.), Alexandria Museum of Art, Alexandria, Georgia, 1993
Photo: Galerie Simonne Stern, New Orleans

Scully, Sean American abstract painter, b. 1945, Dublin. US citizen. Lives in NY and London. Educ. 1965-8, Croydon College of Art; 1968-72, Newcastle University; 1972-3, Harvard University. Moved to the US in 1975
Solo exh.: 1985, Carnegie Institute, Pittsburgh, and see Lit.
Lit.: *Sean Scully: Paintings and Works on Paper 1982-1988* (exh. cat.), Whitechapel Art Gallery, London, 1989
Photo: McKee Gallery, NY

Senise, Daniel Brazilian painter, b. 1955, Rio de Janeiro
Solo exh.: see Lit.
Lit.: *Daniel Senise: pinturas* (exh. cat.), Subdistrito Comercial de Arte, São Paulo, 1987
Modernidade: art brésilien du 20e siècle (exh. cat.), Musée d'Art Moderne de la Ville de Paris, 1987
Photo: Visual Arts Library

Serra, Richard American sculptor, b. 1939, San Francisco. Lives in NY. Educ. University of California, Berkeley; University of California, Santa Barbara; Yale University
Solo exh.: 1978, Museum of Modern Art, NY
Lit.: Guse, Ernst-Gerhard, *Richard Serra*, NY, 1988
Krauss, Rosalind E., *Richard Serra: Sculpture* (exh. cat.), Museum of Modern Art, NY, 1986
Richard Serra (exh. cat.), 2 vols, Kunsthaus, Zurich, 1990
Richard Serra (exh. cat.), Centre Georges Pompidou, Paris, 1983
Photo: Leo Castelli, NY

Shaffer, Richard American Realist painter and environmental artist, b.1947, Fresno, CA. Lives in Oceano, CA. Educ. 1969, University of California, Santa Cruz; New School of Social Research, NY; 1973, San Francisco Art Institute; 1975, San Francisco Art Institute; Stanford University, Palo Alto, CA
Solo exh.: see Lit.
Lit.: Freudenheim, Susan, *Richard Shaffer, Selected Work 1979-1983* (exh. cat.), L.A. Louver Gallery, Venice, CA, 1984
Photo: L.A. Louver Gallery, Venice, CA

Shapiro, Joel American sculptor, b. 1941, NY. Educ. NY University
Solo exh.: see Lit.
Lit.: *Joel Shapiro: Sculpture and Drawings* (exh. cat.), Whitechapel Art Gallery, London, 1980
Photo: Asher-Faure, Los Angeles

Shelton, Peter American sculptor and maker of environments, b. 1951, Troy, Ohio. Lives in Los Angeles. Educ. 1973, Pomona College, Los Angeles; 1974, Hobart School of Welding Technology, Los Angeles; 1979, University of California, Los Angeles
Solo exh.: see Lit.
Lit.: Shelton, Peter, *Floatinghouse Deadman, and Related Work by Peter Shelton* (exh. cat.), Wight art Gallery, University of California, Los Angeles, 1987
Photo; L.A. Louver Gallery, Venice, CA

Sherman, Cindy American photographer, b. 1954, Glen Ridfe, NJ. Lives in NY. Educ. State University College, NY
Solo exh.: 1990, Padiglione d'Arte Contemporanea, Milan; 1989, National Art Gallery, Wellington, and Waikato Museum of Art and History, Waikato, New Zealand; 1987 Whitney Museum of American Art, NY, Institute of Contemporary Art, Boston, and Dallas Museum of Art
Lit.: *Cindy Sherman* (exh. cat.), Whitney Museum of American Art, NY, 1987
Danto, Arthur C., *Cindy Sherman: History Portraits*, NY, 1991
Danto, Arthur C., *Cindy Sherman: Untitled Film Stills*, NY, 1990
Meneguzzo, Marco, *Cindy Sherman*, Milan, 1990
Photo: Metro Pictures, NY

Simonds, Charles American sculptor, b. 1945, NY. Lives in NY. Educ. 1967, University of California, Berkeley; Rutgers University; Douglass College, New Brunswick, NJ
Solo exh.: 1984, Museum of Contemporary Art, Chicago, Los Angeles County Museum of Art, Fort Worth Art Museum, Contemporary Arts Museum, Houston, and Solomon R. Guggenheim Museum, NY
Lit.: *Charles Simonds* (exh. cat.), Galerie Maeght Lelong, Paris, 1986
Photo: Leo Castelli Gallery, NY

Sinnott, Kevin British figurative painter, b. 1947, Wales. Educ. 1967-8, Cardiff College of Art and Design; 1968-71, Royal College of Art
Solo exh.: see Lit.
Lit.: *Kevin Sinnott* (exh. cat.), Bernard Jacobson Gallery, London, 1990
Kevin Sinnott: the Turkish Bath Paintings (exh. cat.), Flowers East, London 1992
Photo: Flowers East, London

Smith, Keir British sculptor, b. 1950, Kent. Educ. 1969-73, University of Newcastle-upon-Tyne; 1973-5, Chelsea College of Art, London
Solo exh.: 1986, Artsite, Bath
Lit.: Kelly, Sean, and Edward Lucie-Smith, *The Self Portrait: a Modern View*, London, 1987
Photo: the artist

Smithson, Robert American Land artist, 1938-73, b. Rutherford, NJ, d. Amarillo, Texas (in a plane crash)
Solo exh. (retrospective): 1980, Herbert F. Johnson Museum of Art, Cornell University, Ithaca, NY (and touring)
Lit.: Boulan, Marie-Sophie, ed., *Robert Smithson: Une Rétrospective. Le Paysage entropique 1960-1973* (exh. cat.), IVAM Centro Julio Gonzalez, Valencia, Palais des Beaux-Arts, Brussels, and Galeries Contemporaines des Musées de Marseille, 1993
Hobbs, Robert, *Robert Smithson: Sculpture*, Ithaca, NY, 1981
Holt, Nancy, ed., *The Writings of Robert Smithson*, NY, 1979
Tsai, Eugenie, *Robert Smithson Unearthed: Drawings, Collages, Writings*, NY, 1991
Photo: John Weber Gallery, NY

Snelson, Kenneth American abstract sculptor, b. 1927, Pendleton, Oregon. Lives in NY. Educ. 1948-9, Black Mountain College, NC; 1950, with Fernand Léger in Paris
Solo exh.: 1981, Hirshhorn Museum and Sculpture Garden, Washington DC, and Albright-Knox Art Gallery, Buffalo
Lit.: Weider, Laurence, *Full Circle: Panoramas by Kenneth Snelson*, NY, 1990
Photo: Virlaine Foundation, New Orleans

Sonfist, Alan American Conceptual and Land artist, b. 1946, NY. Lives in NY
Solo exh.: 1984, Corcoran Gallery, Washington DC
Lit.: Sonfist, Alan, *Autobiography of Alan Sonfist*, Ithaca, NY, 1975
Photo: Visual Arts Library

Spero, Nancy American feminist artist, b. 1926, Cleveland, Ohio. Lives in NY. Educ. 1949, Art Institute of Chicago; with André Lhote in Paris; 1949-50, École des Beaux-Arts, Paris
Solo exh.: see Lit.
Lit.: *Nancy Spero* (exh. cat.), Institute of Contemporary Arts, London, 1987
Philippi, Desa 'The Conjuncture of Race and Gender in Anthropology and Art History: a Critical Study of Nancy Spero's Work', *Third Text*, no. 1, autumn 1987, pp. 39-54
Spero, Nancy, *Rebirth of Venus*, Kyoto, 1989
Photo: Anthony Reynolds Gallery, London

Starn, Mike and Doug American photographers and Conceptual artists, b. twins, 1961. Educ. 1980-5, School of the Museum of Fine Arts, Boston
Solo exh.: 1987, *The Christ Series*, The John and Mable Ringling Museum of Art, Sarasota; 1988, Museum of Modern Art, San Francisco; 1988 (retrospective), *Mike and Doug Starn: Selected Works, 1985-1987*, Honolulu Academy of Art, Hawaii, University Art Museum, University of California, Berkeley, Wadsworth Atheneum, Hartford, Conn., and Museum of Contemporary Art, Chicago
Lit.: Grundberg, Andy, *Mike and Doug Starn*, NY, 1990
Photo: Saatchi Collection, London

Stella, Frank American painter, b. 1936, Malden, Mass. Educ. Phillips Academy, Andover, Mass.; Princeton University
Solo exh.: see Lit.
Lit.: Pacquement, Alfred, *Frank Stella*, Paris, 1988
Rosenblum, Robert, *Frank Stella*, Harmondsworth, 1971
Rubin, Lawrence, *Frank Stella: Paintings 1958 to 1965, Catalogue Raisonné*, NY, 1986
Rubin, William S., *Frank Stella* (exh. cat.), Museum of Modern Art, NY, 1970
Rubin, William, *Frank Stella, 1970-1987* (exh. cat.), Museum of Modern Art, NY, 1987
Stella, Frank, *Working Space: the Charles Eliot Norton Lectures 1983-4*, Cambridge, Mass., 1986
Photo: Leo Castelli Gallery, NY

Sugarman, George American abstract sculptor, b. 1912, NY. Lives in NY. Educ. City College, NY; 1951 with Ossip Zadkine in Paris
Solo exh. (retrospective): 1969-70, Stedelijk Museum, Amsterdam
Lit.: Day, Holiday T., *The Shape of Space: The Sculpture of George Sugarman*, NY, 1981
Gruen, John, 'George Sugarman's Maximal, Musical Sculpture,' *ArtNews*, vol. 86, Jan. 1987, pp. 138-43
Rabinowitz, Miriam, 'George Sugarman's Sculpture,' *Arts Magazine*, vol. 60, Sept. 1985, pp. 98-101
Rubinstein, Meyer Raphael, 'Outdoor Eye: George Sugarman's Public Sculpture,' *Arts Magazine*, vol. 64, Jan. 1990, pp. 76-7
Photo: the artist

Surls, James American sculptor, b. 1943, Terrell, Texas. Lives in Splendora, Texas. Educ. 1966, Houston State College; 1969, Cranbrook Academy of Art
Solo exh.: 1974, Tyler Art Museum, Texas; 1982, Akron Art Museum, Ohio
Lit.: Kutner, Janet, 'James Surls, 1974-1984', *ArtNews*, vol. 84, March 1985
Lucie-Smith, Edward, *American Art Now*, Oxford, 1985
Photo: Virlaine Foundation, New Orleans

Taaffe, Philip American Neo-Op painter, b. 1955, Elizabeth, NJ. Lives in NY and Naples. Educ. Cooper Union, NY
Solo exh.: 1988, Mary Boone Gallery, NY; 1991, Gagosian Gallery, NY
Lit.: Deitch, Jeffrey, *Strange Abstraction* (exh. cat.), Touko Museum of Contemporary Art, Japan, 1991
Double Take (exh. cat.), South Bank Centre, London, 1992
Photo: Gagosian Gallery, NY

Tabenkin, Lev Russian painter, b. 1952, Moscow. Lives in Moscow. Educ.1975, Moscow Polygraphic Institute
Exh.: see Lit.
Lit.: *Von der Revolution zur Perestroika: Sowetische Kunst aus der Sammlung Ludwig* (exh. cat.), Kunstmuseum, Lucerne, 1989

Tacla, Jorge Chilean painter, b. 1958, Santiago. Lives in the US. Educ. 1979, Universidad de Chile, Santiago
Solo exh.: 1991, High Museum of Art, Atlanta
Lit.: Kuspit, Donald, *Jorge Tacla: Hemispheric Problem* (exh. cat.), Nohra Haime Gallery, NY, 1991
Guenther, Bruce, *Jorge Tacla – Borders* (exh. cat.), Nora Haime Gallery, NY 1992
Pryzbilla, Carrie, *Art on the Edge: Tacla* (exh. cat.), High Museum of Art, Atlanta, 1991
Photo: Nohra Haime Gallery, NY

Takubo, Kyoji Japanese sculptor
Photo: Fuji Television Gallery, Tokyo

Tamayo, Rufino Mexican painter 1899-1991, b. Oaxaca, d. Mexico City. Educ. 1917-20, Academia de Bellas Artes, Mexico City
Solo exh.: see Lit.
Lit.: Corredor-Matheos, J., *Tamayo*, Barcelona, 1987
Genauer, Emily, *Rufino Tamayo*, NY, 1974
Rufino Tamayo: Myth and Magic (exh. cat.), Solomon R. Guggenheim Museum, NY, 1979
Photo: CDS Gallery, NY

Tansey, Mark American painter, b. 1949, San Jose, CA. Lives in NY
Solo exh.: 1990, Kunsthalle, Basel; 1990, Seattle Art Museum, Montreal Museum of Fine Arts, St Louis Art Museum, Walker Art Center, Minneapolis, List Visual Arts Center, Massachusetts Institute of Technology, Cambridge, Mass., and Modern Art Museum, Fort Worth, Texas; 1993, Los Angeles County Museum
Lit.: Danto, Arthur C., *Mark Tansey: Visions and Revisions*, NY, 1992
Photo: Curt Marcus Gallery, NY

Thiebaud, Wayne American Realist painter, b. 1920, Mesa, Arizona. Lives in Davis, CA. Educ. 1951-2, Sacramento State College
Solo exh.: see Lit.
Lit.: Tsujimoto, Karen, *Wayne Thiebaud* (exh. cat.), San Francisco Museum of Modern Art, 1985
Photo: Foster Goldstrom Gallery, NY

Tjampitjimpa, Old Walter Australian Aboriginal painter
Photo: Corbally Stourton Contemporary Art Ltd, London

Tjapaltjarri, Tim Leurah Australian Aboriginal painter, c. 1939-84. Lived in Papunya and Napperby Station, Australia
Lit.: *Aratjara: Art of the First Australians* (exh. cat.), Kunstsammlung Nordrhein-Westfalen, Düsseldorf, 1993
Photo: Corbally Stourton Contemporary Art Ltd, London

Tjupurrula, Nosepeg Ununti Australian Aboriginal painter
Photo: Corbally Stourton Contemporary Art Ltd, London

Tokoudagba, Cyprien African painter, b. 1954, Abomey, Benin. Works as a restorer at the National Museum of Abomey, and also as a professional decorator of voodoo buildings. Since 1989 has also made paintings on canvas
Lit.: *Africa Now: The Jean Pigozzi Collection* (exh. cat.), Groninger Museum, Groningen, 1991
Photo: The Jean Pigozzi Collection

Toledo, Francisco Mexican painter, b. 1940, Minatitlan, Oaxaca. Educ. 1959, National Institute of Fine Arts, Mexico City; 1960, with Stanley William Hayter, Paris
Solo exh. (retrospective): 1980, Museo de Arte Moderna, Mexico City
Lit.: Ashton, Dore, *Francisco Toledo*, Beverly Hills, 1991
Photo: Iturralde Gallery, Los Angeles

Toren, Amikam Conceptual artist, b. 1945
Lit.: Coxhead, David, *Amikam Toren, Actualities* (exh. cat.), Matt's Gallery, London, 1984
Kent, Sarah, *Replacing, by Amikam Toren* (exh. cat.), Institute of Contemporary Arts, London, 1989
Photo: Anthony Reynolds Gallery, London

Torreano, John American sculptor and painter, b. 1941, Flint, Michigan. Lives in NY. Educ. 1963, Cranbrook Academy of Art; 1967, Ohio State University
Solo exh.: 1989, Corcoran Gallery, Washington DC
Lit.: Adams, Brooks, 'John Torreano; Scarred Diamonds,' *ArtNews*, vol. 90, Feb. 1991, pp. 120-5
Photo: Margo Leavin Gallery, Los Angeles

Torres, Rigoberto American Super Realist sculptor, b. 1960, Aguadilla, Puerto Rico. Self-taught. Began working with John Ahearn, 1979
Exh.: see Lit.
Lit.: *South Bronx Hall of Fame: Sculpture by John Ahearn and Rigoberto Torres* (exh. cat.), Contemporary Arts Museum, Houston, 1991
Photo: Brooke Alexander, NY

Tremlett, David British Conceptual artist, b. 1945, St Austell, Cornwall. Lives in Bovingdon, Herts. Educ. 1962-3, Falmouth Art School; 1963-6, Birmingham Art School; 1966-9, Royal College of Art, London
Solo exh.: 1972, Tate Gallery, London; 1974, Museum of Modern Art, Oxford; 1986, Institute of Contemporary Arts, London; 1986, Museum van Hedendaagsw Kunst, Ghent
Lit.: Nairne, Sandy, and Nicholas Serota, *British Sculpture in the Twentieth Century* (exh. cat.), Whitechapel Art Gallery, London, 1981
Tremlett, David, *Sometimes We All Do*, Bari, 1988
Photo: Galerie Durand-Dessert, Paris

Tröckel, Rosemarie German installation and Conceptual artist, b. 1952, Schwerte. Lives in Cologne. Educ. Werkunst Schule, Cologne, in addition to studies in anthropology, sociology, theology and mathematics
Solo exh.: see Lit.
Lit.: *Rosemarie Tröckel* (exh. cat.), Institute of Contemporary Arts, London, 1988
Rosemarie Tröckel (exh. cat.), Museum of Modern Art, NY, 1988
Photo: Donald Young Gallery, Seattle

Turrell, James American Land and 'Light and Space' artist, b. 1943, Los Angeles. Lives in Flagstaff, Arizona. Educ. 1965, Pomona College, CA; 1965-6, University of California, Irvine; 1973, Claremont Graduate School
Solo exh.: 1990, Museum of Modern Art, NY
Lit.: Adcock, Craig E., *James Turrell: the Art of Light and Space*, Berkeley, CA, 1990
Photos: the artist

Tuttle, Richard American sculptor, b. 1941, Rahway, NJ. Educ. 1963, Trinity College, Hartford, Conn.
Solo exh.: see Lit.
Lit.: Harris, Susan, *Richard Tuttle* (exh. cat.), Institute of Contemporary Arts, Amsterdam, 1991
The Poetry of Form: Richard Tuttle Drawings from the Vogel Collection (exh. cat.), Institute of Contemporary Arts, Amsterdam, 1993
Richard Tuttle (exh. cat.), Whitney Museum of American Art, NY, 1975
Photo: Brooke Alexander, NY

Twins Seven Seven African painter and performer, b. 1944, Ibadan, Nigeria, youngest and only survivor of seven pairs of twins. Became a painter through his contact with the 'Mbari Club' in Oshobo, founded by Ulli Beier and Suzanne Wenger. Lives and works in Oshogo. In addition to being a painter is an actor, dancer and musician
Lit.: *Africa Now: The Jean Pigozzi Collection* (exh. cat.), Groninger Museum, Groningen, 1991
Photo: The Jean Pigozzi Collection

Twombly, Cy American Abstract painter, b. 1929, Lexington, Virginia. Lives in Rome. Educ. 1948-9, Boston Museum School of Fine Arts; 1950, Washington and Lee University; 1951, Art Students League, NY; 1952, Black Mountain College, NC
Solo exh.: 1994, Museum of Modern Art, NY
Lit.: Bastian, Heiner, *Cy Twombly: Catalogue Raisonné of the Paintings*, Munich, 1992-
Szeeman, Harald, ed., *Cy Twombly: Paintings, Works on Paper, Sculpture* (exh. cat.), Whitechapel Art Gallery, London, 1987
Varnedoe, Kurt, *Cy Twombly: a Retrospective* (exh. cat.), Museum of Modern Art, NY, 1994
Photo: Thomas Amman, Zurich

Tworkov, Jack American abstract painter, 1900-82, b. Biala, Poland, d. Provincetown, Mass. 1913, emigrated to the United States; 1928, US citizen. Educ. 1920-3, Columbia University, NY (studying English); 1923-6, Art Students League, NY
Solo exh.: see Lit.
Lit.: Carrell, Christopher, and Bridget Brown eds., *Jack Tworkov, Paintings 1950-1978* (exh. cat.), Third Eye Centre, Glasgow, 1979
Jack Tworkov: Paintings 1928-1982 (exh. cat.), Pennsylvania Academy of Fine Arts, Philadelphia, 1987
Photo: André Emmerich Gallery, NY

Uglow, Euan British figurative painter, b. 1932. Lives in London. Educ. 1948-51, Camberwell School of Art, London; 1951-4, Slade School of Fine Art
Solo exh.: see Lit.
Lit.: *Euan Uglow* (exh. cat.), Whitechapel Art Gallery, London, 1989
Photo: Salander-O'Reilly Galleries, NY

Ukeles, Mierle Laderman American installation artist, b. 1939, Denver, Colorado. Lives in NY. Educ. 1961, Barnard College, NY (BA); 1974, NY University (MA). 1982, Artist-in-Residence, NY Sanitation Dept
Solo exh.: 1989, Bronx Museum of Art, NY, and NY State University, Old Westbury; 1992, Queens Museum, Flushing, NY
Lit.: Adcock, Craig, *Dispossesed Installations. Steve Barry, John Pekner, Adrian Piper, Bill Viola, Mierle Laderman Ukeles* (exh. cat.), Florida State University Gallery and Museum, Tallahassee, 1992
Ukeles, Mierle Laderman, 'A Journey: Earth/City/Flow', *Art Journal*, vol. 51, summer 1992, pp. 12-14
Photo: Ronald Feldman Fine Art, NY

Valerio, James American Realist painter, b. 1938, Chicago. Lives in Wilemette, Illinois. Educ. 1966-8, Art Institute of Chicago
Solo exh.: 1983, Delaware Museum of Art, Wilmington
Lit.: Arthur, John, *Realists at Work*, NY, 1983
Photo: Frumkin/Adams Gallery, NY

Vallauri, Alex Brazilian installation artist, 1949-87, b. Asmara, Ethiopia (Italian nationality), d. São Paulo. 1965, moved to Brazil.
Solo exh.: 1970, Museum of Modern Art, São Paulo
Lit.: Day, Holliday T., and Hollister Sturges, *Art of the Fantastic: Latin America, 1920-1987* (exh. cat.), Indianapolis Museum of Art, 1987
Photo: Visual Arts Library

van Elk, Ger Dutch Conceptual artist, b. 1941, Amsterdam. Lives in Amsterdam. Educ. 1959-61, Kunstnijverheidesschool, Amsterdam; 1961-3, Immaculate Heart College, Los Angeles; 1965-6, Rijksuniversiteit, Groningen
Solo exh.: 1980, Kunsthalle, Basle, Musée d'Art Moderne de la Ville de Paris, and Museum Boymans-van Beuningen, Rotterdam; 1981, Fruitmarket Gallery, Edinburgh; 1984, Art Institute of Chicago
Lit.: *Ger Van Elk: Recent Paintings and Sculpture and a Selection of Earlier Work* (exh. cat.), Fruitmarket Gallery, Edinburgh, 1981
Photo: Galerie Durand-Dessert, Paris

Vedova, Emilio Italian abstract painter, b. 1919, Venice. Lives in Venice. Self-taught
Solo exh.: see Lit.
Lit.: *Emilio Vedova* (exh. cat.), Staatsgalerie Moderner Kunst, Munich, 1986
Emilio Vedova, Malerei (exh. cat.), Wiener Secession, Vienna, 1987
Photo: Salvatore Ala Gallery, NY

Vilmouth, Jean-Luc French Conceptual artist, b. 1952, Creutzwald. Lives in Paris
Solo exh.: see Lit.
Lit.: *Jean-Luc Vilmouth* (exh. cat.), Centre Georges Pompidou, Paris, 1991
Photo: Anthony Reynolds Gallery, London

Viola, Bill American video artist, b. 1951, NY. Lives in Los Angeles. Educ. 1969-73, Syracuse University, NY.
Solo exh.: 1992, Städtische Kunsthalle, Düsseldorf (and European tour)
Lit.: London, Barbara J., J. Holman and Donald Kuspit, *Bill Viola: Installations and Videotapes* (exh. cat.), Museum of Modern Art, NY, 1987
Photo: Donald Young Gallery, Seattle

Waller, Jonathan British figurative painter, b. 1956, Stratford-upon-Avon. Educ. 1980-3, Lanchester Polytechnic; 1984-5, Chelsea School of Art, London
Solo exh.: see Lit.
Lit.: *Jonathan Waller* (exh. cat.), Flowers East, London, 1990
Photo; Flowers East, London

Wallinger, Mark British Conceptual artist, b. 1959, Chigwell, Essex. Educ. 1977-8, Loughton College, Essex; 1978-81, Chelsea School of Art, London; 1983-5, Goldsmiths College, London
Solo exh.: 1987, Stoke-on-Trent Museum and Art Gallery; 1991, Institute of Contemporary Arts, London
Lit.: Roberts, John, 'Mark Wallinger's History Paintings', *Artscribe*, January-February 1987
Photo: Anthony Reynolds Gallery, London

Wang Guangyi Chinese painter, b. 1953, Harbin. Educ. Zhejian Academy of Fine Arts, Hangzhou, graduating from the Faculty of Oil Painting in 1984. Now teaches at Wuhan College of Technology, Hubei province Widely exhibited in China as well as abroad
Lit.: *China Avant-Garde* (exh. cat.), Haus der Kulturen der Welt, Berlin, 1993
Photo: Hanart TZ, Hong Kong

Wang Ziwei Chinese painter, b. 1963, Shanghai. Lives in Shanghai. Educ. 1983, Shanghai Academy of Arts
Exh.: see Lit.
Lit.: *China's New Art, Post 1989* (exh. cat.), Hanart TZ Gallery, Hong Kong, 1993
Photo: Marlborough Fine Art (London) Ltd

Warhol, Andy American Pop artist, 1928?-87, b. McKeesport, Pennsylvania. d. NY. Educ. 1945-9, Carnegie Institute of Technology, Pittsburgh. 1949-57, worked as an illustrator and commercial artist
Solo exh. (retrospectives): see Lit.
Lit.: Angell, Callie, et al., *The Inaugural Publication: The Andy Warhol Museum*, Pittsburgh, 1994
McShine, Kynaston, ed., *Andy Warhol: a Retrospective* (exh. cat.), Museum of Modern Art, NY, 1989
Photo: Leo Castelli Gallery, NY

Warrens, Robert American painter and sculptor, b. 1933, Sheboygan, Wisconsin. Lives in Baton Rouge, Louisiana. Educ. 1955, University of Wisconsin, Milwaukee; 1959, University of Iowa, Iowa City
Solo exh.: see Lit.
Lit.: Doty, Robert M., *Painstspitter: Paintings and Constructions by Robert Warrens* (exh. cat.), New Orleans Museum of Art, 1990
Photo: Sylvia Schmidt Gallery, New Orleans

Watt, Alison Scottish figurative painter, b. 1966. Educ. 1983-8, Glasgow School of Art
Solo exh.: see Lit.
Lit.: *Alison Watt: Paintings* (exh. cat.), Scottish Gallery, London, 1990
Photo: Flowers East, London

Webb, Boyd British Conceptual artist, b. 1947. Educ. 1972-5, Royal College of Art, London
Solo exh.: see Lit.
Lit.: Morgan, Stuart, *Boyd Webb* (exh. cat.), Whitechapel Art Gallery, London, 1987
Photo: Anthony d'Offay, London

Wegman, William American photographer, b. 1943, Holyoke, Mass. Lives in NY. Educ. 1965, Massachusetts College of Art, Boston; 1967, University of Illinois, Urbana-Champaign
Solo exh.: see Lit.
Lit.: Paul, Frederic, *William Wegman, Photographic Works 1969-1976* (exh. cat.), Limousin, 1992
Photo: the artist

Weiner, Lawrence American Conceptual artist, b. 1940, Bronx. NY. Lives in NY
Solo exh.: see Lit.
Lit.: Martin, Jean-Hubert, ed., *Lawrence Weiner: Werke und Rekonstrucktionen* (exh. cat.), Kunsthalle, Berne, 1983
Photo: Anthony d'Offay Gallery, London

The Welfare State (later Welfare State International), performance group, founded in 1968 by John Fox
Lit.: Coult, Tony, and Baz Kershaw, *Engineers of the Imagination: The Welfare State Handbook*, London 1983
The Welfare State, The Travels of Lancelot Quail, n.p., n.d. [? London, 1972]
Photo: Visual Arts Library

Wentworth, Richard British sculptor, b. 1947, Samoa. Lives in London. Educ. 1966-70, Royal College of Art
Solo exh.: 1987, Riverside Studios, London
Lit.: *Richard Wentworth: Sculptures* (exh. cat.), Lisson Gallery, London, 1986
Warner, Marina, *Richard Wentworth*, London, 1994
Photo: Quint Gallery, Contemporary Art, La Jolla, CA

Wesselmann, Tom American Pop painter, b. 1931, Cinncinati, Ohio. Lives in Long Eddy, NY. Educ. 1951, Hiram College, Ohio; 1956, University of Cincinnati; 1956, Academy of Art, Cincinnati; 1959, Cooper Union, NY
Solo exh.: 1969, Museum of Contemporary Art, Chicago
Lit.: Stealingworth, Slim, *Tom Wesselmann*, NY, 1981
Photo: Visual Arts Library

Whiteread, Rachel British Conceptual sculptor, b. 1963, London. Lives in London. Educ. Brighton Polytechnic; Slade School of Art, London. 1991, winner of the Turner Prize
Exh.: see Lit.
Lit.: Kent, Sarah, *Young British Artists: John Greenwood, Damien Hirst, Alex Landrum, Langlands & Bell, Rachel Whiteread* (exh. cat.), The Saatchi Collection, London, 1992
Photo: Karsten Schubert, London

Wilding, Alison British sculptor and installation artist, b. 1948, Blackburn. Lives in London. Educ. 1967-70, Ravensbourne College of Art and Design, Bromley, Kent; 1970-3, Royal College of Art, London
Solo exh.: see Lit.
Lit.: *Alison Wilding: Immersion/ Exposure* (exh. cat.), Tate Gallery, Liverpool and Henry Moore Sculpture Trust Studio, Halifax, 1991
Alison Wilding (exh. cat.), Serpentine Gallery, London, 1985

Wiley, William T. American painter and draughtsman, b. 1937, Bedford, Indiana. Educ. 1960-2, San Francisco Art Institute
Solo exh.: 1991, Corcoran Gallery, Washington DC
Lit.: *William T. Wiley: Wizdum* (exh. cat.), University Art Museum, Berkeley, CA, 1971
Photo: L.A. Louver Gallery, Venice, CA

Wilhelmi, William American ceramic sculptor, b. 1939, Garwin, Iowa. Lives in Corpus Christi, Texas. Educ. 1960, San Diego State College; 1969, University of California, Los Angeles
Exh.: 1978, *20th Century Ornament*, Cooper-Hewitt Museum, NY
Lit.: Wilhemi, William, 'A Conversation with William Wilhelmi,' *Studio Potter*, vol. 8, no. 2, 1980
Photo: the artist

Wilke, Hannah American performance and installation artist, 1940-93, b. NY, d. NY. Educ. 1961-2, Temple University, Philadelphia
Solo exh.: 1989, Gallery of the University of Missouri, St Louis
Lit.: Kochheiser, Thomas H., ed., *Hannah Wilke, A Retrospective*, University of Missouri Press, Columbia, 1989
Photo: Ronald Feldman Fine Arts, NY

Williams, Glynn British sculptor, b. 1939, Shrewsbury. Lives in London. Educ. 1955-61, Wolverhampton College of Art; 1961-3, British School in Rome
Solo exh.: see Lit.
Lit.: Fuller, Peter, *Glynn Williams* (exh. cat.), Bernard Jacobson Gallery, London, 1985
Photo: Bernard Jacobson Gallery, London

Winters, Terry American painter, b. 1949, Brooklyn, NY. Lives in NY and Switzerland. Educ. High School of Art and Design; 1971, Pratt Institute, NY.
Lit.: Phillips, Lisa, *Terry Winters* (exh cat.), Whitney Museum of American Art, NY, 1992
Photo: Margo Leavin Gallery, Los Angeles

Wizard of Christchurch, The (Ian Brackenbury Channell) New Zealand performance artist, b. 1932, London. Lives in Christchurch, New Zealand. Educ. 1960-3, Leeds University; 1958-60, University of London. 1969, appointed Wizard of the University of New South Wales by the Vice Chancellor and Students' Union; 1970, appointed Wizard of World University Service (Australasia); 1974, arrives in Christchurch, New Zealand, and commences speaking regularly in redesigned Cathedral Square; 1979, the Director of the Robert McDougall Art Gallery, Christchurch, contacts Melbourne and arranges transfer of Living Work of Art title to Christchurch; 1980-1, New Zealand Government Tourist Bureau arranges promotional visits by the Wizard to Melbourne and Sydney; 1980, Canterbury Promotion Council appoints the Wizard official Archwizard of Canterbury; 1990, appointed Wizard of New Zealand by the then Prime Minister, the Honourable Mike Moore
Photo: the artist

Wojnarowicz, David American painter, photographer, writer and homosexual activist, 1954-92, b. Redbank, NJ, d. NY. Self-taught
Solo exh.: see Lit.
Lit.: Blinderman, Barry, ed., *David Wojnarowicz: Tongues of Fire* (exh. cat.), Illinois State University, Normal, 1990
Lippard, Lucy R., 'Out of the Safety Zone (the Art of David Wojnarowicz),' *Art in America*, vol. 78, Dec. 1990
Wojnarowicz, David, *Close to the Knives: a Memoir of Disintegration*, NY, 1991
Wojnarowicz, David, *Memories that Smell like Gasoline*, San Francisco, 1992
Photos: P.P.O.W., NY

Woodrow, Bill British sculptor, b. 1948, Henley-on-Thames, Oxfordshire. Lives in London. Educ. 1968-71, St Martin's School of Art, London; 1971-2, Chelsea School of Art, London
Solo exh.: 1985, Kunsthalle, Basle; 1987, Kunstverein, Munich
Lit.: Cooke, Lynne, *Bill Woodrow, Sculpture 1980-6* (exh. cat.), Fruitmarket Gallery, Edinburgh, 1986
Photo: Visual Arts Library

Yanagi, Yukinori Japanese installation artist, b. 1959, Fukuoka. Educ. 1983, Musashino Art University, Tokyo (BFA); 1985, Musashino Art University, Tokyo (MFA); 1990, Yale University, Fellowship in Arts
Solo exh.: 1987, Kanagawa Prefectural Gallery, Yokohama, Japan; 1988, Fukuoaka Museum of Art, Fukuoka, Japan; 1991, Los Angeles Contemporary Exhibitions (LACE), LA, Yale University Art and Architecture Gallery, New Haven, Conn.
Lit.: *Yukinori Yanagi* (exh. cat.), Lehman College Art Gallery, NY, 1991
Dyer, Richard, 'Yukonori Yanagi, Union Jack Ant Farm', *Third Text*, vol. 27, summer 1994
Photo: Anthony d'Offay Gallery, London

Yu Youhan Chinese painter, b. 1943. Educ. 1970 (graduated) Central Institute of Technology, Beijing
Lit.: *China's New Art, Post 1989* (exh. cat.), Hanart TZ Gallery, Hong Kong, 1993
New Art from China, post-1989, Marlborough Fine Art, London, 1994
Political Pop, China's New Art, post-1989, Hanart Gallery, Taipei, 1993
Photo: Marlborough Fine Art (London) Ltd

Zeng Fanzhi Chinese painter, b. 1964. Educ. 1991 (graduated), Oil Painting Department of the Hubei Academy of Fine Arts
Lit.: *China's New Art, Post 1989* (exh. cat.), Hanart TZ Gallery, Hong Kong, 1993
New Art from China, post-1989, Marlborough Fine Art, London, 1994
Photo: Marlborough Fine Art (London) Ltd

Zhilinski, Dmitri Russian painter, b. 1928, Sochi, Crimea. Lives in Moscow. Educ. 1945-51, Surikov Art Institute
Exh.: 1980, *Nina Shilinskaya und Dimitri Shilinskij: Zwei Künstler in Moskau heute*, Neue Galerie, Sammlung Ludwig, Aachen
Lit.: Bowlt, John E., *The Quest for Self-Expression: Painting in Moscow and Leningrad 1965-1990* (exh. cat.), Columbus Museum of Art, Columbus, Ohio, 1990
Von der Revolution zur Perestroika: Sowjetische Kunst aus der Sammlung Ludwig (exh. cat.), Kunstmuseum, Lucerne, 1989

Zucker, Joe American painter, b. 1941, Chicago. Educ. 1959-60, Miami University; Art Institute of Chicago
Solo exh.: 1982, Albright-Knox Art Gallery, Buffalo
Lit.: Lucie-Smith, Edward, *Art in the Seventies*, Oxford and Ithaca, NY, 1981
Photo: Nancy Drysdale Gallery, Washington DC

Bibliography

The list of books, exhibition catalogues and articles in art magazines given here is intended as a general bibliography covering the whole development of the contemporary visual arts since 1960. Attention has been paid to topics where information is sometimes hard to find – e.g. to developments in contemporary art in the Far East, Oceania and Africa. Books and catalogues of particular interest included under 'Literature' in the individual biographies of artists are, from the sake of convenience, cited again here. As with the publications cited for individual artists, most of the titles listed are in English, but useful items in other languages have not been excluded, especially if they are well illustrated.

Adcock, Craig E., *Dispossessed Installations. Steve Barry, John Pekner, Adrian Piper, Bill Viola, Mierle Laderman Ukeles* (exh. cat.), Florida State University Gallery and Museum, Tallahassee, Fla., 1992

Adcock, Craig E., *James Turrell: the Art of Light and Space,* Berkeley, CA, 1990

Adelman, Bob, *The Art of Roy Lichtenstein: Mural with Blue Brushstroke,* London, 1994

Ades, Dawn, et al., *Art in Latin America: The Modern Era, 1820-1980* (exh. cat.), Hayward Gallery, London, 1989

Adrian Piper (exh. cat.), Ikon Gallery, Birmingham, 1991

Africa Now: The Jean Pigozzi Collection (exh. cat.), Groninger Museum, Groningen, 1991

Against Nature: Japanese Art in the Eighties (exh. cat.), Grey Art Gallery and Study Center, NY University, NY, 1989

Agnes Martin (exh. cat.), Whitney Museum of American Art, NY, 1992

Aksel, Erdag, *Works,* Ankara, Turkey, 1993

Alison Watt: Paintings (exh. cat.), Scottish Gallery, London, 1990
Allan McCollum: Perfect Vehicles (exh. cat.), The John and Mable Ringling Museum, Sarasota, Florida, 1988

Allbright, Thomas, *Art in the San Francisco Bay Area, 1945-1980: an Illustrated History,* Berkeley, CA, 1985
Allen Jones (exh. cat.), Waddington Galleries, London, 1993

Alloway, Lawrence, *Roy Lichtenstein,* NY, 1983

American Art of the 80's (exh. cat.), Museo d'Arte Moderno e Contemporanea di Trento e Rovereto, Italy, 1991

Andersen, Wayne, *American Sculpture in Process: 1930-1970,* Boston and NY, 1975

Andre, Carl and **Hollis Frampton,** *12 Dialogues 1962-1963,* Halifax, Nova Scotia, 1981

Andrews, Julia F., *Painters and Politics in the People's Republic of China, 1949-1979,* NY, 1974

Angell, Callie, et al., *The Inaugural Publication: the Andy Warhol Museum,* Pittsburgh, 1994

Anish Kapoor: British Pavilion XLIV Venice Biennale (exh. cat.), British Council, London, 1990

Anselm Kiefer, Bilder 1986-1980 (exh. cat.), Stedelijk Museum, Amsterdam, 1986

Antonio Berni: obra pictorica, 1922-1981 (exh. cat.), Museo Nacional de Bellas Artes, Buenos Aires

Antonio Lopez-Garcia: Paintings, Sculptures and Drawings 1965-1986 (exh. cat.), Marlborough-Gerson Gallery, NY, 1986

Appasamy, Jaya, *Abanindranath Tagore and the Art of his Times,* New Delhi, 1968

Araeen, Rasheed, *The Other Story: Afro-Asian Artists in Post-War Britain* (exh. cat.), Hayward Gallery, London, 1989

Arakawa (exh. cat.), Städtische Kunsthalle, Düsseldorf, 1977

Arakawa and **Madeline H. Gins,** *The Mechanism of Meaning: Work in Progress (1963-1971, 1978) Based on the Method of Arakawa,* NY, 1979

Aratjara: Art of the First Australians (exh. cat.), Kunstsammlung Nordrhein-Westfalen, Düsseldorf, 1993

Archer Straw, Petrine, and Kim Robinson, *Jamaican Art: an Overview,* Kingston, Jamaica, 1990

Archer Straw, Petrine, *Home & Away: Seven Jamaican Artists* (exh. cat.), October Gallery, London, 1994

Arman 1955-1991: a Retrospective (exh. cat.), Houston Museum of Fine Arts, 1991

Armstrong, Richard, *Mind over Matter: Concept and Object* (exh. cat.), Whitney Museum of American Art, NY, 1990 (Bickerton and Lemieux)

Armstrong, Richard, *The New Sculpture, 1965-1975* (exh. cat.), Whitney Museum of American Art, NY, 1990

Art of Our Time: the Saatchi Collection, 4 vols., London and NY, 1984

Artefakte Francisco Infante (exh. cat.), Wilhelm Hack Museum, Ludwigshafen, 1989

Arthur, John, *Realists at Work: Studio Interviews and Working Methods of 10 Leading Contemporary Painters,* NY, 1983

Artisti Russi Contemporanei: Contemporary Russian Artists (exh. cat.), Centro per l'Arte Contemporanea Luigi Pecci, Prato, 1990

Artschwager (exh. cat.), Centre Georges Pompidou, Paris, 1989

Ashton, Dore, *American Art Since 1945,* NY and London, 1982

Ashton, Dore, *Francisco Toledo,* Beverly Hills, CA, 1991

Ashton, Dore, *Terence La Noue,* NY, 1992

Ashton, Dore, *Jacobo Borges,* Caracas, 1982

Baker, Kenneth, *Minimalism: Art of Circumstance,* NY, 1991

Bann, Stephen, *Ian Hamilton Finlay* (exh. cat.), Arts Council of Great Britain, 1977

Barbara Kruger (exh. cat.), National Art Gallery, Wellington, NZ, 1988

Barette, Bill, *Eva Hesse, Sculpture: Catalogue Raisonné,* NY, 1986

Baro, Gene, *Robert Gordy, Paintings and Drawings 1960-1980* (exh. cat.), New Orleans Museum of Art, 1981

Barreras del Rio, Petra, and **John Perreault,** *Ana Mendieta: a Retrospective* (exh. cat.), The New Museum of Contemporary Art, NY, 1992

Barry Flanagan (exh. cat.), Centre Georges Pompidou, Paris, 1983

Barry, Judith, and **Brad Miskett,** *Rouen: Touring Machines/ Intermittent Futures* (exh. cat.), Rouen, 1993

Barry, Judith, *Public Fantasy, an Anthology of Critical Essays, Fictions and Project Descriptions by Judith Barry* (exh. cat.), Institute of Contemporary Arts, London, 1991

Bastian, Heiner, *Cy Twombly: Catalogue Raisonné of the Paintings,* Munich, 1992–

Battcock, Gregory, ed., *Idea Art,* NY, 1973

Battcock, Gregory, ed., *Minimal Art, a Critical Anthology,* NY, 1968

Battcock, Gregory, ed., *New Artists Video, a Critical Anthology,* NY, 1978

Battcock, Gregory, ed., *Super-Realism,* NY, 1975

Battcock, Gregory and **Robert Nickas,** *The Art of Performance, a Critical Anthology,* NY, 1984

Battersby, Christine, *Gender and Genius: Towards a Feminist Aesthetics,* Bloomington and Indianapolis, 1989

Battino, Freddy, *Piero Manzoni: Catalogue Raisonné,* Milan, 1991

Baykam, Bedri, Livart, etc. ... (exh. cat.), Galerie Lavignes-Bastille, Paris, 1994

Bayon, Damian, *Artistas Contemporaneos de America Latina,* Paris, 1981

Beardsley, John, *Earthworks and Beyond: Contemporary Art in the Landscape,* NY, 1984

Becce, Sonia, *Kuitca,* Buenos Aires, 1989

Beckett, Wendy, *Art and the Sacred,* London 1992

Beckett, Wendy, *Contemporary Women Artists,* Oxford, 1988

Benezra, Neal, *Ed Paschke,* NY, 1990

Benezra, Neal, *Martin Puryear* (exh. cat.), Art Institute of Chicago, 1994

Berger, Maurice, *Robert Morris, Minimalism and the 1960s,* NY, 1989

Bernstock, Judith E., *Joan Mitchell,* NY, 1988

Bernstock, Judith, *Hartigan: Thirty Years of Painting, 1950-1980* (exh. cat.), Fort Wayne Museum of Art, Indiana

Betye Saar (exh. cat.), Museum of Contemporary Art, Los Angeles, 1984

Beyond the 'Nihonga', ed. and published by Tokyo Metropolitan Art Museum, Tokyo, 1993

Bhopal, Bharat Roopanka Bhavan, *Some Aspects of Indian Art Today,* Bhopal, 1985

Bismarck, Beatrice von, *Dan Flavin: Installationem im fluorszlerendem Licht, 1989-1993* (exh. cat.), Stuttgart, 1993

Black Art: Ancestral Legacy – the African Impulse in African American Art (exh. cat.), Dallas Museum of Art, 1989

Blinderman, Barry, ed., *David Wojnarowicz: Tongues of Fire* (exh. cat.), Illinois State University, Normal, 1990

Blume, Dieter, *Anthony Caro: Catalogue Raisonné,* 4 vols., Cologne, 1981; vol. 5, Cologne, 1991

Boatto, A., *Alighiero E. Boetti,* Ravenna, 1984

Boehm, Gottfried, *Ellsworth Kelly: Yellow Curve,* Stuttgart, 1992

Boffin, Tess and **Sunil Gupta,** *Ecstatic Antibodies: Resisting the AIDS Mythology,* London, 1990

Boicos, Chris, 'Where can Video Art Go Now?' *Art International,* vol. 13, winter 1990, pp. 30-2

Bois, Yve-Alain, *Ed Ruscha: the Word Paintings,* NY, 1993

Bonito Oliva, Achille, *Europe-America: the Different Avant-gardes,* Milan, 1976

Bonito Oliva, Achille, *La Transavantguardia tedesca,* Milan, 1982

Booth, Chris, *Chris Booth: Sculpture,* Auckland, NZ, 1993

Borer, Alain, et al., *Joseph Beuys* (exh. cat.), Kunsthaus, Zurich, Museo Nacional Centro de Arte Reina Sofia, Madrid, and Centre Georges Pompidou, Paris, 1993-4

Boulan, Marie-Sophie, ed., *Robert Smithson: une rétrospective. Le Paysage entropique 1960-1973* (exh. cat.), IVAM Centro Julio Gonzalez, Valencia, Palais des Beaux-Arts, Brussels, and Galeries Contemporaines des Musées de Marseille, 1993

Bourdon, David, *Carl Andre, Sculpture, 1959-1977* (exh. cat.), Laguna Gloria Art Museum, Austin, Texas, 1978

Bourdon, David, *Christo,* NY, n.d.

Bourdon, David, *Christo, Running Fence (Sonoma and Marin Counties, CA, 1972-76),* NY, 1978

Bourdon, David, *Christo: Surrounded Islands: Biscayne Bay, Greater Miami, Florida, 1980-3,* NY, 1986

Bowlt, John E., *The Quest for Self-Expression: Painting in Moscow and Leningrad 1965-1990* (exh. cat.), Columbus Museum of Art, Ohio, 1990

Bowman, Russell, *Philip Pearlstein: the Complete Paintings*, NY, 1983

Bozal, Fernández Valeriano, *Pintura y escultura españolas del siglo XX*, Madrid, 1992

Brades, Susan Ferleger, *Gravity and Grace, the Changing Condition of Sculpture 1965-1975* (exh. cat.), South Bank Centre, London, 1993

Brehm, Margrit, et al., *Chuck Close: Works 1967-1992*, Stuttgart, 1994

Brice Marden: Paintings, Drawings and Etchings (exh. cat.), Kassel and NY, 1993

Bridget Riley, Paintings and Drawings 1951-1971 (exh. cat.), Hayward Gallery, London, 1971

Bridget Riley, Works 1959-78 (exh. cat.), Albright-Knox Gallery, Buffalo, 1978

Britannica: 30 ans de sculpture (exh. cat.), Le Havre, 1988

British Art in the 20th Century: the Modern Movement (exh. cat.), Royal Academy of Arts, London, 1987

The British Art Show 1990 (exh. cat.), South Bank Arts Centre, London, 1990

The British Picture (exh. cat.), L. A. Louver Gallery, Venice, CA, 1988

Broude, Norma, and Mary D. Garrard (eds.), *The Power of Feminist Art*, NY and London, 1994

Buchloh, B.H.D., *Gerhard Richter: Catalogue Raisonné of the Paintings*, 3 vols., Stockholm, 1993

Burgin, Victor, *The End of Art Theory; Criticism and Post-modernity*, Atlantic Highlands, NJ, 1986

Bush, Martin H., *Duane Hanson*, Wichita, Kansas, 1976

Bustamante (exh. cat.), Kunsthalle, Berne, 1989

Butterfield, Deborah, *Jerusalem Horses* (exh. cat.), Jerusalem, 1981

Butterfield, Jan, *The Art of Light and Space*, NY, 1993

A Cabinet of Signs: Contemporary Art from Post-Modern Japan (exh. cat.), Tate Gallery, Liverpool, 1990

Calve Serraller, Francisco, *España: medio siglo de arte de vanguardia, 1939-1985*, Madrid, 1985 (?)

Calvesi, M., and G. Gatti, *Bruno d'Arcevia*, Rome, 1989

Cameron, Dan, *NY Art Now: the Saatchi Collection*, Milan, 1988

Cameron, Dan, *Tony Bevan* (exh. cat.), L. A. Louver Gallery, NY, 1991

CARA: Chicano Art, Resistance and Affirmation (exh. cat.), Wight Art Gallery, University of California, Los Angeles, 1991

Carandente, Giovanni, *Caro at the Trajan Markets – Rome*, NY, 1994

Carlozzi, Annette, *50 Texas Artists*, San Francisco, 1986

Carrell, Christopher, and Bridget Brown eds., *Jack Tworkov, Paintings 1950-1978* (exh. cat.), Third Eye Centre, Glasgow, 1979

Caruana, Wally, *Aboriginal Art*, London, 1993

Casanegra, Mercedes, *El color y las artes plasticas: Luis Felipe Noé*, Buenos Aires, 1988

Castleman, Craig, *Getting Up: Subway Graffiti in New York*, Cambridge, Mass., 1982

Celant, Germano, *Arte Povera*, Milan, 1985

Celant, Germano, *Giuseppe Penone*, Milan, 1989

Celant, Germano, et al., *Keith Haring*, Munich, 1992

Celant, Germano, *Keith Haring* (exh. cat.), Castello di Rivoli, Turin, Konsthall, Malmö, Deichtorhallen, Hamburg, and Museum of Art, Tel Aviv, 1994-5

Celant, Germano, *Mapplethorpe* (exh. cat.), Louisiana Museum, Humlebaek, 1992

Celant, Germano, *Mapplethorpe versus Rodin*, Milan, 1992

Celant, Germano, *Pistoletto: Division and Multiplication of Mirrors* (exh. cat.), P.S. 1, NY, 1988

Celant, Germano, *Unexpressionism: Art Beyond the Contemporary*, NY, 1988

Cembalest, Robin, 'The Ecological Art Experience', *ArtNews*, vol. 90, summer 1991, pp. 96-105

Cembalest, Robin, 'Native American Art: Pride and Prejudice', *ArtNews*, vol. 91, Feb. 1992, pp. 86-91

Chadwick, Whitney, 'Narrative Imagism and the Figurative Tradition in Northern California Painting', *Art Journal*, vol. 45, winter 1985, pp. 309-14

Chadwick, Whitney, *Women, Art and Society*, London, 1990

Chase, Linda, *Hyperrealism*, NY, 1975

Chase, Linda, *Ralph Goings*, NY, 1988

Chéri Samba: a Retrospective (exh. cat.), Provinciaal Museum voor Moderne Kunst, Ostend, and Institute of Contemporary Arts, London, 1989

Chicago, Judy, *The Dinner Party: A Symbol of our Heritage*, Garden City, 1979

Chicago, Judy, *Through the Flower, My Struggle as a Woman Artist*, NY, 1977

China Avant-Garde (exh. cat.), Haus der Kulturen der Welt, Berlin, and Museum of Modern Art, Oxford, 1993

China's New Art, Post-1989 (exh. cat.), Hanart T Z Gallery, Hong Kong, 1993

Chipp, Herschel B., *Theories of Modern Art*, Berkeley, Los Angeles and London, 1973

Cindy Sherman (exh. cat.), Whitney Museum of American Art, NY, 1987

Clisby, Roger D., *Roy De Forest* (ex. cat.), Sacramento Museum, CA, 1980

Cockcroft, Eve Spurling and Holly Barnet-Sanchez, *California Chicano Murals*, Venice, CA, 1990

Cohen, Jean Lebold, *The New Chinese Painting 1949-1986*, NY, 1987

Colpitt, Francis, *Minimal Art: The Critical Perspective*, Ann Arbor, 1990

Columbus Drowning (exh. cat.), Rochdale City Art Gallery, 1992

Contemporary Indian Art (exh. cat.), Royal Academy of Arts, London, 1982

Contemporary Indian Art, from the Chester and Davida Herwitz Family Collection (exh. cat.), Grey Art Gallery and Study Center, NY University, NY, 1986

Contemporary Russian Artists: Artisti Russi Contemporanei (exh. cat.), Centro per l'Arte Contemporanea Luigi Pecci, Prato, 1990

Cook, Christopher, *Between the Lights* (exh. cat.), Oldham Art Gallery, 1992

Cooke, Lynne, *Alison Wilding* (exh. cat.), Arts Council of Great Britain, 1983

Cooper, Emmanuel, *The Sexual Perspective: Homosexuality and Art in the Last 100 Years in the West*, London, 1986

Coplans, John, *Ellsworth Kelly*, NY, n.d.

Corredor-Matheos, J., *Tamayo*, Barcelona, 1987

Coult, Tony, and Baz Kershaw, *Engineers of the Imagination: the Welfare State Handbook*, London, 1983

Cowart, Jack, *Roy Lichtenstein, 1970-1980*, NY, 1981

Coxhead, David, *Amikam Toren, Actualities* (exh. cat.), Matt's Gallery, London, 1984

Crane, Diana, *The Transformation of the Avant-Garde: The New York Art World, 1940-1985*, Chicago and London, 1987

Crespoliti, Enrico, *Fontana: catalogo generale*, 2 vols., Milan, 1986

Crichton, Michael, *Jasper Johns*, London, 1994

Crone, Rainer, ed., *Similia/Dissimilia* (exh. cat.), Städtisches Kunsthalle, Düsseldorf, 1987

Crutchfield, Margo A., *Encounterings: an Installation with Drawings* (exh. cat. of work by Robert Stackhouse), The Museum, Richmond, VA, 1990

Cucchi, Enzo, *Sparire (Disappearing)*, 2 vols., NY, 1987

Cullerne Bown, Matthew, *Contemporary Russian Art*, Oxford, 1989

d'Arcevia, Bruno, *Concerto per l'immaginario* (exh. cat.), Aosta, October 1992-January 1993

Dale Chihuly: a Decade of Glass (exh. cat.), Bellevue Museum, Washington, 1981

Damien Hirst (exh. cat.), Institute of Contemporary Arts, London, and Jay Jopling, London, 1991

Dan Flavin: Drawings, Diagrams and Prints, 1972-1975 (exh. cat.), Fort Worth Museum of Art, Texas, 1977

Dan Graham, Pavilions (exh. cat.), Kunsthalle, Berne, 1983

Daniel Buren: c'est ainsi et autrement – so ist es und anders (exh. cat.), Kunsthalle, Berne, 1983

Daniel Senise: pinturas (exh. cat.), Subdistrito Comercial de Arte, São Paulo, 1987

Danto, Arthur C., *Beyond the Brillo Box*, NY, 1992

Danto, Arthur C., *Cindy Sherman: History Portraits*, NY, 1991

Danto, Arthur C., *Cindy Sherman: Untitled Film Stills*, NY, 1990

Danto, Arthur C., *Mapplethorpe*, NY, 1992

Danto, Arthur C., *Mark Tansey: Visions and Revisions*, NY, 1992

Dara Birnbaum (exh. cat.), IVAM Centro del Carme, Valencia, 1990

David Hepher: New Paintings (exh. cat.), Flowers East, London, 1989

David Hockney: A Retrospective (exh. cat.), Los Angeles County Museum of Art, 1988

David Mach (exh. cat.), Tate Gallery, London, 1988

Day, Holliday T., and Hollister Sturges, *Art of the Fantastic: Latin America, 1920-1987* (exh. cat.), Indianapolis Museum of Art, 1987

de Kooning, Elaine, *Spirit of Abstract Expressionism: Selected Writings*, NY, 1994

De Sanna, J., *Fabro*, Ravenna, 1983

Deák, ed., *Kenny Scharf*, Kyoto, 1989

Decker, Edith, *Paik Video*, Cologne, 1988

Deitch, Jeffrey, *Post Human* (exh. cat.), FAE Musée d'Art Contemporain, Pully/Lausanne, 1992

Deitch, Jeffrey, and Dan Friedman, eds., *Artificial Nature* (exh. cat.), Deste Foundation for Contemporary Art, Athens, Geneva and NY, 1990

Deitch, Jeffrey, and Peter Halley, *Cultural Geometry* (exh. cat.), Deste Foundation for Contemporary Art, Athens, 1988

Deitch, Jeffrey, *Strange Abstraction* (exh. cat.), Touko Museum of Contemporary Art, Japan, 1991

Derek Boshier: Texas Works (exh. cat.), Institute of Contemporary Arts, London, 1982

Devriendt, Christine, *L'Oeuvre vidéo de Gary Hill*, Rennes, 1990-1

Diamondstein, Barbaralee, *Inside the Art World*, NY, 1994

Dieter Hacker: Der Mythos des Bildes (exh. cat.), Kunstverein, Hamburg, 1985

Difference: On Representation and Sexuality (exh. cat.), New Museum of Contemporary Art, NY, 1985

A Different Climate (exh. cat.), Städtisches Kunsthalle, Düsseldorf, 1986

Donald Sultan (exh. cat.), Museum of Contemporary Art, Chicago, 1987

Doty, Robert M., *Painstspitter: Paintings and Constructions by Robert Warrens* (exh. cat.), New Orleans Museum of Art, 1990

Doubletake: Collective Memory and Current Art (exh. cat.), Hayward Gallery, London, 1992

Dreher, Thomas, *Konzeptuelle Kunst in Amerika und England zwischen 1963 und 1976*, Frankfurt-am-Main, 1992

Duane Hanson: Skulpturen (exh. cat.), Kunsthalle/Kunstverein, Tübingen, 1990-2

Dunn, Michael, *A Concise History of New Zealand Painting*, Auckland, 1991

Durand, Andre, *Ecce Equus: four paintings for/ quatre tableaux pour UNICEF* (exh. cat.), Rideau Hall, Ottawa, 1986

Dureau, George, *New Orleans: 50 photographs*, London, 1985

Ecker, Gisela, ed., *Feminist Aesthetics*, Boston, Mass., 1986

Ed Ruscha (exh. cat.), Lannan Museum, Lake Worth, Florida, 1988

Eder, Rita, *Gironella*, Mexico City, 1981

Eder, Rita, *Helen Escobedo*, Mexico City, 1982

Edward Ruscha: Paintings (exh. cat.), Museum Boymans-van Beuningen, Rotterdam, 1985

Elderfield, John, *Frankenthaler*, NY, 1989

Ellsworth Kelly: Paintings and Drawings 1963-1979 (exh. cat.), Stedelijk Museum, Amsterdam, 1979

Emilio Vedova (exh. cat.), Staatsgalerie Moderner Kunst, Munich, 1986

Emilio Vedova, Malerei (exh. cat.), Wiener Secession, Vienna, 1987

Endgame: Reference and Simulation in Recent Painting and Sculpture (exh. cat.), Institute of Contemporary Arts, Boston, 1986

English Art Today 1960-76 (exh. cat.), 2 vols., Palazzo Reale, Milan, 1976

Enzo Cucchi (exh. cat.), Centro per l'Arte Contemporanea Luigi Pecci, Prato, 1989

Enzo Cucchi (exh. cat.), Fundacion Caja de Pensiones, Madrid, 1985

Enzo Cucchi (exh. cat.), Solomon R. Guggenheim Museum, NY, 1986

Eric Bulatov: Moscow (exh. cat.), Institute of Contemporary Arts, London, 1989

Euan Uglow (exh. cat.), Whitechapel Art Gallery, London, 1989

Eugene Palmer (exh. cat.), Norwich Gallery, Norwich, 1993

Europe in the Seventies: Aspects of Recent Art (exh. cat.), Art Institute of Chicago, 1977

Eva Hesse: a Memorial Exhibition (exh. cat.), Solomon R. Guggenheim Museum, NY, 1972

Fagaly, William A., and Monroe Spears, *Southern Fictions* (exh. cat.), Contemporary Art Museum, Houston, 1983

Farr, Dennis, and Eva Chadwick, *Lynn Chadwick, Sculptor, 1947-1988*, Oxford, 1990

Ferguson, Russell, Martha Geyer, Trinh T. Minh-Ha, Cornel West, eds., *Out There: Marginalization and Contemporary Culture*, NY, 1990

Fernando de Szyszlo, Bogotá, 1991

Fine, Elsa Honig, *The Afro-American Artist: a Search for Identity*, NY, 1982

Finley, Karen, *Enough is Enough*, NY, 1993

Finley, Karen, *Shock Treatment*, San Francisco, 1990

The First Asia-Pacific Triennial of Contemporary Art (exh. cat.), Queensland Art Gallery, Brisbane, 1993

Fisher, Jean, 'In Search of the Inauthentic: Disturbing Signs in Contemporary Native American Art', *Art Journal*, vol. 51, fall 1992, pp. 44-50

Flack, Audrey, *On Painting*, NY, 1981

Flavin, Dan, *Three Installations in Fluorescent Light* (exh. cat.), Kunsthalle, Cologne, 1973-4

Four Contemporary Mexican Painters (exh. cat.), Phoenix Art Museum, Arizona, 1985

Fox, Howard N., Miranda McClintic and Phyllis Rosenzweig, *Content: a Contemporary Focus 1974-1984* (exh. cat.), Hirshhorn Museum and Sculpture Garden, Washington DC, 1984

Francesco Clemente: Bilder und Skulpturen (exh. cat.), Kestner-Gesellschaft, Hanover, 1984-5

Francis, Richard, *Jasper Johns*, NY, 1984

Francisco Toledo: Paintings and Watercolours 1960-1989 (exh. cat.), Nohra Haime Gallery, NY, 1990

Frank, Peter, *Richard Johnson/John Scott* (exh. cat.), Alexandria Museum of Art, Georgia, 1993

Frankenstein, Alfred, *Karel Appel: the Art of Style and the Styles of Art*, NY, 1980

Franzke, Andreas, *Georg Baselitz*, Munich, 1989

Freudenheim, Susan, *Richard Shaffer, Selected Work 1979-1983* (exh. cat.), L.A. Louver Gallery, Venice, CA, 1984

Friedel, Helmut, *Jannis Kounellis* (exh. cat.), Städtische Galerie im Lenbachhaus, Munich

Friedman, Terry, with Andy Goldsworthy, *Hand to Earth: Andy Goldsworthy Sculpture 1976-1990*, Leeds, 1990

From Art to Archaeology (exh. cat.), South Bank Centre, London, 1991 (Roger Ackling)

Fuchs, Rudi, et al., *Donald Judd: Spaces* (exh. cat.), Stankowski Foundation, Stuttgart, 1994

Fuller, Peter, ed. John McDonald, *Peter Fuller's Modern Painters: Reflections on British Art*, London, 1993

Fuller, Peter, *Glynn Williams* (exh. cat.), Bernard Jacobson Gallery, London, 1985

Gablik, Suzi, *Has Modernism Failed?* London and NY, 1985

Gary Hill (exh. cat.), Stedelijk Museum, Amsterdam, and Kunsthalle, Vienna, 1993

Gatti, G., *La nuova maniera italiana*, Milan, 1986

Gaudibert, Pierre, *Art Africain Contemporain*, Paris, 1992

Geldzahler, Henry, *Charles Bell: the Complete Works, 1970-1990*, NY, 1991

Geldzahler, Henry, *New York Painting and Sculpture: 1940-1970* (exh. cat.), Metropolitan Museum of Art, NY, 1969

Genauer, Emily, *Rufino Tamayo*, NY, 1974

Georg Baselitz, Cologne, 1990

Georg Baseliz (exh. cat.), Kunsthaus, Zurich, 1990

Gérard Garouste, Kyoto, 1989

Gerhard Richter (exh. cat.), Tate Gallery, London, 1991

Gerhard Richter: Atlas (exh. cat.), Ludwig Museum, Cologne, 1989

German Art in the 20th Century; Painting and Sculpture, 1905-1985 (exh. cat.), Royal Academy of Arts, London, 1985

Gianelli, Ida, *Arte & Arte* (exh. cat.), Museo d'Arte Contemporanea, Castello di Rivoli, Turin, 1991

Gilmour, John C., *Fire of the Earth: Anselm Kiefer and the Post-Modern World*, Philadelphia, 1990

Gintz, Claude, *L'Art conceptuel, un perspective* (exh. cat.), Musée de l'Art Moderne de la Ville de Paris, 1989

Giulio Paolini (exh. cat.), Galleria Nazionale d'Arte Moderna, Rome, 1988

Giulio Paolini (exh. cat.), Museé des Beaux-Arts, Nantes, October-December 1987

Giuseppe Penone (exh. cat.), Musée des Beaux-Arts, Nantes, 1986

Glusberg, Jorge, *Art in Argentina*, Milan, 1986

Glusberg, Jorge, *Victor Grippo – Obras de 1965 a 1987* (exh. cat.), Fundacion San Telmo, Buenos Aires, 1989

Glusberg, Jorge, *Victor Grippo*, Buenos Aires, 1980

Godfrey, Tony, *The New Image: Painting in the 1980s*, Oxford, 1986

Goheen, Ellen R., *Christo: Wrapped Walkways, Loose Park, Kansas City, Missouri, 1977-78*, NY, 1978

Gohr, Siegfried, *Georg Baselitz Retrospecktive* (exh. cat.), Kunsthalle der Hypo-Kulturstiftung, Munich, 1992

Goldberg, Roselee, *Performance Art, from Futurism to the Present*, 2nd, revised edn., NY, 1988

Goldman, Judith, *James Rosenquist* (exh. cat.), Art Museum, Denver, 1985

Goldman, Judith, *James Rosenquist*, NY, 1985

Goldstein, Anne and Mary Jane Jacob, *A Forest of Signs*, Museum of Contemporary Art, Los Angeles, 1987

Goosen, E.C., *Ellsworth Kelly* (exh. cat.), Museum of Modern Art, NY, 1972

Gouma-Paterson, Thalia, *Breaking the Rules: Audrey Flack, a Retrospective* (exh. cat.), J.B. Speed Art Museum, Louisville, KY, 1992

Gowing, Lawrence, and Sam Hunter, *Francis Bacon*, London, 1989

Gowing, Lawrence, *Lucian Freud*, London, 1982

Graham-Dixon, Andrew, *Howard Hodgkin*, London, 1994

Graze, Sue, and Kathy Halbreich, *Elizabeth Murray* (exh. cat.), Museum of Contemporary Art, Los Angeles, 1987

Greer, Germaine, *The Obstacle Race: The Fortunes of Women Painters and Their Work*, London, 1979

Gruen, John, *Keith Haring*, Englewood Cliffs, NJ, 1991

Grundberg, Andy, *Mike and Doug Starn*, NY, 1990

Gumpert, Lynn, *Christian Boltanski*, Paris, 1994

Gunther Förg: Painting, Sculpture, Installations (exh. cat.), Newport Beach, CA, 1989

Guse, Ernst-Gerhard, *Richard Serra*, NY, 1988

Gutai – Japanische Avantgarde/Japanese Avant-Garde, 1954-1965 (exh. cat.), Mathildenhohe, Darmstadt, 1991

Habasque, Guy, *Nicolas Schoffer*, Neuchâtel, 1963

Haenlein, Carl, ed., *Jannis Kounellis: Frammenti di Memoria* (exh. cat.), Kestner-Gesellschaft, Hanover, 1991

Haenlein, Carl, et al., *Howard Hodgkin, Bilder 1973 bis 1984* (exh. cat.), Kestner-Gesellschaft, Hanover, 1985

Haeta Maori Women's Art Collective, Project Waitangi, Wellington City Art Gallery, *Mana Tiriti: The Art of Protest and Partnership*, Wellington, 1991

Halbreich, Kathy, and Neal Benezra, *Bruce Nauman, Catalogue Raisonné* (exh. cat.), Walker Art Center, Minneapolis, 1994

Hall, Doug, and Sally Jo Fifer, eds., *Illuminating Video: An Essential Guide to Video Art*, NY and Berkeley, CA, 1990

Harris, Susan, *Richard Tuttle* (exh. cat.), Institute of Contemporary Arts, Amsterdam, 1991

Harrison, Charles, *Essays on Art & Language*, Oxford, 1991

Harrison, Michael, *John Gibbons, Sculpture 1981-1986* (exh. cat.), Arts Council, London, 1986

Haskell, Barbara, *Donald Judd* (exh. cat.), Whitney Museum of American Art, NY, 1989

Headlands: Thinking Through New Zealand Art (exh. cat.), Museum of Contemporary Art, Sydney, 1991

Heiss, Alanna, *Dennis Oppenheim: Selected Works 1967-90, and the Mind Grew Fingers*, NY, 1992

Helen Escobedo (exh. cat.), Museo de Arte Moderno, Mexico City, 1975

Heller, Robert, *Peter Howson*, Edinburgh and London, 1993

Herman Braun-Vega (exh. cat.), Antingua Museo España de Arte Contemporanea, Madrid, 1992

Hertz, Richard, ed., *Theories of Contemporary Art*, Englewood Cliffs, NJ, 1985

Herzogrenrath, Wulf, *Nam June Paik, Fluxus Video*, Munich, 1983

Hewison, Robert, *Future Tense: A New Art for the Nineties*, London, 1990

Hicks, Alistair, *New British Art in the Saatchi Collection*, London, 1989

Hicks, Alistair, *The School of London: the Resurgence of Contemporary Painting*, Oxford, 1989

Hills, Patricia, *Alice Neel*, NY, 1983

Hispanic Art in the United States: Thirty Contemporary Painters and Sculptors (exh. cat.), Museum of Fine Arts, Houston, 1987

Hobbs, Robert, *Robert Smithson: Sculpture*, Ithaca, 1981

Hockney, David, *David Hockney by David Hockney*, London, 1976

Hollander, John, *Landscape Painting, 1960-1990* (exh. cat.), Gibbes Museum of Art, Charleston, South Carolina, and Bayly Museum of Art, Charlottesville, Virginia, 1990

Holt, Nancy, ed., *The Writings of Robert Smithson*, NY, 1979

Homage to Ian Hamilton Finlay: an Exhibition of Works (exh. cat.), Victoria Miro Gallery, London, 1987

Home and the World: Architectural Sculpture by Two Contemporary African Artists: Aboudramana and Bodys Isek Kingelez (exh. cat.), Museum for African Art, NY, 1993

Hough, Katherine Plake, and Roberta Arnold Cove, *Return of the Narrative* (exh. cat.), Palm Springs Desert Museum, Palm Springs, CA, 1984

Howe, Delmas, *Rodeo Pantheon*, London, 1993

Hubbard, Sue, *Anthony Daley* (exh. cat.), Flowers East, London, 1992

Hughes, Robert, *Culture of Complaint*, NY and London, 1993

Hughes, Robert, *Frank Auerbach*, London, 1990

Hunter-Stiebel, Penelope, *William Beckman: Dossier of a Classical Woman* (exh. cat.), Stiebel Modern, NY, 1991

Ibrahim El-Salahi: Images in Black and White (exh. cat.), Savannah Gallery of Modern African Art, London, 1992

Ida Applebroog: Happy Families, A Fifteen-Year Survey (exh. cat.), Contemporary Arts Museum, Houston, 1990

India, Myth & Reality, Aspects of Modern Indian Art (ex. cat.), Museum of Modern Art, Oxford, 1982

The Italian Metamorphosis, 1943-1968 (exh. cat.), Solomon R. Guggenheim Museum, NY, 1994

It's All Part of the Clay: Viola Frey (exh. cat.), Moore College of Art, Philadelphia, 1984

Italian Art in the 20th Century: Painting and Sculpture, 1900-1988 (exh. cat.), Royal Academy of Arts, London, 1989

Jack Tworkov: Paintings 1928-1982 (exh. cat.), Pennsylvania Academy of Fine Arts, Philadelphia, 1987

Jackie Ferrara Sculpture: a Retrospective (exh. cat.), John and Mable Ringling Museum of Art, Sarasota, Florida, 1992

Jahn, Wolf, *The Art of Gilbert & George*, London, 1989

James Magee (exh. cat.), San Antonio Museum of Art, Texas, 1992

Janet Fish: Recent Paintings and Pastels, 1980-1985 (exh. cat.), Smith College Museum of Art, Northampton, Mass., 1986

Jannis Kounellis (exh. cat.), Museo di Rivoli, Turin, 1988

Jannis Kounellis: esposizione di paesaggi ivernali (exh. cat.), Palazzo Fabroni, Pistoia, 1994

Jarman, Derek, *Queer* (exh. cat.), Manchester City Art Galleries, 1992

Jasper Johns: Paintings, Drawings and Sculptures 1954-1964 (exh. cat.), Whitechapel Art Gallery, London, 1964

Jean-Luc Vilmouth (exh. cat.), Centre Georges Pompidou, Paris, 1991

Jeff Koons (exh. cat.), San Francisco Museum of Modern Art, 1992

Jencks, Charles, *Post-Modernism: Neo-Classicism in Art and Architecture*, NY, 1987

Jennifer Bartlett (exh. cat.), Walker Art Center, Minneapolis, 1985

Jennifer Durrant: Painting (exh. cat.), Serpentine Gallery, London, 1987

Jimenez, Luis, *Sodbuster* (exh. cat.), Museum of Fine Arts, Dallas, 1985

Joachimides, Christos M., and Norman Rosenthal, eds., *American Art in the 20th century* (exh. cat.), Royal Academy of Arts, London, 1993

Joachimides, Christos M., and Norman Rosenthal, eds., *Metropolis* (exh. cat.), Martin-Gropius-Bau, Berlin, April-July 1991; English-language version, NY, 1991

Joel Shapiro: Sculpture and Drawings (exh. cat.), Whitechapel Art Gallery, London, 1980

John Baldessari (exh. cat.), Santa Barbara Museum of Art, 1986

John Monks (exh. cat.), Introduction by David Lee, Beaux-Arts Gallery, London, 1994

John Monks: Paintings 1990-93 (exh. cat.), Manchester City Art Galleries and Paton Gallery, London, 1994

Johnson, Patricia Covo, *Contemporary Art in Texas*, Sydney, Australia, 1994

Jörg Immendorff (exh. cat.), Museum Boymans-van Beuningen, Rotterdam, 1992

Jörg Immendorff, Malermut Rundum (exh. cat.), Kunsthalle, Berne, 1983

José Gamarra (exh. cat.), Galerie Albert Loeb, Paris, 1992

José Gamarra (exh. cat.), Donald Morris Gallery, Birmingham, Michigan, 1987

Joseph Raffael, Recent Works: 1982 (exh. cat.), Jacksonville Art Museum, Florida, 1982

Joseph Raffael: The California Years 1969-1978 (exh. cat.), San Francisco Museum of Art, 1978

Juan Cardenas: peintures et dessins (exh. cat.), Galerie Claude Bernard, Paris, 1980

Judy Chicago: The Dinner Party (exh. cat.), Kunsthalle, Frankfurt, 1987

Julio Galán (exh. cat.), Annina Nosei Gallery, NY, 1989

Julio Galán: exposicion retrospectiva (ex. cat.), Museo de Monterrey, 1994

Karl Horst Hödicke: Berliner Ring: Bilder und Skulpturen 1975-1992 (catalogue issued for the Berlin Kunstverein), Stuttgart, 1993

Kabakov, Ilya, *He Lost his Mind, Undressed, and Ran away Naked* (exh. cat.), Ronald Feldman Fine Arts, NY, 1990

Kapur, Geeta, 'Modern Indian Painting: a Synoptic View', *Journal of Arts and Ideas*, I, October-December 1982, pp. 5-18

Kapur, Geeta, *Contemporary Indian Artists*, Delhi, 1978

Karia, Bhupendra, *Yayoi Kusama: a Retrospective* (exh. cat.), Center for International Contemporary Arts, NY, 1989

Karshan, Donald, ed., *Conceptual Art and Conceptual Aspects*, NY, 1970

Katsura Funakoshi: Sculpture (exh. cat.), Annely Juda Fine Art, London, 1991

Kauffman, Linda, ed., *Gender and Theory: Dialogues on Feminist Criticism*, Oxford, 1989

Kellein, Thomas, *Mike Kelley*, Basle and London, 1992

Kelly, Mary, *Post Partum Document*, London, 1983

Kent, Sarah, and Jacqueline Morreau, *Women's Images of Men*, NY, 1985

Kent, Sarah, *Replacing, by Amikam Toren* (exh. cat.), Institute of Contemporary Arts, London, 1989

Kent, Sarah, *Young British Artists* (exh. cat.), Saatchi Collection, London, 1992

Kent, Sarah, *Young British Artists III: Simon Callery, Simon English, Jenny Saville* (exh. cat.), Saatchi Gallery, London, 1994

Keohane, Nannerl O., Michelle Z. Rosaldo and Barbara C. Gelpi, eds., *Feminist Theory: a Critique of Ideology*, Chicago, 1982

Kertess, Klaus, *Robert Mangold: the Attic Series* (exh. cat.), Pace Gallery, NY, 1992

Kevin Sinnott (exh. cat.), Bernard Jacobson Gallery, London, 1990

Klaphek: peintures et dessins (exh. cat.), Galerie Lelong, Paris, 1990

Koether, Jutta, 'Interview with Rosemary Tröckel', *Flash Art*, vol. 134, May 1987, pp. 40-2

Koons, Jeff, *The Jeff Koons Handbook*, London, 1992

Kosuth, Joseph, *Art after Philosophy and After: Collected Writings 1966-1990*, Cambridge, Mass., and London, 1991

Kotz, Mary Lynn, *Rauschenberg: Art & Life*, NY, 1990

Kozloff, Max, *Jasper Johns*, NY, 1968

Krauss, Rosalind E., *Richard Serra: Sculpture* (exh. cat.), Museum of Modern Art, NY, 1986

Krauss, Rosalind, *The Originality of the Avant-Garde and Other Modernist Myths*, Cambridge, Mass.,1986 .

Krempel, Ulrich, *Bernd Koberling*, Stuttgart, 1991

Krens, Tomas ed., with Michael Govan and Joseph Thompson, *Refigured Painting: The German Image 1960-88* (exh. cat.), Solomon R. Guggenheim Museum, NY, 1988

Kubota (exh. cat.), Kodama Gallery, Osaka, 1989

Kudielka, Robert, *Bridget Riley: According to Sensation, Paintings 1982-1992* (exh. cat.), Nuremberg and the South Bank Centre, London, 1992

Kuspit, Donald, *Arman. Monochrome Accumulations 1986-1989, Catalogue Raisonné*, Stockholm, 1990

Kuspit, Donald, *Signs of Psyche in Modern and Post-Modern Art*, NY, 1994

Kuspit, Donald, *The Existential/ Activist Painter: The example of Leon Golub*, New Brunswick, NJ, 1985

Kyube Kiyomisu (exh. cat.), Sakura Gallery, Nagoya, 1988

L'Art en France, 1945-1990 (exh. cat.), Fondation Daniel Templon, Musée temporaire, Fréjus, 1990

Lamarche-Vadel, *Arman*, NY, 1990

Lampert, Catherine, *Lucian Freud: Recent Work* (exh. cat.), Whitechapel Art Gallery London; Metropolitan Museum of Art, NY; Museo Nacional Centro Reina Sofia, Madrid, 1993

Larsen, Jack Lenor, *Olga de Amaral: Tapestries from the 'Moonbasket' and 'Montaña' Series* (exh. cat.), Louise Allrich Gallery, San Francisco, 1989

The Latin American Spirit: Art and Artists in the United States, 1920-1970 (exh. cat.), Bronx Museum of the Arts, NY, 1989

Lemieux, Annette, *The Appearance of Sound* (exh. cat.), John and Mable Ringling Museum of Art, Sarasota, Florida, 1989

Leon Kossoff (exh. cat.), Anthony d'Offay Gallery, London, 1988

Leonard McComb: Drawings, Paintings, Sculpture (exh. cat.), Serpentine Gallery, London, 1983

Leonard, Michael, *Paintings*, London, 1985

Lerner, Abram, *Gregory Gillespie* (exh. cat.), Hirshhorn Museum and Sculpture Garden, Washington DC, 1977

Levin, Kim, *Beyond Modernism: Essays on Art from the '70s and '80s*, NY, 1988

Lewis, Samella, *Art: African American*, 2nd revised edn., Los Angeles, 1990

LeWitt, Sol, *Autobiography by Sol LeWitt*, NY and Boston, 1980

Liebman, Lisa, *Donald Baechler*, Kyoto, 1989

Linker, Kate, *Love for Sale: The Words and Pictures of Barbara Kruger*, NY, 1990

Lippard, Lucy R., 'Jimmie Durham: Post-modernist Savage', *Art in America*, vol. 81, Feb. 1993, pp. 62-9

Lippard, Lucy R., *Mixed Blessings: New Art in a Multi-Cultural America*, NY, 1990

Lippard, Lucy R., *Six Years: The Dematerialization of the Art Object from 1966 to 1972*, NY, 1973

Livingstone, Marco, *Allen Jones, Sheer Magic*, London, 1979

Livingstone, Marco, *David Hockney*, NY, 1981

Livingstone, Marco, *Duane Hanson* (exh. cat.), Montreal Museum of Fine Arts, Montreal, 1994

Livingstone, Marco, ed., *Pop Art* (exh. cat.), Royal Academy of Arts, London, 1991

Livingstone, Marco, *R.B. Kitaj*, Oxford, 1985

London, Barbara J., J. Holman and Donald Kuspit, *Bill Viola: Installations and Videotapes* (exh. cat.), Museum of Modern Art, NY, 1987

Louise Bourgeois (exh. cat), Serpentine Gallery, London, 1985

Louise Bourgeois (exh. cat.), Rijksmuseum Kröller-Müller, Otterlo, 1991

Lucian Freud: Paintings (exh. cat.), The British Council, London, 1987

Lucian Freud: the Complete Etchings 1946-1991 (exh. cat.), Thomas Gibson Fine Art Ltd, London, 1991

Lucian Freud: Works on Paper (exh. cat.), South Bank Centre, London, 1988

Luciano Fabro: Works 1963-1986 (exh. cat.), Fruitmarket Gallery, Edinburgh, 1986

Lucie-Smith, Edward, *Alexander*, London, 1992

Lucie-Smith, Edward, *American Art Now*, Oxford, 1985

Lucie-Smith, Edward, *American Realism*, London and NY, 1994

Lucie-Smith, Edward, and Elisabeth Frink, *Frink: a Portrait*, London, 1994

Lucie-Smith, Edward, *Andres Nagel*, NY, 1992

Lucie-Smith, Edward, *Art in the Eighties*, Oxford, 1990

Lucie-Smith, Edward, *Art in the Seventies*, Oxford, 1980

Lucie-Smith, Edward, Carolyn Cohen and Judith Higgins, *The New British Painting*, Oxford, 1988

Lucie-Smith, Edward, *Changing II: Drawings by Michael Leonard*, London 1992

Lucie-Smith, Edward, *Fletcher Benton*, NY, 1990

Lucie-Smith, Edward, *Harry Holland. The Painter and Reality*, London, 1991

Lucie-Smith, Edward, *Jean Rustin*, London, 1991

Lucie-Smith, Edward, *John Kirby: the Company of Strangers*, Edinburgh, 1994

Lucie-Smith, Edward, *Latin American Art of the 20th Century*, London, 1993

Lucie-Smith, Edward, *Luis Caballero: Paintings and Drawings*, London, 1992

Lucie-Smith, Edward, *Movements in Art since 1945*, revised edn., London, 1984

Lucie-Smith, Edward, *Race, Sex and Gender in Contemporary Art*, London, 1994

Lucie-Smith, Edward, *Steve Hawley* (exh. cat.), Alexander F. Milliken Inc, NY, 1984

Luis Caballero: Retrospectiva de una confesion, Bogotá, 1991

Lynton, Norbert, *Victor Pasmore: Paintings and Graphics 1980-1992*, London, 1992

Lyons, Lisa and Robert Storr, *Chuck Close*, NY, 1987

Lyons, Lisa, and Martin Friedman, eds., *Close Portraits* (exh. cat.), Walker Art Center, Minneapolis, 1980

Macmillan, Duncan, *The Painting of Steven Campbell: the Story so Far*, Edinburgh and London, 1993

Mahsun, Carol Anne Runyon, ed., *Pop Art: The Critical Dialogue*, Ann Arbor, 1989

Mallarino de Rueda, Sylvia, *Arte Colombiano en el Siglo XX*, Bogota, 1987

Malson, Micheline R., Jean F. O'Barr, Sarah Westphal-Wihl and Mary Wyer, eds., *Feminist Theory in Practice and Process*, Chicago, 1989

Mamiya, Christin J., *Pop Art and Consumer Culture: American Super Market*, Austin, 1992

Marcel Broodthaers 1924-1976 (exh. cat.), Galerie Nationale du Jeu de Paume, Paris, 1991

Marcel Broodthaers (exh. cat.), Tate Gallery, London, 1980

Marck, Jan van der, *Arman*, NY, 1984

Mark Di Suvero: Valence (exh. cat.), Musée de Valence, 1994

Markus Lüpertz (exh. cat.), Städtische Galerie im Lenbachhaus, Munich, 1986

Marshall, Richard, *Jean-Michel Basquiat* (exh. cat.), Whitney Museum of American Art, NY, 1992

Martin, Henry, *Arman*, NY, 1973

Martin, Jean-Hubert, ed., *Lawrence Weiner: Werke und Rekonstrucktionen* (exh. cat.), Kunsthalle, Berne, 1983

Masaaki Sato: New York Works 1970-1990 (exh. cat.), Yamanashi Prefectural Museum of Art, Japan, 1990

Masheck, J., 'The Verist Sculptors, 2 Interviews: 'Duane Hanson/John De Andrea', *Art in America*, Dec. 1972

Mattison, Robert Saltonstall, *Grace Hartigan: A Painter's World*, NY, 1990

Mayer, Musa, *Night Studio: a Memoir of Philip Guston*, NY, 1988

McEwen, John, *Paula Rego*, London, 1992

McKenzie, Janet, *Arthur Boyd at Bundanon*, London, 1994

McShine, Kynaston, ed., *Andy Warhol: a Retrospective* (exh. cat.), Museum of Modern Art, NY, 1989

McShine, Kynaston, ed., *Information*, NY, 1970

Mecklenburg, Virginia M., *Wood Works: Constructions by Robert Indiana*, Washington DC, 1984

Meisel, Louis K., *Photo-Realism*, NY, 1980

Meisel, Louis K., *Photorealism since 1980*, NY, 1993

Meisel, Louis K., *Richard Estes: the Complete Paintings 1966-1985*, NY, 1986

Mel Ramos: the Artist's Studio (exh. cat.), Louis K. Meisel Gallery, NY, 1989

Memory and Metaphor: the Art of Romare Bearden, 1940-1987 (exh. cat.), Studio Museum in Harlem, NY, 1991

Meneguzzo, Marco, *Cindy Sherman*, Milan, 1990

Mercer, Kobena, 'Engendered Species (Black Masculinity as seen by Danny Tisdale and Keith Piper)', *Artforum*, vol. 30, summer 1992, pp. 74-7

Messager, Annette, *La Femme et ...*, Geneva, 1975

Meyer, Ursula, ed., *Conceptual Art*, NY, 1972

Michael Heizer (exh. cat.), Museum Folkwang, Essen, 1979

Michael Heizer (exh. cat.), Waddington Galleries, London, 1990

Michael Heizer. Sculpture in Reverse (exh. cat.), Museum of Contemporary Art, Los Angeles, 1984

Michael Sandle: Sculpture and Drawings 1957-88 (exh. cat.), Whitechapel Art Gallery, London, 1988

Michaud, Yves, *Sam Francis*, Paris, 1991

Michelangelo Pistoletto (exh. cat.), Staatliche Kunsthalle, Baden-Baden, 1988

Mike Kelly, Stuttgart, 1992

Millet, Catherine, *L'Art contemporain en France*, Paris, 1987

Milow, Keith, *One Hundred Drawings 1988-1989* (exh. cat.), Nigel Greenwood Gallery, London, 1989

Minamura, Toshaki, *Yayoi Kusama* (exh. cat.), Tokyo, 1986

Moderne Kunst aus Afrika (exh. cat.), Staatliche Kunsthalle, Berlin, 1979

Modernidade: art brésilien du 20e siècle (exh. cat.), Musée d'Art Moderne de la Ville de Paris, 1987

Moffett, Kenworth, *Kenneth Noland*, NY, 1977

Morphet, Richard, et al., *R.B. Kitaj: a Retrospective* (exh. cat.), Tate Gallery, London, 1994

Morphet, Richard, *The Hard-Won Image: Traditional Method and Subject in Recent British Art* (exh. cat.), Tate Gallery, London, 1984

Moszynska, A., *Abstract Art*, London and NY, 1990

Mount, Marshall W., *African Art – the Years since 1920*, 2nd revised edn., NY, 1989

Moure, Gloria, *Kounellis*, Barcelona, 1990

Muller, Grégoire, *The New Avant-Garde: Issues for the Art of the Seventies*, London, 1972

Munroe, Alexandra, *Japanese Art after 1945: Scream Against the Sky* (exh. cat.), Guggenheim Museum, NY, 1994

Mussa, Italo, *La pittura colta*, Rome, 1983

Mussa, Italo, *Luoghi fondamentali, sculture di Arnaldo Pomodoro*, Milan, 1984

Nairne, Sandy, and Caroline Tisdall, eds., *Conrad Atkinson: Picturing the System*, London, 1981

Nairne, Sandy, and Nicholas Serota, *British Sculpture in the Twentieth Century* (exh. cat.), Whitechapel Art Gallery, London, 1981

Nam June Paik: Video Time – Video Space (exh. cat.), Kunsthalle, Basle, 1991

Nam June Paik: Video Works 1963-1988 (exh. cat.), Hayward Gallery, London, 1988

Nancy Spero (exh. cat.), Institute of Contemporary Arts, London, 1987

Nanjo, Fumio and Peter Weiemair, *Japanische Kunst der Achtziger Jahre*, Frankfurt and Schaffhausen, 1990

Narahara (exh. cat.), Galerie Denise René, Paris, 1987

Neich, Roger, *Painted Histories. The Development of Maori Figurative Painting*, Auckland, NZ, and Oxford, 1994

Neil Jeffries (exh. cat.), Flowers East, London, 1990

New Art from China: post 1989 (exh. cat.), Marlborough Fine Art (London) Ltd, London, 1994

The New Culture: Women Artists of the Seventies (exh. cat.), Turman Gallery, Indiana State University, 1984

New French Painting (exh. cat.), Museum of Modern Art, Oxford, 1984

The New Italian Manner (exh. cat.), Mayer Schwarz-Gallery, Beverly Hills, CA, 1989

A New Spirit in Painting (exh. cat.), Royal Academy of Arts, London, 1981

Nicholas, Darcy and Keri Kaai, *Seven Maori Artists*, Wellington, NZ, 1986

Nicola Hicks: Fire and Brimstone (exh. cat.), Flowers East, London, 1991

Nochlin, Linda, *Women, Art and Power and Other Essays*, London and NY, 1989

Noël, Bernard, Marc Le Bot and Michel Troche, *Rustin*, Paris, 1984

Nuevos Momentos del Arte Mexicano/ New Moments in Mexican Art (exh. cat.), Parallel Project, NY, 1990

Oldenburg, Claes, and Coosje van Bruggen, *Large Scale Projects*, London, 1994

Oleg Kudryashov (exh. cat.), Riverside Studios, London, 1982

Orton, Fred, *Figuring Jasper Johns*, London, 1994

Otterness, Tom, *The Tables* (exh. cat.), IVAM Centro Julio Gonzalez, Valencia, 1991

Outside Cuba/Fuera de Cuba (exh. cat.), Zimmerli Art Museum, Rutgers University, New Brunswick, NJ, 1987

Pacific Rim Diaspora (exh. cat.), Long Beach Museum of Art, 1990

Pacquement, Alfred, *Frank Stella*, Paris, 1988

Paget, Jean, *Tibor Csernus* (exh. cat.), Galerie Claude Bernard, Paris, 1982

Panamarenko (exh. cat.), Kunstverein, Hanover, 1991

Panamarenko: a Retrospective 1965-1985 (exh. cat.), Museum of Contemporary Art, Antwerp, 1989

Paschal, Huston, *Tom Phillips: Works and Texts* (exh. cat.), Royal Academy of Arts, London, 1992

Patkin, Izhar, 'Two Artists Sitting under a Tree: chez Neil Jenney's Lumberyard,' *Artforum*, vol. 31, Oct. 1992, pp. 80-2

Paul, Frederic, *William Wegman, Photographic Works 1969-1976*, Limousin, 1992

Paz, Octavio, *Eduardo Chillida*, Paris, 1979

Peasant Paintings from Hu county, Shensi province, China (exh. cat.), Arts Council of Great Britain, London, 1976

Per Kirkeby: Recent Painting and Sculpture (exh. cat.), Whitechapel Art Gallery, London, 1985

Percy, Ann and Raymond Foye, *Francesco Clemente: Three Worlds* (exh. cat.), Philadelphia Museum of Art, 1990

Peter Chevalier (exh. cat.), Raab Galerie, Berlin, 1983

Peter Halley (exh. cat.), Museum Hans Esters, Krefeld, 1989

Pettersson, Jan Åke, *Odd Nerdrum*, Oslo, 1988

Philippi, Desa, 'The Conjuncture of Race and Gender in Anthropology and Art History: a Critical Study of Nancy Spero's Work', *Third Text*, no. 1, autumn 1987, pp. 39-54

Phillips, Lisa, *Terry Winters* (exh. cat.), Whitney Museum of American Art, NY, 1992

Photography and Art 1946-1986 (exh. cat.), Los Angeles County Museum, 1987

Pincus, Robert L., *On a Scale that Competes with the World: the Art of Edward and Nancy Reddin Kienholz*, Berkeley, CA, 1990

Pincus-Witten, Robert, *Postminimalism*, London, 1977

Pino Pascali 1935-1968 (exh. cat.), Pac di Milano, Milan, 1987-8

Pino Pascali: la reconstrucción de la naturaleza 1967-1968 (exh. cat.), IVAM Centro Julio Gonzalez, Valencia, 22 September – 22 November 1992

Pistoletto (exh. cat.), Forte di Belvedere, Florence, 1984

Plagens, Peter, *Sunshine Muse: Contemporary Art on the West Coast*, NY, 1974

The Poetry of Form: Richard Tuttle Drawings from the Vogel Collection (exh. cat.), Institute of Contemporary Arts, Amsterdam, 1993

Poetter, J., *Dan Flavin. Neue Anwendungen fluoresziederen Lichts*, Stuttgart, 1991

Poetter, J., *Donald Judd* (exh. cat.), Staatliche Kunsthalle, Baden-Baden, 1989

Poetter, J., and Helmut Friedel, eds., *Chuck Close* (exh. cat.), Kunsthalle, Baden-Baden and Kunstbau Lenbachhaus, Munich, 1994

Prinz, Jessica, *Art Discourse – Discourse in Art*, New Brunswick, NJ, 1991

Pye, William, *Sculpture for Public Places*, Aberystwyth, 1980

Quattro artisti della nuova maniera italiana (exh. cat.), Museum of Modern and Contemporary Art, Città della Pieve, April-May 1992, and Palazzo Guasco, Alessandria, June-July 1992

Raben, Hubertus, *Keith Sonnier: Lightway*, Stuttgart, 1992

Rabinowitz, Miriam, 'George Sugarman's Sculpture', *Arts Magazine*, vol. 60, Sept. 1985, pp. 98-101

Rafael Ferrer: Impassioned Rhythms (exh. cat.), Laguna Gloria Art Museum, Austin, Texas, 1982

Rafael Ferrer: Paintings 1981-1985 (exh. cat.), Minneapolis College of Art and Design Gallery, 1985

Rainer Fetting (exh. cat.), Museum Folkwang, Essen, 1986

Rainer Fetting: Berlin/ New York: Gemälde und Skulpturen (exh. cat.), Nationalgalerie, Berlin, 1990

Rasmussen, Waldo, *Artistas latinoamericanos del siglo XX/Latin American Artists of the Twentieth Century* (exh. cat.), Museum of Modern Art, NY, 1993

Ratcliff, Carter, *Botero*, NY, 1980

Ratcliff, Carter, *Komar and Melamid*, NY, 1988

Raven, Arlene (ed.), *Art in the Public Interest*, Ann Arbor, 1989

Raven, Arlene, Cassandra Langer and Joanna Frueh, eds., *Feminist Art Criticism: an Anthology*, NY, 1988

Raye, Helen, *Anish Kapoor* (exh. cat.), Albright-Knox Art Gallery, Buffalo, 1986

Rebecca Horn (exh. cat.), Serpentine Gallery, London, 1984

Recent Paintings by Kim, Jong-Hak (exh. cat.), Seoul Contemporary Arts Center, 1994

Reese, Beck Duval, *Texans on My Mind – Contemporary Visions of the Lone Star State* (exh. cat.), Arttrain (exhibition touring the state of Texas by Amtrak train), 1984

Reinhardt, Brigitte, ed., *Eva Hesse: Drawing in Space*, Stuttgart, 1994

Restany, Pierre, et al., *Arte in Francia/Art en France 1970-1993* (exh. cat.), Galleria d'Arte Moderna, Bologna, 1994

Restany, Pierre, *Street Art: le second souffle de Karel Appel*, Paris, 1982

Restany, Pierre, *Yves Klein*, NY, 1982

Reynolds, Jock, *Sol LeWitt: Twenty-Five Years of Wall Drawings, 1968-1993* (exh. cat.), Addison Gallery of American Art, Andover, 1993

Richard Artschwager (exh. cat.), Kunsthalle, Basle, 1985

Richard Artschwager (exh. cat.), Whitney Museum of American Art, NY, 1988

Richard Deacon: Sculptures 1987-1993 (exh. cat.), Kunstverein, Hanover 1993

Richard Long, Walking in Circles (exh. cat.), South Bank Centre, London, 1991

Richard Serra (exh. cat.), Centre Georges Pompidou, Paris, 1983

Richard Serra (exh. cat.), Centro Nacional de Arte Reina Sofia, Madrid, 1992

Richard Serra (exh. cat.), 2 vols., Kunsthaus, Zurich, 1990

Richard Tuttle (exh. cat.), Whitney Museum of American Art, NY, 1975

Richard Wentworth: Sculptures (exh. cat.), Lisson Gallery, London, 1986

Richardson, Brenda, *Brice Marden: Cold Mountain*, Houston, 1992

Richardson, Brenda, *Scott Burton* (exh. cat.), Baltimore Museum of Art, 1986

Rifkin, Ned, *Robert Moskowitz*, London and Washington DC, 1989

Rios, Julián, *Kitaj; Pictures and Conversations*, London, 1994

Risatti, Howard, ed., *Postmodern Perspectives: Issues in Contemporary Art*, Englewood Cliffs, NJ, 1990

Robert Gober (exh. cat.), Museum Boymans-van Beuningen, Rotterdam, 1990

Robert Mason: Broadgate Paintings and Drawings 1989-90, London, 1990

Robins, Corinne, *The Pluralist Era: American Art, 1968-1981*, NY, 1984

Roger Ackling: Flooded Margins (exh. cat.), Annely Juda Fine Art, London, 1994

Rose, Barbara, *Claes Oldenburg* (exh. cat.), Museum of Modern Art, NY, 1969

Rose, Barbara, *Helen Frankenthaler*, NY, n.d.

Rose, Jacqueline, *Sexuality in the Field of Vision*, London, 1986

Rosenberg, Harold, *Art and Other Serious Matters*, Chicago, 1985

Rosenberg, Harold, *Art on the Edge*, NY, 1975

Rosenberg, Harold, *The De-Definition of Art. Action Art to Pop to Earthworks*, NY, 1972

Rosenblum, Robert, *Frank Stella*, Harmondsworth, 1971

Rosenthal, Mark, *Anselm Kiefer* (exh. cat.), Art Institute of Chicago, 1987

Rosenthal, Mark, *Jasper Johns: Work Since 1974* (exh. cat.), Philadelphia Museum of Art, 1988

Rosenthal, Mark, *Neil Jenney: Retrospective* (exh. cat.), Berkeley, CA, 1980

Ross Bleckner (exh. cat.), Kunsthalle, Zurich, 1990

Ross, David A., *Between Spring and Summer: Soviet Conceptual Art in the Era of Late Communism*, Cambridge, Mass., 1990

Ross, David A., *William Wegman: Paintings, Drawings, Photographs, Videotapes* (exh. cat.), Whitney Museum of American Art, NY, 1990

Roy Lichtenstein (exh. cat.), Musée d'Art, Lausanne, 1993

Rubin, Lawrence, *Frank Stella: Paintings 1958 to 1965, Catalogue Raisonné*, NY, 1986

Rubin, William S., *Frank Stella* (exh. cat.), Museum of Modern Art, NY, 1970

Rubin, William, *Frank Stella, 1970-1987* (exh. cat.), Museum of Modern Art, NY, 1987

Rubinstein, Meyer Raphael, 'Outdoor Eye: George Sugarman's Public Sculpture,' *Arts Magazine*, vol. 64, Jan. 1990, pp. 76-7

Rufino Tamayo: Myth and Magic (exh. cat.), Solomon R. Guggenheim Museum, NY, 1979

Russell, John, *Francis Bacon*, NY, 1971

Russell, John, *Jennifer Bartlett: in the Garden*, NY, 1982

Russell, John, *The Meanings of Modern Art*, NY, 1981

Russell Taylor, John, *Ricardo Cinalli*, Florence, 1992

Russische und Sowjetische Kunst – Tradition und Gegenwart: Werke aus sechs Jahrhunderten (exh. cat.), Kunstverein für die Rheinlande und Westfalen and Städtische Kunsthalle, Düsseldorf, Staatsgalerie, Stuttgart and Kunstverein, Hanover, 1984-5

Rustin (exh. cat.), Städtische Galerie Schloss Oberhausen, Oberhausen, 1994

Ruy-Sánchez, Alberto, and Edward Lucie-Smith, *Ofelia Rodriguez* (exh. cat.), Galeria Ramis Barquet, Mexico City, 1994

Saltz, Jerry, *Beyond Boundaries: New York's New Art*, NY, 1986

Sandro Chia: novanta spina al vento (exh. cat.), Museum Moderner Kunst, Vienna, 1989

Schellmann, Jörg, and Josephine Benecke, eds., *Christo, Prints and Objects 1963-1987*, Munich and NY, 1988

Schiff, Richard, 'The Necessity of Jimmie Durham's Jokes: "Indian Arts and Crafts Act of 1990"', *Art Journal*, vol. 51, fall 1992, pp. 74-80

Schjeldahl, Peter, *Eric Fischl*, NY, 1988

Schnabel, Julian, *C.V.J – Nicknames of Maitre D's and other Excerpts from Life*, NY, 1987

Schulz-Hoffmann, Carla, *Emilio Vedova*, Munich, 1986

Schwartzman, Myron, *Romare Bearden: His Life and Art*, NY, 1990

Scott Burton: Skulpturen, 1980-9 (exh. cat.), Kunstverein für die Rheinlande und Westfalen, Düsseldorf, 1989

Selz, Peter and James Johnson Sweeney, *Chillida*, NY, 1986

Selz, Peter, *Sam Francis*, NY, 1982

Sergeant, Philippe, *Donald Sultan, Appogiaturas*, 2 vols., NY and Cambridge, Mass., 1992

Serrano, Eduardo, *Cien años de arte colombiana* (exh. cat.), Museo de Arte Moderna, Bogotá, 1986

Seven in the 80s (exh. cat.), Center for Latin American Arts and Studies, the Metropolitan Museum and Art Center, Coral Gables, Florida, 1986 (Diulio Pierri)

Seymour, Anne, *The New Art* (exh. cat.), Hayward Gallery, Arts Council of Great Britain, London, 1972

Shanes, Eric, *Jack Beal*, NY, 1993

Shani Rhys James, Blood Ties (exh. cat.), Wrexham Library Arts Centre, Wrexham, 1993

Shelton, Peter, *Floatinghouse Deadman, and Related Work by Peter Shelton* (exh. cat.), Wight Art Gallery, University of California, Los Angeles, 1987

Shepherd, Elizabeth, ed., *Secret Dialogues, Revelations: the Art of Betye and Alison Saar* (exh. cat.), The Wight Art Gallery, University of California, Los Angeles, 1990

Sherman, Sandra, 'Titles-Entitlement: Rhetoric and Reappropriation in the Art of James Magee', *Pre-Text: Journal of Rhetorical Theory*, vol. 14.1-2, summer 1994

Shone, Richard, *Damien Hirst* (exh. cat.), British Council London for Turkish Biennial, Istanbul, 1992

Shone, Richard, *Some Went Mad, Some Ran Away…* (exh. cat.), Serpentine Gallery, London, 1994

Shunk, Harry, *Christo: Valley Curtain – Rifle, Colorado, 1970-72*, NY, 1973

Siah Armajani (exh. cat.), Kunsthalle, Basle, and Stedelijk Museum, Amsterdam, 1987

Siegel, Jeanne, ed., *Art Talk: the Early 80s*, Ann Arbor, 1988

Sigmar Polke (exh. cat.), Stedelijk Museum, Amsterdam, 1992

Simon, Joan, *Susan Rothenberg*, NY, 1991

Simonds (exh. cat.), Galerie Maeght Lelong, Paris, 1986

Sims, Lowry Stokes, *Julio Galán* (exh. cat.), Museo de Monterrey, Mexico, 1987

Smith, Peter, *Ralph Hotere: a Survey, 1963-73* (exh. cat.), Dunedin Public Art Gallery, NZ, 1974

Smith, Roberta, *Jennifer Bartlett, Rhapsody*, NY, 1985

Sol LeWitt (exh. cat.), Museum of Modern Art, NY, 1978

Sol LeWitt, Drawings 1958-1992 (exh. cat.), Haags Gemeentemuseum, The Hague, 1992

Sol LeWitt: Structures 1962-1993 (exh. cat.), Museum of Modern Art, Oxford, 1993

Sol LeWitt: Walldrawings, 1984-1988 (exh. cat.), Kunsthalle, Berne, 1988

Sondheim, Alan, ed., *Individuals: Post-Movement Art in America*, NY, 1977

Sonfist, Alan, *Autobiography of Alan Sonfist*, Ithaca, 1975

South Bronx Hall of Fame: Sculpture by John Ahearn and Rigoberto Torres (exh. cat.), Contemporary Arts Museum, Houston, 1991

Spero, Nancy, 'Tracing Ana Mendieta', *Artforum*, April 1992

Spero, Nancy, *Rebirth of Venus*, Kyoto, 1989

Spies, Werner, *Christo: The Running Fence* (exh. cat.), Kestner-Gesellschaft, Hanover, 1978

Spies, Werner, *Fernando Botero: Paintings and Drawings*, Munich, 1992

The Spiritual in Art: Abstract Painting 1890-1985 (exh. cat.), Los Angeles Country Museum of Art, 1986

Springfeldt, Bjorn, *Jonathan Borofsky* (exh. cat.), Moderna Museet, Stockholm, 1984

Stackelhaus, Heiner, *Joseph Beuys*, NY, 1991

Stella, Frank, *Working Space: the Charles Eliot Norton Lectures 1983-4*, Cambridge, Mass., 1986

Storr, Robert, and Yves Michaud, *Joan Mitchell* (exh. cat.), Musée des Beaux-Arts, Nantes, and Galerie Nationale du Jeu de Paume, Paris, 1994

Strand, Mark, *William Bailey*, NY, 1987

Stuart Brisley (exh. cat.), Tate Gallery, London, 1982

Sturges, Hollister, *New Art from Puerto Rico* (exh. cat.), Museum of Fine Arts, Springfield, 1990

Sullivan, Edward J., 'Sanctus Circus: the art of Alejandro Colunga', *Arts Magazine*, vol. 61, Feb. 1987, pp. 72-5

Sullivan, Edward J., and Jean Clarence Lambert, *Alejandro Colunga 1966-1986* (exh. cat.), Museo de Monterrey, 1986

Sullivan, Edward J., *Roberto Marquez: Sojourns in the Labyrinth* (exh. cat.), Tucson Museum of Art, Arizona, 1994

Sussman, Elisabeth, with Thelma Golden, John G. Hanhardt and Lisa Phillips, *1993 Biennial Exhibition* (exh. cat.), Whitney Museum of American Art, NY, 1993

Sylvester, David, *Malcolm Morley* (exh. cat.), Anthony d'Offay Gallery, London, 1990

Sylvester, Julie, *John Chamberlain: a Catalogue Raisonné of the Sculpture, 1954-1985*, NY, 1986

Syring, Marie Luise, ed., *Bill Viola: Unseen Images* (exh. cat.), Städtische Kunsthalle, Düsseldorf and Whitechapel Art Gallery, London, 1992

Szeeman, Harald, ed., *Cy Twombly: Paintings, Works on Paper, Sculpture* (exh. cat.), Whitechapel Art Gallery, London, 1987

Szeeman, Harald, ed., *Live in Your Head: when Attitudes Become Form*, Berne, 1969

Szeeman, Harald, *Georg Baselitz* (exh. cat.), Kunsthaus, Zurich, 1990

Szeeman, Harald, *Mario Merz*, 2 vols., Zurich, 1985

Taiarota (exh. cat. published in conjunction with a touring exhibition of contemporary Maori art in the United States), Te Waka Toi: Council for Maori and South Pacific Arts, Wellington, NZ, 1992

Talley, Charles S., 'Olga de Amaral', *American Craft*, vol. 48, April-May 1988, pp. 38-45

Tannebaum, Judith, *Vija Celmins* (exh. cat.), Institute of Contemporary Art, University of Pennsylvania, Philadelphia, 1992

Taragin, Davina Spiro, *Furniture by Wendell Castle*, NY, 1989

Taylor, Joshua C., et al., *Fritz Scholder*, NY, 1982

Taylor, Paul, 'Jenny Holzer: I Wanted to Do a Portrait of Society', *Flash Art* (international edition), vol. 151, March/April 1990, pp 116-19

Temkin, Ann and Bernice Rose, *Thinking is Form: The Drawings of Joseph Beuys*, London, 1992

Terada,Toru, *Japanese Art in World Perspective*, NY and Tokyo, 1976

Terry Winters: Painting and Drawing (exh. cat.), Walker Art Center, Minneapolis, 1987

Tetsuya Noda, Works 1982-84 (exh. cat.), Fuji Television Gallery, Tokyo, 1983

Tidholm, Thomas, *Mimmo Paladino*, Stockholm, 1991

Tisdall, Caroline, *Joseph Beuys* (exh. cat.), Solomon R. Guggenheim Museum, NY, 1979

Tomkins, Calvin, *Off the Wall, Robert Rauschenberg and the Art World of Our Time*, NY, 1980

Tomkins, Calvin, *Post- to Neo-: The Art World of the 1980s*, NY, 1988

Tony Berlant, New Work 1990-3 (exh. cat.), L.A. Louver Gallery, Venice, CA, 1993

Tony Cragg (exh. cat.), Hayward Gallery, South Bank Centre, London, 1987

Tosatto, Guy and Bernard Marcadé, *Sigmar Polke* (exh. cat.), Carré d'Art, Nîmes, and IVAM Centro Julio Gonzalez, Valencia, 1994

Tremlett, David, *Sometimes We All Do*, Bari, 1988

Tsai, Eugenie, *Robert Smithson Unearthed: Drawings, Collages, Writings*, NY, 1991

Tsujimoto, Karen, *Wayne Thiebaud* (exh. cat.), San Francisco Museum of Modern Art, 1985

Tufts, Eleanor, *Our Hidden Heritage: Five Centuries of Women Artists*, London, 1974

Twenty One Figures By Robert Graham (exh. cat.), Robert Miller Gallery, NY, 1990

Ukeles, Mierle Laderman, 'A Journey: Earth/City/Flow', *Art Journal*, vol. 51, summer 1992, pp. 12-14

Ulrich Rückriem: Skulpturen, Zeichnungen (exh. cat.), Landesmuseum für Kunst und Kulturgeschichte, Münster, 1985

Un certain art anglais: sélection d'artistes britanniques 1970-1979 (exh. cat.), ARC/ Musée d'Art Moderne de la Ville de Paris, 1979

Unbound: Possibilities in Painting (exh. cat.), Hayward Gallery, London, 1994

Vaizey, Marina, *Christo*, Barcelona, 1990

Vallier, Dora, *La Peinture en France: début et fin d'un système visuel 1870-1970*, Milan, 1976

Van Bruggen, Coosje, *Bruce Nauman*, NY, 1988

Varnedoe, Kirk, *Duane Hanson*, NY, 1985

Varnedoe, Kirk, *Cy Twombly: a Retrospective* (exh. cat.), Museum of Modern Art, NY, 1994

Verso l'Arte Povera (exh. cat.), Padiglione d'Arte Contemporanea, Milan, 1989

Viola Frey: a Retrospective (exh. cat.), Crocker Art Museum, Sacramento, CA, 1981

Vogel, Susan, *Africa Explores; 20th Century African Art* (exh. cat.), The Center for African Arts, NY, 1991

Von Der Revolution zur Perestroika: Sowjetische Kunst aus der Sammlung Ludwig (exh. cat.), Kunstmuseum, Lucerne, 1989

Waldberg, Michel, *Joan Mitchell*, Paris, 1992

Waldberg, Michel, *Sam Francis: métaphysique du vide*, Paris, 1986

Waldman, Diane, *Anthony Caro*, NY, 1982

Waldman, Diane, *Jenny Holzer* (exh. cat.), Solomon R. Guggenheim Museum, NY, 1989

Waldman, Diane, *Kenneth Noland: a Retrospective* (exh. cat.), Solomon R. Guggenheim Museum, NY, 1977

Waldman, Diane, *Roy Lichtenstein*, NY, 1993

Walker, John A., *Art Since Pop*, London, 1975

Walker, John A., *Art in the Age of the Mass Media*, 2nd revised edn., London, 1994

Wallis, Brian, ed., *Art After Modernism: Rethinking Representation*, NY, 1984

Warner, Marina, *Paula Rego's Nursery Rhymes*, London, 1994

Warner, Marina, *Richard Wentworth*, London, 1994

Weider, Laurance, *Full Circle: Panoramas by Kenneth Snelson*, NY, 1990

Weight, Angela, *Gulf/John Keane* (exh. cat.), Imperial War Museum, London, 1992

The Welfare State, The Travels of Lancelot Quail, n.p. [London?], n.d. [1973?]

West, Margie K.C., *The Inspired Dream: Life as Art in Aboriginal Australia* (exh. cat.), Queensland Art Gallery, Northern Territory, Australia

Wheeler, Daniel, *Art Since Mid-Century: 1945 to the Present*, NY, 1991

Who Chicago? (exh. cat.), Ceolfrith Gallery, Sunderland Arts Centre, Sunderland, 1981

Wilkin, Karen, *Kenneth Noland*, NY, 1990

Willder, Jill, *Elisabeth Frink, Sculpture: Catalogue Raisonné*, Salisbury, Wiltshire, 1984

William Beckman; Gregory Gillespie (exh. cat.), Rose Art Museum, Waltham, Mass., 1984

William T. Wiley: Wizdum (exh. cat.), University Art Museum, Berkeley, CA, 1971

Wojnarowicz, David, *Close to the Knives: a Memoir of Disintegration*, NY, 1991

Wojnarowicz, David, *Memories that Smell like Gasoline*, San Francisco, 1992

Wolfgang Laib (exh. cat.), Kunstmuseum, Lucerne, 1990

Working with Nature: Traditional Thought in Contemporary Art from Korea (exh. cat.), Tate Gallery, Liverpool, 1992

Wye, Deborah, *Louise Bourgeois* (exh. cat.), Museum of Modern Art, NY, 1983

Yukinori Yanagi (exh. cat.), Lehman College Art Gallery, NY, 1991

Yves Klein (exh. cat.), Centre Georges Pompidou, Paris, 1983

Yves Klein (exh. cat.), The Jewish Museum, NY, 1967

Yvonne Jacquette: Recent Drawings and Pastels, 1982-3 (exh. cat.), St Louis Art Museum, 1983-4

Zweite, Armin, *Joseph Beuys: Natur, Materie, Form*, Munich, 1992

Zweite, Armin, *Robert Rauschenberg* (exh. cat.), Kunstsammlung Nordrhein-Westfalen, Düsseldorf, 1994

Chronology

1960 Andy Warhol makes his first comic strip painting, *Dick Tracy*. Wesselman exhibits his first *Great American Nudes* at the Tanager Gallery, New York. Exhibition 'New Forms, New Media', the Martha Jackson Gallery, New York. 'Monochrome Malerei', Städtisches Museum, Leverkusen. 'Kinetische Kunst', Kunstgewerbe Museum, Zurich. César makes his first *Compressions*. Pierre Restany publishes his New Realist Manifesto.

1961 Berlin Wall constructed. 'The Art of Assemblage', The Museum of Modern Art, New York. 'Le Nouveau Réalisme à Paris et à New York', Galerie Rive Droite, Paris. Joseph Beuys begins teaching at Düsseldorf Kunstakademie. Publication of Clement Greenberg's *Art and Culture*. Independently of Warhol, Roy Lichtenstein paints his first works based on comic strips. Claes Oldenburg opens his 'Store' on East 2nd Street. David Hockney paints *We Two Boys Together Clinging*. Nueva Prescencia group (opposed to Mexican Muralism) founded in Mexico.

1962 Warhol paints Marilyn Monroe and Campbell's soup cans, and has his first solo exhibition at the Ferus Gallery, Los Angeles. Ed Ruscha produces his first book of photographs, *Twenty Six Gasoline Stations*. 'The New Painting of Common Objects', Pasadena Art Museum. BBC television film 'Pop goes the Easel'. Pop Art covered by *Time*, *Life*, and *Newsweek*. First Fluxus concerts in Europe. 'Anti-peinture', Hessenhuis, Antwerp.

1963 Kennedy is assassinated. US begins its involvement in Vietnam. 'Towards a New Abstraction', Jewish Museum, New York. 'Mixed Media and Pop Art', Albright-Knox Art Gallery, Buffalo.

1964 'Post-Painterly Abstraction', Los Angeles County Museum. 'The Shaped Canvas', Solomon R. Guggenheim Museum, New York. 'Amerikanst Pop-Konst', Moderna Museet, Stockholm. 'Hard-Edge', Galerie Denise René, Paris.

1965 Andy Warhol's first retrospective, University of Pennsylvania, Philadelphia. 'Inner and Outer Space', Moderna Museet, Stockholm. 'The Responsive Eye', The Museum of Modern Art, New York. First 'New Generation' show at Whitechapel Art Gallery, London. Colombian critic Marta Traba publishes the book *Los cuatro monstruos cardinales* in Mexico City: a further attack on Muralism.

1966 'Primary Structures', Jewish Museum, New York. 'Systematic Abstraction', Solomon R. Guggenheim Museum, New York. First 'Hairy Who' group show, Hyde Park Art Center, Chicago. 'Art of Latin America since Independence', Yale University Art Gallery. Cutai Group exhibition, Galerie Stadler, Paris. 'Weiss auf Weiss', Kunsthalle, Berne.

1967 Six-Day War between Israel and Arab nations. Che Guevara killed in Bolivia. 'Language to be Looked at and/or Things to be Read', Dwan Gallery, New York. 'Lumière et Mouvement' exhibition in Paris. 'Light-Motion-Space', Walker Art Center, Minneapolis. 'Arte Povera', Galleria la Bertesca, Genoa. 'Sculpture of the Sixties', Los Angeles County Museum of Art. 'Yves Klein', Jewish Museum, New York. 'Funk', University of California, Berkeley.

1968 Martin Luther King assassinated. 'Les événements' - student rioting in Paris. 'The Art of the Real', The Museum of Modern Art, New York. 'Minimal Art', Gemeentemuseum, The Hague. 'Earthworks', Dwan Gallery, New York. 'Realism Now', Vassar College Art Museum, Poughkeepsie.

1969 'Anti-Illusion: Procedures/Materials', Whitney Museum of American Art, New York. 'When Attitudes Become Form', Kunsthalle, Berne, Museum Haus Lange, Krefeld, and ICA, London. 'Conceptual Art', Städtisches Museum, Leverkusen. 'Land Art', Fernsehgalerie, Düsseldorf. 'Art by Telephone', Museum of Conceptual Art, Chicago. Joseph Kosuth publishes 'Art After Philosophy' in *Studio International*. First issue of *Art & Language* is published.

1970 'Conceptual Art and Conceptual Aspects', New York Cultural Center. 'Conceptual Art, Arte Povera, Land Art', Galleria Civica de Arte Moderna, Turin. 'Information', The Museum of Modern Art, New York. 'Kunst und Politik', Kunst- und Museumverein, Wuppertal. Judy Chicago organizes the first feminist art course at the California State College at Fresno.

1971 Fighting in Vietnam spreads to Laos and Cambodia. 'Art and Technology', Los Angeles County Museum of Art. 'Contemporary Black Artists in America', Whitney Museum of American Art, New York. 'Multiples - The First Decade', Philadelphia Museum of Art. 'Earth, Air, Fire, Water: Elements of Art', Museum of Fine Arts, Boston. 'Radical Realism', Museum of Contemporary Art, Chicago.

1972 'The New Art', Hayward Gallery, London. 'Sharp-Focus Realism', Sidney Janis Gallery, New York. 'American Women Artists', Kunsthaus, Hamburg.

1973 Allende is overthrown in Chile. 'Photo-Realism', Serpentine Gallery, London. 'Kunst aus Fotografie', Kunstverein, Hanover. Mary Kelly begins work on *Post Partum Document* (-1979). First Sydney Biennale.

1974 Nixon resigns in the aftermath of Watergate. 'Art vidéo - confrontation 74', ARC/Musée d'Art Moderne de la Ville de Paris. 'Art into Society, Society into Art: Seven German Artists', Institute of Contemporary Arts, London. 'The Great Decade of American Abstraction: Modernist Art 1960 to 1970', Museum of Fine Arts, Houston.

1975 Last Americans are evacuated from South Vietnam. 'Bodyworks', Museum of Contemporary Art, Chicago. 'Images du peuple chinois', ARC/Musée d'Art Moderne de la Ville de Paris. 'Artists' Video Tapes', Palais des Beaux-Arts, Brussels. 'The Video Show', Serpentine Gallery, London. 'Jubilee: Afro-American Artists in Afro America', Museum of Fine Arts, Boston.'

1976 'The Human Clay', selected by R.B. Kitaj, Hayward Gallery, London. 'Women Artists: 1550-1950', Los Angeles County Museum of Art. 'Two Centuries of Black American Art', Los Angeles County Museum of Art.

1977 Opening of the Centre Pompidou, Paris. 'Europe in the Seventies: Aspects of Recent Art' , Art Institute of Chicago. 'Unofficial Art from the Soviet Union', Institute of Contemporary Arts, London.

1978 'Bad Painting', New Museum of Contemporary Art, New York. 'Art about Art', Whitney Museum of American Art, New York. 'New Image Painting', Whitney Museum of American Art, New York.

1979 'Moderne Kunst aus Afrika', Staatliche Kunsthalle, Berlin. 'Joseph Beuys ' (retrospective exhibition), Solomon R. Guggenheim Museum, New York. International Symposium of Performance Art, ELAC, Lyons. 'Pattern Painting', Palais des Beaux-Arts, Brussels. 'The Art of Performance', Palazzo Grassi, Venice. 'Un certain art anglais: sélection d'artistes britanniques 1970-1979', ARC/ Musée d'Art Moderne de la Ville de Paris. Germaine Greer publishes *The Obstacle Race: the Fortunes of Women Painters and Their Work*. Judy Chicago, *The Dinner Party*.

1980 'Die Neuen Wilden', Neue Galerie, Sammlung Ludwig, Aachen. 'Women's Images of Men', Institute of Contemporary Arts, London. Robert Mapplethorpe exhibits the series *Black Males* at the Galerie Jurka, Amsterdam.

1981 'A New Spirit in Painting', Royal Academy of Arts, London. 'Westkunst', Museen der Stadt, Cologne.'Not Just for Laughs - The Art of Subversion', The New Museum, New York.

1982 'Transavantguardia', Galleria Civica, Modena. 'Zeitgeist', Martin Gropius-Bau, Berlin. 'Englische Plastik Heute', Kunstmuseum, Lucerne. 'India, Myth and Reality, Aspects of Modern Indian Art', Museum of Modern Art, Oxford. 'Postminimalism', Aldrich Museum of Contemporary Art, Ridgefield, Conn.

1983 'The New Art', Tate Gallery, London. 'D'un autre continent: Australie, le rêve et le réel' (with twelve Aboriginal artists), ARC/Musée d'Art Moderne de la Ville de Paris. 'Art vidéo - rétrospectives et perspectives', Palais des Beaux-Arts, Charleroi. 'Post Graffiti', Sidney Janis Gallery, New York. Museum of Contemporary Art (designed by Isozaki) opens in Los Angeles. Italo Mussa publishes *La pittura colta*. Mary Kelly publishes *Post Partum Document*.

1984 'An International Survey of Recent Painting and Sculpture', The Museum of Modern Art, New York. 'Primitivism in 20th Century Art', The Museum of Modern Art, New York.'The Hard-Won Image', Tate Gallery, London.'Content: a Contemporary Focus 1974-1984', Hirshhorn Museum and Sculpture Garden, Washington DC.

1985 Gorbachev comes to power in Russia - beginning of *perestroika*. 'Kunst in der Bundesrepublik Deutschland 1945-1985', Nationalgalerie, Berlin.

1986 'The Spiritual in Art: Abstract Painting 1890-1985 ', Los Angeles County Museum of Art. 'Performance Art and Video Installations', Tate Gallery, London. 'Japon des avant-gardes, 1910-1970', Centre Georges Pompidou, Paris. 'Damaged Goods - Desire and the Economy of the Object', The New Museum, New York. 'Endgame: Reference and Simulation in Recent Painting and Sculpture', Institute of Contemporary Art, Boston.

1987 'New York Art Now', Saatchi Collection, London. 'Berlinart 1961-1987', The Museum of Modern Art, New York. 'Art of the Fantastic: Latin America, 1920-1987', Indianapolis Museum of Art. 'Hispanic Art in the United States: Thirty Contemporary Painters and Sculptors' , Museum of Fine Arts, Houston. 'Modernidade: art brésilien du 20e siècle', Musée d'Art Moderne de la Ville de Paris. 'Similia/Dissimilia', Städtische Kunsthalle, Düsseldorf. 'Art Against AIDS', exhibitions in 72 New York galleries. Charles Jencks publishes *Post-Modernism: Neo-Classicism in Art and Architecture*.

1988 'Cultural Geometry', Deste Foundation for Contemporary Art, Athens. 'Refigured Painting: The German Image 1960-88', Solomon R. Guggenheim Museum, New York.

1989 The wall comes down in Berlin. 'The Other Story: Afro-Asian Artists in Post-War Britain', Hayward Gallery, London. 'Black Art: Ancestral Legacy - the African Impulse in African American Art', Dallas Museum of Art. 'Magiciens de la terre', Centre Georges Pompidou and la Grande Halle de la Villette, Paris. 'Art in Latin America', Hayward Gallery, London. 'L'Art conceptuel, une perspective', Musée d'Art Moderne de la Ville de Paris. 'A Forest of Signs - Art in the Crisis of Representation', Museum of Contemporary Art, Los Angeles. 'The New Italian Manner', Mayer Schwarz Gallery, Beverly Hills, CA. Linda Nochlin publishes *Women, Art and Power and Other Essays*.

1990 Germany is reunited. Collapse of the Soviet empire. 'The Quest for Self-Expression: Painting in Moscow and Leningrad 1965-1990', Columbus Museum of Art, Columbus, Ohio. 'Contemporary Russian Artists: Artisti Russi Contemporanei', Centro per l'Arte Contemporanea Luigi Pecci, Prato. 'Artificial Nature', Deste Foundation for Contemporary Art, Athens, Geneva, New York. Ilya Kabakov, *He lost his Mind, Undressed, and Ran away Naked*, Ronald Feldman Fine Arts, New York. 'L'Art en France, 1945-1990', Fondation Daniel Templon, Musée temporaire, Fréjus. 'Nuevos momentos del arte mexicano/New Moments in Mexican Art', Parallel Project. 'Between Spring and Summer: Soviet Conceptual Art in the Era of Late Communism', Institute of Contemporary Arts, Boston.'Culture and Commentary - an Eighties Perspective', Hirshhorn Museum and Sculpture Garden, Washington DC. Lucy R.Lippard publishes *Mixed Blessings: New Art in a Multi-Cultural America*.

1991 Civil war in Yugoslavia. 'CARA: Chicano Art, Resistance and Affirmation', Wight Art Gallery, University of California, Los Angeles. 'Strange Abstraction', Touko Museum of Contemporary Art, Japan. 'From Art to Archaeology', South Bank Centre, London. 'Arte e arte', Museo d'Arte Contemporanea, Castello di Rivoli, Turin. 'Mana Tiriti: the Art of Protest and Partnership', Haeta Maori Women's Art Collective, Project Waitangi, Wellington City Art Gallery,Wellington, NZ. 'Headlands: Thinking Through New Zealand Art', Museum of Contemporary Art, Sydney. 'Metropolis', Martin Gropius-Bau, Berlin.

1992 'Post Human', FAE Musée d'Art Contemporain, Pully/Lausanne. 'Young British Artists', Saatchi Collection, London. 'Quattro artisti della nuova maniera italiana', Museum of Modern and Contemporary Art, Città della Pieve. 'Working with Nature: Traditional Thought in Contemporary Art from Korea', Tate Gallery, Liverpool.

1993 'Aratjara: Art of the First Australians', Kunstsammlung Nordrhein-Westfalen, Düsseldorf. 'China Avant-Garde', Haus der Kulturen der Welt, Berlin, and Museum of Modern Art, Oxford. 'Artistas latinoamericanos del siglo XX: Latin American Artists of the Twentieth Century', The Museum of Modern Art, New York. 1993 Biennial Exhibition' (the 'politically correct Biennial'), Whitney Museum of American Art, New York.

1994 *Some Went Mad, Some Ran Away ...*, Serpentine Gallery, London. 'Unbound: Possibilities in Painting', Hayward Gallery, London. 'Japanese Art after 1945: Scream Against the Sky', Solomon R. Guggenheim Museum, New York.

Index

Acknowledgements

Chapter openers

p. 15 (David Hockney): Tate Gallery Archive

p. 47 (Richard Serra): *Weight and Measure*, 1992, courtesy Tate Gallery, London

p. 75 (Frank Stella): photo Hollis Frampton/Knoedler Gallery, NY

p. 111 (Christo): Annely Juda Fine Art, London

p. 135 (Rebecca Horn): Marian Goodman Gallery, NY/photo Uteperrey, Berlin

p. 171 (Leon Golub): photo David Reynolds

p. 203 (Chuck Close): © David A. Gaffiga/Pace Wildenstein, NY

p. 253 (Bruce McClean): photo Rory Carnegie/Anthony d'Offay Gallery, London

p. 279 (Rachel Whiteread): Karsten Schubert, London

p. 300 (Julian Schnabel): photo Paul Seward

p. 330 (Ed Moses): photo Jim McHugh

p. 358 (Julio Galán): Annina Nosei Gallery, NY

p. 386 (Komar & Melamid): photo James Dee/Ronald Feldman Fine Arts, NY

p. 398 (Shusaku Arakawa): the artist and Madeline Gins

p. 422 (Leonard Daley): Barbara Goodbody Photography/ National Gallery of Jamaica

p. 434 (Martin Puryear): McKee Gallery, NY

p. 458 (Cindy Sherman): photo David Seidner/Metro Pictures, NY

All works of art by artists still in copyright are © the artists or their successors in title.

The portraits of artists opening each
chapter are as follows:

Phaidon Press Limited
Regent's Wharf
All Saints Street
London N1 9PA

First published 1995
© Phaidon Press Limited 1995

A CIP catalogue record for this book is
available from the British Library

ISBN 0 7148 3201 4

Printed in Italy

Publisher's note: This is a completely
new book, bearing no relation in
content, illustration or design to the
author's previous *Art Today*, first
published by Phaidon Press in 1977.